DIRECTORY OF BRITISH PHOTOGRAPHIC COLLECTIONS

DIRECTORY OF BRITISH PHOTOGRAPHIC COLLECTIONS

Compiled by
John Wall, PhD, MA, FRPS
at The National Photographic Record,
a department of
The Royal Photographic Society

A Royal Photographic Society Publication

HEINEMANN : LONDON

William Heinemann Ltd.
15 Queen Street, Mayfair, London W1X 8BE

LONDON MELBOURNE TORONTO
JOHANNESBURG AUCKLAND

First published 1977
© Royal Photographic Society 1977

434 92226 9

Printed in Great Britain by Eyre and Spottiswoode Ltd.
at Grosvenor Press, Portsmouth, Hampshire

CONTENTS

HOW TO USE THE DIRECTORY

Photographic collections can be classified in a number of different ways, but experience has shown conclusively that the majority of *users* of photographs are above all interested in their *subject matter*. For convenience this Directory is therefore *subject-ordered*, that is to say collections are grouped together in one place according to their dominant subject. These subjects do *not* follow each other alphabetically but according to a connected sequence of ten major divisions which are given, together with their sub-divisions, in the Quick Subject Guide between pages xvii–xix. For example, all collections whose dominant subject is Arts and Crafts will be found between pages 34–56, and within that major division, all collections whose dominant subject is Architecture will be found between pages 37–49. For someone whose primary interest lies in subject matter therefore the first way into the Directory is to consult the Quick Subject Guide.

Of course most collections consist of not one but many subjects. We have tried to identify as many as possible for each collection – first the Dominant Subject and then the Subsidiary Subjects. All are listed alphabetically in the Subject Index between pages 179–201. Every collection featured in this Directory – and there are almost 1600 in all – has been allocated a serial number, and it is this number which is used in all the Indexes. The numbers, and hence the entries to which they have been allocated, follow each other in sequence through the Directory from 1 to 1582. Having consulted an Index the reader will discover that it is quite easy to locate the particular collection or collections which he has in mind by means of these serial numbers. As an additional aid each page is headed with the first and last serial numbers for the entries on that page; and the first and last subjects with which they deal. For example page 86 contains entries numbered 784–792 the first of which has as its dominant subject Butterflies and the last of which has as its dominant subject Medicine. For someone whose primary interest is subject matter therefore, the second way into the Directory is to consult the Subject Index. In each entry the dominant subject is printed in capitals, whilst in the Index it is indicated by a number in heavy type; a subsidiary subject is printed in lower case in the entry, whilst in the Index it is denoted by a number in light type.

The *subject* of a particular collection is not, however, by any means the only fact which a user may wish to know. Again, experience has shown that such information can conveniently be grouped under thirteen main headings: Owner; Location; Title; Custodian; Dates; History; Photographer; Subjects; Numbers; Aids; Access; Copies; Charges. The reader will find that every entry in this Directory contains information under some or all of these standard headings. (The wealth of carefully annotated information which they introduce in total, has never before been assembled between the covers of a single volume). The headings themselves are explained in greater detail in the section 'Guide to the Entries' on page 00, which should be consulted before proceeding.

For even greater convenience all the most sought after information has been thoroughly indexed. Thus, in addition to the subject index, we have provided separate indexes for the owners, locations and titles of collections, and finally an index to the photographers whose names appear in the entries.

Some of the more commonly used words and photographic conventions have been abbreviated. A key to abbreviations has been provided at the foot of each facing page.

For Easy Reference

1. There are a limited number of very large 'commercial' collections, running to some millions of photographs each, which are so comprehensive in scope that it is impossible either to name one dominant subject or to list all the many subsidiary subjects which they compass. All collections of this kind are included either in the *General* subject category or in the *History and News* category (between pages 170–177 and 168–170 respectively). Users will be able to obtain from any of these collections copies of almost any subject they may require. The principal *General* and *News* collections in this country are listed below, but the individual entries should be consulted for fuller details.

General
Barnaby's Picture Library
B. T. Batsford Ltd.
Colour Library International Ltd.
Daily Telegraph
North Atlantic Press Agencies Ltd.
Pictor International Ltd.
Pictorial Press Ltd.

Popperfoto
Radio Times Hulton Picture Library
Spectrum Colour Library
Zefa Picture Library (UK) Ltd.

News
Bensen's International Press Services Ltd.
Financial Times
Keystone Press Agency Ltd.
Pixfeatures Picture Library
The Press Association Ltd.
Rex Features Ltd.
S & G Press Agency Ltd.
Syndication International Ltd.

2. One very important category which has generated a great deal of interest in recent years is that of Collections of Historic or Antique Photographs. Foremost among such collections are examples of the work of the pioneers of photography in Britain, at whose head stands William Henry Fox Talbot. They may also include, however, early examples of historic photographic processes and techniques, or rare photographs of particular subjects, especially portraits and historic events. All are valuable in monetary terms and individual photographs of this kind are much sought after by collectors. For their convenience and that of the many other cognoscenti who have a particular interest in historic photographs, in this one instance we have departed from the strict rule by which the Directory is subject-ordered and we have grouped this relatively small number of collections together (numbers 493–509) between pages 53–56.

3. Where there are a number of collections dealing with the same subject they are arranged alphabetically according to the owner's surname or according to the title of the collection, as appropriate. Similarly, places in England, in Wales, in Scotland and in Northern Ireland are arranged alphabetically, as are places abroad.

This first-ever Directory of British Photographic Collections has been compiled by the National Photographic Record which is a Department of The Royal Photographic Society of Great Britain. It provides a comprehensive account of all the photographic collections of note in the British Isles, in response to a widespread need felt and voiced increasingly in the world of photography at large. It seems fitting that Great Britain, the home of so many notable advances in the science and the art of photography, should at last be provided with a 'native' Directory of its photographic collections, many of which are unique and irreplaceable.

Scope

The scope of this work has largely been dictated by the principal users of photographs of every kind – that is publishers, newspapers, agencies, television companies, educational institutions, social historians, students and researchers, and conservationists. It is therefore tailored to meet their specific needs. For all classes of user, however, the Directory should be a mine of information and an invaluable reference work. It is unique of its kind, for remarkably there has been hitherto no single, up-to-date, comprehensive reference work devoted solely to photographs as such.

Conservation

There is an additional reason why a Directory has been long overdue, which can be summed up in the one word CONSERVATION. Coinciding with the demand for a readily accessible source of information relating to photographic collections, there has been an increasing recognition of the *worth* of photographs – in fact there has been an explosion of interest in their significance. In the first place, there has been a marked increase in the monetary value of truly 'historic' photographs. In the second place photographs have 'come of age' as pictorial sources of information in their own right, as social documentaries of every aspect of life and work in Britain from the beginnings of photography in the 1830s to the present day. Photographs are now recognized as valuable archives in themselves. With the passage of time all photographic collections acquire an archival interest for students and historians. Yet paradoxically many photographic collections are under the threat of damage, deterioration, destruction or dispersal. Consequently there has grown a widespread recognition of the need to

conserve Britain's rich heritage of photographic collections, to make them more readily accessible, and to bring into the light of day, as the National Photographic Record has done, interesting collections – even family albums – which have hitherto been considered by their owners to merit no special care, and which in many cases have been relegated to dusty attics. The identification of such collections in a Directory is the first step towards their preservation, and it is our hope that the publication of this work will itself stimulate other 'anonymous' owners to seek out and appraise their hitherto unregarded collections and to inform us of their existence for inclusion in a future edition.

Definition

In the event, the compilation of this volume has been an unusually complex undertaking. It has involved the co-operation of all those who have responsibility in one form or another for the many thousands of photographic collections in Great Britain. It should be emphasized that *every kind* of photographic collection has been the subject of this enquiry and that none has been excluded from consideration: private or commercial; personal or open to public view; published or unpublished; 'historic' or contemporary; negatives, copy-negatives or positive prints and transparencies; whether or not copyright in the originals, or reproduction rights, are held by some other person or body elsewhere. For the National Photographic Record the term 'photographic collection' is all-inclusive – all is grist that comes to our mill. This Directory is therefore certainly not only concerned with Victorian or antique photographs, important and interesting as they undoubtedly are, but with every kind from the discovery of photography to the present day. It is as contemporary as today's newspaper! To merit inclusion in the Directory, however, a collection has to be 'significant', either in terms of the numbers of photographs it compasses, its subject matter, or its historical associations – or a combination of all three. Perhaps this will provide the basis for an answer to a question which we are often asked, but which it is almost impossible to answer because it is so subjective: 'How do you define a photographic collection?'.

Like the units of a conventional book-form library, the units of a photographic library can be removed, dispersed, transferred to other

collections, begged, borrowed and even stolen. There is thus an unstable quality about even the most apparently permanent of photographic collections. What we have done is to 'fix' or record a collection at a particular moment in time, just as the photograph of, say, a moving object is itself a 'moment frozen out of time'.

Confidentiality

We should emphasize that for the most part the co-operation of owners and custodians of collections has been gladly given. In a small minority of cases there has been an understandable reluctance to volunteer information lest its publication might alert and encourage that new brand of thieves who have become aware of the fiscal value of antique collections of photographs. In order to accommodate such reservations the National Photographic Record has devised an arrangement whereby the published entry in these cases contains as much descriptive matter as is consonant with security, but the vital details as to ownership and location are suppressed. The owner or custodian can thus rest secure in the knowledge that confidentiality and anonymity have been preserved. A further refinement of the arrangement permits the National Photographic Record to act as a neutral 'postbox': enquiries by letter or telephone are passed on to owners or custodians who may then reply or not, direct or via the postbox, at their discretion. A very small number have failed to be reassured by this provision. Nevertheless it is our hope that as the passage of time validates the security of this arrangement, even this residue of owners will be persuaded to have their collections included in a second edition. We invite other owners who may hitherto have remained unknown to us because of this same veil of secrecy, to have their collections registered with the National Photographic Record under a similar guarantee and safeguard of confidentiality.

Antecedents

Tribute must be paid to a number of individuals and organizations who have undertaken to complete Records in the past, but who have been unable to bring them to completion because of inadequate resources. In a number of instances they have very generously made over their files to the National Photographic Record in order to avoid duplication and in recognition of our enhanced resources. In particular we must mention our incorporation of the incomplete but extensive enquiries of Mr B. R. Curle and Mr D. F. Radford, who had hoped to publish a separate Register of Photographic Surveys of Buildings in the British Isles, and Mr Colin Osman's embryo 'National Register of Photographic Archives'.

Historically, some collections of photographs have themselves been termed 'Records'. Two in particular, quite coincidentally, have borne the title 'National Photographic Record', and might therefore, without this explanation, be confused with our own organization. It is indicative of the lack of resources in the past (or of the unrealistic aspirations of their sponsors) that none achieved its original intention of a truly comprehensive, national coverage. First and foremost was the project of Sir Benjamin Stone, inaugurated in May 1897, to establish 'a systematic collection and preservation of existing evidences of our former and present national life and history', for which a 'National Photographic Record Association' was formed. Sir Benjamin Stone himself contributed 100 planinotypes of Westminster Abbey, and the British Museum agreed to act as a repository for other suitable contributions which were vetted by a distinguished committee. The effort petered out after a few years, but the resulting collection still remains with the British Museum, the entry for which, below, provides further details. The bulk of Sir Benjamin Stone's own work is deposited with the Birmingham City Library.

The second collection under this title is a smaller one consisting of representative photographs of social significance taken between 1917–1972, now lodged with the National Portrait Gallery, the entry for which gives further details.

Finally, mention must be made of the *Guide to Collections of Topographical Drawings*, edited by Professor M. W. Barley and published by the Council for British Archaeology. Although, as its title suggests, this work is primarily concerned with drawings and similar material, it does contain details of some photographic collections of a topographical nature, and we are grateful to Professor Barley for permission to reproduce certain information.

History of the Project

One indication of the complexity of this undertaking is the fact that the Directory has been four years in the making. It was following a widely representative Conference on Photographic Archives held at The Royal

Photographic Society's House in March, 1972, that at the suggestion of the present Editor the Society decided to sponsor the compilation of a Directory of British Photographic Collections, with a modest but as it turned out entirely inadequate budget. The scale of the operation only became apparent after the first few months of initial research. Providentially, at this point *The Sunday Times* decided that the time was opportune to launch an appeal in its columns for a £10,000 fund to underwrite the venture and to enable its scope to be expanded under the overall title of *The National Photographic Record*. The appeal included the publicizing and sale of attractive reproductions of masterpieces from The Royal Photographic Society's own unique collection of historic photographs by a special *collotype* printing process which faithfully copies the sepia tones of the originals. The profits from these sales were devoted to the Fund. No doubt *The Sunday Times* sponsored this cause because the paper was alert to an aroused public interest, and an imperative need that required something to be done, in the absence of any government initiatives, before it was too late; and in recognition of the fact that the Directory of Collections, by identifying those that were rare, significant or threatened in some way, would help to ensure their preservation in Britain. Happily, the newspaper's published forecast was speedily fulfilled: 'The Fund will put the project on a fully professional basis, establish a permanent office, and employ researchers who will follow up questionnaires sent to all possible owners of photographic collections. Trained assistants will collate the information so that in the end the National Record will provide a sophisticated Index to Britain's historic image.' In the event, the response to the appeal was immediate and generous, particularly from the major *users* of photographs – an indication that they commended its objectives. We are particularly indebted to Mr John Bentley for one very substantial donation. The National Photographic Record was established, with offices in Darlington and London, and an Advisory Committee was appointed, composed of representatives of The Royal Photographic Society and the wider interests involved, with Mr C. J. V. Roberts of Kodak Limited, as a particularly able and knowledgeable chairman.

Disclaimer
Each of the entries in this Directory has been compiled from a detailed questionnaire completed by our correspondents. Whilst we have attempted to achieve a degree of consistency from these very diverse returns, we should emphasize that whatever inconsistencies remain are due to the particular style of correspondents, whose actual words we have preferred to quote wherever possible. However, we do not hold ourselves responsible for any errors or omissions which result from this procedure.

Addresses and Telephone Numbers
Two features of each entry in particular have been standardized in the interests of consistency. First, all addresses have been converted so as to conform with the boundary changes consequent on Local Government Reorganization in April, 1974. Secondly, local telephone exchanges have been expressed as an STD code where such exists. Normally there are three groups of digits, and occasionally two. The last group represents the subscriber's own number, the other groups represent the exchange. This STD code, however, only operates for trunk calls, not for local calls to neighbouring exchanges. Some of these can be called only through the operator, but when a number is allocated to a neighbouring exchange, whilst the subscriber can be called direct, it should be noted that this prefix number differs from the STD code. In every case of doubt consult your local issue of the Post Office booklet 'Dialling Instructions and Call Charges'.

Up-Dating
Because the bulk of photographic collections are not static and inert, but organic and changing and evolving from year to year, future up-dated editions are envisaged. We are confident that any owners or custodians who may have escaped our net, despite the fineness of its mesh, on seeing the utility of the Directory and the many benefits which it affords, will now be persuaded to come forward so that their material may be included. We invite them now to send for a questionnaire, which will arrive by return of post.

Sets
Where a large collection is divided into a number of self-contained sections, whether according to subject matter or in any other way, these are called *sets*. If a particular set has been assembled under a single subject heading, and we consider it large enough, or significant in

some other respect, it will merit a separate entry to itself and will be found in the Directory apart from all other sets in the same collection, but nevertheless positioned strictly according to its subject matter.

Single Photographs

It is perhaps necessary at this point to make explicit what has been implicit all along: that this Directory features *collections* or *sets* of photographs, not individual photographs, except insofar as they belong to collections. The near-impossibility of cataloguing every single photograph in collections running to five millions or more each may be imagined, although some Institutions have bravely attempted the task. Nevertheless our classification system is capable of expansion even to that degree of precision. At the extreme limit of refinement it is theoretically possible, if impracticable, to list *all* the subjects which occur in one individual photograph, and to do the same for every photograph in a collection. We are confident that our classification system would even be equal to that Herculean task, were it ever attempted.

A National Deficiency

Question 16 of the questionnaire enquired whether the collection was being properly maintained. The answers, taken together, reveal a disturbing state of affairs, which might with some justification be described as a reproach to the nation's cultural conscience. It is a situation which anyone who has a concern for Britain's artistic heritage, and in particular its photographic patrimony, should take to heart and resolve to remedy. Time and again the answers demonstrate that those to whom we entrust the care of important photographic collections are expected to discharge their responsibilities with pitifully inadequate resources. One senses the frustration behind such oft repeated laments as 'not enough staff or financial allocation even to begin to tackle the problem'. Especially is this true of the Libraries and Museums run by Local Authorities. Too often they are themselves the Cinderellas of Local Government services, whilst the proper conservation and display of photographic collections must of necessity figure low down on their scale of priorities. The consequence is that far too many curators, through no fault of their own, are not even aware of what it is, precisely, that they hold (although this problem is not confined to Local Authority collections by any means), in terms of numbers, subject matter, format, antiquity and the like. Important collections remain entirely uncatalogued, stored in the most damaging and deleterious conditions of temperature and humidity etc., unavailable for public inspection and display.

Inflation

No doubt the severe effects of inflation have been a prime cause of the curtailment of funds for the proper maintenance of collections, and for the same reason we have thought it prudent to add the word 'from . . .' to any charges which we have quoted from material supplied to us by correspondents. Whilst the figures given are therefore as near accurate as possible, they represent the rate at the time of going to press and may well have increased in the interval. It would be as well to check with the supplier before ordering. Since this is an English Edition, charges are given in sterling.

SOME USEFUL INFORMATION

Copyright

Copyright law is broadly the same for photographs as for printed matter. Every photograph which is ever taken is automatically copyright, and this copyright belongs to someone. Usually it is the photographer. His stock-in-trade are his negatives and he makes his living by selling prints or transparencies copied from them. Copies cannot be made by anyone else without the photographer's permission.

The situation is rather different, however, if a customer, say an author, commissions a photographer to take specific pictures to illustrate his work. Copyright then belongs to the author, since the photographs are considered to be part of the whole work. Nevertheless, even here, in the normal case, the negatives are owned by the photographer and remain in his hands. (In exceptional cases the author may himself, by agreement and the payment of a special fee, become possessed of the negatives and all rights in them.) The author commissions as many prints as he requires from the photographer, either for the purpose of showing to the publisher before publication or for extra copies after publication of the work. The photographer makes a specific charge per print. A publisher does not therefore own the copyright of photographs appearing in any books which he produces, unless he has himself directly commissioned the photographer. Some publishers maintain picture libraries of photographs, whether used or unused, commissioned for their works. Normally, however, these consist of copy-prints: the negatives remain in the hands of a variety of photographers, whilst the copyright belongs to a variety of authors. (It is clear from the foregoing that the possession of a negative as such, has nothing to do with the ownership of the copyright in the photograph.)

The copyright relationship between the commissioner and the photographer is such that the photographer may not publish a photograph, or sell further copies from a negative to other customers – that is, engage in the multiplication of copies – without the consent of the commissioner, who is entitled to agreed royalties on such sales. On the other hand the commissioner is obliged to get any further copies which he may need from the photographer who holds the negative. But if, for example, the two parties quarrel, the commissioner – because he owns the copyright – can always commission another photographer to make a new negative 'at one remove' by rephotographing any print taken from the original negative (albeit with a consequent loss of quality in the copy). If anyone other than the commissioner does this – that is, makes a copy-negative – he would be guilty of an infringement of copyright.

Nevertheless, although no one but the copyright owner may authorize the publication of photographs (in other words he holds the *production* rights), it is not an infringement for either the photographer, or anyone else, to make a single copy of a photograph for his own private study and research. But he may not make copies for a number of friends, even if they want them for private study, as this involves the multiplication of copies and issue to the public.

It is also not an infringement to show anyone's copyright photograph in an exhibition, or to project it onto a screen in the course of a lecture; and no permission for such uses need be sought.

The duration of copyright in a photograph *taken before the 1st June 1957* is fifty years from the end of the calendar year in which the photograph was taken, whether or not the photograph has been published meanwhile; it then enters the public domain, and may be published freely by anyone.

The duration of copyright in a photograph *taken after 1st June 1957* remains perpetual until it is first published; then the copyright continues to run for a further period of fifty years from the end of the calendar year in which it is first published. For example, a photograph taken in 1958 may remain hidden and unpublished until, say, the year 1995, when it is published for the first time; it will therefore remain in copyright until the end of 2045.

When a picture agency sells or lends a copy of an old photograph, even though it has passed beyond the period of copyright protection, it can only be published with the consent of the agency and on the payment of a reproduction fee. Making a copy of a 'copyright expired' old photograph does not establish a new copyright in that copy-negative.

Firms of portrait photographers who take photographs of 'personalities' free of charge own the copyright in them since they are 'self

commissioned'. They have the right to circulate such portraits freely, without the subjects' consent, and to collect fees from newspapers and magazines who might wish to publish them. An individual can only claim copyright in his portrait, and thus control its circulation, publication or reproduction, if he has commissioned a photographer to take it on the payment of a fee.

Even someone who commissions a photograph and, for whatever reason, does not pay for it, still owns the copyright. All the photographer can do is to take legal action against the offender to recover his fee.

If photographs are taken of copyright paintings, drawings or engravings, then the owner of the copyright in the photographs may run the risk of infringement of the copyright in the paintings etc., but he still owns the copyright in such infringing photographs.

Photographic Agencies

Although photographic agencies are of various kinds they have usually been started by a particular photographer, who not only retains his own negatives and their copyright, but also reproduction rights from any copy-prints or transparencies. He is in effect an 'amalgam' of the photographer and the commissioner rolled into one. The nucleus of his own stock, however, is often added to in the form of copy-prints, from the work of other photographers for whom he merely acts as an agent, taking a percentage of sales by way of commission. Each photographer whom the agent represents normally retains copyright in his own work.

Fees

The different kinds of fees, which are listed under the heading *Charges* in each entry, are as follows:

Print/transparency fee. For an actual print or transparency supplied.
Handling fee. For a specific number of prints/transparencies supplied to a prospective customer from which to make a final selection.
Holding fee. Charged in similar circumstances, but in this case the customer retains the prints/transparencies for some time before making a choice. Normally the fee for an initial period (usually a month) is waived and there is a sliding scale thereafter depending on the period of retention.

Search fee. Incurred when a required print cannot be immediately or readily traced through the indexes and thereby involving a search of some kind. Alternatively, when every print relating to a particular theme is required without limitation on number, involving a search through all the indexes and files.
Service fee. Occasionally charged as a percentage of other fees incurred, analogous to Value Added Tax.

It should not be imagined from the foregoing that there is a standard scale of fees which is universally accepted. On the contrary, suppliers of photographs tend to be individualists and a large proportion of photographers operate as 'freelances'. Moreover, photography is such a precarious livelihood that its practitioners may be excused for endeavouring to earn as much as they can on an open market. The consequence is that fees vary widely. Attempts have been made, in the interests of the photographers themselves, by some professional organizations, notably the I.I.P. (Institute of Incorporated Photographers) and the N.U.J. (National Union of Journalists), to regulate the market and to establish agreed scales, but these seem to be the exceptions. (See the entries for details, where these initials are used.) More often a supplier will quote his own scale, or simply 'by negotiation'. It is then up to the customer to obtain the best terms he can. In addition it should be noted that the fee for reproduction of a particular print or transparency may vary widely according to the nature of the reproduction. The highest charges are levied for reproduction on television, then for use in publications, and the lowest for reproduction in unpublished theses and the like. In every case colour attracts a far higher fee than black and white.

For the very reason that many suppliers regard themselves as free agents, they will often waive some or all of the fees cited above. Especially is this the case if the end result of the transaction is the payment of a reproduction fee, or if the customer is willing to add an acknowledgement of source known as a 'credit line' in any publication. Credit lines, because of their value as advertisements, have now become standard practice and may be required by suppliers in addition to their normal charges. They should be supplied in any case as a matter of courtesy.

When prints are supplied, not for reproduction, but for a customer's private use, charges are

rather less and correspond to those which are current with any High Street photographer for prints supplied from a customer's own negatives. Similarly the cost of a commercially produced slide – that is a transparency mounted in a form suitable for projection – is standard for the usual 2″ × 2″ format.

'Library' and 'Archive'

Some organizations, such as the National Trust and the Department of the Environment, maintain a stock of slides for sale to the general public in addition to a photographic archive for their own internal use. The latter may consist of the original transparencies from which the slides were copied, or additional photographs, or both. This distinction between a 'Library' of photographs, whether of prints or transparencies, for sale or loan, and an 'Archive' for internal and research purposes (but on which a Library may be based), is an important one. Archival material, almost by definition, is seldom used, so as to preserve it, although in some cases it may be open to inspection by the public, under proper safeguards. It is of much better quality than Library stock.

Loan Services

There are circumstances in which prints or slides may be 'lent' to a customer, other than those for which a Handling fee or a Holding fee is charged. Typical cases are the need to assemble a set of slides for a limited duration for lecture purposes, or a set of prints for an exhibition. Again, suppliers may be prepared to waive their charges depending on the purpose for which the material is borrowed. Custodians are understandably reluctant to lend original material, however. They may well do so in the case of copy-prints and transparencies, especially if the customer is prepared to pay the cost of such 'one-off' copying. It should be noted that the cost of indemnifying a supplier for lost or damaged prints or transparencies whilst on loan is high and is usually quoted as one of the conditions of the transaction.

On Making the Best Use of Photographic Collections

The majority, but by no means all, of the private collections are not open to inspection by the public. (See under *Access* in each case). Many, however, are prepared to make an exception in the case of *bona fide* enquirers, students and research workers. *'Bona fide'* needs emphasis,

since it can be a laborious business seeking out individual prints from a miscellaneous collection, especially if it is uncatalogued. Owners are understandably impatient of the casual enquirer. A good rule is always to make an appointment in advance, either by letter or telephone, and never to arrive 'on spec'.

The remaining collections of Societies and Institutions, Local Authority and Government Departments, commercial concerns and the like are usually, but not invariably, open to the public. Unless the entry clearly indicates that this is the case, however, the same rule about making an appointment in advance applies.

Because collections vary so widely in the efficiency of their organization, arrangements for inspection range from completely open access to all the material at one end of the scale, to a requirement to complete a detailed request slip for each individual print at the other. It is rare nowadays for a client to be allowed to browse freely through a whole library of original negatives or prints, since custodians have learned from bitter experience how injurious this can be to their stock. Two alternative procedures are normally adopted. First, if the resources of the library allow, indexed copies of all the items on file are assembled in clear-view wallets, for immediate inspection. Depending on the size of the original, these may be contact prints, or more usually reductions in a smaller format, say 35mm (in which case the client may be supplied with a magnifier for viewing). The copies in the wallets may be accompanied by a brief description, giving significant details of location, photographer, etc., either attached to or on the reverse of the print. In this case the wallets themselves may constitute the only catalogue which the library possesses. The client, having made his selection, is only required to quote the serial number attached. The librarian then supplies a copy-print from a stock kept for the purpose. These are usually copy-prints of the same size as the original negative, but if a different size or format is required, arrangements are usually made for it to be printed-out, with a consequent and sometimes considerable delay in completing the order. This first 'unattended' procedure is more convenient for the client, since it enables him to make his own selection at leisure.

The second alternative involves a search through the stock (whether originals or copy-prints) by

the library assistants. This is less satisfactory for the client since the assistant may not be professionally trained in photographic librarianship. All this underlines the need to prepare oneself thoroughly in advance of a visit to a photographic library, to know exactly what it is one wants, and to be as specific as possible when making a request. Never was the old adage 'time costs money' more true, for an uncertain enquirer lays himself open at least to an extended search fee. For this reason we urge potential clients of photographic libraries to read as much literature about them as possible in advance – see under *Aids* for each entry – either by sending to the library itself for copies of catalogues, finding lists, etc., or by enquiry of the National Photographic Record.

Picture Researchers

Much of the labour involved in securing prints from libraries may be avoided by employing an experienced picture researcher to do the job, although this eliminates the satisfaction to be gained from doing it oneself. Picture researching is a relatively new profession, so new in fact that its few practitioners are only now beginning to organize themselves along professional lines. Nevertheless, most are highly efficient and know the ropes in respect of photographic libraries of every kind. Especially do they know their way around the larger libraries which tend to be concentrated in London. If a relatively inexperienced client requires a comparatively large number of prints he would be well advised to trust the work of selection to a picture researcher. Many authors, and certainly the majority of those who are involved in the publication of 'pictorial' works, do so, and as a consequence the principal clients of photographic libraries are picture researchers. We hope that they will find this Directory a considerable boon to their profession. Indeed, may all who use it find here something to their advantage, and at the end of the day, may they come across just those photographs which will instruct the mind and satisfy the spirit.

Photographic Galleries

The number of galleries devoted solely to exhibitions of photography, although comparatively few, is growing. The photographs which constitute an exhibition may be considered to be a collection, but in the nature of the case they are too impermanent to feature in this Directory. Nevertheless some galleries do retain photographs from, or maintain photographs for, their changing exhibitions. Details of those currently operating are given below.

London

The Asahi Pentax Gallery, 6 Vigo Street, London W1. Tel. 01 437 9222. Director: Ron Spillman.
The Boxroom, Shaftesbury Avenue, London W1. Director: Roger Perry.
The Half Moon Gallery, 27 Alie Street, London E1. Tel. 01 488 2595.
Kodak Ltd., 246 High Holborn, London WC1. Tel. 01 405 7841.
The Photographer's Gallery, 8 Great Newport Street, London WC2. Tel. 01 240 1969 and 01 836 7860. Director: Sue Davies.
The Royal Photographic Society of Great Britain, 14 South Audley Street, London W1Y 5DP. Tel. 01 493 3967. Three Exhibition areas, including the Dudley Johnston Gallery.

Provinces

The Fox Talbot Museum, Lacock, Chippenham, Wiltshire. Tel. Lacock 459. Curator: R. E. Lassam.
The Impressions Gallery, 17 Colliergate, York. Tel. 0904 54724. Directors: Val Williams and Andrew Sproxton.
The Photographic Gallery, University of Southampton, SO9 5NH. Tel. 0703 559122. Director: Leo Stable.
Side Gallery, 9 Side, Newcastle-upon-Tyne, NE1 3JE. Tel. 0632 22208.
Spectro Arts Workshop, Bell's Court, Pilgrim Street, Newcastle upon Tyne. Tel. 0632 22410

Standard Sizes of Photographic Images

Lantern slides	3¼″ × 3¼″ (8.2cm × 8.2cm)
	3½″ × 4″ (8.2cm × 10cm) (American)
Cabinet Photographs	4″ × 5½″ (10.2cm × 14cm) Usually on mount 4½″ × 6½″ (11.5cm × 16.5cm)
Carte-de-visite	2¼″ × 3½″ (5.7cm × 9cm)
Stereo pairs	3½″ × 7½″ (9cm × 18.7cm) (when mounted)
Whole plate	6½″ × 8½″ (16.5cm × 21.6cm)
Half plate	4¼″ × 6½″ or 4½″ × 5½″ (12cm × 16.5cm or 11.5cm × 14cm)
Quarter plate	3¼″ × 4¼″ (8.2cm × 10.8cm)
Sixth plate	2¾″ × 3¼″ (7cm × 8.2cm)
Eighth plate	2⅛″ × 3¼″ (5.4cm × 8.2cm)
Ninth plate (so called)	2″ × 2½″ (5cm × 6.3cm)
Sixteenth plate	1⅜″ × 1⅝″ (3.5cm × 4.1cm)

QUICK SUBJECT GUIDE

MAJOR SUBJECT DIVISIONS

B

SUBJECT SUB-DIVISIONS

SOCIETY AND HUMAN RELATIONSHIPS

Customs and Folklife
Fairs
Religion
 Observances
 Objects
 Work

Domestic and Home Life
Food
Drink
Clothes
Period Costume
Jewellery
Shoes

Recreations
Puppet Shows
Stage Shows
Theatre and Drama
Opera
Ballet
Film
Musical Performances
Musicians
Seaside Holidays

Athletic Sports and Outdoor Games
Football
Cricket
Croquet
Climbing
Cave Exploration
Mountaineering
Archery
Swimming
Fishing

Associations and Societies
Scouts and Guides

Education
Schools
Children at Play
Colleges and Universities

Occupations and Services
The Forces
 The Army
 The Navy
 The Air Force
 Uniforms and Regalia
Banks and Bankers
Politicians and Parliament
Medical and Hospitals
Lifeboats and Lifeboatmen
The Postal Service
Police
Fire Service
Gypsies

PORTRAITS
Individuals
Personalities
Groups
Family Albums

ARTS AND CRAFTS

Architecture
Buildings
 Public
 Ecclesiastical – Churches
 and Cathedrals
 Residences
 Commercial
 Industrial
 Vernacular
Street Scenes
Street Furniture

Paintings – Photographic Reproductions

Antiques

Sculpture
Woodcarving

Ceramics
Pottery
Porcelain

Textiles

Leather

Glass

Musical Instruments – Keyboard

Photography
Apparatus
Processes
History

Numismatics – Coin Collecting

Philately – Stamp Collecting

Genealogy

Commercial Design and Packaging

AGRICULTURE AND FOOD PRODUCTION

Horticulture

Poultry

Fishing

Whaling

COMMUNICATIONS AND TRANSPORT

Communications
Radio
Television
Telecommunications

Road Transport
Cars
Trams
Commercial Vehicles
Roads

Sea Transport
Sailing Ships
Cargo Boats
Steamships
Warships

Docks and Harbours

Inland Waterways
Sailing Barges
Motor Barges

Air Transport

Rail Transport
Locomotives
Railways
Stations

ENGINEERING

Mechanical Engineering
Electrical
Static Steam Engines
Windmills
Watermills
Nuclear Reactors
Factories
Smaller Fabricated Objects

Civil and Building Construction
Underwater Salvage

Mining
Oil Industry
Aluminium
Minerals
Dredging

Shipbuilding

PHYSICAL AND LIFE SCIENCES

Botany
Flowers
Gardens
Trees
Other Plants

GUIDE TO THE ENTRIES
(See also the key at the foot of each facing page)

Owner
The name of the owner or trustee is given, or in the case of commercial concerns, the name of the establishment. The full address, with postal code and telephone number, follow, where known

Location
The present location of the collection, where this differs from the entry under owner. Where possible place names are as adopted under local government reorganization from 1st April 1974.

Title
An entry will only occur under this head if the collection, or a set within a major collection, is customarily referred to by a title which differs from that of the owner or the name of the establishment

Custodian
An entry will only occur under this head when there is, in addition to the nominal owner, a custodian to whom the administration of the collection is delegated, and to whom enquiries concerning the collection should be addressed.

Dates
Figures not enclosed in brackets but separated by a hyphen represent the earliest and latest dates of photographs within the collection. Figures in brackets represent the date of formation and the date of completion of the collection, according to their position. A dash after the last figure indicates that the collection is still being added to. Thus 1840 (1890) -1914 (1960) indicates that whilst the photographs comprising the collection range in date from 1840 - 1914, the collection itself was begun in 1890 and completed in 1960. An entry 1856 (1860) - 1914 - would indicate that whilst the photographs comprising the collection range in date from 1856 - 1914 and the collection was begun in 1860, photographs within this period (but not outside it) are still being added to the collection.

History
Notable historical associations - social, biographical, or technical - of the collection or its founder.

Photographer
Major photographers whose work is represented in the collection.

Subject Matter
The most important, and in practice the most useful, section of each entry. The 'dominant subject' for each collection are first given, in capitals, and thereafter the subsidiary subjects in lower case. The latter appear not in their order of importance but in the order in which they occur in the Subject Guide Classification which was used as a basis for compiling information under this head (reproduced on pp xvii-xix). The comprehensive subject index between pages 179-201 indicates however that very many more subjects are listed in the entries than occur in the summary subject guide. The index clearly distinguishes between collections in which a particular subject is dominant and those in which it is subsidiary, by the use of bold and light type respectively for the indentifying numbers.

Aids
Unfortunately relatively few collections are accompanied by aids which facilitate the identification of individual images. In general four kinds of aids to use are distinguished - Simple Guides, Catalogues and Lists, Card Indexes, and Subject Indexes. Where these exist they are included in the entry, together with an indication of their format - whether single copies, published or duplicated. Published aids are of course freely available, duplicated aids are normally available on request. In other cases a single asterisk indicates that the aid is restricted for internal use only, whilst a double asterisk indicates that it may be consulted by appointment.

Numbers
Numbers of photographs/images in the collection. The full range of information under this head is indicated in the following table;

Format	No. Black & White	No. Colour	Dimensions
Prints			
Film negatives			
Glass negatives			
Glass positives			
Lantern slides			
Other slides and Transparencies – negatives			
– positives			

In addition special features such as cartes de viste, cabinet photographs, stereo pairs etc are noted, and where some or all of the photographs are also held in the form of copy negatives.

In all too many cases correspondents have only been able to approximately estimate the numbers of photographs in their collections. In such cases the figure is accompanied by the abbreviation c (circa, for approximately).

Access
Relatively few collections are open to unrestricted public access. Entries indicate whether the collection is open to inspection by the following classes of user: the General Public; Photographic Picture Researchers; Bona Fide Students; the Media - Press and T.V. Any special restrictions are also noted - e.g. where access is permitted to copy prints or microfilm copies but not to the original images - and where applicable, the normal working hours.

Copies
The reference under this head is to copy prints. Information is given as to whether these are available for Sale, Display, Reproduction, or Publication. Special conditions are also noted, and whether and under what circumstances a credit line would be required.

Charges
All commercial establishments naturally charge fees for their services, whilst some non-commercial concerns may levy a nominal fee towards their costs. The commonest fees which the user may expect to encounter are given in the entries under this head, as follows: Fees for Print/ Transparency; Publication/Reproduction; Handling; Holding; Search; and Service Charge. There is no standardization of fees, but whilst each establishment will fix its own charges, in practice the range is not very great. Where possible actual charges are quoted at the time of going to press, but the user should always check with the establishment concerned.

Notes
Under this head is given additional information volunteered by correspondents and not covered elswhere in the entry.

1

Owner American Museum in Britain Trustees
Location Claverton Manor Bath Avon County BA2 7BD
 0225 60503
Dates c1690 (1961) - 1850 -
Photographer Derek Balmer
Subjects AMERICAN DOMESTIC LIFE
Numbers pr c500 b&w
 sl c200 col
Aids *Card index
Access Bona fide students
Copies available for sale
Charges Print fee reproduction fee on application

2

Owner Beck Isle Museum of Rural Life Trustees
Location Bridge Street Pickering North Yorkshire
Title S Smith Collection
Custodian T D Dewes 5 Swainsea Drive Pickering North
 Yorkshire 0751 73359
 G Clitheroe 49 Eastgate Pickering North Yorkshire
 0751 72152
Dates 1918-1958
History Mr Smith was a local photographer in Pickering
 who entered and won many competitions in his day. After
 his death and at the formation of the Museum 7 years
 ago the Trustees were presented with photographs,
 glass negatives, and most of his equipment which he
 made himself
Photographer S Smith
Subjects COUNTRY LIFE AND CUSTOMS pastoral
 geography
Numbers pr c100 b&w 8¼"x6" 14¾"x11½"
 gl negs c150 b&w 4¾"x6½"
Aids The records are in the course of preparation
Access General public bona fide students

3

Owner Biggar Museum Trust
Location Gladstone Court Museum Biggar ML12 6DN
 Biggar 5
Custodian Brian Lambie
Dates 1859 (1955) -
Photographer J C Annan Andrew Elliot
Subjects SOCIAL SCIENCES Biggar - all aspects
 Glasgow Edinburgh Lanarkshire Melrose Abbey
Numbers pr 252 various
 cartes de visite c1000
 pl c1900 1-pl
 sl c400 35mm
Aids Guide for Early Biggar Photographs
Access General public bona fide students on request
Copies available for sale
Charges Print fee reproduction fee by arrangement

4

Owner British Museum Trustees
Location Department of Prints and Drawings
 London WC1 3DG 01 636 1555 Ext 409
Custodian Reginald Williams
Dates 1853 (1897) - 1911
Photographer Benjamin Stone
Subjects SOCIAL SCIENCES TOPOGRAPHY - UK
 portraits
Numbers sl 3232 b&w 8"x6"
Aids Ms indexes as arranged by photographer
Access General public bona fide students application for
 ticket of admission valid 1 year
Copies available for sale on request
Charges Print fee

5

Owner Angela Bromley-Martin
Location 3 Tuffs Hard Bosham Hoe Chichester Sussex
 0243 572160
Dates 1790 (1969) -
Subjects SOCIAL SCIENCES Bosham - all aspects
Numbers pr c200 b&w c36 col
Access General public bona fide students by arrangement
Copies available for sale

Charges Print fee for personal use only photographs
 required for publication by arrangement with the owner

6

Owner Antony Brown
Location 14 Cornfield Green Hailsham East Sussex BN27
 1SS
Dates c1850 (1935)-
Photographer Antony Brown
Subjects SOCIAL SCIENCES veteran and vintage cars
 sailing boats astronomic observatories meteorology
 botany insects wind and water mills agriculture and
 food production food architecture photographic
 apparatus seaside holidays portraits geography
 Lancashire landscapes
Numbers pr c1000 b&w various
 fi negs c7500 b&w various
 gl negs c300 b&w various
 L sl c600 col 24mm x 36mm
 tr c450 col 6cm x 6cm 5"x4"
Aids Catalogue card index subject index
Copies available for sale

7

Owner Clive Bubley
Location 44 Berners Street London W1 01 580 0644
Dates c1860 (1973)-
Subjects SOCIAL SCIENCES transport customs and
 folklore agriculture and food production home
 clothes architecture photographic apparatus
 recreations horse-riding hunting fishing biography
 and portraits geography
Numbers pr c1200 b&w various
Access Picture researchers press tv media 9.30 am -
 5.30 pm
Copies available for sale for display for loan for
 publication
Charges Publication/reproduction fee print/transparency
 fee holding fee if held for more than 30 days and
 unpublished search fee damage or loss fee

8

Owner Hugh Cavendish
Location Holker Hall Cark-in-Cartmel Cumbria
 Flookburgh 220
Custodian J Braithwaite
Dates 1908-
Subjects SOCIAL SCIENCES social life of large country
 house travel
Numbers pr substantial number
Access Bone fide students by appointment only

9

Owner Cecil Higgins Art Gallery Trustees
Location Castle Close Bedford 0234 53791
Custodian Miss H Grubert
Dates c1890 (1940) - 1910 -
Subjects SOCIAL SCIENCES PORTRAITS CLOTHES
 contemporary dress period costume
Numbers pr 1000 b&w various
Aids *Card index
Access General public
Copies available by special request
Charges Print fee £1

10

Owner Alan Clifton (Photography) Ltd
Location 116 Streatham Road Mitcham Surrey CR4 2AE
 01 648 8467
Dates 1960 -
Photographer Alan Clifton
Subjects SOCIAL SCIENCES occupations and services
 education transport customs and folklore
 meteorology oceanography zoology medicine
 engineering agriculture and food production sculpture
 architecture painting recreations outdoor games
 portraits geography
Numbers fi negs c100000 b&w 35mm
 tr c12000 col 35mm
Aids Card index
Access Picture researchers press tv media

Copies available for sale for publication
Charges Print/transparency fee publication fee
 holding fee search fee
Notes Mostly results of assignments from Time-Life,
 London.

11
Owner Mark Edwards Photographer
Location 199a Shooters Hill Road Blackheath London
 SE3 01 858 8307
Dates 1967-
Photographer Mark Edwards
Subjects SOCIAL SCIENCES Britain development - India
 Ceylon Nepal Korea education - Asia Europe
 Japan U.S.A. Family planning - Asia
Numbers fi negs c20000 b&w c3000 col 35mm
 tr c3000 b&w
Aids Published catalogue in preparation
Access Bona fide students picture researchers press tv
 media 9 am - 7 pm
Copies available for sale for display for loan for
 publication credit line required
Charges Reproduction fee holding fee after one month

12
Owner English Folk Dance and Song Society
Location Vaughan Williams Library Cecil Sharp House
 2 Regents Park Road London NW1 7AY 01 485 2206
Title Photographic Collection of the Vaughan Williams
 Memorial Library
Custodian Mrs B Newlin
Dates 1900-
Subjects SOCIAL SCIENCES customs and folklore
 musical instruments for folk music folk plays
 musical performances folk festivals folk dancing
 traditional dancing portraits of folk singers and
 musicians
Numbers pr 10500 b&w various
 gl pos c500 b&w various
 tr c550 col 35mm
 mic 38 b&w 35mm
Aids *Card index *subject index for col tr only accession
 book
Access General public bona fide students
Copies available for loan
Charges Loan fee of £2 if not members of the society

13
Owner George Fisher
Location Borrowdale Road Keswick Cumbria Keswick
 72178
Dates 1880-1939
Photographer Abraham Brothers
Subjects SOCIAL SCIENCES horse drawn vehicles
 ceremonies climbing geography
Numbers gl negs c1000 b&w
 sl c50 b&w
Access to copy prints
Charges Reproduction fee

14
Owner FOT Library
Location 74 Woodland Rise London N10 01 883 7336
Custodian Brian Innes
Dates (1961)-
Photographer Brian Innes
Subjects SOCIAL SCIENCES town life children at play
 transport customs and folklore mechanical
 engineering architecture static models recreations
Numbers tr 3000 col 35mm
Access Bona fide students picture researchers press tv
 media 10 am - 5 pm
Copies available for loan for publication
Charges Reproduction fee holding fee search fee

15
Owner Colin Green
Location 64 Coleshill Road Water Orton Warwickshire
Title The Jaques Collection
Dates c1861 -
Photographer C S Breese and Company
 Edwin Howard Jaques
Subjects SOCIAL SCIENCES transport trees windmills
 factory equipment buildings cattle sheep
 architecture theatre and drama seaside holidays
 portraits landscapes
Numbers pr c200 b&w various
 fi negs 89 b&w 5"x4"
 gl negs 429 b&w 8½"x6½" 6½"x4¾"
 gl pos 1 8½"x6½"
 L sl 44 b&w 8½"x3¼" 6½"x3¼"
 stereographs 14 b&w 6½"x3"
Aids Printed list on application 15p
Copies available for sale
Charges On application

16
Owner Neil Gulliver
Location 35a Lansdowne Gardens London SW8 2EL
 01 720 7572
Dates 1969-
Photographer Neil Gulliver
Subjects SOCIAL SCIENCES village life country life and
 customs old people's clubs sea transport East coast
 sailing-barges fairs fishing landscapes
Numbers pr 400 b&w 10"x8"
 fi negs 4000 b&w 35mm
Aids Subject index
Access Bona fide students
Copies available for sale

17
Owner Dennis Jeeps
Location 23 Green Street Willingham Cambridge 0954
 60244
Dates 1880 (1956)-
Photographer Dennis Jeeps Thomas Graves Smith
 Harold Smith Horace Thoday
Subjects VILLAGE LIFE all aspects
Numbers pr 350 b&w 10"x8" 1-pl ½pl
 L sl c1000 7cm x 7cm
 tr c200 col 7cm x 7cm
 fi negs 1200 b&w 2¼"x2¼"
Access Bona fide students by appointment not August or
 September
Copies available of limited numbers only
Notes A unique portrait of the development of a
 Cambridgeshire village from the 1880's to the present
 day.

18
Owner Pamela Johnson
Location 1 Shere Court Hook Lane Shere Surrey Shere
 2920
Dates 1909 - 1930
Subjects SOCIAL SCIENCES
Numbers pr c20
Access Bona fide students authors publishers press tv
 media
Charges For loan of originals depending on circumstances
 students and struggling authors gratis

19
Owner G J Keen
Location 25b Clarence Street Staines Middlesex
Subjects SOCIAL SCIENCES theatre
Numbers fi negs 2¼"x2¼" 2¼"x3¼"
Access Bona fide students by appointment only

20
Owner Linenhall Library Governors

Key () = dates when collections were begun or terminated
C = Century c = approximately pr = print fi = film
gl = glass neg = negative sl = slide L sl = lantern slide
tr = transparency mic = microform col = colour

b&w = black and white ¼, ½, 1-pl = quarter, half and whole
plate * = single copy, no public access ** = single copy,
access by appointment

Location 17 Donegal Square North Belfast BT1 5GD
 Northern Ireland 0232 21707
Title Postcard Collection
Custodian The Librarian
Subjects SOCIAL SCIENCES views of Belfast historic
 events 'quaint' Irish customs architecture
 landscapes
Numbers postcards c950 b&w col
Aids Self indexing
Access General public bona fide students
Copies available for loan to other libraries

21

Owner Marshall Cavendish Limited
Location 119 Wardour Street London W1
 Postal address 58 Old Compton Street London
 W1V 5PA 01 734 6710
Title Marshall Cavendish Picture Library
Custodian Maggi Baxter
Dates 1968 -
Subjects PEOPLE medical health and beauty cookery
 crafts knitting and crochet flowers do-it-yourself
 the Bible
Numbers pr c450 b&w
 tr 25000 col various
Aids Card index in preparation
Access Picture researchers bona fide students press tv
 media 9.30 am - 5.30 pm
Copies available for loan for publication
Charges Reproduction fee by arrangement holding fee
Notes Consists largely of photographs covering a wide
 range of material commissioned for the Company's
 partworks and other publications.

22

Owner Roger Mayne
Location Colway Manor Colway Lane Lyme Regis Dorset
 DT7 3HD Lyme Regis 2821
Dates c1840 (1950) -
Photographer Karlsson Roger Mayne R Moore
 Paul Nadar Sernek Paul Strand Otto Steinert
 Stettner W H Fox Talbot Telbez Brett Weston
 M White Hugo Van Wodenozen
Subjects SOCIAL SCIENCES slum streets children
 Teddy boys Royal Court Theatre - personalities
 Sheffield Costa del Sol Greece Britain Devon
 travel abroad British at leisure
Numbers pr c3000 b&w
 fi negs 10000 b&w
 tr 3000 col 35mm
 calotypes 4
 daguerreotypes 3
Access Bona fide students picture researchers press tv
 media by appointment only
Copies Material loaned or copied
Charges Print fee reproduction fee
Notes This collection also includes various albums, cartes
 de visite and postcards.

23

Owner R C Neve
Location Dora Creek Barnaby Mead Gillingham Dorset
 Gillingham 2961
Title Rural Crafts and Industries
Dates c1920 - c1925
Subjects SOCIAL SCIENCES INDUSTRY
Numbers L sl 160 b&w 3¼"x3¼"
Access Bona fide students publishers press tv media
Charges By negotiation

24

Owner Normal College of Education
Location Bangor Caernarvon North Wales
Custodian Bryn Lloyd Jones
Dates (c1968) -
Subjects SOCIAL SCIENCES social services - Poor Law
 education transport bridges
Numbers sl c24 col 35mm
Access Bona fide students

25

Owner Dennis Norton
Location The Old School Upton Warren Bromsgrove
 Worcestershire 052 786 456
Title The Norton Collection
Dates 1890 (1954) -
Subjects SOCIAL SCIENCES
Access General public bona fide students picture
 researchers press tv media Saturday and Sunday
 2 pm - 6 pm Tuesday and Thursday 10 am - 3 pm

26

Owner Norwich City Centre
Location Library Resources and Careers Centre Ipswich
 Road Norwich NOR 67D 0603 60011
Dates (1972) -
Subjects SOCIAL SCIENCES OCCUPATIONS AND
 SERVICES education transport science mechanical
 engineering agriculture and food production
 architecture geography
Numbers sl c600 col 50mm
Aids *Card index *subject index
Access General public bona fide students

27

Owner Order of St John
Location St John's Gate London EC1M 4DA 01 253 6644
Title The Most Venerable Order of St John of Jerusalem
Custodian Miss Pamela Willis
Dates c19th C (c1880) -
Subjects ST JOHN AMBULANCE all aspects of the history
 of the Order of St John ceramics sculpture and
 carving architecture painting numismatics
 genealogy antiques biography and portraits
 geography of Palestine Cyprus Rhodes Malta
 historic and newsworthy events
Numbers pr substantial numbers b&w col
 fi negs substantial numbers b&w col
 gl negs substantial numbers b&w col
 gl pos substantial numbers b&w col
 L sl substantial numbers b&w col
 sl substantial numbers b&w col
 tr substantial numbers b&w col
Aids *Card index *subject index
Access General public bona fide students by appointment
Copies available for loan only by special arrangement

28

Owner Osborne Studios (Falmouth) Limited
Location 16 Arwenack Street Falmouth Cornwall TR11
 3JA Falmouth 312361
Title Images of the Past
Custodian B L Osborne
Dates 1890 -
History The majority of photographs in this collection
 have been taken by four generations of the Osborne
 family
Photographer A D Osborne B L Osborne E A Osborne
 F L Osborne M D Osborne
Subjects SOCIAL SCIENCES THE FORCES TRANSPORT
 local government lifeboats Boys Brigade docks and
 harbours ships sailing shipwrecks
Numbers pr c200 b&w
 fi negs c100
 gl negs c200
 L sl c200
Access General public bona fide students
Copies available for sale
Charges Print fee

29

Owner Ron Oulds
Location Little Farm Studio West Chiltington Lane
 Coneyhurst Billingshurst West Sussex RH14 9DX
 040 387 368
Dates 1945 -
Photographer Ron Oulds
Subjects SOCIAL SCIENCES occupations and services
 associations and societies children at play transport
 fairs chronology skyscapes animals botany
 mechanical engineering civil and building construction

precision instruments agriculture and food production
home pottery glass architecture painting dolls
houses antiques recreations athletic sports and
outdoor games portraits geography historic and
newsworthy events
Numbers fi negs c51000 b&w various
gl negs c1000 b&w 5"x4"
L sl c5000 col
Aids Card index
Access Picture researchers press tv media 9 am -
5.30 pm other times by arrangement
Copies available for sale for display for publication
Charges Reproduction fee print/transparency fee
handling fee plus postage and packing

30
Owner Plymouth College of Further Education
Location Kings Road Devonport Plymouth Devon
0752 68859
Title Library Collection
Custodian Paul Burton
Dates (1974) -
Subjects SOCIAL SCIENCES OCCUPATIONS AND
SERVICES communications transport science
nature mechanical engineering civil and building
construction domestic home clothes architecture
geography historic and newsworthy events
Numbers sl c40 b&w c300 col 5cm x 5cm
fi c30 col various
Aids Card catalogue with subject and author indexes
Access General Public bona fide students for reference
only

31
Owner Mrs Tricia Porter
Location 2 Huskisson Street Liverpool Merseyside
Title Bedford Street Some Liverpool Kids
Dates 1972 -
Photographer Tricia Porter
Subjects TOWN LIFE EDUCATION PSYCHOLOGY
youth clubs
Numbers pr c80 b&w 10"x12"
fi neg c2520 b&w 35mm
Copies available for sale for loan
Charges Print fee

32
Owner J H Rushton
Location 10 Mayfield Whitby Road Pickering
North Yorkshire
Title Local History of North East Yorkshire
Dates 1850 (1964) -
Photographer Boak Cromack Smith Captain Fuller
Hayes Smith Chester Vaughan
Subjects SOCIAL SCIENCES associations and societies
customs domestic recreations portraits events
naval
Numbers pr c2000 b&w
sl 400 b&w
Access Bona fide students
Notes This collection has been compiled as a teaching
tool for adult education classes.

33
Owner School of Scottish Studies
Location University of Edinburgh 27 George Square
Edinburgh 031 667 1011 Ext 6676
Custodian B R S Megaw
Dates 19thC (1951) -
Photographer Dr Verner Kissling
Subjects SOCIAL SCIENCES occupations and services
customs and folklore wind and water mills
agriculture and food production domestic architecture
Numbers pr 8000 b&w ½pl
fi negs 5000 b&w 35mm
L sl 1000 b&w 2"x2"

Aids Card index subject index
Access Bona fide students
Copies available for sale
Charges Print fee

34
Owner Shelter The National Campaign for the Homeless
Location 86 The Strand London WC2R 0EQ 01 836 2051
0256 64985
Title Shelter Picture Library
Dates 1968 -
Photographer Nick Hedges Stuart McPherson
Subjects SOCIAL SCIENCES human behaviour related to
hardships of homelessness slums and slum clearance
public housing health and welfare squatting
harrassment and exploitation schools children at
play biography and portraits
Numbers pr c15000 b&w 6"x9"
fi negs c20000 b&w 35mm
sl c5000 col 35mm
Access General Public bona fide students picture
researchers press tv media by appointment
Copies available for sale for display for loan in special
cases for publication
Charges Publication/reproduction fee print/transparency
fee holding fee handling fee search fee
Notes The library's main subject is Homelessness in
Britain and its related social deprivations.

35
Owner Ronald Sheridan
Location 11 Harvard Court Honeybourne Rd London
NW6 1HJ 01 435 3257
Title Ronald Sheridan's Photo Library
Dates (1960) -
Photographer Ronald Sheridan
Subjects SOCIAL SCIENCES ARTS AND CRAFTS
GEOGRAPHY religion children at play customs
and folklore geology archaeology home
architecture painting numismatics textiles
antiques Mediterranean Middle East European
countries historic events topography historical
costume sculpture
Numbers fi negs c25000 b&w various
sl c25000 col various
Aids Duplicated catalogue *card index *subject index
Access Picture researchers press tv media 9 am - 5 pm
Copies available for sale for display for loan for
publication
Charges Reproduction fee print fee holding fee loss fee

36
Owner Joanna Smith
Location Edells Markbeech Edenbridge Kent 034286 313
Title John Topham Picture Library
Dates 1923 -
Photographer Harold Bartin Harold Chapman Stanley
Jeeves John Topham
Subjects SOCIAL SCIENCES rural and surburban life in
South East England agriculture natural history
Edwardian life
Numbers pr c100000 10"x8"
fi negs c100000
gl pl c50000
Aids Catalogue card index

37
Owner Dave Thomas - Photographer
Location 22 Park Crescent Leeds West Yorkshire
LS8 1D4 0532 667420
Dates 1967 -
Photographer Dave Thomas
Subjects SOCIAL SCIENCES air force equipment
transport customs and folklore mining clothes
architecture landscapes Yorkshire woollen industry

Key () = dates when collections were begun or terminated
C = Century c = approximately pr = print fi = film
gl = glass neg = negative sl = slide L sl = lantern slide
tr = transparency mic = microform col = colour

b&w = black and white ¼, ½, 1-pl = quarter, half and whole
plate * = single copy, no public access ** = single copy,
access by appointment

Numbers pr c300 b&w 10"x8"
 tr c200 col 35mm
Access Bona fide students by special arrangement
Copies available for sale for loan

38

Owner Ulster Museum Trustees
Location Botanic Gardens Belfast BT9 5AB
Title R J Welch collection
Dates 1880 - 1930
Photographer R J Welch
Subjects SOCIAL SCIENCES ARCHITECTURE geology palaeontology landscapes historic and newsworthy events
Numbers gl negs c5000 b&w 1-pl

39

Owner University of Nottingham
Location University Library University Park Nottingham 0602 56101 Ext 3437
Title Includes D H Lawrence Collection Newcastle Collection Middleton Collection Dury-Lowe Collection University of Nottingham Records
Custodian M A Welch
Dates c1855 -
History The D H Lawrence Collection consists of social and biographical connections of the author
Photographer F H Evans
Subjects SOCIAL SCIENCES horse drawn tramway - coal carriage botany architecture painting biography and portraits landscapes Crimean War historic and newsworthy events University of Nottingham history ecclesiastical buildings Southwell Minster Lincoln Cathedral
Numbers pr substantial numbers b&w various
 fi negs substantial numbers b&w col various
 gl negs substantial numbers b&w various
 sl c154 b&w 35mm
 tr 34 col 35mm
Aids *Catalogue
Access Bona fide students
Copies available for sale subject to copyright restrictions
Charges Print fee

40

Owner University of Reading
Location Whiteknights Reading Berkshire RG6 2AG 0734 85123
Title Museum of English Rural Life
Custodian C A Jewell
Dates c1850 (1951) -
Subjects SOCIAL SCIENCES museum acquisitions agricultural manufacturing firms agricultural organisations and societies farm records other manuscripts
Numbers pr c168000 b&w various
 fi negs c30000 b&w 35mm - ½pl
 gl negs c170500 b&w 3¾"x2¼" - 1-pl
 gl pos c20 b&w
 L sl c200 b&w 3¼"x3¼"
 sl c2100 b&w col 2"x2"
 mic 54 rolls b&w 35mm
Aids *Card index *subject index
Access General public bona fide students
Copies available for sale
Charges Print fee black and white from 26p transparencies (lantern slides) black and white from 35p colour 5"x4" from £3.50p colour 2"x2" from 50p Microfilm (negative only) minimum charge of £2.50 reproduction fee subject to copyright
Notes A number of series show stages in various rural crafts. A major part of the collection is concerned with the development of agriculture and its associated industries.

41

Owner University of St Andrews
Location University Library St Andrews Fife Scotland St Andrews 4333
Custodian R N Smart
Dates 1839 -
Photographer John Adamson D O Hill and Robert Adamson Thomas Rodger James Valentine
Subjects SOCIAL SCIENCES religion occupations and services the forces associations and societies education transport customs and folklore science zoology agriculture and food production domestic home clothes architecture painting recreations athletic sports and outdoor games biography and portraits geography events
Numbers pr c100000 b&w
 fi negs c5000 b&w
 gl negs c2000 b&w
Aids *Sheaf index
Access General public bona fide students by application in writing
Copies available for sale
Charges Print fee

42

Owner University of Stirling
Location A V A Unit Stirling FK9 4LA Stirling 3171
Custodian R B Stewart
Dates 1967 -
Photographer R B Stewart
Subjects SOCIAL SCIENCES psychological research education microscopy archaeology zoology fishes mechanical engineering - smaller fabricated objects painting musical instruments outdoor games - volley ball climbing aquatic sports swimming diving canoeing
Numbers fi negs c15000 b&w
 sl 5000 col 35mm
Access General public bona fide students picture researchers press tv media on application by letter 9am - 5-15pm
Copies available for publication credit line required
Charges Reproduction fee

43

Owner Mrs Pearl Margaret Vose
Location 20 The Crescent Nettleham Lincoln 0522 50695
Dates 1888 - 1945
Subjects SOCIAL SCIENCES Nettleham - people and their lives
Numbers pr c160 8"x6"
Aids Card index
Access Bona fide students on application only

44

Owner W H Smith and Son Limited
Location Strand House New Fetter Lane London EC4 01 405 4343
Custodian The Archivist
Dates c1874 (1964) -
Photographer Fradell and Young Lombardi and Company
Subjects SOCIAL SCIENCES OCCUPATIONS AND SERVICES TRANSPORT arts and crafts architecture recreation athletic sports and outdoor games bookstalls shops personnel
Numbers pr c4000 b&w c50 col 10"x8"
 fi negs 10 b&w 10 col 10"x8"
 gl negs 18 b&w 6½"x4¾"
 L sl c75 b&w 3¼"x3¼" 2"x2"
 sl c50 b&w c40 col 2"x2"
 tr 10 col 4¼"x3½"
Aids *Catalogue *subject index
Access Bona fide students on written application only
Copies available for loan

45

Owner National Museum of Wales
Location Welsh Folk Museum St Fagans Cardiff South Glamorgan CF5 6XB 0222 561357/8
Custodian W Linnard
Dates c1870 -
Subjects WELSH FOLK LIFE - all aspects ethnology crafts furniture domestic life costume buildings traditions
Numbers pr c10000
 negs and sl 80000

Aids Subject card index
Access Bona fide students by prior arrangement
Copies available for sale subject to copyright
Notes This is a specialised collection of folklife mainly related to Wales

46
Owner University of Cambridge
Location University Archives University Library West Road Cambridge CB3 9DR 0223 61441
Title Ref Phot 1 - 103
Custodian Miss H E Peek
Dates 1902 (c1909) - 1956
History This is the collection of Mrs Cameron wife of John Forbes Cameron, Master of Gonville and Caius' College, Cambridge 1928 - 1948, and Vice-Chancellor 1933 - 1935
Subjects CUSTOMS AND FOLKLORE University ceremonies 1930 - 40 biography and portraits
Numbers pr 103 b&w
Aids *Catalogue
Access Bona fide students
Copies available for sale
Charges Reproduction fee commercial rates

47
Owner Reginald T Smith
Location Sunnyside Church Street Charlbury Oxfordshire OX7 3PR
Title Charlbury Fairground Photographic Collection
Dates 1869 (1920) -
Photographer Reginald T Smith
Subjects OLD-TIME FAIRS AND FAIRGROUND EQUIPMENT - rides shows organs showman's road locomotives steam driven road and farm machines
Numbers pr c10000 b&w various
 fi negs c1000 b&w various
 gl negs 50 b&w $\frac{1}{4}$pl $\frac{1}{2}$pl
Aids Catalogue and card index in preparation
Access Inspection only by fellow collectors personally known to the owner or accredited students by appointment

48
Owner Keith Ellis
Location 75 Bellclose Road West Drayton Middlesex UB7 9DF
Title The Keith Ellis Collection
Dates 1964 -
Photographer Keith Ellis
Subjects RELIGION NATURE ARCHITECTURE Christian activities customs festivals portraits youth work London - churches buildings customs activities views nature study
Numbers pr 300 10"x8" 1-pl
 fi negs 4000 b&w 2$\frac{1}{4}$"x2$\frac{1}{4}$"
 tr 1000 col 35mm
 sl 300 col 2$\frac{1}{4}$"x2$\frac{1}{4}$"
Aids Catalogue cross index file for various subjects
Access General public bona fide students picture researchers press tv media prints can be sent to press tv or publishers
Copies available for sale
Charges Reproduction fee commercial rates
Notes Photographs are supplied mainly to Christian newspapers magazines and publications.

49
Owner English Province of the Society of Jesus
Location 114 Mount Street London W1Y 6AH
Dates c1860 -
Subjects RELIGION Christian religion education biography and portraits historic and newsworthy events
Numbers pr c2000 various
 L sl c500 various
 gl negs substantial number 2$\frac{1}{4}$"x2$\frac{1}{4}$"

Aids *Subject index
Access Bona fide students with reservation
Copies available for sale for special reasons
Notes The Society of Jesus is otherwise known as the Jesuit Order.

50
Owner Essex Education Committee
Location Colchester Institute of Higher Education Clacton-on-Sea Essex Clacton 22324
Custodian G Nelson
Dates (1973) -
Subjects RELIGION transport astronomy geology meteorology palaeontology botany zoology agriculture and food production domestic home clothes arts and crafts recreations athletic sports and outdoor games geography
Numbers sl c1000 col 35mm
Aids *Catalogue *card index *subject index
Access Bona fide students

51
Owner Ann and Bury Peerless
Location 'St David's' 22 King's Avenue Minnis Bay Birchington on Sea Kent CT7 9QL 0843 41428
Dates 1960 -
Photographer Bury Peerless
Subjects WORLD RELIGIONS history art sculpture and carving architecture customs and folklore observatories archaeology dams coins industry and agriculture rural scenes village life arts and crafts in India Nepal Pakistan Sri Lanka Bangla Desh Burma Afghanistan Indian miniature paintings
Numbers pr 500 col 10"x15" 10"x7"
 sl 5000 col 35mm
Aids Duplicated catalogue
Access General public picture researchers bona fide students press tv media 6 pm - 10 pm
Copies avilable for sale for display for publication
Charges Reproduction fee print/transparency fee handling fee holding fee

52
Owner Pluscarden Benedictines
Location Pluscarden Abbey by Elgin Moray Grampian Region of Scotland IV30 3UA 034 389 257
Custodian Giles N Conacher
Dates 1902 (c1900) -
Subjects RELIGION monks monasteries ecclesiastical matters events connected with the community
Numbers pr substantial number b&w col
 sl substantial number col 35mm
 fi negs c1400 35mm
 postcards substantial number
Aids Partial index
Access Bona fide students by appointment
Notes This collection is not unified, some parts of it are not easily accessible and some notice would be required to view certain photographs.

53
Owner United Reformed Church History Society
Location 86 Tavistock Place London WC1H 9RT 01 837 7661
Custodian Hon Secretary
Dates Mid 19thC (Late 19thC) -
Subjects RELIGION Congregational Presbyterian United Reformed Denominations - ministers churches
Numbers pr c20000 b&w various
Aids *Catalogue
Access General public 10.30 am - 12.30 pm 1.30 pm - 4 pm Tuesdays - Fridays
Copies available for loan

Key () = dates when collections were begun or terminated
C = Century c = approximately pr = print fi = film
gl = glass neg = negative sl = slide L sl = lantern slide
tr = transparency mic = microform col = colour

b&w = black and white $\frac{1}{4}, \frac{1}{2}$, 1-pl = quarter, half and whole plate * = single copy, no public access ** = single copy, access by appointment

54
Owner United Society for the Propagation of the Gospel
Location 15 Tufton Street London SW1P 3QQ
 01 222 4222
Title Photographic Bureau Historical Collection
Custodian Brenda Hough
Dates Mid 19thC -
History This organisation covers the world-wide work of
 the two societies which amalgamated to become the
 U S P G, ie the Society for the Propagation of the
 Gospel and Universities Mission to Central Africa
Subjects RELIGION Christian and non-Christian religion
 social sciences transport costume education
 botany zoology
Numbers pr substantial numbers
 tr substantial numbers
 sl substantial numbers
Access Bona fide students researchers by appointment only
Copies available for loan
Charges Reproduction fee
Notes The scope is missionary work in its widest sense
 ie it includes photographs of topographical and
 biographical interest and of social and religious
 practices both Christian and non-Christian.

55
Owner Arthur Findlay College
Location Stansted Hall Stansted Essex CM24 8UD
Title Britten Memorial Collection
Custodian P J Baker
Dates - 1940
Photographer William Hope
Subjects PSYCHIC PHOTOGRAPHY photographs of
 discarnate people
Numbers pr c200 b&w 5"x4"
 L sl b&w
Access Bona fide students
Copies available for loan

56
Owner N V Salt
Location Ravenswood Village Crowthorne Berkshire
 Crowthorne 2660
Dates (1973) -
Photographer N V Salt
Subjects RELIGIOUS OBJECTS misericords - British
 Isles Medieval church woodcarvings
Numbers pr c2500 b&w 10"x8"
 fi negs c2500 b&w 35mm
Aids *Catalogue
Access Bona fide students appointment required
Copies available for sale for loan
Charges Print fee

57
Owner Library of the Society of Friends
Location Friends House Euston Road London NW1 2BJ
 01 387 3601
Custodian Jon North
Dates c1850 (19thC) -
Subjects SOCIETY OF FRIENDS relief and missionary
 work World Wars I and II Quaker portraits
 meeting houses
Numbers pr c15000 b&w various
 fi negs c400 b&w 1-pl
 gl negs c600 b&w 1-pl
 L sl c1000 b&w
 mic c200 reels b&w
Aids Partial catalogue partial subject index
Access General public bona fide students picture
 researchers press tv media 9.30 am - 5.30 pm
Copies available for sale for loan for display and
 publication subject to copyright credit lines required
Charges Publication/reproduction fee print/transparency
 fee copy pr 1-pl 60p reproduction £3 per picture
 photographs of library picture where no neg exists
 £2.10

58
Owner Earl of Harrowby
Location Sandon Hall Sandon Stafford ST18 0BZ
 088 97 392
Dates c1850 -
Subjects DOMESTIC family travel
Numbers Substantial
Access Bona fide students by appointment only

59
Owner Herefordshire College of Art
Location The Library Herefordshire College of Art
 Folly Lane Hereford 0432 3359
Custodian Mrs S J Addis
Subjects DOMESTIC ARCHITECTURE PAINTING
 ANTIQUES glass textiles Victorian costume
Numbers L sl 2½"x2½"
Access College staff only
Copies available
Charges Reproduction fee by arrangement
Notes The College would be willing to lend to other
 educational establishments in the County of Hereford
 and Worcester. Loan service outside this area
 negotiable.

60
Owner W N Marshall
Location 'Armthorpe' Tixall Stafford ST18 0XP
 0785 62520
Dates 1944 -
Photographer Miss E A Marshall Miss P J Marshall
 W N Marshall
Subjects DOMESTIC - HOME LIFE family holidays home
 and abroad - France Spain Kenya flora and fauna
Numbers pr c2000 col 3½"x5½"
Access Bona fide students by appointment
Copies available for sale
Charges Print fee

61
Owner National Magazine Company Limited
Location 276 Vauxhall Bridge Road London SW1V 1BB
 01 834 2331
Custodian Geoffrey T Large
Dates 1970 -
Subjects DOMESTIC cookery fashion interior decor
 furnishing
Numbers pr substantial number b&w various
 tr substantial number col various
Access By appointment normal office hours 9 am - 5 pm
 Monday to Friday
Copies available for loan
Charges Print fee reproduction fee by arrangement
Notes This collection is for editorial use only.
 Magazines in which photographs appeared may be
 consulted for reference.

62
Owner Flour Milling and Baking Research Association
Location Chorley Wood Rickmansworth Hertfordshire
 WD3 5SH 092 78 4111
Custodian C B French
Dates 1948 -
Subjects FOOD cereal chemistry baking technology and
 allied subjects
Numbers sl 850 3¼"x3¼" 2150 2"x2"
Aids *Subject index accession register
Access Bona fide students by appointment only
Copies available for loan

63
Owner Kraft Foods Limited
Location 259/269 Old Marylebone Road London NW1 5RB
Custodian B Warner Helen Allen
Dates 1924 -
Subjects FOOD food manufacture factories: interior and
 exterior products food dishes Kraft Foods Limited -
 personnel

Numbers pr c250 b&w c20 col 6"x8" 8"x10"
 fi negs c40 b&w
 tr 150 col 1-pl
Copies available for loan

64

Owner Distillers Company Limited
Location 20/21 St James's Square London SW1Y 4JF
 01 930 1040
Title The Distillers Company Limited Photographic Library
Custodian Miss V H Stanley
Dates 1947 (1958) -
Photographer Maurice Broomfield Percy Hennell Alan
 Marshall Walter Nurnberg
Subjects DRINK Scotch Whisky and London Gin production
Numbers pr c1280 b&w c160 col 1-pl 12"x10"
 fi negs c1280 b&w c160 col various
 gl negs 50 b&w 5"x4"
 L sl c60 col 35mm
 sl c250 col various
Aids *Card index *subject index *location index
 *numerical index
Access Bona fide students on prior written or telephone
 request
Copies available for loan
Charges No charge for reproduction but acknowledgement
 to DCL requested

65

Owner Bath City Council
Location Museum of Costume Assembly Rooms Alfred
 Street Bath Avon 0225 28411
Custodian Mrs Myra Mines
Dates c1850 (1963) -
Photographer Anthony Armstrong-Jones David Bailey
 Cecil Beaton Earl of Lichfield French Lenare
Subjects CLOTHES - contemporary dress period costume
 jewellery shoes accessories textiles toys dolls
 costume
Numbers pr c2700
Access General public when research centre is open
 Monday to Friday 2 pm - 5 pm
Copies Postcards and transparencies are available for sale
Charges Print fee postcards 6p each slides 15p each
Notes This collection contains about 2000 photographs from
 the Sunday Times fashion photography archives and
 about 700 from family albums dating from Victorian
 times onwards.

66

Owner Manchester City Council
Location Gallery of English Costume Platt Hall Platt
 Fields Manchester 14 5LL 061 224 5217
Custodian Mrs Christina Walkley
Dates c1840 (1947) -
Subjects COSTUME PORTRAITS
Numbers pr c3000 various
 tr 13 col
 daguerrotypes c150
 postcards
 stereo prints 200
Aids Subject index
Access Bona fide students by appointment only
Copies Colour transparencies and postcards available for
 sale

67

Owner H M S O
Location Atlantic House Holborn Viaduct London
 EC1P 1BN 01 248 9876
Title British Crown Regalia
Custodian B J Jones
Dates 1965 -
Subjects JEWELLERY British Crown Regalia Gold Plate
 in Tower of London Orders of Chivalry Robes of
 Chivalry precious stones medals VC and GC

insignia of Orders of Merit Coronation Regalia
 ceremonies
Numbers pr c150 b&w 10"x8"
 gl negs b&w ½pl
 tr c300 b&w col ½pl
Aids Published guide
Access General public by appointment
Copies Black and white prints available for sale
 transparencies for loan only
Charges Reproduction fee black and white £3.60 excluding
 VAT colour £7.20 excluding VAT loan charge payable
 whether or not the transparency is reproduced from
 £2.10 replacement charge in the event of loss or
 damage whilst on loan from £7.35
Notes The Crown Regalia photographs are Crown copyright
 and may not be reproduced without prior written
 permission from the copyright section, HMSO. They may
 not be used in connection with advertising or on the
 covers of publications.

68

Owner K Shoes Limited
Location 44/46 Lound Road Kendal Cumbria LA9 7DZ
 0539 24343
Title K Shoes Eyelet Library Collection
Custodian John F Watton
Dates 1880 (1949) -
Subjects SHOES shoe industry
Numbers pr substantial number b&w ½pl 1-pl
 fi negs substantial number col
 L sl c100 col
Aids *Catalogue *subject index
Access Bona fide students
Copies available depending on availability of negative or
 print
Charges Reproduction fee by arrangement
Notes The K Shoe Eyelet Library of photographs is kept for
 the benefit of the K Shoe makers - family photographs.
 (The Company was founded in 1842). Its main purpose
 is to be a memorial to all K Shoe makers, it could be
 regarded as a chantry, particularly for those killed in
 the world wars.

69

Owner Northampton Borough Council
Location Central Museum Guildhall Road Northampton
 0604 34881
Title Northampton Museum Collection
Custodian W N Terry J M Swann
Dates 1860 (1930) -
Subjects NORTHAMPTON SHOES BIOGRAPHY AND
 PORTRAITS architecture leather
Numbers pr c300 b&w various
 fi negs c15 various
 gl negs c60 ½pl 1-pl
 L sl c100 2½"x2½"
Aids *Card index
Access General public bona fide students
Copies available for sale where negatives exist
Charges Print fee

70

Owner F W French
Location Oakleigh Batts Corner Dockenfield Farnham
 Surrey GU10 4EY Frensham 3825
Dates 1946 -
Subjects RECREATION humorous - posters signs people
Numbers tr 200 col 35mm
Notes The collection is used primarily for lectures to
 photographic clubs.

71

Owner Susan Griggs Agency
Location 17 Victoria Grove London W8 01 584 6738
Dates 1965 (1968) -
Photographer Michael Boys Julian Calder Tor Eigeland

Key () = dates when collections were begun or terminated
C = Century c = approximately pr = print fi = film
gl = glass neg = negative sl = slide L sl = lantern slide
tr = transparency mic = microform col = colour

b&w = black and white ¼, ½, 1-pl = quarter, half and whole
plate * = single copy, no public access ** = single copy,
access by appointment

Victor Englebert John Garrett Anthony Howarth
Monique Jacot John Marmaras Horst Munzig Reflejo
Adam Woolfitt Ian Yeomans
Subjects RECREATIONS TRAVEL ABROAD arts and
crafts accidents animals antiques armoury
archaeology architecture auctions banks birds
boats and ships books cafes and restaurants
camping candles and lighting cars cemeteries
churches cinemas clocks clothing computers
dance desert demonstrations and protest dereliction
and decay drought drugs earthquakes eating and
drinking education energy crisis entertaining
customs and folklore farming fire fireworks
fishing funerals food and drink furniture
gambling geology glass and glassblowing graffiti
grooming industry insects jewellery medicine
mining mountains museums music occult
parades people personalities plants pollution
prostitutes refugees religion science sleeping
smoking superstitions taxidermy transport
volcanoes war water weather weddings zoos
Numbers tr 100000 col 35mm $2\frac{1}{4}$"x$2\frac{1}{4}$"
Aids Duplicated subject index
Access General public picture researchers bona fide
students press tv media by appointment
Copies available for sale for publication credit line
required
Charges Holding fee search fee compensation for loss or
damage

72
Owner The Magic Circle
Location 84 Chenies Mews London WC2
Title Magic Magicians and the Magic Circle
Custodian Mac Wilson 29 Shepperton Road Petts Wood
Orpington Kent Orpington 24676
Dates (1950) -
Subjects MAGIC magicians the Magic Circle
Numbers sl c80 col 35mm
Copies available for sale for loan for publication
Charges Reproduction fee
Notes Lecturers visit various societies and clubs by
arrangement.

73
Owner Waldo S Lanchester
Location 5 Swanfold Wilmcote Nr Stratford-on-Avon
Warwickshire CV37 9XH 0789 3774
Dates 1936 -
Subjects THE ART OF PUPPETRY celebrations in
Stratford-on-Avon wild flowers National Trust
gardens and houses steam fairs and Stratford Mops
Numbers Totals several thousands fi negs and sl b&w col
Access Not normally open for inspection (really a
private collection)
Copies Can supply colour slides and/or black and white
prints for publication
Charges Print fee reproduction fee dependent entirely on
circumstances
Notes Waldo S Lanchester has had a 16mm silent film
made by Douglas Fisher 'The Creation of the
Marionette' which is suitable for most associations. He
also gives a demonstration at the end of the film with
the actual marionette made on the screen together with
some of the other marionettes in the company. He also
gives talks with slides on wild flowers of the hedgerow
and fields, National Trust Gardens and garden flowers,
and steam fairs and Stratford Mops from 1951-1974
within 30-40 miles of Stratford.

74
Owner Reg Wilson Photography
Location 55 Beechwood Avenue London N3 01 346 7776
Dates 1961 -
Photographer Reg Wilson
Subjects PERFORMING ARTS theatre opera ballet
musicians composers
Numbers fi negs 350000 b&w 3500 col various
tr 75000 col 35mm $2\frac{1}{4}$"x$2\frac{1}{4}$"
Aids *Card index *subject index
Access Picture researchers press tv media 9 am - 6 pm

Copies available for publication
Charges Reproduction fee print/transparency fee
Notes This is a working library of mono and colour
transparencies of the 'performing arts'.

75
Owner Aldwych Theatre
Location Aldwych London WC2
Dates 1964 -
History The collection consists of photographs of
productions staged at the Aldwych Theatre by the
Royal Shakespeare Company
Photographer Zoe Dominic Doug Jeffery Reg Wilson
Subjects THEATRE AND DRAMA Shakespeare productions
Numbers pr substantial numbers b&w 10"x8" 16"x20"
Copies available for sale for loan
Charges Reproduction fee

76
Owner F T Appleby
Location Manager's Office Opera House Manchester 3
061 834 9282
Dates 1947 -
Photographer Baron Tom Hustler Angus McBean
Houston Rogers Lord Snowdon Dorothy Wilding
Subjects THEATRE STARS
Numbers pr 60 b&w 10"x8"
Access Bona fide students
Copies not available as the photographs are personally
inscribed and autographed

77
Owner Bush Theatre
Location 2 Goldhawk Road London W12 01 745 5050
Custodian Luke Randolph 01 749 0485
Dates 1972 -
Photographer Nobby Clark
Subjects THEATRE Bush Theatre productions
Numbers pr 30 b&w 12"x15"
fi negs c130 b&w 35mm
Aids *Guide
Access Bona fide students visitors to the Theatre

78
Owner Coventry Theatre
Location Hales Street Coventry West Midlands
Dates 1935 -
Subjects THEATRE - personalities
Numbers pr c300 b&w 10"x8"
Access Bona fide students

79
Owner Dominic Photography
Location 9a Netherton Grove London SW10 9TQ
01 352 6118
Dates 1956 -
Photographer Zoë Dominic
Subjects THEATRE BALLET OPERA FILMS
television music biography and portraits
Numbers pr c10000 b&w 10"x8"
fi negs c120000 b&w 35mm $2\frac{1}{4}$"x$2\frac{1}{4}$"
tr c5000 col 35mm $2\frac{1}{4}$"x$2\frac{1}{4}$"
Aids Subject index
Access Bona fide students picture researchers press tv
media 9.30 am - 5.30 pm by appointment
Copies available for sale for display for publication
credit line required
Charges Print/transparency fee handling fee
reproduction fee search fee holding fee for colour
after one month

80
Owner Richard Gill
Location Polka Children's Theatre 4 Sunnyside London
SW19 4SL 01 946 9478
Dates 1967 -
History The collection traces the complete development of
the Polka Children's Theatre
Photographer Richard Gill
Subjects CHILDREN'S THEATRE puppets

Numbers pr substantial number b&w 10"x8"
　　fi negs substantial number b&w 35mm
Access Bona fide students press
Copies available for sale for loan
Notes This collection refers only to Polka and its work.

81

Owner Greenwich Young People's Theatre Limited
Location Stage Centre Burrage Road Plumstead London
　　SE18
Custodian B Newton
Dates 1970 (1971) -
Subjects THEATRE work of the Greenwich Young People's
　　Theatre
Copies available for loan

82

Owner Holte Photographics Limited
Location 8 Church Street Stratford-on-Avon Warwichshire
　　0789 2336
Custodian Mig Holte
Dates 1952 -
Photographer Mig Holte T F Holte
Subjects THE ROYAL SHAKESPEARE THEATRE
　　PRODUCTIONS Stratford-on-Avon views
Numbers fi negs c3000 b&w
　　sl 30000 col 35mm
Aids Published Catalogue
Access General public bona fide students picture
　　researchers press tv media 9 am - 5.30 pm
Copies available for sale for display for publication
Charges Reproduction fee print/transparency fee search fee

83

Owner Inter-Action Trust
Location 14 Talacre Road London NW5 3PE　　01 267 1422
Custodian Jim Donovan
Dates 1968 -
Subjects THEATRE Ambiance Lunch-Hour Theatre Club
　　free theatre street theatre Inter-Action's
　　Community Arts Work
Numbers pr c3000 b&w c300 col 10"x8"
　　fi negs substantial number b&w col
　　sl c1000 col
Aids *Subject index
Access General public bona fide students by appointment
Copies available by arrangement

84

Owner Mermaid Theatre Trust
Location The Mermaid Theatre Stage Puddledock
　　Blackfriars London EC4　　01 236 9521
Custodian Chris Miles
Dates 1959 -
History The Theatre was founded by Sir Bernard Miles
Subjects THEATRE Mermaid Theatre productions
Numbers pr c5000 b&w various

85

Owner Questors Limited
Location The Questors Theatre Mattock Lane Ealing
　　W5 5BQ　　01 567 0011
Custodian Wyllie Longmore
Dates 1929 -
Subjects THEATRE The Questors Theatre - history
　　productions building operations
Numbers pr substantial number
Aids *Card index
Access Bona fide students
Copies available for loan

86

Owner Mrs Houston Rogers
Location 10 Phillimore Gardens London W8 7QD
　　01 937 1445
Title Houston Rogers Collection

Dates 1934 - 1970
History The collection is a record of notable theatre
　　opera and ballet productions and of artists in different
　　roles over a period of years
Photographer Houston Rogers
Subjects THEATRE ballet opera artists personalities
　　travel
Numbers pr18000 b&w 10"x8"
　　fi negs c40000 b&w $\frac{1}{2}$pl 2$\frac{1}{4}$"x2$\frac{1}{4}$"
　　L sl c500 b&w c20 col 3$\frac{1}{4}$"x3$\frac{1}{4}$"
　　tr c1500 col $\frac{1}{2}$pl 2$\frac{1}{4}$"x2$\frac{1}{4}$"
Aids Alphabetical lists
Access Bona fide students anyone wanting illustrations for
　　books tv programmes etc by appointment only
Copies available for sale for loan
Charges Reproduction fee payable according to use and size

87

Owner Tavistock Repertory Company (London)
Location Tower Theatre Canonbury Place London N1 2NQ
　　01 226 5111
Dates (1932) -
Subjects THEATRE productions of the Tavistock
　　Repertory Company
Numbers pr c700 b&w 10"x8"
Access Bona fide students
Copies available for loan for publication credit line
　　required
Charges No reproduction fee

88

Owner Theatre Museum c/o Victoria and Albert Museum
Location South Kensington London SW7 2RL
　　01 589 6371
Title Theatre Museum Collection
Custodian Alexander Schouvaloff
Dates c1850 (1924) -
Photographers Alfred Ellis and Walery Gordon Anthony
　　Cecil Beaton Pollard Crowther J W Debenham
　　James Russell and Sons Angus McBean
　　Edward Mandinian Denis de Marney Duncan Melvin
　　Bertram Park Window and Grove
Subjects PERFORMING ARTS theatre ballet opera
　　pantomine music hall mime customs and folklore
　　theatrical architecture street scenes toy theatre and
　　costume models of sets and stages recreations
　　portraits of performers - in and out of costume
　　scenes scene designs costume designs
Numbers pr substantial number b&w col various
　　fi negs substantial number b&w various
　　gl negs substantial number b&w col various
　　gl pos substantial number b&w various
　　mic L sl substantial number b&w col 2$\frac{1}{4}$"x2$\frac{1}{4}$"
Aids *Card index *subject index
Access General public bona fide students
Copies available for sale for loan
Charges Print fee

89

Owner Unity Theatre Society Limited
Location Unity Theatre 1 Goldington Street London
　　NW1 1UD
Photographer Baron Bob Brimson
Subjects THEATRE Unity Theatre productions
Numbers pr Substantial number
Access Bona fide students on application

90

Owner John Vickers Studio John Vickers School
Location 54 Kenway Road London SW5 0RA　　01 373 3091
Custodian John Vickers
Dates 1938 - 1960
History John Vickers was official photographer to the
　　Unity Theatre 1937 - 1942 and the Old Vic 1943 -1958
Photographer John Vickers

Key () = dates when collections were begun or terminated
C = Century c = approximately pr = print fi = film
gl = glass neg = negative sl = slide L sl = lantern slide
tr = transparency mic = microform col = colour

b&w = black and white $\frac{1}{4}$,$\frac{1}{2}$,1-pl = quarter, half and whole
plate * = single copy, no public access ** = single copy,
access by appointment

Subjects THEATRE stage productions actors connected with the straight theatre musicians quartets and ensembles
Numbers fi negs c50000 b&w various
gl negs c75000 b&w 4¼"x3¼" ½pl
Aids Duplicated guide duplicated catalogue duplicated index
Access Picture researchers by special arrangement only 10 am - 5 pm
Copies available for sale for display and for publication only
Charges Publication/reproduction fee print/transparency fee handling fee holding fee service charge search fee

91
Owner World Centre for Shakespeare Studies Limited
Location 40 Bankside Liberty of the Clink London SE1 01 928 4229
World Centre for Shakespeare Studies Bear Gardens Museum 1 Bear Gardens London SE1
Custodian Sam Wanamaker
Dates 1971 -
Subjects THEATRE AND DRAMA Shakespeare Elizabethan theatre productions events personalities local social history community affairs
Numbers pr c700 b&w 1 pl
sl c30 col 35mm
Aids *Subject index
Access Bona fide students
Copies available for sale
Charges Adults 10p students and OAP and children 5p

92
Owner English National Opera
Location London Coliseum St Martin's Lane London WC2 01 823 0111
Title Sadler's Wells Opera and English National Opera Collection
Custodian Helen Saloman
Dates 1949 -
Photographer Chris Arthur Donald Cooper Anthony Crickmay Zoe Dominic John Garner Douglas Jeffery Terence de Marney Angus McBean Stuart Robinson Houston Rogers Donald Southern Reg Wilson
Subjects OPERA ballet Sadler's Wells Theatre and London Coliseum - buildings
Numbers pr substantial number b&w col 10"x8"
sl substantial number b&w col
Copies available for sale
Charges Print fee

93
Owner English Opera Group Limited
Location Royal Opera House Covent Garden London WC2
Title English Opera Group Archives
Custodian C R Gregson
Dates 1946 -
Subjects OPERA English Opera Group productions personalities
Numbers pr c150 b&w various
fi negs c10 b&w various
Access Bona fide students personal application only
Copies available for loan in special circumstances only

94
Owner Glyndebourne Productions Limited
Location Lewes East Sussex BN8 5UU 0273 812321
Title Glyndebourne Festival Opera Collection
Custodian Helen O'Neill
Dates 1934 -
Photographer Anthony Crickmay Zoe Dominic Guy Gravett Anthony Armstrong-Jones Angus McBean
Subjects OPERA Glyndebourne Festival Opera and Glyndebourne Touring Opera productions
Numbers pr substantial numbers b&w 10"x8"
fi negs
Aids *Card index
Access Bona fide students by arrangement only
Charges By arrangement

Notes Guy Gravett has covered every production since 1952 and all negatives of his pictures are held by him. The Angus McBean negatives are kept by the Theatre Department, Harvard University, Boston, Mass., copy prints available from the Curator.

95
Owner Royal Opera House
Location Covent Garden London WC2 01 240 1200
Title Archives
Custodian T Benton B J Skidelsky
Dates 1920 (1967) -
Photographer Cecil Beaton Anthony Crickmay Angus McBean Houston Rogers Donald Southern Reg Wilson
Subjects OPERA Ballet Royal Opera House - history
Numbers pr substantial number b&w various
fi negs substantial number b&w col various
Aids *Card index *subject index
Access Bona fide students by appointment only
Copies available for sale
Charges On application

96
Owner Welsh National Opera and Drama Company Limited
Location John Street Cardiff CF1 4SP South Glamorgan 0222 40541
Custodian Mrs N A Whyte
Dates 1946 -
Subjects OPERA DRAMA Productions including Simon Boccanegra The Flying Dutchman The Elixir of Love
Numbers pr c700 b&w 10"x8" 20"x16"
sl col
Access Bona fide students by permission only
Copies available for sale for loan
Charges Print fee from 50p reprints to order from 75p

97
Owner J M D Davis
Location Flat 2 2-6 Douglas Street London SW1 01 821 1754
Dates 1955 -
Photographer Jessie Davis Mike Davis
Subjects BALLET pets horses recreations exploration and travel abroad Nureyev in Russia
Numbers pr substantial number b&w col 10"x8" 12"x10"
fi negs substantial number b&w col various
tr substantial number col various
Aids Subject index
Access Picture researchers press tv media
Copies available for sale for display for publication
Charges Reproduction fee print/transparency fee holding fee by arrangement
Notes The collection forms the best colour library dealing with Ballet.

98
Owner Royal Ballet School
Location 155 Talgarth Road London W14 9DE 01 748 3123
Custodian Sanina E Rosoman
Dates 1920 -
Subjects BALLET dance Royal Ballet School - productions class photographs
Numbers pr c2500 various
Aids Filed in date order

99
Owner Frank Allen
Location 135 Fordwych Road London NW2
Dates 1900 (c1967) -
Subjects FILM INDUSTRY
Numbers pr b&w 10"x8"
fi negs c700 b&w 5"x4"
tr 67 col 10"x8"
Aids Classified by Studio
Access Bona fide students picture researchers press tv media
Copies available for sale

100
Owner Ronald Grant
Location The Guildhall 20/21 High Street Clare
 Nr Sudbury Suffolk CO10 8NY 078 727 669
Title Ronald Grant's Entertainments Collection
Dates 1906 -
Photographer Ronald Grant
Subjects SCENES FROM FILMS portraits - actors
 actresses technicians scenes of film making
Numbers pr c70000 10"x8" 11"x14"
 tr 250 col 35mm - 10"x8"
Access Press tv media
Copies No copies but original material lent
Charges Reproduction fee on application

101
Owner A J Mitchell
Location 159 Mortimer Road London NW10 01 960 3048
Dates 1910 (1968) -
Subjects FILM INDUSTRY cinematography special
 photographic and electronic effects in motion pictures
 tv studios
Numbers pr c150 b&w
 tr c120 col
Aids Card index
Access Bona fide students by appointment only

102
Owner Rank Film Distributors
Location Pinewood Studios Ivor Heath Buckinghamshire
 Ivor 651700
Custodian Publicity/Advertising Manager
Dates 1935 -
Subjects FILM INDUSTRY British film productions
 stills film stars producers directors periods
Numbers pr substantial numbers b&w 10"x8" 5"x4"
 fi negs substantial numbers b&w 10"x8" 5"x4"
 tr substantial numbers b&w
Aids *Card index
Copies available for sale in special circumstances
Charges Credit line or fee

103
Owner Cyrus Andrews Photo Library
Location 54 The Grove Ealing London W5 5LG
 01 579 6449 or 01 567 2929
Title The History of Pop Music
Dates 1957 - 1969 -
History The collection covers the boom years of the
 Pop Music era
Subjects MUSICAL PERFORMANCES recording artists
 and pop groups in action at home and in other
 locations disc jockeys composers American
 artists visiting this country T V personalities
Numbers pr c1000 b&w 10"x8"
 fi negs c20000 b&w 2¼"x2¼" 5"x4"
 gl negs 167 b&w 5"x4"
 sl 6000 col 2¼"x2¼" 5"x4"
Aids Alphabetical index
Access Picture researchers press tv media by
 appointment only 9 am - 5.30 pm
Copies available for publication
Charges Reproduction fee holding fee service charge
 search fee - often waived

104
Owner Leslie Bryce Kimron Hanyards End Cuffley
 Hertfordshire EN6 4EN Cuffley 4282
Location 78 York Street London W1H 1DP 01 723 7862
Title The Beatles
Dates 1963 - 1968
History The collection was formed when the owner was
 touring with the Beatles as their photographer
Photographer Leslie Bryce
Subjects MUSICAL PERFORMANCES The Beatles - tours
 to America Austria Germany Holland

Numbers fi negs b&w substantial number 2¼"x2¼" 35mm
Copies available for sale

105
Owner Alan Johnson
Location 34 Leahurst Crescent Harborne
 Birmingham B17 0LG 021 426 1654
Title Music Makers
Dates (1968) -
Photographer Alan Johnson
Subjects MUSICAL PERFORMANCES musicians and
 singers - jazz rock blues pop progressive music
 cabaret cabaret artistes
Numbers pr 1500 b&w 10"x8"
 tr 250 col 35mm 5"x4"
Aids Duplicated subject index
Access Picture researchers press tv media to copy
 prints and original images
Copies available for sale for display for publication
Charges Reproduction fee print/transparency fee
Notes Photographs of over 300 artistes.

106
Owner David Redfern Photography
Location 30 Charing Cross Road London WC2H 0DE
 01-836 0421
Title David Redfern Picture Library
Dates 1959 -
Photographer David Ellis Paul Lloyd Stephen Morley
 David Redfern Tony Russell
Subjects POPULAR MUSIC jazz rock folk-music
 festivals models - girls
Numbers pr c1000 b&w 10"x8"
 fi negs c300000 b&w 35mm
 tr c500000 col 35mm 2¼"x2¼"
Aids Card index duplicated subject index
Access Bona fide students picture researchers press
 tv media 9 am - 5.30 pm
Copies for sale for loan for display for publication
Charges Reproduction fee holding fee

107
Owner A P M Vidal
Location 23 Kingsfield Grange Road Bradford-on-Avon
 Wiltshire 022 16 2641
Title Modern music through camera
Dates 1974 -
Photographer A P M Vidal
Subjects MUSICAL PERFORMANCES
Numbers pr c100
 fi negs c200 35mm
 sl c100 2"x2"
Access Bona fide students by appointment only
Copies available for sale subject to copyright
Notes Copyright does not always belong to photographer.

108
Owner Cyrus Andrews
Location 54 The Grove Ealing London W5 5LG
 01 579 6449
Title Show Business Collection
Dates 1957 -
Subjects MUSICIANS recording artistes pop groups
 disc jockeys composers tv personalities actors
 and actresses comedians
Numbers pr c1000 b&w 10"x8"
 fi negs c20000 b&w 2¼"x2¼" 5"x4"
 gl negs 167 b&w 5"x4"
 tr 6000 col 2¼"x2¼" 5"x4"
Aids Alphabetical index
Access Picture researchers press tv media
 9 am - 5.30 pm by appointment only
Copies available for publication credit lines required
Charges Reproduction fee holding fee search fee

Key () = dates when collections were begun or terminated
C = Century c = approximately pr = print fi = film
gl = glass neg = negative sl = slide L sl = lantern slide
tr = transparency mic = microform col = colour

b&w = black and white ¼,½,1-pl = quarter, half and whole
plate * = single copy, no public access ** = single copy,
access by appointment

109
Owner Erich Auerbach
Location 29 Abercorn Place St John's Wood
London NW8 9DU　01 624 5208
Title Composers and Musicians and Allied Subjects
Dates 1932 (1957) –
Photographer Erich Auerbach
Subjects MUSICIANS　world wide coverage
Numbers pr substantial numbers 10"x8"
fi negs substantial numbers
L sl c50 b&w 3¼"x3¼"
tr col 6cm x 6cm 35mm
Aids *Cross reference card index
Access General public picture researchers press tv
media by appointment 10 am – 5 pm
Copies available for sale for loan for display for
publication
Charges Print/transparency fee holding fee

110
Owner London Photo Agency Limited
Location L P A House Lambs Conduit Passage
London WC1　01 242 0707/8
Dates 1967 –
Photographer Alec Byrne
Subjects MUSICIANS show business personalities
Numbers fi negs c100000 b&w
tr c50000 col
Access Picture researchers press tv media
Copies available for publication
Charges reproduction fee print/transparency fee
holding fee search fee

111
Owner Royal College of Music
Location Department of Portraits Prince Consort Road
London SW7　01 589 3643
Custodian Oliver Davies
Dates c1850 (1883) –
Subjects MUSICIANS portraits musical instruments
buildings and monuments related to music
Numbers pr c1000 b&w
Aids *Card index
Access Bona fide students
Copies available for sale
Charges Reproduction fee on application

112
Owner Cyrus Andrews Photo Library
Location 54 The Grove Ealing London W5 5LG
01 579 6449 and 01 567 2796
Title Tourist Photo Library Limited
Dates 1964 –
Subjects HOLIDAYS holidays abroad natural history
crafts buildings Arctic
Numbers tr 10000 col 2¼"x2¼"
Aids Alphabetical index
Access Publishers by appointment 9 am – 5.30 pm
selection of colour transparencies posted on approval
Copies available for publication credit line required if
appropriate
Charges Reproduction fee holding fee charged only
after 28 days

113
Owner Dr I Castleden
Location 43 Parkside Mill Hill London NW7 2LN
01 959 1797
Dates c1890 –
Photographer Dr I Castleden
Subjects HOLIDAYS in England Suffolk scenes
architecture – East Anglia Kent family portraits
Numbers pr c600 ¼pl 1pl 2¼"x3¼"
gl negs c100 ½pl
sl c300 col 2¼"x2¼"
Access Bona fide students by appointment only

114
Owner Colorsport
Location 44 St Peter's Street Islington London N1 8JT
01 359 2714

Title Albert Wilkes Library of Football and Cricket
Photographs
Custodian Michael J Wall
Dates 1884 –
History Albert Wilkes who started the collection played
for Aston Villa F C. He also played in the England
team against Scotland and Wales in 1901 and
Scotland Wales and Northern Ireland in 1902
Subjects SPORT United Kingdom Football teams and
individuals match action shots United Kingdom and
overseas (visitors to this country) cricket teams
and individuals personal family photographs
Numbers gl negs c30000 ½pl – 15"x12"
Aids Cross referenced in alphabetical index books
Access Written authorisation required in first instance
Monday to Friday 9 am – 7 pm
Copies available for reproduction in publication and
research projects only
Notes The Wilkes collection is used in conjunction with
Colorsport's own library of colour and black and
white material which was started in 1969 and covers
United Kingdom and overseas sporting events.

115
Owner E D Lacey
Location 16 Post House Lane Great Bookham Leatherhead
Surrey KT23 3EA　259 3077
Dates 1950 –
Photographer E D Lacey
Subjects ATHLETIC SPORTS AND OUTDOOR GAMES
geography travel abroad
Numbers fi negs substantial number b&w col 2¼"x2¼"
35mm
Aids List available
Access Request by writing or phone 9 am – 11.30 pm
Copies available for sale for display for publication
Charges Print fee holding fee publication fee
Notes Commissions.

116
Owner Cyril Posthumus
Location 35 Staneway Ewell Epsom Surrey KT17 1PN
01 393 2336
Title Cyril Posthumus Collection
Dates 1895 (1948) – (1960) –
Subjects MOTOR RACING historic motoring racing
drivers
Numbers pr c10000 b&w various
fi negs c2000 b&w
gl negs c250 b&w
gl pos c80
Copies available for sale for loan for publication
Charges Print/transparency fee reproduction fee

117
Owner Sportography
Location 13 New Road Orpington Kent
Orpington 70048
Custodian J D Lloyd
Dates 1969 –
Photographer John Lloyd Chris Maddock
Subjects SPORTS AND GAMES transport architecture
Numbers fi negs c5000 b&w 35mm 6cm x 6cm
tr c5000 col 35mm 6cm x 6cm
Aids Card index
Access Picture researchers press tv media
9 am – 5 pm
Copies for sale for loan for display for publication
credit line required
Charges Print fee from 30p holding fee reproduction fee
according to use

118
Owner Sportsworld Magazine
Location 23-27 Tudor Street London EC4Y 0HR
01 583 9199
Dates 1960 –
Photographer Don Morley
Subjects SPORTS
Numbers tr c12000 col 35mm 2¼"x2¼"

c

Access Bona fide students picture researchers press tv media 9.30 am - 6.00 pm
Copies available for sale for loan for display for publication credit line required
Charges Publication/reproduction fee print/transparency fee handling fee search fee holding fee if held in excess of 1 month

119
Owner Starr Duffy Studios and Allsport Photo Agency
Location 83 Sutton Heights Albion Road Sutton Surrey 643 5790
Dates 1964 -
Photographer Tony Duffy John Starr
Subjects SPORTS all aspects ballet general advertising
Numbers pr 2500 b&w 10"x8"
fi negs 74000 b&w 35mm 120mm
tr 26000 col 35mm 120mm
Aids Duplicated subject index
Access Picture researchers 9 am - 6 pm to copy prints and the original images
Copies available for sale for display for publication
Charges Reproduction fee print/transparency fee holding fee and search fee charged if reproduction or transparency fee not charged

120
Owner Anthony Todd
Location Clearways Dalton-on-Tees Darlington Co Durham 0325 720508
Dates c1970 -
Photographer Anthony Todd
Subjects MOTOR SPORT transport flowering plants small mammals Steam Cavalcade 1975 motor cycle scrambles running cycling
Numbers fi negs c12000 b&w 35mm
tr c2000 col 35mm
Aids Contact sheet
Access Bona fide students picture researchers press tv media by special appointment by telephone
Copies available for sale for publication for loan in special circumstances only
Charges Reproduction fee print/transparency fee
Notes Commissions.

121
Owner Charlton Athletic Football Club
Location The Valley Floyd Road Charlton London SE7 8AW 01 858 3711
Dates 1919 -
Subjects FOOTBALL history of Charlton Athletic
Numbers Substantial

122
Owner Everton Football Club
Location Goodison Park Liverpool L4 4EL 051 521 2020
Custodian E D Hassell
Dates 1904 -
Subjects FOOTBALL Everton Football Club teams
Numbers pr c200

123
Owner Owen Barnes Camera Sport International Limited
Location Pangbourne House Magpie Hall Road Bushey Heath Watford Hertfordshire 01 950 1141
Dates 1969 -
Photographer Owen Barnes
Subjects FOOTBALL association football world wide football
Numbers pr 1000 b&w
sl 40000 35mm 2¼"x2¼"
Access Picture researchers press tv media to the original images 24 hours daily

Copies available for loan for publication for commercial use only requests are discussed individually
Charges Reproduction fee print/transparency fee handling fee holding fee service charge
Notes "We are very flexible and discuss each request individually".

124
Owner West Bromwich Albion Football Club
Location The Hawthorns West Bromwich West Midlands
Dates 1882 -
Subjects FOOTBALL West Bromwich Albion teams
Numbers pr c45

125
Owner Leicestershire County Cricket Club
Location County Ground Grace Road Leicester 0533 832128
Custodian E E Snow
Dates 1879 (1900) -
Subjects CRICKET - history
Numbers pr c200 various
Access General public during the summer season

126
Owner Marylebone Cricket Club
Location Lord's Cricket Ground London NW8 8QN 01-289 1611
Title Photographic Library
Custodian Stephen E A Green
Dates 1850 (1893) -
Photographer Leith Air Limited
Subjects CRICKET
Numbers pr several thousand
fi neg c50 b&w
gl neg c50 b&w
L sl c50 b&w c150 col
sl c1000 b&w
copy negs of some images
Aids Card index
Access General public by prior appointment
Copies available for sale
Charges Print fee from 46p including postage and VAT

127
Owner Patrick Eagar
Location 49 Bushwood Road Kew Richmond Surrey TW9 3BG 01 940 9269
Dates 1965 -
Subjects CRICKET - action photographs portraits - team groups cricket grounds - England Australia West Indies test matches between all major cricket playing countries
Numbers pr c3000 10"x8"
fi negs c35000 b&w 35mm
tr c20000 col 35mm
Aids Card index
Access Bona fide students by special arrangement only
Copies available
Charges Print fee reproduction fee PSPA rates ie b&w from £5 colour from £15
Notes The collection contains modern portraits of early cricketers eg Sir Donald Bradman.

128
Owner Surrey County Cricket Club
Location Kennington Oval London SE11 01 735 2424
Custodian W H Sillitoe
Subjects CRICKET
Numbers pr c100 various
Access Bona fide students by appointment only freely available to members

Key () = dates when collections were begun or terminated
C = Century c = approximately pr = print fi = film
gl = glass neg = negative sl = slide L sl = lantern slide
tr = transparency mic = microform col = colour

b&w = black and white ¼,½,1-pl = quarter, half and whole plate * = single copy, no public access ** = single copy, access by appointment

129
Owner Croquet Association
Location Hurlingham Club Ranelagh Gardens
London SW6 01 736 3148
Custodian Vandeleur Robinson
Dates 1865 -
Subjects CROQUET croquet tournaments and players
Numbers pr c200 b&w
L sl b&w
Access General public
Copies available for sale for loan for publication
by arrangement

130
Owner George Crosby
Location 45 King's Avenue Woodford Green Essex
Dates 1938 -
Photographer Ann Crosby George Crosby
Subjects MOUNTAINEERING ROCK CLIMBING
snow scenes India Sikkim and Tibetan border
cats London scenes general pictorial
Numbers pr 400 b&w 10"x8" 20"x16"
fi negs 2000 2¼"x2¼"
tr 300 2¼"x2¼"
Copies available for sale for loan
Charges Print fee reproduction fee by arrangement

131
Owner Craven Pothole Club
Location Castle Chambers Skipton North Yorkshire
0756 3270
Title Craven Pothole Club Records
Custodian S E Warren 15 Moorland Terrace Skipton
North Yorkshire BD23 2JT
Dates 1920 (1948) -
History Craven Pothole Club is the oldest club with aims
related specifically to caving, formed in 1928
Photographer H W Rhodes
Subjects POTHOLING caving climbing and walking in
British holes mountaineering in Europe
Numbers pr c400 b&w
gl negs c200
gl pos c2000 b&w 2½"x2½"
Access Open to members and interested persons

132
Owner John Cleare
Location 67 Vanbrugh Park Blackheath London SE3 7JQ
01 858 8667
Dates (1957) -
Photographer John Cleare
Subjects MOUNTAINEERING mountain landscapes
mountain rescue lighthouses transport geology
meteorology wild animals birds civil and building
construction food production in Africa and Nepal
outdoor life winter sports exploration and travel
abroad historic and newsworthy events
Numbers c3000 b&w 10"x12"
fi negs c45000 b&w 2¼"x2¼" 35mm
tr c14000 col 35mm 2¼"x2¼"
Aids *Card index *subject index
Access Bona fide students picture researchers press
tv media 10 am - 10 pm
Copies available for sale for display for publication
credit line required
Charges Depending on use holding fee and search fee may
be charged in certain circumstances
Notes The owner was photographer on the 1971
Expedition to Mount Everest.

133
Owner Fell and Rock Climbing Club of the English
Lake District
Location c/o Messrs Sale Lingards and Company
Solicitors PO Box 490 29 Booth Street
Manchester M60 2DU
Title The Abraham Negatives
Custodian F H F Simpson
Dates 1895 - 1930
Photographer A P Abraham G D Abraham
Subjects ROCK CLIMBING AND MOUNTAINEERING - rock

faces mountain landscapes climbing action in Lake
District North Wales Scotland Skye the Alps
Numbers gl negs c300 b&w 1-pl
Access Inspection by appointment with custodian
Charges Reproduction fee from £2.50p

134
Owner S E Crisp
Location Rangemoor Lytchett Matravers Poole Dorset
BH16 6AJ 020 122 2287
Title The Crisp Photographic Collection
Dates 1910 -
Photographer S E Crisp
Subjects ARCHERY Olympics rowing collectors' items
photography
Numbers fi negs c4000 b&w various
gl negs b&w ¼ pl
sl c1000 col 35mm

135
Owner J W Wilcox
Location Holmside Heath Road Leighton Buzzard
Bedfordshire LU7 8AG 05253 3787
Dates 1950 -
Subjects ARCHERY - in films theatre etc
Numbers pr c200 b&w 6½"x8½"
fi neg c1000 b&w
sl c100
Aids *Card index
Copies available for sale for loan

136
Owner Amateur Swimming Association
Location Harold Fern House Derby Square Loughborough
Leicestershire Loughborough 30431
Title Swimming Times
Custodian R Brown
Dates 1940 -
Subjects SWIMMING Olympics
Numbers pr substantial number b&w
Access Bona fide students
Copies available for loan

137
Owner Angling Press Service
Location 53 Cromwell Road Hounslow Middlesex
TW3 3QG 01 570 2811
Title Angling Photo Library
Custodian Bill Howes
Dates (c1950) -
History Bill Howes the founder of this collection has
written numerous books on angling
Photographer Bill Howes
Subjects FISHING - ANGLING fish waterways
Numbers pr c5000 b&w
fi negs c25000 b&w
sl c10000 col 2¼'X2¼" 35mm
Aids *Subject index
Access Picture researchers
Copies available for sale for display for publication
Charges Reproduction fee holding fee

138
Owner Church Army
Location C S E House North Circular Road
London NW10 7UG
Custodian Sister J Wilbourne
Dates 1883 (1972) -
History Development of the Evangelistic and social work
of the Church Army including work with the forces
Subjects THE CHURCH ARMY Religious and social
studies
Numbers pr substantial number b&w various
gl negs c1000 b&w ¼pl
l sl c200 col 3¼"x3¼"
Aids *Catalogue for lantern slides *card index
*subject index
Access Bona fide students to prints only
Copies Some copies available
Charges Print fee by arrangement

139
Owner Oxfam
Location 274 Banbury Road Oxford OX2 7DZ
0865 56777 Ext 295
Title Oxfam Photographic Library
Custodian Nick Fogden
Dates c1959 -
Photographer Helen Craig Nick Fogden
Peter Keen Donald McCullen Penny Tweedie
Subjects OXFAM all aspects of development and life
in 3rd world - agriculture irrigation medical work
family planning community development
training and education emergency relief work
Numbers pr c10000 b&w 6"x8" 10"x8"
fi negs c10000 b&w
tr c7000 b&w col 35mm
Aids *Card index *subject index
Access General public bona fide students
Copies available for sale for loan
Charges No charge is made for prints or slides on loan
nominal reproduction fee

140
Owner Youth Hostels Association (England and Wales)
Location Trevelyan House St Albans Hertfordshire
AL1 2DY St Albans 55215
Title Youth Hostels Association Photographic Library
Collection
Custodian B Trayner
Dates 1946 -
Subjects YOUTH HOSTELS youth hostelling activities
buildings views of the countryside
Numbers pr c1000 b&w 1pl
Aids *Catalogue
Access Bona fide students picture researchers press
tv media
Copies available for loan subject to copyright

141
Owner Scout Association
Location Baden-Powell House Queens Gate
London SW7 5JS 01 584 6896
Dates 1907 -
Subjects SCOUTS public entertainments outdoor life -
camping climbing cave exploration walking
winter sports swimming horse-riding biography
and portraits travel abroad historic and
newsworthy events
Numbers pr c25000 b&w col 8"x6"
fi negs c25000 b&w col 35mm
gl negs c200 b&w 6"x4"
sl c700 col 35mm
Copies available for sale

142
Owner C I Audio Visual Limited
Location Durham Road Boreham Wood Hertfordshire
01 953 0291
Dates (1969) -
Subjects EDUCATION educational audio-visual software
Numbers sl 1500 col 2"x2"
Aids Published catalogue
Access Bona fide students 9 am - 5 pm
Copies available for sale for display for loan
for publication

143
Owner Henry Grant Photos
Location 34 Powis Gardens London NW11 01 455 1710
Dates 1950 -
Subjects EDUCATION children people at work and
leisure social services towns and cities scenic -
landscapes churches cathedrals historic
buildings animals entertainment food and drink
Christmas travel abroad

Numbers fi negs 75000 b&w 6cm x 6cm
tr 6000 col 6cm x 6cm 35mm
Aids Published list of subject headings
Access Picture researchers press tv media by
appointment only
Copies available for sale for display for loan credit
line required
Charges Publication/reproduction fee print/transparency
fee holding fee service charge and search fee
is charged depending on work done exhibition fees by
arrangement

144
Owner Hertfordshire County Council
Location College of Technology Letchworth Hertfordshire
Custodian A Jackson
Dates 1954 (1955) -
Subjects EDUCATION equipment inland-waterways
microscopic photographs static engines
factory - machine shop equipment domestic
Numbers pr 200 b&w 30 col 10"x10" 12"x10"
fi negs 150 b&w 50 col various
gl negs 150 b&w 3"x4"
sl 200 b&w 35mm
tr 600 col 35mm
Access Bona fide students

145
Owner Kelsterton College North East Wales Institute
Location Resources Centre Connah's Quay Deeside
Clwyd CH5 4BR 024 451 7531
Custodian K H Smith
Dates 1970 -
Subjects EDUCATION further education
Numbers fi negs c800 b&w 35mm
Access Bona fide students
Copies available for sale

146
Owner E T Leigh-Smith
Location 5 Greenlands Tattenhall Chester Tattenhall
70476
Dates 1962 -
Photographer E T Leigh-Smith (all photographic material
is published under the name John Rowan)
Subjects EDUCATION ARCHITECTURE educational
activities buildings - exteriors public buildings
residences street scenes - mainly Cheshire
Numbers pr c1600 b&w 35mm
fi negs c1600 b&w 35mm
Access Bona fide students requests in writing only
Copies available for sale for loan
Charges Print fee reproduction fee by arrangement

147
Owner Liverpool City Council
Location C F Mott College of Education Liverpool Road
Prescot Lancashire 051 489 6201
Custodian W Newby
Dates (1972) -
Subjects EDUCATION inland-waterways docks and
harbours locks industrial tramways self-acting
inclines industrial archaeolgy wind and water mills
North Wales slate quarries
Numbers pr c150 b&w
fi negs c300 b&w 35mm
sl 200 col 35mm
Access Bona fide students

148
Owner Lincolnshire Educational Television Consortium
and J Howard
Location Bishop Grosseteste College Lincoln LN1 3DY
0522 27347
Custodian J Howard Thorpe Lane Tealby Lincoln
LN8 3XJ

Key () = dates when collections were begun or terminated
C = Century c = approximately pr = print fi = film
gl = glass neg = negative sl = slide L sl = lantern slide
tr = transparency mic = microform col = colour

b&w = black and white $\frac{1}{4}, \frac{1}{2}$, 1p-1 = quarter, half and whole
plate * = single copy, no public access ** = single copy,
access by appointment

Dates c1960 -
Photographer J Howard
Subjects EDUCATION television sailing archaeology
 wind and water mills farming school buildings
 portraits Lincolnshire landscapes physical education
Numbers pr c300 b&w 10"x8"
 fi neg c300 b&w
 sl 35mm
Access By appointment
Copies available for sale for loan
Charges Print fee reproduction fee negotiable at normal
 professional rates
Notes This collection has been largely made for
 educational TV purposes in Lincolnshire and its
 contents reflect these interests in the main. A great
 deal of material is in schools showing teachers and
 pupils in a wide variety of activities and situations.

149
Owner Newbury College of Further Education
Location Newbury Berkshire
Title College Scrapbook
Custodian The Principal
Dates 1947 (1950)-
Subjects EDUCATION adult further education
Numbers pr 30 b&w 15 col 8"x4"
 sl 15 b&w 20 col 2"x2"
Aids Folder sequence
Access Bona fide students notice appreciated of intention
 to view
Copies available at cost
Charges Reproduction fee

150
Owner St Anne's College (University of Oxford)
Location Library
Custodian Mrs A K Swift
Dates c1896
History The collection covers the establishment of the
 Oxford Home Students under their first Principal,
 Mrs Bertha Johnson - the Home Students were the fore-
 runners of St Anne's Society which became St Anne's
 College
Subjects EDUCATION education of women at Oxford
 visit of Queen Mary and the Princess Royal in 1921
 college buildings visit of Queen Elizabeth II and Prince
 Phillip in 1960 portraits - Principals tutors
 undergraduates granting of degrees to women for first
 time in 1920
Numbers pr c220 various
Aids Card index
Access Bona fide students

151
Owner Shrewsbury School Chairman and Governors
Location The Schools Shrewsbury Shropshire
Title Shrewsbury School Library Collection
Custodian J B Lawson
Dates 1860 (c1900)-
Subjects EDUCATION public school life athletic sports
 and outdoor games - rowing biography and portraits
Numbers pr c1000 b&w
Aids Partial card index
Access Bona fide students
Copies available for loan

152
Owner A Wheaton and Company
Location Publishing Department Hennock Road Exeter
 Devon EX2 8RP Exeter 74121
Custodian The Production Manager
Dates 1960-
Subjects EDUCATION printing
Numbers pr c400 10"x8"
 tr c100 35mm 2¼"x2¼"
Access Written application only
Charges By arrangement

153
Owner Wiltshire County Council

Location County Record Office County Hall Trowbridge
 Wiltshire 022 14 4036
Custodian M G Rathbone
Dates c1900-c1912
Subjects EDUCATION schools
Numbers pr 216 b&w 8"x6"
Aids *Catalogue
Access General public
Copies Available for sale by arrangement

154
Owner Grampian Regional Council Education Department
 Woodhill House Aberdeen
Location Schools Resource Services Old Academy Little
 Belmont Street Aberdeen
Custodian County Librarian
Dates (c1960)-
Subjects SCHOOLS general collection of all potential
 subjects for all schools at all levels
Numbers fi negs 100 col 35mm
 sl c80000 col 35mm
Aids Published guide published catalogue card index
 published subject index
Access Employees of County Education Department only

155
Owner Girl Guides Association
Location 17-19 Buckingham Palace Road London SW1 0PT
 01 834 6242
Custodian Miss T Wallis Myers
Dates 1910-
Subjects CHILDREN AND YOUNG PEOPLE - activities
 outdoors and indoors in the Girl Guide Programme
Numbers pr c12000
Copies available for sale for loan
Notes A very large collection of historical material dating
 back to the beginnings of the Guide Movement from
 1908 onwards.

156
Owner Exeter College (University of Oxford)
Location The Muniment Room
Dates c1854 (c1880)-1914
Subjects EXETER COLLEGE buildings College sports
 teams groups
Numbers pr c400 various
Access Bona fide students
Copies available by special arrangement

157
Owner University of Dundee
Location University Library Dundee 0382 23181 Ext 204
Title Photographic Department Collection
Custodian Stanley C Turner
Dates 1884 (1963)-
Subjects UNIVERSITY OF DUNDEE - staff buildings
 activities
Numbers pr c1100 b&w c50 col
 fi negs c1100 b&w c50 col
Access Bona fide students
Copies available for sale
Charges Print fee

158
Owner University of Hull
Location The Brynmor Jones Library
Custodian P Sheldon
Dates 1959-
Photographer A Marshall
Subjects UNIVERSITY OF HULL - buildings events
 personalities
Numbers pr c750 b&w c50 col 10"x8"
 fi negs c2000 b&w c100
 L sl c100 b&w c100 col 2"x2"
Aids *Card index *subject index
Access Bona fide students
Copies available for sale to members of the University
 on application

159

Owner St Edmund Hall (University of Oxford) Principal, Fellows and Scholars
Location St Edmund Hall Library
Custodian C J Wells
Dates c 1868 -
Photographer Gillman and Soame Limited H A F Radley
Subjects ST EDMUND HALL - groups sports clubs buildings St Peter in the East Church Church Crypt
Numbers pr c200 col various
Copies available
Charges Print fee reproduction fee depending on individual cases

160

Owner St John's College (University of Oxford)
Title St John's College Building Record
Custodian H M Colvin
Dates c1880-
Subjects ST JOHN'S COLLEGE - buildings
Numbers pr substantial numbers b&w gl negs substantial numbers b&w
Aids Card index in preparation
Access Bona fide students
Copies Not normally available

161

Owner Corpus Christi College (University of Oxford) President and Fellows
Dates 1858-
Subjects CORPUS CHRISTI COLLEGE - buildings College groups former members societies gold and silver plate
Numbers pr c300 various
Aids Handlists
Access Bona fide students
Copies available for sale to scholars and publishers only for loan to recognised institutions or organisations only

162

Owner Jesus College (University of Oxford)
Location The Library
Custodian The Librarian
Subjects JESUS COLLEGE - buildings members of the College servants travel
Numbers pr substantial numbers
Access By arrangement
Notes The collection contains a 19th C album compiled by a former Master of the College.

163

Owner Lincoln College (University of Oxford)
Location The Library
Custodian The Archivist
Dates c1861-
Subjects LINCOLN COLLEGE - buildings portraits of groups
Numbers pr c150 various
Access Bona fide students by arrangement

164

Owner Magdalen College (University of Oxford)
Location The Library
Custodian The Librarian
Dates c1860-
Photographer Henry W Taunt
Subjects MAGDALEN COLLEGE - buildings personalities Old Oxford
Numbers pr substantial numbers scattered through 10 albums
Aids Card index
Access bona fide students by advance notice only
Notes Henry W Taunt took an album of college views used by Byron Brown in his recent book 'Taunt's England'. The collection contains two albums of views of Old Oxford compiled 1896 but containing earlier material.

165

Owner Merton College (University of Oxford) Warden and Fellows
Custodian J. R Highfield
Dates c1850-
Photographer Latterly Gillman and Soame
Subjects MERTON COLLEGE - fellows and undergraduates
Numbers pr c500 b&w various
Access Bona fide students only
Copies available from the studio of Oxford University Press or Thomas-Photos 2 Collingwood Close Headington Oxford
Charges on application

166

Owner Somerville College (University of Oxford) Principal and Fellows
Custodian P A Adams
Dates c1880-
Subjects SOMERVILLE COLLEGE - buildings staff undergraduates benefactors
Numbers pr c300
Access Bona fide students

167

Owner Winchester College Warden and Fellows Winchester 64242
Title Wiccamica Collection
Custodian P J Gwyn J P Sabben-Clare
Dates 1860-
Photographer W B Croft Sidney Pitcher
Subjects WINCHESTER COLLEGE - buildings and personnel optical phenomena
Numbers pr c3000 b&w col various gl negs 70 various L sl 325 b&w 3''x3'' sl 90 b&w 2''x2''
Aids *Subject index
Access Bona fide students
Copies available for sale for loan
Charges Print fee
Notes The collection includes photographs by W B Croft of early experiments in optics.

168

Owner W H Morris
Location 66 Station Road Kidwelly Dyfed 055 43 304
Title Carmarthen Historical Collection
Dates c1900 (1960) -
Subjects OCCUPATIONS AND SERVICES lifeboats lighthouses travel by: rail road sea inland-waterways sailing boats stations docks and harbours archaeology engineering farm buildings architecture portraits aerial mapping
Numbers fi neg 100 b&w sl c500 col
Access General public

169

Owner Birmingham City Council The Council House Birmingham B1 1BB 021 235 2038
Location Museum of Science and Industry Newhall Street Birmingham B3 1RZ 021 236 1022
Custodian N W Bertenshaw
Dates c1860 (1950) -
Subjects OCCUPATIONS AND SERVICES TRANSPORT CIVIL AND BUILDING CONSTRUCTION lighthouses tools postal services telecommunications radio television astronomy chronology mechanical engineering precision instruments
Numbers pr c6600 b&w c2100 1-pl c2500 En prints c2500 35mm sl 1500 1300 b&w 200 col 2''x2'' fi negs c6000 b&w gl negs b&w L sl 700 3¼''x3¼''

Aids *Card index *subjects index
Copies available for sale

170

Owner Trades Union Congress
Location Congress House Great Russell Street London
WC1 01 636 4030
Custodian Christine Coates
Dates 1890 (1974)-1950-
Subjects OCCUPATIONS AND SERVICES - Trade Unions
TUC personnel communications transport
mechanical engineering civil and building construction
mining ceramics architecture biography and
portraits historic and newsworthy events
Numbers pr substantial number b&w various
Aids *Card index *subject index both in preparation

171

Owner U M L Limited
Location Lever House Port Sunlight Cheshire 645 2000
Dates 1888-
History The collection covers the establishment and
growth of Port Sunlight village and the Lever Brothers
soap factory
Subjects OCCUPATIONS soap industry village life
civil and building construction architecture
personalities Leverhulme family
Numbers pr substantial number b&w
Aids *Subject index
Access Bona fide students by special arrangement only
Copies available for loan
Charges Print fee subject to requirements

172

Owner Womens Royal Voluntary Service
Location 17 Old Park Lane London W1 01 834 6655
Custodian Doreen Hallis
Dates 1938 -
Subjects OCCUPATIONS AND SERVICES war time
activities of WVS post war activities of WVS and
WRVS
Numbers pr substantial number b&w
Aids Subject index
Access Picture researchers press tv media by
appointment 10.30 am - 3 pm
Copies available for loan for publication
Charges If several photographs are required a donation
to WRVS welfare work is welcomed

173

Owner Imperial War Museum Trustees
Location Lambeth Road London SE1 6HZ 01 735 8922
Title Imperial War Museum Photographic Collection
Custodian D P Mayne
Dates 1900 (1917) -
Photographer Sir Cecil Beaton James Jarche
Horace Nicholls
Subjects WAR - all aspects
Numbers pr c2500000 b&w $2\frac{1}{4}$"x$2\frac{1}{4}$" - 10"x8"
fi negs c1000000 b&w various 35mm - 1-pl
gl negs c750000 b&w various $\frac{1}{2}$pl - 12"x10"
L sl c20000
sl c3000 col 35mm - 5"x4"
Aids *Catalogue part visual index part subject index
Access General public bona fide students
Copies available for sale
Charges Print fee

174

Owner Royal Highland Fusiliers Museum Trustees
Location R H Q and Museum 518 Sauchiehall Street
Glasgow G2 3LT 041 332 0961
Custodian Captain A J Wilson
Subjects THE FORCES
Numbers pr c700 b&w various
some contained in albums
Aids *Catalogue
Access General public bona fide students

175

Owner John Neal

Location Quinton House 33 Bath Road Maidenhead
Berkshire 0628 25010
Title The Great War 1914-1918
Dates 1910 (1956) - 1959
Subjects THE FORCES The Great War 1914-1918
Numbers pr c400 b&w
fi negs c400 b&w $2\frac{1}{2}$"x$2\frac{1}{2}$"
Access Bona fide students picture researchers publishers
press tv media by appointment
Copies available for sale
Charges Print fee reproduction fee by negotiation

176

Owner Parachute Regiment Trustees
Location Airborne Forces Museum Depot Para and
A B Forces Browning Barracks Aldershot
0252 24432 Ext 619
Custodian Major H M McRitchie
Dates 1940 (1946) -
Subjects AIRBORNE FORCES - all aspects
Numbers pr c3000 b&w col various
Aids *Subject index
Access Bona fide students only Monday to Friday
9 am - 12.30 pm 2 pm - 5 pm Saturday 9.30 am -
12.30 pm 2 pm - 5 pm Sunday 10 am - 12.30 pm
2 pm - 4.30 pm only closes Christmas Day
Copies available for limited loan and publication
Charges Admission to Museum - children 3p soldiers 5p
civilians 10p

177

Owner Royal Scots Regimental Museum Trustees
Location Regimental Headquarters The Castle Edinburgh
EH1 2YT 031 336 1761
Custodian Colonel B A Fargus
Dates 1865 -
Subjects THE FORCES personnel training equipment
history uniforms and regalia relics
Numbers pr c3000 b&w various
Access General public on application to Museum Director
Copies available by arrangement
Charges Print fee reproduction fee commercial rates
Notes Many of the photographs are in albums bequeathed by
individuals.

178

Owner Durham County Council County Hall Durham
0385 64411
Location Durham Light Infantry Regimental Museum and
Arts Centre Aykley Heads Durham 0385 2214
Custodian Miss N A Johnson
Dates c1856 (1930) - 1968 -
Photographer Roger Fenton
Subjects ARMY - all aspects
Numbers pr c2800 b&w various
sl 189 col 35mm
Access General public bona fide students by appointment
Copies for sale subject to availability
Charges Print fee reproduction fee by negotiation

179

Owner King's Own Regimental Museum Trustees
Location City Museum Old Town Hall Market Square
Lancaster 0524 64637
Custodian Mrs Edith Tyson
Dates 1860 (1929) - 1950 -
History The collection has been compiled from individual
gifts and official sources
Subjects KING'S OWN REGIMENT - personnel in action
Numbers pr c4000
Aids Partial card index register
Access Bona fide students
Copies available to special order at cost
Charges Reproduction fee by arrangement

180

Owner King's Own Scottish Borderers
Location Regimental Museum R H Q The Barracks
Berwick upon Tweed 0289 7426
Custodian Lieut-Col W M B Dunn
Dates c1900 (1951) -

Photographer Hector Innes
Subjects ARMY equipment history uniforms and regalia relics
Numbers pr 1000+ b&w 20+ col 8"x4½" blocks c1200 b&w
Aids Record books
Access Picture researchers by appointment
Charges Admission to Museum

181
Owner Queen's Lancashire Regiment Fulwood Barracks Preston PR2 4AA 0772 700161
Location Blackburn Museum and Art Gallery Library Street Blackburn 0254 55201
Title Photographic Section of the East Lancs Regiment Collection
Custodian P Lewis
Dates c1850 (1900) -
Subjects ARMY personnel in action
Numbers pr c50 b&w 10"x8"
Aids List catalogue incomplete
Access General public
Copies available for loan on request for private use and for publication subject to approval

182
Owner Royal Army Education Corps Museum
Location Wilton Park Beaconsfield Wycombe Bucks
Custodian Brigadier H T Shean
Dates 1760 (1967) -
Subjects ARMY EDUCATION personnel history uniforms and regalia relics schools teachers children at play
Aids General accession lists
Access General public bona fide students all visitors must write to confirm visit

183
Owner 13/18th Royal Hussars (QMO) Museum Trustees
Location Regimental Museum Cannon Hall Cawthorne nr Barnsley Silkstone 270
Custodian OC Home HQ 13/18th Hussars (QMO) T A Centre Tower Street York 0904 55615
Dates 1899 -
Subjects ARMY - 13/18th Royal Hussars - all aspects
Numbers Substantial number
Access Bona fide students
Copies available for sale for publication
Charges Print fee reproduction fee by arrangement

184
Owner Queen's Own Royal West Kent Regimental Museum Museum Trustees St Faiths Street Maidstone Kent
Location County Archives Office County Hall Maidstone 0622 54497
Dates 1961 -
Subjects ARMY
Access By arrangement

185
Owner The Commandant Royal Military Academy Sandhurst (Trustee) H Q Building Camberley Surrey 0276 63344 Ext 206
Location R M A S Old Building Camberley Surrey 0276 63344 Ext 208
Custodian Dr T A Heathcote
Dates c1870 -
Subjects ARMY - all aspects
Numbers pr c5000 b&w various fi negs c5000 b&w various
Aids Catalogue card index subject index
Access General public bona fide students by prior appointment
Copies available for sale for loan for publication subject to individual arrangement
Charges Reproduction fee commercial rates

186
Owner South Wales Borderers Regimental Museum Trustees
Location The Barracks Brecon Powys Brecon 3111 Ext 263
Custodian Major G J B Egerton
Dates 1850 (1934) -
Subjects ARMY personnel in action training history
Numbers pr 4650 b&w various
Access General public bona fide students by appointment
Copies available for sale
Charges Voluntary donations only

187
Owner Aldershot Garrison Historical Committee
Location Prince Consorts Library Cavans Road Aldershot Hampshire GU11 2LQ 0252 24431 Ext 3274
Custodian Colonel R J H Harding-Newman
Dates 1850 (1970) -
Subjects ARMY - all aspects
Numbers pr substantial number b&w various sl c30 col fi 16mm
Aids Card index subject index in preparation

188
Owner Black Watch (Royal Highland Regiment) Trustees
Location The Black Watch Museum Balhousie Castle Perth 0738 26287 Ext 1
Custodian James E R Macmillan
Dates 1854 (1924) -
Photographer Roger Fenton Cundall Howlett James E R Macmillan Dr Murray James Robertson
Subjects ARMY - all aspects biography and portraits historic and newsworthy events
Numbers pr substantial number
Aids Catalogue
Access Bona fide students
Copies could be made available by individual arrangement with Dr W H Findlay further details on request
Charges Print fee

189
Owner 22nd (Cheshire) Regiment Trustees
Location R H Q The Castle Chester 0244 27617
Custodian Brigadier B L Rigby
Subjects ARMY - all aspects
Access General public bona fide students on personal application to the Regimental Secretary
Notes This collection is in the process of classification.

190
Owners King's Shropshire Light Infantry Regimental Museum Trustees
Location Sir John Moore Barracks Copthorne Shrewsbury SY3 8LZ 0743 4427
Custodian Maurice E Jones
Dates c1870 -
Subjects ARMY - all aspects
Numbers pr c1000 b&w various
Access General public
Charges Admission free

191
Owner Royal Army Chaplains' Department Museum Trustees
Location Bagshot Park Bagshot Surrey Heath Surrey Bagshot 73172
Custodian Lieut-Col G C E Crew
Dates c1900 (1953) -
Subjects ARMY personnel in action uniforms regalia relics medals ecclesiastical architecture sculpture and carving - stone wood stained glass religion - objects work

Key () = dates when collections were begun or terminated
C = Century c = approximately pr = print fi = film
gl = glass neg = negative sl = slide L sl = lantern slide
tr = transparency mic = microform col = colour

b&w = black and white ¼,½,1-pl = quarter,half and whole plate * = single copy,no public access ** = single copy, access by appointment

Numbers pr c5000 b&w col
 fi negs c1000
 gl negs c100
 L sl c250 b&w
 sl c1000 b&w col
Aids Publishers guide catalogue card index subject index
Access General public bona fide students by appointment only
Copies available in specific cases only
Notes A specialised collection of the Royal Army Chaplains' Department and Army Chaplains' work, worship and religion in the Army, particularly in war.

192
Owner Queen Alexandra's Royal Army Nursing Corps Museum Trustees
Location Training Centre Royal Pavilion Farnborough Road Aldershot Hart Hampshire　0252 24431 Ext 301
Custodian Mrs J A Churchill
Dates 1900 (1955) -
Subjects ARMY personnel in action hospitals and medical doctors nurses ancillary services
Numbers pr c5000
Aids *Card index
Access Bona fide students

193
Owner Royal Fusiliers Regimental Museum Trustees
Location Sovereign's House The Mall Armagh N Ireland 0861 522911
Title The Royal Irish Fusiliers Photographic Collection
Custodian Major G A N Boyne
Dates 1861 (1933) - 1968 -
Photographer Matthew Brady
Subjects ARMY TRANSPORT BIOGRAPHY AND PORTRAITS geography sport architecture flags banners
Numbers pr c7500 7300 b&w 200 col various
 fi negs 200 b&w
 gl negs 80 b&w
 sl 50 col
Access General public bona fide students
Copies available for sale on application to Curator
Charges On application

194
Owner Royal Inniskilling Fusiliers Museum Trustees
Location The Castle Enniskillen Co Fermanagh N Ireland　Enniskillen 3142
Title The Royal Inniskilling Fusiliers Museum Collection
Custodian Major H E P F Thrupp
Dates c1860 (1931) - 1968 -
History The Museum was founded in Omagh Co Tyrone in 1931, moved to present location in 1968
Subjects ARMY personnel history
Numbers pr 2-3000 various
 fi 16 & 35mm
Access General public bona fide students
Copies available for publication
Charges Appropriate donation to Museum funds

195
Owner Royal Signals Institution Trustees Cheltenham Terrace Chelsea London SW3 4RH　01 930 4466
Location Royal Signals Historical Library Blandford Camp Dorset
Custodian Lieutenant Colonel D A Dixon
Dates Late 19thC -
Subjects ARMY COMMUNICATIONS Royal Signals activities
Access General public bona fide students
Copies available for sale on request
Notes Contains personal albums of individuals.

196
Owner Argyll and Sutherland Highlanders
Location R H Q Stirling Castle Stirling
Custodian Lieutenant Colonel J Wood
Dates 1880 -
History The collection covers the history of the regiment
Subjects ARMY Argyll and Sutherland Highlanders
Numbers pr substantial numbers
Access Bona fide students by appointment only

197
Owner Army Museum's Ogilby Trust
Location 85 Whitehall London SW1　01 839 1979
Custodian Colonel P S Newton
Dates 1845 (1954) -
Subjects THE ARMY all aspects biography and portraits
Numbers pr c50000 b&w ½pl
 fi negs 1700 b&w
 gl negs 1700 b&w
 L sl 100 b&w 3"x3"
Aids *Card index subject box files
Access General public by appointment only
Copies available
Charges Reproduction fee

198
Owner Border Regiment and King's Own Royal Border Regiment Museum
Location Queen Mary's Tower The Castle Carlisle Cumbria
Custodian Lt-Col R K May
Dates 1865 (1932) -
Subjects ARMY personnel in action training equipment relics uniforms and regalia landscapes local inhabitants - particularly India
Numbers pr c1000
 gl neg 20
Aids Catalogue
Access Bona fide students
Copies available for loan

199
Owner Green Howards Museum Trustees
Location Richmond North Yorkshire　0748 2133
Custodian Colonel J M Forbes
Dates 1854 (1880) -
Subjects ARMY Green Howards - all aspects
Numbers pr c2000 b&w
Access General public by arrangement
Charges Donation would be appreciated

200
Owner Ronald G Harris
Location 62 Bath Road Southsea Hampshire PO4 0HT 0705 33465
Dates 1854 (1938) -
Photographer F G O Stuart
Subjects ARMY dress uniforms equipment regalia relics
Numbers pr 15000 b&w ¼pl - 12"x10"
 fi neg 500 b&w ¼pl
 gl neg b&w ¼pl - 12"x10"
Access Bona fide students

201
Owner Manchester City Council
Location City Art Gallery Mosley Street Manchester 061 236 2391
Title Local Topography The Manchester Regiment and 14/20 King's Hussars English Costume
Custodian A J N Arber
Dates 1860 -
Photographer Francis Frith James Mudd
Subjects ARMY Manchester Regiment 14/20 King's Hussars 1887 Royal Jubilee Exhibition Old Cheshire and Lancashire Halls Manchester period costume
Numbers pr c500 b&w
 fi 2
Aids Lists card index to local topography
Access General public picture researchers bona fide students press tv media 10 am - 5 pm
Copies available for sale for display for loan for publication standard publication conditions
Charges Reproduction fee print/transparency fee service charge

202
Owner Ministry of Defence
Location Prince Consort's Army Library Knollys Road
 Aldershot Hampshire GU11 1PS
Custodian Mrs J Sears
Dates 1870-1936 -
Photographer Gale & Polden Ltd
Subjects THE ARMY in action history Aldershot
 Horse Show Aldershot Show Aldershot Tattoo
 Boer War War in Egypt Zulu War World War I
 advertisements
Numbers pr c800 b&w various
 L sl c400 b&w 8.3cm x 8.3cm
Access Bona fide students
Charges Reproduction fee £3.50p per photograph

203
Owner National Army Museum
Location Royal Hospital Road London SW3 01 730 0717
Title Department of Records
Custodian Keeper of Records B Moilo Keeper of
 Photographs Miss M Allum
Dates 1840 (1950) -
Photographer Felice Beato Roger Fenton John McCosh
 James Robertson
Subjects ARMY - British - Indian
Numbers pr c170000 b&w 100 col
 fi negs 35000 b&w
 gl neg c250 b&w
 L sl c50 b&w
 sl c100 b&w c4000 col
Aids Catalogue card index subject index
Access Picture researchers bona fide students press tv
 media readers ticket required 10 am - 5 pm
 Tuesday to Saturday
Copies Black and white for sale only colour for loan only
Charges Black and white print fee from 20p colour loan
 fee from £2 reproduction fee black and white 50p
 colour £2

204
Owner Dr W H Findlay
Location 9 Rosemount Place Perth PH2 7EH
 0738 24157
Title Photolog Services of Perth
Dates 1946 -
Photographer Dr W H Findlay
Subjects THE BLACK WATCH PERTHSHIRE SCOTLAND
 City of Perth landscape buildings historical sites
 forestry fishing Russia Yugoslavia Austria
 Italy
Numbers pr c1000 b&w 6½"x8½" and 10"x8"
 fi neg c2000 mostly b&w 2¼"x2¼"
 tr c10000 col 35mm
Access Enquiries will be dealt with personally
Copies available for sale
Charges Print fee reproduction fee on application

205
Owner D W Quarmby
Location 18 Watergate Road Newport Isle of Wight
 PO30 1XN
Title The D W Quarmby Military Collection
Dates c1850 (1968) -
Photographer D W Quarmby
Subjects ARMY UNIFORMS AND REGALIA
 ceremonies military bands navy air force
Numbers pr c5000 b&w c2000 col 3"x5½" - 10"x8"
 fi negs c3500 col
Access Bona fide students by private arrangement
Copies Only in exceptional cases by private arrangement
 only
Charges Reproduction fee by arrangement
Notes This collection consists of black and white copies of
 photographs dating from the 1850s and of colour prints

mainly taken by Mr Quarmby almost exclusively of
military bands.

206
Owner Stanley D Eagle
Location 19 Ryehill Terrace Edinburgh EH6 8EN
 031 554 5686
Dates c1870 (c1929) -
Photographer Gale and Polden Limited
Subjects ARMY UNIFORMS bands ceremonial parades
Numbers pr c5500 b&w col various
 fi negs substantial number b&w col 35mm
 gl pl ½pl
 tr
Access By arrangement
Copies available by private arrangement
Charges Print fee commercial rates
Notes The collection of an enthusiastic collector of
 Militaria.

207
Owner S C Newton
Location 2 Minster Walk Hurworth Nr Darlington
 Co Durham
Dates Late 19thC (1957) -
Subjects NAVY TRANSPORT architecture geography -
 Yorkshire events - disasters floods shipwrecks
 accidents locomotives
Numbers pr 200 b&w 50 col various
 tr 600 col 2"x2"
 postcards 2500 b&w 6"x4"
Access On prior application to the above named only
 applications treated on their merits
Copies Copies available for publication purposes only
Charges Any costs will be charged to the enquirer

208
Owner Royal Air Force
Location Aviation Records Department R A F Museum
 Hendon London NW9 01 205 2266
Title R A F Museum Hendon Photographic Collection
Custodian D C Brech
Dates 1900 (c1963) -
Photographer Cyril Peckham
Subjects ROYAL AIR FORCE personnel in action
 training equipment history uniforms and regalia
 relics transport - air - balloons airships gliders
 helicopters hovercraft astronautics aircraft
 factory and machine shop interiors aviation - historic
 and newsworthy
Numbers pr c100000 b&w
 fi negs c5000 b&w
 gl negs c2000 b&w
Aids Subject index accessions list
Access Bona fide students apply for access to the Archivist
Copies available for sale by arrangement

209
Owner Royal Air Force College
Location College Library Cranwell Sleaford Lincolnshire
 Cranwell 201 Ext 329
Title College Archives
Custodian Mrs J M King
Dates 1920 -
Subjects AIR FORCE history of Royal Air Force College
Numbers pr c400 b&w 50 col various
Access Bona fide students with special permission
Copies available for loan
Notes This is a collection of photographs of items
 pertaining to the history of the R A F College.

210
Owner National Union of Bank Employees
Location Queens House 2 Holly Road Twickenham
 Middlesex 01 891 0911
Title NUBE News Press File

Key () = dates when collections were begun or terminated
C = Century c = approximately pr = print fi = film
gl = glass neg = negative sl = slide L sl = lantern slide
tr = transparency mic = microform col = colour

b&w = black and white ¼,½,1-pl quarter,half and whole
plate * = single copy, no public access ** = single copy,
access by appointment

Custodian W A Vose
Dates 1950 (1971) -
Subjects BANKS trade unions
Numbers pr c4000 b&w various
Access Bona fide students
Copies available for loan

211

Owner Labour Party
Location Transport House Smith Square London
 SW1P 3JA 01 834 9434
Title Labour Party Photograph Library Collection
Custodian Mrs J P Samuel
Dates 1900 -
History History of the Labour party from its foundation
Subjects POLITICIANS Labour party MPs candidates
 peers trade unionists Socialist - International
 Labour party functions General Elections from 1922
 Labour party posters
Numbers pr c16000 b&w various
 sl 600 col 35mm
Aids *Card index
Access Bona fide students by appointment only
Copies available for loan

212

Owner Department of Health and Social Security
Location Health Buildings Library Room 1120 Euston
 Tower 286 Euston Road London NW1 3DN
 01 388 1188 Ext 206
Title Health Buildings Library Slide Collection
Custodian Miss I M M Cameron
Dates c1960 -
Subjects HOSPITAL BUILDINGS
Numbers pr c4000 b&w 2½"x2"
 tr c6000 col 2"x2"
Aids Subject index
Access Accredited research workers architects
Copies available for loan with restrictions
Charges Print fee reproduction fee

213

Owner Royal National Orthopaedic Hospital (Country
 Branch) Brockley Hill Stanmore Middlesex
 HA7 4LP 01 954 2300 Ext 112
Location Department of Medical Photography
Title Historic Prints of the Royal National Orthopaedic
 Hospital
Custodian John S Collins
Dates 1924 (1970) -
Photographer J S Collins R J Whitley
Subjects HOSPITAL - Royal National Orthopaedic -
 historic development
Numbers pr 50 b&w 15"x12"
 fi negs 50 b&w 5"x4" 2¼"x2¼"
Access Bona fide students only by appointment
Copies available for sale
Charges Print fee reproduction fee IIP rates

214

Owner Institute of Orthopaedics (University of London)
Location Royal National Orthopaedic Hospital 234 Great
 Portland Street London W1N 6AD 01 387 5070
Title Museum of Orthopaedic Radiology (Prints and Slides)
Custodian Dr Murray
Dates c1948 -
Subjects HOSPITAL ORTHOPAEDICS
Numbers pr substantial number
 sl 2000 35mm
Aids Catalogue
Access Bona fide students by appointment
Notes The Museum of Radiology is a specialist collection
 of Orthopaedic X-ray films of special interest to
 Orthopaedic Post-Graduates.

215

Owner Medical Recording Service Foundation
Location Kitts Croft Writtle Chelmsford Essex
 CM1 3EH Chelmsford 421475
Custodian Dr J C Graves Dr Valerie Graves
Dates 1960 -

Subjects MEDICAL medico-social medical conditions
Numbers sl c3000 col 35mm
Aids *Card index *subject index
Access Bona fide students
Copies available for sale retricted to medical or social
 medicine uses
Charges Print fee UK 30p each slide card mounted

216

Owner Mersey Regional Health Authority
Location Pearl Assurance House 55 Castle Street
 Liverpool L2 9TU
Custodian Mrs H McNabb
Dates 1960 -
Photographer Stewart Bale John Mills
Subjects HOSPITALS - Merseyside - all aspects
Numbers pr 550 b&w various
 sl 80 col 35mm
Aids *Card index
Access Bona fide students
Copies available for sale

217

Owner Royal National Life-Boat Institution
Location West Quay Road Poole Dorset BH15 1HZ
 020 13 71133
Title Life Boat Photographic Collection
Custodian Ray Kipling
Dates 1860 (Late 19thC) -
History The collection covers the development of lifeboats
 and equipment and also famous rescues and notable
 lifeboatmen
Subjects LIFEBOATS
Numbers pr c10000 b&w various
 fi negs c2000 b&w
 L sl c30 b&w
 sl c2500 b&w 35mm 2¼"x2¼"
Aids Card index for slides only subject index for prints
 and slides
Access Bona fide students picture researchers press
 tv media 9 am - 5 pm
Copies available for sale for display for loan for
 publication
Charges Various conditions - enquiries treated individually

218

Owner Donald Morris
Location 59 Boma Road Trentham Stoke-on-Trent
 Staffordshire ST4 8EA 0782 659290
Title The Bottle-Ovens of Stoke-on-Trent Bottle-Oven
 Workers/Craftsmen Stoke-on-Trent: Architecture
 and Landscape
Dates (1956) -
History Bottle-ovens are almost extinct, this collection
 includes photographs of craftsmen on the last working
 bottle-ovens of the potteries in about 1960
Photographer Donald Morris
Subjects BOTTLE-OVENS CRAFTSMEN INDUSTRIAL
 ARCHITECTURE inland-waterways children at
 play child art child studies babies child
 activities
Numbers fi negs 350 b&w 2¼"x2¼"
 sl 41 col 2¼"x2¼"
Access Postal or telephone enquiries only
Copies available for sale
Charges Reproduction fee
Notes A set of prints of this collection is housed in the
 Reference Library, Hanley, Stoke-on-Trent, and is the
 most convenient place for viewing. The Gladstone
 Pottery Museum, Longton, Stoke-on-Trent hope to
 house a complete set of prints in the near future.

219

Owner Devon and Cornwall Constabulary
Location Police Training College Headquarters
 Middlemoor Exeter Devon EX2 7HQ Exeter
 52101
Title Devon and Cornwall Constabulary Museum Collection
Custodian Commandant Chief Superintendent E J E Stowers
Dates c1857 (1970) -

Subjects POLICE policemen and policewomen
 equipment civic occasions
Numbers pr c500 b&w 8½"x6½"
 fi negs c500 b&w 35mm
Access Visiting parties by arrangement
Notes The photographic collection forms a small part of
 the Devon and Cornwall Force Museum which is
 maintained for training purposes only.

220
Owner Commissioner of Police for the Metropolis
Location New Scotland Yard Publicity Branch
 Broadway London SW1H OBG 01 230 1212
 Metropolitan Police Publicity and Public Relations
 Photographs
Custodian R Keppel Press and Publicity Library
 01 230 2840
Dates 1900 -
Subjects POLICE Metropolitan Police duty and training
 crime prevention accident prevention
Numbers pr c4500 b&w
 fi negs c4500 b&w
 tr 2100 col 2¼"x2¼" 35mm
Access Bona fide students researchers publishers and
 publicists
Copies available for loan
Charges None for bona fide purposes

221
Owner Mrs Lily Warden
Location 30a Eaton Place Brighton East Sussex
Dates 1914 - 1925
Subjects Salonika Fire - 1914 - 1918 War Jerusalem
Numbers pr c40 various
Access Limited access by appointment only

222
Owner Tony Boxall
Location 4 Lechford Road Horley Surrey RH6 7NB
 Horley 2560
Title Gypsy Life
Dates 1965 - 1970
History This collection of Gypsy Life photographs was of the
 last of the horse-drawn caravan Gypsy families in the
 Surrey Area
Photographer Tony Boxall
 GYPSY HORSE-DRAWN CARAVAN and its people -
 South East area Dorking Charlwood Penshurst Kent
Numbers pr 150 20"x16"
 fi neg 3000 b&w 500 col
Access General public
Copies available for sale for loan on stock ready printed
 c150 10"x8" prints c200 2¼"x2¼" transparencies
Charges Reproduction fee normal agency rates
Notes Quite a large percentage of these photographs have
 been published and exhibited all over the world.

223
Owner University of Liverpool
Location Ashton Street PO Box 123 Liverpool L69 3DA
 051 709 6022
Title Scott Macfie Collection
Custodian M R Perkin
Dates c1888 -
Photographer Fred Shaw
Subjects GYPSIES customs and folklore portraits
 caravans camps ceremonies
Numbers pr contained in 20 albums
 gl negs c350
 sl small number
Access Bona fide students
Notes The collection consists of the archive of the Gypsy
 Lore Society founded 1888, photographs principally
 by Fred Shaw.

224
Owner Dennis Gladstone Adams
Location 11 Beverley Park Monkseaton Whitley Bay
 Tyne and Wear 089 44 25242
Dates 1900 - 1966
History The collection is a representative cross section
 of the work of Master Photographer Gladstone Adams
Photographer Gladstone Adams
Subjects PORTRAITS local government lighthouses
 transport flowers dogs architecture photographic
 reproductions seaside holidays outdoor games
 aerial photography historic and newsworthy events
 World War I
Numbers pr substantial numbers b&w 2¼"x2¼" - 20"x16"
 L sl c500 b&w 3¼"x3¼"
 fi negs substantial numbers b&w 35mm-12"x10"
 gl negs substantial numbers b&w various
 gl pos b&w ½pl
Access Bona fide students
Copies available by arrangement
Charges Reproduction fee by arrangement
Notes Gladstone Adams (1880 - 1966) started his career in
 1900, employed a staff of 90. One time President of
 the Photographic Dealers Association and Professional
 Photographers Association, inventor of the Windscreen
 Wiper.

225
Owner Dennis Gladstone Adams
Dates 1926 -
History The owner is the son of the photographer
 Gladstone Adams
Photographer Dennis Gladstone Adams
Subjects PORTRAITS weddings royalty
Numbers pr c500 2¼"x2¼"-½pl
Notes Dennis Gladstone Adams was official photographer
 to HRH Princess Margaret when visiting Tyneside and
 to the Princess Royal when visiting Whitley Bay.
 Location, Access, Copies and Charges as for No. 224
 above.

226
Owner George Anderson Miss Louie Boutroy
Location 42 Linden Gardens London W2 4ER
 01 229 5475
Title Mansell Collection
Custodian Terence Pepper
Dates 1860 (1953) - 1930
Photographer Samuel Bourne Roger Fenton E O Hoppé
 Dorein Leigh W F Mansell Richard N Speaight
Subjects PORTRAITS CULTURE PAINTINGS
 THEATRE agriculture air-balloons gliders
 aeroplanes architecture astronomy biblical book
 illustrations botany commerce communications
 costume customs dancing education exhibitions
 exploration food furniture history home humour
 industries children labour - slavery trade unions
 child labour strikes riots law literature maps
 medical meteorology mining music mythology
 naval and military occult recreation religion
 sport textiles topography transport people
 zoology
Numbers pr c1800 b&w various
 fi negs c22000 b&w ½pl 1pl
Aids List of subject headings
Access Publishers press tv media by appointment only
Notes The Mansell Collection is a commercial undertaking
 and has a wide variety of illustrations for loan for use
 in publications comprising engravings, etchings,
 lithographs as well as photographs. Named after W F
 Mansell whose photographs of paintings and objets
 d'art constitute the oldest part of the collection.

227
Owner Marquess of Anglesey
Location Plas Newydd Llanfairpwll Anglesey North Wales

Key () = dates when collections were begun or terminated
C = Century c = approximately pr = print fi = film
gl = glass neg = negative sl = slide L sl = lantern slide
tr = transparency mic = microform col = colour

b&w = black and white ¼, ½, 1-pl = quarter, half and whole
plate * = single copy, no public access ** = single copy,
access by appointment

Dates c1860 - c1870
Subjects PORTRAITS country houses views keepers outdoor staff cricketers
Numbers pr substantial number various
Access Bona fide students by appointment only
Notes A heavily bound album gold-tooled on red, numerous very detailed decorations in ink and water colour. This album was probably put together by the contemporary Marchioness of Anglesey.

228
Owner Professor & Mrs H Baum
Location Yew Trees 356 Dover House Road London SW15 01 789 9352
Dates c1880
History This collection was bought in a junk shop in Devon and appears to be a personal memoir of a senior British Army Officer serving in the Far East
Photographer S Bourne Duval
Subjects PORTRAITS REGIMENTAL GROUPS visiting dignitaries Prince Albert Victor scenes and monuments in India and Burma Alpine scenes - Italy Switzerland Austria England
Numbers pr c150 b&w 1-pl
Access Bona fide students by appointment
Copies available for sale depending on precise nature of request
Charges Reproduction fee commercial publications by arrangement academic publications - gratis

229
Owner Lord Montagu of Beaulieu
Location The Muniment Room Palace House Beaulieu Hampshire SO4 7ZN 0590 612345
Title Beaulieu Family and Estate Records, Photographic Section
Custodian The Archivist
Dates c1870 -
Subjects PORTRAITS FAMILY PHOTOGRAPHS Travels abroad Beaulieu
Numbers pr c800 b&w
Aids Catalogue in preparation
Access General public
Copies available for sale only by special arrangement
Charges On application

230
Owner Birmingham Photographic Society
Location BPS Headquarters Birmingham and Midland Institute Margaret Street Birmingham
Title Birmingham Photographic Society Permanent Collection
Custodian Leslie Penn Flat 2 Hamstead Road Handsworth Wood Birmingham B20 2RD
Dates c1860 (c1930) -
Photographer J Craig Annan Julia Margaret Cameron Charles Job Sir Benjamin Stone
Subjects PORTRAITS cathedral interiors rural scenes pictorial foreign travel
Numbers pr substantial numbers b&w various
L sl substantial numbers b&w col 3¼"x3¼"
ambrotypes 20 b&w 3"x2"
Access Bona fide students

231
Owner H R Wright (Housemaster)
Location Boyne House College Road Cheltenham Gloucestershire
Dates 1864 -
Subjects PORTRAITS Cheltenham College boys period dress
Numbers pr c200 10"x8"
Access Bona fide students by appointment only
Copies available for sale
Charges £3.50p per photograph

232
Owner British Edgar Rice Burroughs Society
Location Reference Library 113 Chertsey Rise Stevenage Hertfordshire SG2 9JQ
Custodian Paul Norman

Dates 1875 (1973) -
Subjects PORTRAITS Edgar Rice Burroughs and associates old book covers
Numbers pr c150 b&w 10"x8"
sl c100 col 35mm
mic
Aids Card index subject index
Access Used for reference purposes by the British Edgar Rice Burroughs Society and members
Copies available for sale for loan
Charges Reproduction fee on application
Notes It is the Society's intention to make available to members and the public copy photographs and transparencies relating to the life and work of Burroughs. In time the collection may be expanded into a library of science fiction and science fantasy.

233
Owner Mrs Anita Bruce Binnerts
Location The Villa Thornton Steward Ripon North Yorkshire HG4 4BB
Dates 1870 (1896) - 1909
Subjects PORTRAITS landscapes botanical specimens
Numbers c35 cartes de visite
pr c40 contained in 3 albums
Access General public bona fide students by appointment only

234
Owner A Campbell
Location 82 High Street Kirkcudbright Dumfries and Galloway Region Scotland Kirkcudbright 30333
Title Album of Kirkcudbright Photographs
Dates c1860-1870
History This photograph album which contains contemporary pencil notes on the persons portrayed is a very useful gallery of life in a small town at this period
Photographer W Stewart
Subjects PORTRAITS - the Shand family and townsfolk of Kirkcudbright
Numbers c91 b&w 2½"x3½"
Access Bona fide students on application

235
Owner Christopher Methuen Campbell
Location Penrice Castle Reynoldston Swansea West Glamorgan
Dates 1841 -
Photographer W H Fox Talbot Calvert Jones
Subjects PORTRAITS landscapes - local
Access Bona fide students by appointment only
Notes Fox Talbot was a relative of the builder of Penrice Castle and often visited here. This collection is in the main unsorted and it is difficult for the owner to estimate numbers.

236
Owner Chemical Society
Location Burlington House London W1V UBN 01-734 9971
Dates 1870 (1880) -
Subjects PORTRAITS chemists
Numbers pr 700 b&w various
Aids *Card index
Access Bona fide students
Copies available for loan to members

237
Owner William Coulthard
Location Wellholme Scotby Nr Carlisle Cumbria
Dates c1860 (1922) -
Subjects PORTRAITS - family photographs
Numbers pr and negs c1000 2¾"x3¼"

238
Owner J H Craster
Location Craster Tower Alnwick Northumberland NE66 3SS 066 576 686
Dates c1850 -
Subjects PORTRAITS

Numbers pr substantial number
 Daguerreotype
Notes A numerous collection of a typical long-established
 Northumberland landowning family including. e. g. 2
 1850 Daguerreotypes of a gardener and a nurse.

239
Owner Mrs R Darnton
Location Sissinghurst Court Cranbrook Kent
 Sissinghurst 345
Dates c1860 -
Subjects PORTRAITS family portraits world wide
 travel - Europe India Burma Ceylon Siam Tasmania
 Australia Africa Borneo Costa Rica Egypt Brazil
Numbers pr substantial number
 fi

240
Owner Reginald Davis
Location 29 Heriot Road London NW4 2EG
 01 202 7941
Dates 1959 -
Photographer Reginald Davis
Subjects PORTRAITS Royalty - British and Foreign -
 informal and formal historic and newsworthy events
Numbers tr 20000 col various
Aids *Catalogue
Access Picture researchers press tv media
 10 am - 5 pm
Copies available for display for publication
Charges Publication/reproduction fee dupe transparency
 fee holding fee search fee

241
Owner Dickens House Museum Trustees
Location The Dickens House Museum 48 Doughty Street
 London WC1N 2LF 01 405 2127
Title The Tyrrel Collection
Custodian Marjorie E Pillers
Dates c1920 -
History This collection is confined to the life and work
 of Charles Dickens (1812-1870)
Subjects PORTRAITS Dickens and family and friends
 architecture - mentioned in Dickens works London
 topography European residences
Numbers gl negs c4000 b&w ¼pl ½pl
Access General public bona fide students picture
 researchers by appointment only
Copies available for sale for publication
Charges Reproduction fee by arrangement research
 and consultation fee sometimes
Notes A private collection relevant to Dickens with
 a topographical emphasis.

242
Owner Simon Wingfield Digby
Location Sherborne Castle Dorset
Custodian P A Howe Digby Estate Office Cheap Street
 Sherborne Dorset DT9 3PY 093 581 3182
Dates c1905 -
Subjects PORTRAITS family albums World War
 Sherborne Pageant dogs Keeshonden - Dutch
 barge dog Sherborne Castle
Numbers pr substantial number various
 sl c50
 tr
 postcards
Access General public bona fide students picture
 researchers press tv media by prior
 arrangement with the controller
Copies Current commerical transparencies and
 postcards for sale. Bona fide researchers may
 photograph material by arrangement
Charges Reproduction fee by arrangement
Notes Sherborne Castle is open to the public from Easter
 to the end of September on Thursdays Saturdays and

Sundays from 2pm - 6pm. It is essential that any
interested people should make prior arrangements
with the Controller if they wish to see the material.
Subject to other commitments research students
or other people with a genuine interest can be given
facilities to see the material 'out of season'.

243
Owner Dr Barnardo's Home
Location Tanners Lane Barkingside Ilford Essex
 IG6 1QG 01 550 8822
Custodian Roy Ainsworth
Dates 1874 -
Subjects PORTRAITS children medical school rooms
 buildings games
Numbers pr c200000 various
 fi negs 35mm 2¼"x2¼"
 tr col 35mm 2¼"x2¼"
Aids *Card index
Access Bona fide students picture researchers press tv
 media 9 am - 5 pm apply by letter
Copies available for publication credit line required
Charges Prints sold for publication with acknowledgement
 at £5.50 each

244
Owner Fife Herald and Fife News J A G Innes Limited
Location 20 Crossgate Cupar Fife Cupar 2206
Dates 1890 (1900) -
Subjects BIOGRAPHY AND PORTRAITS historic
 and newsworthy events Fife local history
Numbers pr c750 b&w various
Aids *Subject index
Access Bona fide students picture researchers press
 tv media 9 am - 5 pm
Copies available for loan for publication by arrangement
 only credit line required
Charges Reproduction fee

245
Owner First Beaverbrook Foundation
Location The Library 121 Fleet Street London EC4
 01 353 8000
Title Beaverbrook Library Collection
Custodian A J P Taylor
Dates 20thC (1910) - 1964
Subjects BIOGRAPHY AND PORTRAITS politicians
 and Parliament
Numbers pr contained in 160 albums b&w
Aids *Catalogue
Access Bona fide students
Copies available for loan
Notes 60 of the albums relate to Lord Beaverbrook and
 some of the collection relates to Lloyd George.

246
Owner Major A F Flatow
Location 45 Berrylands Surbiton Greater London
 KT5 8JU 01 399 4651
Dates c1855 - 1890
Photographer Felice Beato James Robertson
Subjects PORTRAITS - military foreign and British
 Royalty recipients of V C British and foreign
 military
Numbers Substantial Number

247
Owner R Forester-Smith
Location Burnvale West End West Calder Lothian
 West Calder 515
Dates 1962 (1970) -
Photographer R Forester-Smith
Subjects PORTRAITS leading Scots personalities in
 legal business academic and other representative
 fields
Numbers pr c80 col 20"x16"

Key () = dates when collections were begun or terminated
C = Century c = approximately pr = print fi = film
gl = glass neg = negative sl = slide L sl = lantern slide
tr = transparency mic = microform col = colour

b&w = black and white ¼,½,1-pl = quarter,half and whole
plate * = single copy,no public access ** = single copy,
access by appointment

Aids Catalogue
Access General public by appointment only
Copies available to order at current list prices
 prevailing at time of order
Charges Reproduction fee at scales set down by
 Institute of Incorporated Photographers

248
Owner Richard Fortescue-Foulkes
Location 20 Matford Lane Exeter Devon EX2 4PS
Dates c1876 - c1878
Photographer Bourne and Shepherd Westfield
Subjects PORTRAITS Government of India - groups and
 individuals India and Ceylon - buildings
Numbers pr 120 various 2½"x3" - 9"x12"
Access Bona fide students
Copies available on request
Charges Print fee only provided due acknowledgement is
 made in the publication
Notes Prints contained in one album.

249
Owner Smith Art Gallery and Museum Friends
Location Smith Art Gallery and Museum Albert Place
 Stirling FK8 2RQ 0786 2849
Custodian James K Thomson
Dates 1874 -
Photographer Crowe and Rodgers Serjeant McKenzie
Subjects BIOGRAPHY AND PORTRAITS army personnel
 rock formation fossils bridges architecture
 golf bowls curling fishing landscapes -
 Scotland India
Numbers pr c500 b&w
 gl negs 179 b&w ¼pl ½pl 1-pl
 L sl 2 col
Aids *List card index
Access Bona fide students

250
Owner Brian J Gower
Location The Billit 31 Gorselands Sedlescombe Battle
 East Sussex TN38 OPT
Title Incorporates James T Smith (Regent Street
 Polytechnic) Collection
Dates 1888 (1890) - 1912 - 1924
History Photographic records of subjects taken by the late
 James T Smith plus a collection of dufaycolor slides
 taken 1950 - 1956 by Brian J Gower
Photographer James T Smith F W Woods
Subjects PORTRAITS groups Brighton - sea front sea
 railway Old Wembley Tower Salisbury Stonehenge
 Royal Navy Fleet Spithead Plymouth - HMS Victory
 Channel crossing - Boulogne Canada Reading - locks
 Eastbourne
Numbers pr 370 b&w col various
 sl c60 col 2¼"x 3¼"
Aids Part subject index
Access By appointment only
Copies available by arrangement
 restrictions on use of photographs and limitations on
 supply
Charges Print fee by arrangement copy negative fee
Notes Collection contains prints of historic thatched and
 timber built farmhouses 1892 - 1894 and covers the
 counties of Kent Sussex Hampshire Surrey Devon
 Cornwall Wiltshire Berkshire West London and
 Middlesex

251
Owner John Gurney
Location The Abbey Walsingham Norfolk NR22 6DQ
 Walsingham 219
Dates c1850 -
Subjects PORTRAITS - family travel
Numbers pr c1000
Access Bona fide students by appointment only
Charges By arrangement

252
Owner E Chambré Hardman
Location 59 Rodney Street Liverpool Merseyside L1 9ER

Dates c1923 -
Photographer E Chambré Hardman
Subjects PORTRAITS Liverpool - buildings docks
 streets landscapes - England Wales Scotland
 France India
Numbers gl negs c200000
Access By arrangement
Copies available by arrangement
Charges By arrangement
Notes The portraits in this collection are of men and
 women prominent in business and cultural life,
 particularly associated with Merseyside.

253
Owner James Hervey-Bathurst
Location Eastnor Castle Ledbury Herefordshire
 0531 2304
History Begun by Third Earl Somers
Photographer Julia Margaret Cameron Lewis Carroll
 (Charles Lutwidge Dodgson)
Subjects PORTRAITS Eastnor Castle - interior and
 exterior
Numbers pr c100 various
Access General public to part of the collection only

254
Owner Captain E M B Hoare
Location Velhurst Farm Afold Cranleigh Surrey
 0403 752224
Dates c1864 - c1869
Subjects PORTRAITS - single and groups
Numbers pr 117 b&w various - mainly 3"x2"
Access Bona fide students by appointment
Notes This is a family album passed down to Captain Hoare.

255
Owner G Hollingshead
Location 9 Sherwell Grove Allerton Bradford West
 Yorkshire 0274 46751
Dates c1900 (1920) -
Photographer G Hollingshead
Subjects PORTRAITS family portraits country scenes
 water and horse power railways steam engines
 museums industrial archaeology industry
 engineering Windermere Steamers Ravenglass and
 Eskdale Narrow Gauge Railway
Numbers pr c100 ¼ pl
 L sl c1000 b&w col 3¼"x3¾"
 fi negs c1000 2¼"x2¼"
 tr 35mm
Access Bona fide students by appointment

256
Owner H Hood
Location 13 Eastwick Park Avenue Great Bookham
 Leatherhead Surrey
Title Richmond Collection
Dates c1862 (1971) -
Subjects PORTRAITS ITALIAN SCULPTURE
Numbers pr c307 various

257
Owner Mrs E M Hugill
Location 3 Harpers Terrace Middleton St George Nr
 Darlington Co Durham 0325 73 2511
Dates 1861 (c1969) -
Photographer Elliot and Fry John Mayall Nadar C Silvey
 George Washington Wilson
Subjects PORTRAITS - Charles Kingsley Royal Family
 famous clerics
Numbers pr c500 b&w various
Access Bona fide students on written request
Copies available for sale for loan depending on
 circumstances

258
Owner Mrs G Huntrods and Mrs E Brown
Location 19 Johnstone Street Eldon Lane Co Durham
 51 Wesley Street Coundon Grange Co Durham
Dates c1900 - 1916

History J E Huntrods started a cinema in Eldon Lane in 1914
Photographer J E Huntrods
Subjects PORTRAITS Victorian family photographs Brotton in Cleveland
Numbers pr 34 5½"x3½"
 L sl 40
 Cabinet photographs 24
Access General public picture researchers bona fide students press tv publishers appointment by letter only
Copies could be made available by private arrangement only

259
Owner Daisy M James
Location 4 Dale Gardens Woodford Wells Essex IG8 0PB
Title The James Collection
Photographer Daisy M James Fred G James
Subjects PORTRAITS Civil Defence activities travel UK and abroad Italian Lakes Ross-on-Wye Roman figures "Knights of Malta"
Numbers pr substantial number contained in albums sl substantial number col 35mm 3¼"x3¼"
Notes Includes collections of: South Essex Camera Club (1901-1959) East Anglian Photographic Federation (1910-1960).

260
Owner Philip Dodgson Jaques 42 Crabtree Lane Harpenden Hertfordshire
Location Guildford Muniment Room Castle Arch Guildford Surrey GU1 3SX 0483 66551
Title The Dodgson Family Collection
Dates 19thC -
Photographer Lewis Carroll (Charles Lutwidge Dodgson)
Subjects BIOGRAPHY AND PORTRAITS Lewis Carroll's near relatives and a child friend Xie Kitchin
Numbers pr 8 b&w 2½"x4" 5"x8"
Aids *Catalogue
Access Bona fide students
Notes The eight photographs by Lewis Carroll from a part of large collection of archive and other material from the Dodgson family.

261
Owner E Norman Jones
Location Beck House Lund House Green Harrogate North Yorkshire HG3 1QG 0432 81194
Title The Norman Jones Collection
Dates 1880 - 1930 -
Photographer Julia Margaret Cameron Lewis Carroll Francis Frith Herbert Jones
Subjects PORTRAITS Nyasaland - natives social functions views topography
Numbers cartes de visite c600
 cabinet photographs c200
 Edwardian postcards c1000
Access General public bona fide students press tv media by appointment
Notes The father of the owner of this collection was a photographer in Nyasaland c1898 - 1910, therefore it includes many photographs of Malawi, natives, social functions, and views in the early part of the century.

262
Owner Lady Lever Art Gallery Trustees
Location Port Sunlight Wirral Merseyside 051 645 3623
Custodian Ralph Fastnedge
Dates 1922 -
Subjects PORTRAITS - BIOGRAPHY
Numbers pr c50 b&w various
Access No access except in the case of a specific enquiry

Notes The collection records events in the history of the Gallery.

263
Owner Serge Lemoine
Location City Golf Club Building Bride Lane Fleet Street London EC4 01 353 9933
Title Photographs of the Royal Family
Dates 1971 -
Photographer Serge Lemoine
Subjects PORTRAITS Royal Family
Numbers fi negs 10000 b&w 35mm
 tr 10000 col 35mm
Access to original images picture researchers press tv media 9 am - 8 pm
Copies available for display for publication
Charges Reproduction fee print/transparency fee holding fee search fee

264
Owner Lincolnshire County Council (Trustees)
Location Usher Gallery Lincoln and Tennyson Research Centre Central Library Free School Lane Lincoln
Title Tennyson Collection
Custodian R H Wood of the Usher Gallery and E H W Roberts of Lincolnshire County Library
Dates 1850 (1850) -
History Collection refers to Alfred, Lord Tennyson and other distinguished Victorians
Photographer Julia Margaret Cameron Lewis Carroll W Jeffrey I Mayall O G Rejlander
Subjects PORTRAITS Tennyson homes family distinguished Victorians
Numbers pr c800 b&w c100 col various
Aids Catalogue
Access General public bona fide students on application by appointment only
Copies available for sale with certain restrictions
Charges Reproduction fee basically NUJ rates apply and are varied according to the purpose for which the copies are required
Notes This collection is on permanent loan to the Lincolnshire County Council from the Tennyson Trust.

265
Owner Angus McBean
Location Flemings Hall Eye Suffolk Worlingworth 202
Dates 1936-
History Residue of prints for 30 years of photographing English Theatre, the collection is of prints only, the negatives deposited with Harvard University
Photographer Angus McBean
Subjects PORTRAITS - theatre personalities stage productions travel houses East Anglia - topography
Numbers Substantial number
Access Picture researchers press tv media
Copies available for loan under special circumstances for sale
Notes Angus McBean, Britain's leading theatrical photographer, for many years combined surrealist fantasy with photographic realism in his portraits of actresses and other compositions.

266
Owner Ian Macdonald
Location 8 North Row Lazenby Cleveland
Dates 1860 (1969) -
Photographer Ian Macdonald Frank Meadow Sutcliffe
Subjects PORTRAITS - people in their environment Cleveland - landscapes coast and estuary
Numbers pr
 fi negs c1450 various
 gl negs c30 5"x7" ½pl
Aids Subjects index
Access Bona fide students by appointment only

Key () = dates when collections were begun or terminated
C = Century c = approximately pr = print fi = film
gl = glass neg = negative sl = slide L sl = lantern slide
tr = transparency mic = microform col = colour

b&w = black and white ¼, ½, 1-pl = quarter, half and whole plate * = single copy, no public access ** = single copy, access by appointment

267
Owner Major J C Mansel
Location Smedmore Kimmeridge Wareham Dorset
Dates c1860 - 1870
Subjects PORTRAITS celebrities family photographs
Numbers pr c100 3½"x2¼" contained in 2 albums
Access Bona fide students writers historians written
 appointment only

268
Owner L Mensforth
Location 6 North End Villas Fir Tree Crook Durham
 DL15 8DQ
Dates 1870 (1972) -
Subjects PORTRAITS cokeworkers
Numbers pr c50 2¼"x3½"
Access General public by appointment only

269
Owner National Galleries of Scotland Trustees
Location Scottish National Portrait Gallery 1 Queen
 Street Edinburgh EH2 1JD
Custodian R E Hutchison
Dates 1843 (1928) -
History D O Hill collection assembled from bequests
 together with a small collection of other early
 photographs
Photographer D O Hill and Robert Adamson
Subjects PORTRAITS some topographical
Numbers pr c4000 b&w 8"x6½"
 some paper negs for the calotypes
Aids Subject index
Access General public special facilities for bona fide
 students - gratis
Copies available for sale by special order

270
Owner National Portrait Gallery
Location London WC2H 0HE 01 930 8511
Title Department of Film and Photography Daily Herald
 Picture Library Collection
Custodian Colin Ford
Dates c1840 -
Subjects PORTRAITS
Numbers Total c500000
Aids Card index
Access Bona fide students
Copies available for sale
Notes As the department of film and photography was only
 established in 1972, it obviously is not yet in a position
 to implement all its plans. It only has two full time staff
 members and they have the problem not only of sorting
 out collections which have been in the Gallery's
 stores for up to 100 years, but of rationalising storage
 and indexing procedures.

271
Owner Nuffield College
Location The Library Oxford OX1 1NF 0865 48014
Subjects PORTRAITS - Fabian Society
 cars car factories
Access Picture researchers written request only for
 appointment bona fide students

272
Owner H L O'Bryan-Tear
Location 8 Blomfield Road London W9 01 286 5456
Dates 1880 - 1920
History The collection of a Court Photographer
Photographer Edward Adolphus Tear
Subjects PORTRAITS Royal Family pre-1914 India
 Edwardian family life in India
Numbers pr c30 1pl
Access Bona fide students by appointment only with Mrs
 O'Bryan-Tear
Notes One very large photograph (c4'6"x3') of a group
 including George V and Queen Mary taken at an English
 country house c 1910.

273
Owner Mrs Ann I Oliver

Location 15 Stockton Road Wilmslow Cheshire
 SK9 6EU 099 64 20215
Dates c1885 - c1925
History James Temple was an artist who later became
 interested in photography. He was a well-known
 fisherman and taught some of the Royal Family
Photographer James Temple
Subjects PORTRAITS - The Kaiser George V
 Edward VII buildings fishermen James Temple
 with family
Numbers pr c15 8½"x6½" 6"x4"
Access Bona fide students by appointment only

274
Owner Mrs S M Pritt
Location Eaton House Aldeburgh Suffolk Coastal Suffolk
 072 885 2132
Dates c1860 - c1900
Subjects PORTRAITS family life
Numbers pr c40 various
Access Bona fide researchers strictly by appointment only

275
Owner Pusey House Governors
Location Pusey House St Giles Oxford OX1 3LZ
Title E J Hall Collection
Dates 1895
History The collection was formed by Henry Hall and was
 presented to the library of the English Church Union
 by his son the Rev Edward J Hall in 1895. At some
 later date it was transferred to the library of Pusey
 House
Subjects PORTRAITS Bishops and clergy of the 19thC
 the Catholic Revival in the Church of England
Numbers pr c2214 b&w various
Aids Guide
Access Bona fide students on application
Copies available for sale on special request by
 arrangement

276
Owner James R Reynolds
Location Leighton Hall Carnforth Lancashire LA5 9SS
 052 473 2729
Dates c1870 -
Subjects PORTRAITS - family India Ireland
Numbers pr substantial number
Access By appointment pm Wednesday Sunday and
 bank holidays May to September

277
Owner Kensington and Chelsea Royal Borough Council
Location Central Reference Library Phillimore Walk
 London W8 7RX 01 937 2542
Title Alexander Family Collection
Custodian R J Ensing
Dates c1845 - c1964
Photographer Elliott and Fry Samuel Fry
Subjects PORTRAITS continental tours country house
 life relief work and scenes in France 1916 - 18
Numbers pr c200 b&w various
 albums 7 b&w
Access General public bona fide students picture
 researchers press tv media 10 am - 8 pm
 Wednesday and Saturday 10 am - 5 pm
Copies available for sale for display for loan
 for publication
Charges Reproduction fee print/transparency fee
Notes Library notation MS 5024 - 5113.

278
Owner Royal College of Physicians of London
Location 11 St Andrew's Place Regents Park London
 NW1 4LE 01 935 1174
Custodians C E Newman D N Cole
Dates Mid 19thC -
Subjects BIOGRAPHY AND PORTRAITS named medical
 portraits
Numbers pr 5000 b&w various
Aids *Card index
Access Bona fide students

D

Copies Copies available on request
Charges Access fee
Notes The collection is supported by an index of portraits of medical men published in books.

279
Owner Ruskin Galleries Trust
Location Ruskin Galleries Bembridge School Isle of Wight Bembridge 2101
Title The Ruskin Galleries Collection
Custodian J S Dearden
Dates c1862 -
Subjects PORTRAITS - Ruskin Italy France
Numbers pr c240 b&w
gl negs c40 b&w
daguerreotypes c110
Access By appointment
Notes Contains more photographs and Daguerreotypes relating to Ruskin than any other collection. Materials in the process of being catalogued.

280
Owner Edward St Maur Pencarreg House Llangibby Usk Gwent Usk 2608
Location Edward St Maur Photography Seymour Studios 76 Bridge Street Newport Gwent 0633 65188
Title The St Maur Collection
Dates c1850 (c1910) -
Subjects PORTRAITS Royal Family - Queen Victoria political personalities statesmen army transport paintings geography antiques historic and newsworthy events - India Gallipoli Sinai Palestine Egypt World War I
Numbers pr c250 b&w various
Access Bona fide students on request
Copies Certain copies could be made available on request
Charges Print fee reproduction fee

281
Owner School of Slavonic and East European Studies (University of London)
Location The Library S S E E S London WC1 01 637 4934
Custodian A Helliwell
Dates 1909 - 1913
Subjects PORTRAITS Grand Duke Mikhail Aleksandrovich and family
Numbers pr contained in 14 albums
Access General Public bona fide students by arrangement
Copies available for sale by arrangement
Charges Print fee
Notes The albums belonged to the late Countess N S Brasova (1880-1952).

282
Owner Scottish Photographic Circle
Location c/o 45 Campsie Gardens Clarkston Glasgow G76 7SE 041 638 0208
Custodian A Ronald Aitchison Secretary
Dates c1912 (1963) -
History Many processes are represented including a number of bromoil works
Photographer Miss Grace Allison J Stevens Orr Frederick Pessel J M Whitehead
Subjects PORTRAITS NATURAL HISTORY
Numbers pr c50 various
Aids Catalogue
Access May be viewed by appointment only
Notes Arrangements may be made, if suitable, to have a member of the Circle accompanying the collection to talk on subject.

283
Owner E J Sidery
Location 36 Milford Road Johnston Haverfordwest Dyfed Johnston 890442

Title William Boyer's Victorian Sandwich
Dates 1863-1895
History Photographic record of life in and around a small market town, showing all social levels at home and at work
Photographer William Henry Boyer
Subjects PORTRAITS country folk outdoor groups buildings hop-picking tennis croquet transport
Numbers gl neg 3000 4¼"x3¼"
Aids Catalogue and card index in preparation
Access Bona fide students
Copies available for sale for loan
Charges Reproduction fee approximately £5 per photograph
Notes The photographs have been placed on the Science Museum 'A' list.

284
Owner R M Simpson
Location Burton Court Eardisland Leominster Herefordshire
Dates 1902 - 1903
Photographer Sidney Pitcher
Subjects PORTRAITS family portraits architecture - Burton Court Gloucester Cathedral
Numbers pr c500 b&w various contained in 2 albums
Access General public bona fide students
Notes Portrait of a typical Squire's family early this century.

285
Owner P Telfer Smollett
Location Cameron House Alexandria Dumbartonshire
Dates 1900 -
Subjects PORTRAITS - family World War I Shanghai War 1937
Numbers pr contained in c30 albums
Access House is open to the public Easter to October each year

286
Owner Colin Smythe
Location Cornerways Mill Lane Gerrards Cross Buckinghamshire 028 13 86000
Dates 1880 (1969) -
Photographer George Bernard Shaw
Subjects PORTRAITS figures of the Irish Literary Revival Lady Gregory W B Yeats
Numbers pr c250
Access Bona fide students by appointment only
Copies available by arrangement
Charges By arrangement

287
Owner Andrew Stevens
Location 13 Groby Road Chorlton-cum-Hardy Manchester M21 2AF 061 881 9203
Dates 1850 (1970) -
Subjects PORTRAITS
Numbers pr 55 b&w various
gl pos b&w
tr 10 b&w
daguerreotypes
Access Bona fide students

288
Owner J F Tomas
Location Beau-Sir 56 Longlands Charmandean Worthing West Sussex Worthing 32579
Dates 1914 -
Subjects PORTRAITS - Royal Family Edward VII George V
Numbers gl negs 14 various
Access Bona fide students publishers
Copies available for sale

Key () = dates when collections were begun or terminated
C = Century c = approximately pr = print fi = film
gl = glass neg = negative sl = slide L sl = lantern slide
tr = transparency mic = microform col = colour

b&w = black and white ¼,½,1-pl = quarter,half and whole plate * = single copy,no public access ** = single copy, access by appointment

Notes There are also letters and comments by the Prince of Wales on various subjects which go together with the photographs as a whole.

289

Owner Mr and Mrs P A Tritton
Location Parham Park Pulborough West Sussex
 RH20 4HS
Dates 1851 –
Subjects PORTRAITS historic families Parham
Numbers gl pl 38
 pr contained in 2 albums

290

Owner Universal Pictorial Press & Agency Ltd
Location 30/34 New Bridge Street London EC4V 6BN
 01 236 6730
Custodian The Librarian
Dates 1943 –
Subjects PORTRAITS AND ACTION PHOTOGRAPHS –
 politicians scholars ecclesiastical business people
 military entertainers sports personalities views –
 buildings scenes ships aircraft
Numbers fi negs 200000 various
 gl negs 100000 various
 tr 60000 col
Aids Alphabetical card index of subjects
Access General public picture researchers press tv
 media 9 am – 5.30 pm Monday to Friday
Copies available for reproduction for transmission
 for sale
Charges Print fee reproduction fee and transmission fee
 depending on use

291

Owner University of Dundee
Location Department of Physiology Smalls Wynd
 Dundee DD1 4HN 0524 23181 Ext 252
Custodian Professor G H Bell
Dates 1964 –
Subjects PORTRAITS Doctors Philosophers Theologians
Numbers pr c200 b&w 8"x6"
 fi negs c200 b&w 2¼"x2¼"
Aids Alphabetical subject index
Access Picture researchers press tv media
Copies available for sale
Charges Reproduction fee print/transparency fee

292

Owner University of Edinburgh
Location University Library George Square Edinburgh
 EH8 9LJ
Custodian The Librarian
Dates Late 19thC –
Subjects PORTRAITS Medical men scientists
 geography – Africa Sudan Persia USA Russia
Numbers pr substantial numbers some contained in 22
 portfolios and 12 albums
Access General public bona fide students
Copies available for sale for academic purposes only

293

Owner University of Glasgow
Location Archives Department Glasgow G12
 041 339 8855 Ext 543
Title Glasgow University Archives Collection Business
 Record Collection
Custodian Michael S Moss
Dates c1860 –
Photographer James Craig Annan
Subjects PORTRAITS – University personalities
 students and members of staff student activities and
 sports University buildings – exteriors and interiors
 Glasgow street scenes Glasgow 1901 exhibition
 forensic subjects geology – UK and abroad
 naval and merchant ships and their construction
 machine tools women war workers in shipyards
 and engine works
Numbers Pr 2124 b&w various
 fi negs 650
 gl negs 20 b&w

 L sl 1300 b&w 120 col 3"x3" 2"x2"
 mic 12 b&w
Aids Duplicated list card index subject index
Access General public 9 am – 5 pm
Copies available for sale by arrangement
Notes Photographs from this collection can only be
 published with permission from the University Court.

294

Owner A F Walker
Location Mulberry Cottage Park Road Toddington
 Nr Dunstable Bedfordshire Toddington 2687
Title Rainforth Collection
Custodian A F Walker
Dates 1872 – 1930
Subjects PORTRAITS
Numbers Substantial
Aids *Subject index
Copies available for display for publication credit line
 required
Charges Reproduction fee print handling holding and
 search fees may be chargeable if material not used
Notes The Rainforth collection is a commercial picture
 library specialising in portraits.

295

Owner London Borough of Waltham Forest Council
Location The Water House Lloyd Park Forest Road
 London E17 4PP 01 527 5544 Ext 390
Title William Morris Gallery and Brangwyn Bequest
Custodian H L Chambers
Dates (1936) –
History William Morris and the Pre-Raphaelite
 Brotherhood A H Mackmurdo and the Century Guild
 Sir Frank Brangwyn
Photographer Emery Walker
Subjects PORTRAITS PAINTING ANTIQUES
 earthenware base metal work architecture objects
 of art textiles of Morris and Company and Century
 Guild cartoons for stained glass
Numbers fi negs c270 b&w 8"x6" 4½"x6½"
 gl negs c100 b&w 4"x5"
 sl 30 col 35mm
Aids Duplicated catalogue list card index
Access Bona fide students
Copies Prints and slides available for sale
Charges Print fee from 25p
Notes It is hoped that all glass plate negatives will be
 re-photographed on celluloid negatives .

296

Owner Church of England
Location Lambeth Palace Library London SE1 7JU
 01 928 6222
Custodian The Librarian
Dates (1958) –
Subjects PORTRAITS local topography Lambeth Palace
 Manuscripts
Numbers fi negs 400 b&w
 sl 30 col
 mic 400 b&w
Aids *Card index
Access Bona fide students
Copies available for sale
Notes Lambeth Palace is the London home of the
 Archbishop of Canterbury.

297

Owner Neville Hickman
Location 21 North Drive Heathfield Park Handsworth
 Birmingham 20 021 554 3027
Dates c1864 – 1877
Photographer Julia Margaret Cameron
Subjects PORTRAITS
Numbers pr c12
Access Persons genuinely interested in Julia Margaret
 Cameron

298

Owner Bath Academy of Art
Location Corsham Wiltshire Corsham 712571

Custodian R Whally
Dates c1850 (c1950) -
Subjects PORTRAITS family photographs
Numbers pr c5500 b&w various
 daguerreotypes
 ambrotypes
Aids *Card index *subject index
Access By prior arrangement with Tutor - Librarian
 9.30 am - 9.30 pm to the original images
Notes The collection is largely concerned with the history
 of photography.

299
Owner W McLean Mitchell
Location R Clapperton Photographer Meadow Cottage
 Selkirk
Dates 1860 -
Subjects PORTRAIT GROUPS farm scenes buildings
 motor car rally c1902
Numbers gl neg b&w 10"x8"
 L sl
Access General public bona fide students publishers
 press tv media by appointment only
Copies available for sale
Charges Reproduction fee

300
Owner Mrs Roz Hair
Location 81 Downs Court Road Purley Surrey CR2 1BJ
Dates 1890s - 1925
Subjects FAMILY GROUPS CHILDREN
Numbers pr c60
Access Bona fide students
Copies available by arrangement
Charges Reproduction fee by negotiation subject to use

301
Owner Mrs G M Hoare
Location Velhurst Farm Alfold Cranleigh Surrey
 0403 752224
Custodian Captian E M B Hoare
Dates c1861 - c1864
History Edward Brodie Hoare, who compiled this album
 during his undergraduate days at Trinity College, was
 the eldest son of Canon Edward Hoare of Tunbridge and
 was a banker by profession. From 1888 - 1902 he was
 Member of Parliament for Hampstead
Subjects FAMILY PHOTOGRAPHS
Numbers pr 93 b&w 3½"x2¼"
Access Bona fide students by arrangement
Notes Although located at the same address, this is a
 different collection of photographs to that described in
 no.254 above.

302
Owner R L Morris
Location Long Gable Cherry Tree Lane Chalfont St Peter
 Buckinghamshire 028 13 83020
Dates c1853 - 1856
History John Dillwyn Llewelyn married Emma Talbot, a
 cousin of William Henry Fox Talbot. He worked with
 Claudet on daguerreotypes, invented the Oxymel
 process and was a founder committee member of the
 (Royal) Photographic Society. The album was
 presumably compiled by John Dillwyn Llewelyn for
 his brother's wife Bessie Dillwyn, daughter of Sir
 Henry de la Beche
Photographer John Dillwyn Llewelyn (1810 - 1882)
Subjects FAMILY PHOTOGRAPHS views in South Wales
Numbers pr c145
Aids Typed list of the photographs
Access Bona fide students picture researchers publishers
 press tv media on written application
Copies Possibly for sale where copy negatives have been
 made

Access Bona fide students by appointment only
Charges Reproduction fee commercial rates depending on
 use

303
Owner E R W Robinson
Location Moor Wood Nr Cirencester Gloucestershire
Title Henry Peach Robinson Collection
Dates c1850 - 1880s
History Henry Peach Robinson was the great uncle of the
 present owner
Photographer Henry Peach Robinson
Subjects FAMILY PHOTOGRAPHS genre North Wales
Numbers pr 48 b&w
Charges by arrangement

304
Owner Simon P Slinger
Location 58 Galloway Lane Leeds LS28 8LE
 0274 665514
 43 Valley Drive Harrogate HG2 0JH
Title The Simpson/Slinger Collection
Dates 1910 -
Photographer David Clifford Simpson Frank Jeffery
 Slinger Simon Paul Slinger
Subjects FAMILY PHOTOGRAPHS
Numbers pr c900 b&w c100 col
 fi neg c900 b&w c100 col
 tr 100 col
Notes A family collection of photographs taken by the
 owner's grandfather c1910 - 1940 and by his father
 from 1940.

305
Owner A A Towells
Location 97 Cannon's Close Bishops Stortford
 Hertfordshire 0279 53357
Dates c1850 (1972) -
Subjects FAMILY PHOTOGRAPHS - Mauritius
Numbers pr c1500 carte de visite and cabinet photographs
 ambrotypes c30
 daguerreotypes 2
Access by application only
Copies available for loan
Charges Print fee
Notes Included are some interesting scenes of the
 destruction of Port Louis (Mauritius) by cyclone 1892.

306
Owner Brunel University
Location University Library Kingston Lane Uxbridge
 Middlesex 0895 37188
Title Brunel Collection
Custodian C E N Childs
Dates 1840 (1965) - 1880 -
History Isambard Kingdom Brunel was perhaps the greatest
 of the pioneer engineers of the early British railway
 and steamship age
Subjects BIOGRAPHY Isambard Kingdom Brunel -
 engineering achievements railways tunnels early
 steamships The Great Eastern
Numbers pr 400 b&w various
 fi negs 100 b&w various
Aids *Guide
Access Bona fide students
Copies available for sale for loan
Charges Print fee

307
Owner Jane Austen Trust
Location Chawton Alton Hampshire 0420 83262
Custodian Mrs E M Roal
Subjects BIOGRAPHY Jane Austen
Numbers pr
 postcards c1000
Access General public

Key () = dates when collections were begun or terminated
C = Century c = approximately pr = print fi = film
gl = glass neg = negative sl = slide L sl = lantern slide
tr = transparency mic = microform col = colour

b&w = black and white ¼,½,1-pl = quarter, half and whole
plates * = single copy, no public access ** = single copy,
access by appointment

Copies available for sale
Charges Print fee entrance fee

308
Owner Rhodes Centre Management Committee
Location South Road Bishops Stortford Hertfordshire
 Bishops Stortford 51746
Title Rhodes Memorial Museum Collection
Custodian Lieutenant Colonel R John Venn
Dates 1853 (1938) - 1902
Subjects BIOGRAPHY - life and work of Cecil John Rhodes
 history - development of South Africa
Numbers pr 200 b&w various
Aids Published guide
Access General public 10 am - 4 pm Monday - Saturday
 except Bank Holidays
Copies available by special arrangement

309
Owner Roger Taylor
Location 5 Psalter Lane Sheffield South Yorkshire
 S11 8YW
Dates c1850 -
Photographer W H Fox Talbot George Washington Wilson
Subjects GEORGE WASHINGTON WILSON portraits
 landscape social sciences working
 classes pre - 1930
Numbers pr c300 various
 fi negs c300 9cm x 12 cm
 gl negs c1500 various
 L sl c3000 $3\frac{1}{4}$"x$3\frac{1}{4}$"
 sl
 ambrotypes 50
 daguerreotypes
 stereos
Aids Proposed contact file system for negatives
Access Bona fide students by arrangement
Copies available for sale where possible
Charges Current commercial rates
Notes Roger Taylor has a special interest in George
 Washington Wilson and is at present preparing
 a biography including upwards of 600 prints,
 stereocard portraits etc.

310
Owner The Shakespeare Birthplace Trust and the Royal
 Shakespeare Company
Location The Shakespeare Centre Henley Street Stratford
 upon Avon Warwickshire 0789 4016
Custodian Dr Levi Fox
Dates 1880 (c1880) -
History The collection includes the Bram Stoker Collection
 of Sir Henry Irving
Photographer "Anthony" Ernest Daniels Angus McBean
 F D Spencer
Subjects BIOGRAPHY AND PORTRAITS - theatre and drama
 - architecture of the Shakespeare Memorial Theatre
Numbers pr c15000 various
 gl negs c650 b&w various
 L sl c150 b&w col 3"x3"
 sl c400 col 35mm
 mic c40 35mm
Aids *Card index
Access Bona fide students general public for specific
 research purposes only reading room hours 10 am -
 5 pm Monday to Friday 9.30 am - 12.30 pm Saturday
Copies available for sale by special arrangement only

311
Owner The Shakespeare Birthplace Trust
Location Records Office The Shakespeare Centre
 Henley Street Stratford upon Avon Warwickshire
Title Records Office Collection
Dates c1850 (c1855) -
Photographer Benjamin Stone
Subjects BIOGRAPHY William Shakespeare - portraits
 life history work Properties of the Shakespeare
 Birthplace Trust and contents archaeology furniture
 ceramics portraits customs and folklife local
 history and topography of Stratford upon Avon
 muniments historical documents

Numbers pr c6000 b&w various
 fi negs 1700 various
 gl negs 2900 various
 L sl 1280 3"x3"
 sl 500 35mm
Aids Classified arrangement supplemented by card index
Notes Custodian, Telephone, Access and Copies as for no.
 310 above.

312
Owner British Broadcasting Corporation
Location 10 Cavendish Place London W1A 1AA
 01 580 4468
Title BBC Photograph Library
Custodian Brian Clifford
Dates 1922 -
Photographer David Edwards John Green Douglas Playle
Subjects PERSONALITIES broadcasting production
 stills technical
Numbers pr 745000 b&w
 fi negs 745000 b&w
 tr 87000 col 35mm $2\frac{1}{4}$"x$2\frac{1}{4}$"
Aids *Card index *subject index
Access Bona fide students at librarian's discretion
Copies available for sale for loan in certain cases only
Charges Fees charged for all uses except publicity
 b&w prints lent if to be returned in good condition
 otherwise sold duplicate tr made of col and charged
 for
Notes The library operates as a commercial photograph
 library as well as providing free black and white
 publicity photographs to the press. Photographs are
 available to book and magazine publishers TV
 companies researchers. Preliminary selections of
 photographs are made for clients by the library
 researchers.

313
Owner Mark Gerson
Location 24 Cavendish Avenue St Johns Wood London
 NW8 9JE 01 286 5894
Dates 1950 -
Photographer Mark Gerson
Subjects LITERARY PERSONALITIES
Numbers fi negs c1300 b&w 200 col 5"x4" $2\frac{1}{4}$"x$2\frac{1}{4}$"
Aids Subject index file
Access Picture researchers press tv media
 9 am - 6 pm
Copies available for sale for display for loan for
 publication
Charges Reproduction fee print/transparency fee
 holding fee

314
Owner Newcastle Chronicle and Journal Limited
Location Thomson House Groat Market
 Newcastle upon Tyne 0632 27500
Custodian Senior Librarian
Dates c1900 -
Subjects PERSONALITIES views sporting general
Numbers pr c500000 b&w various
Aids Card index subject index
Access Picture researchers press tv media
 9 am - 4 pm Monday to Friday by appointment
 fee payable rights to access reserved
Copies available for sale credit line required
Charges Reproduction fee print fee handling fee
 service charge search fee subject to negotiation

315
Owner Royal Town Planning Institute
Location 26 Portland Place London W1 01 636 9107
Dates 1918 -
Subjects PERSONALITIES Presidents of the Royal Town
 Planning Institute
Numbers pr 56 b&w 10"x8"
Access General public
Copies available for sale for loan

316
Owner George Wilkes
Location 13 St Albans Road Kingston Surrey 01 546 4173
Title George Wilkes Picture Library
Dates 1970 -
Photographer George Wilkes
Subjects SHOW BUSINESS PERSONALITIES
Numbers pr 4000 b&w 10"x8"
　　sl 2000 col 2¼"x2¼"
Aids *Subject index
Access Picture researchers press tv media
　　9 am - 6 pm by appointment only
Copies available for publication only
Charges Reproduction fee NUJ rates

317
Owner W Teacher and Sons Limited
Location 14 St Enoch Square Glasgow G1 4BZ
　　041 204 2633
Title "Company History"
Custodian Maureen Ramsay
History The collection covers the growth of the Company
　　and its founder
Photographer William Teacher
Subjects PERSONALITIES William Teacher and family
　　distilling processes distilleries Old Glasgow
　　sales promotions visiting parties social events
Numbers pr substantial number 8"x10"
　　fi negs substantial number
　　L sl substantial number col
Aids *Subject index
Access Bona fide students
Copies available for loan

318
Owner Bournemouth and Poole College of Art
Location The Library 7th Floor Royal London House
　　The Lansdowne Bournemouth PH1 3JL
　　0202 20772
Custodian Nicholas Pollard
Dates (1965) -
Subjects ARTS transport astronomy botany zoology
　　clothes ceramics sculpture and carving
　　architecture painting textiles antiques theatre
　　and drama portraits aerial photography historic
　　and newsworthy events
Numbers sl c15000 b&w c15000 col
Aids The collection is intended to be self cataloguing by
　　its very arrangement
Access General public under supervision

319
Owner Bristol City Council
Location Art Gallery Queens Road Bristol Avon
　　0272 299771
Custodian E Clark Crick
Dates 1920 -
Subjects SCULPTURE AND CARVING PAINTINGS
　　BIOGRAPHY AND PORTRAITS
Numbers pr c500
　　fi negs c5700 b&w ¼pl
　　gl negs c4500 b&w ¼pl ½pl 1-pl 12"x10"
　　L sl c200 2"x3"
　　sl c350
Aids *Card index
Copies available for sale

320
Owner Glasgow City Council
Location Camphill Museum Glasgow S1 041 332 1350
Title The Burrell Collection
Custodian William Wells
Dates 1861 (1944) - 1958
Subjects ARTS TEXTILES GLASS tapestries pottery
　　woodwork ancient civilisations
Access Bona fide students by arrangement

Notes Collection made by Sir William Burrell and given to
　　Glasgow in 1944.

321
Owner Crafts Advisory Committee
Location Waterloo Place Gallery 12 Waterloo Place
　　London SW1Y 4AU 01 839 8000
Dates 1970 (1973) -
Subjects CRAFTS pottery metal work leather
　　silver jewellery weaving embroidery furniture
　　musical instruments toys bookbinding glass -
　　painted engraved blown batik and fabric printing
　　wood lettering
Numbers tr 5000 col 35mm
Aids Duplicated catalogue
Access General public bona fide students
Copies available for loan
Charges Reproduction fee postage and packing
Notes There is an Index of craftsmen which consists of
　　colour slides and biographical information. There is
　　also a slide library which represents a wider view
　　than the highly selective Index and which also
　　includes a record of diploma work in Colleges of
　　Art, and of exhibitions.

322
Owner Dartington Hall Trustees
Location Library and Resources Centre Dartington
　　College of Arts Totnes Devon 0803 862224
Dates (1952) -
History The collection takes in the development of
　　Dartington Hall
Subjects ARTS AND CRAFTS village life customs and
　　folklore agriculture and food production field crops
　　architecture painting theatre and drama musical
　　performances dancing geography - India
Numbers pr 350 b&w various
　　fi negs 350 b&w various
Aids *Catalogue *card index
Access Bona fide students on application to College
　　Librarian
Copies available for loan
Charges Print fee reproduction fee by arrangement

323
Owner C M Dixon
Location 21 Ashley Road London N19 3AG 01 272 5062
Dates 1953 -
Photographer C M Dixon
Subjects WORLD-WIDE ART ARCHAEOLOGY TRAVEL
　　geography meteorology and clouds scientific
　　experiments mountaineering landscape people
　　workers everyday life
Numbers pr c1000 b&w c100 col 8"x10"
　　fi negs c2000 b&w c100 col various
　　tr c40000 col 6cmx6cm
Aids Send sae for list
Access Picture researchers press tv media by
　　appointment only 9 am - 6 pm
Copies available for publication
Charges Publication fee search fee holding fee by
　　negotiation

324
Owner Edinburgh City Council
Location Central Library George IV Bridge Edinburgh
　　EH1 1EG 031 225 5584
Title Fine Art Department Slide Collection
Custodian A P Shearman
Dates (1957) -
Subjects ARTS period costume ceramics stained glass
　　sculpture and carving architecture painting
　　furniture embroidery textiles illuminated
　　manuscripts
Numbers L sl 2188 b&w 3¼"x3¼"
　　sl 7027 b&w col 2"x2"

Key () = dates when collections were begun or terminated
C = Century c = approximately pr = print fi = film
gl = glass neg = negative sl = slide L sl = lantern slide
tr = transparency mic = microform col = colour

b&w = black and white ¼, ½, 1-pl = quarter, half and whole
plate * = single copy, no public access ** = single copy,
access by appointment

Aids Subject index artist index
Access General public
Copies available for loan to members of Edinburgh City
Libraries for sale by arrangement
Charges Loan fee 1p per slide

325

Owner The Hamlyn Group Picture Library
Location Astronaut House Hounslow Road Feltham
Middlesex 01 890 1480 Ext 277
Title Hamlyn Group Picture Library
Custodian Liza Mostyn
Dates (1968) -
Subjects FINE ART THE FORCES TRANSPORT
MYTHOLOGY crafts religion occupations and
services education communications customs and
folklore geology meteorology oceanography
palaeontology archaeology nature biology
zoology medicine mechanical engineering
precision instruments mining agriculture and
food production domestic home clothes
architecture painting athletic sports and outdoor
games biography and portraits geography
country life
Numbers c100000 b&w
gl negs c12 b&w
tr c12000 col
Aids Duplicated subject index
Access Picture researchers press tv media
9. 20 am - 5. 20 pm
Copies available for loan for display for publication
credit line required
Charges Reproduction fee print/transparency fee
holding fee loan fee

326

Owner Hertfordshire County Council
Location Hertfordshire College of Art and Design
7 Hatfield Road St Albans Hertfordshire
St Albans 64414
Title Hertis Slide Loan Scheme
Custodian P R B Moore
Dates (1968) -
Subjects ART ceramics metal work sculpture and
carving architecture painting numismatics
textiles toys genealogy antiques photography
musical instruments
Numbers L sl 30000 col 35mm
Aids Published catalogue £3 except to Hertfordshire
schools card index
Access The collection is for the use of teachers in
Hertfordshire Schools and colleges

327

Owner Michael Holford Library Photographs
Location 119 Queens Road Loughton Essex 01 508 4358
Dates (1958) -
Subjects ART HISTORY ARCHITECTURE CERAMICS
painting sculpture textiles Greece Rome Egypt
Central America ethnography
Numbers tr c15000 col
Aids Duplicated Catalogue
Access Publishers picture researchers press tv media
9. 30 am - 5. 30 pm
Copies available for loan for publication
Charges Reproduction fee

328

Owner Leslie Jackman and Rodger Jackman
Location 44 Old Torquay Road Preston Paignton Devon
0803 522913
Dates 1956 -
Photographer Leslie Jackman Rodger Jackman
Subjects COUNTRY CRAFTS NATURE zoology
agriculture and food production fishing education
Numbers fi neg 18000 b&w 35mm
tr 5000 col 35mm
Aids Card index subject index
Copies available for sale
Charges Print fee

329

Owner Coventry Education Department Council House
Earl Street Coventry 0203 25555
Location Faculty of Art and Design Lanchester
Polytechnic Gosford Street Coventry
0203 24166 Ext 497
Title Faculty of Art and Design Slide Library
Custodian Mrs T Humphries
Dates (c1960) -
Subjects ART art history architecture design
social sciences transport archaeology history
of mechanical engineering mining agriculture and
food production home clothes ceramics
metal work sculpture and carving painting
numismatics textiles genealogy antiques
photography puppet shows theatre and drama
music hall biography and portraits historic and
newsworthy events mosaics armour body art
bookbinding ethnology evolution fairground
heraldry Industrial Revolution insanity
postage stamps psychology religion scientific
equipment silverware tombs and monuments
wall paper College work
Numbers gl pos c200 b&w 3¼"x3¼"
sl 39000 b&w col 35mm
Aids Acquisition catalogue

330

Owner Manchester Polytechnic
Location Faculty of Humanities Chatham Building
All Saints Manchester M15 6BR 061 273 2715
Title Slide Collection Department of Art History and
General Studies
Custodian Tom Beetham
Dates (c1964) -
History Rapid growth from minimal establishment to a
major facility for degree courses especially in Art
History
Photographer S Yates
Subjects HISTORY OF ART AND DESIGN HISTORY OF
ARCHITECTURE SOCIAL HISTORY ARCHAEOLOGY
town planning interior design landscape
architecture psychology fashion and textiles
film stars Thomas Worthington English
and Border Castles Manchester and surrounding
towns English halls and mansions paintings - by
Robert Cozens Thomas Girtin theory of design and
colour motor car - history and design parish church
cathedrals and abbeys Persian Indian and Oriental
carpets art nouveau tapestry embroidery
American Indian - art and life studies in housing
Victorian architects history of ancient and modern
European and American architecture culture of
Greece and Rome Muybridge history of civil and
military aircraft
Numbers sl c92000 col c15000 b&w 2"x2"
Aids Card index subject index slide index
Access Bona fide members of Manchester Polytechnic on
application
Copies available for sale for loan by special arrangement
for educational purposes only
Notes The chief emphasis is in design. The collection has
widespread use in the Faculties of Humanities and
Art and Design but it is not a branch of the Polytechnic
Library. Although this collection is essentially private
and geared to educational programmes visitors are
welcome on application.

331

Owner S and O Mathews
Dates 1845 -
Photographer Richard Beard Francis Frith
George Washington Wilson
Subjects ART PHOTOGRAPHY British topography and
landscapes genre photography portraits
Numbers pr c8000
L sl c50
Access Bona fide students by appointment only
Copies available for sale
Charges Print fee

Notes Requests to view this collection must be made through the National Photographic Record c/o The Royal Photographic Society. The owner reserves the right to refuse access.

332
Owner Saint David's University College
Location German Department Lampeter Dyfed Wales 422 351 Ext 36
Custodian H G Siefken
Dates c1850 (1970) -
Subjects ARTS AND CRAFTS Germany - art architecture sculpture and carving painting historic events 1930-1945 National Socialism the German Baroque
Numbers L sl c100 b&w c300 col 35mm
Aids *Guide
Access Bone fide students

333
Owner Search Press Limited
Location 2-10 Jerdan Place London SW6 5PT 01-385 6261
Dates 1967 -
Photographer Jeet Jain Robert Harding Toni Schneiders
Subjects CRAFT hobbies
Numbers pr c2000
tr 2¼"x2¼" ½pl
Aids Subject index
Copies available for reproduction by arrangement

334
Owner Twickenham College of Technology
Location The Library Egerton Road Twickenham Middlesex
Custodian Miss H A Taylor
Subjects ART art reproductions architecture sculpture and carving printing electronics France - geography sociology history daily life European Economic Community
Numbers sl 19084 col 35mm
Aids *Card index
Access Bona fide students

335
Owner University of East Anglia
Location Photographic Library School of Fine Art and Music Norwich NOR 17G Norfolk 0603 610630
Custodian Jane Beckett
Dates (1966) -
Photographer M Brandon-Jones Malcolm Thurlby
Subjects ARTS AND CRAFTS mechanical engineering civil and building construction domestic home clothes ceramics metal work sculpture and carving architecture painting numismatics textiles toys genealogy antiques photography musical instruments recreations
Numbers pr c70000 b&w 500 col 1pl
fi negs c70000 b&w
L sl 40000 b&w 35mm
sl 40000 col 35mm
Access Bona fide students
Copies available for sale
Charges On application

336
Owner University of Leicester
Location History of Art Department 17th Floor Attenborough Building
Dates (1967) -
Subjects ARTS Europe (1300-1950) - painting drawings prints sculpture architecture all aspects of the applied arts
Numbers pr c25000 b&w
sl c25000 b&w c10000 col
Access Bona fide students

Notes This collection is designed to meet the specific needs of History of Art students in the Department, the photographs are also used for teaching, as are the slides.

337
Owner Courtauld Institute of Art
Location University of London 20 Portman Square London W1
Title The Conway Library
Custodian Mrs C Hill 01 935 9292
Subjects ARTS metal work sculpture European architecture architectural drawings numismatics textiles stained glass ivories and seals wall and panel painting mosaics manuscripts Byzantine monuments
Numbers pr 651262 b&w various
Aids Card index to Manuscript collection only
Access Bona fide students on application to the Librarian
Copies available for sale subject to copyright
Charges Print fee from 75p reproduction fee from £5 special reductions for students of University of London
Notes Lord Conway gave his collection of photographs to the Courtauld Institute in 1931. He had started quite early in his career to collect photographs as an aid to his art historical studies. The collection now occupies three floors and has been enriched by gifts and bequests of photographs and negatives and by the activities of the teaching and library staff and research students of the Institute.

338
Owner School of Oriental and African Studies (University of London)
Location S O A S Library Malet Street London WC1E 7HP 01 637 2388
Title S O A S Library Illustrations Collection including Courtauld Collection Hunt Collection Mills Collection Palace and Central Museums Collection
Custodian The Librarian
Dates c1890 (1957) -
History Includes photographs from the London Missionary Society Archives
Photographer E H Hunt J P Mills Professor W P Yetts
Subjects ARTS AND CRAFTS art - Chinese Japanese archaeology - Chinese Indian Indian sculpture architecture - Indian Islamic Khmer anthropology Chinese bronze mirrors Tibetan banners travel - Africa India Spain Algeria Tunisia Egypt paintings ceramics bronzes
Numbers pr c20000
sl c25800 2"x2" 3¼"x3¼"
mic 7
Access Bona fide students
Copies available for sale
Notes The establishment of a separate section of the Library for Art and Archaeology took place in 1957 when the Asian collection of the Courtauld Institute of Art Library was deposited on permanent loan with the School.

339
Owner University of Reading
Location English Department
Title Includes the Italian Collection Yeats Collection Modern Movement Collection
Custodian Mrs F M Everest
Dates 19thC (1940) -
History Locations associated with eminent authors
Photographer Alving Langdon Coburn Howard Coster Hoppé Vajenti
Subjects ART painting Italian Rennaissance Pre-Raphaelite architecture and sculpture - Greek Italian Byzantine French English medieval manuscript illuminations

Key () = dates when collections were begun or terminated
C = Century c = approximately pr = print fi = film
gl = glass neg = negative sl = slide L sl = lantern slide
tr = transparency mic = microform col = colour

b&w = black and white ¼,½,1-pl = quarter,half and whole plate * = single copy,no public access ** = single copy, access by appointment

Numbers pr 4356 b&w various
 gl negs 20
 gl pos 1524 b&w 3¼"x3¼"
 L sl 1500 b&w
 tr 172 b&w
Aids Published catalogue for Yeats Collection
Access General public bona fide students with permission
 and under supervision

340
Owner University of Reading
Location Department of Topography and Graphic
 Communication 2 Earley Gate Whiteknights Reading
 0734 85123
Title Photographic Collection of Lettering
Dates (1968) -
Subjects ARTS printing sculpture and carving
 architecture archaeology cemeteries Roman
 inscriptional lettering Cornish slate grave stones
 Shropshire iron grave stones drug jars signwriting
 lithographed and engraved lettering
Numbers pr 3000 b&w 10"x8"
 sl 3000 b&w 2"x2"
Aids Each print is filed in a wallet together with a printed
 form giving details (where known) of subject date
 artist material size location and other relevant
 information
Access Bona fide students
Copies available for sale for loan in special cases only

341
Owner University of Stirling
Location University Library Stirling Scotland
 Stirling 3171
Dates (1974) -
Subjects ARTS history of art Renaissance art
 modern art
Numbers sl c6000 col 35mm
Aids Manufacturers catalogues
Access General public bona fide students picture
 researchers application in writing

342
Owner Cheshire Education Committee County Hall
 Chester
Location Warrington College of Art and Design Museum
 Street Warrington Cheshire 0925 32712
Title Art History Slide Collection
Custodian W Forbes
Dates (1967) -
Subjects ARTS ceramics sculpture and carving
 architecture painting textiles antiques
 stained glass home clothes
Numbers sl c12000 col 35mm
Aids *Card index
Access Bona fide students

343
Owner Welsh Arts Council
Location Museum Place Cardiff South Glamorgan
 CF1 3NX 0222 394711
Title Welsh Arts Council Collection
Custodian Valmai Ward
Dates (1951) -
Photographer David Hurn Raymond Moore
Subjects ARTS painting sculpture ceramics
 Wales - geography early industry - slate
 quarrying coalmining landscape
Numbers pr substantial number
Aids Catalogue
Access Bona fide students by special arrangement
Copies available for sale by arrangement with
 photographer
Notes The works in the collection are distributed on hire
 for two year periods to public organisations in Wales.
 Those not distributed are stored by the Council or are
 in touring exhibitions. Photographic acquisitions are
 mainly through commissioning for exhibitions and
 Commission Awards to photographers.

344
Owner Winchester School of Art
Location Park Avenue Winchester Hampshire
 Winchester 61891
Custodian Slide Librarian
Dates (1966) -
Subjects ARTS dress stations ceremonies home
 clothes porcelain sculpture and carving
 architecture painting textiles objects of art
 portraits historic and newsworthy events
Numbers sl c6000 b&w c10000 col 2"x2"
Aids *Guide
Access Bona fide students

345
Owner Angelo Hornak Photograph Library
Location 10 Exeter Mansions 106 Shaftesbury Avenue
 London W1 01 437 2920
Dates (1972) -
Photographer Angelo Hornak
Subjects ARCHITECTURE archaeology antiques
 fine arts world wide travel
Numbers sl c3000 col various
Aids *Catalogue
Access Picture researchers press tv media
 9 am - 6 pm
Charges Reproduction fee

346
Owner Architectural Association
Location 36 Bedford Square London WC1 01 636 0974
Title Architectural Association Slide Library Collection
Custodian Andrew Higgott
Dates (1891) -
Photographer E R Jarrett F R Yerbury
Subjects ARCHITECTURE - all aspects periods countries
Numbers fi negs c25000 b&w
 L sl c5500 b&w col 3¼"x3¼" 2"x2"
Aids Subject index
Access Members of the society and members of RIBA
 and accredited lecturers
Copies Copy prints available for publication
Charges Slide hire fee from 7½p per slide for AA members
 from 15p per slide for other borrowers copy/slides
 from 50p reproduction fee from £7
Notes This collection includes a good coverage of early
 'Modern Movement' 20thC photographs.

347
Owner Architectural Press Limited
Location 9 Queen Anne's Gate Westminster London
 SW1H 9BY 01 930 0611
Custodian Winifred G Constable
Dates 1930 -
Photographer Hugh de Burgh Galwey Bill Toomey
Subjects ARCHITECTURE and allied subjects
Numbers pr substanital numbers b&w 10"x8"
 fi negs substantial numbers b&w
 gl negs c200 b&w
Aids *Guide *card index
Access General public bona fide students picture
 researchers press tv media 9.30 am - 5.30 pm
Copies available for sale for display for publication
Charges Reproduction fee print/transparency fee

348
Owner Weald and Downland Open Air Museum
Location J R Armstrong Highover Bracken Lane
 Storrington Sussex Storrington 2856 The Museum
 Singleton Nr Chichester West Sussex
Dates (1950) -
Subjects ARCHITECTURE archaeology farm buildings
 home landscapes and physical features
Numbers sl c25000 b&w 2"x2"
Copies available for sale with certain restrictions
Notes The Museum, which will open in 1977, is envisaged
 as a centre where advice and help can be obtained
 in the restoration and preservation of buildings. The
 scope of the collection reflects the purposes and scope
 of the Museum - namely the traditional buildings of
 the Weald and Downland area.

349
Owner James Austin
Location 36 Malcolm Place Cambridge CB1 1LS
 0223 65776
Dates (1965) -
Subjects ARCHITECTURE SCULPTURE
Numbers pr 7500 b&w 10"x8"
 fi negs 9000 b&w 2¼"x2¼" 4"x5"
Aids Published catalogue
Access General public bona fide students picture
 researchers press tv media 9 am - 6 pm
Copies available for sale for loan for display
 for publication
Charges Publication/reproduction fee print/transparency
 fee holding fee submission fee

350
Owner Bath Preservation Trust
Location 1 Royal Crescent Bath Avon BA1 2LR
 0225 27229
Custodian Thomas Cairns
Dates c1920 (1972) -
Subjects ARCHITECTURE Bath
Numbers pr c500
 fi negs c2000
 tr c400 col
Notes The photographs in the collection are used in the day
 to day work of the Trust.

351
Owner Captain John Beetham
Location 26 Ormonde Street Sunderland SR4 7PH
 0783 76668
Title John Beetham Library
Dates 1963 -
Photographer John Beetham
Subjects ARCHITECTURE ARCHAEOLOGY churches
 industrial archaeology of transport lighthouses
 mineralogy geology palaeontology Hadrians Wall
 nature mills factories mining bridges and
 dams agriculture and food production photography
 outdoor life winter sports fishing geography of
 the British Isles travel abroad Saxon churches
 abbeys castles wild flowers
Numbers fi negs 1000 b&w
 sl 7000 35mm 6cm x 7cm 4"x5"
Aids *Card index in part
Access Picture researchers bona fide students press
 tv media after 6 pm
Copies available for sale for display for loan
 for publication
Charges Reproduction fee print/transparency fee handling
 fee IIP rates
Notes Assignments undertaken AY aids prepared.

352
Owner Berkshire County Council
 Berkshire Archaeological Society
Location Record Office Shire Hall Reading Berkshire
 0734 55981
Title Berkshire Architectural Records Committee
 Collection
Custodian County Archivist
Dates 20thC (1939) -
History The Berkshire Architectural Records Committee
 was founded in 1940 to secure photographic records of
 buildings of interest in the county which might be
 damaged or destroyed by enemy action. The Committee
 was dissolved in 1946 but the work was subsequently
 continued by the Architectural Records Committee of
 the Berkshire Archaeological Society.
Subjects ARCHITECTURE - Berkshire
Numbers pr c600 b&w
Access General public

353
Owner Berkshire County Council
Location Berkshire County Library Reading Reference
 Library Blagrave Street Reading Berkshire
 0734 54382
Title Berkshire Local History Collection
Custodian D Phillips
Dates c1880 (1883) -
Subjects ARCHITECTURE BIOGRAPHY AND
 PORTRAITS EVENTS all Reading area
Numbers pr c1000 b&w various
 fi negs c100 b&w
 L sl 333 col
Aids Card index in preparation
Access General public bona fide students picture
 researchers press tv media 9.30 am - 7 pm
 Tuesday to Friday 9.30 am - 5 pm Saturday

354
Owner Brecht-Einzig Limited
Location 65 Vineyard Hill Road London SW19
 01 946 8561
Title Architectural and Allied Photography Services
Custodian Mrs R Einzig
Dates c1950 (1962) -
Photographer Richard Einzig
Subjects ARCHITECTURE - modern
Numbers pr b&w
 fi negs col
 sl col substantial numbers of each
Aids Guide card index duplicated subject index
Access Picture researchers bona fide students
 press tv media 9 am - 5 pm
Copies available for sale for loan for display
 for publication
Charges Reproduction fee print/transparency fee
 handling fee holding fee search fee

355
Owner Brighton Borough Council
Location Preston Manor Preston Park Brighton
 East Sussex BN1 6SD 0273 552101
Custodian Marion W Allen
Dates 1890 (Late 19thC) -
Photographer John Barrow Ellen Thomas-Stanford
Subjects ARCHITECTURE Preston Manor - exterior
 and interior portraits South Africa Cecil Rhodes'
 estate Thomas-Stanford family and their travels
 objects in Preston and Macquoid bequest collections
Numbers pr c500 b&w
Aids Many of the photographs are bound into subject
 albums card index in preparation
Access Bona fide students by arrangement only
Copies available for sale on request
Charges Print fee from 55p each 1pl 40p each ½pl -
 specially taken 1pl prints £2.80 each. A reduced
 charge may be made when five or more items are
 specially photographed. Colour transparencies
 5"x4" (for reproduction) from stock - hiring fee
 from £5 per two-month period. Any transparencies
 not available from stock may be prepared but will be
 subject to an extra charge. 35mm from stock from 15p
 each. 2¼"x2¼" price on application. All charges are
 subject to VAT

356
Owner Charles Rodger Bruce
Location 38 Lanark Road West Currie Midlothian
 EH14 5JY 031 449 3250
Dates 1967 (1972) -
Photographer Charles Rodger Bruce
Subjects ARCHITECTURE - ecclesiastical ruins and
 buildings forts and castles Heughs Chambered
 tombs and passage graves crosses and inscribed
 stones Mercat crosses Roman remains
Numbers sl c1465

Key () = dates when collections were begun or terminated
C = Century c = approximately pr = print fi = film
gl = glass neg = negative sl = slide L sl = lantern slide
tr = transparency mic = microform col = colour

b&w = black and white ¼,½,1-pl = quarter, half and whole
plate * = single copy, no public access ** = single copy,
access by appointment

Aids Rough catalogue
Access Bona fide students
Copies available for loan for publication
Charges Print fee at cost

357
Owner P Norman Button
Location 5 Oak Hill Burpham Guildford Surrey
 0483 66040
Dates 1913 -
Photographer P Norman Button Fred Judge
Subjects ARCHITECTURE LANDSCAPES
Numbers pr c50 various mostly carbon
 bromoil transfers 19
 oil lithograph 1
Access Bona fide students
Copies available for publication
Notes The collection includes 19 Bromoil transfers and
 1 oil lithograph by the late Fred Judge.

358
Owner Cambridge City Council
Location Department of Architecture and Planning
 Guildhall Cambridge 0223 58977 Ext 429
Custodian Norman Mason-Smith
Dates 1964 -
Photographer Norman Mason-Smith
Subjects ARCHITECTURE - Cambridge - civic affairs
 changing face
Numbers pr
 fi negs
 sl
 tr
 total c1000 b&w col
Aids Catalogue subject index
Access General public bona fide students
 by appointment

359
Owner Canterbury College of Art
Location New Dover Road Canterbury Kent
 Canterbury 69371
Title Slide Library
Custodian Colin Ball
Dates (c1950) -
Subjects ARCHITECTURE SCULPTURE AND CARVING
 PAINTING civil and building construction
Numbers sl c12000 col 35mm
Aids *Card index *subject index
Access General public by appointment
Copies available for sale subject to copyright
Charges Slide fee reproduction fee

360
Owner Malcolm Charlesworth
Location 18 Rokeby Park Hull Humberside
 0482 53608
Title Villages on the Outskirts of Hull
Dates 1973 -
Photographer Malcolm Charlesworth
Subjects ARCHITECTURE building exteriors street
 scenes
Numbers sl c500 col 35mm
Aids Address index
Access Bona fide students by personal arrangement
Copies available for sale
Charges By arrangement

361
Owner Mrs E P Cooper
Location 35 West Street Harrow on the Hill Middlesex
 HA1 3EN
Title Local History of Harrow and Area
Dates (1967) -
Subjects ARCHITECTURE historic and newsworthy events
 in Harrow
Numbers tr c300 col
Aids List of slides
Access Bona fide students
Copies available for loan to students
Charges Print fee at cost

Notes This is a small private collection for teaching
 purposes.

362
Owner J H Cordingly
Location 83 Sandy Lane Romiley Stockport SK6 4NH
Dates (1960) -
Photographer J H Cordingly
Subjects ARCHITECTURE - German Baroque and Rococo -
 English post-Reformation parish churches English
 domestic from Elizabethan to Georgian Renaissance
 architecture - Greek Roman Italian French Chateaux
 country houses and their interiors Church art -
 monuments funerary heraldry
Numbers tr c7000 col 35mm
Aids Lecture notes - bare details only
Access Serious enquiries will be considered
Copies available on request
Charges By arrangement

363
Owner The Dean and Canons of Windsor
Location The Aerary Deans Cloister Windsor Castle
 Berkshire
Title St George's Chapel Windsor Castle Photographic
 Collection
Custodian M A Bond
Dates c1860 (c1880) -
Photographer A C Cooper Ltd George Spearman
Subjects ARCHITECTURE inhabitants of Lower Ward
 Windsor Castle
Numbers pr b&w
 fi negs b&w
 gl negs b&w
 gl pos b&w
 L sl b&w
 sl b&w
 total c1000
Aids *Catalogue in preparation
Access Bona fide students
Copies available by arrangement with A C Cooper of
 Pollen Street London

364
Owner Department of the Environment
Location Room 401 Hannibal House Elephant and Castle
 London SE1 6TD 01 703 6380
Custodian Mrs M P Harper
Dates c1920 (1946) -
History Ministry of Works (later Ministry of Public
 Building and Works) 1946-1970. Department of the
 Environment 1970 -
Subjects ARCHITECTURE - ancient monuments and
 historic buildings public statues and memorials
 construction and maintenance of government
 buildings in the UK and overseas - palaces
 embassies - furnishings paintings army navy and
 air force buildings Royal parks and ceremonial
 roads and motorways
Numbers pr c500000 b&w 8"x6" 10"x8"
 fi negs c500000 b&w c1000 col $\frac{1}{2}$pl 8"x6"
 gl negs c100000 b&w $\frac{1}{2}$pl 8"x6"
 tr c1000 col $\frac{1}{2}$pl
Aids Card index subject index
Access General public bona fide students by appointment
Copies available for sale for loan
Charges Print fee on request

365
Owner Department of the Environment
Location Room 601 Prince Consort House 27-29
 Albert Embankment London SE1 7TF
 01 211 6926
Title Department of the Environment Slide Library
Custodian A R Grove
Dates c1947 (1953) -
Subjects HOUSING - planning and development in New
 Towns mineral working and reclamation transport
 communications
Numbers sl c5000 b&w c30000 col 35mm

Aids *Card index *subject index *area index
 **catalogue of Accessions list
Access Bona fide organisations with an interest in, or
 involvement with, the environment and environmental
 problems
Notes This collection originated in the former Ministry of
 Housing and Local Government to provide illustrations
 for lectures and talks. The classification system
 is the same as that used by the Department's Map
 Library for classifying thematic maps and is based on
 a subject division.

366
Owner Design Council
Location The Design Centre 28 Haymarket London
 SW1Y 4SU 01 839 8000
Title Slide Library
Dates c1940 (1948) -
Subjects DESIGN engineering and consumer products
 graphics exhibitions interiors transport
Numbers pr 20000 b&w 6"x8"
 fi negs 40000 b&w
 tr c11000 b&w col 35mm
Aids Guide for black and white published catalogue for colour
Access General public picture researchers bona fide
 students press tv media 10 am - 5 pm
Copies available for sale for loan for publication
 credit line required
Charges Reproduction fee print/transparency fee
 loan charge for slides copyright strictly reserved
 on all slides in the collection the loan service is
 available in the UK only applications may be made by
 post or in person

367
Owner Philip G M Dickinson
Location The Willows Wyton Huntingdon Cambridgeshire
Dates (1939) -
Subjects ARCHITECTURE TOPOGRAPHY
Numbers pr 6"x4"
 fi negs various
Aids Card index
Access May be inspected on application

368
Owner East Sussex County Council
Location Brighton Museum Brighton East Sussex
 0273 63005
Custodian Caroline Dudley
Dates 1970 -
Photographer John Barrow Guy Ryecart
Subjects ARCHITECTURE - Brighton and Hove
Numbers fi negs c350
Aids Catalogue
Access Bona fide students by appointment only

369
Owner A D Gill
Location Court House East Meon Petersfield Hampshire
 GU32 1NJ East Meon 274
Dates Early 20thC
Subjects ARCHITECTURE Court House
Numbers pr c50
Access Bona fide students

370
Owner Grantham Teachers Centre
Location Castlegate Grantham Lincolnshire
Title Slides of Grantham
Custodian The Warden
Dates 20thC (1970) -
Subjects ARCHITECTURE Grantham - buildings streets
Numbers tr 100 b&w 200 col 2"x2"
Access Bona fide students

371
Owner Hayes and Harlington Local History Society
Location 14 North Way Uxbridge Middlesex UB10 9NG
Title Local Buildings Record
Custodian B T White
Subjects ARCHITECTURE - Hayes and Harlington
Numbers pr b&w 6"x4"
 fi negs 2¼"x2¼" 35mm
Aids Indexed by area
Access General public bona fide students by
 appointment only
Copies available for sale
Charges Print fee

372
Owner J Howdle
Location 65 Curriehill Road Currie Midlothian EH14 5PT
 031 449 2916
Dates c1857 (1963) -
Photographer Ernest B Fry J Howdle Newton and Company
 George Washington Wilson
Subjects ARCHITECTURE ARCHAEOLOGY
 METEOROLOGY TRANSPORT mechanical
 engineering observatories seas and oceans dogs
 cattle sheep Guides youth clubs educational
 equipment radio athletics camping and climbing
 horse riding hunting portraits geography
Numbers pr c200 b&w
 fi negs c200 b&w 2¼"x2¼" 35mm
 L sl 450 b&w col 3¼"x3¼"
 tr c200 b&w 35mm
 sl 2000 col 35mm
Aids Subject index
Access Bona fide students' enquiries will be answered
Copies possibly available for loan
Charges Stamped addressed envelope

373
Owner Dr Quentin Hughes
Location Department of Architecture University of
 Liverpool Abercromby Square Liverpool
 Merseyside L69 3BX 051 709 6022 Ext 2920
Title Military Architecture Architecture of Malta
Dates (1958) -
Photographer Dr Quentin Hughes David Wrightson
Subjects ARCHITECTURE IN MALTA MILITARY
 ARCHITECTURE - Italy Germany Holland Belgium
 France Britain Austria Poland Gibraltar
 aerial photography guns
Numbers pr c2500 b&w various
 fi negs c4000 b&w 2½"x2¼" 35mm
Aids Catalogue
Access Bona fide students on application in writing
Copies available for sale in special cases for publication
 or research
Charges Reproduction fee

374
Owner Greater London Council
Location Iveagh Bequest Kenwood Hampstead Lane
 London NW3 7JR 01 348 1286
Custodian John Jacob
Dates c1900 (1927) -
Subjects ARCHITECTURE - Kenwood House Marble Hill
 House, Twickenham Ranger's House, Blackheath
 PAINTINGS SCULPTURE FURNITURE - Iveagh
 Bequest (Kenwood) Suffolk Collection (Ranger's House)
Numbers pr c3000 ½pl 1pl
Aids The collection is arranged by subject
Access Bona fide students by appointment only
Notes This is a working collection which is intended
 to form a record of the three houses and their
 collections administered from the Iveagh Bequest.

Key () dates when collections were begun or terminated
C = Century c = approximately pr = print fi = film
gl = glass neg = negative sl = slide L sl = lantern slide
tr = transparency mic = microform col = colour

b&w = black and white ¼, ½, 1-pl = quarter, half and whole
plate * = single copy, no public access ** = single copy,
access by appointment

375
Owner A F Kersting
Location 37 Frewin Road Wandsworth Common London
 SW18 01 874 1475
Dates 1937 -
Subjects ARCHITECTURE geography - Britain West
 Europe Middle East India exploration and
 travel abroad
Numbers pr 30000 b&w 10"x8" 15"x12"
 fi negs 30000 b&w various
 gl negs 10000 b&w 8½"x6½" ½pl
 tr 10000 col 5"x4" ½pl 2¼"x2¼"
Aids Card index
Access General public picture researchers press tv
 media appointment preferred 9 am - 5 pm
Copies available for sale for display for publication
Charges Reproduction fee print/transparency fee
 handling fee holding fee service charge search fee
Notes Commissions.

376
Owner Kimbolton School Governors
Location Kimbolton Huntingdon Cambridgeshire
 PE18 0EA 048 084 505
Custodian P R Burkett
Dates 1860 (1972) -
Photographer A Maddison
Subjects ARCHITECTURE - Kimbolton Castle
 Dukes of Manchester
Numbers pr c50 various
 tr c40 col 2"x2"
Access Bona fide students by appointment only

377
Owner George Thomas Hall
Location 72 Faulkner Road Newton Aycliffe Nr Darlington
 Co Durham
Dates 1965 -
Photographer George Thomas Hall
Subjects ARCHITECTURE BOTANY ZOOLOGY racing
 landscapes ice and snow scenes psychology
Numbers pr c50 b&w 10"x12"
 fi neg c1500 b&w 35mm
 sl c500 col 2"x2"
Access Bona fide students only interested persons by
 written appointment
Copies available for sale for loan

378
Owner Dr Ivan Hall
Location 7 Hengate Beverley East Yorkshire
Dates 1856 (1946) -
Subjects ARCHITECTURE fine arts applied arts - 18thC
 demolished churches - Manchester West Yorkshire
 Synagogues - silver plate work of James Wyatt and
 John Carr Chippendale furniture
Numbers pr substantial numbers b&w various
 L sl substantial numbers b&w 2"x2"
 fi negs substantial numbers b&w 2¼"x2¼"
 gl negs b&w ¼pl
 gl pos b&w ¼pl
 tr c1000 col
Copies available for sale for loan

379
Owner Clive Hicks
Location 72 Brentham Way London W5 1BE
 01 997 7974
Title Colour Slides of British Architecture and Landscape
Dates (c1960) -
Photographer Clive Hicks
Subjects ARCHITECTURE LANDSCAPE British and
 some foreign historic and vernacular architecture -
 prehistoric structures Roman buildings early
 Mediaeval crosses Cathedrals Abbeys Parish
 Churches castles fortifications houses cottages
 bridges windmills public buildings garden
 buildings traditional aspects of towns and villages
 early development of housing modern architecture
Numbers L sl c20000 col 2"x2"
Aids Duplicated guide in preparation

Access Arrangements for inspection might be possible
 under some circumstances
Copies available for sale for display for publication
Charges All charges will depend upon the work or research
 involved approximately 20p per transparency
 reducing with quantity
Notes This collection is expanding constantly and it is
 possible to direct current work in any direction if a
 particular need arises and sufficient notice is given.
 Clive Hicks' aim is to give the collection a
 representative and full coverage of architecture and
 landscape (primarily British but some foreign). Every
 effort will be made to co-operate with enquiries in
 order to make the collection as useful and effective as
 possible.

380
Owner Eric Houlder
Location 27 Northfield Drive Pontefract West Yorkshire
 0977 2995
Dates (1959) -
Photographer Eric Houlder
Subjects ARCHITECTURE railways archaeology
 wind and water mills landscapes aerial
 photography
Numbers fi negs c500 b&w various
 L sl c3000 col 2"x2"
Copies available for sale
Charges Reproduction fee standard rates

381
Owner George Howard
Location Castle Howard York North Yorkshire
 065 384 333
Dates 1850 -
Subjects ARCHITECTURE family photographs
 topography paintings portraits
Numbers pr substantial number various
Notes Castle Howard, Vanbrugh's masterpiece, built for
 the Earl of Carlisle, is arguably the largest country
 house in Britain. The collection relates to the building,
 and to the Howard family who have lived here for
 generations.

382
Owner Donald W Insall
Location Donald W Insall and Associates Architects
 19 West Eaton Place London SW1X 8LT
 01 245 9888
Dates c1960 -
Photographer Christopher Dalton Donald W Insall
Subjects ARCHITECTURE town planning conservation
 Mexican architecture
Numbers sl c41000 col b&w
Access Mexican architecture by appointment
Charges Reproduction fee by negotiation

383
Owner Institute of Landscape Architects
Location 182 Gloucester Place London NW1 6DS
 01 723 9417
Title Institute of Landscape Architects Slide Collection
Custodian Wendy Powell, Hon. Librarian
Dates c1950 (c1960) -
Photographer J St. Bodfan Gruppydd
Subjects ARCHITECTURE landscape architecture
 landscapes
Numbers sl col 35mm 2"x2"
Aids *Catalogue *subject index
Access Bona fide students Institute members
Copies available for sale

384
Owner West Norfolk District Council
Location King's Lynn Museum Old Market Street King's
 Lynn West Norfolk 0553 61241 Ext 272
Title King's Lynn Museum Collection
Custodian Robert Tuelt
Dates Late 19thC -
History The founder was E M Beloe 1880 - 1930, a noted
 local antiquary

Subjects ARCHITECTURE BOTANY PLANTS – factories forestry paintings steam roundabouts pastoral geography
Numbers pr 290 b&w col various
gl pos 265 b&w
L sl various
sl c2200 col 6cmx6cm
Daguerreotypes 3 various
Aids Duplicated list of slides in inventory
Access Bona fide students by appointment
Copies available for sale
Notes Mainly local collection of King's Lynn and flora of Norfolk.

385

Owner Leicestershire Archaeological and Historical Society Trustees
Location The Guildhall Guildhall Lane Leicester LE1 5FQ
Title The Henton Collection of Photographs of Leicestershire and Rutland
Custodian D H Thompson
Dates 1903 – 1924
History G M Henton who took these photographs was a well known local topographical water-colourist
Photographer G M Henton
Subjects ARCHITECTURE physical features of Leicestershire and Rutland
Numbers pr c1500 b&w 6"x4¼"
Aids *Catalogue *subject index
Access Bona fide students

386

Owner James Lees-Milne
Location Alderley Grange Wotton-under-Edge Gloucestershire
Dates 1936 –
History The owner of this collection was adviser on Historic Buildings to the National Trust 1951-1966
Subjects ARCHITECTURE
Numbers pr Substantial number
Aids Card index
Notes James Lees-Milne is author of Worcestershire: A Shell Guide,1964 St Peter's,1967 English Country Houses: Baroque 1685-1714,1970 Another Self,1970.

387

Owner Quentin Lloyd
Location Great Dixter Northiam East Sussex Northiam 3160
Dates 1913 – 1933
Photographer Nathaniel Lloyd
Subjects ARCHITECTURE – domestic
Numbers gl negs c3000 5"x4" ½pl 1pl

388

Owner Robin McGhie
Location 40 Egerton Road Prescot Merseyside L34 3LT 051 426 6399
Dates c1858 (1972)
Photographer Francis Bedford Francis Frith
Subjects ARCHITECTURE Fountain's Abbey Twizel Bridge and castle Alton Towers Canterbury North Wales confessional box Shakespeare's house Melrose Abbey Durham Cathedral Windsor Castle Locomotion no 1 Thames Furness Abbey Oxford Batley Abbey Babbacombe Alnwick Castle Lincoln Cathedral York Minster Coventry
Numbers pr 36 6¼"x8¼"
Access Bona fide students by appointment only
Copies available for sale

389

Owner G Bernard Mason
Location 'Gwyndy' Caernarvon Road Criccieth Gwynedd LL52 OAP

Dates 1916 –
Photographer G Bernard Mason
Subjects ARCHITECTURE Morocco Guernsey Mesopotamia Baghdad India
Numbers sl c400 3¼"x3¼"

390

Owner National Trust
Location 42 Queen Anne's Gate London SW1H 9AS 01 930 0211
Title The National Trust Photographic Library Collection
Custodian Miss J F Barran
Dates 1880 (1970) –
Photographer John Bethell Jeremy Whitaker
Subjects ARCHITECTURE decorative arts landscape seascape
Numbers fi negs 3000 b&w 2¾"x2¼" 4"x5"
sl 5000 col 2¼"x3¼" 4"x5"
Aids Catalogue card index in preparation
Access General public bona fide students by appointment
Copies available for sale for loan
Charges Search fee reproduction fee £5 for UK rights and £10 for World rights on b&w £10 and £25 on col

391

Owner National Trust in Ireland
Location Malone House Barnett Demesne Belfast 9 0232 669564
Dates 1896 (1957) –
Subjects ARCHITECTURE – Northern Ireland National Trust properties – countryside coasts mountains woods gardens conservation – Strangford Lough Wildlife Scheme Murlough Nature Reserve nature trails
Numbers pr c2500
sl c2000
Aids Filed under headings
Access Bona fide students by appointment only
Notes The working library of the Regional Office in Northern Ireland.

392

Owner The Council of the Norfolk and Norwich Archaeological Society (Trustees)
Location Garsett House St Andrew's Hall Plain Norwich Norfolk NR3 1AT
Title Norfolk and Norwich Archaeological Society's Collection
Custodian G A F Plunkett 29 Margetson Avenue Thorpe St Andrew Norwich NR7 ODG 0603 35164
Dates c1880 –
Photographer Canon H H Peck G H Tyndall Rev J F W Williams
Subjects NORFOLK ARCHITECTURE portraits of Norfolk 'worthies'
Numbers pr 1274 b&w various
fi negs 831 b&w various
gl negs 432 b&w various
gl pos 2 b&w 4½"x6½"
L sl 12 b&w 3¼"x3¼"
mic 1 b&w
postcards 505 b&w col
Aids *Catalogue *card index
Access Open free to members general public and bona fide students on payment of £1 per day (or part of day)
Copies available for publication for loan for exhibitions applications to custodian
Charges On application

393

Owner North Middlesex Photographic Society
Location 46 Barrington Road Hornsey Greater London N8 01 340 4137 after 7 pm
Custodian F G H Eaton

Key () = dates when collections were begun or terminated
C = Century c = approximately pr = print fi = film
gl = glass neg.= negative sl = slide L sl = lantern slide
tr = transparency mic = microform col = colour

b&w = black and white ¼,½,1-pl = quarter,half and whole plate * = single copy,no public access ** = single copy, access by appointment

Dates 1903 - c1920
Subjects ARCHITECTURE - ARCHAEOLOGY - North
 Middlesex - photographic survey
Numbers pr c1000 various
Access General public bona fide students
Copies available for loan for publication in books
 by bona fide authors
Charges The North Middlesex Photographic Society
 reserves the right to make a charge for copies
 for reproduction normally no charge would be made
Notes The collection is on permanent loan to Hornsey
 Public Library.

394
Owner North Yorkshire County Council
Location York City Library Library Square Museum
 Street York YO1 2DS 0904 55631
Title Local Illustrations Collection
Custodian O S Tomlinson
Dates c1850 (1950) -
History Collection is based on a series of Northern Echo
 newspaper photographs taken in 1940
Subjects ARCHITECTURE
Numbers pr 4000 b&w various
 L sl 800 b&w 3"x3"
Access General public

395
Owner Oxfordshire Architectural Record
Location 59 Five Mile Drive Oxford Oxfordshire
 OX2 8HP 0865 56989
Title Oxfordshire Architectural Record
Custodian P S Spokes
Dates 1943 -
Photographer P S Spokes I H Taylor
Subjects ARCHITECTURE Oxfordshire England
 exterior and interior genealogy
Numbers pr c7400 b&w 8"x6"
 fi negs
 gl negs
Aids Catalogue
Access General public bona fide students
Copies available for sale for loan
Notes There are some duplicate prints from this
 collection in Bodleian Library Oxford.

396
Owner Geoffrey Poole
Location 7 Fernhill Avenue Weymouth Dorset
 Weymouth 2768
Dates 1950 -
Photographer Geoffrey Poole
Subjects ARCHITECTURE GEOMORPHOLOGY
 AGRICULTURAL HISTORY ECOLOGY locational
 groups - Cambridge Weymouth Portland Dorset
 Vienna Teneriffe Malta Spain
Numbers sl 10000 col 35mm
Aids Subject index
Access Bona fide students publishers press tv
Charges Reproduction fee
Notes This is a private collection to support lecturing
 requirements. Locational groups cover geographical
 and cultural aspects.

397
Owner Miss Constance Purser
Location The White House Museum of Buildings and
 Country Life Aston Munslow Shropshire
Title The White House Homestead Museum of Buildings
 and Country Life
Dates (1947) -
History Saxon Manor held by Lord Elmund 1042 AD.
 Owned and lived in by the Stedman family 1335 - 1946
 Ancestral home of the famous campanologist Fabian
 Stedman
Subjects ARCHITECTURE of a house of 4 periods
 historic events museum displays and exhibits
 details of timber frame construction
Access Open to the public Saturday 11 am - 6 pm
 Wednesday 2 pm - 6 pm April 1st - October 31st
 for further days in June July August September see

 leaflets and local publicity enquiries by letter
Copies available

398
Owner Ravenscourt Society
Location 26 Ashchurch Grove London W12
Custodian D P Wilson
Dates (1971) -
Subjects ARCHITECTURE - Ravenscourt Park -
 Photographic survey
Numbers pr b&w
Copies available for sale
Charges Print fee at cost

399
Owner C H Robinson
Location Ightham Mote Ivy Hatch Sevenoaks Kent
 073 276 378
Dates 1885 (1953) -
Subjects ARCHITECTURE - local people
Numbers pr substantial number some contained in albums
 sl 10 2¼"x2¼"
Access Bona fide students by appointment only
Copies available for loan as appropriate
Charges Reproduction fee by arrangement

400
Owner Royal Commission on Historical Monuments
 (England) Trustees
Location Fortress House 23 Savile Row London W1X 1AB
 01 734 6010
Title National Monuments Record (England)
Custodian Cecil Farthing
Dates 1859 (1941) -
Subjects ARCHITECTURE historic English architecture
Numbers pr c800000 b&w ¼pl - 15"x12"
 fi negs c10000 b&w
 gl negs c600000 b&w ¼pl - 15"x12"
 L sl c20000 b&w 3¼"x3¼"
 tr c1000 b&w
Aids Card index
Access General public bona fide students
Copies available for sale for loan
Notes In some cases copyright clearance from the
 original photographer is required, this is always
 indicated on the reverse of the photograph.

401
Owner Royal Institute of British Architects
Location Sir Banister Fletcher Library 66 Portland Place
 London W1N 4AD 01 580 5533
Title Royal Institute of British Architects Photographic
 Collection
Custodian The Librarian
Dates c1910 (c1930) -
History The collection has been built up over the years
 through contributions from RIBA members and a
 number of bequests
Photographer Deakin Emslie Harper
Subjects ARCHITECTURE - modern British
Numbers pr c20000 various
Aids Card index
Access Press broadcasting specialist writers
 publishers picture researchers bona fide students
Copies available for sale
Charges On request
Notes A collection of modern British architecture with
 emphasis on the growth and development of the
 modern movement.

402
Owner Lord St Oswald
Location Nostell Priory Nr Wakefield West Yorkshire
 0924 862221
Dates 1951 -
Subjects ARCHITECTURE Nostell Priory
Numbers tr col b&w Substantial numbers

403
Owner Slide Centre Limited
Location 143 Chatham Road London SW11 01 223 3457

Custodian Mrs Sheila M Serjeant
Subjects GENERAL ARCHITECTURE art astronomy
environmental studies geography meteorology
history economic history biology ecology
religion moral education social studies technical
science transport
Numbers sl substantial numbers
Aids Published catalogue
Access General public bona fide students by appointment
9 am - 5 pm
Copies available for publication
Charges Reproduction fee
Notes The Slide Centre, originator of the Slidefolio, is
principally involved in supplying colour slides for
educational purposes from a large stock of originals.

404
Owner Frank E Smith
Location 45 Ashbourne Road Hanger Hill London
W5 3EH 01 997 5284
Dates 1940 -
Photographer Frank E Smith
Subjects ARCHITECTURE LANDSCAPE - European
holiday resorts natural history cacti and other
succulents
Numbers pr 2000 b&w 8"x6" 10"x8"
fi negs 5000 b&w 24mm x 36mm
tr 3000 col 24mm x 36mm
Copies available for sale slides for reproduction

405
Owner South Kesteven District Council
Location Planning Department Sandon Close Grantham
Lincolnshire 0476 5365
Custodian P G Robinson
Dates 1963 -
Subjects ARCHITECTURE - historic buildings
street scenes - Stamford Grantham Bourne
Numbers fi negs c1000 b&w 35mm
L sl c800 col 35mm
Access General public bona fide students 9 am - 5 pm
Copies available for sale for loan for display
for publication
Charges Print/transparency fee reproduction fee
on application

406
Owner F N Stevens
Location 1a Park Grove Horsforth Leeds West Yorkshire
LS18 5EE 097 34 3029
Dates c1870 (1969) -
Subjects ARCHITECTURE Leeds Horsforth
school portraits
Numbers pr 250 b&w 6"x4"
fi negs 250 b&w 35mm
sl 250 b&w 35mm
Aids List
Access General public on occasions bona fide students
on request
Copies available for sale for loan on request
Notes Many subjects of architectural photographs are now
demolished.

407
Owner Sussex Archaeological Trust
Location Michelham Priory Upper Dicker Hailsham
East Sussex BN27 3QS Hellingly 224
Custodian G W R Harrison
Dates c1870 (1960) -
History The collection has gradually grown since the
Priory was opened to the public in 1960
Subjects ARCHITECTURE - Monastic and Tudor buildings
medieval moat water mill trees gardens barns
excavations
Numbers pr c30
fi negs

Access Bona fide students by appointment only
Copies Prints published by the Trust for sale for
publication only in specific approved cases private
copies approved in specific cases
Charges A small donation would be requested otherwise no
fixed charges
Notes This collection supplements information on the
history and development of this historic site and
buildings.

408
Owner Dr Jennifer Tann
Location Historical Studies Group Management Centre
University of Aston Birmingham 021 359 3611
Dates (c1963) -
Subjects ARCHITECTURE industrial architecture
manufacturers' houses 'great houses' workers'
housing mechanical engineering
Numbers pr c400 b&w 1pl
fi negs c1000 b&w
tr c800 b&w 2"x2"
Aids *Subject index
Access Bona fide students

409
Owner Thomas-Photos (J W Thomas)
Location 1 Collinwood Close Headington Oxford
OX3 8HS 0865 61350
Custodian E Thomas
Dates 1939 -
Photographer J W Thomas
Subjects ARCHITECTURE restoration Oxford
motorways bridges old cars Western Desert
Middle East
Numbers fi negs 500 b&w
gl negs 7500 b&w ½pl
Aids *Subject index
Access Picture researchers press tv media
by appointment only 9 am - 6 pm
Copies available for sale for display for publication
credit line required
Charges Reproduction fee print/transparency fee
handling fee holding fee search fee

410
Owner Kent County Council
Location Tunbridge Wells Reference Library Mount
Pleasant Tunbridge Wells Kent
Custodian J K Page
Dates c1860 (1955) -
Photographer Joseph Chamberlain George Glanville
D J Johnson Carl Norman A J Pelton
Subjects ARCHITECTURE buildings - exteriors
interiors public ecclesiastical residences
commercial street scenes monuments biography and
portraits aerial photography
Numbers pr c1200 b&w various
Aids *Card index
Access General public
Copies available for loan on special occasions
Charges Reproduction fee by negotiation

411
Owner Major Herbert Brake Turnor
Location Little Ponton Hall Grantham South Kesteven
Lincolnshire 047 683 221
Dates 1890 - 1945
Subjects ARCHITECTURE - houses Guildford
Numbers pr c380 contained in two albums
Access Bona fide students by appointment only
Notes In one of the albums the photographs are of houses
built, altered or re-decorated by Christopher Hatton
Turnor (1873-1940).

Key () = dates when collections were begun or terminated
C = Century c = approximately pr = print fi = film
gl = glass neg = negative sl = slide L sl = lantern slide
tr = transparency mic = microform col = colour

b&w = black and white ¼, ½, 1-pl = quarter, half and whole
plate * = single copy, no public access ** = single copy,
access by appointment

412
Owner University of Cambridge
Location University Library West Road Cambridge
 CB3 9DR 0223 61441
Title Views Collection
Custodian E B Ceadel
Dates c1860 (c1880) -
Subjects ARCHITECTURE topography
Numbers pr substantial numbers b&w
Aids *Card index
Access Bona fide students
Copies available for sale
Charges Print fee

413
Owner University of Durham
Location Palace Green Durham 0385 61262
Custodian The Librarian
Dates c1860 -
Photographer W A Bramwell C W Gibby E Greatorex
Subjects ARCHITECTURE - medieval - Durham
 England Europe
Numbers Substantial numbers
Aids Card index in preparation
Access General public bona fide students
Copies available for sale

414
Owner University of Lancaster
Location University Library Bailrigg Lancaster
 0524 65201 Ext 247
Title University of Lancaster Collection
Custodian Miss W R Kenyon
Dates c1900 (1969) -
Photographer M C Fair John Hardman
Subjects ARCHITECTURE and industrial archaeology
 of North West England social sciences transport
 customs and folklore bridges mining agriculture
 aerial photography historic and newsworthy events
Numbers pr c1400 b&w 8½"x6½"
Aids *Card index *subject index
Access General public bona fide students with written
 permission from the librarian
Copies available for sale subject to copyright limitations
Charges Print fee

415
Owner 'Guild of St George' (University of Reading)
Location Department of Fine Art University of Reading
 Reading Berkshire 0734 85123
Title Ruskin Museum and Library Collection
Custodian Mrs Andrea Finn
Dates c1870 - 1915
Photographer Arthur Burgess Frederick Hollyer
 John Ruskin Frank Meadow Sutcliffe William Ward
Subjects ARCHITECTURE architectural painting
 numismatics stained glass May Queens
 crystallography mineralogy travel abroad
 painting - photographic reproductions
Numbers pr c550 b&w
 gl negs c1400 b&w 3¼"x3¼" 6½"x4¾"
 L sl 1598 b&w some hand col
Aids Card index
Access General public bona fide students by appointment
 only
Copies available on request

416
Owner Institute of Advanced Architectural Studies
 (University of York)
Location King's Manor York YO1 2EP 0904 24919
Custodian K V Parker
Dates (c1950) -
Subjects ARCHITECTURE
Numbers pr 3056 b&w 8"x6"
 sl c8800 b&w 3¼"x3¼" 35mm
Aids *Card index to prints
Access General public bona fide students

417
Owner Vaux Breweries Limited

Location Sunderland Tyne and Wear SR1 3AN
 0783 76277
Custodian L R P Lawford
Dates c1920 -
Photographer Saxons of Sunderland Turners of Newcastle
Subjects ARCHITECTURE public houses horse-drawn
 vehicles rowing cycling racing horse shows
 Percheron Exhibition horses
Notes The Collection constitutes a record of new or
 rebuilt public houses taken about the time of their
 opening to the public.

418
Owner Cheshire County Council
Location Warrington Library Museum Street Warrington
 Cheshire 0925 31873
Title Warrington Photographic Survey
Custodian Divisional Librarian
Dates 1974 -
Subjects ARCHITECTURE LANDSCAPE social record
 of Warrington
Numbers pr b&w 10"x8"
Aids Divided into project areas
Access General public
Copies available for sale
Charges Print fee

419
Owner T I Williams
Location 46 The Avenue St Paul's Cray Orpington Kent
 BR5 3DJ 01 300 3890
Dates 1900 (1960) - 1968
Photographer M O Dell
Subjects ARCHITECTURAL LANDSCAPES - Pyrenees
 pictorial
Numbers pr c150 b&w
 fi neg c1000 b&w
 L sl c250 b&w
Access Bona fide students
Copies available by arrangement with owner
Charges By arrangement

420
Owner Yorkshire Architectural and York Archaeological
 Society
Location The Castle Museum York 0904 53611
Title Evelyn Collection
Custodian R J Malden Honorary Secretary
Dates Late 19thC - 1930
Subjects ARCHITECTURE PAINTING
Numbers gl negs c2500 b&w ¼pl
 L sl c2500 b&w 3¼"x3¼"
Aids *Catalogue *card index
Access Restricted access to general public by arangement
 with the Honorary Secretary

421
Owner Yorkshire Arts Association Glyde House
 Glydegate Bradford BD5 OBQ
Location Director's Office Leeds Polytechnic Calverley
 Street Leeds LS1 3HE 0532 41101
Title The Industrial Architecture of Yorkshire
Custodian Dr Patrick Nuttgens
Dates (1972) -
Subjects ARCHITECTURE industrial architecture
 North and East Yorkshire - buildings
Numbers pr 1000 b&w 135mm
 fi negs 1000 b&w 135mm
Aids *Card index
Access Bona fide students by appointment

422
Owner Christ's Hospital Governors
Location Maine Christ's Hospital Horsham Sussex
 0403 66558
Custodian N M Plumley
Dates 1857 -
Subjects CHRIST'S HOSPITAL BUILDINGS and boys and
 masters - London and Horsham

E

Numbers pr
 fi negs
 sl
 total c1000
Aids Catalogue
Access General public bona fide students by appointment
 only with the Archivist

423
Owner E Gillett 80 South Street Cottingham HU16 4AT
Location Department of Adult Education University of Hull
Title Gillett Collection
Dates c1845 (1953) -
Subjects BUILDINGS English history in buildings
 manuscripts
Numbers L sl c6000 col 35mm 2"x2"
Aids Guide
Access Bona fide students
Copies available for sale
Charges Print fee
Notes This collection was made for teaching purposes.

424
Owner John R Hume
Location Department of History University of Strathclyde
 Glasgow G1 1XO 041 552 4400
Title Scottish Industrial Archaeology
Dates 1964 -
Subjects BUILDINGS industrial buildings machinery
 all related to Scotland
Numbers pr c10000 b&w ½pl
 fi negs c20000 b&w 35mm 2¼"x2¼"
Aids *Catalogue
Copies available for sale

425
Owner O G Jarman
Location Suffolk Record Office Bury St Edmunds Branch
 Schoolhall Street Bury St Edmunds IP33 1RX
 0248 63141
Title Spanton-Jarman Collection
Custodian W R Serjeant
Dates Late 19thC - early 20thC
Photographer H I Jarman W Spanton
Subjects BUILDINGS VIEWS domestic and ecclesiastical
 architecture institutions events interiors
 portraits and groups
Numbers gl negs c4000 b&w
Aids Ms catalogue duplicated place index
Access Bona fide students
Copies available for sale by arrangement
Charges available on request

426
Owner J A Longbottom
Location 75 Chatsworth Road Pudsey West Yorkshire
 LS28 8JX 0274 665664
Dates 1966 -
Photographer J A Longbottom
Subjects HISTORIC BUILDINGS castles churches
 mills sundials bridges inland waterways -
 Rochdale Huddersfield Thames Severn railways
 British landscapes market towns Victorian and
 modern town centres customs folklore rambling
 traction engines
Numbers fi negs c3500 b&w 35mm 6cm x 6cm
 tr c2300 col 35mm 6cm x 6cm
Aids *Card index
Access Bona fide students requests in writing or by
 telephone after 6 pm
Copies available for sale for loan in certain cases
Charges Print fee reproduction fee commercial rates
Notes Negatives from this collection have been accepted
 by the Historical Monuments Commission, Dorset
 County Library, West Yorkshire County Library and
 Gloucester Library.

427
Owner George A F Plunket
Location 29 Margetson Avenue Thorpe St Andrew Norwich
 Norfolk NR7 0DG 0603 35164
Dates 1931 -
Photographer George A F Plunkett
Subjects BUILDINGS OF HISTORICAL AND
 ARCHITECTURAL INTEREST Norwich Norfolk
 City wall Cathedral churches domestic
 architecture old doorways current events
Numbers pr 4986 b&w 2"x3" - 2¼"x3¼"
 fi neg 4986 b&w 2"x3" - 2¼"x3¼"
 L sl 623 b&w 23 col 3¼"x3¼"
Aids *Manuscript registers
Access No facilities for inspection of the collection by
 members of the public but information given regarding
 the availability of any particular subject on receipt of
 written or telephone request
Copies available for sale
Charges Reproduction fee on request

428
Owner P F Sheppy
Location Long Tehidy Thorney Green Road Stowupland
 Stowmarket Suffolk Stowmarket 4672
Dates 1930 (1964) -
Subjects BUILDINGS scenes rebuilding of London Bridge
 natural history wild flowers fungi trees formal
 gardens butterflies moths
Numbers pr substantial number b&w
 sl c3000 col 2"x2"

429
Owner Sun Villas Limited
Location 19 Great Portland Street London W1
Custodian Advertising and Promotions Manager
Dates 1973 -
Photographer Tony Freeman Paul Harris
Subjects BUILDINGS villas countryside
Numbers sl 5000 col 2½"x2½"
Access General public
Copies available for loan in certain cases

430
Owner Surrey County Council
Location County Hall Kingston-upon-Thames Surrey
 01 546 1050 Ext 556
Title Antiquities of the County of Surrey
Custodian K Harvey
Dates (c1950) -
Photographer D Yellan
Subjects HISTORIC BUILDINGS ancient monuments
 antiquities - stocks coal tax posts pumps transport
 archaeology mechanical engineering civil and
 building construction agriculture and food production
Numbers pr 14000 b&w 6½"x8½"
 fi negs c8000 b&w
 gl negs c4000 b&w
Aids *Card index
Access General public bona fide students
Copies available for sale

431
Owner Trans-Globe Film Distributors Ltd
Location 23 Crisp Road London W6 9RL 01 748 0017
Custodian Alexander de Rahn
Dates (1958) -
Photographer Jeremy Whitaker
Subjects HISTORIC HOUSES castles gardens
Numbers fi negs substantial numbers col 35mm 5"x4"
 tr substantial numbers col 35mm 5"x4"
Aids Guide catalogue card index subject index
Access General public bona fide lecturers picture
 researchers press tv media by appointment only
Copies available for sale for publication
Charges Print/transparency fee publication fee

Key () = dates when collections were begun or terminated
C = Century c = approximately pr = print fi = film
gl = glass neg = negative sl = slide L sl = lantern slide
tr = transparency mic = microform col = colour

b&w = black and white ¼,½,1-pl = quarter, half and whole
plate * = single copy, no public access ** = single copy,
access by appointment

432
Owner Wotton-under-Edge Historical Society
Location Tolsey House Market Street Wotton-under-Edge
Gloucestershire
Title Photographic Records
Custodian Mrs M G Milner Librarian
Dates Late 19C -
Subjects BUILDINGS - public shops houses mills
historic events notable citizens
Numbers pr small collection b&w various
Access Bona fide students by arrangement with the
Librarian

433
Owner King's Lynn Preservation Trust Ltd
Location Serpentine House Holbeach Lincolnshire
Custodian Mrs N E Lane Hon Secretary
Dates 1957 -
Subjects BUILDINGS - restored by the Preservation Trust
Trust social events

434
Owner C B Chapman
Location 76 De Grey Street Hull Humberside HU5 2SB
0482 441314
Dates 1949 (1971) -
Photographer C B Chapman
Subjects MISERICORDS
Numbers pr c500 b&w
Aids Catalogue in preparation card index subject index
Access Bone fide students by appointment only

435
Owner Chester Cathedral Dean and Chapter
Location Cathedral Office 1 Abbey Square Chester
CH1 2HU 0244 24756
Title Chester Cathedral and Precincts
Custodian Peter J Porter
Dates 1910 -
Subjects ECCLESIASTICAL ARCHITECTURE Chester
Cathedral all aspects
Aids *Subject index
Access Bona fide students
Notes The Collection is intended for students of the history
of the Cathedral and to provide illustrations for guide
books.

436
Owner Durham Cathedral Dean and Chapter
Location The Dean and Chapter Library The College
Durham DH1 3EH 0385 62489
Custodian Roger C Norris
Dates (1961) -
Photographer Miss Daisy Edis Jeffrey Teesdale
Alan Wiper
Subjects CHURCH ARCHITECTURE Durham Cathedral
interior and exterior books and treasures
manuscripts
Numbers pr c100 b&w
fi negs c1550 b&w 3½"x2½"
gl negs c430 b&w ½pl 1pl
L sl c280 b&w 3"x3"
tr c900 col 35mm
fi 160 b&w 35mm
Aids Duplicated catalogue of slides only **card index
Access Bona fide students
Copies available for sale
Charges Colour transparencies from 25p each black and
white prints from 50p each 1pl microfilm 10p per
frame

437
Owner Exeter Cathedral Dean and Chapter
Location Cathedral Library Bishop's Palace Exeter
Devon Exeter 72894
Title Exeter Cathedral Library Collection
Custodian Librarian University of Exeter Prince of
Wales Road Exeter Devon Exeter 77911
Dates 20thC -
Photographer C P Cave Miss E P Prideaux Whiteley
Subjects CHURCH ARCHITECTURE sculpture and

carving monuments portraits - Cathedral clergy
misericords
Numbers pr substantial number
Access General public bona fide students picture
researchers press tv media Monday to Friday
2 pm - 5 pm
Copies Not generally available
Notes The collection consists of prints from photographs
taken by C P Cave for his book 'Medieval carvings in
Exeter Cathedral', a set of prints taken by a Mr
Whiteley in 1959 of the Misericords and an album of
photographic prints taken by Miss E Prideaux of many
items in the Cathedral.

438
Owner Exeter Cathedral Dean and Chapter
Title E E Norris Collection
Custodian J F Stirling
Dates 1942 - 1945
Photographer E E Norris
Subjects Exeter Cathedral - Exterior
Numbers pr c1000 b&w 3½"x2½"
Notes Location, Access and Copies as for No. 437 above.

439
Owner R A L Ford
Location 19 Brackenwood Road Clevedon Avon BS21 7AB
02757 4029
Dates (1970) -
Subjects CHURCH ARCHITECTURE West Country
churches interiors and furnishings
Numbers sl c250 col 2¼"x2¼"
Aids *Subject index

440
Owner General Synod Council for Places of Worship
Location 83 London Wall London EC2M 5NA
01 638 0971
Custodian Library: David Williams Slide Collection:
Alison Knight
Dates (1922) -
History The national survey of Churches was founded by
the first Secretary of the Council for the Care of
Churches, Francis C Eeles
Subjects CHURCH ARCHITECTURE church art
furnishings ecclesiology conservation
Numbers pr c25000 b&w various
sl c4000 col 35mm
Aids Duplicated slide catalogue *card index
Access General public bona fide students by appointment
only
Copies available for loan slides only
Charges Print fee slides up to 30 at 60p thereafter at
2p each slide including postage

441
Owner Hereford Cathedral Dean and Chapter
Location The Muniment Room Hereford Cathedral
Library The Cathedral Hereford HR1 2NG
0432 3537
Title Hereford Cathedral Library Collection
Custodian F C Morgan Penelope E Morgan
Dates 1925 (1945) -
Photographer F C Morgan
Subjects CHURCH ARCHITECTURE Hereford Cathedral
manuscript books deeds and seals portraits of clergy
chained library
Numbers pr c500 b&w various
fi negs c100 b&w 4¼"x3¼"
gl negs c1360 b&w 4¼"x3¼"
L sl c900 b&w 3¼"x3¼"
mic 227 b&w 35mm
Aids *Card index for prints *subject index
Access Bona fide students by appointment
Copies available for sale on request

442
Owner W Leary
Location Brantwood St Edward's Drive Sudbrooke
Lincoln LN2 2QR 0522 51749
Dates (1962) -

Photographer W Leary
Subjects CHURCH ARCHITECTURE Methodist chapels in Lincolnshire
Numbers pr c600 b&w
fi negs c600 b&w 35mm 3½"x3½"
Aids Guide
Access Bona fide students
Copies available for sale for loan

443
Owner Manchester Cathedral Dean and Chapter
Location Manchester Cathedral Manchester M3 1SX
061 834 7503
Custodian Harry S Fairhurst & Son 55 Brown Street
Manchester M2 2JR
Dates 20thC
Photographer Elsam Mann and Cooper J McCormack
S W Newbery
Subjects CHURCH ARCHITECTURE Manchester Cathedral
Numbers Substantial number
Access Bona fide students
Copies available for sale
Charges Print fee

444
Owner B D Hughes
Location 26 Fore Street Northam Devon Bideford 6211
Dates 1850 (1961) -
Photographer B D Hughes W H Puddicombe A L Pacey
Subjects CHURCH ARCHITECTURE TRANSPORT -
wind and water mills factory interiors maritime
Numbers fi negs 800 b&w
gl neg c2200 b&w
L sl 20 b&w
sl 300 b&w
Aids Subject index (partial only)
Access Bona fide students
Copies available for sale subject to copyright permission to reproduce must be obtained from B D Hughes
Charges Print fee reproduction fee all books from £3 per photograph advertising double standard rate education non profit making trusts etc half standard rate

445
Owner The Provost of Leicester Provost's Lodging
1 St Martin's East Leicester LE1 5FX
0533 25294
Location Leicester Cathedral
Custodian H Hughes
Dates c1850 -
Subjects CHURCH ARCHITECTURE Leicester Cathedral
clergy of the Cathedral re-hallowing of the
Cathedral in 1927
Numbers pr c500 b&w
tr c200 col
Access Bona fide students
Copies Colour transparencies by Woodmansterne available for sale
Notes Photographs of the Cathedral silver and treasures are for police and insurance purposes only and not available for release.

446
Owner St Ninians Cathedral Chapter
Location St Ninians Cathedral North Methven Street
Perth
Custodian Alastair H Cruickshank 2 Tay Street
Perth PH1 5LJ Perth 25381 Ext 13
Dates 1880 - 1950
History The collection covers Cathedral and diocesan and provincial life over the years
Subjects CHURCH ARCHITECTURE St Ninians
Cathedral Bishops of Diocese Provosts of the
Cathedral Precentors of the Cathedral College of
Bishops in Scotland Provincial Synod Meetings

Numbers pr 27 b&w various
Access Bona fide students on special application only
Charges Donation to Cathedral funds should be made for inspection

447
Owner Southwell Cathedral Chapter
Location The Library Southwell Minster Southwell
Nottinghamshire 0636 812649
Custodian R M Beaumont
Dates c1861 (1947) -
Photographer Alfred John Loughton H A Summers
Subjects SOUTHWELL MINSTER local scenes portraits
Christian institutions Christian objects sculpture
architecture
Numbers pr c3500 b&w various
gl negs c890 ½pl 1-pl postcard size
L sl 193
sl
mic
Access Bona fide students by appointment only
Copies Transparencies available for sale
Charges Reproduction fee current commercial rates

448
Owner Winchester Cathedral Dean and Chapter
Title Winchester Cathedral Archives Collection
Custodian Canon F Bussby
Dates c1870 -
Subjects CHURCH ARCHITECTURE Winchester
Cathedral personnel
Numbers pr b&w various
tr c400 col 35mm
fi 1 b&w
Aids *Card index *subject index
Access Bona fide students
Copies Credit line required
Notes Parish Churches of Winchester Diocese 1910 - 1912 included.

449
Owner W F Pardoe
Location 38 Perrins Lane Stourbridge West Midlands
DY9 8XP 038 482 2880
Title Pictures of Witley Court and its Baroque church
Dates c1900 (1966) -
Photographer W F Pardoe
Subjects WITLEY COURT and CHURCH portraits
Numbers pr c200 b&w ½pl
gl neg 50
sl c500 col 2"x2"
Aids Subject index
Access Restricted
Copies available
Charges Print fee reproduction fee standard rates
Notes Witley Court was the residence of famous Black
Country ironmasters for 300 years. The ruins are now
an ancient monument and are in the care of the
Department of the Environment.

450
Owner T Rigby
Location 12 Adela Road Runcorn Cheshire
Dates 1864 - 1894
Photographer Bentley Buxton J A Rigby
Subjects RESIDENCES - stately homes Chatsworth
House - Derbyshire statues life in the Colonies -
Natal construction of Runcorn Railway bridge
Numbers pr c70 various collodion plate 1
Access Bone fide students by appointment only
Charges Reproduction fee only to cover expenses

451
Owner House of Fraser Limited 12 Buchanan Street
Glasgow C1 041 221 6401
Location London Office John Barker and Company

Key () = dates when collections were begun or terminated
C = Century c = approximately pr = print fi = film
gl = glass neg = negative sl = slide L sl = lantern slide
tr = transparency mic = microform col = colour

b&w = black and white ¼,½,1-pl = quarter, half and whole
plate * = single copy, no public access ** = single copy,
access by appointment

Limited Kensington High Street London W8
01 937 7270
Title House of Fraser Records
Custodian Sir Robert Hobart Bt
Dates 1930 (1957) –
Subjects COMMERCIAL BUILDINGS House of Fraser –
shops retail interests promotions personnel
events
Numbers pr 2000 b&w 50 col 1pl
Aids Catalogue in preparation
Copies can be made available to press tv and publishers
and to persons with genuine interest
Notes Many photographs reproduced in House Journal.

452
Owner John Lewis Partnership Limited Oxford Street
London W1
Location Archives Department Cavendish Road Stevenage
Hertfordshire 0438 2388 Ext 202
Custodian Mrs L Poole
Dates c1900 (1964) –
History The collection covers the growth of the John Lewis
Partnership
Subjects COMMERCIAL ARCHITECTURE retailing
personalities commercial transport – horse drawn
steam driven merchandise Brownsea Castle –
Dorset Leckford Estate – Hampshire
Numbers pr c500 b&w various
Aids *Card index *subject index
Access There is no direct public access and all enquiries
should be in writing arrangements for visits are
sometimes made if appropriate but only after
preliminary written enquiry
Copies available on an ad hoc basis but enquiries
must be in writing

453
Owner Sydney Boyle
Location Gell Pool Leyburn North Yorkshire
096 92 3207
Title A Picture of Billingham
Dates c1923 – 1944
Photographer Sydney Boyle W L Walker
Subjects INDUSTRIAL BUILDING ICI chemical plant
Cleveland – local landscapes
Numbers pr 60 b&w 12"x10"
Access Bona fide students by permission only
Notes The original negatives are held at ICI Billingham.

454
Owner E J Connell
Location 26 St Ronan's Road Harrogate North Yorkshire
HG2 8LE 0423 884489
Title Industrial Archaeology
Dates c1900 (1964) –
Subjects INDUSTRIAL BUILDINGS IN HERTFORD, LEEDS
and NIDDERDALE goods trains veteran and vintage
road transport steam driven vehicles navigations
docks and harbours archaeological sites factories
bridges cranes farm buildings cattle sheep
pigs commercial architecture
Numbers fi neg 500 b&w 35mm
sl 200 col 35mm
Access Bona fide students
Copies available for loan
Charges Reproduction fee by negotiation

455
Owner Mack of Manchester Limited
Location Victoria Mill Pollard Street Manchester
M4 7AY 061 273 3625
Title General Industrial Photography
Dates 1964 –
Subjects INDUSTRIAL PHOTOGRAPHY OCCUPATIONS
AND SERVICES TRANSPORT mechanical
engineering civil and building construction
agriculture and food production domestic
architecture
Numbers fi negs c50000 b&w 5"x4" 2¼"x2¼"
Aids *Card index cross reference alphabetical and
numerical

Access 9 am – 5.30 pm
Copies available for sale only to clients concerned ie
owners of copyright
Notes Mack of Manchester specialise in Industrial
Photography and Public Relations work. All
photographs commissioned by clients.

456
Owner J R Armstrong
Location Highover Bracken Lane Storrington West
Sussex Storrington 2856
Photographer J R Armstrong
Subjects VERNACULAR ARCHITECTURE South East
England building materials crafts furnishing
social and economic history and relevant material
Numbers tr 50000 b&w col 2"x2"
Access Bona fide students
Notes The collection will eventually be placed in the
Weald and Downland Open Air Museum.

457
Owner Mrs Iris Hardwick and Mrs Kay Sanecki
Location 64 Icknield Way Tring Hertfordshire HP23 4HZ
Tring 3522
Title The Iris Hardwick Library
Dates 1953 –
Photographer Mrs Iris Hardwick Mrs Kay Sanecki
Subjects VERNACULAR ARCHITECTURE village
churches of the West Country plants gardens
topography coastline mountains outdoor activities
rural industries
Numbers pr c2000 b&w 1pl
tr c7000 2¼"x2¼"
Aids Catalogue subject index
Access General public bona fide students by appointment

458
Owner D H Smith
Location 81 Narborough Road Cosby Leicester LE9 6TB
053 729 2833
Dates 1962 –
Subjects VERNACULAR ARCHITECTURE – fields and
landscape local history and folk custom in Ireland
gypsies and other travelling people
Numbers pr 250 b&w 35mm
ti negs b&w
sl 675 col 35mm
Aids Catalogue under revision
Access Bona fide students on written application

459
Owner Mrs Pamela Mole
Location 10 Bridle Crescent Iford Bournemouth
Hampshire
Title Martin Ridley Collection
Dates 1880 – 1915
Photographer Martin Ridley
Subjects STREET SCENES – South and West Thames
Valley South Wales Northern Ireland trams cats
etchings engravings stereos soldiers trains
churches
Numbers gl negs c5000
Copies available for sale

460
Owner Mrs Barbara Denness
Location 7 Hudshaw Gardens Hexham Northumberland
0434 3677
Dates 1962 –
Photographer Mrs Barbara Denness
Subjects STREET FURNITURE – mounting steps drinking
fountains foot scrapers farms roofs markets
streets doors pele towers castles churches cottages
Numbers pr c5000 col 3"x5"
fi neg c5000 col
Aids Subject index
Access Bona fide students
Copies available for sale for loan
Charges Print fee 20p
Notes This collection of photographs has been taken in

Northumberland East Anglia London Durham Cumbria
Dorset Cornwall Edinburgh Shetland Perthshire
Galloway.

461

Owner Glasgow City Council
Location Glasgow Scotland
Subjects PAINTINGS sculpture
Numbers fi negs 1813 b&w ½pl
 sl 184 col 2"x2"
 ektachromes 60 5"x4"
Access Bona fide students
Notes The collection covers the city's Art collections.

462

Owner Gainsborough's House Society
Location Gainsborough's House Sudbury Suffolk
 Sudbury 72958
Title Gainsborough's House Photographic Archive
Custodian Robert McPherson
Dates 18thC (1973) -
Subjects PAINTING Thomas Gainsborough and
 contemporaries
Numbers pr 129 b&w 8"x10"
Aids *Card index in preparation
Access Bona fide students for reference
Copies available for loan

463

Owner John R Freeman and Company (Photographers)
 Limited
Location Harleyson House 74 Newman Street London
 W1P 3LA 01 636 4148
Title The Fotomas Index
Custodian B E Freeman
Dates 19thC (1957) -
Subjects PAINTINGS engravings printed books
 title pages prints drawings
Numbers pr c150000 b&w 10"x8" 8"x6"
 fi negs c75000 b&w
 gl negs c75000 b&w
 tr c2500 col 5"x4" - 10"x8"
Aids General guide subject index
Access General public bona fide students picture
 researchers press tv media 9 am - 5.30 pm
Copies available for sale for display for loan
 for publication credit line required
Charges Reproduction fee print/transparency fee
 handling fee holding fee service charge research fee
 on application
Notes The collection contains Victorian photographs
 covering some 350 subject headings. All photographs
 supplied are direct from originals. The collection
 was formed as an aid to picture illustration in
 historical publications.

464

Owner Merseyside Metropolitan County Council
Location Walker Art Gallery William Brown Street
 Liverpool Merseyside 051 207 1371
Title Walker Art Gallery Collection
Custodian Timothy Evans
Dates c1920 -
Subjects PAINTING SCULPTURE DRAWINGS
Numbers fi negs c4000 b&w
 sl c320 col
Aids List of colour slides
Access General public
Copies available for sale for publication
Charges Print fee from £1.30p reproduction fee

465

Owner National Film Archive
Location 81 Dean Street London W1V 6AA
 The British Film Institute Ernest Lindgreen House

Kingshill Way Berkhamstead Hertfordshire
01 437 4355
Title Stills Collection National Film Archive
Custodian Mrs M Snapes
Dates 1895 -
History This collection was established in 1948 as a
 research and preservation department of the
 National Film Archive (founded 1935)
Subjects PHOTOGRAPHS AND FILM PUBLICITY STILLS -
 relating to the history of the cinema including
 pre-cinema from its origins to the present day
Numbers pr c1000000 b&w 10"x8"
 tr c15000 col
 posters c3000
 set designs c600
Aids Card indexes by film-titles actors actresses
 directors limited subject index to film techniques
 and apparatus and staff expertise
Access General public bona fide students BFI members
Copies available for sale
Charges Print fee from 90p to members of the BFI
 from £1 + VAT to bona fide students from £1.65p +
 VAT for publication search fee moderate rate
 charged according to length of research undertaken
 enquiries by post and personal visit preferred
 waiting period for copy stills from two to eight
 weeks according to priority

466

Owner Bournemouth District Council Town Hall
 Bournemouth 0202 22066
Location Russell-Cotes Road East Cliff Bournemouth
 0202 21009
Title Russell-Cotes Art Gallery and Museum Collection
Custodian Graham Teasdill
Dates Late 19thC (1922) -
Subjects PAINTING NUMISMATICS CERAMICS
 trams trolley buses
Numbers pr c300 b&w 1-pl
 L sl c2000 b&w 3¼"x3¼"
 sl c2000 col 2"x2"
Aids Catalogue card index
Access General public by appointment only
Copies available for sale school loans only
Notes Including the large glass lantern slides from the
 collection of the British Association of Numismatic
 Societies.

467

Owner Sir John Soane's Museum Trustees
Location 13 Lincolns Inn Fields London WC2
 01 405 2107
Custodian Sir John Summerson
Dates c1904 - 1917 -
Photographer A C Cooper Limited W L Spiers
Subjects PAINTING ANTIQUITIES casts models
Numbers pr c3500
Access Bona fide students
Copies available for sale on request
Charges Print fee commercial rates reproduction fee
 by arrangement
Notes The negatives for prints in this collection are
 stored with A C Cooper Limited.

468

Owner University of London
Location Courtauld Institute of Art 20 Portman Square
 London W1 01 935 9292
Title Witt Library
Custodian John Sunderland
Dates (c1900) -
History The collection was founded and built up by Sir
 Robert Witt as a private library and was bequeathed
 to the Courtauld Institute on his death in 1952
Subjects PAINTING AND DRAWINGS engravings
 photographic reproductions

Key () = dates when collections were begun or terminated
C = Century c = approximately pr = print fi = film
gl = glass neg = negative sl = slide L sl = lantern slide
tr = transparency mic = microform col = colour

b&w = black and white ¼, ½, 1-pl = quarter, half and whole
plate * = single copy, no public access ** = single copy,
access by appointment

Numbers pr and reproductions c1200000
Aids Card index
Access General public bona fide students
Copies available on request subject to copyright restrictions photostats available
Charges Print fee from 75p (students half-price) reproduction fee (Courtauld Institute negatives) £2 - £7

469
Owner Dr John Wall
Location 'Ashfield' 45 Middleton Lane Middleton St George Darlington DL2 1AA 0325 73 2338
Title The Hadrian Collection
Dates 1954 -
History The owner of this collection is Editor of the National Photographic Record
Photographer John Wall
Subjects ANTIQUITIES Roman North Britain ecclesiastical architecture landscapes in Britain foreign travel - Russia Scandinavia Austria George Washington - sites associated with
Numbers sl 3000 col 2¼"x2¼" 35mm
Aids *Subject index
Access General public bona fide students picture researchers press tv media 9 am - 5 pm
Copies available for sale for display for loan for publication credit line required
Charges Reproduction fee
Notes The collection includes a unique record of traverse of the Roman Wall from East to West.

470
Owner R G Morton
Location 28 Massey Avenue Belfast Northern Ireland BT4 2JT 0232 63844
Title The Grenfell Morton Collection
Dates 1965 -
Photographer R G Morton
Subjects ANTIQUES INDUSTRIAL ARCHAEOLOGY castles country houses Georgian townscapes railways inland waterways
Numbers sl c3800 col 2"x2"
Access Bona fide students
Copies available for sale
Charges Reproduction fee standard rates
Notes Collection mainly of Irish interest, but also Great Britain, Northern Italy, France and Austria.

471
Owner Glasgow City Council
Location Art Gallery and Museum Kelvingrove Glasgow G3 8AG 041 334 1134
Custodian T A Walden
History All photographs and negatives in the collection are records of the Gallery's art and local history collections
Subjects SCULPTURE AND CARVING PAINTING Glasgow - local history
Numbers fi negs 1813 b&w ½pl
 L sl 184 b&w 35mm
 tr 60 b&w 5"x4"
Access Bona fide students
Copies available for sale for loan
Charges Print fee from 40p plus postage and packing
Notes There are also small collections of technological and archaeological negatives for curatorial use.

472
Owner Sladmore Gallery
Location 32 Bruton Place London SW1 01 499 0365
Custodian Mary H Hayner
Dates (1967) -
Subjects SCULPTURE bronze animal sculptures wildlife paintings
Numbers fi negs c2000 b&w ½pl
Aids *Catalogue
Access Bona fide students picture researchers press tv media 10 am - 6 pm
Copies available for sale for publication credit line required

Charges Print/transparency fee
Notes This is a commercial gallery and every work purchased is photographed.

473
Owner Warburg Institute
Location Woburn Square London WC1H 0AB 01 580 9663
Title The Warburg Institute Collection
Custodian Jennifer Montagu
Dates (c1920) -
Photographer Otto Fein
Subjects SCULPTURE AND CARVING painting medals
Numbers pr c300000 b&w various
 fi negs c20000 b&w various
 gl negs c1500 b&w various
 L sl 30000 b&w 2000 col
Aids Card index subject index
Access Bona fide students on application slides for the use of members of the Institute only
Copies available for sale
Charges Print fee

474
Owner J C D Smith
Location Old Arch Four Forks Spaxton Bridgwater Somerset TA5 1AA Spaxton 404
Photographer J C D Smith
Subjects MEDIEVAL AND ECCLESIASTICAL WOOD CARVINGS
Numbers pr 2000 b&w 8½"x5"
 fi neg 3000 2¼"x2¼"
 L sl 400 b&w 100 col 2"x2"
Aids *Card index
Access General public by arrangement with owner
Copies available for sale

475
Owner British Ceramic Research Association
Location Queens Road Penkhull Stoke-on-Trent Staffordshire ST4 7LQ 0782 45431
Title Technical Ceramics Ceramic Materials Scientific and Research Work
Custodian Director of Research
Dates 1945 -
Subjects CERAMICS and associated industries - apparatus diagrams graphs charts tables manufacturing processes allied products
Numbers fi negs c42000 various
 gl pl c2000 3¼"x3¼"
Aids Subject index card index
Access Bona fide students picture researchers press tv media only with specific permission from the Director of Research
Notes The negatives from the Technical Ceramics Collection are electron micrographs and are unselected. Negatives from the Scientific and Research Collection are connected with work within the Association and some photographs taken in associated industries. Photographs from the Ceramic Materials Collection are mainly of a highly specialised and technical nature. Almost all the photographs have been used to illustrate the various technical publications used by the research association, as well as in lectures given by members of staff to outside bodies.

476
Owner Robert Copeland
Location Spode Limited Spode Works Stoke-on-Trent Staffordshire ST4 1BX
Dates 1948 -
Subjects SPODE ANTIQUE WARES - industrial archaeology of North Staffordshire potteries transport water mills factory interiors and equipment
Numbers fi neg c600 b&w 35mm
 sl 1500 col 35mm
Aids *Catalogue
Copies Specific items by written request
Charges Reproduction fee by arrangement depending on use
Notes This is a private collection and it is virtually

impossible to provide public access. Requests for special items might be met if written application is made.

477
Owner Spode Limited
Location Spode Works Stoke-on-Trent Staffordshire ST4 1BX
Custodian Robert Copeland
Dates (1950) -
Subjects CERAMICS processes of manufacture of bone china and earthenware Spode - antique wares
Numbers pr c400 b&w ¼pl
fi negs 1000 b&w ½pl 35mm
sl c1000 col 35mm
Aids *Catalogue
Access Bona fide students
Copies available for sale for loan
Charges Print fee reproduction fee by arrangement depending on use

478
Owner University of London
Location Institute of Classical Studies 31-34 Gordon Square London WC1H 0PY 01 387 7696
Title Institute of Classical Studies Photographic Archive
Custodian Miss Margaret Packer
Dates (1959) -
Subjects POTTERY Greek dramatic monuments - masks terracottas vases Greek papyri vases in museums and private collections
Numbers pr c8000 b&w various
Access Bona fide students
Copies Prints may be ordered for research purposes

479
Owner Wedgwood Museum Trust
Location Barlaston Stoke-on-Trent 078 139 2141
Custodian Bruce Tattersall
Dates c1880 (1906) -
History The collection relates to the manufacture of pottery and the Wedgwood family, pioneers in the craft
Subjects POTTERY painting antiques Wedgwood family
Access Bona fide students
Copies available for sale for loan
Charges No charge for reproduction but acknowledgement required

480
Owner Dyson Perrins Museum Trustees and The Worcester Royal Porcelain Company Limited
Location Royal Porcelain Works Severn Street Worcester
Custodian Henry Sandon
Dates c1860 -
Photographer John Becherley A G Neale
Subjects PORCELAIN ceramic working china objects of art collectors items biography and portraits historic and newsworthy events Queen Adelaide King Edward VII visits to the Worcester Royal Porcelain Works
Numbers pr c5000 b&w
fi negs c100 b&w 2½"x3½"
gl negs c5000 b&w various
sl c350 col
Copies available for sale
Notes Copies of some of the more important glass plates have been made by the photographic department of the City of Worcester Archives Department.

481
Owner Courtaulds Limited 18 Hanover Square London W1A 2BB 01 629 9080
Location 22 Hanover Square London W1A 1BS 01 629 8000
Custodian G Hill
Dates c1900 (1946) -

Photographer G Hill
Subjects TEXTILES Courtaulds Limited chemicals engineering packaging material paint production plastics wood pulp production fabric designs man made fibre production and all textile activities Cellophane Polythene Polypropylene
Numbers fi negs c23000 b&w col 4"x5" 2¼"x2¼"
Aids *Subject index
Access Bona fide students and users of photographs prior appointment only
Copies available for sale for loan
Charges Usually no reproduction fee payable

482
Owner Dr D Leaback
Location The Institute of Orthopaedics c/o Department of Biochemistry Brockley Hill Stanmore Middlesex 01 954 2300
Title Sir William Perkins Dye Works
Dates 1870 - 1976
History William Perkins Dye Works was where the first synthetic dye was produced
Photographer J S Collins Sir William Perkins D Sayers
Subjects Perkins Dye Works
Numbers pr c200
Access By arrangement with Dr Leaback
Copies available for sale
Charges Reproduction fee IIP rates

483
Owner University of Leeds
Location Department of Textile Industries Leeds LS2 9JT 0532 31751 Ext 562
Title The Baker-Beaumont Collection
Custodian Dr J M Woodhouse
Dates c1890 - 1933
Subjects TEXTILES - equipment University of Leeds buildings spinning weaving design finishing and testing of wool
Numbers pr c3000 b&w 3½"x2½"
gl negs 6400 b&w ¼pl ½pl
L sl c3000 b&w 3¼"x3¼"
Aids Catalogue each negative and slide is numbered
Access Bona fide students only at present
Charges By arrangement with the Department of Textile Industries
Notes The collection was formed to aid the teaching of textile subjects eg spinning, weaving, design, finishing and testing.

484
Owner British Leather Manufacturers' Research Association
Location Milton Park Stroude Road Egham Surrey TW20 9UQ 078 43 3086
Custodian B M Haines
Dates 1922 -
Subjects LEATHER hides skins leather under microscope
Numbers fi negs 10000 b&w ¼pl
gl negs 20000 b&w ¼pl
L sl 4000 b&w
Aids *Subject index
Access Bona fide students
Copies available for sale
Notes This collection of photomicrographs has been made during the course of leather research. It is constantly being added to as the daily work proceeds in the laboratory. Since 1973 a scanning electron microscope has been used in conjunction with the light microscope and negatives of this work are added to the collection.

Key () = dates when collections were begun or terminated
C = Century c = approximately pr = print fi = film
gl = glass neg = negative sl = slide L sl = lantern slide
tr = transparency mic = microform col = colour

b&w = black and white ¼,½,1-pl = quarter, half and whole plate * = single copy, no public access ** = single copy, access by appointment

485
Owner Pilkington Brothers Limited
Location Group Archives St Helens Lancashire
 WA10 3TT 0744 28882 Ext 2253
Title Pilkington Brothers Limited Group Archives
 Collection
Custodian Miss P A Pemberton
Dates c1867 -
Photographer Stuart Bale
Subjects GLASS glass industry factory commercial
 buildings biography and portraits aerial
 photography flat fibre optical glass decorative glass
Numbers fi negs substantial number b&w col
 gl pos c100 b&w
 sl 150 col
Aids *Guide
Access General public bona fide students by arrangement
Copies available for sale for loan
Charges Reproduction fee by arrangement

486
Owner James A MacKenzie
Location 76 Randolph Drive Clarkston Glasgow G76 8AP
 041 637 5576
Dates 19C (1953) -
Subjects CHURCH ORGANS - 19C & 20C organ cases and
 church interiors organs dismantled under repair and
 restoration mainly in Glasgow area
Numbers pr 630 b&w up to 1-pl
 fi neg 350 b&w
Aids *Subject index

487
Owner Co-optic (Photography) Limited
Location 28 Camden Square London NW1 01 485 3623
Title Co-optic Archive of Contemporary Creative
 Photography
Custodian Stephen Weiss
Dates 1972 -
Subjects PHOTOGRAPHY personal work of
 contemporary British creative photographers
Numbers pr 500 various
 sl 800 35mm
Aids Catalogue with cross reference
Access Bona fide students by arrangement
Copies Transparency copies of original bromides

488
Owner J and W Barnes
Location 44 Fore Street St Ives Cornwall
Title Barnes Museum of Cinematography
Custodian John Barnes
Dates 1842 - (1939) -
History The Museum was established in 1963
Subjects PHOTOGRAPHY - history film stills
Numbers Several hundred historic photographs
Aids Catalogue card index
Access General public
Copies available for sale on application on loan by
 special arrangement
Charges Print fee reproduction fee
Notes This collection includes material by many eminent
 Victorian photographers.

489
Owner Brian Lee Polden
Location Blue Vista 299 Brighton Road Worthing Sussex
 Worthing 38943
Title The Widescreen Museum Collection
Dates (1964) -
Subjects PHOTOGRAPHIC APPARATUS panoramic prints
 and tapestries from 1400 panoramic paintings
 specialises in the history of panoramic and widescreen
 media
Numbers pr b&w
 fi negs b&w
 tr
 fi clips
Access Bona fide students by arrangement
Copies available for sale depending on copyright
Notes The collection also includes some interesting

exhibits such as Henri Chretien's original twin
projector, the precursor of Cinemascope.

490
Owner Rank Xerox Limited
Location Communications Department Rank Xerox House
 338 Euston Road London NW1 3BH 01 387 1244
Title Rank Xerox Photographic Library
Custodian Mrs Rosemary Vaux
Dates 1956 -
History The collection includes pictures of the first
 xerographic copy, the apparatus and the inventor
Subjects PHOTOGRAPHIC APPARATUS xerographic
 equipment facsimile transmission equipment
 digital computers
Numbers pr substanial numbers b&w
 sl substantial numbers b&w
Access General public bona fide students publishers
 press tv media on application to the Company
Copies available for loan
Charges No reproduction fee if Company copyright
Notes This collection contains mainly product and plant
 photographs taken for press and publicity purposes.

491
Owner University of Oxford
Location Museum of the History of Science Broad Street
 Oxford 0865 43997
Custodian F R Maddison
Subjects PHOTOGRAPHY - cameras - lenses
Numbers pr pl L sl sl substantial numbers
Aids Descriptive leaflet
Access General public bona fide students
Copies available for sale

492
Owner Douglas F Lawson
Location 12 Park Road Banstead Surrey
Dates 1947 -
Photographer Douglas F Lawson
Subjects PHOTOMICROGRAPHY natural history
 pictorial
Numbers pr c400 b&w 20"x16"
 fi negs
 gl negs
 L sl c300 b&w 3¼"x3¼"
 tr c200 col 3¼"x3¼"
Copies available for publication
Charges Reproduction fee print/transparency fee
Notes Owner/photographer is the author of books on
 photomicrography.

493
Owner See Notes
Dates 1843 (1939) -
History The collection concentrates on historic
 processes eg platinotype bromoil bromoil transfer
 carbon carbro (autotype) gum bichromates
 gevaluxe velours fresson
Photographer R Adamson E R Bull Julia Margaret
 Cameron M O Dell Jose Ortiz Echague
 Frederick Evans Donald S Herbert D O Hill
 Charles Job Walter Marynowicz F J Mortimer
 W H Fox Talbot Will Till
Subjects LANDSCAPE architecture flowers portraits
 photographic processes Royal families - British
 and foreign
Numbers pr c190 b&w 10 col various
 L sl c200
 rare glass 3D deep picture process 2
Access Bona fide students by prior arrangement only
Copies The owner is prepared to consider loan in
 exceptional cases
Charges Reproduction fee at owner's discretion
Notes This is an important private, but very representative
 historical collection. The owner has a number of
 photographic distinctions. Requests to view this
 collection must be made through the National
 Photographic Record c/o The Royal Photographic
 Society. The owner reserves the right to refuse access.

494
Owner See Notes
Dates 1835 - 1899
Photographer Richard Beard Brady Julia Margaret Cameron Disderi D O Hill and R Adamson W E Kilburn J Mayall John Moffatt Nadar H P Robinson Ross and Thomson Silvy William Henry Fox Talbot
Subjects PORTRAITURE - LANDSCAPE
Numbers pr and paper negs 100
daguerreotypes and collodions 30
cabinets 17
cartes de visite 28
Access Limited by appointment only
Notes Requests to view this collection should be made through the National Photographic Record, c/o The Royal Photographic Society. The owner reserves the right to refuse access.

495
Owner K Bass
Location Leonard Moor Farm Sampford Peverell Tiverton Devon Sampford Peverell 820420
Dates (1955) -
Photographer James Annan Richard Beard Francis Bedford Julia Margaret Cameron Elliott and Fry Francis Frith W Friese-Greene D.O. Hill and R Adamson Henry Peach Robinson James Valentine George Washington Wilson
Subjects SOCIAL SCIENCES ARMY TRANSPORT customs and folklore mining agriculture sculpture and carving architecture painting recreations biography and portraits geography historic and newsworthy events
Numbers pr c4000 b&w including cartes de visite and postcards
gl neg 30
gl sl 130
L sl 60
calotypes ambrotypes
Aids Catalogue subject index

496
Owner Fox Talbot Museum
Location Lacock Wiltshire Lacock 459
Custodian R E Lassam
Dates 1840 - 1858
Photographer W H Fox Talbot
Subjects FAMILY ALBUMS
Numbers pr c125 contained in 5 albums
Access Bona fide students
Copies available for sale

497
Owner Bill Gaskins
Location 85 Lower Bagthorpe Underwood Nottinghamshire 0773 810358
Dates 1839 (1970) -
Photographer Claudet A L Coburn Frederick Evans Francis Frith D O Hill and R Adamson Frank Sutcliffe William Henry Fox Talbot James Valentine Watkins
Subjects GEOGRAPHY topography social landscape Victorian period portraiture
Numbers pr c50 b&w
gl neg c12 b&w
ambrotypes c20 b&w
daguerreotypes c60 b&w
Access Bona fide students

498
Owner Professor Margaret Harker
Location c/o The National Photographic Record
Dates c1845 (1968) -
Photographer James Craig Annan Thomas Annan Walter Barnett Bassano E Beanchy Francis Bedford

Bonfils Adolphe Braun J B Dancer George Davison G Christopher Davies W J Day Dr P H Emerson William England Frank Eugene Francis Frith D O Hill and R Adamson Lafayette Harold Leighton Lock and Whitfield J E Mayall Baron de Meyer A H Robinson Sache Sommer Richard Speighton Sudek Jerry Uelsmann James Valentine Walery George Washington Wilson
Subjects HISTORY OF PHOTOGRAPHY
Numbers pr c900 b&w col
daguerreotypes 24
ambrotypes 60
L sl c150 3¼"x3¼"
stereos 23 sets b&w 3 sets col
cartes de visite
albums 10 travel and family albums 16
books illustrated with real photographs 10
calotypes 6 photogenic drawings 3
photographs on - silk 8 ceramics 30
mic 12 b&w
Aids Card index subject index
Access Bona fide students

499
Owner J E Jones
Location 20 Hollin Lane Leeds LS16 5L8
Dates c1850 -
Photographer Claudet Disderi Francis Frith Jabez Hughes Sommer James Valentine George Washington Wilson
Subjects PHOTOGRAPHY apparatus stereographs lantern slides archaeology of the cinema
Numbers L sl substantial numbers
stereographs substantial numbers
stereodaguerrotypes 16
cartes de visites substantial numbers
Access Restricted access
Copies available for sale
Charges Reproduction fee

500
Owner Kodak Limited
Location Kodak Museum Headstone Drive Harrow Middlesex 01 427 4380 Ext 76
Custodian Brian W Coe
Dates 1839 (1927) -
Photographer Most of the early classic photographers represented
Subjects GENERAL social sciences the forces education transport customs and folklore astronomy microscopy mechanical engineering agriculture and food production domestic architecture painting photography recreations athletic sports and outdoor games biography and portraits geography events
Numbers fi negs substantial number b&w col various
gl negs substantial number b&w various
gl pos substantial number b&w col various
L sl substantial number b&w col various
Aids Partial card index partial subject index
Access General public bona fide students Monday-Friday 9.30 am - 4.30 pm
Copies available for loan
Notes The premier private (i.e. commercial) photographic museum. The collection probably runs to over 100,000 images.

501
Owner Clifford Stuart Middleton
Location 38 Tollhouse Road Norwich Norfolk NR5 8QF 0603 610209
Dates 1842 (1958) -
Photographer Richard Beard Julia Margaret Cameron Dr Hugh W Diamond T D Eaton Dr P H Emerson Roger Fenton Nicolaas Henneman D O Hill and R Adamson Yousuf Karsh Kilburn J J Edwin

Key () = dates when collections were begun or terminated
C = Century c = approximately pr = print fi = film
gl = glass neg = negative sl = slide L sl = lantern slide
tr = transparency mic = microform col = colour

b&w = black and white ¼,½,1-pl = quarter, half and whole plate * = single copy, no public access ** = single copy, access by appointment

Mayall Angus McBean William Notman
Frank Sutcliffe William Henry Fox Talbot J Wiggins
Edith Willis
Subjects GENERAL
Numbers gl neg 500 b&w
L sl 600 b&w
sl 16 b&w
tr 450 b&w
Aids Subject index - partial
Access Bona fide students and fellow collectors
Copies available for sale for loan
Notes This collection is designed to cover the evolution of
photography by decades. The owner has collected
examples of the chief exponent of the development which
was characteristic of each decade. The collection also
covers the development of Kinematography, both
visual material and apparatus.

502
Owner North Western Museum of Science and Industry
Location 97 Grosvenor Street Manchester M1 7HF
061 273 6636
Title Collections - Beyer Peacock Shanks Craven
Crossley Motors Chapman Cockshoot John Clark
Glover J B Dancer O B Dancer
Custodian Dr R L Hills Museum Director
Dates 1851 (1950) -
Photographer Annan Brothers J B Dancer James Mudd
Stuart
Subjects PHOTOGRAPHIC HISTORY INDUSTRIAL
TECHNOLOGY fire service tools transport
railway signalling microscopy engineering mining
portraits
Numbers pr c10000 b&w various
pr c10000 b&w various
fi negs 12000 b&w various
gl negs 3000 b&w 1-pl 15"x12"
gl pos 50
L sl 2000 2"x2" 3¼"x3¼"
paper negs 3
daguerreotypes 3 stereodaguerreotypes 3 b&w
fi 12 35mm mic 80
Aids Card index for Beyer Peacock collection
Access On application to the Director
Copies available for sale
Charges Print fee on application reproduction fee ΠP
rates
Notes 50 signed prints by James Mudd are in original
condition. The 1842 Dancer daguerreotype was one of
the first to have an export stop order placed upon it
because of its early date and historical importance.

503
Owner Photographic Collections Limited
Location 27 Baker Street London W1M 1AE
01 487 4831
Title The Francis Bedford Collection
Custodian Barry Lane
Dates c1860 - 1880
Photographer Francis Bedford
Subjects ARCHITECTURE TOPOGRAPHY banks
parks hospitals lighthouses schools transport
mills bridges
Numbers pr 2000 sepia various
gl negs 2500 b&w 10"x8"
mic
Aids Catalogue
Access Bona fide students
Copies available for sale by arrangement

504
Owner Royal Photographic Society
Location 14 South Audley Street London W1Y 5DP
01 493 3967
Title Royal Photographic Society collection Including
Colonel Henry Wood collection Horace W Nicholls
collection Medical Group Archives
Dates Pre-photographic to present date
c1820 (c1920) -
History The collection was started by J Dudley Johnston
Photographer Marcus Adams J C Annan F Scott-Archer

E Auerbach A C Banfield C Beaton Francis Bedford
Walter Bird M Bourke-White S Bourne Brassai
Wynn Bullock Julia Margaret Cameron Lewis Carroll
A L Coburn Bertram Cox G Davison F H Day
W J Day P H Delamotte R Demachy Dr H Diamond
Franz Ditikol Maxine Du Camp Dr H E Edgerton
A Eisenstaedt William England Frank Eugene
F H Evans R Fenton Francis Frith W H Fox Talbot
Philippe Halsman D O Hill and R Adamson
A Horsley Hinton Harold Holcroft E O Hoppe
F Hollyer J Jardie Charles Job F Judge Y Karsch
G Kasebier A Keighley J H Leighton J D Llewellyn
H Bedford Lemere J Furley Lewis Paul Martin
F J Mortimer E Muybridge A McBean
Baron A de Meyer J and R Mudd Horace Nicholls
Bertram Park Oliver Pike Richard Polak
Herbert G Ponting Tony Ray-Jones O G Rejlander
A Renger-Patzsch Guido Rey James Robertson
H P Robinson Arthur Rothstein August Sander
E Steichen A Steiglitz J Sudek F M Sutcliffe
A G Tagliaferro J Thomson Col Tripe J Velsmann
Miss A Warburg J C Warburg J B Wellington
E Weston C H White Madame Yvonde
Subjects PHOTOGRAPHY GEOGRAPHY
ARCHITECTURE BIOGRAPHY AND PORTRAITS
social sciences worldwide travel India
landscapes aerial photography street scenes
country life and customs children at play
period costume animals hunting fishing
meteorology oceanography palaeontology
agriculture and food production seaside holidays
Numbers pr c30000 b&w c500 col various
fi negs c200 b&w various
gl negs c4000 b&w various
ambrotypes c100 b&w ½pl 1pl
L sl c4000 b&w c1000 col
tr c25 col 35mm
daguerreotypes c150 b&w
Aids Catalogue partial card index
Access General public bona fide students picture
researchers press tv media fee must be paid by
non-RPS members 9.15 am - 5.15 pm
Copies for sale for display for publication
Charges Reproduction fee print/transparency fee
search fee packaging and postage
Notes This is the largest and most representative
historical photographic collection in Britain. It is
particularly rich in items pertaining to the history
of photography and in photographs which in
themselves are works of art. The pictorial side of
the RPS collection can broadly be divided into
documentary photography and creative photography,
both from 1839 to the present day. Groups of
students may visit the collection by prior
arrangement. A changing exhibition of representative
photographs is always on view in the Dudley Johnston
Gallery.

505
Owner Science Museum Library
Location South Kensington London SW7 5NH
01 589 6371 Ext 536
Title Photography and Cinematography Collections
Custodian Dr D B Thomas
Dates 1827 (1882) -
Photographer Roger Fenton D O Hill and R Adamson
Eadweard Muybridge W H Fox Talbot
Subjects PORTRAITS VIEWS - Central and North
America history and development of photographic
industry motion studies
Numbers pr and paper negs c10000
collodian pos c100
gl negs c500
positive images on metal c300 - daguerreotypes
ferrotypes
L sl c6500
small collection of examples of early processes
Aids Published catalogue card index
Access General public certain restrictions
Copies available for sale

Notes The collection includes Fox Talbot Collection, Muybridge Collection and Ilford Collection.

506
Owner Denis Stanley
Location 33 Moss Lane Pinner Middlesex 01 866 1643
Dates 1854 - 1918
Photographer Claudet
Subjects GENERAL PORTRAITS Malta Harbour - views Alexandria India - railway building and engineering
Numbers pr c600 contained in 10 albums
 cartes de visite
 dagueereotypes 3
Access By arrangement
Copies available for loan

507
Owner Dr Jeffrey Stern Minstergate Books Fossgate York
Location Rose Cottage Heslington Lane York
Dates 1850 - 1920 -
Photographer E Baldus Bonfils K Dimitrion William Hindshaw G Sarolides Sebah and Jonillier Zangaki
Subjects EVENTS - historic and newsworthy landscapes
Numbers pr c650 $\frac{1}{4}$pl $\frac{1}{2}$pl
 cartes de visites c340
 special album
 daguerreotypes 2 or 3
 several ambrotypes
Notes Collection formed personally.

508
Owner Whitby Literary and Philosophical Society The Museum Pannett Park Whitby North Yorkshire
Location 1 Flowergate Whitby North Yorkshire YO21 2BA 0947 2239
Title The Sutcliffe Collection
Custodian Bill Eglon Shaw
Dates 1870 - 1910
Photographer Frank Meadow Sutcliffe
Subjects WHITBY - boats fisher people carrying out their daily tasks street scenes local village scenes seascapes outdoor portraits and groups fox hound meetings haymaking harvesting ploughing shoeing horses seaweed collecting harrowing hoeing sheep washing peat stacking landscapes building railways and railway viaduct architecture
Numbers pr substantial number b&w various
 gl negs c1424 various
 copy negs of some images
Aids Subject index
Access For prints only general public bona fide students picture researchers press tv media 9 am - 5 pm
Copies available for sale for publication credit line required
Charges Print fee reproduction fee publication fee
Notes This collection was handed to the present owners by Bill Eglon Shaw in 1967 after he bought the photographic business once owned by Frank Meadow Sutcliffe. Mr Shaw has an agreement with the Society giving him sole access to the negatives for commercial use.

509
Owner W Raymond Wingate
Location Bracken House Bulls Green Knebworth Hertfordshire Bulls Green 475
Dates 1848 (1972) -
Photographer Julia Margaret Cameron Alvin Langdon Coburn Edward Curtis Roger Fenton Francis Frith D O Hill and R Adamson Charles Job Edweard Muybridge Horace W Nicholls Henry Peach Robinson Benjamin Stone Frank Meadow Sutcliffe
Subjects PORTRAITS - historic
Numbers pr c30
 daguerreotypes ambrotypes tintypes

Aids Catalogue
Access Bona fide students by appointment only
Notes This collection includes photographs on porcelain and ivory.

510
Owner British Numismatic Society Warburg Institute Woburn Square London EC1H 0AB
Location Messrs A H Baldwin and Sons Limited 11 Adelphi Terrace London WC2N 6BJ 01 6879 1310
Title The Gordon V Doubleday Collection
Custodian Peter Mitchell
Dates 1972
Photographer Ray Gardner
Subjects NUMISMATICS coins of Edward III
Aids Published catalogue
Copies available for sale

511
Owner Peter A Clayton
Location 41 Cardy Road Boxmoor Hemel Hempstead Hertfordshire HP1 1RL 0442 67400
Dates (1953) -
Photographer Peter A Clayton
Subjects RELIGION NUMISMATICS ARCHAEOLOGY EGYPTOLOGY arts and crafts architecture ancient athletic sports and games exploration and travel
Numbers fi negs c5000 b&w 35mm
 tr c10000 col 35mm
Aids Catalogue
Access Phone or write for details of material
Copies available for sale for loan for display for publication
Charges Print/transparency fee reproduction fee
Notes Photographs have been widely used throughout the world for publication films TV etc.

512
Owner Post Office
Location King Edward Building King Edward Street London EC1 01 432 3851
Title National Postal Museum Collection
Custodian A G Rigo de Righi
Dates 1837 -
Subjects PHILATELY postage stamp designs notable philatelic personalities
Numbers Substantial
Access General public no admission charge
Copies available for sale
Charges On application

513
Owner C Blair
Location c/o Victoria and Albert Museum South Kensington London SW7 2RL 01 589 0687
Photographer C Blair Major Victor H Farquharson
Subjects ARMS ARMOUR - counties - countries
Numbers gl negs 3$\frac{1}{4}$"x4$\frac{1}{4}$"
 fi 120mm 35mm
Aids Card index
Access Bona fide students by appointment
Notes May eventually be given to National Monuments Record or Tower of London Armouries.

514
Owner Department of the Environment
Location New Armouries Tower of London 01 709 0765
Title Tower of London Armouries Photographic Section
Custodian Master of the Armouries
Dates c1916 -
Subjects ARMS AND ARMOUR
Numbers pr 30000 b&w 8"x6"
 copy negs of some images
Access General public by appointment only

Key () = dates when collections were begun or terminated C = Century c = approximately pr = print fi = film gl = glass neg = negative sl = slide L sl = lantern slide tr = transparency mic = microform col = colour

b&w = black and white $\frac{1}{4}$, $\frac{1}{2}$, 1-pl = quarter, half and whole plate * = single copy, no public access ** = single copy, access by appointment

Copies available for sale
Charges Print fee from 35p plus postage and VAT

515
Owner Victoria and Albert Museum
Location South Kensington London SW7 2RL
01 589 6371
Title The Cripps-Day Manuscript
Custodian G Blair
Dates 1922 - 1939
Subjects ARMS AND ARMOUR IN CHURCHES
Numbers pr c500 various
Access To ticket holders
Copies Xerox copies only

516
Owner Alec Davis
Location 6 Primrose Mansions Prince of Wales Drive
London SW11 4ED
Dates c1890 (c1920) -
Subjects PACKAGING - history
Numbers pr c500 b&w
gl neg 60 $\frac{1}{2}$pl
L sl 50 2$\frac{1}{4}$"x2$\frac{1}{4}$"
Access Bona fide students by appointment only
Charges Reproduction fee commercial rates
Notes About 200 of these photographs can be seen in
Package & Print by Alec Davis.

517
Owner Bath and West and Southern Counties Society
Location The Showground Shepton Mallet Somerset
BA4 6QN 0749 3366
Title Bath and West Show Collection
Custodian John W Davis
Dates Late 19thC -
History The Bath and West is the oldest Agricultural
Society in England having been founded in 1777
Subjects AGRICULTURE livestock ring events
sheep shearing produce section
Numbers tr substantial number b&w
Access Bona fide students

518
Owner Godfrey W B Bell
Location 19 Highcroft Road Felden Hemel Hempstead
Hertfordshire HP3 0BU 0442 53213
Dates 1950 -
Photographer Godfrey W B Bell
Subjects AGRICULTURE all aspects
Numbers fi negs c57000 b&w c400 col various
gl negs b&w col 5"x4" $\frac{1}{2}$pl
Aids *Catalogue *subject index
Access Picture researchers
Copies available for sale for publication
Charges Print fee reproduction fee NUJ rates
Notes The owner was staff photographer for the NFU
1961 - 1972 and is still retained by the Union.

519
Owner Felinfach Further Education College
Location Lampeter Dyfed Aeron 209
Custodian D G M Thomas
Dates 1962 -
Subjects AGRICULTURE horticulture
Numbers sl substantial number 2"x2"
Aids *Catalogue
Access Bona fide students
Copies available for loan

520
Owner E J W Hulse
Location Breamore House Breamore Hampshire
01 236 5080 - office hours
Dates c1900 (1970) -
Subjects AGRICULTURE HORTICULTURE
Numbers pr c25
Access Bona fide students by appointment only
9 am - 5 pm

521
Owner Imperial Group Limited
Location Imperial House 1 Grosvenor Place London
SW1X 7HB 01 235 7010 Ext 361
Title Public Affairs Department Industrial Photography
Library
Custodian A N Rees
Dates 1967 -
Subjects FOOD PRODUCTION public houses
plastic production carton board production
packaging production - paper plastic tin
cigarette cards snuff production cigarette production
pipe tobacco production tobacco leaf growing in the
USA frozen food production fish production
potato crisp production nut production vegetable
and fruit production table sauce and pickle
production woollen mill Cooper at work
Nottingham churches
Numbers fi negs c2000 b&w c1000 col various
Aids *Card index *subject index
Copies available for loan

522
Owner Lancashire College of Agriculture
Location Myerscough Hall Bilsborrow Preston
Lancashire Brock 40611
Custodian Audio Visual Aids Technician
Dates 1900 -
Subjects AGRICULTURE AND FOOD PRODUCTION
animal nutrition crops horticulture - equipment
dairying land reclamation
Numbers pr c250 b&w various
gl negs c100 b&w various
L sl c300 b&w various
fi c200 b&w col 35mm
sl c3000 col 2"x2"
Access Bona fide students by appointment
Copies available by arrangement

523
Owner National College of Agricultural Engineering
Location Silsoe Bedford Silsoe 60 428
Title The Library Collection
Custodian M A Keech B A Morgan
Dates (1963) -
Subjects AGRICULTURE AND FOOD PRODUCTION
livestock field crops tropical agriculture
soil conservation geography landscapes
physical features aerial photography
Numbers pr 1500 b&w col 9"x9"
sl 1200 col 35mm
fi 60 b&w col
Aids *Guide *card index
Access Bona fide students

524
Owner National Farmers Union
Location Agriculture House Knightsbridge London
SW1X 7NJ 01 235 5077
Title Post-War British Agriculture
Custodian Godfrey Bell 19 Highcroft Road Hemel
Hempstead Hertfordshire 0422 53213
Dates c1955 -
Photographer Godfrey Bell
Subjects AGRICULTURE country life and customs
food production biography and portraits of past and
present N F U personalities
Numbers pr substantial number b&w col 10"x8" $\frac{1}{2}$pl
fi negs c4000 per annum b&w col
Aids *Card index *subject index
Access General public bona fide students
Copies available for sale for loan

525
Owner Thomas A Wilkie and Company Limited
Location 41/42 Drummond Road Guildford Surrey
GU1 4NX 0483 73810
Dates 1950 -
Subjects AGRICULTURE SOCIAL SCIENCES
youth clubs hospitals seascapes dogs cats
horses architecture camping geography

Numbers pr 10000 b&w 10"x8"
 tr 2000 col 5"x4" 2¼"x2¼"
Aids Duplicated Catalogue write for copy
Access Picture researchers press tv media
 8.30 am - 5.30 pm
Copies available for sale for display for publication
Charges Reproduction fee print/transparency fee
 service charge handling fee search fee holding fee

526

Owner Three Counties Agricultural Society Malvern
 Worcestershire WR13 6NW 068 45 61731
Title Three Counties Agricultural Society Collection
Custodian The Secretary
Dates 1920 -
History This collection shows the development of the
 Society
Subjects AGRICULTURE the Annual Agricultural Show -
 various locations in Herefordshire Worcestershire
 and Gloucestershire
Numbers pr substantial numbers
Access Bona fide students

527

Owner Brian Furner
Location 38 Northend Road Erith Kent DA8 3QE
Dates 1955 -
Photographer Brian Furner
Subjects HORTICULTURE - all aspects insects
 plants fruit vegetables beekeeping
Numbers pr 5000 b&w ½pl
 sl 6500 2¼"x2¼" 35mm
Aids *Card index *subject index
Access Picture researchers publishers authors
 press tv media
Copies available
Charges Reproduction fee by arrangement
Notes Negatives held of all black and white photographs,
 some copies of colour transparencies.

528

Owner Reginald Kaye
Location Waithman's House Silverdale Carnforth
 Lancashire LA5 0TY 052 470 252
Dates 1940 -
Subjects HORTICULTURE alpine plants herbaceous
 plants flowering shrubs ferns lichens
Numbers tr 2000 col 6cm x 6cm
Aids *Card index
Access Publishers
Charges Reproduction fee £4 per print
Notes This collection is primarily for the owner's own use
 for lectures on horticultural subjects.

529

Owner Donald Smith
Location Kingfisher's Mead Riverside Bramerton
 Norfolk NR14 7EG 032 876 260
Dates (1944) -
Photographer Donald Smith
Subjects HORTICULTURE fruit flowers gardens
Numbers tr 7000 col 2¼"x2¼" 35mm
Access Bona fide students
Charges Reproduction fee by arrangement

530

Owner Cyril Grange
Location West Hill House Horringer Road Bury St
 Edmunds Suffolk P35 2DO Bury St Edmunds 5330
Photographer Cyril Grange
Subjects POULTRY INDUSTRY 1926 - 1956 WILD FLOWERS
 OF EUROPE wild flowers - The Breckland East
 Anglia Greece Rhodes Crete French Alps Dolomites
 Ireland Norway Switzerland South Africa a journey
 through the Iron Curtain - West to East Berlin

Numbers gl neg c5000 b&w 4¼"x3¼"
 sl 4000 col 35mm
Access Publishers press tv media personal
 application
Copies available in rare instances
Charges Reproduction fee
Notes Slide lectures with full personal commentary
 available on application, all apparatus provided
 except screen.

531

Owner Raymond Irons Photography
Location 35 Langbourne Mansions Highgate London
 N6 6PR 01 348 1805
Dates 1969 - 1970
Photographer Raymond Irons
Subjects FISHING fishing trawler on a voyage to Iceland
 first 365 days of a child's life
Numbers pr 6500 35mm
Access Picture researchers press tv media
 9.30 am - 5.50 pm
Copies for sale for display for loan for publication
Charges Reproduction fee print/transparency fee
 handling fee holding fee service charge search fee

532

Owner Royal National Mission to Deep Sea Fishermen
Location 43 Nottingham Place London W1M 4BX
 01 935 6823
Custodian J C Lewis
Dates 1881 -
Subjects FISHING deep sea fishermen
Numbers fi negs 5 col 16mm 35mm
 tr substantial number
Aids Guide
Access Bona fide students picture researchers press
 tv media 8.30 am - 4.30 pm
Copies available for loan credit line required
Charges No charges for reproduction

533

Owner Dundee City Council
Location Dundee City Museum Albert Square Dundee
 0382 25492 /3
Custodian James D Boyd
Dates 1890 - 1910 -
History This collection reflects the importance of the
 whaling industry in the city during the late 19th C
Subjects ARCTIC - whaling vessels - activities aboard ship
 arctic landscapes Eskimos
Numbers gl negs c12 b&w 4"x3"
 L sl c300 b&w 3¼"x3¼"
Access General public bona fide students on application
Copies available for sale for loan
Charges Print fee from existing negatives from 40p
 production of negative £1 reproduction fee on
 application

534

Owner Beaulieu Museum Trust
Location National Motor Museum Beaulieu Hampshire
 SO4 7ZN 0590 612345
Title The Photographic Library
Custodian M E Ware
Dates c1880 (1960) -
History Founded by Lord Montagu of Beaulieu in memory of
 his father
Photographer Branger W J Brunell Charles Dunn
 Michael E Ware
Subjects TRANSPORT - road motor cycle car omnibus
 commercial veteran vintage roads steam traction
 engines
Numbers pr 50000 b&w 6½"x8½"
 fi negs b&w 35mm - 10"x12"
 L sl few
 sl 5000 col 5"x4" ektachrome

Key () = dates when collections were begun or terminated
C = Century c = approximately pr = print fi = film
gl = glass neg = negative sl = slide L sl = lantern slide
tr = transparency mic = microform col = colour

b&w = black and white ¼, ½, 1-pl = quarter, half and whole
plate * = single copy, no public access ** = single copy,
access by appointment

Aids Card index subject index
Access General public bona fide students preferably
 by appointment
Copies available for sale for loan xerox photocopies
Charges Reproduction fee print fee on application

535

Owner British Railways Board 222 Marylebone Road
 London NW1 01 262 3232
Location 66 Porchester Road London W2
 01 229 0879
Title British Transport Historical Records
Custodian D Barlow Public Record Office Chancery Lane
 London WC2 01 405 0741
Dates c1900 (1952) -
History The basis of this collection is the records of all
 the original railway and canal companies
Photographer Rev A Malan
Subjects TRANSPORT civil and mechanical engineering
 staff and officials railway scenes
Numbers pr substantial number b&w col various
Aids *Card index *subject index
Access General public bona fide students
Copies Copies of specific photographs can be ordered
 delivery of copies of prints currently subject to
 three months delay
Charges Print fee reproduction fee charges of £2 per
 print (minimum) would-be publishers should negotiate
 direct with Controller of Press and Public Relations
 British Railways Board

536

Owner Central Association of Photographic Societies
Location 16 Glencoe Road Weybridge Surrey
 KT13 8JY 0932 41062
Title Central Association Permanent Collection of Prints
Custodian L S Douch
Dates 1894 -
Photographer James Annan Herbert Bairstow
 J Alan Cash Noel Habgood Alfred Horsley Hinton
 Eric Hoskings Charles Job Alexander Keighley
 F J Mortimer H G Ponting
Subjects TRANSPORT NATURE ARCHITECTURE
 RECREATIONS athletic sports and outdoor games
 biography and portraits geography historic and
 newsworthy events
Numbers pr c150 b&w various
 tr c150 b&w various
Aids Duplicated catalogue
Access Access to the collection other than to affiliated
 clubs for special purposes only (eg research) by
 arrangement with the C A P S
Copies available on loan to affiliated photographic clubs
 any other persons by special arrangement only
Charges The curator charges out of pocket expenses
 when visiting clubs
Notes The collection represents some of the finest work
 of members of photographic clubs/societies over
 the past 80 years. Publication of prints cannot be
 arranged with the C A P S, only with authors or where
 deceased, their heirs or representatives.

537

Owner T E K Chambers
Location 5 Haymoor Letchworth Hertfordshire SG6 4HS
 Letchworth 72702
Dates 1932 (1947) -
Subjects TRANSPORT - locomotives rolling stock
 passenger and goods trains engineering railways
 history derelict railway lines piston and jet
 aeroplanes R A F and U S A F N A T O airshows
 canals harbours and docks windmills local
 history of Hertfordshire villages towns churches
 industrial archaeology
Numbers pr 150 b&w 10"x8" - postcard
 fi neg c2000 b&w 2¼"x2¼" - 35mm
 sl c50 b&w c4600 col 35mm
Aids *Card index *subject index
Copies available for publication
Charges Reproduction fee

538

Owner John Cowan
Location Vicarage Close Blewbury Oxfordshire
 0235 850267
Custodian Mrs C P Messenger
Dates 1956 -
Photographer John Cowan
Subjects TRANSPORT psychology occupations and
 services forces customs and folklore meteorology
 archaeology nature civil and building construction
 mechanical engineering agriculture and food
 production food drink architecture outdoor games
 biography and portraits geography historic and
 newsworthy events
Numbers fi negs substantial number 35mm 120
 tr c5000 col
Access Bona fide students picture researchers press
 tv media 9 am - 5.30 pm by appointment only
Copies available for sale for publication
Charges Reproduction fee print/transparency fee
 search fee

539

Owner Foden Limited
Location Elsworth Works Sandbach Cheshire CW11 9HZ
 093 67 3244
Custodian A V Evans
Dates 1900 -
Subjects TRANSPORT ENGINEERING early farm
 equipment steam wagons early motor vehicles
Numbers gl pl c800
Access General public bona fide students publishers
 press tv media
Copies available for sale for loan
Charges Reproduction fee depending on individual cases

540

Owner IPC Business Press Limited
Location IPC Transport Press Limited Dorset House
 Stamford Street London SE1 9LU 01 262 8000
Title Incorporating the collections of Flight International
 Aeroplane Monthly Autocar Motor Commercial Motor
 Motor Transport Motor Boat and Yachting
 Yachting World etc
Custodian J A Lee
Dates 1895 -
Photographer Charles Sims John Yoxall
Subjects TRANSPORT road safety lifeboats lighthouses
 air force cloud formations oceanography
 motor racing and rallies power boat racing
 biography and portraits exploration and travel abroad
Numbers pr c500000 b&w 10"x8"
 fi negs c850000 b&w various
 gl negs c420000 b&w various
 tr c40000 col 35mm 2¼"x2¼"
Aids Card index
Copies available for sale when copyright is held
Charges Reproduction rights sold to authors and
 publishers at current rates

541

Owner Leicestershire County Council
Location Art Gallery and Museum New Walk Leicester
 LE1 6TD 0533 539111
Title Includes Newton Collection Henton Collection
 Lumbers Collection Hawke Collection Brush
 Collection
Custodian I Cruikshank
Dates c1860 -
Photographer Adams Brush Hawke Lumbers
 Alfred Newton
Subjects TRANSPORT Great Central Railway people
 topography vehicles
Numbers pr c20000 b&w various
 fi negs c5000 b&w 3"x4½" 4¾"x6½"
 gl negs c10500 b&w various
 L sl c5775 b&w 3¼"x3¼"
Aids *Card index visual files to Newton Collection only
Access General public to certain parts of the collection
 only Newton and British Collections during Museum
 hours all others by appointment only

Copies for sale
Charges Print fee
Notes The Newton Collection records the building of the Great Central Railway from start to finish.

542

Owner Graham P Norman
Location 8 Rockbourne Avenue Liverpool L25 4TW
Dates 1972 -
Subjects TRANSPORT motoring - historic and modern steam locomotives water ski-ing English Lake District
Numbers pr c150 b&w 10"x8"
 fi negs 4000 b&w 35mm
 sl 100 col 2¼"x2¼"
 tr 500 col 35mm
Aids *Card index *subject index
Access Bona fide students would be considered
Copies available for sale for loan for exhibitions only
Charges Current magazine and journal rates

543

Owner Oxford House Industrial Archaeology Society
Location Risca Adult Education Centre Oxford House Risca Gwent 0633 612245
Custodian The Secretary
Dates 19thC -
Photographer R Derek Sach David Thomas
Subjects TRANSPORT INDUSTRIAL HISTORY Penllwyn Tramroad Rudry furnace Melworiffith water pump shuffleboat paddleboat Brecon and Merthyr railway Brecon canal mining equipment
Numbers pr c1000 b&w
 sl c2500 col
Aids *Subject index
Access Bona fide students picture researchers press tv media 9 am - 5 pm
Copies available for loan depending on use
Charges Fees are rarely charged

544

Owner Ruston Diesels Limited PO Box 25 Lincoln 0522 21241
Location Archives Office Lincoln Castle Lincoln
Title Ruston and Hornsby Collection
Custodian R E Hooley
Dates c1860 (1960) -
Subjects TRANSPORT invention of the 'diesel' engine caterpillar tracks products for World Wars internal-combustion engines steam engines excavators locomotives pumps motor cars aeroplanes tractors farm machinery
Numbers pr c5000 b&w
 fi negs c5000 b&w
 gl negs c10000 b&w
 L sl c500 b&w
 sl c500 b&w
Aids Part subject index
Access Bona fide students by arrangement
Copies available at discretion of custodian
Charges Print fee on application

545

Owner Peter W Robinson
Location 2 Lynngarth Drive Gillinggate Kendal Cumbria 0539 26194
Dates c1870 (c1965) -
Photographer Peter W Robinson
Subjects TRANSPORT IN CUMBRIA - railways - all aspects
Numbers pr c2500 various
 fi negs c1500 35mm
Access Bona fide students by arrangement

546

Owner P W B Semmens

Location 18 Low Poppleton Lane York YO2 6AZ
Dates 1945 -
Photographer P W B Semmens
Subjects TRANSPORT - rail and air locomotives trams aeroplane - piston and jet engines - steam diesel and electric railways stations docks and harbours airports industrial archaeology building exteriors public buildings seaside holidays mountains and hills rivers and lakes in Great Britain and India
Numbers pr c1500 b&w c200 col
 fi neg c4000 b&w c2000 col 2"x2" - 35mm
 sl 4000 col 2"x2" - 35mm
Access Bona fide students
Copies available for sale

547

Owner Air Commodore A H Wheeler (Trustee)
Location Old Warden Aerodrome Biggleswade South Bedfordshire SG18 9ER 076 727 288
Title The Shuttleworth Collection
Custodian D F Ogilvy
Dates 1909 (1930) -
Photographer M Vines
Subjects TRANSPORT - veteran and vintage road bicycles airships aeroplane models cars horse-drawn carriages
Numbers pr b&w various
 sl col
 tr
Copies available for sale for loan
Charges Print fee by arrangement
Notes The photographic collection is incidental to the Shuttleworth collection of aircraft cars motor cycles fire engines aero engines and horse drawn carriages.

548

Owner B S Trinder
Location 20 Garmston Road Shrewsbury Shropshire 0743 52310
Dates 1954 -
Photographer B S Trinder
Subjects TRANSPORT - rail road inland-waterways locomotives navigations stations locks public festivals fairs mills mining equipment buildings pottery landscapes Scandinavia Germany Benelux countries
Numbers pr 400 b&w
 fi neg 500 b&w
 sl 4000 35mm
Aids Catalogue
Access Bona fide students

549

Owner IPC Business Press Limited - Electrical-Electronic Press
Location Dorset House Stamford Street London SE1 9LU 01 261 8000
Title Hi-Fi Year Book Illustrations
Custodian G H Mansell
Dates 1973 -
Subjects COMMUNICATIONS audio radio tape disc components and equipment
Numbers pr substantial numbers b&w various
Access Bona fide students by arrangement only
Copies available subject to copyright

550

Owner IPC Business Press Limited
Location Dorset House Stamford Street London SE1 9LU 01 261 8425
Title Wireless World Historical Photographs
Custodian T H Hall Editor 01 261 8425
Dates c1920 - 1973
Subjects COMMUNICATIONS radio television electronics
Numbers pr c3500 b&w various

Key () = dates when collections were begun or terminated
C = Century c = approximately pr = print fi = film
gl = glass neg = negative sl = slide L sl = lantern slide
tr = transparency mic = microform col = colour

b&w = black and white ¼, ½, 1-pl = quarter, half and whole plate * = single copy, no public access ** = single copy, access by appointment

Access Bona fide students
Copies available for loan

551
Owner Post Office
Location Postal Headquarters Publicity Division
St Martin's-Le-Grand London EC1A 1HQ
01 432 3513
Title Postal Publicity Photographic Library
Custodian P G Howe
Dates 1863 -
Subjects POSTAL SERVICE uniforms stamps
transport historic and newsworthy events
Numbers pr c20000 b&w col 8½"x6½"
fi negs c15000 b&w col various
sl c10000 b&w col 35mm 2¼"x2¼" 5"x4" 10"x8"
Aids *Catalogue *subject index
Access General public bona fide students picture
researchers through the Public Relations Officers
situated to cover the whole of Great Britain
Copies available for sale for loan for reproduction
Charges Reproduction fee on application
Notes "The library illustrates all aspects of the postal
service. Its earliest illustration is of a Roman
messenger c52 BC and the earliest photographs show
a stiffly-posed London Letter Carrier in Summer and
Winter uniform."

552
Owner GEC-Marconi Electronics Limited
Location Marconi House Chelmsford Essex CM1 1PL
0245 53221
Title Marconi Archival Collection
Custodian Mrs B Hance
Dates 1896 (1897) -
Subjects RADIO history of radio occupations and
services the forces communications biography
and portraits historic and newsworthy events
Numbers fi negs c200 b&w
gl negs c400 b&w
Aids *Card index *subject index
Access Bona fide students
Copies available for sale for loan credit line required
Charges No charge for reproduction
Notes The Marconi Archival Collection forms a small
part of the Company's large photographic library
which covers all aspects of the Company's work.

553
Owner Granada Television Limited
Location Quay Street Manchester 3 061 832 7211
Ext 497
Custodian Picture Librarian
Dates c1890 (1956) -
Subjects TELEVISION studios and equipment religion
occupations and services the forces associations
and societies education transport customs and
folklore science nature botany zoology
mechanical engineering mining agriculture and food
production clothes sculpture and carving
painting architecture photography musical
instruments recreations portraits geography
historic and newsworthy events
Numbers pr substantial numbers b&w various
sl c15000 col 35mm
Aids *Card index
Access Bona fide students written appointment only
Copies available for sale for loan depending on copyright

554
Owner Thames Television and ABC Television
Location 308 Euston Road London NW1
Custodian John William Breckon
Dates 1954 -
Subjects TELEVISION drama comedy religion
adult education current affairs musicals
schools
Numbers pr substantial number b&w 10"x8"
fi negs c250000 2¼"x2¼" 35mm
tr c20000 2¼"x2¼" 35mm
sl c20000 2¼"x2¼" 35mm

Copies available for sale
Charges Subject to negotiation

555
Owner Telecommunications Limited
Location PO Box 53 Coventry Warwickshire CV3 1HJ
0203 452152
Custodian Publicity Manager
Dates 1910 -
Photographer J P Delaney
Subjects TELECOMMUNICATIONS
Numbers fi negs 35000 b&w 500 col 5"x4" 2¼"x2¼"
tr 500 b&w 35mm
Aids *Subject index
Access The collection is not open to inspection but
written applications will be considered
Copies available on application
Charges No reproduction fee acknowledgement requested
Notes The majority of the photographs are of components
and products unique to the Company and were taken
for engineering record purposes.

556
Owner Standard Telephones and Cables Limited
Location 190 Strand London WC2 1DU 01 836 8055
Custodian J Read
Dates c1895 (c1927) -
Subjects TELECOMMUNICATIONS electronics
Numbers pr c9000 b&w 10"x8"
Aids Subject index
Charges Reproduction fee by negotiation

557
Owner Alan B Cross
Location 8 Rollswood Drive Solihull West Midlands
021 704 1009
Dates 1945 -
Photographer Alan B Cross
Subjects TRANSPORT - road tram trolleybus omnibus
Numbers pr c4000 b&w 5½"x3½"
fi negs c50000 b&w 3½"x2½" - 35mm
Aids Partial card index
Access Bona fide students limited access by
appointment
Copies available for sale
Charges Print fee reproduction fee £1 per photograph
Notes This collection is solely concerned with passenger
carrying road vehicles in Great Britain, with
particular reference to buses, trams and trolley buses
operated by the London Passenger Transport Board,
and its predecessors and successors.

558
Owner Crosville Motor Services Limited
Location Crane Wharf Chester CH1 3SQ 0244 24151
Title Crosville Photographic Record Files
Custodian Publicity Officer
Dates 1914 -
History The collection is an historical record of the
Company
Subjects ROAD TRANSPORT buses and coaches
bus depots bus stations staff functions and
personalities engineering - bus industry
Numbers pr c1500 b&w col various
Aids *Subject index
Notes Photographs are sometimes released for
transportation, student and advertising purposes.

559
Owner G Jesieniecki
Location 6 Redcliffe Street West Brompton London
SW10 9DS
Title G Jasieniecki Collection
Dates (1960) -
Photographer A B Cross D W K Jones P J Marshall
Subjects LONDON BUSES TRAMS AND TROLLEYBUSES -
all aspects social sciences customs and folklore
architecture circuses pageants
Numbers pr 8000 b&w various
fi negs 4000 b&w various
tr c600 col 35mm

F

Access Bona fide students by arrangement
Copies available for sale

560

Owner Mercury House Publications Limited
Location Mercury House Waterloo Road London SE1
Title Car Mechanics Magazine Library
Dates 1958 -
Subjects TRANSPORT technical motoring
Numbers pr substantial numbers b&w col various
Aids Card index

561

Owner Vauxhall Motors Limited
Location Kimpton Road Luton Bedfordshire 0582 21122
Title Public Relations Department Collection
Custodian Glyn Davies
Dates c1900 (1946) -
History The collection covers the history and development
of Vauxhall Motors Limited including Bedford
commercial vehicles
Subjects ROAD TRANSPORT all aspects Vauxhall
Motors - Vauxhall passenger cars Bedford
commercial vehicles factories personnel
Numbers pr c10000 b&w
fi negs c20000 b&w
Notes Material generally available on request, free of
charge, to any member of the public, to advertising
agencies, authors, newpapers, students, collectors,
etc. The collection can now only supply Photos of
modern subjects and a limited selection of historic
cars and commercial vehicles.

562

Owner York Trailer Company Limited
Location Yafforth Road Nothallerton North Yorkshire
Northallerton 3155
Custodian E S Bone
Dates 1965 -
Photographer E S Bone
Subjects ROAD TRANSPORT
Numbers fi negs 100000 b&w 20000 col 5"x4" 2¼"x2¼"
Aids *Card index *subject index customer/end user index
tractor unit index
Access Picture researchers journalists publishers
press tv media 8.30 am - 5 pm appointment by
phone or letter
Copies available for display for publication credit line
required
Charges No charges are normally made for reasonable
quantities black and white colour laboratory charges
are sometimes charged direct

563

Owner Shell Research Limited
Location Thornton Research Centre PO Box 1 Chester
Cheshire CH1 3SH 051 355 3755
Title Scientific Technical and Research Photographs
Custodian Francis Fox
Dates 1939 -
Photographer H R Barker F Fox R Harris A J Insall
A M Pantony R Thomas R P Wilson
Subjects INTERNAL COMBUSTION engine components
laboratory equipment scientific phenomena
building projects local village history
Numbers fi negs 95922 b&w col various
gl negs c22180 b&w
L sl substantial number
Aids Catalogue subject index
Access Only by prior appointment through letter giving
full details of requirements and purpose
Copies available for approved purposes
Charges By arrangement
Notes A collection of photographs of objects connected
with research in the performance of various types of
internal combustion engines. There are a number of

periphotographs ie 360° views of the periphery of
various objects taken with a special camera developed
by Shell.

564

Owner Automobile Association
Location Fanum House Basingstoke Hampshire
RG21 2EA 0256 20123
Title The AA Photographic Library
Custodian M D Tuckfield
Dates 1906 -
Subjects THE AA motoring services general activities
Numbers pr c10000
Access Bona fide students by special arrangement
Copies available
Charges Mainly for free reproduction with acknowledgement
print fee at cost plus postage

565

Owner A Carter c/o National Westminster Bank Silsden
Keighley West Yorkshire
Subjects CARS motor cars racing cars land speed
record
Numbers pr
fi negs
sl
tr
Access Bona fide students by appointment only
Copies available for sale
Charges Print fee on request
Notes "A Unique Collection".

566

Owner Haymarket Publishing Limited
Location Craven House 34 Fouberts Place London W1
01 439 4242
Title Autosport
Custodian David Winter
Dates 1950 -
Subjects CARS motor racing motor rallies
motor sport
Numbers pr c3000 b&w various
tr c500 col 35mm
Copies available for sale - limited to recent prints
for loan
Charges Print fee

567

Owner London Art Technical Drawings Limited
Location Standard House Bonhill Street London
EC2A 4DA 01 628 4741
Title Photographic Libraries of Motor Sport and
Motoring News
Dates (1947) -
Photographer John Dunbar Laurence A Morton
Maurice Selden Michael J Tee
Subjects CARS motor racing and rallying vintage and
veteran cars driver portraits landscapes of
U S A and South Africa
Numbers fi negs 428000 b&w 2¼"x2¼" 35mm
sl 96000 col 2¼"x2¼" 35mm
Aids Contact prints
Access Picture researchers press tv media
9 am - 5 pm by appointment only
Copies available for sale for loan for display
for publication b&w pr for sale only not for loan
col for loan and reproduction not for sale
Charges Reproduction fee print fee holding fee
search fee

568

Owner Neill Bruce Photographic
Location 17 Cedar Drive Kingsclere Newbury
Berkshire RG15 8TD 0635 298929
Title The Neill Bruce Motoring Library
Dates 1971 -

Key () = dates when collections were begun or terminated
C = Century c = approximately pr = print fi = film
gl = glass neg = negative sl = slide L sl = lantern slide
tr = transparency mic = microform col = colour

b&w = black and white ¼, ½, 1-pl = quarter, half and whole
plate * = single copy, no public access ** = single copy,
access by appointment

Photographer Neill Bruce Miggie Bruce
Subjects MOTOR CARS - action and portraits
Numbers fi negs c3300 b&w col 5"x4" 35mm
 tr c1300 col 5"x4" 2¼"x2¼"
Aids Printed list on application
Access By appointment only
Copies available for sale
Charges On application
Notes The collection covers cars from 1904 to the
 present time.

569
Owner Science Museum Library
Location London SW7 2DD 01 589 6371
Title Hooper and Company Collection
Dates c1918 - 1957
Subjects CAR BODIES
Numbers pr 1066 b&w various
Access General public

570
Owner Science Museum Library
Location London SW7 2DD 01 589 6371
Title D Napier and Son Limited Collection
Dates 1911 - 1931
Subjects CARS AEROPLANES MOTOR BOATS
 engines workshops early flying records
 Sir Malcolm Campbells racing cars Schneider
 Trophy races World War I vehicles
Numbers pr c3500 b&w various
Access General public

571
Owner Science Museum Library
Location London SW7 2DD 01 589 6371
Title Dr H A Whitcombe Collection
Dates 1870 - 1940
Subjects TRAMS TROLLEYBUSES BUSES - British
 and foreign
Numbers pr 8240 b&w various
 gl negs c1000 b&w ¼pl ½pl
Aids *Catalogue *subject index
Access General public
Copies available for sale

572
Owner Manchester Transport Museum Society Trustees
Location 1020 Manchester Road Castleton Rochdale
 Greater Manchester 0706 43918
Title Manchester Transport Museum Society Collection
Dates 1865 (1961) - 1949 -
Subjects TRAMS trams in Greater Manchester
Numbers pr 4975 b&w various
Access Postal enquiries only other Museum
 organisations only
Copies available for loan

573
Owner Science Museum Library
Location Department 5 London SW7 2DD 01 589 6371
Title Thorneycroft Collection
Dates 1885 - c1950
History This is a comprehensive collection of a firm's
 history
Subjects COMMERCIAL ROAD VEHICLES
Numbers pr c3000 b&w 10"x8"
 fi negs 2 rolls
 gl negs c3000 b&w various
Access General public
Copies available for sale on request

574
Owner Cheshire County Council Director of Highways
 and Transportation
Location Backford Hall Backford Nr Chester
 0244 315451
Custodian Technical Services Section Ref SR/ECMS
Subjects ROADS aerial-photography of M56 Preston
 Brook - Bowden section M531 Ellesmere Port
 Motorway microscopy mineralogy geology
 bridges plant land reclamation farm lands

 landscapes physical features
Numbers pr substantial numbers b&w
 tr substantial numbers col
Aids Catalogue
Access No access but written requests will be considered
Copies available
Charges Print fee on application

575
Owner Merseyside Metropolitan County Council
Location The Mersey Tunnels Georges Dock Buildings
 Liverpool Merseyside 051 236 8602
Title Construction of the Queensway and Kingsway
 Mersey Road Tunnels
Custodian G P J Davies
Dates 1924 - 1973
Photographer Steward Bale
Subjects ROADS construction of the Queensway and
 Kingsway Mersey road tunnels town life geology
 mining public buildings historic and newsworthy
 events
Numbers pr 500 b&w col 10"x8"
 tr 40 col 16mm 8mm
Access Bona fide students
Copies available for sale

576
Owner Bristol City Council Council House College Green
 Bristol 1 0272 26031
Location City Museum Queens Road Bristol BS8 1RL
 0272 299771
Title Keen Collection Shipping Photographs
Custodian Enquiries to the Director
Dates 1900 - 1950
History This is a wide collection of prints mainly based
 on photographs taken by Richard Keen during a lifetime
 spent in and around Bristol
Photographer Edwin R Keen
Subjects SEA TRANSPORT American shipping
 Bristol owned steamers British cargo steamers
 British coasters coastal passenger steamers
 cross channel packets Ellerman lines foreign
 shipping oil tankers Royal Naval vessels sail
 square rig and fore and aft shipwrecks White
 Funnel fleet
Numbers pr c20000 b&w contained in 63 volumes
Aids Volumes arranged by type of shipping or country
 or shipping line roughly chronological
Access General public bona fide students by appointment
 research projects will not be dealt with unless
 arrangements are made to study the
 collection personally
Copies for sale provided that arrangements have been
 made beforehand to study the collection and make a
 specific order quoting appropriate negative numbers
 and details
Charges Print fee at cost from commercial photographers
Notes Every effort will be made to allow access to the
 Bristol City Museum Collections for genuine research
 and study but the Museum does not have a full-time
 photographer in charge of the Collections and most
 enquiries have to be dealt with by the appropriate
 curator. Delays are inevitable therefore and general
 requests for 'information and photographers'
 will not be entertained unless arrangements have
 been made to study the Museum's archive and
 photographic collections in person so that a sensible
 and detailed request for copies of specific photographs
 or prints can be made.

577
Owner Bristol City Council
Title York and Parsons collections
Custodian Enquiries to the Director
Dates 1890 (1896) 1930
History John York built up a remarkable record of the
 ships using Bristol between 1895 - 1914. Particularly
 fine record of the final phase of commercial sailing
 ships
Photographer John York Parsons

Subjects TRANSPORT SEA sailing ships steam ships
local coastal craft paddle steamers
Numbers gl negs 3632 b&w ½pl ¼pl
Aids Card index arranged according to name of ship
Notes Owner, Location, Access, Copies, Charges and
Notes as for No. 576 above.

578
Owner Inverclyde District Council Department of
Libraries and Cultural Services
Location McLean Museum and Greenock Art Galleries
9 Union Street Greenock Renfrewshire
0475 23741
Title Clyde and other river steamers
Custodian Alex Donald
Dates Mid 1800 – 1930
Subjects SEA TRANSPORT inland waterways
paddleboats sailing boats docks and harbours
lifeboats architecture biography and portraits
views of old towns Glasgow University
James Watt Buildings
Numbers pr c3000 1pl
Aids *Subject index
Access Bona fide students

579
Owner Jonathan Eastland and Peter Eastland
Location 17 Kent Road Southsea Hampshire PO5 3EG
0705 29120
Title Ajax News and Feature Service Ajax News Photos
Dates 1962 –
Photographer Jonathan Eastland Peter Eastland
Subjects SEA TRANSPORT NAVY YACHTING TRAVEL
occupations and services architecture recreations
children – from birth
Numbers fi negs c10000 35mm
tr c5000 col 35mm
Aids List sent on receipt of sae
Access Picture researchers press tv media by
appointment only 10 am – 10 pm
Copies available for sale for publication credit line
required
Charges Print/transparency fee holding fee publication
fee service charge NUJ rates
Notes Collection includes some glass plates of 1890 – 1920
of Naval subjects, people at leisure, transport and
farming in Canada. The modern section begun by
Jonathan Eastland specialising in marine subjects,
later joined by Peter Eastland specialising in Spanish
travel, people etc. Current projects include long term
coverage of all aspects of merchant marine life by
Jonathan Eastland.

580
Owner Lancashire County Council
Location College Library Nautical College Fleetwood
Lancashire
Title Nautical Slide Collection
Custodian M Wilson
Dates (1965) –
Subjects SEA TRANSPORT communications – radio
telecommunications science meteorology
Numbers tr 1500 b&w 2000 col 2"x2"
Aids Duplicated guide
Access Bona fide students

581
Owner National Maritime Museum Trustees
Location The National Maritime Museum Greenwich
London SE10 9NF 01 858 4422
Title The National Maritime Museum Historic Photograph
Collection
Custodian The Director
Dates 1843 (1947) –
History There is a small quantity of material from the
Lacock Abbey collection

Photographer Amos of Dover Bedford Lemere Coates of
Harwich Cozens of Portsmouth Cribb of Portsmouth
Fox of London Francis Frith Oliver Hill Hopkins of
Portsmouth Rev Calvert Jones McFee of London
F J Mortimer Nautical Photo Agency of Beccles
Owers of Portsmouth Perkins of Newton Abbot
Seward of Weymouth West of Portsmouth
Subjects SHIPPING – naval and mercantile ports and
harbours – dock systems cranes subsidiary crafts –
lifeboats tugs harbour craft inland-waterway craft
naval portraits
Numbers pr c300000 b&w
fi neg 55000 b&w
gl neg 60000 b&w
L sl 10000 b&w 3¼"x3¼"
sl & tr 200 col 2"x2"
others 15000 b&w
Access By appointment
Copies available for sale only where negatives exist
Charges Prints from 20p transparencies from 75p
postage and packing from 20p reproduction fees by
arrangement
Notes Also included are the Perkins, Nautical Photo
Agency, McFee, Fox and Oliver Hill collections, and
Admiralty World War II Merchant Ship photographs.

582
Owner Port of Lowestoft Research Society
Location Central Library Lowestoft Suffolk
0502 66325
Title Port of Lowestoft Research Society Collection
Custodian D Lester King
Dates 1860 –
Subjects SHIPPING LOWESTOFT – lifeboats – docks and
harbours
Numbers pr c10000 b&w 8"x6"
fi negs c15000 b&w various
gl negs c1000 b&w various
Access General public bona fide students
Copies available for sale by arrangement with the Society

583
Owner Sail Training Association
Location 3 Tuffs Hard Bosham Hoe Chichester
Sussex PO18 8ET 0243 572160
Custodian Mrs D Bromley-Martin
Dates 1965 –
Subjects SEA TRANSPORT schooners Sir Winston
Churchill schooner Malcolm Miller schooner
interior and exterior
Numbers pr c250 b&w
fi negs c250 b&w
tr 100 b&w
Access General public bona fide students
Copies available for sale
Charges Reproduction fee depending on individual cases
commercial use standard charges

584
Owner Science Museum Library
Location South Kensington London SW7 5NH
01 589 6371 Ext 536
Title Berner Collection
Custodian J A Chaldecott
Dates 1901 – 1931
Subjects SUBMARINE CABLE LAYING ships
scenes ashore
Numbers pr 100 b&w
fi negs c1200 b&w ¼pl
gl negs 60 b&w
gl pos 30 b&w
Access General public
Copies available for sale

Key () = dates when collections were begun or terminated
C = Century c = approximately pr = print fi = film
gl = glass neg = negative sl = slide L sl = lantern slide
tr = transparency mic = microform col = colour

b&w = black and white ¼,½,1-pl = quarter, half and whole
plate * = single copy, no public access ** = single copy,
access by appointment

585
Owner Submarine Museum Trustees
Location H M S Dolphin Gosport Hampshire
 Portsmouth 22351 Ext 41250
Title Submarine Photographs
Dates 1900 (1963) -
History The Submarine Museum opened in 1968
Subjects SUBMARINES - primarily British
Numbers pr c2000 b&w
Access Bona fide students
Copies available by arrangement
Charges Print fee commercial rates
Notes Owing to the small staff and lack of facilities it is
 not possible for the Museum to provide a general
 service but they do endeavour to help serious enquiries.
 Visitors by arrangement only through the Visits Office,
 H M S Dolphin, Portsmouth 22351 Ext 41868.

586
Owner Swan Hunter Group Limited
Location Wallsend Shipyard Wallsend Tyne and Wear
 NE28 6EQ 0632 628921
Custodian Press and Public Relations Manager
Dates Early 20thC -
Subjects SEA TRANSPORT launches and sea trials of
 ships
Numbers pr substantial numbers
 fi negs substantial numbers
 gl negs substantial numbers
 sl substantial numbers
Aids *Subject index
Access Bona fide students in special circumstances
Copies available for sale for loan
Charges Reproduction fee by arrangement
Notes This collection is basically a working tool for the
 public relations/press department of Swan Hunter.

587
Owner World Ship Society 28 Natland Road Kendal
 Cumbria
Location Southampton Horsham Brockworth
Title World Ship Society Photographic Library
 Potts Collection Parsons Collection and others
Custodian D Ridley Chesterton 27 Howard Road
 Coulsdon Surrey CR3 2EB 01 660 1338
Dates 1900 -
Subjects SHIPS steam and sail from 1880's
Numbers fi negs c50000
Copies available by arrangement with the Custodian
Charges On application

588
Owner Humberside County Council
Location Goole Area Library Carlisle Street Goole
 Humberside 0405 3784
Title Garside Collection
Custodian Area Librarian
Dates c1890 - c1960
Photographer Norman Burnitt Harold Garside
Subjects SHIPS DOCKS - Goole - municipal celebrations
 aerial views roads and streets residential buildings
Numbers pr c700
Access General public bona fide students Monday to
 Friday 9.30 am - 7 pm Saturday 9.30 am - 5 pm
Copies available

589
Owner E N Taylor
Location 41 Vale Grove Gosport Hampshire
Title British and Foreign Cargo Ships
Dates 1860 (c1932) -
Photographer J Clarkson A Duncan Frank Parry
 F Sherlock
Subjects CARGO SHIPS
Numbers pr c10000 5½"x3½"
 fi negs c2000 3"x2½"
 gl negs c1500 9"x5"
Aids Catalogues
Access Bona fide students
Copies available for sale for loan
Charges No reproduction fee

590
Owner G R Scott
Location 12 The Grove Broom Lane Whickham Newcastle
 upon Tyne NE16 4QY 0632 881894
Dates 1870 (1946) -
Subjects MERCHANT MARINE STEAMSHIPS/MOTORSHIPS
Numbers pr c12000 b&w 5½"x3½"
Access Bona fide students

591
Owner Tom Molland Limited
Location Cornwall Street Plymouth Devon 0752 69284
Custodian Ray Smith
Dates 1900 (c1930) -
Subjects WARSHIPS warships worldwide from 1900 to
 present time
Numbers fi negs c4000 b&w ½pl
Aids *Catalogue *card index
Access General public bona fide students picture
 researchers press tv media 8.30 am - 5.30 pm
Copies available for sale for display for loan
 for publication
Charges Reproduction fee print/transparency fee
 holding fee

592
Owner C and S Taylor
Location 3 North Avenue Eastbourne East Sussex
 BN20 8RB
Title C and S Taylor Warship Photograph Collection
Dates c1968 -
Photographer Clive Everard Taylor
 Susan Margaret Taylor
Subjects WARSHIPS technical equipment
Numbers pr c500 b&w 13"x8"
 fi negs c8000 b&w 35mm 6cm x 9cm
Aids *Card index
Access Bona fide students by appointment only
Copies available for sale
Charges Reproduction fee by arrangement

593
Owner Ian Maclagan
Location Carmonadh Eastlands Road Rothesay
 Isle of Bute
Dates 1860 (1968) -
Photographer Ian Maclagan
Subjects HARBOURS Rothesay harbour Clyde and
 Western Isles steamers
Numbers pr c250 b&w various
 sl c50 b&w c1000 col 2¼"x2¼" 35mm
Access Bona fide students by appointment only
Copies Some black and white negatives available

594
Owner Mrs Connie Regan
Location 176 Hammersmith Grove London W6
 01 748 4997
Dates (1964) -
Photographer Connie Regan
Subjects DOCKS Port of London River Thames
Numbers pr c200
 sl c200
Charges On application dependent on slide
Notes This is an ever-changing and growing collection
 as research develops. Prints are only available
 during lectures or exhibitions.

595
Owner J D Anderson
Location 29 The Fairway Blaby Leicester
 053 729 3434 Ext 488 - working hours
Dates 1880 (1970) -
Subjects CANALS - Britain especially Leicestershire
Numbers pr b&w
 fi negs c2200 b&w 35mm
 tr c300 col 35mm
Aids Card index subject index
Access Bona fide students written appointment only
Copies available for sale
Charges Reproduction fee commercial rates

596
Owner John L Brown
Location Churchward 88 Bromsgrove Road Romsley
 Halesowen West Midlands B62 OLF 0562 710 226
Dates 1939 -
History Portraits of A E Housman and Francis Brett Young
Photographer John L Brown
Subjects INLAND WATERWAYS canals signs and
 signals - road and rail docks and harbours
 Birmingham portraits
Numbers pr c250 b&w
 sl c300 2¼"x2¼"
 tr c4600 col 2"x2"
Aids Subject index
Access General public picture researchers bona fide
 students press tv publishers by appointment only
Copies available on request
Charges Print fee trade rates reproduction fee

597
Owner Port of Manchester
Location Ship Canal House King Street Manchester
 M2 4WX 061 872 2411
Title The Manchester Ship Canal Company Collection
Dates 1870 -
Subjects INLAND WATERWAYS Manchester Ship Canal -
 history building operation traffic equipment
Aids *Subject index
Access General public bona fide students prior
 application
Copies available for sale for loan
Charges Certain prints may be subject to a copyright
 charge if reproduced

598
Owner Mrs S M Rolt
Location Stanley Pontlarge Winchcombe Gloucestershire
 0204 602594
Title Late L T C Rolt Collection
Dates (c1920) -
History The collection is a working photographic collection
 compiled over forty five years by a popular author
 in Mechanical and Railway Engineering, History and
 Biography and in Canals
Subjects CANALS INDUSTRIAL BIOGRAPHY
 mechanical engineering transport railways
 civil and building construction
Access Bona fide students by written appointment only
 giving purpose of visit
Charges Contribution to selected body eg Ironbridge
 Gorge Museum Trust etc
Notes It is not yet decided what the ultimate destination of
 the Rolt Archive shall be. The photographs are an
 integral part of the archive and will not be separated
 from it.

599
Owner Michael E Ware
Location Flat 2 Upper Palace Stables Beaulieu
 Hampshire SO4 7YL 0590 612345 (day)
 0590 612386 (evening)
Dates c1850 (1970) -
Subjects BRITISH INLAND WATERWAYS
Numbers pr 400 b&w
 sl 400 col 2¼"x2¼"
 Copy negatives of some images
Copies available to authors only
Charges Reproduction fee on application
Notes The collection also includes a large number of
 postcards of inland waterways.

600
Owner Alan Cordell
Location Yieldsted 17 Court Way Twickenham Middlesex
 TW2 7SA
Dates 1857 -

Subjects SPRITSAIL BARGES
Numbers pr c1750 2¼"x2¼" - 10"x8"
 fi neg c500 2¼"x2¼"
 gl neg c20 3½"x4½"
 tr negs c250 24mmx36mm
 tr c500 24mm x 36mm
Access Bona fide students by appointment
Copies available for sale as owner's time allows
Charges Prints up to 10"x8" at ¾ of normal professional
 price

601
Owner R H Perks
Location Weald Cottage Eastling Faversham Kent
 079 589 203
Title Hugh Perks Maritime Collection
Dates c 1840 -
History Mr Perks is a founder member of the Dolphin
 Sailing Barge and Museum Trust and also the Society
 for Spritsail Barge Research
Subjects THAMES SAILING BARGES - coastal maritime
 history country cottages rural crafts Thameside
 scenes
Numbers pr c3000 b&w c150 col ½pl
 fi neg c1000 b&w 2¼"x2¼"
 L sl c150 b&w
 sl c300 col 35mm
Aids A catalogue and card index in preparation
Access General public by appointment
Copies available for sale for loan for reproduction
Charges Print/transparency fee reproduction fee

602
Owner Thames Barge Sailing Club
Location National Maritime Museum Romney Road
 Greenwich SE10 9NF 01 858 4422
Title Thames Barge Sailing Club Collection
Custodian Alan Cordell 'Yieldsted' 17 Court Way
 Twickenham Middlesex TW2 7SA
Dates 1875 -
Subjects INLAND WATERWAYS Spritsail Barges
Numbers pr 300 various
Access General public bona fide students with
 restrictions
Copies available for sale for specific purposes
Charges Normal commercial rates for 24"x24" copy negs

603
Owner E C Watt
Location 39 Beaumont Drive Rosherville Gravesend
 Kent DA11 9NN Gravesend 52181 after 7.30 pm
Dates c1905 (1970) -
Subjects SAILING BARGES river scenes S E England
Numbers postcards c200
Access Bona fide students by appointment
Charges 50p donation to Society of Spritsail Barge
 Research Society

604
Owner Peter J Bish
Location 4 Goodways Drive Bracknell Berkshire RG12
 3AU Bracknell 21527
Dates 1967 -
Photographer Peter J Bish
Subjects CIVIL AVIATION - airliners light aircraft
 helicopters modern hot air balloons gyroplanes
 Britten-Norman Islander and Trislander series
Numbers pr c1000 b&w 4½"x2¾" - ½pl
 fi neg 4000 b&w 35mm
 tr 400 col 35mm 2¼"x2¼"
Aids Lists of specific aircraft types on request
Access Contact owner for details
Copies available for sale
Charges Prices and sizes available on request

Key () = dates when collections were begun or terminated
C = Century c = approximately pr = print fi = film
gl = glass neg = negative sl = slide L sl = lantern slide
tr = transparency mic = microform col = colour

b&w = black and white ¼,½,1-pl = quarter, half and whole
plate * = single copy, no public access ** = single copy,
access by appointment

605
Owner British Aircraft Corporation
Location Civil Aircraft Division Weybridge Surrey
0932 45522
Title B A C Aircraft
Custodian D Childerhouse 0932 45555
Dates (1954) -
Photographer D Childerhouse
Subjects AIR TRANSPORT British Aircraft Corporation -
construction personalities design facilities
aircraft - Viscount Valiant Vanguard TSR2
VC10 1-11 Concorde
Numbers fi negs c50000 b&w col 4"x5" 2¼"x2¼"
tr 3000 col 4"x5" 2¼"x2¼"
Aids *File print guide *register
Access Bona fide students
Copies available copy negs will be made on request

606
Owner James Gilbert
Location 1 Grafton Square London SW4 0DE
01 622 9253
Dates 1903 (1960) -
Subjects AIR TRANSPORT - Europe U.S.A. early
aeroplanes in flight all types of general aviation
aircraft historic aircraft
Numbers pr 2000 b&w 10"x8"
fi negs 10000 b&w 35mm 2¼"x2¼"
tr 1000 b&w 35mm
Aids Filed alphabetically by aircraft type
Access Picture researchers press tv media
9 am - 6 pm
Copies available for sale for publication
Charges Publication/reproduction fee print/transparency
fee
Notes The owner is Editor of Pilot magazine.

607
Owner Foto Hunter
Location 29 Ridgeway Drive Lydiate Liverpool
L31 0DE 051 526 7464
Title International Aviation Fotos
Custodian B W Hunter
Dates 1965 (1970) -
Photographer B W Hunter
Subjects AIR TRANSPORT aviation aircraft
helicopters military aviation
Numbers pr 1500 b&w various
fi negs 20000 b&w 35mm 2¼"x2¼"
tr 2000 col 35mm
Aids Published catalogues 50p each *subject index
Access General public aviation enthusiasts picture
researchers press tv media by appointment
9 am - 9 pm
Copies available for sale for display for publication
Charges Print fee prices given in catalogue reproduction
fees on request
Notes Photographs listed in the catalogue are of a
'record' nature, particularly suited to recognition
training. Material of a more creative and interpretative
nature on file is available for publication.

608
Owner Leggett and Gray International Photojournalists
Location Suite 71 5 Acre Drive Glasgow G20 0TL
041 945 0148
Title Leggett and Gray Collection
Leggett Early Aviation Library
Dates 1957 -
Photographer Anne Gray Jim Leggett
Subjects AIR TRANSPORT World War I aircraft army
air force religion social sciences old cemeteries
police children at play transport public festivals
meteorology archaeology anthropology flowers
reptiles birds sheep home clothes arts and
crafts architecture string instruments
musical performances golf camping horse-riding
portraits travel abroad historic and newsworthy
events motorcycle - race sport custom space
launches (Apollo) Americana
Numbers pr 500 b&w 8"x10"

fi negs 3000 b&w 35mm
tr 10000 b&w 10000 col 35mm
Aids In the process of being catalogued
Access Bona fide students picture researchers
press tv media publishers 9 am - 2 pm
Copies available for sale for display for publication
credit line required
Charges Publication/reproduction fee print/transparency
fee holding fee if held longer than 30 days

609
Owner Stephen Peltz
Location 9 Cambridge Square London W2 01 439 3951
Title Aircraft and Reptiles
Dates 1958 -
Subjects AIR TRANSPORT military aircraft reptiles -
lizards insects
Numbers fi negs 50000 b&w various
tr c18000 col 35mm
negs 4000 col 35mm
Aids *Subject index
Access Bona fide students publishers press tv media
Copies available for sale for publication
Charges Reproduction fee print/transparency fee
commercial rates

610
Owner Mrs I M Burns (Trustee)
Location 33 Devonshire Road Hazel Grove Stockport
Cheshire SK7 6BX
Title The Aeroplane Collection
Custodian I M Burns
Dates 1903 (1961) -
Subjects AEROPLANES aviation
Numbers fi negs c2500 b&w
sl 300 col 35mm
Aids *Catalogue *card index in preparation
Access Bona fide students publishers press no personal
callers
Copies available for sale
Charges Reproduction fee standard rates or negotiable
for non-profit organisations

611
Owner Air Portraits
Location 85 Waseley Road Rubery Birmingham
B45 9TL 021 453 3735
Title Historic and Modern Aeroplanes
Custodian David Davies Michael Vines
Dates 1900 (1968) -
Photographer David Davies Michael Vines
Subjects AEROPLANES piston: jet veteran and vintage
helicopters
Numbers fi negs c1500 b&w 2¼"x2¼"
sl c5000 col 2¼"x2¼"
Aids Subject index
Access To the original images picture researchers
press tv media
Copies available for sale for publication credit line
required
Charges Reproduction fee negotiable dependent on use
print/transparency fee holding fee
Notes Specialising in vintage and veteran aircraft owned
by the Shuttleworth Collection, Old Warden
Bedfordshire.

612
Owner J B Harrison
Location 12 Widgeon Road Darlington Durham DL1 1BJ
Title Aircraft of the 1930s
Dates 1930 (1936) - 1939
Photographer J B Harrison
Subjects CIVIL AND SERVICE AIRCRAFT
Numbers pr c50 b&w 2¼"x3¼"
fi neg c50 b&w 2¼"x3¼"
Access Bona fide students publishers press tv media
Copies available for sale by arrangement
Charges Reproduction fee by arrangement

613

Owner Royal Aeronautical Society
Location 4 Hamilton Place London W1V 0BQ
 01 499 3515
Custodian A W L Nayler
Dates 1875 (Late 19thC) -
Subjects AERONAUTICAL
Numbers pr 12000 b&w various
 gl negs 500 b&w 3¼"x3¼"
 L sl 12000 b&w 3¼"x3¼"
 sl 500 b&w various
Aids *Catalogue *card index *subject index
Access Bona fide students
Copies available for sale
Charges Research fee
Notes A comprehensive collection, unrivalled in its field.

614

Owner N D Welch
Location 70 Wordsworth Avenue Stafford ST17 9UB
Dates 1955 -
Subjects AIRCRAFT - civil military veteran vintage
 static and flying - world wide
Numbers fi neg 6100 b&w
 tr 1400 col 35mm
Aids Card index
Access Picture researchers bona fide students press tv
 media on written application
Copies for sale for display for publication
Charges Print/transparency fee reproduction fee

615

Owner J H L Adams
Location Finstall Croft Nr Bromsgrove Worcestershire
 B60 1EW 021 444 2907
Dates 1900 -
Photographer J H L Adams
Subjects RAIL TRANSPORT
Numbers pr substantial number 10"x8"
 fi negs substantial number
 tr substantial number
 fi c100 b&w col
Access Bona fide students by special arrangement
Notes The collection is jointly owned by P B Whitehouse
 59 Cambridge Road Birmingham B13 9UF.

616

Owner R A and P R Bowen
Location Park House 108 Sydney Road London N10 2RN
Dates 1873 (1958) -
Photographer E A Powen P A Bowen R A Bowen
Subjects RAIL TRANSPORT British Railways
 stations locomotives - French Swiss
 pre-grouping Companies preserved locomotives
 Narrow Gauge Railways Industrial Railways
Numbers pr c6000 5"x7"
 fi negs various
Aids Subject index
Access Bona fide students by appointment only

617

Owner Bristol City Council Council House College Green
 Bristol 1. 0272 26031
Location City Museum Queens Road Bristol BS8 1RL
 0272 299771
Title Woodfin Collection (Great Western Railway
 Photographs)
Custodian Enquiries to the Director
Dates 1850 - 1950
History Large collection of 35mm negatives taken by
 Richard Woodfin over many years until his death in
 1971. The negatives are often copies of original GWR
 official drawings photographs etc., and there is also a
 wide range of documentary material, list of rolling
 stock, officiial inventories etc. to supplement the
 negatives. The collection was presented to the Museum

by Mrs Woodfim in 1971
Photographer Richard Woodfin
Subjects RAIL TRANSPORT - locomotives rolling stock
 goods and passenger of Great Western Railway - Bristol
 and Exeter Railway - South Devon and Cornwall
 Railways engineering features stations
Numbers pr c2000 various
 fi negs 21000 b&w 35mm
Aids Inventory list and subject index (not completed)
Access General public bona fide students by appointment
 research projects will not be dealt with unless
 arrangements are made to study the collection
 personally
Copies available for sale provided that arrangements are
 made beforehand to study the collection and make a
 specific order quoting appropriate negative numbers
 and details
Charges Print fee at cost from commercial photographers
Notes Every effort will be made to allow access to the
 Bristol City Museum Collections for genuine research
 and study but the Museum does not have a full time
 photograper in charge of the collections amd most
 enquiries have to be dealt with by the appropriate
 curator. Delays are therefore inevitable.

618

Owner Darlington Borough Council
Location Darlington Museum Tubwell Row Darlingon
 Durham DL1 1PD 0325 63795
Custodian A Suddes
Dates c1820 - 1960 -
Subjects RAIL TRANSPORT
Numbers pr c2000 b&w
Access General public bona fide students
Copies available for loan

619

Owner British Rail
Location Regional Headquarters Paddington Station
 London W2 1HA 01 723 7000
Title Great Western Negatives Midland Region
 Scottish Region Eastern Region and British Rail
 Engineering Works L M S Collection
Custodian J R Hodson
Dates 1865 -
Subjects RAIL TRANSPORT - all aspects
Numbers pr substantial numbers 8"x6"
Aids Subject index
Access General public bona fide students picture
 researchers press tv media by appointment only
Copies available for sale for loan for display for
 publication
Charges Print/transparency fee if no negative 25p fee
 cost of print 37p
Notes This collection is in the process of being organised
 and enquiries should be sent to the Oxford Publishing
 Company, 8 The Roundway, Risinghurst, Headington,
 Oxford. Prints from the collection are to be marketed
 jointly with the Oxford Publishing Company in the
 future.

620

Owner Festiniog Railway
Location Porth Madog Gwynedd
Title Festiniog Railway Collection
Dates c1850 -
Subjects FESTINIOG RAILWAY
Numbers pr substantial numbers b&w col
 fi b&w col 16mm
Access By special arrangement
Copies available for sale
Charges Standard rates

621

Owner Allan Garraway
Location Minppordd Penrhyndeudraeth Gwynedd

Key () = dates when collections were begun or terminated
C = Century c = approximately pr = print fi = film
gl glass neg = negative sl = slide L sl = lantern slide
tr = transparency mic = microform col = colour

b&w = black and white ¼,½,1-pl = quarter, half and whole
plate * = single copy, no public access ** = single copy,
access by appointment

Title Allan Garraway Collection
Dates c1936 -
Photographer Allan Garraway R H R Garraway
Subjects RAIL TRANSPORT locomotives rolling stock -
 passenger goods engineering stations Germany
Numbers pr 127 b&w col various
 fi b&w col 16mm
Access By special arrangement
Copies available for sale
Charges Standard rates

622

Owner Gloucester Railway Carriage and Wagon Company
 Limited
Location Bristol Road Gloucester GL1 5RR 0452 25104
Custodian J F G Ash
Dates 1862 -
Subjects RAIL TRANSPORT railway rolling stock
Numbers pr c7500 b&w 20 col various
 fi negs c3000 b&w 20 col various
Aids *Catalogue
Access Customers and Railway organisations
 i.e. preservation societies
Copies available for sale on request
Charges Print fee reproduction fee on request negatives
 to remain Gloucester's property

623

Owner Michael Hale
Location 132 Sedgley Road Woodsetton Dudley
 West Midlands DY1 4LJ 021 553 2451
Dates (1948) -
Subjects RAIL TRANSPORT Great Western Railway
 stations buildings junctions loco sheds signalling
 locomotives scenery - Black Country
Numbers pr c6000 b&w 5½"x3½"
 fi negs c6000 b&w 3¾"x2¼" 2¼"x1⅝"
 tr c1500 col 35mm
Access By appointment only enquiries by letter
Copies available for sale in limited numbers
Charges Reproduction fee on application

624

Owner D Hardy
Location 6 Headingley Crescent Darlington Durham
Title Railway Photographs
Custodian D Hardy
Dates 1920 (1956) -
Photographer D Hardy
Subjects RAIL TRANSPORT Darlington works official negs
 1930 - 1950
Numbers pr c2500 b&w
 fi negs c2000 b&w
 gl negs c250 b&w
Aids Duplicated catalogue
Access General public bona fide students publishers
 press tv media
Copies available for sale from: Folk Train 95 Parkgate
 Darlington
Charges Print fee postcards 8p wholeplates from 25p

625

Owner Locomotive Club of Great Britain
Location 11 Braywood Avenue Egham Surrey
 TW20 9RQ
Title Ken Nunn Collection
Custodian G T V Stacey
Dates 1897 - 1962
History Ken Nunn was President of the Locomotive Club
 of Great Britain from its foundation in 1949 until his
 death in 1965
Photographer H L Hopwood C D E R Nunn K A C R Nunn
Subjects TRANSPORT - rail
Numbers fi negs 2000 b&w
 L sl 150 b&w
 gl negs 10000 b&w ¼pl
Aids *Subject index
Access Bona fide students
Copies available for sale lists available
Charges Print fee reproduction fee from £1.50p per
 subject

626

Owner J F Mallon
Location 112 Stooperdale Avenue Darlington
 Co Durham DL3 OUD
Dates 1953 -
Subjects RAIL TRANSPORT North Eastern Railway -
 all aspects pre-grouping locomotives
Numbers fi negs 5500 b&w 2¼"x3¼" 35mm
Aids Published catalogue
Copies available for sale

627

Owner Railway and Canal Historical Society
Location Littlemoor Paddington Nr Tiverton Devon
 EX16 8LN
Custodian A P Voce Honorary Secretary
Dates c1870 (1954) -
Subjects RAILWAY AND CANALS bridges
Numbers substantial numbers
Copies available to Society members only

628

Owner N E Skinner
Location 6 Headingley Crescent Darlington Durham
Title Railway Photographs
Custodian D Hardy
Dates 1950 -
Photographer N E Skinner
Subjects RAIL TRANSPORT railways all aspects
Numbers fi negs c10000 b&w
Aids Duplicated catalogue
Access Bona fide students
Copies available for sale from: Folk Train
 95 Parkgate Darlington
Charges Print fee postcards 8p wholeplates from 25p

629

Owner W E Boyd
Location Scottish Record Office PO Box 36 H M General
 Register House Edinburgh EH1 3YY 031 556 6585
 031 226 5101
Title W E Boyd Collection (S R O Reference GD257)
Custodian G Barbour
Dates 1850 -
Subjects LOCOMOTIVES steam locomotives of LMSR
 LNER GWR SR and pre-grouping Railway
 companies European subjects - French Dutch
 locomotives
Numbers pr c350 b&w various
 fi negs c3160 b&w various
 gl negs c160 b&w various
Aids Catalogue numerical lists
Access Bona fide students
Copies available for sale by arrangement
Charges Print fee commercial rates

630

Owner Rex Owen Coffin
Location 90 Sweets Road Kingswood Bristol Avon
 0272 676343
Title King George V Preserved Steam Locomotive
Dates 1968 -
History King George V was the most powerful steam
 engine in Britain in its day. It was the principal
 locomotive of the Great Western Railway and
 represented Britain at the Baltimore and Ohio
 Railway celebrations in 1972
Photographer Rex Owen Coffin
Subjects STEAM LOCOMOTIVE King George V
Numbers fi negs c5000 b&w 2¼"x2¼" 3¾"x3¼"
Aids Books containing contact prints of all negatives
Access General Public by prior arrangement only
Copies available for sale
Charges Reproduction fee standard rates
Notes Some of these photographs have been published in
 books written by the owner - 'Mainline Steam in the
 Seventies' and 'Steam Around Bristol'.

631

Owner Rex Owen Coffin
Title Steam Locomotives of the British Railways

Dates 1920 - 1964 -
Subjects STEAM LOCOMOTIVES
Numbers fi neg c4000 2¼"x2¼" - 3¼"x2¼"
 gl neg c100 5½"x3½"
Aids Subject index
Notes Photographs 1952 - 1964 by Rex Coffin, prior to
these dates photographer unknown. A number of these
photographs are reproduced in a book written by the
owner 'Steam Around Bristol'. Location, Photographer
Access, Copies and Charges as for No. 630 above.

632

Owner Rex Owen Coffin
Title Preserved Steam Locomotives in the British Isles
Dates 1971 -
Subjects STEAM LOCOMOTIVES
Numbers fi negs c2500 b&w 2¼"x2¼"
 tr 400 col 35mm
Notes A number of these photographs are reproduced in a
book written by the owner 'Mainline Steam in the
Seventies' and in 'Renaissance from Rust' by Gordon
Wood. Location, Photographer, Aids, Access, Copies
and Charges as for No. 630 above.

633

Owner A G Ellis
Location 16 Almond Crescent Standish Lancashire
 WN6 0AZ Standish 422923
Dates 1865 - 1970
Photographer A G Ellis
Subjects LOCOMOTIVES rolling stock
Numbers fi negs c37000 various
Aids Prints arranged in numerical order
Access Bona fide students by appointment only

634

Owner Glasgow City Council
Location The Mitchell Library Charing Cross
 Glasgow G3 7DN 041 248 7121
Title North British Locomotive Company Collection
Custodian W A G Alison
Dates c1864 - 1945
History The collection was acquired on North British
Locomotive Company's liquidation
Subjects LOCOMOTIVES
Numbers gl negs c9000
Access General public bona fide students
Copies available for sale

635

Owner J A Peden
Location 18 Rockhill Road Liverpool Merseyside
 L25 8RB 051 428 5615
Dates 1954 -
Photographer J A Peden
Subjects LOCOMOTIVES - industrial and main line -
road steam canals trams ships industrial
archaeology
Numbers pr c13000 b&w 5"x4"
Access Bona fide researchers by appointment only
Copies available on request exchange basis preferred
Charges Normal commercial rates

636

Owner Pendon Museum Trust Limited
Location Pendon Museum of Miniature Landscape and
Transport Long Wittenham Abingdon Oxford
OX14 4QD Clifton Hampden 365
Title Pendon Collection
Custodian Roye England
Dates 1925 (1925) -
History Basis for 1:76 detailed model of landscape and
transport in the Vale of the White Horse in the period
1923 - 1937
Photographer Roye England

Subjects TRANSPORT railways rural architecture in
Vale of the White Horse
Numbers pr b&w col various
 fi negs b&w various
 L sl col 35mm
 sl col 120mm
Copies available by arrangement
Charges Print fee commercial rates
Notes Includes special collections of rural West Country
architecture in its setting and G W Railway items.

637

Owner Science Museum Library
Location London SW7 2DD 01 589 6371
Title P C Dewhurst Collection
Dates 1880 - 1930
Subjects LOCOMOTIVES
Numbers pr c2000 b&w various
Aids List of Negatives
Access General public
Copies available for sale

638

Owner J M Boyes
Location 3 Central Avenue Billingham Cleveland
 TS23 1LU
Dates 1953 -
Subjects RAILWAYS - rail transport locomotives steam
transport stations electrical appliances and machines
Numbers pr c4000 b&w 1-pl
 fi neg c 12000 2¼"x2¾"
 sl 20000 2"x2" - 3¼"x3¼"
Access Bona fide students
Copies available for sale for loan

639

Owner Ian S Carr
Location 126 Mount Road Sunderland Tyne and Wear
 SR4 7QD
Dates 1955 -
Subjects RAILWAYS - N E England
Numbers fi negs substantial number 2¼"x2¼" 2¼"x3¼"
Copies Postal applications for assistance with prints for
reproduction purposes
Charges Fees on request

640

Owner Derek Cross
Location Knockdon Farm Maybole Ayrshire KA19 8EH
 0655 83186
Title Railways in the Landscape
Dates 1951 -
History A series of photographs initially taken out of an
interest in the steam locomotive and latterly in the
railway as part of the landscape
Photographer Derek Cross
Subjects RAILWAYS - steam internal-combustion diesel
and electric engines stations landscapes and physical
features in New Zealand and parts of the Pacific
Islands and the Far East aerial photography in
New Zealand and the Far East
Numbers pr 15000 b&w 1-pl
 tr c500 col 35mm
 sl c500 2¼"x2¾"
Aids Subject index
Access Bona fide authors or publishers
Copies available for sale by prior agreement
Charges Reproduction fee standard professional charges
Notes Photographs not on the owner's files take up to six
weeks to be delivered.

641

Owner N Forrest
Location Auchlochan 14 Gordon Road Bridge of Don
 Aberdeen AB2 8PT 0224 703298
Dates 1959 -

Key () = dates when collections were begun or terminated
C = Century c = approximately pr = print fi = film
gl = glass neg = negative sl = slide L sl = lantern slide
tr = transparency mic = microform col = colour

b&w = black and white ¼,½,1-pl = quarter, half and whole
plate * = single copy, no public access ** = single copy,
access by appointment

Photographer N Forrest
Subjects RAILWAYS STEAMERS
Numbers pr c300 b&w
 fi neg 12500 b&w 35mm
 sl 100 b&w c14000 col 35mm
Aids Catalogue in progress
Access Publishers press bona fide students by
 prior arrangement
Copies available on request commercial rates
Charges Print fee reproduction fee by arrangement

642

Owner Great North of Scotland Railway Association
Title Barclay-Harvey Collection
Custodian N Forrest
Photographer Sir C M Barclay-Harvey
Subjects RAILWAYS Great North of Scotland Railway
 foreign railways
Numbers pr c175 b&w 2¼"x3½"
Aids GNSR items catalogued
Notes Location, Access, Copies, Charges as for No. 641
 above.

643

Owner Great North of Scotland Railway Association
Dates c1860 (1964) -
Subjects RAILWAYS Great North of Scotland Railway
Numbers pr c350 b&w various
 fi negs c186 b&w 35mm
 L sl c100 b&w 2¼"x2¼"
Aids Catalogue in progress
Notes Location, Custodian, Access, Copies and Charges
 as for No. 641 above.

644

Owner S H Pearce Higgins
Location 67 London Road Worcester Hereford and
 Worcester 0905 356401
Dates c1860 (c1920) -
Photographer J F Bruton S H Pearce Higgins W H Wright
Subjects RAILWAYS tramways industrial archaeology
 social history
Numbers negs c4000 various
Aids Subject index (incomplete)

645

Owner K Hoole
Location Broughton House 25 Pickering Road West Ayton
 Scarborough 0723 83 2129
Dates c1860 (1930) -
History The collection shows the rise and decline of the
 railways of North Eastern England
Subjects RAILWAYS - the former North Eastern Railway
Numbers pr c42000 b&w 4"x3" 8½"x6½"
 fi neg 2000 b&w 2¼"x3¼"
Aids *Subject index
Access by special arrangement only
Copies Copy negatives for some images

646

Owner Industrial Locomotive Society
Location 18 Rockill Road Liverpool L25 8RB
 051 428 5615
Title Industrial Locomotive Society Photographic Collection
Custodian J A Peden
Dates 1870 (c1930) -
History Photographs have been donated to the collection
 by members of the Society
Subjects RAILWAYS industrial locomotives scenes
Numbers pr c1200 b&w 5"x4"
Aids *Card index
Access Generally Society members only although
 sometimes exceptions can be made
Copies available for loan for publication in railway
 enthusiasts journals
Charges No charge for loan apart from postage

647

Owner David Joy
Location Hole Bottom Hebden Skipton North Yorkshire
 0756 752369

Dates 1855 (1958) -
Subjects RAILWAYS - South and West Yorkshire Cumbria
Numbers pr c750 various
Access Bona fide students by appointment only
Copies available for sale for publication
Charges Reproduction fee

648

Owner Charles Alfred John Keevil
Location Penhurst York Road West Hagbourne Didcot
 Oxford OX11 0NG
Dates 1953 -
Subjects RAILWAYS fire appliances current events
 floods crashes general views aeroplanes vehicles
 religious buildings ambulances ships animals
Numbers pr c2000 b&w
 tr c600 col 35mm
Aids Subject index
Access Bona fide students by appointment only

649

Owner London Underground Railway Society
Location 6 Redcliffe Street West Brompton London SW10
Title The London Underground Railway Society
 Photograph Collection
Custodian G Jasieniecki
Dates 1863 (1961) -
Subjects RAILWAYS all aspects of London's Underground
 Railway system
Numbers pr c1500 b&w various
 sl c750 col 35mm
 mic 35mm
Access Society members only bona fide students
 by appointment
Copies available for sale
Charges Reproduction fee by arrangement subject to
 copyright

650

Owner Narrow Gauge Railway Society 47 Birchington
 Avenue Birchencliffe Huddersfield HD3 3RD
 04227 4526
Location The Sycamores Church Street Golcar
 Huddersfield West Yorkshire HD7 4AJ
Title Narrow Gauge Railway Society Library Collection
Custodian Dr R P Lee
Dates 1870 (1951) -
Subjects RAILWAYS narrow gauge railway locomotives
 rolling stock and fixtures operations
Numbers pr c2000 b&w col various
 fi negs c200 b&w
 fi b&w 16mm
Aids Duplicated catalogue
Access Bona fide students by prior arrangement
Copies available for loan only in special circumstances
Notes The collection has largely been donated by
 members from their own photographs taken since 1930.

651

Owner North Eastern Railway Association
Location 325 Ryhope Road Sunderland Tyne and Wear
 SR2 9SS
Custodian K L Taylor 77 West Crescent Darlington
 Co Durham DL3 7PS 0325 61377
Dates 1870 - 1960
Photographer K Hoole R J Purvis Canon Tracy L Ward
Subjects NORTH EASTERN RAILWAY - rolling stock
 engines stations
Numbers pr 900 b&w
 fi neg 15 b&w 6"x4"
 gl neg 380 b&w 5"x4"
Aids Catalogue available from custodian
Access Bona fide students
Copies available for sale for loan
Charges Print fee reproduction fee on application

652

Owner V B Orchard
Location 26 Litchfield Way Guildford Surrey GU2 5QH
Title Rail Record
Dates 1890 (1950) - 1965

Photographer V B Orchard
Subjects RAILWAYS
Numbers pr c2000 various
Charges By negotiation

653
Owner M L Ridley
Location The Squinting Cat Pannal Ash Harrogate
 North Yorkshire 0423 65650
Custodian Colin Bullock
Dates 1962 -
Subjects RAILWAYS - N E England
Numbers pr c400 b&w
 fi negs c400 b&w 35mm
 sl c100 col 35mm
Access Bona fide students
Copies available on request negatives available for loan
Charges Print fee at cost

654
Owner J D Shutler
Location 9 Crescent Avenue Barnstaple North Devon
 EX31 2ED 0271 71472
Title Lynton-Barnstaple Railway
Dates 1896 - 1935
Photographer R L Knight Major, Darker & Lorraine
Subjects RAILWAY - Lynton to Barnstaple
Numbers pr 67 b&w 6"x4" - 12"x8"
 fi neg 60 3¼"x4¼"
 gl neg 60 3¼"x4¾" - 4¾"x6¼"
Access General public bona fide students picture
 researchers press tv media by appointment
 10 am - 6 pm
Copies available for sale for display for publication
 credit line required
Charges Print fee reproduction fee search fee
Notes Part of this collection is at the North Devon
 Athenaeum.

655
Owner Peter Tatlow
Location Pear Tree Cottage Little Tangley Wonersh
 Guildford Surrey GU5 OPW 0483 69574
Dates c1900 (1950) -
Subjects RAILWAYS in Britain rail mounted cranes
 and wagons narrow gauge railways civil engineering
Numbers fi negs c5000 b&w 35mm
 sl c1000 col 35mm
Access Bon fide students by appointment only

656
Owner Kenneth L Taylor
Location 77 West Crescent Darlington Co Durham
 DL3 7PS 0325 61377
Dates 1870 (1948) -
Photographer K Hoole P Purvis Canon Tracy L Ward
Subjects NORTH EASTERN RAILWAY LOCOMOTIVES -
 carriages wagons stations
Numbers fi negs 200 b&w various
 gl neg 10 b&w 5"x4"
Aids *Subject index
Access Bona fide students
Copies available for sale for loan

657
Owner Bluebell Railway Preservation Society Trustees
 Sheffield Park Nr Uckfield East Sussex
Location 13 Coalecroft Road Putney London SW15
Title Archives of the Bluebell Railway Preservation
 Society
Custodian Klaus Marx
Dates 1876 (1959) -
Photographer Maurice P Bennett
Subjects RAILWAYS history of the Bluebell Railway
Numbers pr c1200 b&w 5"x4"
 mic b&w

Aids Listed in a notebook
Access By private arrangement
Copies available by private arrangement and agreement
Notes The collection includes the London, Brighton and
 South Coast and other associated Companies south
 of the Thames.

658
Owner J S Whitfield
Location 11 Gloucester Place Darlington Co Durham
 0325 67134
Dates c1900 -
Subjects RAILWAYS
Numbers pr c20 b&w
Access Bona fide students
Copies available for loan by negotiation
Notes Mr Whitfield also has railway catalogues containing
 prints.

659
Owner P Wilson
Location 99 Grange Road Darlington Co Durham
 0325 64711
Dates 1850 (1945) -
Photographer Edward Haigh Cecil Ord
Subjects RAILWAYS
Numbers fi negs c5000

660
Owner W B Yeadon
Location 1151 Holderness Road Hull Humberside
 HU9 9EE 1482 783103
Title The Yeadon LNER collection
Dates 1923 (1933) - 1967 -
History The collection comprises a 98½% complete
 photographic record of the locomotives of the London &
 North Eastern Railway showing technical differences
 of detail and illustrates the trains they hauled and the
 areas in which they worked
Subjects LONDON AND NORTH EASTERN RAILWAY
Numbers pr c22000 b&w mostly postcard size
Aids *Catalogue
Access Bona fide students by written appointment only
Copies available only where own negatives are held
Charges Reproduction fee by negotiation

661
Owner Douglas Thompson
Location 7 Norfolk Road Bury St Edmunds Suffolk
 IP32 6AY Bury St Edmunds 3126
Dates c1930 (1953) -
Photographer Rev D Rokeby Douglas Thompson
Subjects RAILWAY STATIONS England Wales Scotland
 Ireland
Numbers pr c8500 5½"x3½"
 fi negs c12500 35mm 5½"x3½"
Aids Catalogue
Access General public Bona fide students by appointment
 only
Copies available
Charges Print fee post card size from 7p + postage

662
Owner Dormer Tools (Sheffield) Limited
Location Summerfield Street Sheffield South Yorkshire
 S11 8HL 0742 78633
Custodian R G Fisher
Dates c1913
History The collection covers the history of the company
 which was founded in 1913
Subjects PRACTICAL ENGINEERING tools manufactured
 by Dormer Group - twist drills reamers end mills
 milling cutters taps dies counterbores countersinks
 Company employees and overseas visitors
 factory interiors

Key () = dates when collections were begun or terminated
C = Century c = approximately pr = print fi = film
gl = glass neg = negative sl = slide L sl = lantern slide
tr = transparency mic = microform col = colour

b&w =black and white ¼,½,1-pl = quarter, half and whole
plate * = single copy, no public access ** = single copy,
access by appointment

Copies available for loan in special circumstances
 Credit line required
Charges Reproduction fee subject to requirement

663
Owner Hargreaves Group Limited Group Public Relations
 Department
Location Bowcliffe Hall Bramham Wetherby West
 Yorkshire LS23 6LP 0937 843535
Title Hargreaves Group Limited Photographic Collection
Custodian R C Miller
Dates 1920 -
Subjects PRACTICAL ENGINEERING soild and liquid fuel
 distribution canal carriage road haulage waste
 disposal plant hire shipping quarrying
 structural engineering motor vehicle distribution
 effluent treatment equipment Bowcliffe Hall
 Royal family
Numbers pr c400 b&w 20 col 10"x8" 8"x6"
 tr 25 col
 sl 50 col
Aids *Subject index
Access General public bona fide students by request in
 writing only to the custodian
Copies available for sale for loan depending on
 circumstances and availability

664
Owner James Neill Holdings Limited Napier Street
 Sheffield S11 8HB
Location Sheffield Wolverhampton Cannock Warrington
Custodian G Fidler
Dates c1940 -
History James Neill (Sheffield) Limited was founded in
 1889
Photographer Brian Cocker Gordon Fidler Albert Keats
Subjects PRACTICAL ENGINEERING hand and
 industrial tools magnetic tools precision measuring
 tools spanners and wrenches files pliers
 building and plant
Numbers pr 11500 b&w col 8½"x6½" 10"x8"
 fi negs 11500 b&w col 5"x4"
 gl negs 500 b&w 5"x4"
Aids Published catalogue
Access Bona fide students written request
Copies available for sale for loan subject to approval
Charges Print fee

665
Owner W J Kings
Location 140 Stourbridge Road Bromsgrove Hereford
 and Worcester 0527 73836
Dates 1930 (c1940) -
Subjects PRACTICAL ENGINEERING hand wrought nail
 trade in Bromsgrove
Numbers pr 12
 sl 15
Aids Card index
Notes These photographs and slides illustrate talks and
 lectures.

666
Owner Vickers Limited
Location Photographic Department Millbank Tower
 Millbank Westminster London SW1 01 828 7777
Custodian B J Wexham
Dates c1900 -
Photographer W G Carrington Leslie Sansom
 Ian Stokes Brian John Wexham
Subjects MECHANICAL ENGINEERING armaments
 shipbuilding aircraft company personalities
Numbers fi negs c40000 b&w c5000 col various
Aids *Card index
Access Each application dealt with on merit
Copies available for sale
Charges By arrangement depending on use

667
Owner Aveling Marshall Limited Gainsborough
 Lincolnshire 0427 2301

Location Museum of English Rural Life Reading
 University Reading Berkshire 0734 85123
Title Fowlers Collection
Custodian Miss S B Ward
Dates 1862 - 1947
History The collection covers the technical development
 of engineering in relation to farming, road and rail
 transport
Subjects MECHANICAL ENGINEERING farm
 machinery road construction plant road haulage
 vehicles locomotive engines rolling stock
 and materials
Numbers pr c9000 b&w 5"x4" 10"x8"
 fi negs c200 b&w
 gl negs c6000 b&w
Aids *Subject index
Access General public bona fide students
Copies available for sale
Charges Print fee £1 8"x6" print bona fide students
 half-price

668
Owner Babcock and Wilcox Limited
Location Cleveland House St James' Square London
 SW1Y 4LN 01 930 9766
Custodian R W M Clouston 165 Great Dover Street
 London SE1 4YB 01 407 8383
Dates c1900 -
History The collection is technical and includes some
 items of importance to those concerned with the history
 of technology
Photographer Ralstons of Glasgow
Subjects MECHANICAL ENGINEERING boilers - land and
 marine associated equipment
Numbers pr c32000 b&w various
 L sl c13000 b&w 2"x2"
 fi 40 b&w 35mm 16mm
Aids Catalogue (post 1957)

669
Owner Clarkson International Tools Limited
Location King Edward Road Nuneaton Warwickshire
 CV11 4DT 0682 4244
Custodian D G Smart
Dates 1960 -
Subjects MECHANICAL ENGINEERING engineers
 precision cutting tools Clarkson milling cutters
 twist drills reamers taps and dies
Numbers pr c200 b&w various
 tr c100 col

670
Owner G E C Turbine Generators Limited
Location Willans Works Rugby Warwickshire CV21 2NH
 0788 2100
Title Photographs of Engines Steam Turbines
Custodian Mrs C A Sharp
Dates c1897 -
Subjects MECHANICAL ENGINEERING engines
 steam turbines static steam engines factories
Numbers tr 450 b&w
Access Bona fide students
Copies available by private arrangement
Notes The collection is contained in 4 albums.

671
Owner International Computers Limited Director of
 Communication ICL House Putney London
 01 788 7272
Location Putney Letchworth Kidsgrove West Gorton
Custodian B Bellringer ICL Cavendish Road Stevenage
 Hertfordshire 0438 3361
Dates 1920 -
History The collections cover the development of the
 British Computer Industry in Great Britain
Subjects MECHANICAL ENGINEERING computers
Numbers pr c15000
 fi
 sl
Aids Each site has an index

672
Owner Molins Limited
Location Evelyn Street London SE8 5DH 01 237 4581
Custodian K G Payne
Subjects MECHANICAL ENGINEERING tobacco
 machinery
Numbers pr substantial number
 fi negs substantial number
 tr
Copies available for loan

673
Owner Portsmouth Water Company
Location PO Box 8 West Street Havant Hampshire
Custodian S A Owen
Dates 1925 -
Subjects MECHANICAL ENGINEERING water industry
 civil and building construction water mains
 pumping stations boreholes reservoirs
Numbers pr
 fi negs
 gl negs c1000 b&w
 L sl
Access General public bona fide students

674
Owner Walter Nurnberg
Location 18 Cornwood Close London N2 OHP
 01 455 9546
Dates 1947 -
Photographer Walter Nurnberg
Subjects ELECTRICAL ENGINEERING ELECTRONICS
 GENERAL INDUSTRY mechanical engineering
 architecture botany geography travel abroad
Numbers pr small number b&w
 fi negs c13000 b&w $2\frac{1}{4}"$x$2\frac{1}{4}"$
 tr 2200 col $2\frac{1}{4}"$x$2\frac{1}{4}"$
Aids Catalogue Subject index
Access Press tv media only by request and appointment
Copies available for sale for publication black and white
 subject to copyright clearance with clients colour
 copyright Walter Nurnberg
Charges Publication/reproduction fee print/transparency
 fee
Notes Two collections are included. Industrial (film
 negatives) and general (transparencies).

675
Owner Ransomes Sims and Jefferies Limited Ipswich
 0473 72222
Location Museum of English Rural Life Reading
 University Reading and Photographic Department
 Ipswich
Title University of Reading Ransome's Collection
Custodian A R J Frost
Dates c1856 -
History The collection covers the technical development
 of engineering in relation to farming
Subjects MECHANICAL ENGINEERING farm machinery
 grass machinery forklift trucks
Numbers pr c36000 b&w $2\frac{1}{4}"$x$2\frac{1}{4}"$ 12"x10"
 fi negs c23000 b&w
Aids *Subject index
Access General public bona fide students
Copies available for sale
Charges Prints from £1 per 8"x6" print (bona fide
 students half-price)

676
Owner Strathclyde Regional Council
Location 30 John Street Glasgow Strathclyde Region
 G2 1DU 041 221 9600 Ext 2021
Title Strathclyde Regional Archives
Custodian R F Dell
Dates c1860 (1964) -

Photographer Thomas Annan Messrs W Ralston and
 Company Limited
Subjects MECHANICAL ENGINEERING town life
 local government - slum conditions housing
 clean air traffic education transport bridges
 mining equipment Clyde Valley - aerial photography
 historic and newsworthy events in Glasgow
Numbers pr c10000 b&w
 fi negs c5000 b&w
 gl negs c25000 b&w
 L sl c800 b&w
 tr c500 col
Aids Catalogue card index subject index
Access General public
Copies available for sale for loan
Charges Reproduction fee

677
Owner 3M United Kingdom Limited
Location 3M House Wigmore Street London W1A 1ET
 01 486 5522
Custodian Martin Cannon
Dates 1955 -
Subjects MECHANICAL ENGINEERING 3M United
 Kingdom - production products locations people
Numbers pr c1000 b&w c100 col various
 tr c2500 col
Aids Card index subject index
Copies available for loan

678
Owner Central Electricity Generating Board
Location Room 623 Bankside House Sumner Street
 London SE1 01 928 2011 Ext 415
Custodian P J Way
Dates 1895 - 1900
Subjects POWER STATION - Bankside - building
 street scenes
Numbers pr c100 b&w $3\frac{1}{2}"$x5"
Access General public bona fide students picture
 researchers press tv media by appointment
Copies available for sale for display for publication
 credit line required
Charges Print fee transparency fee

679
Owner English Electric Valve Company Limited
Location Chelmsford Essex CM1 2QU 0245 61777
 Ext 480
Title E E V Photographic Library
Custodian M G Knight
Dates 1947 -
Subjects ELECTRICAL APPLIANCES electron tubes
 (valves)
Numbers pr c10000 b&w c200 col 8"x6"
 sl c500 col 2"x2"
Aids *Card index *subject index
Access By appointment
Copies available for sale gratis for publicity for loan
 credit line required
Charges Print fee

680
Owner G E C Fusegear Limited
Location East Lancashire Road Liverpool L10 5HB
 051 525 8371
Custodian Publicity Manager
Dates 1956 -
Subjects ELECTRICAL APPLIANCES high rupturing
 capacity fuse links fusegear
Numbers pr substantial number b&w 10"x8"
 L sl substantial number b&w 35mm 2"x2"

681
Owner G E C Rectifiers Limited
Location Lichfield Road Stafford ST17 4LN 0785 51222

Dates 1965 -
Subjects ELECTRICAL APPLIANCES AND MACHINES
rectifiers and associated equipment
Aids *Catalogue
Copies available on application
Charges Reproduction fee subject to use

682
Owner G E C Semiconductors Limited
Location East Lane Wembley Middlesex WA9 7PP
01 904 9303
Custodian J C Warren
Dates (1974) -
Subjects ELECTRICAL APPLIANCES electronic devices
Aids Guide in preparation
Access Bona fide students
Copies available for sale for loan
Charges Print fee

683
Owner Sena Sugar Estates Limited
Location Fulham Park House 654 Fulham Road London
SW5 01 731 4256
Custodian D J Sheppard
Dates 1900 -
History The collection includes a photograph of Mrs
Livingstone's grave and that of a member of the
Emin Pasha Expedition
Subjects MACHINES sugar mills transport people and
machinery in Mozambique portraits
Members pr b&w various
Access Bona fide students
Copies available by private arrangement

684
Owner George Watkins
Location Centre for the Study of the History of
Technology University of Bath Claverton Down
Bath Avon 0225 6941
Title The Watkins Collection
Custodian Dr R A Buchanan
Dates c1930 -
Photographer George Watkins
Subjects STEAM ENGINES power transmission
water power associated industries
Numbers pr c1400 b&w 6½"x4¾"
fi negs c5000 b&w
gl negs c250 b&w
Aids *Catalogue
Access Bona fide students subject to convenience and
office hours
Copies available for sale

685
Owner Science Museum Library
Location South Kensington London SW7 5NH
01 589 6371 Ext 536
Title H E S Simmons Collection
Custodian J A Chaldecott
Dates 1930 - 1970
Subjects WIND AND WATER MILLS - BRITAIN
Numbers pr c3000 b&w 6½"x4¾"
fi negs c2600 b&w 2¼"x3¼"
gl negs c400 b&w 3¾"x4¼"
Aids *Catalogue
Access General public

686
Owner Peter Jennings
Location 26 Rowan Close St Albans Hertfordshire
A14 0ST St Albans 61835
Dates 1900 (1972) -
Subjects WINDMILLS - British and foreign
Numbers pr 300 b&w col
fi negs c500 b&w 6cm x 9cm
tr c500 col 6cm x9cm
Aids Books and notes
Access Picture researchers publishers
Copies available for publication
Charges Reproduction fee commercial rates

Notes This will eventually be a complete record of
surviving British windmills, supplemented by interior
shots and historic pictures of many of them.

687
Owner E J Upton
Location Rowan Cottage North Trade Road Battle
East Sussex TN33 OHU 042 46 2319
Title Industrial Archaeology in South East England
Dates (1968) -
Subjects WINDMILLS watermills buildings
industrial machinery water pump installations
turnpike tollhouses and milestones Wealden iron-
sites remains artifacts
Numbers fi negs 2500 b&w 35mm
tr 500 col 35mm
Aids Card index
Access General public bona fide students picture
researchers press tv media by appointment only
Copies available for sale

688
Owner East Yorkshire Local History Society
Location c/o 32 Newgate Street Cottingham Humberside
Custodian Dr K J Allison
Dates (1967) -
Subjects WATERMILLS - buildings machinery equipment
Numbers sl col
fi negs various
Aids Arranged alphabetically by village
Access General public bona fide students

689
Owner East Yorkshire Local History Society
Location Hull Central Library Albion Street Hull
Humberside 0482 36680
Custodian Local History Librarian
Dates (1967) -
Subjects WATERMILLS - buildings machinery equipment
Numbers pr b&w various
Aids Arranged alphabetically by village
Access General public bona fide students

690
Owner United Kingdom Atomic Energy Authority
Location 11 Charles II Street London SW1Y 4QP
01 930 6262 Ext 368/9
Title UKAEA Photographic Library
Custodian Mrs M C Evans
Dates 1958 -
Photographer Brian Goodman Eric Willmott
Subjects ATOMIC ENERGY development and work
of the authority atomic bomb tests
Numbers pr 15000 b&w 8"x6"
L sl 3000 b&w col 35mm
tr c14000 b&w col 3¼"x3¼" 5"x4"
Aids Card index
Access General public bona fide students
Copies available for sale for loan
Charges Print fee b&w for 13p col prints from 75p
col tr from £3.40p sl monochrome from 20p
col from 75p

691
Owner Brooke Bond Oxo Limited
Location Leon House High Street Croydon London
CR9 1JQ 01 686 8899 night 01 686 4113
Custodian C Doeg
Dates c1900 -
Subjects FACTORIES tea and Oxo cube production
Numbers pr substantial number 10"x8"
Copies available on request to press and publishers
Charges No reproduction fee

692
Owner University of Reading
Location The Library Whiteknights Reading Berkshire
RG6 2AE 0734 84331
Title Alec Davis Collection
Custodian J A Edwards
Dates (c1920) - 1974

Photographer Alec Davis
Subjects PACKAGING
Numbers pr c500 b&w various
 fi negs c100 b&w ½pl
 L sl c50 b&w 2¼"x2¼"
Aids Catalogue and card index in progress
Access General public bona fide students picture
 researchers press tv media Monday to Friday
 9 am - 5 pm
Copies available for sale for publication
Charges Reproduction fee print/transparency fee
Notes About 200 of the photographs have been reproduced
 in 'Package and Print' by Alec Davis.

693

Owner Bacal Construction Limited
Location Bacal House Lodge Way Harlestone Road
 Northampton NN5 7UG 0604 52444
Custodian J A Disley
Dates 1966 -
Subjects BUILDING CONSTRUCTION
Numbers pr 1500 b&w 1500 col 10"x8"
 tr 2000 b&w 3000 col 1pl
 sl 2000 b&w 5000 col 35mm
Aids *Subject index
Access Bona fide students

694

Owner Foseco Minsep Limited
Location 36 Queen Anne's Gate London SW1
 01 839 7030
Title Slide Library
Custodian R M Tester
Dates (1973) -
Subjects BUILDING CONSTRUCTION chemical products -
 foundry industry - steel industry water treatment
Numbers pr c200 b&w c100 col various
 sl c600 col 35mm
Aids *Catalogue
Access Bona fide students

695

Owner Science Museum Library
Location South Kensington London SW7 5NH
 01 589 6371 Ext 536
Title S Pearson and Son Collection
Custodian J A Chaldecott
Dates 1890 - 1925
Subjects CIVIL AND BUILDING CONSTRUCTION -
 world wide
Numbers pr c12000 sepia various
Aids *Catalogue
Access General public
Copies available on request credit line required

696

Owner Thames Polytechnic
Location The Library Vencourt House King Street
 London W6 9LU 01 854 2030
Custodian Pat Bailey 01 748 6053
Dates (1972) -
Subjects CIVIL AND BUILDING CONSTRUCTION
 architecutre landscape architecture stations
 airports nature botany ceramics sculpture and
 carving painting textiles geography design
 theory town planning environmental science
Numbers sl 6000 b&w 3300 col 2"x2"
Aids *Card index *subject index
Access Bona fide students
Notes This is a special collection to meet the requirements
 of the Faculty of Architecture and Surveying.

697

Owner Wates Limited
Location 1258 London Road Norbury London SW16

Title Wates Photographic Library
Custodian Communications Manager
Dates 1900 (1968) -
Photographer Chris Morris A Taylor
Subjects BUILDING CONSTRUCTION
Numbers pr c8000 b&w 1pl
 sl 5000 col
Copies available for sale for loan
Charges Print fee

698

Owner Ackworth School
Location Ackworth Pontefract West Yorkshire
 WF7 7LT Hemsworth 611401
Dates c1800 -
Subjects ACKWORTH SCHOOL - School and social life
Numbers pr c3500
Aids Housed in volumes

699

Owner Lound Hall Mining Museum Trust and National Coal
 Board North Nottinghamshire Area Edwinstowe
 Mansfield Nottinghamshire 0632 822481
Location Lound Hall Bothamsall Nr Retford
 Nottinghamshire
Title Lound Hall Mining Museum Collection
Custodian Dr A R Griffin
Dates 1895 -
History Some photographs of Brinsley Colliery where the
 father of D H Lawrence worked
Subjects MINING
Numbers pr c1000 b&w
Access General public bona fide students

700

Owner Millom Folk Museum Society
Location The Folk Museum St George's Road Millom
 Cumbria LA18 4DD Millom 2555
Custodian E James
Dates 1880 (1969) -
Photographer Miss Mary Fair
Subjects MINING - SOUTH WEST CUMBRIA HODBARROW
 MINE - MILLOM development of iron ore mining
Numbers pr c40 20"x15"
 sl 2¼"x2¼"
Access General public

701

Owner Salford Mining Museum
Location The Mining Museum Buile Hill Park
 Eccles Old Road Salford M6 8GL 061 736 1832
Custodian G P J Preece
Dates 1890 (1920) -
Photographer Henry Irving Charles Kirk
Subjects MINING GEOLOGY ASTRONOMY BOTANY -
 geology meteorology palaeontology zoology
 geography Derbyshire Cumbria South Africa
Numbers pr c1300 b&w various
 gl negs c200 b&w 4½"x6½"
 L sl c500 b&w 3¼"x3¼"
 sl 550 col 35mm
 fi strips 70 b&w 35mm
Access Bona fide students by appointment only

702

Owner National Coal Board Hobart House Grosvenor
 Place London SW1X 7AE 01 235 2020
Location Central Reference Archives Mid-Cannock
 Colliery Cannock Staffordshire 05435 2581
Custodian Miss B Ramsbotham
Dates (1974) -
Subjects MINING coal mining personnel equipment
 operations
Aids *Card index *subject index
Access Picture researchers bona fide students press
 tv media 9 am - 5 pm by appointment

Key () = dates when collections were begun or terminated
C = Century c = approximately pr = print fi = film
gl = glass neg = negative sl = slide L sl = lantern slide
tr = transparency mic = microform col = colour

b&w = black and white ¼, ½, 1-pl = quarter, half and whole
plate * = single copy, no public access ** = single copy,
access by appointment

Copies available for sale
Charges Print/transparency fee
Notes The collection is an archive collection, subject to
the Public Records Act 1958, and is not intended to be
used for commercial purposes.

703

Owner Northern Cavern and Mine Research Association
33 Gledhow Avenue Roundhay Leeds 8 0532 666208
Location 1 Valley View Cross Hills Nr Keighley
North Yorkshire 0535 32040
186 Station Road Billingham Cleveland TS23 2RT
0642 554437
Custodian M Gill Central Recorder
Robert Guthrie North East Recorder
Dates c1960 -
Subjects METALIFEROUS MINING
Numbers pr substantial numbers
fi negs substantial numbers
Aids Record file
Access Bona fide students

704

Owner Northwich Salt Museum
Location Weaver Hall 162 London Road Northwich
Cheshire
Custodian The Curator
Dates c1880 (1972) -
Subjects SALT MINING salt mining equipment open
pan salt making brine pumping subsidence geology
modern mining methods uses of salt
Numbers pr c250 b&w various
gl negs c100 b&w
sl c100 b&w
Aids *Card index
Access Bona fide students
Copies available for sale for loan
Notes This is a specialised collection relating to the salt
industry.

705

Owner Dr Arthur Raistrick
Location Linton Skipton North Yorkshire BD23 5HH
0756 752392
Dates 1890 (1920) -
Photographer Dr Arthur Raistrick Bertram Unne
Subjects LEAD MINING ironmaking geology
social history architecture - North of England
Numbers pr c200 various
fi negs c500 35mm
gl negs c200 $\frac{1}{4}$ pl
L sl c2000 $3\frac{1}{4}$"x$3\frac{1}{4}$"
Notes The collection is a working collection used in
publications and for lectures.

706

Owner RTZ Services Limited
Location 6 St James's Square London SW1Y 4LD
01 930 2399
Title RTZ Photographic Library
Custodian J T Player
Dates c1967 -
Subjects MINING metal smelting and manufacturing
UK overseas
Numbers pr c250 b&w 10"x8"
fi negs c100 b&w 4"x5"
sl c1500 col various
Aids Classified according to operating company in
RTZ Group
Access Bona fide students publishers press tv media
by prior arrangement
Copies available black and white copies available
colour duplicates by arrangement
Charges Reproduction fee subject to permission from
the Company
Notes Parent Company is the Rio-Tinto-Zinc Corporation.

707

Owner British Petroleum
Location Britannic House Moor Lane London EC2
01 920 7491

Custodian Miss Audrey King 01 920 8518
Dates c1900 -
Subjects OIL INDUSTRY - shipping exploration research
marketing chemicals plastics
Numbers pr c10000 b&w 8$\frac{1}{2}$"x6$\frac{1}{2}$" 10"x8"
fi negs c10000 b&w various
sl 35000 col various
Aids *Subject index
Copies available for sale for loan
Charges Print fee

708

Owner Science Museum Library
Location Department 2 London SW7 2DD 01 589 6371
Title Shell Petroleum and Petrochemicals
Dates (c1920) - c1960
Subjects PETROLEUM AND PETROCHEMICALS -
history production and uses
Numbers gl pos c5000 b&w 2$\frac{1}{2}$"x2$\frac{1}{4}$"
Aids *Catalogue *card index *subject index
Access Bona fide students
Notes This is an important technical collection associated
with the petroleum industry and Shell in particular.

709

Owner Alcan International Limited
Location Banbury Research Centre Southam Road
Banbury Oxford OX16 7SP 0295 2821
Custodian Information Officer
Dates 1948 -
Subjects ALUMINIUM - industry - applications research
Numbers fi negs 48000 b&w 5"x4"
Aids *Card index *subject index
Access Open to non-Alcan personnel at the discretion
of the owner
Copies available for loan in certain circumstances

710

Owner M B Dredging Company Limited
Location Botany Road Northfleet Kent Gravesend 64143
Custodian L R Hughes
Dates 1955 -
Subjects DREDGING dredging equipment contract sites
Numbers pr 200 b&w 6 col 10"x8"

711

Owner R K Barrett
Location 31 Valley Gardens Whitley Bay Tyne and Wear
NE25 9AQ
Title Smith's Dock Company Limited Royal Visit to Tees
and Tyne June 4th 16th 1917
Dates 1917
History This collection was compiled to commemorate the
visit of Queen Mary and King George V to merchant
shipbuilding yards and steel rolling mills of the River
Tees at South Bank on Thursday June 14th 1917
and to the north east coast shipbuilding and engineering
works on the Tyne on June 16th 1917
Subjects SHIPBUILDING DURING 1914-1918 WAR
dress uniforms tools ships cargo boat steam
transport docks and harbours locks factory
machine shop building exteriors portraits of named
persons historic and newsworthy events of
1914-1918
Numbers pr 18
Aids Subject index
Access Bona fide students

712

Owner Heather Angel
Location Biofotos Sunset Cottage Clovelly Road
Hindhead Surrey GU26 6RT 042 873 5414
Dates (1967) -
Photographer Heather Angel
Subjects BIOLOGY NATURAL HISTORY ECOLOGY -
Bermuda Britain Canaries Corfu Galapagos
Gibraltar Himalayas Indian Ocean Kashmir Kenya
New Zealand Portugal Seychelles Spain Zanzibar
boglands canals coral reefs lava fields
mangrove swamps salt marshes savanna
photomicrography animal behaviour - all aspects

G

bioluminescence genetics pollination mechanisms symbiosis pollution commensalism erosion dimorphism
Numbers tr c40000 col 35mm 2¼"x2¼"
Aids Catalogue card index subject index
Access Visits by appointment
Notes The owner is author of Photographing Nature Series. Commissions.

713
Owner Biophoto Associates Smithy Hall Cookridge Lane Leeds LS16 7NE
Location Department of Plant Sciences University of Leeds Leeds LS2 9JT
Title Biophoto Associates Collection
Custodian Gordon F Leedale
Dates (1954) -
Subjects NATURE botany: plants zoology palaeontology underwater plants microscopy - light electron scanning electron viruses bacteria algae protozoa organelles cells anatomy histology morphology ecology pathology industrial biology
Numbers c12000 b&w various
fi negs c2000 b&w various
gl negs c10000 b&w 6.5cm x 9cm
L sl c1000 b&w 2"x2" 3½"x3½"
sl c700 col 2"x2"
Aids Books and files
Copies available for sale
Notes Biophoto Associates is a group of professional botanists and zoologists who are also expert photographers.

714
Owner Sdeuard C Bisserôt
Location 40 Nugent Road Bournemouth Dorset BH6 4ET 0202 45028
Dates 1946 -
Subjects WILD LIFE
Numbers fi negs c5000 b&w various
tr c2000 col 2¼"x2¼"
Access Bona fide students picture researchers publishers press tv media by appointment only
Copies available by arrangement depending on reason for request
Charges Print fee reproduction fee

715
Owner Paul Brierley
Location 250 Felmongers Harlow Essex Harlow 25169
Title Science and Technology Photography and Photographic Library
Dates 1969 (1970) -
Photographer Paul Brierley
Subjects SCIENCE abstracts and concepts adhesives agricultural plant architecture automobile engineering biology biomedical equipment chemical technology computers cryogenics electrical engineering electronics engines environment exhibitions fibres gas turbines heat exchangers industrial - components equipment plant processes infra-red technology instruments machine tools marine biology and engineering materials mechanisation memories metalforming microelectronics micrography molecular models nuclear reactors nuclear sciences optics optoelectronics plant biology plasma science pollution primary metal production prime movers radiotelescopes relay technology semi-conductor devices servomechanisms spectra structures superconductivity television systems test equipment vacuum techniques visual display systems waste welding
Numbers tr c20000 2¼"x2¼"
Aids Subject index
Access Bona fide students by appointment only

Copies Free to bona fide enquirers
Charges Reproduction fee black and white £15 - £40 colour £40 - £150

716
Owner Raymond Chaplin
Location 'Netherfield' Upper Blainslie Galashiels Selkirkshire 089 686 255
Dates 1960 -
History The photographer is an active wildlife biologist
Photographer Raymond Chaplin
Subjects NATURE plants animals horses wildlife archaeology geology
Numbers pr negs tr total 4000 2¼"x2¼" 35mm
Access By arrangement
Copies available by arrangement
Charges Print fee reproduction fee by arrangement

717
Owner Bruce Coleman Ltd
Location 16a-17a Windsor Street Uxbridge Middlesex UB8 1AB 0895 32333/36398
Dates 1955 (1960) -
Photographer Des Bartlett Jen Bartlett Chris Bonington Jane Burton John Markham Goetz D Plage Hans Reinhard Mirella Ricciardi
Subjects SCIENCE astronomy microscopy mineralogy geology meteorology oceanography palaeontology archaeology anthropology nature botany zoology agriculture and food production architecture world wide geography art medical athletic sports and outdoor games
Numbers tr c250000 col various
Aids Card index
Access Picture researchers press tv media 9.15 am - 5 pm to original images
Copies available for sale for display for publication
Charges Reproduction fee print/transparency fee holding fee service charge search fee
Notes Photographs by experts in the field, e.g. for mountaineering - Chris Bonington.

718
Owner British Naturalists' Association
Location 'Willowfield' Boyneswood Road Four Marks Alton Hampshire GU34 5EA Alton 63659
Custodian Mrs K L Butcher
Dates 1905 -
History The collection was photographed by the founder of the British Naturalists' Association, E Kay-Robinson
Photographer E Kay-Robinson
Subjects NATURAL HISTORY
Numbers L sl c50 b&w 3¼"x3¼"
Aids *Catalogue
Access Bona fide students

719
Owner British Museum (Natural History) Trustees
Location Cromwell Road London SW7 5BD 01 589 6323
Title Holdings include the Marius Maxwell, Henry Irving, Warwick James and Rothschild Collections
Custodian P Rowlands
Dates 1873 (c1900) -
Photographer Henry Irving Marius Maxwell
Subjects NATURAL HISTORY - animals minerals rocks meteorites geology palaeontology anthropology botany British trees mammalian dentition
Numbers pr c5000 b&w
fi negs c75000 b&w 4"x3" - 8"x6"
gl negs b&w c10000 4"x3" - 10"x8"
L sl c5000 b&w 3¼"x3¼"
tr 10000c col 2"x2"
mic 100000 b&w

Key () = dates when collections were begun or terminated
C = Century c = approximately pr = print fi = film
gl = glass neg = negative sl = slide L sl = lantern slide
tr = transparency mic = microform col = colour

b&w = black and white ¼,½,1-pl = quarter, half and whole plate * = single copy, no public access ** = single copy, access by appointment

Aids Card index subject index to various separate
 collections
Access Bona fide students on application
Copies available for sale for loan on application

720

Owner Essex County Council and Colchester and Essex
 Museum The Castle Colchester Essex
 0206 77475
Location All Saints Church High Street Colchester Essex
 CO1 1DN 0206 76071 Ext 344
Title Colchester and Essex Museum Department of Natural
 History Collection
Custodian Keeper of Natural History
Dates 1930 (1958)-
Subjects BOTANY PLANTS ZOOLOGY ANIMALS -
 flowers trees wild animals vertebrates -
 amphibians reptiles birds mammals
 invertebrates - insects
Numbers gl negs c200 b&w ¼pl
 L sl c150 b&w 3½"x3½"
 sl c750 col 2¼"x2¼"
Aids *Subject index
Access Bona fide students prior notice required
Copies available where Museum holds copyright

721
Withdrawn

722

Owner Central Association of Photographic Societies
Location 68 Toll Bar Court Brighton Road Sutton
 Surrey 01 643 5565
Title Kay Collection of Monochrome Slides
Custodian Mrs Dorthy Quemby
Dates 1877 (1954) -
Photographer M O Dell J Dudley Johnson
Subjects NATURE ARCHITECTURE RECREATIONS
 BIOGRAPHY AND PORTRAITS geography
Numbers L sl c230 b&w 2¼"x2¼" 3¼"x3¼"
Aids *Card index
Access The Curator is prepared to make the collection
 available by appointment only to bona fide enquirers
Notes The collection represents nearly 100 years of
 monochrome slide making by some of the finest
 photographers in the South of England. Publication of
 prints cannot be arranged with the C A P S, only with
 authors or where deceased, their heirs or
 representatives.

723

Owner James Cross
Location 52 Crockford Park Road Addlestone Weybridge
 Surrey KT15 2LX 0932 47554
Title Cross Sections
Dates 1961 -
Photographer James Cross
Subjects NATURAL HISTORY TRAVEL animals
 birds insects and life cycles molluscs lizards
 amphibia aquatic creatures flowers trees
 plants gardens building of a motorway
 architecture bridges fountains
Numbers pr b&w 10"x8"
 fi negs c1600 b&w 6cm x 6cm
 tr c20000 col 35mm 6cm x 6cm
Aids General coverage lists available subject index in
 preparation
Access Bona fide students picture researchers
 by arrangement
Copies available for sale for loan
Charges Commercial rates

724

Owner Divine Unity of Faiths
Location Sananda 67 Wildmoor Road Shirley Solihull
 West Midlands 744 8254
Title The History of Flying Saucers The Great Plan
 for Earth
Custodian Sananda
Dates (1963) -

Subjects SCIENCE ancient civilisations rock carvings
 space flight educational aspects
Numbers pr 100 b&w 10 col various
 tr 200 b&w 50 col 24mm x 36mm
Access By appointment

725

Owner Su and John Gooders
Location 35 Brodrick Road Wandsworth Common London
 SW17 01 672 8787 and 2067
Title Ardea Photographics
Custodian Su Gooders Shirley Ambridge
Dates (1970) -
History One of the founders of this organisation is a
 wildlife author
Photographer Tony Beamish Kenneth Fink Clem Haagner
 Peter Steyn Valerie Taylor
Subjects NATURAL HISTORY GEOGRAPHY
 ANTHROPOLOGY - disappearing people life forms
 mountains rivers mammals birds plants fish
 insects reptiles underwater wildlife
Numbers pr 10000 b&w 1pl
 tr c75000 col various
 col separations 100
Aids Published subject index cross reference available
 to researchers
Access Picture researchers press tv media
 9 am - 6 pm
Copies available for publication credit line required
Charges Publication/reproduction fee or holding fee
 or service charge as appropriate
Notes One of the most important and comprehensive
 collections of wildlife photographs in the world:
 growing quantity of material of anthropological and
 geographical nature: specialists in colour for books
 magazines TV posters and filmstrips.

726

Owner Roy A Harris and K R Duff
Location 1 Tan-y-Rhos Isa Glyn Ceirog Nr Llangollen
 Glyn Ceirog 418
Dates 1964-
Photographer K R Duff Roy A Harris
Subjects NATURAL HISTORY WILD LIFE animals
 plants forestry hunting landscapes
Numbers pr c1500 col 10"x8"
 fi negs c3000 col 35mm
 tr c3000 col 35mm 2¼"x2¼"
Notes For Access, Copies and Charges contact J Allan
 Cash Limited, Agents for the collection.

727

Owner Eric Hosking
Location 20 Crouch Hall Road London N8 8HX
 01 340 7703
Title Natural History
Dates (1929) -
Photographer Eric Hosking
Subjects NATURE birds mammals amphibians
 reptiles of the world
Numbers pr c250000 b&w 8½"x6½"
 fi negs c170000 b&w various
 gl negs c40000 b&w 4¼"x3¼"
 tr c50000 col various
Aids *Card index *subject index
Access Picture researchers publishers by appointment
Copies available for sale for loan
Charges Reproduction fee
Notes One of the largest private collections of Natural
 History photographs in the world.

728

Owner George E Hyde
Location 26 Warnington Drive Bessacarr Doncaster
 South Yorkshire DN4 6SS 0302 868444
Dates 1939 (1946) -
Photographer G E Hyde
Subjects NATURAL HISTORY insects plants trees
 fungi food production

Numbers fi negs c2000 b&w
gl negs c4000 b&w
L sl b&w
tr c9000 b&w 35mm 6cmx6cm
Aids Catalogue subject index
Access Picture researchers 9 am - 6 pm
Copies available for sale for loan for display
for publication
Charges Print/transparency fee reproduction fee holding
fee
Notes The owner of this collection is author and
illustrator of a number of books.

729
Owner Frank W Lane
Location Drummoyne Southill Lane Pinner Middlesex
HA5 2EQ 01 866 2336
Title Natural History and Meteorology
Dates 1942 -
Photographer Ronald Austing Arthur Christiansen
Trent Davidson Ronald Thompson
Subjects NATURAL HISTORY wildlife botany violence
in nature - windstorms lightning earthquakes water
spouts volcanoes floods waves scenery ice and snow
Numbers pr c10000 b&w 10"x8"
tr c15000 col various
Access Picture researchers press tv media 9 am - 6 pm
on application
Copies available for sale for loan for display for
publication credit line required
Charges Reproduction fee search fee £3 holding fee -
£1 per month after 1 month gratis
Notes A specialist agency representing some of the
world's finest natural history photography. The
holdings include the Douglas English (Natural History)
Collection. Commissions for natural history subjects
undertaken.

730
Owner Natural History Photographic Agency
Location The Studio Betsoms The Avenue Westerham
Kent Westerham 62193
Custodian L Hugh Newman M Newman
Dates 1950 -
History Founded by L Hugh Newman in 1950 to provide
illustrations for his own MSS books broadcasting and TV
programmes, the business quickly expanded into an
international concern. It now has more than fifty
leading natural history photographers as exclusive or
contributing members, mostly expert in their own
field of nature
Photographer Anthony Bannister Douglas Baglin Kenneth
Beckett Frank Blackburn Stephen Dalton Brian
Hawkes Peter Johnson Ken Newman Dr Ivan Polunin
E Hanumantha Rao Lady Peter Scott Michael Tweedie
Subjects NATURAL HISTORY World flora and fauna
geology crops Arctic Antarctic deserts tropics
country life and customs at home and abroad
mountains insects
Numbers pr c25000 b&w
tr c50000 col 35mm 2¼"x2¼"
Aids Price card with full details of range of colour
transparencies
Access Picture researchers press tv media 9 am - 5 pm
Copies available for sale for loan for display for
publication. Black and white prints and colour
transparencies are lent to the BBC, TV studios,
editors and publishers but not to individual authors.
Authors may enquire the scope of the Agency known
internationally as N H P A but all business
transactions must be conducted with the editor or
publisher concerned. Credit line required
Charges Holding fee reproduction fee by negotiation
on free approval for one month then 25p per week per
transparency package deals arranged

Notes This Agency specialises in insect photography.
L Hugh Newman is an author, broadcaster and
naturalist.

731
Owner Nature Conservancy Council
Location Interpretative Branch 19 Belgrave Square
London SW1X 8PY 01 235 3241
Title National Collection of Nature Photographs
Custodian M W Henchman
Dates c1890 (1955) - 1970
History The collection includes work of 19thC and early
20thC pioneers of nature photography
Subjects NATURE flowering plants ferns fungi mosses
reptiles birds mammals insects
Numbers pr c1500 b&w various
Aids *Card index *subject index index to photographers
Access Bona fide students by appointment
Copies available for loan for exhibitions in museums and
galleries only
Notes A selection from the National Collection of Nature
photographs is contained in a book 'British Wildlife'.

732
Owner R N Neep
Location 3 Springfield Crescent Bedworth Warwickshire
CV12 8NX
Dates (1965) -
Photographer R Neep
Subjects NATURAL HISTORY African wildlife
European birds birds of prey
Numbers sl c6000 col 2"x2"
Aids Catalogue
Access By appointment
Copies available for sale by arrangement
Notes The owner of this collection is the British
Representative of the East African Wildlife Society
and organises and leads photographic safaris in East
Africa. Several hundered slides are now in the library
of Robert Harding Associates, Botts Mews, London.

733
Owner Northamptonshire Natural History Society and
Field Club
Location The Humfrey Rooms Castilian Terrace
Northampton NN1 1LD
Custodian Miss M A Blincow
Dates 1880 -
Subjects NATURAL HISTORY SCIENCE
Numbers sl c1000 col
Aids Catalogue
Access On request and with a specific reason for so asking
Notes The Society has approximately 400 process line and
half tone blocks of items produced in the Society's
journals.

734
Owner C E Palmar
Location 24 Hamilton Park Avenue Glasgow G12 8DT
041 339 2088
Title C E Palmar Collection
Dates (1934) -
Photographer C E Palmar
Subjects NATURE birds - Golden Eagle plants
topography geology
Numbers pr substantial number b&w 10"x8"
fi negs substantial number b&w 2¼"x2¼" 2¼"x3¼"
gl negs substantial number b&w ¼pl
sl substantial number col 2¼"x2¼" 35mm
Access By arrangement
Copies available for sale
Charges Print fee reproduction fee
Notes The owner of the collection is keeper of the
Department of Natural History, Glasgow Museums
and Art Galleries.

Key () = dates when collections were begun or terminated
C = Century c = approximately pr = print fi = film
gl = glass neg = negative sl = slide L sl = lantern slide
tr = transparency mic = microform col = colour

b&w = black and white ¼,½,1-pl = quarter, half and whole
plate * = single copy, no public access ** = single copy,
access by appointment

735
Owner Roger Perry
Location Trapalanda Bradfield St George Suffolk
 IP30 0AY Sicklesmere 277
Dates 1957 -
Subjects NATURE South America wildlife birdlife -
 penguins petrels cormorants seals plants
 National Parks of South America Antarctica
 South Shetlands Falklands Galapagos people and
 places-Northern Andes Patagonia
Numbers pr c200 b&w 10"x8"
 fi negs c4000 b&w 35mm
 tr c3000 col 35mm
Aids Duplicated subject index
Access Picture researchers by arrangement only
Copies available for publication
Charges Reproduction fee print/transparency fee

736
Owner S C Porter
Location 57 Billesley Lane Moseley Birmingham
 B13 9QT 021 449 3293
Dates 1936 -
Photographer S C Porter
Subjects NATURAL HISTORY fungi birds
Numbers pr c2000 1pl
 fi negs 35mm - ¼pl
 L sl 200 3¼"x3¼"
 tr 1000 col 35mm

737
Owner D G Rands
Location 51 Wychwood Avenue Luton Bedfordshire
Dates c1970 -
Subjects NATURAL HISTORY mollusca botany insects
 amphibians fresh water life plants mammals
Numbers sl col 35mm substantial numbers
Access Bona fide students on request

738
Owner G S Smith
Location 17 Cypress Avenue Crews Hill Enfield
 Middlesex EN2 9BY 01 363 6074
Dates 1962 -
Subjects NATURE alpine flowers botany plants
 flowers fungi
Numbers sl 750 col 35mm
Access Only by public and club slide shows

739
Owner Alan Faulkner Taylor
Location 7 King Ecgbert Road Totley Rise Sheffield
 South Yorkshire S17 3QQ 0742 365979
Dates 1946 -
Photographer Alan Faulkner Taylor
Subjects NATURAL HISTORY - pictorial scenes in Europe
 Algeria Kenya Tanzania Britain
Numbers pr c200 b&w 6½"x8½" - 16"x20"
 gl neg c600 b&w ¼pl
 L sl c200 b&w 3¼"x3¼"
 sl c2000 col 35mm
Aids Guide
Copies available for sale for loan
Charges By arrangement

740
Owner C James Webb
Location 17 Michleham Down Woodside Park London
 N12 01 636 8636
Title Human and Social Biology
Dates 1952 -
Photographer C James Webb
Subjects PHYSICAL AND LIFE SCIENCES entomology -
 insects of medical importance microbiology
 human and social biology
Numbers pr c1500 b&w 1pl 8"x10"
 fi negs c2000 b&w
 sl c2500 col 35mm
Aids *Card index
Access Picture researchers by arrangement
Copies available for sale for publication

Charges Reproduction fee holding fee search fee
Notes C James Webb is the co-author of 'Certificate
 Human and Social Biology'.

741
Owner Mrs M Pat Whitehouse
Location 1 Millington Road Cambridge CB3 9HW
 0223 52417
Dates 1958 -
Title Whitehouse Three-Dimensional Colour Transparencies
Photographer Mrs M Pat Whitehouse
Subjects NATURAL HISTORY UK landscapes North
 American deserts European travel
Numbers sl stereoscopic c10000 col 4"x1"
Notes The owner is a specialist in stereoscopic photography
 and has designed her own equipment for both
 photographing and projecting the transparencies -
 many in close-up.

742
Owner A to Z Botanical Collection Limited
Location Holmwood House Mid Holmwood Dorking
 Surrey RH5 4HE 0306 6130
Custodian Mark MacAndrew
Dates 1970 -
Subjects BOTANY PLANTS flowers flowering plants
 trees other plants grasses ferns fungi mosses
 field crops fruit growing horticulture forestry
 landscapes - to show ecology
Numbers pr c500
 tr c50000 col 6cm x 6cm
Aids *Subject index
Access Picture researchers press tv media
 by appointment only 9 am - 5 pm
Copies available for display for publication
Charges Reproduction fee print/transparency fee
 holding fee search fee
Notes A - Z owns the copyright of over 35000 and acts
 as agent for over 15000 colour transparencies of other
 photographers. Transparencies are sent out for
 selection and client has one month's free holding time;
 after that a charge is made, also a search fee is
 charged. If transparencies from a selection are used
 and reproduction fee paid then both holding and search
 fees are refundable. Reproduction fees are calculated
 in accordance with use made and rights required by
 the client.

743
Owner Aquila Photographs
Location PO Box 1 Studley Warwickshire B80 7JG
 052 785 2357
Custodian A J Richards
Dates (1973) -
Photographer A Faulkner Taylor F Harvey H A Hems
 W S Paton Colin Smith E K Thompson
 D D V Weaving
Subjects BOTANY ZOOLOGY
Aids Card index Subject index
Access Press tv media 10 am - 4 pm
Copies available for publication
Charges Reproduction fee holding fee search fee

744
Owner C A Burland
Location 246 Molesey Avenue West Molesey Surrey
 KT8 0ET 01 979 6297
Dates 1960 -
Photographer C A Burland
Subjects BOTANY ARCHITECTURE meteorology
 arts and crafts clothes religion archaeology
 antiques figure work
Numbers tr c15000 col 35mm
Aids Boxes all labelled
Access Bona fide students picture researchers press tv
 media 10 am - 5 pm phone for appointment
Copies available for publication
Charges Publication fee £20 colour

745
Owners Mrs J M Clayton
Location 142 Preston Down Road Preston Paington
Torbay Devon
Subjects BOTANY zoology seashells - tropical and
European animals and plants of the seashore
Numbers pr 1500 b&w
tr 2000 col 35mm - 2¼"x2¼"

746
Owner Charles J Cook
Location 'Tritone' Downsview Edington Westbury
Wiltshire BA13 4QL Bratton 514
Dates (1967) -
Subjects MICROSCOPY material sciences
Numbers pr
fi negs
sl
photomicrographs substantial numbers
Aids Duplicated catalogue
Access Picture researchers press tv media by
telephone appointment
Copies available for sale for display for publication
credit line required
Charges Print fee reproduction fee holding fee search fee

747
Owner Leslie H Pinkess
Location 17 Wheatsheaf Road Birmingham B16 0RZ
021 454 3941
Dates 1954 -
Photographer Leslie H Pinkess
Subjects BOTANY entomology alpine plants
Numbers pr c100 b&w
tr c1150 col 35mm
Aids Catalogue according to botanical species
Access Bona fide students by appointment only
Copies available by arrangement
Charges Commercial rates but negotiable according to use
Notes The photographer makes use of these slides for
lecture purposes. Most are of good quality for
reproduction.

748
Owner University of Newcastle upon Tyne
Location Hancock Museum Newcastle upon Tyne
Tyne and Wear 0632 22359
Custodian Anthony Tynan
Dates 1960 -
Subjects NATURE BIOLOGY BOTANY PLANTS -
geology palaeontology zoology forestry landscape
Numbers sl c6000 2"x2"
Aids *Subject index
Access Bona fide students by arrangement
Copies available for sale

749
Owner Miss Iris R Webster
Location 4 Farndale Crescent Grantham Lincolnshire
047 683 337
Dates 1960 -
Photographer Miss Iris R Webster
Subjects BOTANY - flowers flowering plants macro fungi
ecology local nature reserves
Numbers tr c1000 col 2¼"x2¼" - 35mm
Aids Subject index
Copies This collection is not open to inspection but the
owner could submit slides under appropriate headings
on request
Charges Reproduction fee standard rates

750
Owner British Iris Society
Location 72 South Hill Park London NW3 2SN
01 435 2700
Custodian Honorary Secretary

Dates (c1960) -
Subjects FLOWERS irises the Iridaceae the British
Iris Society
Numbers tr c350 col 35mm
Aids *List
Access Generally slides only available to members of the
Society
Notes There are two main sections in different locations
which makes access difficult.

751
Owner Valerie Finnis
Location Boughton House Geddington Kettering
Northamptonshire 0536 82279
Dates 1961 -
Photographer Valerie Finnes
Subjects FLOWERS gardens horticulture
horticultural personalities
Numbers tr c20000 col 2¼"x2¼"
Aids *Subject index
Access Bona fide students publishers
Charges Reproduction fee on application

752
Owner Floracolour
Location 21 Oakleigh Road Uxbridge Middlesex
UB10 9EL 0895 51831
Custodian H C W Shaw
Subjects FLOWERS PLANTS - gardens in Europe
Chelsea Flower Show Kew Gardens Chartwell
Manor - garden Derry and Toms' Roof Garden
Venice Windsor Great Park Syon Park - gardens
Queen Mary Rose Garden Royal National Rose
Society Gardens historic cars and motorcycles
London Transport Museum river trip to Greenwich
Travel abroad London by day and night Yorkshire
Snowdonia English churches costume London Zoo
warplanes of two world wars Museum of British
Transport Steam Expo 72 miniature railways
Numbers sl substantial number col 35mm
Aids List
Copies available for sale
Charges Transparency fee on request
Notes Probably the most comprehensive flowers and
gardens commercial collection in Europe.

753
Owner Ron and Christine Foord
Location 155b City Way Rochester Kent ME1 2BE
0634 47348
Dates 1960 -
Photographer Ron Foord Christine Foord
Subjects FLOWERS British wild flowers alpine plants
and flowers insects scenery natural history
gardens local archaeology
Numbers Fi negs 1000 b&w 2¼"x1⅝"
sl c35000 col 35mm
Access Bona fide enquiries by appointment
Copies available for reproduction terms to be negotiated
Charges Reproduction fee by arrangement

754
Owner H Grisbrook
Location 315 Old Birmingham Road Bromsgrove
West Midlands 021 445 2573
Dates 1962 -
Photographer H Grisbrook
Subjects FLOWERS fungi botanical gardens
Numbers tr c250 2"x2"
Access Bona fide students by telephone appointment only
Copies available subject to discussion
Charges Reproduction fee
Notes The collection will eventually be handed over to
Professor Hawkes (Botany Department) The
University of Birmingham.

Key () = dates when collections were begun or terminated
C = Century c = approximately pr = print fi = film
gl = glass neg = negative sl = slide L sl = lantern slide
tr = transparency mic = microform col = colour

b&w = black and white ¼,½,1-pl = quarter, half and whole
plate * = single copy, no public access ** = single copy,
access by appointment

755
Owner F L Harris
Location Old Hall Cottage Fir Tree Lane Haughley Green
 Stowmarket Suffolk IP14 3RL 044 970 458
Dates 1966 -
Photographer F L Harris
Subjects FLOWERS TREES UK LANDSCAPES - grasses -
 ferns fungi mosses butterflies moths birds' nests
Numbers sl c2000 col 2"x2"
Aids *Card index (partial)
Access Bona fide students by appointment

756
Owner D N Paton
Location Crakehall Bedale North Yorkshire
Dates 1947 -
Photographer D N Paton
Subjects FLOWERS wild flowers in natural habitat
 Britain Europe Mediterranean Canary Islands
 South Africa
Numbers pr b&w
 tr c1500 col 2"x2" 5"x4"
Notes Many of the photographs in this collection have
 been used to illustrate books and articles.

757
Owner G Rodway
Location Botanic Gardens Glasgow G12 0UE
 041 334 2422
Dates 1959 -
Subjects ORCHIDS tropical species temperate region
 species
Numbers tr c5000 col 35mm
Access Bona fide students by appointment only
Copies available by arrangement
Charges Print fee by arrangement
Notes This collection is privately owned but lodged at the
 Botanic Gardens.

758
Owner Mrs Frances Perry and Roger Perry
Location Bulls Cross Cottage 3 Bulls Cross Enfield
 Greater London Waltham Cross 24346
Dates (c1950) -
Subjects GARDENS flowers trees plants reptiles
 mammals gardening travel South America -
 Galapagos birds Falkland Islands - flowers Australia
 - plants
Numbers sl c6000 col 2"x2"
Notes Author on flowers and plants. Roger Perry was for
 six years Director of the Charles Darwin Research
 Station in the Galapagos. He has lectured on the
 Antarctic Patagonia Peru Ecuador etc.

759
Owner Maurice Nimmo
Location Pen-y-Cefn Hayscastle Cross Haverfordwest
 Dyfed Letterston 382
Dates 1926 -
Photographer Maurice Nimmo J D V Ward
Subjects TREES shrubs flowers - wild garden
 fungi lichens grasses Dorset Pembrokeshire
 cliffs coastal scenery clouds sunbeams sunsets
 rainbows morning mist snow and ice weather
 effects scenery Geology
Numbers pr c2000 b&w ½pl 1pl
 fi negs 5000 b&w various
 gl negs 400 b&w ¼pl
 sl 8000 col various
Aids Lists
Access Bona fide students picture researchers
 publishers press tv media by appointment only
 requests in writing
Copies available for sale
Notes Includes possibly the most comprehensive
 collection of the species of trees found in Britain.

760
Owner Alpine Garden Society Trustee
Location 20 Reservoir Road Elburton Plymouth Devon
 PL9 8JR 0752 45350

Title Alpine Garden Society Slide Library
Custodian D J T Rose
Dates 1955 -
Subjects ALPINE PLANTS a trip to Turkey Lebanon
Numbers sl c5000 col 35mm 2"x2"
Aids Duplicated catalogue
Access Bona fide students by special arrangement
Copies for loan to members
Charges Hire charges various according to number
Notes Applications for slides should be made as early
 as possible, at least 14 days before the time they
 are required.

761
Owner H H Fowkes
Location 2 Middleton Road Sutton Coldfield West
 Midlands B74 3EU
Dates 1961 -
Photographer H H Fowkes
Subjects EUROPEAN FLORA Mediterranean and
 Andalusia British Species
Numbers sl c2000 2"x2"
Access Bona fide students

762
Owner Scottish Rock Garden Club
Location c/o Cluny House Aberfeldy Perthshire
 Aberfeldy 323
Title Scottish Rock Garden Club Slide Library
Custodian R S Masterton
Dates (1960)
Subjects ALPINE PLANTS
Numbers sl 3000 col 35mm
Aids Duplicated catalogue
Access Members of the Scottish Rock Garden Club only

763
Owner Animal Photography Limited
Location 4 Marylebone Mews New Cavendish Street
 London W1 01 935 0503
Custodian John Thompson Sally Anne Thompson
Dates 1955 -
Photographer Sally Anne Thompson
Subjects ANIMALS domestic pets wild animals from
 abroad views of Gold Coast Nigeria horses
 wild life Russia
Numbers fi negs c8000 b&w 2¼"x2¼"
 tr c12000 col 2¼"x2¼" 35mm
 stereoscopic tr
Access Bona fide students
Copies available for sale for loan to bona fide
 persons only
Charges Print fee reproduction fee depends on use

764
Owner British Deer Society
Location National Headquarters Forge Cottage Askham
 Penrith Cumbria CA10 2PF Hackthorpe 400
Custodian General Secretary and Education Director
Dates 1960 (1963) -
History Collected from a wide range of deer photographers
Photographer Dr Peter Delap R Harris L MacMally
 Dr W Wince
Subjects DEER - species habitat behaviour
 British Deer Society functions
Numbers pr c500 b&w c20 col ¼pl ½pl 1pl
 sl c1000 b&w col 2"x2"
Aids *Card index *subject index in preparation
Access Bona fide students
Copies available for loan or study slide collection for
 loan to lecturers
Charges Print fee with required permission each
 applicant considered separately and charged
 according to circumstances charge to lecturers - 75p
 per set of c50 - recorded delivery both ways - with
 notes £1

765
Owner J A S Carson
Location 46 Pentyla Port Talbot West Glamorgan
 SA12 8AA

Dates (1959) -
Photographer J A S Carson
Subjects ZOOLOGY birds dogs cats horses
Numbers fi negs c100 b&w 35mm
Copies available for sale
Charges Print fee

766
Withdrawn

767
Owner Game Conservancy
Location Fordingbridge Hampshire SP6 1EF
0425 52381
Custodian John Marshall
Dates 1950 -
Subjects ZOOLOGY pheasants partridges wildfowl
ground predator control gamebird diseases
nest sanctuaries agriculture irrigation
farm hazards general habitat hedges and fences
winter feeding forestry winged predator control
shooting dogs deer personalities and staff
game fair travel UK and abroad
Numbers pr substantial numbers b&w
fi negs substantial numbers b&w
tr substantial numbers col
Aids *Catalogue *card index *subject index
Access Bona fide students
Copies available for sale
Charges Reproduction fee £3 for each black and white
or colour transparency
Notes Colour transparencies are used extensively for
lectures by the staff of The Game Conservancy and by
representatives from outside organisations.In some
circumstances lecture notes could be supplied.

768
Owner Kenneth W Green
Location 27 Dee Banks Chester Cheshire CH3 5UU
0244 28629
Dates 1939 -
Subjects ZOOS general transport curiosities
Numbers pr c7000 8½"x6½"
negs c7000 various
tr c500 35mm 2¼"x2¼" 9cm x 6cm
Copies available for sale
Charges Reproduction fee at commercial rates

769
Owner Anne Jordan
Location Low Shield Sparty Lea Hexham Northumberland
Title Recorded Encounters
Dates 1970 -
Photographer Anne Jordan
Subjects ANIMALS - wild birds mammals
Numbers pr 40 b&w 16"x20" 8"x10"
fi negs various b&w
sl various b&w col 2¼"x2¼" 35mm
Access General public
Copies available for sale
Charges Reproduction fee £3.50p per print
Notes A record of all the birds and wild animals that
inhabit the fields and garden round the house.

770
Owner Neill Bruce Photographic
Location 17 Cedar Drive Kingsclere Newbury Berkshire
0635 298929
Title The Arthur Radclyffe Dugmore Wildlife Collection
Dates c1899 - 1935
History Major Dugmore was believed to be one of the first
wildlife photographers, especially in respect of big
game in Africa in 1909 and Caribou in Newfoundland
c1909. Several books are based on his expeditions.
Photographer Major Arthur Radclyffe Dugmore

Subjects ZOOLOGY big game - lions birds beaver
caribou Rockies Ireland
Numbers pr c100 b&w to 10"x12"
fi negs c700 b&w 5"x4"
gl negs c12 b&w 5"x7" 5"x4"
L sl c150 col 2¼"x2¼" hand coloured
Access Picture researchers bona fide students publishers
press tv media by appointment only
Copies available for sale
Charges Print fee reproduction fee on application

771
Owner Scottish Society for the Prevention of Vivisection
Location 10 Queensferry Street Edinburgh EH2 4PG
031 225 6039
Title Animals - Welfare Exploitation Vivisection and
Studies
Custodian Clive Hollands
Dates (1950) -
Subjects ZOOLOGY animal - welfare exploitation
vivisection
Numbers pr 700 b&w 1pl
Aids *Guide
Copies available for loan

772
Owner Zoological Society of Glasgow and West of Scotland
Location Calderpark Zoo Uddingston Glasgow G71 7RZ
041 771 1185
Title Calderpark Zoo's Collection
Custodian R T P O'Grady
Dates 1947 -
Photographer S H Benson N Nicholson R T P O'Grady
Subjects ANIMALS buildings landscapes
Numbers pr c600 b&w col
L sl c600 b&w col
tr b&w 35mm
Access Bona fide students
Copies available for sale for loan
Charges By negotiation

773
Owner Zoological Society of London
Location Regents Park London NW1 4RY 01 722 3333
Custodian R Fish
Dates c1900 -
Photographer F W Bond Frederick Martin Duncan
David Seth-Smith
Subjects ZOOLOGY animals fishes amphibians
reptiles birds mammals molluscs insects
buildings
Numbers pr substantial number b&w various
fi negs c18000 b&w
gl negs c12000 b&w
L sl
tr 5000 col
Access Open to people wishing to purchase and to
members of the Society 9.30 am - 5.30 pm
Copies available for sale for display for publication
Charges Reproduction fee print/transparency fee
holding fee search fee

774
Owner Will Green's British Photograph Library
Location 90 Wells Way Camberwell London SE5 7UA
01-703 4008
Dates 1955 -
Subjects CATS children architecture customs and
folklore geography education social sciences
transport mechanical engineering archaeology
Numbers pr substantial number b&w 10"x8"
fi negs c60000 6cmx6cm 35mm
tr c6000 col 6cmx6cm 35mm
Aids Catalogue on request

Key () = dates when collections were begun or terminated
C = Century c = approximately pr = print fi = film
gl = glass eng = negative sl = slide L sl = lantern slide
tr = transparency mic = microform col = colour

b&w = black and white ¼,½,1-pl = quarter, half and whole
plate * = single copy, no public access ** = single copy,
access by appointment

Access General public bona fide students picture
researchers press tv media 10 am - 12 noon
2 pm - 5 pm
Copies available for sale for display for loan for
publication
Charges Publication fee col minimum £12 5"x4" and pro
rata b&w minimum £4 5"x4" and pro rata
Notes The owner has also published a book about cats.

775
Owner Miss D E Machin Goodall
Location Sparrow's House Great Henny Near Sudbury
Suffolk Twinstead 276
Dates (1956) -
Photographer Miss D E Machin Goodall
Subjects HORSES zebra onager landscapes in
Antarctica Chile Poland West Germany Argentina -
Eva Peron's childrens village
Numbers fi neg c300
tr c800 35mm
Access Press tv media publishers
Copies available for sale for display for publication
credit line required
Charges Publication fee
Notes Miss Goodall is the author of a number of self
illustrated books on horses.

776
Owner Glasgow City Council
Location Art Gallery and Museum Kelvingrove
Glasgow G3 8AG 041 334 1134
Title Charles Kirk Collection of Natural History
Photographs
Custodian C E Palmar
Dates c1894 - 1920
History Charles Kirk was author and illustrator of
Wild Birds At Home - a series of picture books.
He also ran a taxidermist shop in Glasgow
Photographer Charles Kirk
Subjects BIRDS mammals plants - in Glasgow and Clyde
area Ailsa Craig
Numbers gl negs c400 b&w ½pl 5"x4"

777
Owner Mrs Gerald Askew
Location Halland Lewes East Sussex Halland 260
Title The Bentley Wildfowl Collection
Dates 1962 -
Subjects WILDFOWL - worldwide
Numbers pr c1000
tr
Aids Catalogue
Access General public bona fide students
27th March - 3rd October 11 am - 6 pm

778
Owner Frank V Blackburn
Location 15 The Park Dolley's Hill Normandy
Guildford Surrey 048 642 2569
Title European Birds
Photographer Frank V Blackburn
Subjects EUROPEAN BIRDS natural history
Numbers pr 500 b&w 10"x8"
sl 9000 col 6cm x 6cm 35mm
Access Picture researchers press tv media
by appointment only 7 am - 6 pm
Copies available for sale for display for publication
credit line required
Charges Reproduction fee holding fee

779
Owner R J Copping
Location Caretaker's Bungalow Lavenham Way
Stowmarket Suffolk
Dates 1965 -
Photographer R J Copping
Subjects BRITISH BIRDS AND THEIR NESTS
Numbers sl c700 col
Copies available for reproduction
Charges Reproduction fee by arrangement

780
Owner Wildfowl Trust (Education Department)
Location Slimbridge Gloucestershire GL2 7BT
045 389 333
Title Wildfowl Trust Photographic Library
Custodian J B Blossom
Dates 1946 -
History The Wildfowl Trust was founded by Sir Peter Scott
Subjects WILDFOWL ducks geese swans flamingoes
screamers wildfowl habitat wildfowl aviculture
general natural history
Numbers fi negs c10000 b&w 35mm 2¼"x2¼"
tr c15000 col 35mm 2¼"x2¼"
line negs for litho work b&w 5"x4"
Aids *Card Index *subject index
Copies available for sale for loan to bona-fide
organisations
Charges Print fee by arrangement

781
Owner Royal Society for Protection of Birds
Location The Lodge Sandy Bedfordshire Sandy 80551
Title British Birds and Habitat
Custodian Michael Richards
Dates (1970) -
Subjects BIRDS trees plants fungi mammals
landscapes habitat - aerial photography
Numbers negs c600 b&w 2¼"x2¼" 35mm
sl c300 col 35mm
sl c600 col b&w 2¼"x2¼" 35mm
Aids *Card index *subject index
Access Bona fide students picture researchers press
tv media by appointment by phone 9 am - 5 pm
Copies available for sale for display for loan
for publication
Charges Print fee reproduction fee agency fee of 50% of
the non exclusive reproduction fee for any work used
through the RSPB of other photographers copyright
and full fees for RSPB photographs
Notes Communication by telephone or letter is preferred
since the collection is not yet fully comprehensive.

782
Owner British Killifish Association
Location High Croft 11 Hill Street Upper Gornal Dudley
West Midlands DY3 2DE
Title Instructional Slides and Tape Lectures Devoted
to the keeping and breeding of Killifish
Custodian F Bolton
Dates (1964) -
History Formed in the West Midlands by 21 members
(1965). Approximately 600 members from all over
the world
Subjects KILLIFISH top and switch spawners peat divers
soil spawners rivulus species killifish egg
development fish-house construction trip to Ghana
plants
Numbers tr substantial numbers
Access General public information available on receipt
of sae
Copies available for loan by postal request UK only
at least one month's notice required individual
transparencies are available to members at cost price
Charges £1.25 hire fee plus postage hire period 1 week
except by prior arrangement
Notes Tape and slide lectures are available in all subjects
listed. Projector and spool type tape recorder required
by hirer.

783
Owner Rentokil Limited
Location Felcourt East Grinstead West Sussex
RH19 2JY East Grinstead 23661
Custodian R Edwards
Dates 1959 -
Subjects INSECTS rodent pests in buildings
fungal decay timber treatment hygiene services
pest control laboratories
Numbers fi negs c6500 b&w c100 col 4"x5"
L sl c5000 col 2"x2"
sl c2000 col 4"x5"

Aids *Card index *subject index
Access This collection is not open to inspection - postal application only
Copies available for loan for publication colour slides for sale credit line required

784

Owner S Beaufoy
Location 98 Tuddenham Road Ipswich Suffolk IP4 2SZ 0473 52340
Dates 1935 -
Photographer S Beaufoy
Subjects BUTTERFLIES MOTHS DRAGONFLIES - all their stages of life history - other insects
Numbers pr 2000 b&w
gl neg 2000 b&w
L sl 500 $3\frac{1}{4}$"x$3\frac{1}{4}$"
sl 100 b&w 2"x2"
tr 2200 col 35mm
Aids Card index subject index
Access Publishers press tv media by appointment
Copies of black and white prints available for reproduction purposes at normal fees

785

Owner British Red Cross Society National Headquarters 9 Grosvenor Crescent London SW1X 7EJ 01 235 5454
Location National Training Centre Barnett Hill Wonersh Guldford Surrey 048 647 3361
Title British Red Cross Society Historical Photographic Library
Custodian Mrs Joy Fawcett
Dates 1870 (1969) -
Subjects MEDICINE British Red Cross Society - activities history war service general work in wartime and peacetime
Numbers pr c900 b&w col 8"x6"
fi negs
L sl
tr
Aids *Subject index
Access Bona fide students picture researchers press tv media by appointment
Copies available for sale from existing negatives for loan
Charges Print fee plus postage
Notes The photographs form part of a standing exhibition showing the history of the Society over the last 104 years. There are also a number of press cutting books which are of interest for research.

786

Owner Guy's Hospital
Location The Gordon Museum London SE1
Custodian John Maynard
Subjects MEDICINE clinical disease pathology histology
Numbers sl 30000 col 2"x2"
Aids Subject index
Access Bona fide students
Notes This is a patient record as well as a collection for teaching.

787

Owner Guy's Hospital Medical School
Location Wills Library London Bridge London SE1 9RT
Custodian Miss J M Farmer
Dates 19th and early 20thC
Subjects MEDICINE hospitals and medical doctors ancillary services
Numbers pr c250 b&w
Access General public bona fide students by prior arrangement
Copies by arrangement
Charges By arrangement

788

Owner Incorporated School of Tropical Medicine (Affiliated to Liverpool University)
Location Pembroke Place Liverpool Merseyside L3 5QA 051 709 7611
Custodian G Joan Smith
Dates 1898 -
History The collection was started in 1898 when expeditions were sent to tropical areas of the world
Subjects MEDICINE - tropical clinical conditions parasites insects pathological conditions buildings ceremonies staff students - School of Tropical Medicine portraits - scientists in tropical medicine
Numbers pr substantial number
Aids Card index
Access Bona fide students by appointment only

789

Owner Institute of Ophthalmology (University of London)
Location Judd Street London WC1 01 387 9621
Title Ophthalmic Illustrations
Custodian Dr Peter Hansell
Dates 1949 -
Subjects MEDICINE ophthalmology
Numbers pr substantial numbers b&w $\frac{1}{2}$pl
fi negs substantial numbers b&w 5"x4"
gl negs substantial numbers b&w 9cm x 12cm
L sl substantial numbers b&w col 2"x2"
Aids *Catalogue *card index *subject index
Access Bona fide students
Copies available for sale with conditions
Charges Print fee

790

Owner International Planned Parenthood Federation and U N E S C O
Location 18-20 Lower Regent Street London SW1
Title International Audio Visual Resource Service
Custodian Catherine H Wood
Dates 20thC -
Subjects MEDICINE social sciences hospitals and medical educational equipment communications customs and folklore food production domestic photography recreations biography and portraits landscapes Family planning movement
Numbers pr c4000 b&w 10"x8"
L sl c2500 col 35mm
Access People involved in family planning and population activities telephone or written requests
Copies available for sale

791

Owner The London Hospital Medical College (University of London)
Location Whitechapel London E1 01 247 0644 Ext 17
Custodian The Librarian
Dates c1880 (19thC) -
Subjects MEDICINE The London Hospital - staff students buildings social events painting numismatics biography and portraits historic and newsworthy events Edith Cavell "Elephant Man" second World War Royal visits
Numbers pr substantial numbers
Aids Lists
Access Bona fide students

792

Owner Royal Society of Medicine
Location 1 Wimpole Street London W1M 8AE 01 580 2070
Title Royal Medical and Chirurgical Society Photographic Collection
Dates c1856 - 1870
Photographer Dr H Diamond

Key () = dates when collections were begun or terminated
C = Century c = approximately pr = print fi = film
gl = glass neg = negative sl = slide L sl = lantern slide
tr = transparency mic = microform col = colour

b&w = black and white $\frac{1}{4}$,$\frac{1}{2}$,1-pl = quarter, half and whole plate * = single copy, no public access ** = single copy, access by appointment

Subjects MEDICINE - mental deficiency period
 costume
Numbers pr 113 b&w various
Access Bona fide students with written permission
 from the librarian
Copies available for sale
Charges Rent fee £2 per copy

793
Owner St Mary's Hospital Medical School
Location Department of Audio Visual Communication
 Paddington London W2 01 723 1252
Title Medical Teaching Collection
Custodian Dr P N Cardew
Dates 1900 (1950) -
History Sir Alexander Fleming, the discoverer of
 Penicillin, was associated with this hospital as also
 Sir Almoth Wright, Dr Spilsburg - forensic pathologist,
 and Alec Bourne, the surgeon who challenged the
 Abortion Act in the 1930's
Subjects MEDICINE
Numbers fi negs 20000 b&w 5''x4''
 L sl 20000 col 2''x2''
 tr 1000 col 3¼''x3¼''
Aids *Subject index
Access Bona fide students medical only
Copies available for sale
Charges Reproduction fee standard rates

794
Owner University of Manchester
Location The Department of Medical Illustration
 The Royal Infirmary M13 9WL 061 273 3300
Custodian Dr Robert Ollerenshaw
Dates 19thC -
Subjects MEDICINE all aspects
Numbers substantial numbers
Aids *Catalogue *Subject index
Access Picture researchers bona fide students press
 tv media by appointment 9 am - 5 pm
Copies available for sale for publication credit line
 required
Charges Reproduction fee print/transparency fee

795
Owner Westminster Hospital Medical School
 (University of London)
Location 17 Page Street London SW1P 2AP
 01 828 9811 Ext 2470
Title Medical Photographic Records
Custodian Dr Peter Hansell
Dates 1945 -
Subjects MEDICINE
Numbers pr substantial numbers b&w ½pl
 fi negs substantial numbers b&w 5''x4'' 35mm
 gl negs substantial numbers b&w 5''x4'' 9''x12''
 L sl substantial numbers col 2''x2''
Aids Visual files *card index cross referenced subject
 index
Access Bona fide students
Copies available for sale
Charges Print fee

796
Owner M Fodor (on permanent loan to the University of
 Dundee)
Location University Library Dundee 0382 23181
Title Complete photographic work of Michael Peto
Custodian Stanley C Turner
Dates 1945 - 1970
History Michael Peto, Hungarian with an amateur interest
 in the art of photography, arrived in Britain in 1939
 and after spending the war years working as
 directed by the Ministry of Labour turned his full
 attention to photography, which he then pursued
 till his death in 1970
Photographer Michael Peto
Subjects HUMAN BEHAVIOUR children at play
 politics in Hungary c1946 London Ballet - behind
 scenes animals workmen Prospect Theatre
 productions politicians geography in India

Korea Spain Israel historic and newsworthy events
 1950-1970
Numbers pr substantial number b&w
 fi negs c50000 b&w 35mm
 gl negs b&w
 sl c1000 col 35mm
Access Picture researchers press tv media
Copies available for sale for exhibition for loan
Charges Reproduction fee
Notes Michael Peto's photographs have been published
 and exhibited widely, he spent eleven years working
 for the Sunday Observer and illustrated two books;
 The Dancer's World 1963 in collaboration with
 Alexander Bland and About Britain 1968 in
 collaboration with Kenneth Harris.

797
Owner People's Dispensary for Sick Animals
Location Head Office South Street Dorking Mole Valley
 Surrey RH4 2LB 0306 81691
Title P D S A Photographic Library Collection
Custodian R I Cookson
Dates 1920 -
Subjects VETERINARY SCIENCE sick animals dogs
 cats horses birds budgerigars parrots swans
 accident and emergency services ambulances
 floods road accidents blizzards war rescues
 dispensaries animal treatment centres mobile
 units overseas establishments events and functions
 publicity and education awards and presentations
 personalities animal studies charitable fund raising
Numbers pr c7500 b&w
 fi negs c2000 b&w
 sl c100 col
Aids *Guide
Copies available for loan

798
Owner Warner Lambert Group of Companies
Location Chestnut Avenue Eastleigh Hampshire
 SO5 3ZQ 042 126 3131
Title Warner Lambert Group of Companies Record
Custodian Mrs Janet Courtice
Dates 1932 -
Subjects PHARMACEUTICAL family health care
 hair care confectionery
Access The collection is not open to inspection. Requests
 for maeterial should be made to the custodian

799
Owner Royal Anthropological Institute Library
Location 6 Burlington Gardens London W1X 2EX
 01 734 6370
Dates c1866 -
Subjects ANTHROPOLOGY
Numbers pr c12500
 gl negs c1600
 L sl c1750
Aids Catalogue with contact print attached to card
 in preparation
Notes The collection is of considerable historic interest
 in the field of Anthropology.

800
Owner Cambridge University Museum of Archaeology
 and Ethnology
Location Downing Street Cambridge 0223 59714
Title Haddon Collection
Custodian Curator
Dates c1888 - c1935
History The collection is a valuable ethnographic record
 of the late 19th and early-middle 20thC
Subjects ETHNOLOGY - mainley non-European world
Numbers pr c11000 b&w 8''x6''
 gl negs c5000 b&w 4½''x3½''
Aids Catalogue card index
Access Bona fide students
Copies available for sale
Charges Print fee reproduction fee by arrangement

801
Owner Janet and Colin Bord
Location Melangell House Princes Street Montgomery
Powys SY15 6PY Montgomery 405
Dates (1970) -
Photographer Colin Bord Janet Bord
Subjects ARCHAEOLOGY prehistoric and Roman sites
in Britain rural scenic and historical Britain
Numbers pr substantial number b&w 6"x8"
fi negs c10000 b&w 2¼"x2¼" 35mm
sl c5000 col various
Aids Descriptive leaflet
Access Publishers by appointment
Copies available for publication credit line required
Charges Reproduction fee holding fee

802
Owner Halifax Antiquarian Society
Location Bankfield Museum Halifax West Yorkshire
0422 54823
Custodian A Betteridge Honorary Librarian Halifax
Antiquarian Society 30 Rothwell Drive Halifax
Dates 1900 (1930) - 1950
Photographer W B Crump R Eccles H P Kendall
W B Trigg
Subjects ARCHAEOLOGY - ARCHITECTURE
Numbers gl neg c450 b&w
gl sl c400 b&w
Aids Catalogue
Access Bona fide students

803
Owner London Borough of Southwark Council Library
Services Administration Department 20/22 Lordship
Lane London SE22 01 693 9221
Location Cuming Museum 155 Walworth Road London SE17
01 703 3324/5529 Ext 32
Custodian The Curator
Dates (1959) -
Subjects ARCHAEOLOGY ARCHITECTURE - Southwark
area
Numbers pr c1000 b&w
fi negs c1000 b&w 35mm
gl pos c100 b&w 3½"x3¼"
L sl c1500 col 35mm
Aids Catalogue and subject index for part of the slide
collection
Access Bona fide students
Notes Photographic items are ancillary to the Museum
collection and primarily for staff use.

804
Owner Department of Archaeology
(University of Manchester)
Location Manchester Museum The University Oxford
Road Manchester M13 9PL 061 273 3333 Ext 560
Custodian A J N W Prag
Dates (Late 19thC) -
Subjects ARCHAEOLOGY country life and customs
transport customs and folklore astronomy
meteorology botany zoology mining
food production architecture biography and
portraits geography exploration and travel abroad
Egyptology
Numbers pr c5000 b&w 14"x10" 10"x8"
fi negs c3760 b&w ¼pl ½pl 5"x4"
gl negs c950 b&w ¼pl
L sl c16782 b&w 236 col 3¼"x3¼" 2"x2"
tr 75 col 5"x4"
x-ray fi 31 b&w various
Aids *Guide *card index
Access General public picture researchers bona fide
students press tv media by appointment
10 am - 4.45 pm
Copies available for sale for display for publication
credit line required

Charges Print fee black and white from 50p from existing
negative from £1 from new negative black and white
lantern slides from 35p Colour transparencies from
35p Ektachrome col transparencies from £5
Microfilm charges on application

805
Owner Norfolk Archaeological Unit
Location Union House Gressenhall Dereham Norfolk
NR20 4DR 036 286 528/9
Title The Norfolk Archaeological Unit Sites and
Monuments Record
Custodian Derek A Edwards
Dates c1960 (1973) -
Subjects ARCHAEOLOGY excavations and projects
of the Norfolk Archaeological Unit
Numbers pr c3000 b&w various
fi negs c3000 b&w 35mm 2¼"x2¼"
tr c2000 col 35mm
Aids *Card index for slides only *subject index by
optical coincidence system fi record sheets for
b&w pr
Access General public bona fide students picture
researchers press tv media by appointment only
Copies available for sale for publication for display
subject to purchase
Charges Reproduction fee print/transparency fee
all charges by arrangement

806
Owner Norfolk Archaeological Unit
Title Air Photographs Index
Dates 1973 (1974) -
Subjects ARCHAEOLOGY air photographs of
archaeological sites
Numbers pr c2000 b&w various
fi negs c2000 b&w various
tr c1000 col 35mm
Aids **Card Index
Notes Location, Access, Copies and Charges as for No.
805 above.

807
Owner Northamptonshire Industrial Archaeology Group
Location c/o 17 Mayfield Road Northampton NN3 2RE
Custodian Geoffrey H Starmer
Subjects ARCHAEOLOGY ironstone quarries and mines
breweries and maltings watermills rural water
supplies canals
Numbers pr b&w 4¾"x6½"
fi negs 2¼"x2¼" 35mm
Aids Card index
Notes Enquiries will only be answered if accompanied by
a stamped addressed envelope.

808
Owner Pontefract and District Archaeological Society
Location Friarwood House Pontefract West Yorkshire
0977 4201
Title Pontefract and District Archaeological Society
Photographic Record
Custodian Miss D Roberts
Dates 1960 -
Subjects ARCHAEOLOGY Pontefract - religion social
sciences banks hospitals education stations
home architecture cinemas shops old almhouses
war memorial fire station hotels public houses
industrial premises windmill
Numbers fi negs 134 b&w 35mm
Access Bona fide students
Copies available for sale
Charges Print fee

809
Owner Robert Harding Associates

Key () = dates when collections were begun or terminated
C = Century c = approximately pr = print fi = film
gl = glass neg = negative sl = slide L sl = lantern slide
tr = transparency mic = microform col = colour

b&w = black and white ¼, ½, 1-pl = quarter, half and whole
plate * = single copy, no public access ** = single copy,
access by appointment

Location 5 Botts Mews Chepstow Road Bayswater
London W2 5AG 01 229 2234
Custodian Ellen Crompton
Dates c1960 -
Photographer Jon Gardy Robin Hanbury-Tenison
Robert Harding Sybil Sassoon
Subjects ARCHAEOLOGY ARCHITECTURE
WORLD WIDE GEOGRAPHY AND TOPOGRAPHY
travel anthropology botany zoology modern man
at work arts and crafts customs anf folklore
Alaska China Sahara Himalayas Indonesia
Malaysia Mexico India Afghanistan Iran
Middle East Chinese exhibition pictures
World of Islam Festival
Numbers tr c100000 col various
Aids Duplicated guide subject index
Access Picture researchers AD agencies designers
press tv media 9.30 am - 5.30 pm to original images
Copies available for sale for publication subject to
copyright restrictions credit line required
Charges Print fee reproduction fee search/holding fee
if material borrowed for publication is kept more than
a month and returned unused

810

Owner Royal Commission on Historical Monuments
(England) National Monuments Record
Location Air Photographs Unit Fortress House
23 Savile Row London W1X 1AB 01 734 6010
Title Air Photographs for Archaeology
Custodian J N Hampton
Dates 1920 (1965) -
History Includes Crawford Collection of R A F
pre-1939 air photographs
Photographer Major Allen W A Baker Crawford
J Pickering
Subjects ARCHAEOLOGICAL SITES aerial photography
ecology geography geology
Numbers pr c250000 b&w various
fi negs c70000 b&w
Aids *Map index catalogue
Access Bona fide students 9.30 am - 5 pm to copy prints
Copies available for sale for display for publication
Charges Reproduction fee print/transparency fee
Notes Resources very limited. 6 - 9 months waiting
depending on size of order.

811

Owner Royal Commission on Ancient Monuments Scotland
Location National Monuments Record of Scotland
54 Melville Street Edinburgh 3 031 225 5994
Custodian K A Steer
Dates c1850 (1941) -
Subjects ARCHAEOLOGY ARCHITECTURE
Numbers pr c150000 b&w various
fi negs c150000 b&w various
Aids Card index subject index
Access General public bona fide students picture
researchers press tv media 9.30 am - 5 pm
Copies available for sale for loan with certain
restrictions for publication credit line required
Charges Print fee from 35p $\frac{1}{2}$pl lantern slides from 80p
each (from existing negative) photocopies 6p per
sheet prints or transparencies from existing colour
negatives at cost mounting of prints and sepia toning -
50% of cost postage and packing VAT exempt trader
Notes The collections of the Royal Commission on Ancient
Monuments, Scotland (1908-) and the Scottish National
Buildings Record (1941-) were amalgamated in 1966
to form the National Monuments Record of Scotland.

812

Owner Royal Commission on Ancient and Historical
Monuments in Wales
Location Edleston House Queen's Road Aberystwyth
Dyfed SY23 2HP 0970 4381
Title National Monuments Record for Wales
Photographic Library
Custodian P Smith
Dates 1860 (1908) -

Subjects ARCHAEOLOGY archaeological sites
historic buildings industrial monuments
Numbers pr c25000 b&w $\frac{1}{4}$pl - 10"x8"
fi negs c10000 b&w 2$\frac{1}{4}$"x2$\frac{1}{4}$" 2$\frac{1}{4}$"x3$\frac{1}{4}$"
gl negs c8000 b&w 5"x4" - 13cm x 18cm
L sl c300 b&w col
Aids Card index
Access General public bona fide students
Copies available for sale
Charges Print fee from 15p black and white slides from
80p colour slides from £1.30

813

Owner Thomas Warnock Smith
Location 2 Thorns Cottage Dolton Nr Winkleigh Devon
Title Our National Heritage Dartmoor
Dates (1959) -
Photographer Thomas Warnock Smith
Subjects ARCHAEOLOGY ARCHITECTURE - castles -
churches domestic architecture prehistoric and Roman
remains gardens parks scenery - especially
Dartmoor
Numbers sl c6000 col
Aids Catalogue card index
Access By direct correspondence
Copies available
Charges By arrangement
Notes These slides are used entirely for lecture purposes.

814

Owner Society of Antiquaries of Newcastle upon Tyne
Location Black Gate Newcastle upon Tyne Tyne and Wear
0632 27938
Custodian J C Day
Dates c1890 (c1890) -
Subjects ARCHAEOLOGY ARCHITECTURE
Access Bona fide students

815

Owner South West Wales Industrial Archaeology Society
Location Main Library Photographic Department
University College of Swansea Singleton Park
Swansea West Glamorgan 0792 25678 Ext 633
Title South West Wales Industrial Archaeology Society
Collection
Custodian Hayden Holloway
Dates 1971 -
Photographer Hayden Holloway
Subjects INDUSTRIAL ARCHAEOLOGY
Numbers pr c100 b&w 5"x4" - 10"x8"
fi negs c100 b&w 35mm 2$\frac{1}{4}$"x2$\frac{1}{4}$"
tr c150 b&w col 35mm
Aids Personal record
Access Bona fide students
Copies available for sale on request
Charges Print fee to members at a nominal cost

816

Owner Tewkesbury Borough Council
Location Archaeological Centre Mill Street
Tewkesbury Gloucestershire
Custodian A Hannan
Dates (1972) -
Subjects ARCHAEOLOGY architecture geography of
Gloucestershire
Numbers pr c80 b&w 15"x12"
fi negs 792 b&w various
sl 235 b&w col 35mm
Aids Subject index
Access Bona fide students
Charges Print fee from 10p minimum charge £1 per order
including postage

817

Owner G S G Toms
Location 29 Mount Street Shrewsbury Salop SY3 8QH
Dates 1968 -
Photographer G S G Toms

Subjects ARCHAEOLOGY - sites finds antiquities
buildings - exteriors interiors public buildings
ecclesiastical residences landscapes physical
features mountains and hills in Salop Greece
Italy
Numbers sl c3000 col 35mm
Access By appointment
Copies available for sale for loan
Charges Loan - 10p per slide sale of copies - 25p per
slide reproduction fee £1 per photograph

818

Owner University of Aberdeen
Location Aberdeen University Library King's College
Aberdeen AB9 2UB 0224 40241
Title W Douglas Simpson Collection
Dates c1920 - c1960
History W Douglas Simpson was an eminent archaeologist
and historian
Subjects ARCHAEOLOGY ARCHITECTURE
Numbers L sl c5000 $3\frac{1}{4}$"x$3\frac{1}{4}$"
Aids *Catalogue
Access Bona fide students
Copies available for sale to bona fide researchers only
Charges Reproduction fee

819

Owner University of Oxford
Location Ashmolean Museum Beaumont Street Oxford
0865 57522
Title Ashmolean Museum and University Galleries and
Griffith Institute Collection The Allan Collection
of Aerial Photographs
Custodian Ian Charlton
Dates c1880 (1900) -
History Photographic records of excavations at Knossos
by Sir Arthur Evans and also excavation of
Tut'ankhamun's tomb by Howard Carter and Lord
Caernarvon
Subjects ARCHAEOLOGY ART ARCHITECTURE -
Western Eastern Oriental European coins and
medals aerial photography - S E England
Museum objects
Numbers gl negs c65000 6"x4"
sl 35mm
tr 6"x4"
mic 35mm
Aids Card index
Access General public bona fide students on application
Charges Black and white prints from existing negative
10p if new negative has to be made from 35p colour
prints from £4 lantern slides from 13p ektachrome
colour transparencies £7.50p developing and
printing client's own negatives 13p and 15p
mic negs 5p each

820

Owner Yorkshire Archaeological Society
Location Claremont Clarendon Road Leeds 0532 457910
Dates c1880 -
Subjects ARCHAEOLOGY aerial photographs of sites
metal work stone architecutre antiques
biography and portraits mainly of Yorkshire interest
Numbers Pr c1000 b&w various
gl negs c250 b&w various
gl pos c250 b&w various
L sl c1000 b&w $3\frac{1}{4}$"x$3\frac{1}{4}$"
Aids *Card index
Access General public
Copies available for loan
Notes Special collections for Selby and Church fonts.

821

Owner North Yorkshire County Council
Location Yorkshire Museum Museum Gardens York
YO1 2DR 0904 29745

Title Includes the William Watson Collection
Custodian T M Clegg
Dates c1905 - c1925
Subjects ARCHAEOLOGY ARCHITECTURE
Numbers fi negs c500 b&w col various
gl negs c800
L sl c600
Access Bona fide students
Copies available for sale by arrangement
Charges Reproduction fee on application advertising
fees double the standard rates educational fees will
be half the standard rates television will be charged
at a flat rate where a large numbers of photographs
are required charges will be reduced - rates will be
quoted on application.

822

Owner Geoffrey H Starmer
Location 2 Greenfield Avenue Spinney Hill Northampton
NN3 2AA 0604 42979
Dates 1948 (1950) -
Photographer Geoffrey H Starmer
Subjects INDUSTRIAL ARCHAEOLOGY IN
NORTHAMPTONSHIRE - sites buildings power
sources machines iron industry railways tramways
boot and shoe manufacture people at work
Numbers pr c2000 b&w $4\frac{3}{4}$"x$6\frac{1}{2}$"
fi negs c22500 b&w various
sl c9000 col 35mm
Aids Catalogue card index
Copies available for sale
Charges Reproduction fee £3 b&w £10 col

823

Owner Royal Astronomical Society
Location Burlington House Piccadilly London W1
01 734 4582
Title Photographic Collection of the Royal Astronomical
Society
Custodian Dr R E W Maddison
Dates c1860 (Mid 19thC) -
Subjects ASTRONOMY - celestial objects instruments
Numbers gl negs c2500 b&w various
L sl c550 b&w
Aids Published catalogue of current slides *card index
of archive collection *and published subject index
Access Bona fide students on written application to custodian
Copies available for sale

824

Owner Royal Greenwich Observatory
Location Herstmonceux Castle Hailsham East Sussex
Herstmonceux 3171
Title Photographic Negative Files
Custodian D A Calvert
Dates c1860 -
History The collection covers the development of the
Observatory between late 19thC and present day
Photographer P J Mellotte
Subjects ASTRONOMY CHRONOLOGY architecture
outdoor games biography and portraits
Numbers pr c100 b&w c50 col various
fi negs c3500 b&w 100 col 5"x4"
gl negs c100000 b&w various
L sl c1000 b&w $3\frac{1}{4}$"x$3\frac{1}{4}$"
tr c200 col 35mm
Aids Catalogue for astronomical plates only day to day
file of current negatives
Copies available for sale
Charges Print fee

825

Owner Antiquarian Horological Society New House
High Street Ticehurst Wadhurst East Sussex
TN5 7AI Ticehurst 3255
Location Guildhall Library Aldermanbury London EC2

Key () = dates when collections were begun or terminated
C = Century c = approximately pr = print fi = film
gl = glass neg = negative sl = slide L sl = lantern slide
tr = transparency mic = microform col = colour

b&w black and with $\frac{1}{4}$,$\frac{1}{2}$,1-pl = quarter,half and whole
plate * = single copy,no public access ** = single copy,
access by appointment

Title Antiquarian Horology
Dates c1920 (1953) -
Subjects HOROLOGY portraits of horologists
Numbers pr substantial numbers b&w
 fi negs substantial numbers b&w
 gl negs substantial numbers b&w
 gl pos substantial numbers b&w
 L sl substantial numbers b&w
Access Bona fide students
Notes The collection is generally intended for record
 purposes only, in many cases the original may be lost or
 destroyed.

826

Owner D F Malin
Location Heyrose Cottage Over Tabley Knutsford
 Cheshire Pickmere 3421
Dates (1965) -
Subjects CRYSTALS - optical photomicrographs
Numbers pr c20 col 8"x10"
 fi neg c40 col 5"x4"
 L sl 150 col 35mm
 tr 100 col $2\frac{1}{4}$"x$3\frac{1}{4}$"
Aids Subject and technical notes
Access Bona fide students
Copies available for sale for loan
Charges Print fee

827

Owner Geologists' Association Burlington House
 Piccadilly London W1 01 734 2356
Location Old Stones Elmstead Glade Chislehurst Kent
Title Geologists' Association Albums
Custodian Mrs Marjorie W Carreck
Dates 1860 (1907) -
History The collection was compiled by a few members
 of the Association in this century, from many sources
Photographer Thomas William Reader
Subjects GEOLOGY mineralogy palaeontology
 archaeology biography and portraits geography
 ice and snowscenes mineralogical or pre-historic
 archaeological sites
Numbers pr substantial number b&w col various
Aids Chronological order
Access Bona fide students by appointment on written
 application
Copies available on request at cost of production
 if for study or research
Charges Enquiries for commercial use or publication
 to be sent to the Secretary of the Association for
 its council's consideration

828

Owner Institute of Geological Sciences
Location Geological Museum Exhibition Road London
 SW7 2DE 01 589 3444
Title British Geological Photographs
Custodian J M Pulsford
Dates c1900 -
Photographer A F Christie H J Evans W D Fisher
 C J Jeffrey J M Pulsford J Rhodes K E Thornton
Subjects GEOLOGY - crystals minerals rock formations
 fossils geography
Numbers pr 20000
 fi negs 12000 b&w col
 gl neg 12000 b&w
 L sl 3500 col
 sl 250 col
Aids Catalogue colour transparency library list
Access General public 10 am - 4.30 pm
Copies available for sale except the colour transparency
 (large format) library
Charges Photographic services tariff list available free
 on request

829

Owner North Yorkshire County Council
Location Yorkshire Museum Museum Gardens
 York YO1 2DR 0904 29745
Custodian T M Clegg
Dates c1900 -

Subjects GEOLOGY
Numbers fi negs c500 various
Access Bona fide students
Copies available for sale by arrangement
Charges Reproduction fee on application advertising fees
 double the standard rates educational fees will be
 half the standard rates television will be charged at a
 flat rate where a large number of photographs are
 required charges will be reduced - rates will be
 quoted on application.

830

Owner John W Perkins
Location Department of Extra-Mural Studies
 38/40 Park Place Cardiff South Glamorgan
 CF1 3BB
Dates 19thC (1958) -
Photographer John W Perkins
Subjects GEOLOGY INDUSTRIAL ARCHAEOLOGY
 inland-waterways water mills historical buildings
 mineralogy palaeonotology landscapes and physical
 features - South Wales South West England mining
 limekilns transport - road
Numbers sl c9000 col 2"x2"
Access Bona fide students
Copies Slides available for sale
Charges Reproduction fee

831

Owner D A Simmons
Location Eyhorne Manor Hollingbourne Maidstone Kent
Dates 1923 - c1925
Subjects GEOLOGY in relation to architecture
Numbers pr 8"x6"
Aids Catalogue
Access General public bona fide students
Notes Assembled by C F A Voysey, Architect.

832

Owner University of Nottingham
Location University Library (Department of Special
 Collections) University Park Nottingham
 0602 56101 Ext 3420
Custodian Michael Brook Special Collections Librarian
 Ext 3433
Dates 1898 - 1939
History Henry Howe Arnold-Bemrose 1879-1912
 belonged to the Bemrose family of printers in Derby,
 and contributed many articles on Derbyshire geology
 to learned journals; he also wrote a number of books
 on Derbyshire subjects
Photographer Henry Howe Bemrose W Walker
Subjects GEOLOGY Derbyshire railway track
 quarry workings quarrymen in working clothes with
 tools
Numbers pr c240 b&w various
Aids Subject Catalogue
Access General public
Notes The photographs were taken to illustrate articles
 on aspects of Derbyshire geology by H H Bemrose
 published 1898-1907 and are mounted in six albums.
 These albums are treated as books and form part
 of the University library's East Midlands Collection.

833

Owner North Yorkshire County Council
Location Yorkshire Museum Museum Gardens York
 YO1 2DR 0904 29745
Title Tempest Anderson Photographic Collection
Custodian T M Clegg
Dates 1880 - 1910
History Tempest Anderson was a well known scientist
 specialising in volcanoes and glaciers, optical
 instruments and photography
Subjects GEOLOGY volcanoes glaciers
Numbers gl negs c2000
Access Bona fide students
Copies available for sale by arrangement

Charges Reproduction fee on application advertising fees double the standard rates educational fees will be half the standard rates television will be charged at a flat rate where a large number of photographs are required charges will be reduced - rates will be quoted on application

834
Owner Meteorological Office
Location London Road Bracknell Berkshire RG12 2S2
0344 20242 Ext 2250
Title The Meteorological Office Library Collection
Custodian F A Seamman
Dates c1870 (c1937) -
History The collection includes some photographs of early meteorological conferences and W J S Lockyer Collection 1868 - 1936
Subjects METEOROLOGY GEOLOGY seascapes
Numbers pr c2500 b&w col various
 fi negs c300 b&w various
 L sl c2000 b&w 3"x3"
 tr c5000 col 35mm
 mic c750 b&w 35mm
Aids Duplicated guide *catalogue *card index
 *subject index
Access General public bona fide students prior appointment preferred
Copies available for loan only
Charges No search fee but a charge may be made if undue library staff time is involved

835
Owner Beken of Cowes Limited
Location 16 Birmingham Road Cowes Isle of Wight
Cowes 2223
Custodian A K Beken
Dates 1880 -
Photographer Frank Beken Keith Beken Kenneth Beken
Subjects MARINE YACHTING
Numbers fi negs 10000 b&w 2¼"x2¼"
 gl negs 60000 b&w various
 tr 7000 col 2¼"x2¼"
Access General public bona fide students picture researchers press tv media 9 am - 5.30 pm
Copies available for sale for display for publication credit line required
Charges Reproduction fee on application
 print/transparency fee search fee
Notes A unique collection of a family firm of marine photographers spanning three generations.

836
Owner British Marine Aquarists Association
Location 5 Catherine Road Hurst Hill Coseley
Nr Bilston Wolverhampton West Midlands
090 73 72097
Title Marine Life
Custodian J Jones
Dates (1973) -
Subjects MARINE LIFE all aspects
Numbers tr c100 col 35mm
Aids *Card index *subject index
Access Bona fide students written permission only
Copies available for loan
Notes The collection was started by the members to help each other to identify marine life in their aquariums and also for lecture service.

837
Owner Dr Horace E Dobbs
Location Horace Dobbs Underwater Photographic Service
Dolphin Parklands North Ferriby North
Humberside HU14 3ET 0482 632650
Dates 1958 -
History Dr Horace Dobbs is one of the pioneers of underwater photography who started taking underwater

pictures as the result of the introduction of the sport of aqualung diving in the UK. He is the author of the book Camera Underwater.
Photographer Dr Horace Dobbs
Subjects MARINE LIFE - underwater subjects associated with sport and professional diving
Numbers pr c400 b&w
 fi negs c4000 b&w 35mm
 tr 3500 col 35mm
Access Bona fide students publishers press tv media
Copies available for sale
Charges Print fee reproduction fee by arrangement
Notes This collection also includes 6000ft of 16mm cine film. The collection, and an underwater consultancy service, are available from the Location named above. Dr Dobbs has broadcast on radio and television and lectures on subjects associated with photography and the underwater world.

838
Owner Douglas Wilson Ltd
Location 49 Torland Road Plymouth Devon PL3 5TT
0752 771454
Dates 1920 -
Photographer Douglas P Wilson M Alison Wilson
Richard J H Wilson
Subjects MARINE PLANTS AND ANIMALS including microscopic mainly British species wildflowers fungi lichens Devon and Cornwall coastal and moorland views Italy and Greece - archaeological sites towns and scenery
Numbers pr substantial number b&w 1pl
 fi negs c3000 b&w 2¼"x2¼" 3¼"x2¼"
 gl negs c2000 b&w 3½"x2½" ¼pl
 gl pos c300 b&w ¼pl
 L sl 1000 b&w 3¼"x3¼"
 sl c40000 col 35mm
 stereo 4000 col each single image 23mmx20mm
Access Bona fide students picture researchers press tv media only by prior arrangement by letter
Copies available for publication only except for sale in special circumstances credit line required
Charges Publication/reproduction fee print/transparency fee search fee holding fee £100 charged for loss or damage according to value

839
Owner Seaphot
Location 91 Houndean Rise Lewes East Sussex
079 153 465
Custodian G Lythgoe
Dates 1950 (1970) -
Photographer Peter David Christian Petran
Flip Schulke Peter Scoone
Subjects THE OCEANS and all related subjects surface and underwater photographs marine line - invertebrates fish reptiles mammals birds marine technology leisure activities - sailing diving water-skiing surfing islands - people plants animals - Seychelles Galapagos Tahiti Greenland the sea - waves seascapes coastlines beaches
Numbers pr 1100 b&w col 10"x8"
 fi negs b&w
 tr c500 col 35mm 2¼"x2¼"
 sl c10000 col 35mm - 10"x8"
Aids Subject index photographers index
Access Picture researchers bona fide students press tv media 9 am - 12 pm 2 pm - 5.30 pm
Copies available for display for publication
Charges Reproduction fee holding fee search fee
 IIP rates
Notes Photographs taken underwater and on surface.

840
Owner British Trust for Conservation Volunteers
Location Zoological Gardens Regents Park London NW1
01 722 7112
Dates 1959 -
Subjects CONSERVATION volunteers doing practical
conservation work practical conservation techniques
Numbers pr c400 b&w col 8"x10"
tr c600 col 35mm
Aids *Card index *subject index
Access General public
Copies available for sale for loan
Charges Print fee reproduction fee by arrangement

841
Owner Mrs P G Hooper
Location 16 Baddesley Road Chandlers Ford Hampshire
SO5 1NG
Dates 1967 -
Subjects CONSERVATION - Hampshire landscapes -
threats to the environment - domestic buildings
Numbers fi neg 20 2¼"x2¼"
sl c150 18mm
Aids Catalogue in County Library
Access to copies at Hampshire County Library
Notes These photographs were taken with the needs of the
Council for the Preservation of Rural England in mind
and copies of them are kept at the Hampshire County
Library.

842
Owner Douglas Beaven
Location 11 Palace Place Mansions Kensington Court
London W8 01 937 4530
Dates 1961 - 1973
Photographer Douglas Beaven
Subjects GEOGRAPHY - Cyprus Egypt France Greece
Greek Islands Israel - old frontiers Italy Jordan -
old frontiers Lebanon Morocco Norway
Scotland Syria Turkey USA Yugoslavia -
landscapes seascapes monuments and sites
portraits museum exhibits architecture
trees plants monasteries excavations
Numbers tr c1600 b&w col 2¼"x2¼"
Access By special request
Copies available for loan

843
Owner J Phillip Dodd
Location 21 Townfield Lane Frodsham Via Warrington
WA6 7QZ
Dates (c1930) -
Subjects GEOGRAPHY INDUSTRIAL ARCHAEOLOGY
ARCHITECTURE prisons lighthouses tools
schools children at play transport sundials
geology seascapes botany mills bridges dams
mining agriculture domestic interiors furniture
contemporary dress seaside holidays climbing
walking portraits
Numbers pr c400 b&w ½pl - 1-pl
fi negs c6000 b&w 35mm 3½"x2½"
tr c12000 col 35mm
Copies available for sale
Charges Print fee

844
Owner Feature Pix Colour Library
(Gerry Brenes and Ken Hackett)
Location 20 Great Chapel Street London W1V 3AQ
01 437 2121
Dates (1962) -
Photographer Gerry Brenes Ken Hackett Van Phillips
Subjects GEOGRAPHY TRAVEL WORLDWIDE
customs and folklore
Numbers pr 10000 b&w
tr c50000 col 2¼"x2¼" 6cm x 9cm 5"x4"
Aids Card index subject index
Access General public bona fide students picture
researchers press tv media 9.30 am - 5.30 pm

Copies available for sale for display for loan
for publication credit name of individual photographer
Charges Reproduction fee holding fee according to
period held search fee according to time involved

845
Owner Paul David Lewis
Location 12 Swincross Road Oldswinford Stourbridge
West Midlands DY8 1NL 0902 29911
Dates c1850 (1973) -
Photographer Beato Valentine George Washington Wilson
Subjects GEOGRAPHY PAINTING PORTRAITS
landscapes travel abroad stereoscopes
Numbers pr c430 b&w 1"x1" - 9"x11"
ambrotypes 6 b&w 2½"x2½" - 3¼"x4¼"
stereoscopic lumière autochromes 15 col 3¼"x6¾"
Aids Catalogue card index in preparation
Access Bona fide students
Notes This collection was started to support the owner's
historical research in the area of photography and to
aid the teaching of the history of art.

846
Owner Miss Billie Love
Location 112 Weir Road Clapham Park London SW12 0ND
01 673 3711
Title Billie Love Collection
Dates 1850 (1974) -
Subjects GEOGRAPHY TRANSPORT banks and banking
the forces - personnel and uniforms archaeology
dogs and cats field crops home painting
antiques theatre and drama biography and
portraits foreign travel enamels wood carving
street scenes
Numbers pr c2000 b&w
Access Bona fide students picture researchers press
tv media 10 am - 5 pm to copy prints
Copies available for sale for loan for display
for publication
Charges Reproduction fee print/transparency fee
service charge search fee by arrangement

847
Owner Picturepoint Limited
Location 7 Cromwell Place London SW7 2JN 01 589 2489
Custodian K E Gibson
Dates 1959 (1964) -
Subjects WORLD GEOGRAPHY WORLD TOPOGRAPHY
fine art sports space travel agriculture animals
babies ballet birds boats bull fights camping
circuses Christmas climbing clouds cruising
dams dancers entomology fairs fishing flying
geology gliding Highland games horticulture
hunting illuminations industrial music
microscopy motoring national costume oast houses
pubs quarrying religion seascapes ships
traction engines tug of war viniculture
Numbers tr 500000 col various
Access Picture researchers press tv media
9.15 am - 5.15 pm to original images
Copies Originals only
Charges Reproduction fee holding fee service charge
search fee charges for loss or damage
Notes Very wide world coverage.

848
Owner George E Pike
Location 173 Tower Road Lancing West Sussex
Title The Brook
History This collection of photographs was accepted by
Queen Victoria. Each photograph in the collection
has verse from the poem The Brook by Tennyson
printed underneath
Photographer Arthur Brown
Subjects BROOKS
Numbers pr 13
Copies available for loan

H

849
Owner Royal Geographical Society
Location 1 Kensington Gore London SW7 2AR
 01 589 5466
Title Royal Geographical Society Photographic Collection
Custodian Keeper of the Map Room
Dates 1860 (c1880) -
History Special collection of Mount Everest
Photographer H G Ponting Sir Aurel Stein John Thomson
Subjects GEOGRAPHY all aspects portraits of eminent
 geographers and explorers
Numbers pr 46000 b&w various
 fi negs 37000 b&w various
 gl negs 37000 b&w various
 L sl 34000 b&w col 3¼"x3¼"
 sl 200 col 35mm
Aids *Card index
Access Members of the Society and others on prior
 application
Copies available for sale to order only
Charges On application

850
Owner P J Simms
Location Suilven Baronagh Fintona Omagh Co Tyrone
 Northern Ireland Omagh 3275
Dates 1969 -
Subjects GEOGRAPHY - mountains of Scotland
 flowers flowering plants European alps
Numbers tr c500 col 5cm x 5cm
Copies of slides could be made available
Notes The owner of this collection is compiling
 photographs of the Mountains of Scotland and the
 European Alps into audio-tape shows.

851
Owner Doreen M Thomas and J Kendall Thomas
Location 457 Acklam Road Middlesbrough Cleveland
 TS5 7HB 0642 88530
Dates c1890 - 1914
Photographer James Valentine George Washington Wilson
Subjects TOPOGRAPHY
Numbers pr c200 b&w sepia various
Access Bona fide students publishers press tv media
Charges Reproduction fee by arrangement

852
Owner Tony Stone Associates Limited Stockphotos
 International
Location 28 Finchley Road St John's Wood London
 NW8 6ES 01 586 3322
Dates 1962 -
Subjects GEOGRAPHY lomotives veteran and vintage
 vehicles flowers birds painting models
 aeroplanes travel girls houses wildlife
Numbers sl 100000 col various
Aids Duplicated subject index
Access Picture researchers press tv media
 9.15 am - 5.30 pm
Charges Reproduction fee holding fee if held for longer
 than 4 weeks
Notes Stockphotos International (trading name of
 Stockshots Limited) sells mainly to advertising agents
 and design studios. Tony Stone Associates sells to
 other users of stock photographs.

853
Owner Transworld Feature Syndicate (UK) Limited
Location 52 High Holborn London WC1 01 242 8262
Custodian Raymond Wergan
Dates 1965 -
Subjects GEOGRAPHY films television international
 celebrities cover pictures glamour nudes
 adventure sport general feature material
 womens magazine material - fashion beauty craft
Numbers Substantial

Access By appointment 10 am - 6 pm
Copies available for publication only
Charges Reproduction fee search fee service charge
 holding fee by arrangement
Notes This collection is made up of photographs and art
 illustrations from a wide range of international
 periodicals.

854
Owner Voluntary Service Overseas
Location 14 Bishops Bridge Road London W2 6AA
 01 262 2611
Custodian Katherine Parry
Dates 1958 -
History The collection is the historical record of the
 organisation
Subjects GEOGRAPHY volunteers at work overseas
 personnel travel abroad
Numbers pr 500 b&w
 sl 500 col
Aids Set of file copies
Access Bona fide students people assembling VSO
 exhibitions press tv media
Copies available for loan

855
Owner N F V Williams
Location 7 Clevelands Close Chandlers Ford Eastleigh
 Hampshire 042 15 5318
Title Williams & Carrington Collection
Dates 1874 - 1876
Subjects GEOGRAPHY - Europe India Australia buildings
 - exterior and interior
Numbers pr 250 b&w col various
Notes The collection has been a family possession for over
 50 years.

856
Owner G N Fabb
Location 194 Parkside Avenue Romford Essex
Dates 1932 -
Photographer G N Fabb
Subjects LANDSCAPES ALPINE AND ENGLISH WILD
 FLOWERS pub signs statues small railways
 John Constable British trees Swiss and Italian
 scenery historic buildings in Cotswolds Devon and
 Essex
Numbers pr c50 b&w 15"x12"
 fi neg c5000 b&w 2¼"x2¼"
 sl 5000 col 2"x2"
Aids Subject index b&w and col separate
Access Bona fide students publishers press tv media
 by appointment
Copies available for loan
Charges Reproduction fee

857
Owner James Fitzpatrick
Location Illustrative and Pictorial Photography Ryvoan
 Dyce Aberdeen AB2 0AP 0224 723969/722209
Dates 1967 -
Photographer James Fitzpatrick
Subjects LANDSCAPES Scottish castles oil industry
Numbers fi negs substantial number
 sl substantial number col 4"x5" 2¼"x2¼" 6cm x 7cm
Aids *Card index subject index
Access press tv media to the original image selections
 sent out on request
Copies available for sale for display for publication
Notes Personal visits are not permissible.

858
Owner Gwynedd County Council National Park Committee
Location National Park Information Service Yr Hen Ysgol
 Maentwrog North Wales LL41 4HW

Title The Ronald Thompson Collection
 The Oakeley Quarry Collection
Dates 1972 1954 – 1962
Subjects LANDSCAPES in the Snowdonia National
 Park and North Wales Oakeley Quarry slate
 mining operations
Numbers pr c500 b&w various
 fi negs c8000 b&w 55mm x 60mm
 gl negs 114 b&w
Aids *Subject index
Access Bona fide students
Copies available for sale for loan
Notes Oakeley Quarries are now closed but the operations
 are of historical interest.

859
Owner Halifax Photographic Society
Location 38 Gibbet Street Halifax West Yorkshire
Title Halifax Photographic Society Permanent Collection
Custodian H C Morris 7 Trinity Place Halifax
Dates 1923 –
Photographer Herbert Bairstow Mrs K Blenkhorn
 J S Waring
Subjects LANDSCAPES PORTRAITS RECORD
Numbers pr 250 b&w
Aids Catalogue
Access Arrangements could be made for bona fide students
Charges Reproduction fee by negotiation
Notes The collection is mainly the work of members of the
 Society. Correspondence to the Custodian.

860
Owner Hammersmith Hampshire House Photographic
 Society
Location Hammersmith Central Library Shepherds Bush
 Road London W6 01 748 6032
Title Permanent Collection
Custodian The Librarian
Dates c1920 –
Photographer Mark Oliver Dell
Subjects LANDSCAPES record portraits
Numbers pr 90 b&w 20"x16"
Aids Subject index
Access Bona fide members of the Society
Notes This is a 'Club' collection which is available to
 other clubs in lecture form.

861
Owner Kingston upon Hull City Council
Location City Museum 23/24 High Street Hull
 Humberside 0482 36680
Custodian The Curator
Dates Late 19thC (1906) –
Subjects LANDSCAPES portraits formal occasions
Numbers pr substantial number
Access Bona fide students
Copies Photographs supplied where available
Charges Print fee 65p plus postage reproduction fee £2
 plus 16p VAT

862
Owner The Lancashire and Cheshire Photographic Union
Location 350 Clipsley Lane Haydock St Helens
 Lancashire WA11 0SL
Title The Lancashire and Cheshire Photographic Union
 Permanent Loan Collection
Custodian Gerry Logan Secretary
Dates 1921 –
Subjects LANDSCAPES RECORD NATURAL HISTORY –
 pictorial
Numbers pr 437 ¼pl–20"x16"
 L sl 250 3¼"x3¼"
 sl 252 2"x2"
Aids Catalogue in preparation
Charges On free loan to Member Societies of Photographic
 Alliance of Great Britain

863
Owner A H Leach and Company Limited
Location Photo Works Brighouse Calderdale West
 Yorkshire 048 47 5241

Title B Matthews Post Card Negatives
 Photowork Commercial Negatives
Custodian A J Leach
Dates c1950 –
Subjects LANDSCAPES post cards – general
 commercial or view
Numbers gl negs c10000 b&w ½pl 1pl
Aids *Card index
Access Bona fide students
Copies available for sale
Charges Reproduction fee £2 per print up to 10"x8"

864
Owner Manchester Amateur Photographic Society
Location Memorial Hall Albert Square Manchester
Custodian H Milligan
Dates c1900 – 1930
Photographer Travis Burton J D Berwick S L Coulthurst
 Fred Curzon T B Howell G B Keary G M Morris
 G A Platt James Shaw J W Wade
Subjects LANDSCAPES PORTRAITS snowscenes
 English architecture Midland Counties South Wales
 North Wales Cheshire Kent Surrey Isle of Man
 Holland Sweden Belgium birds
Numbers L sl c1850 3¼"x3¼"
Access Photographers only by special arrangement with
 H Milligan or through the Honorary Secretary

865
Owner James Marett
Location 95 Northey Avenue Cheam Surrey SM2 7HQ
Dates 1961 –
Photographer James Marett
Subjects SCENERY buildings vintage and veteran cars
 railway engines Richmond Twickenham
Numbers pr 1200
 sl col
Aids Subject index
Access Individuals by appointment if genuinely interested

866
Owner Dr B H Most
Location 34 Penwood Heights Burghclere Newbury
 Berkshire
Dates 1956 –
Photographer Dr B H Most
Subjects LANDSCAPES – Natal Norway Paris U K
 Belize Jamaica flowers and leaves pictorial record
 abstract and derivative pictures
Numbers sl c15000 col
Access Bona fide students
Charges Reproduction fee depending on individual cases

867
Owner Photographic Collections Limited
Location 27 Baker Street London W1M 1AE 01 487 4831
Title The Francis Frith Collection
Custodian Barry Lane
Dates c1860 – 1970
Photographer Francis Frith
Subjects LANDSCAPES topography coastal and beach
 scenes street scenes – city town village
 architecture Victorian buildings – interiors and
 exteriors geography – Britain and Europe
Numbers fi negs c500000 5"x4"
 pr c250000 6"x8"
 gl negs c61000 6"x8"
Aids Catalogue
Access By special arrangement in writing
Copies available for sale by negotiation
Charges On application

868
Owner The Photographic Greeting Card Company Limited
Location 57/63 Wharfdale Road London N1 01 278 1488
Title Scenic Views
Custodian L O Freeman
Dates 1960 –
Subjects LANDSCAPES AND PHYSICAL FEATURES
 scenic views – London Kent Sussex Windsor
 Isle of Wight Edinburgh

Numbers tr 1500 col 5"x4" 2½"x3¼"
Access Specific requirements to publishers only
Charges Reproduction fee £10 per subject

869
Owner Philip Saunders
Location Higher Colmer Modbury Ivybridge Devon
Dates 1950 -
Photographer Philip Saunders
Subjects LANDSCAPES historic and beautiful buildings
animals steam engines rallies carnivals inn signs
Numbers fi neg 200 35mm
sl 874 35mm 2¼"x2¼"
Stereo tr 50
Access On written application only
Copies available for sale
Charges Print fee reproduction fee

870
Owner Public Record Office
Location Chancery Lane London WC2 01 405 0741
Title Includes 1 Dixon Scott Collection 2 Cobb Collection
Custodian Keeper of the Public Records
Dates c1920 - 1943
Photographer Rev F W Cobb Dixon Scott
Subjects LANDSCAPES townscapes buildings schools
coal mining - all aspects
Numbers 1 fi negs 13000 b&w
pr 13000 b&w
2 fi negs 115 b&w
pr 115 b&w
Aids Typed subject list
Access General public picture researchers bona fide
students press tv media 9.30 am - 4.45 pm
Copies available for sale for publication
Charges Reproduction fee print fee
Notes The Dixon Scott Collection was bought by the Central
Office of Information and presented to the P R O.
The Cobb Photographs were presented to the N C B
by Rev Cobb in turn presented to the P R O.

871
Owner The Royal Photographic Society
Location 14 South Audley Street London W1Y 5DP
01 493 3967
Title The Tyng Collection
Custodian T I Williams 46 The Avenue St Pauls Cray
Orpington Kent and S Holbrook 7 Pennington Road
Beaconsfield Buckinghamshire
Dates 1927 -
History The late Stephen H Tyng, a New York businessman
joined the R P S in the early years of this century. He
paid a number of visits to England during which he
practised landscape work under the guidance of A C
Benfield and Bertram Cox. In appreciation of the help
given him he vested with trustees a sum of money for
the specific encouragement of pictorial photography
and the constitution therewith to
be known as the Stephen H Tyng Foundation. The annual
interest was to be expended on the purchase of
pictorial photographs of outstanding merit for the
Society's Permanent Collection. Thus would be assured
the addition to that collection year by year of good
examples of contemporary work.
Subjects PICTORIAL - landscapes portraiture abstract
Numbers pr 172 b&w 20 col
Aids Card index
Access By arrangement with the Pictorial Group Committee
Notes The collection manifests the changes in the tastes
and fashions of pictorial photography from the Found-
ation's inception in 1927 to the present time.

872
Owner David A C Royle
Location Brantwood Cottage Headlam Gainford
Darlington Co Durham Gainford 350

Dates 1894 - 1930
Photographer Albert Royle Cyril Nutter Royle
Subjects VIEWS - Wales Cheshire Lancashire seascapes
family photographs
Numbers L sl c200 b&w
Access Bona fide students

873
Owner Dr G Schoenewald
Location 185 Wadham Gardens Greenford Middlesex
01 422 2120
Title Carbon Prints
Dates c1956 - c1971
History The owner is probably the last person to have
made such carbon prints with the "Carbro" process,
now lost
Subjects LANDSCAPES PORTRAITS
Numbers pr c35 various
Access Bona fide students by appointment only
Notes "A gathering of good specimens of a dead art
and technique".

874
Dates Kenneth Scowen
Location The White House Headley Grove Nr Epsom
Surrey 037 23 77292
Dates 1953 -
Photographer Kenneth Scowen
Subjects LANDSCAPES British horticulture
Numbers pr c15000 b&w 8½"x6½"
fi negs c15000 b&w 5"x4" 2¼"x2¼"
tr c15000 col 5"x4"
Aids *Card index
Access Publishers
Copies available for sale
Charges Print fee

875
Owner Miss V H C Stirling
Location Gargunnock House by Stirling Central Region
Scotland FK8 3AZ
Dates c1870 - c1910
Subjects LANDSCAPES British and foreign West Indies
British India
Numbers pr c300 various

876
Owner A P M Vidal
Location 23 Kingsfield Grange Road Bradford - on - Avon
Wiltshire BA15 1BE 022 16 2641
Dates 1895 - 1905
Subjects LANDSCAPE SEASCAPE railway views
18C derelict buildings
Numbers fi neg 20 b&w 12"x4"
Access Bona fide students by written appointment
Copies available for sale for loan
Notes Photographs taken on Kodak panoramic camera.

877
Owner University of Aberdeen
Location Aberdeen University Library
Title George Washington Wilson Collection
Dates c1860 (1954) - c1910
Photographer George Washington Wilson
Subjects LANDSCAPE AND ARCHITECTURAL VIEWS -
Scotland England Spain Gibraltar Morocco
South Africa Australia
Numbers gl negs c27000 b&w 5½"x3½" - 12"x10"
Aids Catalogue subject index
Access Bona fide students by appointment only
Copies available for sale to bona fide researchers only
Charges Reproduction fee

878
Owner Andy Williams

Key () dates when collections were begun or terminated
C = Century c = approximately pr = print fi = film
gl = glass neg = negative sl = slide L sl = lantern slide
tr = transparency mic = microform col = colour

b&w = black and white ¼, ½, 1-pl = quarter, half and whole
plate * = single copy, no public access ** = single copy,
access by appointment

Location 21 Longmead Merrow Guildford Surrey
0483 72778
Dates 1965 -
Photographer Andy Williams
Subjects LANDSCAPES pictorial illustrative interiors
product photography
Numbers tr c4000 5"x4" 6cm x 7cm
Aids Subject index
Access Prospective purchasers by appointment
Charges by arrangement

879

Owner William Arthur Poucher
Location 4 Heathfield Reigate Heath Surrey
Title The Mountains and Wild Scenery of the Northern
Hemisphere
Dates 1919 -
Photographer William Arthur Poucher
Subjects MOUNTAIN SCENERY - from Canadian Rockies
to the UK States of Western America the Alps
the Dolomites British hills
Numbers pr 20000 6"x4"
fi negs 25000 35mm
L sl 2000
sl 5000 col 35mm
Access Students publishers and general public should
first inspect the author's books in any library and
then contact him when any specific subject is required
Copies available for sale for loan - exhibition prints only
Notes This collection has been used in a collection of books
by W A Poucher.

880

Owner G P Cooper
Location c/o Coutts and Company 16 Cavendish Square
London W1
Title Oxford to London
Dates 1880 -
Subjects RIVERS riverside scenes along the Thames
from Oxford to London
Numbers pr 200 7"x3¾"
Access By appointment

881

Owner Barbara A Mowitt
Location 5 Tees View Croft Nr Darlington Durham
0325 721175
Dates c1870 (1975) -
Photographer Francis Frith George Washington Wilson
Subjects TRAVEL UK
Numbers pr c50 b&w various
Access Picture researchers publishers press tv media
Copies available by arrangement
Charges Print fee by arrangement reproduction fee

882

Owner Sefton Samuels
Location 6 Longton Avenue Manchester M20 9JN
061 445 4170 or 061 834 9423
Dates (c1960) -
Photographer Sefton Samuels
Subjects GENERAL VIEWS industry buildings docks
housing estates services North West England
Cheshire Lake District North Wales Derbyshire
West Yorkshire Bristol Area Orkney and Shetland
Scotland Algarve (Portugal) Spain Expo '67
(Montreal) musicians artists famous personalities
Numbers pr c5000 b&w various
sl c4000 col 35mm
Aids Duplicated subject index in preparation
Access By special appointment only
Copies available for sale for loan
Charges Reproduction Fee Print fee loan fee
dependent on usage
Notes Commissions. NUJ freelance colour television
work and book illustrations a speciality also
photo-journalism.

883

Owner Marchioness of Aberdeen and Temair
Location Haddo House Aberdeen AB4 OER Tarves 216

Dates c1867 -
History The 7th Earl of Aberdeen was Governor General
of Canada (1890-1896) and Viceroy of Ireland
(1886,1906-1915)
Subjects TRAVEL UK AND ABROAD portraits
early motor cars sports European visits
Numbers pr c1000 various some contained in albums
Access Bona fide students by appointment only
Notes Over 60 large albums including a unique record of
life on a large country estate from 1870; portraits of
distinguished visitors, including Gladstone.

884

Owner Peter Baker Photography
Location 24 Old Church Road Clevedon Avon ES21 6LY
0272 873523
Title P B P International Picture Library
Dates (1964) -
Photographer Peter Baker
Subjects TRAVEL UK AND ABROAD scenic travel
architecture ethnic characters
Numbers pr 15000 b&w 10"x8"
tr 15000 col 5"x4" 2¼"x2¼"
Aids Duplicated subject index newsletter
Access Picture researchers press tv media
9 am - 5.30 pm to the original images
Copies available for sale for display for loan
for publication
Charges Reproduction fee print/transparency fee
fees negotiated with customers

885

Owner Mrs Prudence K N Barker
Location Thistledown Crondall Nr Farnham Surrey
GU10 5PW 0252 850464
Dates 1953 -
Photographer Prudence K N Barker
Subjects TRAVEL U K AND ABROAD - Lebanon Cairo
Baghdad Kurdistan Cyprus France Switzerland
flowers butterflies birds dockyard Aldershot
Army Show Chartwell Basingstoke Canal Savil
Gardens portraiture
Numbers pr c370 b&w col various
fi negs c2650 b&w col 35mm 2¼"x2¼"
sl 4300 col 35mm - 2¼"x2¼"
Aids Subject index
Access Bona fide students publishers written application
only
Copies available for sale
Charges Print fee reproduction fee commercial rates

886

Owner Birmingham City Council
Location Reference Library Birmingham B3 3HQ
Title Sir Benjamin Stone Collection
Custodian City Librarian
Dates 1868 - 1913
History This extensive collection covers all aspects of
Sir Benjamin Stone's work and life. When purchased
prints proved unsatisfactory, he began to take his own
photographs from the mid 1880's.
Photographer Sir Benjamin Stone
Subjects SOCIAL SCIENCES PORTRAITS TRAVEL-
UK AND ABROAD customs state occasions
Numbers pr 22000
stereoscopic pr c600
gl negs 17000 1pl
L sl 2500 3"x3"
Aids Subject index negative index
Access General public bona fide students
Copies available on request
Charges Print fee from 70p per print inc VAT reproduction
fee £2 + VAT payable where commercial use of the
collection is involved
Notes Library possesses Sir Benjamin Stone's albums and
scrapbooks (over 100) also some catalogues and
manuscripts together with a large number of books of
newspaper cuttings relating to the man and his
pictures.

887
Owner Mrs Catherine Cairns
Location 110 Morrison Street Edinburgh 3
Dates c1850 -
Photographer Moffat
Subjects TRAVEL ABROAD - Egypt Greece Norway
 whaling antiquities scenes dress arts and crafts
 Tutankhamen figure Sphynx Pyramids icebergs
 and glaciers portraits aerial photography
 Palestine Suez Canal Queen Victoria's tour of the
 Borders Church disruption movement members of
 United Services Club
Numbers pr c150 b&w various
Notes This collection is contained in albums and books.

888
Owner J Allan Cash Limited
Location 8 - 10 Parkway London NW1 7AE
 01 485 7211/8212
Title Camera and Pen International
Dates 1950 -
Photographer J Allan Cash Noel Habgood Derek Norman
 Eileen Ramsey David Travers Max Wilkins
Subjects WORLD WIDE TRAVEL religion social
 sciences hospital education communications
 transport natural history buildings arts and crafts
 geography industrial sport leisure
Numbers fi negs 250000
 tr 100000 $2\frac{1}{4}$"x$2\frac{1}{4}$" 5"x4"
Aids Brochure/newsletter subject index card index
Access Bona fide students picture researchers press
 tv media 10 am - 4 pm
Copies available for sale for loan for display
 for publication credit line required
Charges By arrangement

889
Owner James Davis
Location The Craft Centre Moor Lane Clevedon Avon
 0272 875729
Title Worldwide Photographic Travel Library
Dates 1966 -
Photographer James Davis
Subjects TRAVEL UK AND ABROAD customs and
 folklore people places
Numbers pr c4500 b&w 10"x8"
 fi negs c4500 b&w $2\frac{1}{4}$"x$2\frac{1}{4}$"
 sl c3500 col various
Aids Duplicated catalogue *card index *subject index
 cross index system
Access General public bona fide students picture
 researchers press tv media 9 am - 5.30 pm
Copies available for sale for display for loan for
 publication
Charges Reproduction fee print/transparency fee loss fee
 based on current IIP rates
Notes Commissions. Photographs taken on request on a no
 charge basis, results supplied via library service.

890
Owner Douglas Dickins
Location 2 Wessex Gardens Golders Green London
 NW11 9RT 01 455 6221
Dates 1942 -
Photographer Douglas Dickins
Subjects WORLD WIDE TRAVEL religions customs and
 folklore arts and crafts industry animals
 archaeology plants meteorology historical
 buildings architecture
Numbers pr 20000 b&w 10"x8"
 fi neg 30000 b&w $2\frac{1}{4}$"x$2\frac{1}{4}$"
 tr 20000 col $2\frac{1}{4}$"x$2\frac{1}{4}$"
 L sl 20000 col 35mm
Aids Duplicated subject index
Access Picture researchers press tv media
 9 am - 6 pm

Copies available for sale for loan for display
 for publication credit line
Charges Reproduction fee print/transparency fee holding
 fee for excessive delay usual Fleet Street scales
Notes The owner is a specialist in Asiatic countries, a
 member of the Guild of Travel Writers, and a Fellow
 of the Royal Photographic Society.

891
Owner Fotofass Travel Picture Library
Location 59 Shaftesbury Avenue London W1
 01 437 5951
Dates (1968) -
Photographer Martin Chaffer Virginia Fass
 Mirella Ricciardi
Subjects TRAVEL UK AND ABROAD sunsets views
Numbers sl substantial numbers col 35mm
Access Picture researchers press tv media
 10 am - 5.30 pm to copy prints and original images
Copies available for sale for loan for publication
Charges Reproduction fee print/transparency fee
 handling fee holding fee search fee

892
Owner Fotolink Picture Library
Location 38 Crawford Street London W1H 1HA
 01 262 5156
Custodian Lee Tuppen
Dates 1968 (1970) -
Subjects TRAVEL UK AND ABROAD documentary
 agriculture
Numbers tr 50000 col various
Aids *Guide *subject index cross file index
Access Picture researchers press tv media
 9.30 am - 5.30 pm
Charges Reproduction fee holding fee search fee
 for loss of or damage to transparencies

893
Owner Martin F Gostelow
Location 43 Milton Abbas Blandford Dorset 025 888 654
Dates 1965 -
Photographer Martin F Gostelow
Subjects TRAVEL EMBROIDERY fans archaeology
Numbers fi negs c5000 b&w 35mm
 sl c10000 col 35mm $2\frac{1}{4}$"x$2\frac{1}{4}$"
Aids Topic list
Access Picture researchers press tv media
Copies available for sale for loan for publication
Charges Range from £5 b&w loan to £40 col sale exclusive

894
Owner Peter Kershaw Associates
Location 143/145 Eastbank Street Southport Merseyside
 PR8 1EE 0704 36945
Dates 1965 -
Photographer George Dawber Peter Kershaw
Subjects EUROPEAN TRAVEL scenic views children
Numbers pr 500
 tr c500 col various
Aids *Subject index
Access Bona fide students picture researchers press
 tv media 9 am - 5.30 pm
Copies available for sale for loan for display
 for publication
Charges Reproduction fee print/transparency fee
 handling fee

895
Owner Janet March-Penney
Location 27 Wooburn Manor Park Wooburn Green
 Buckinghamshire HP10 0ET 06 285 21171
Dates 1950 -
Photographer Janet March-Penney
Subjects TRAVEL UK AND ABROAD - Austria Britain
 Belgium Canada Chile Colombia Denmark France

Key () = dates when collections were begun or terminated
C = Century c = approximately pr = print fi = film
gl = glass neg = negative sl = slide L sl = lantern slide
tr = transparency mic = microform col = colour

b&w = black and white $\frac{1}{4}$, $\frac{1}{2}$, 1-pl = quarter, half and whole
plate * = single copy, no public access ** = single copy,
access by appointment

Germany Greece Holland Ireland Italy Jamaica
Japan Mexico Martinique Norway Peru Portugal
Sardinia Spain Sweden Switzerland Thailand
Tunisian USA Hong Kong Hawaii - ways of life
crafts industry archaeology landscape buildings
people general tourist and juvenile interests
costumes museum and art objects
Numbers pr substantial number b&w 6½"x8½"
fi negs 30000 b&w
sl 20000 col 2¼"x2¼" 35mm
Aids Subject index
Access Publishers on request 9 am - 5 pm
Charges Reproduction fee print/transparency fee
by negotiation holding fee £1.10p per week after 1
month £5.50
Notes Commissions.

896
Owner P Morris
Location 22 Wolsey Road Esher Surrey KT10 8NX
0372 65272
Dates 1960 -
Photographer P Morris
Subjects TRAVEL UK AND ABROAD natural history -
British and World animals bats botany
social sciences
Numbers tr c12000 col 35mm
Access Bona fide students if wishing to purchase for
publication
Copies available for sale
Charges Reproduction fee for world rights c£35
open to negotiation for batches of more than 10

897
Owner Jonathan Howard Robbins
Location 66 Jesty's Avenue Broadway Weymouth
Dorset 030 581 2864
Dates 1860 (1972) -
Subjects TRAVEL UK AND ABROAD DORSET
ROYAL NAVY - ships aircraft radio operators
France Italy Great Britain Northern India Scotland
Outer Hebrides Japan Singapore costume farming
animals social sciences wild flowers Dorset
hurdle maker Poole pottery thatching
traction engines sand yachting
Numbers pr c3000 b&w col various
Access General public bona fide students by appointment
only
Copies available by arrangement

898
Owner Seeley Service and Cooper Limited
Location 196 Shaftesbury Avenue London WC2H 8JL
01 836 6225
Custodian John Service
Dates c1904 (1906) - 1961
Subjects TRAVEL UK AND ABROAD Asia Africa
Australia Americas Europe anthropology religion
customs
Numbers pr 4514 b&w various
Aids *Subject index
Access Picture researchers 9.30 am - 5.30 pm
Notes A collection of travel photographs submitted for
publication over a period of 50 years.

899
Owner Mike Andrews
Location 18 Hopefield Avenue London NW6 6LH
01 969 4760
Title Mike Andrews Photographer
Photographer Mike Andrews
Subjects TRAVEL ABROAD - Libya Tanzania Zanzibar
Costa Rica El Salvador Guatemala Mexico
Honduras Nicaragua Panama Northern Italy
Greece France Portugal Spain Switzerland
Morocco Turkey Iran Argentina Bolivia Brazil
Chile Colombia Ecuador Paraquay Peru
West Indies Pacific Islands
Numbers fi negs 6000 b&w 35mm
sl 6000 col 35mm
Aids Duplicated subject index

Access Picture researchers 9 am - 6 pm to the
original images
Copies available for sale for display for loan
for publication credit line required
Charges Reproduction fee print/transparency fee
search fee
Notes The collection began as a result of many foreign
assignments for magazines.

900
Owner Miss Anne Bolt
Location 34 Homer Street London W1H 1HL
01 262 7484
Dates (1953) -
Photographer Anne Bolt
Subjects FOREIGN TRAVEL - Bermuda West Indies
South and Central America Europe North Africa
yachting
Numbers fi negs 25000 b&w
tr 20000 col 2¼"x2¼"
Access Picture researchers press tv media by
appointment only
Copies available for sale for loan for display
for publication
Charges Holding fee publication fee

901
Owner Kenneth G Clark
Location 8 Highfield Close Ravenshead Nottinghamshire
NG15 9DZ
Dates 1965 -
Photographer Kenneth G Clark
Subjects TRAVEL - U S A West Indies Europe Hong
Kong Japan commercial and industrial photography
Numbers pr 55 b&w 15"x12"
fi neg c100 2¼"x2¼"
tr c300 col 35mm
Aids Subject index
Access By appointment
Copies available for sale for loan
Charges Normal reproduction fee of the publication using
the photograph

902
Owner Stephanie Colasanti
Location 38 Hillside Court Finchley Road Hampstead
London NW3 01 435 3695
Title Stephanie Photography
Dates 1950 -
Photographer Stephanie Colasanti
Subjects WORLD WIDE TRAVEL - Morocco Tunisian
Turkey Austria Tenerife Corsica Spain Capri Italy
Sicily Greece Greek Islands Caribbean Islands
USA Canada army in Israel Safari religion
social sciences children at play people transport
customs and folklore geology meteorology
oceanography plants archaeology zoology dates
bananas fruit growing domestic clothes
arts and crafts - furs sculpture embroidery
architecture antiques holidays abroad geography
athletic sports and outdoor games flowers
Numbers pr 200 b&w
fi negs 10000 b&w
sl 20000 col 2¼"x2¼"
Access Picture researchers press tv media
by appointment only to the original images
Copies available for display for sale for publication
leasing for publication
Charges N U J and I I P recommended rates
reproduction fee print/transparency fee handling fee
holding fee search fee
Notes Creative general holiday atmosphere photographs
with unspecific backgrounds.

903
Owner A R R Holden
Location 6 Gladys Road Bearwood Warley
West Midlands B67 5AN 021 429 8499
Dates c1910 (1967) -
Photographer A R R Holden Dr Herbert Ponting

Subjects EXPLORATION - polar veteran and vintage
motor cycles
Numbers pr c300 b&w various
fi negs c800 b&w c200 col 2¼"x2¼" 35mm
Copies available for sale
Charges Print fee

904
Owner Victor Kennett
Location 31 Gloucester Place Mews London W1H 3PN
01 486 3301
Dates 1959 -
Photographer Victor Kennett
Subjects TRAVEL ABROAD USSR India Peru
Caribbean Bulgaria Italy Sicily France
Aeolian Islands Finland Sweden Yugoslavia
Czechoslovakia Ceylon USA Leningrad -
interiors exteriors historic portraits gravures
Moscow religion village life ships customs and
folklore geology seascapes archaeology
racial and ethnic features botany mammals
bridges field crops fruit growing cattle pigs
sculpture cottage industries architecture
painting antiques horse riding - Arizona geography
Numbers pr c20000 b&w 10"x8"
negs c10000 b&w 2¼"x2¼" 35mm
tr c8000 col 2¼"x2¼" 35mm
Aids Duplicated catalogue card index
Access Picture researchers press tv media
9 am - 6 pm
Copies available for publication for display
credit line required
Charges Reproduction fee print/transparency fee
holding fee

905
Owner J E Llewellyn-Jones
Location 16 Brierley Walk Cambridge
Dates 1960 -
Subjects TRAVEL ABROAD Morroco Sahara
British natural history
Numbers sl c2000 col 35mm
Aids Subject index
Access General public bona fide students on request
Copies available for sale for loan
Charges Print fee

906
Owner Outlook Films Limited
Location Mote Mount Nan Clarke's Lane London
NW7 4HH 01 959 5311
Title The MacQuitty International Collection
Custodian William MacQuitty
Dates 1925 -
History William MacQuitty Collection was made on his
many journeys round the world photographing for his
publications
Photographer Betty MacQuitty Miranda MacQuitty
William MacQuitty
Subjects TRAVEL ABROAD animals birds fish
insects reptiles peoples of the world arts and
crafts dancing farming fishing caviar
pot making wine surgery death customs
embalming funerals dolls climatic conditions
flowers fruit orchids cacti vegetables
gardens and botanic gardens sunsets clouds lakes
lands dams rivers roads seas ships boats
archaeology architecture churches cathedrals
mosques temples tombs religions: Christian
Buddhist Hindu Moslem Tribal museums
Numbers pr c200000 col
fi negs 100000 b&w 35mm
tr 100000 col 35mm
Aids Published catalogue *subject index
Copies available for publication credit line required

Notes William MacQuitty is the author of Abu Simbel;
Great Botanical Gardens of the World; Persia, The
Immortal Kingdom; Tutankhamun - The Last Journey;
World in Focus and Princes of Jade.

907
Owner Picture Index Limited
Location Hope Lodge Hassocks Road Hurstpierpoint
Sussex BN6 9QL 0273 832365
Custodian Guy Gravett
Dates 1951 -
Photographer Guy Gravett
Subjects GENERAL TRAVEL EUROPE France
wine viticulture throughout Europe oil exploration
in Middle East oil exploration and discovery in
Alaska archaeological antiquities in Greece and
Jordan Glyndebourne Opera from 1950
Numbers pr substantial numbers b&w 10"x8"
fi negs substantial numbers b&w 35mm 2¼"x2¼"
tr substantial numbers 35mm 2¼"x2¼"
Aids *Subject index
Access Picture researchers specific requirement by
request
Copies available for sale for display for publication
Charges Publication/reproduction fee print/transparency
fee holding fee

908
Owner Victor James Robertson Parkside 36 Nevern
Square London SW5
Location Crowthorne Berkshire
Dates 1961 -1972
Photographer Victor James Robertson
Subjects TRAVEL ABROAD sea ports from London to
Yokohama ships P and O Line Suez canal
cruise ports in the Mediterranean Panama canal
Numbers pr 700 b&w col
fi negs 2000 b&w 35mm
L sl 2000 col 35mm
Copies available for sale with restrictions
Charges Print fee
Notes Photographs collected over 10 years when the
owner was in the Merchant Navy.

909
Owner Royal Borough of Kingston upon Thames
Location Museum and Art Gallery Fairfield West
Kingston upon Thames Greater London 01 546 5386
Title Eadweard Muybridge Collection
Custodian M P Smith
Dates c1870 (c1904) -
History Eadweard Muybridge was the first photographer to
reveal the principles of human and animal locomotion
by means of a series of time-lapse photographs
Photographer Eadweard Muybridge
Subjects TRAVEL ABROAD human and animal locomotion
topography
Numbers pr c200 various
gl pos c200 various
L sl c150 3¼"x3¼"
Aids List of slides
Access General public by appointment
Copies available for sale
Notes Collection also includes zooprakiscope and printed
books by or about Muybridge.

910
Owner J Rufus
Location Little Dene Elstree Hill South Elstree
Hertfordshire 01 953 2550
Dates 1965 -
Photographer J Rufus
Subjects TRAVEL ABROAD people landscape general
Numbers pr c3500 b&w 10"x8"
fi negs c3500 2¼"x2¼"

Aids Card index
Notes The collection is used for illustration of travel articles etc in the press.

911
Owner Scientific Exploration Society
Location Mildenhall Nr Marlborough Wiltshire 067 25 2994
Custodian Lieutenant C Harper Warden of the Base
Dates 1968 -
Subjects WORLD EXPLORATION
Numbers pr substantial number
 fi negs substantial number
 gl negs substantial number
 tr substantial number
 sl substantial number
Access General public bona fide students on application
Copies available for sale

912
Owner Scott Polar Research Institute
Location Lewsfield Road Cambridge CB2 1ER 0223 66499
Title Scott Polar Research Institute Photographic Collection
Custodian H G R King
Dates 1845 (1920) -
Subjects EXPLORATION ABROAD Scott's expeditions polar geography and history ice and snowscenes
Numbers pr 3000 b&w
 fi negs 2000 b&w
 gl pos 50 b&w
 L sl 500 b&w 3¼"x3¼"
 tr 900 col 2"x2"
 mic 320 b&w
Aids Subject index
Access Bona fide students persons using the library for the first time are asked to apply to Librarian
Copies available for sale credit line required
Charges Reproduction fee black and white £5 colour £10 search fee print fee handling fee commercial rates
Notes This collection contains both published and unpublished material relating to the Arctic and the Antarctic. It aims to cover the whole field of knowledge as it applies to these regions and in addition a number of associated topics.

913
Owner University of Durham
Location University Library School of Oriental Studies Elvet Hill Durham 0385 64371
Custodian The Librarian
Dates c1900 -
Photographer W A Bramwell C W Gibby E Greatorex
Subjects TRAVEL ABROAD Russia the Caucasus the Sudan Palestine Far East
Numbers pr substantial numbers various
Access General public bona fide students
Copies available for sale

914
Owner Werner Forman 19 Prospect Road London N2 01 435 0540
Location 24 Patshull Road London NW5 2JY 01 267 1034
Title Werner Forman Archive
Custodian Barbara Heller
Dates (1940) -
Photographer Werner Forman
Subjects EXPLORATION AND TRAVEL ABROAD ARCHAEOLOGY ART AND ARCHITECTURE - world-wide religion customs and folklore anthropology home numismatics textiles antiques ceramics metal work sculpture and carving puppet shows theatre and drama
Numbers sl c10000 b&w c15000 col
Aids Duplicated list catalogue subject index and card index in preparation
Access Bona fide students authors researchers and editors picture researchers
Copies available for loan

Charges Dependent on rights required - available on request
Notes Photographs taken during the making of over fifty illustrated books on art, architecture and archaeology of which Werner Forman is either the author, co-author or sole photographer.

915
Owner R Williams
Location 12 Chelsham Close Warlington Surrey CR3 9DN
Title Travels of Unknown Lady
Dates 1896 - 1907
Subjects TRAVEL ABROAD - India Cyprus Greece Aden Egypt Tibet buildings street scenes portraits landscapes harbour scenes Royal Yacht in Athens c1896 Bulgarian refugees Olympic Games in Athens in 1896 Port Said visit of King of Italy to Greece in 1896 Sir Donald Currie's yacht Iolaire at Corfu 1907 mule wagons horses handdrawn carriages
Numbers pr 242 b&w various contained in two large albums
Access Bona fide students publishers press tv media
Copies available on request
Charges Print fee reproduction fee commercial rates

916
Owner Aerofilms Ltd
Location Elstree Way Boreham Wood Hertfordshire WD6 1SB 01 953 6161
Dates 1890 (1919) -
History The first commercial aerial photographic company in the world
Photographer Sir Alan Cobham C E Murrell F L Wills
Subjects AERIAL PHOTOGRAPHY - oblique and vertical communications transport geology meteorology archaeology botany building construction mining agriculture sports architecture worldwide geography historic events
Numbers pr 335000 b&w 3000 col 5"x5" to 10"x8"
 fi neg 305000 col 20000 col 2¼"x2¼" to 9"x9"
 gl neg 78000 b&w 5"x4"
 tr 3000 col 2¼"x2¼" to 5"x5"
Aids Published guide Numerical negative registers prints filed by subject and geographical location
Access General public picture researchers press tv media 9 am - 5.30 pm Friday 9 am - 4.30 pm
Copies available for sale for loan for display for publication
Charges Print/transparency fee reproduction fee service charge search fee holding fee
Notes Includes the Mills Collection 1890 - 1910.

917
Owner Airviews (Manchester) Limited
Location Manchester Airport Manchester M22 5PQ 061 437 2502
Title Aerial Photography
Custodian J B Martin
Dates 1947 -
Photographer B Hunter J Martin
Subjects AERIAL PHOTOGRAPHY
Numbers pr 15000 b&w 10"x8"
 fi negs 50000 b&w 25000 col 5"x4" 5"x5"
 gl negs 24 b&w
 tr 15200 col 5"x4" 2¼"x2¼" 6cm x 7cm
Aids *Card index *subject index
Access General public bona fide students on application
Copies available for sale
Charges available on application
Notes Some photographs from this collection are Airviews Limited copyright others are customers' copyright.

918
Owner Department of the Environment
Location P13 Air Photo Unit Prince Consort House Albert Embankment London SE1 7TF 01 211 6216
Title Aerial Photography - England and Wales
Custodian J McInnes
Dates c1940 (1945) -
Subjects AERIAL PHOTOGRAPHY - England and Wales

Numbers pr c1250000 b&w 8"x7" 9"x9"
fi negs c1500000 b&w 200' x10"
mic c750000 b&w 16mm
Access General public bona fide students by prior
appointment
Copies available for sale for loan the photography is
Crown copyright having been flown by the RAF and
the Ordnance Survey
Charges Print fee reproduction fee on request
Notes Loans are made to other Government Departments
and Public Authorities, but not to individual members
of the public, who may however view the prints in the
Unit. It includes a Central Register of Air Photography
which contains information on the coverage and scale of
commercial photography in addition to the information
available regarding RAF and Ordnance Survey flying.

919
Owner Fairey Surveys Limited
Location Reform Road Maidenhead Berkshire SI6 8BU
0628 21371
Custodian E Ford
Dates 1946 -
Subjects AERIAL PHOTOGRAPHY vertical and oblique
photography aerial survey of the United Kingdom
Numbers fi negs c287000 b&w c3200 col 5"x5" 9"x9"
sl 200 b&w 50 col
Aids *Card index annual sortie list registered and
flight plots
Access General public picture researchers bona fide
students press tv media 9 am 5.30 pm
Copies available for sale for display for publication and
loan if arranged
Charges Reproduction fee print/transparency fee
holding fee standing charge search fee
Notes Much work is done for overseas Governments but
Fairey Surveys Limited do not hold the film.

920
Owner Meridian Airmaps Limited
Location Marlborough Road Lancing West Sussex
Lancing 2992
Custodian R Smith
Dates 1950 -
Subjects AERIAL PHOTOGRAPHY - United Kingdom
Numbers pr c1000000
Access General public bona fide students by
appointment only
Copies available for sale for display for publication
credit line required

921
Owner Ministry of Defence Metropole Building
Northumberland Avenue London WC2N 5BL
01 930 7022
Public Record Office Chancery Lane London
WC2A 1LR 01 405 0741
Location Department of Geography University of Keele
Keele Staffordshire ST5 5BG 078 271 371
Title The Air Photography Library Collection
Custodian Mrs S Walton
Dates 1939 - 1945
History This is what remains of the Royal Air Force
war-time collection of vertical reconnaissance
photographs over German occupied Europe west of the
Iron Curtain built up at Allied Central Interpretation
Unit, Royal Air Force, Medenham.
Subjects AERIAL-PHOTOGRAPHY geography
historic events
Numbers pr 5500000 b&w 9"x7"
Aids *Card index
Access General public bona fide students
Copies available for sale
Charges Print fee from 40p
all matters of publication and copyright should be
taken up directly with the Ministry of Defence

Notes Access may be obtained to limited specified areas
or targets at any time by appointment. Cover of
Germany Italy Belgium Netherlands and Denmark
is not restricted. Requests for access to cover of
France Greece Norway and Yugoslavia are subject
to diplomatic scrutiny before access is granted.
There is no cover of the United Kingdom.

922
Owner Institute of Archaeology (University of London)
Location Institute Library 31-34 Gordon Square
London WC1M OPY 01 387 6052
Custodian The Librarian
Dates (1920) -
Subjects AERIAL PHOTOGRAPHY Iraq Jordan
Israel Syria Egypt the Sudan archaeology
Numbers pr c1000 b&w 8"x6"
fi negs c350 b&w 5½"x5½"
gl negs c1400 b&w various
Access Bona fide students
Copies available for sale
Charges Print fee

923
Owner University of Reading
Location Department of Geography Whiteknights Reading
Berkshire RG6 2AB 0734 85123 Ext 7823
Title Department of Geography Map and Air Photo Collection
Custodian R B Parry
Dates 1944 (1970) -
Subjects AERIAL PHOTOGRAPHY
Numbers pr c2500 b&w 166 col 9"x9"
Aids *Card index location maps and flight indexes
Access General public by prior appointment
bona fide students
Notes This is a small but growing air photograph collection
acquired specifically to meet the teaching and research
needs of the Geography Department.

924
Owner J P Treglown
Location Halwell House Lelant St Ives Cornwall
TR26 3EL Hayle 2370
Dates 1867 (c1910) -
Subjects AERIAL PHOTOGRAPHY - Great Britain
Cornwall - local scenes harbours boats Southwold
Cromer Great Yarmouth Lowestoft travel UK
and abroad (1870-1900) Montreal Vancouver
St Petersburgh Berlin Cologne Cathedral
Numbers pr substantial number contained in albums
gl pl c500 various
sl
Access Bona fide students by appointment only
Copies available
Charges Print fee reproduction fee by arrangement

925
Owner West Air Photography
Location 23 Cecil Road Weston super Mare Avon
BS23 2NG Weston super Mare 21333
Title Air Photographs
Custodian John White
Dates 1969 -
Photographer John White
Subjects AERIAL PHOTOGRAPHY - West of England
South West England South and West Wales abbeys
aircraft airports ancient buildings castles
cathedrals churches archaeological sites beaches
boats bridges camping sites ancient camps
cities coast colleges commerce country-houses
countryside docks factories farms golf courses
harbours holiday camps industrial estates islands
lakes motorways parks peatfields piers
playing fields ports power stations priories
quarries reservoirs rivers roads schools
seaports seaside ships sports grounds towns
trading estates universities villages weather

Key () = dates when collections were begun or terminated
C = Century c = approximately pr = print fi = film
gl = glass neg = negative sl = slide L sl = lantern slide
tr = transparency mic = microform col = colour

b&w = black and white ¼, ½, 1-pl = quarter, half and whole
plate * = single copy, no public access ** = single copy,
access by appointment

Numbers fi negs c18000 b&w 2000 col 6cm x 7cm
tr c3000 col 35mm
Aids Duplicated catalogue card index subject index
Access Bona fide students picture researchers press
tv media 9 am - 5 pm
Copies available for sale for display for publication
credit line required
Charges Reproduction fee print/transparency fee

926

Owner Aberdeen City Council
Location Aberdeen Central Library Rosemount Viaduct
Aberdeen AB9 1GH 0224 28991
Title George Washington Wilson Photographic Collection
Custodian Peter Grant
Dates 1854-1899
Subjects PEOPLE AND PLACES - Aberdeen Scotland
England Wales South Africa
Numbers pr 1796
Aids Card index
Access General public bona fide students
Copies available on request

927

Owner British Tourist Authority 64 St James's Street
London SW1A 1NF
Location 239 Old Marylebone Road London NW1 5QT
01 262 0141
Title British Tourist Authority Photographic Library
Custodian C Ulyatt
Dates 1958 -
Photographer Brian Boyd J Barry Hicks Eric Rowell
Subjects BRITAIN tourism
Numbers fi negs 80000 b&w various
tr 80000 col various
Aids *Subject index
Access General public bona fide students
Copies available for sale
Charges Reproduction fee commerical rates
Notes Charges may vary according to proposed use.
When it is promotion of tourism to UK charges may be
waived.

928

Owner Reece Winstone
Location 23 Hyland Grove Bristol Avon 0272 628803
Title Beautiful Britain
Dates 1930 - 1960
Photographer Reece Winstone
Subjects BRITAIN landscapes villages customs and
folklore buildings farming occupations human
behaviour observatories transport pottery
architecture geography fishing stained glass
Numbers pr 10000 b&w 1-pl
11 negs c40000 2¼''x2¼'' 3¼''x2¼''
gl neg b&w 500 3¼''x2¼''
Copies available on request
Charges Print fee reproduction fee
Notes Work from this collection has been published in
over 1000 books and magazines.

929

Owner F W Boden R A Calderbank A J M Henstock
Location 25 Church Street Ashbourne Derbyshire and
18 Buxton Road Ashbourne Derbyshire
Custodian A J M Henstock 0602 54524 or Ashbourne 2827
Dates c1875 (1880) - c1940
History Mr Henstock and Mr Calderbank purchased part
of R & R Bull's collection, chiefly topographical views
and events, on the closure of the firm c1960. The
larger part, portraits and groups, was purchased by
Mr Boden.
Photographer R & R Bull
Subjects ASHBOURNE AND SURROUNDING COUNTRYSIDE
country and town life and customs buildings street
scenes
Numbers pr c100 b&w
gl negs c400 b&w ½pl 1-pl postcard
Access Persons with a genuine interest only
Copies available for sale by special arrangement
Charges Print fee reproduction fee commercial rates

930

Owner Avon County Council
Location Reference Library College Green Bristol
BS1 5TL Avon 0272 26121
Title Bristol Pictorial Collection
Custodian G Langley
Dates c1855 (1968) -
Subjects AVON Bristol - local history and development
geography
Numbers pr c4000 b&w various
fi negs c1000 b&w 6''x6'' 35mm
gl negs c400 b&w various
L sl c200 b&w 3¼''x3¼''
sl c3000 col 35mm
Aids List of accessions
Access Bona fide students by appointment only
Copies available for sale
Charges available by arrangement

931

Owner Bath and West Evening Chronicle
Location 33 Westgate Street Bath Wansdyke Avon
0225 5871
Custodian G Tarling
Dates 1900 (1954) -
Subjects AVON Bath and district all aspects
Numbers pr c96000 b&w 8''x6''
Aids *Card index *subject index
Access Bona fide students picture researchers press tv
media by appointment 9 am - 5 pm
Copies available for sale for loan for display
for publication
Charges Reproduction fee print/transparency fee

932

Owner Robert Cooke
Location Athelhampton Dorchester Dorset
Title Athelhampton
Dates 1880 -
Photographer Thomas Hardy Herman Lea
Subjects ATHELHAMPTON AND DISTRICT Biography -
Thomas Hardy and others views 1914 - 18 war
Numbers pr 1000 b&w various
gl neg 1200
stereoscopic photographs
Copies will be available in due course

933

Owner R Sankey
Location 52 Wheatclose Road Barrow in Furness
Cumbria LA14 4EJ 0229 21309
Dates 1900 - 1970
Photographer E Sankey R Sankey
Subjects BARROW IN FURNESS - views launching of
ships events trams railways Fleetwood
Blackpool
Numbers pr c3000 contained in albums
fi negs c10000 ½pl
Access By special request

934

Owner Avon County Council
Location Bath Reference Library 18 Queen Square Bath
Avon 0225 28144
Title Bath Local History Photographic Collection
Custodian Chief Archivist
Dates 1850 (1930) -
Subjects BATH - local history architecture
redevelopment transport portraits
Numbers pr 5100 b&w ½pl 1-pl
fi negs 759 b&w various
gl negs 76 b&w 6''x4''
sl 472 b&w col
Aids Card index subject index
Access General public
Copies available for loan under certain conditions

935

Owner Gerald Lacey
Location The How Rosthwaite Borrowdale Keswick
Cumbria CA12 5XB Borrowdale 243

Title Zermatt, the Matterhorn and Alpine Flowers
Borrowdale in All Seasons
Dates 1948 -
Photographer Gerald Lacey
Subjects BORROWDALE THE ALPS - alpine flowers
Numbers tr c320 col 35mm

936
Owner Humberside County Council
Location Bridlington Library King Street Bridlington
 North Humberside YO15 2DF 0262 2917
Custodian Area Librarian
Dates c1870 (1946) -
Subjects BRIDLINGTON - seaside holidays fishing
 lifeboats architecture civic occasions
Numbers pr c3000 b&w
 sl c300 b&w
Aids Place index
Access General public
Copies by special arrangement with a local photographer
Charges Commercial rates
Notes A comprehensive collection showing the development
 of a seaside resort from Victorian times.

937
Owner J S Gray
Location The Knab 2 Shirley Avenue Hove East Sussex
 BN3 6UN 0273 553506
Dates 1850 (1950) -
Photographer G Casinello W Cornish Edward Fox
 A H Fry W H Mason
Subjects BRIGHTON AND HOVE - buildings streets
 beach scenes transport piers Royal Pavilion and Dome
 stations parks windmills fishermen slums
Numbers pr c5000 b&w 6"x4" - 10"x8"
 fi neg 3000 b&w 5"x4"
 gl negs
Access Bona fide students persons with a particular
 interest in any subject in the collection by appointment
Copies available for sale
Charges Print fee
Notes Photographs from this collection can be seen in
 Victorian and Edwardian Brighton from old photographs
 and Victorian and Edwardian Sussex from old
 photographs and Brighton between the Wars from old
 pnotographs.

938
Owner Bristol City Council Council House College Green
 Bristol 1 0272 26031
Location City Museum Queens Road Bristol BS8 1RL
 0272 299771
Title Bristol City Museum Collection including Pritchard
 Collection and Bristol and West of England Amateur
 Photographic Association Collection of Calotypes
Custodian Enquiries to the Director
Dates 1850 (1933) -
History Varied collection derived from many sources but
 including important views of the city taken between
 1865 and 1900 by F Little
Photographer F Beech-Williams P M James F Little
 Pritchard
Subjects BRISTOL - local history street scenes buildings
 docks shipping
Numbers pr c2000 various
 gl negs c8000 b&w various
 L sl c4000 3¼"x3¼"
 calotype negs c75 1-pl
Aids Subject index in numerical order
Access General public bona fide students by appointment
 research projects will not be dealt with unless
 arrangements are made to study the collection
 personally
Copies available for sale provided that arrangements have
 been made beforehand to study the collection and

make a specific order quoting appropriate negative
numbers and details
Charges Print fee at cost from commercial photographers
Notes Every effort will be made to allow access to the
 collections for genuine research and study but the
 Museum does not have a full time photographer in
 charge of the collections and most enquiries have to be
 dealt with by the appropriate curator. Delays are
 inevitable therefore and general requests for
 'information and photographs' will not be entertained
 unless arrangements have been made to study the
 Museum's material in person so that a sensible and
 detailed request for copies of specific photographs or
 prints can be made.

939
Owner Reece Winstone
Location 23 Hyland Grove Bristol Avon 0272 628803
Title Bristol as it Was 1840-1970
Dates 1840 (c1950) - 1970
Photographer Hugh Owen W H Fox Talbot Reece Winstone
Subjects BRISTOL all aspects
Numbers pr 10000 b&w 1-pl
 fi neg 5000 b&w 2¼"x2¼" to ½pl
 gl neg 500 b&w 3¼"x2¼" to 1-pl
 L sl 2000 b&w 3¼"x3¼"
Copies Approval for reproduction on request credit line
 required
Charges Reproduction fee print/transparency fee
Notes 3500 photographs from this collection have been
 published in Reece Winstone's books.

940
Owner Luton Borough Council Town Hall Luton
 Bedfordshire 0582 31291
Location Luton Museum and Art Gallery Wardown Park
 Luton Bedfordshire LU2 7HA 0582 36941
Custodian Mrs E Rogers
Dates c1860 (1931) -
Subjects BEDFORD Luton social sciences associations
 and societies education transport customs and
 folklore archaeology mills agriculture and food
 production domestic home clothes architecture
 numismatics textiles toys recreations athletic
 sports and outdoor games biography and portraits
 events
Numbers pr c4000 b&w various
 fi negs c200 b&w various
 gl negs c450 b&w various
 L sl c3000 b&w col 3¼"x3¼"
 sl c1500 b&w col 35mm
Aids *Catalogue *card index
Access General public bona fide students by appointment
Copies available for sale on special request
Notes The main strength of this collection is that it forms a
 social and topographical record of the rural area of
 South Bedfordshire. It also includes an outstanding
 collection of negatives and prints by the Thurston
 family who were photographers in Luton from the 19C.

941
Owner Bedfordshire County Council
Location Bedford County Record Office County Hall
 Bedford MK42 9AP 0234 63222 Ext 277
Custodian County Archivist
Dates c1850 -
Subjects BEDFORDSHIRE all aspects manuscripts
 from 14thC
Numbers pr b&w col
 gl negs
 L sl
 sl 35mm
 mic 35mm substantial numbers of each
Aids Lists and indexes

Access General public bona fide students picture
 researchers press tv media Monday to Friday
 9.15 am - 1 pm 2 pm - 5 pm
Copies available subject to depositor's copyright
Charges Print fee on application

942

Owner Luton Borough Council
Location Town Hall Luton Bedfordshire 0582 31291
Title Record of Redevelopment in Luton
Custodian Borough Engineer
Dates (1958) -
Subjects BEDFORDSHIRE Luton - photographic survey
Numbers pr b&w various
 fi negs 35mm
Copies could be made available in certain cases

943

Owner Berkshire County Council
Location County Branch Library Didcot Berkshire
Dates (1970) -
Subjects BERKSHIRE Didcot - photographic survey
Numbers sl col 35mm substantial number
Aids Typed list
Access General public bona fide students
Copies available for sale

944

Owner Berkshire County Council
Location Reading Public Library Blagrave Street Reading
 0734 54382
Title Reading Local History Collection
Dates Mid 19thC (c1930) -
Subjects BERKSHIRE Reading architecture biography
 and portraits
Numbers pr c1300 b&w various
 fi negs 80
 sl 50
Aids *Card index *subject index
Access General public bona fide students on application
 to the Librarian
Copies available
Charges Print fee reproduction fee

945

Owner Cambridgeshire County Council
Location Central Library 7 Lion Yard Cambridge
 CB2 3QD 0223 58977
Title The Cambridgeshire Collection
Custodian M J Petty
Dates (1855)
Photographer D Grainger Captain G W Hatfield
 W M Lane E W Morley
Subjects CAMBRIDGE social sciences occupations and
 services the forces education transport
 customs and folklore mills architecture
 recreations biography and portraits geography
 events
Numbers pr c5000 b&w
 gl negs c1000
 L sl c600
Aids *Catalogue *card index *subject index
Access General public
Copies available for sale under certain conditions
Charges Reproduction fee from £5 negotiable
Notes This collection is continually growing by c1500
 photographs per year.

946

Owner Cambridge and County Folk Museum Trustees
Location 203 Castle Street Cambridge CB3 0AQ
 0223 55159
Custodian Miss E M Porter Museum Cottage Northampton
 Street Cambridge
Dates 1860 (1936) -
Photographer Arthur Nichols
Subjects CAMBRIDGE - all aspects
Numbers pr c1650 b&w various
 L sl 80
Aids *Catalogue *card index *subject index
Access General public bona fide students

Notes The Folk Museum (a small museum of 10 rooms
 housed in a 16thC former inn) collects photographs in
 order to maintain a record of Cambridge and the County.

947

Owner John Shepperson
Location 148 Boxworth End Swavesey Cambridge
 CB4 5RA Swavesey 30313
Dates 1882 (1964) -
Subjects CAMBRIDGE - Swavesey local history
Numbers tr c1000
Access Bona fide students by appointment only

948

Owner Wisbech and Fenland Museum Trustees
Location Wisbech and Fenland Museum Museum Square
 Wisbech Cambridge PE13 1ES Wisbech 3817
Title Wisbech and Fenland Museum Photographic Collection
Custodian M A E Millward
Dates c1850 (19thC) -
Photographer Thomas Craddock Samuel Smith
Subjects CAMBRIDGE Wisbech village life town life
 architecture biography and portraits
Numbers pr c2000 b&w various
 fi negs c500 b&w 35mm
 gl negs c50 b&w various
 L sl c100 col 35mm
 calotype negs 190 b&w 7½"x9½" 8½"x10½"
Aids Catalogue card index subject index in preparation
Access General public bona fide students by appointment
Copies available for sale
Charges Print fee

949

Owner Cambridgeshire County Council
Location Peterborough Divisional Headquarters
 Broadway Peterborough Cambridgeshire PE1 1RX
 0733 69105
Title Local Studies Library Collection
Custodian Barry Hall
Dates c1890 (c1970) -
History The collection acts as a continuous record of
 life in Peterborough
Subjects CAMBRIDGESHIRE Peterborough all aspects
Numbers pr c200 b&w
 fi negs c200 b&w
 gl negs c110 b&w
Aids *Catalogue *subject index
Access General public bona fide students
Copies available for sale
Charges By arrangement

950

Owner Ramsey and Muspratt Limited
Location Post Office Terrace Cambridge
 Cambridgeshire 0223 50633
Title Old Cambridge
Dates 1860 - 1900
Subjects CAMBRIDGESHIRE Cambridge - street scenes
 buildings costumes
Numbers pr 8"x6" 12"x10"
 gl negs c74 b&w 8½"x6½" - 12"x10"
Aids List with subject and date
Access General public bona fide students picture
 researchers publisher press tv media
 9 am - 5.30 pm
Copies available for sale for publication
Charges Reproduction fee print/transparency fee

951

Owner Penwith District Council
Location The Norris Library and Museum The Broadway
 St Ives Cambridgeshire PE17 4BX
Custodian C I Morris
Dates 1895 -
Photographer S Inskip Ladds H E Norris
Subjects CAMBRIDGESHIRE - churches buildings events
 personalities
Numbers pr substantial number various
Aids Catalogue
Access General public bona fide students

Copies available for sale
Charges Postcards 15p each
Notes The collection also includes old postcard views
of Cambridgeshire villages.

952
Owner E Whitney 2 Sapley Road Hartford Huntingdon
Cambridgeshire
Location County Record Office Grammar School Walk
Huntingdon Cambridgeshire
Title The Whitney Collection
Custodian The Archivist
Dates 1875 - 1920
Photographer Maddison
Subjects CAMBRIDGESHIRE Huntingdon
Numbers fi negs c2500 b&w
Aids Duplicated catalogue to part of the collection
Access Bona fide students
Copies available for sale
Charges Contact b&w prints of the catalogued section 25p

953
Owner Cambridgeshire County Council
Location County Record Office Shire Hall Cambridge
CB3 0AP 0223 58811 Ext 281
Title Cambridgeshire and Isle of Ely Pictorial Collection
Custodian J M Farrar
Dates c1900 (c1950) -
Photographer Aerofilms Limited Francis Frith
Subjects CAMBRIDGESHIRE AND ISLE OF ELY
education archaeological sites wind and water mills
architecture biography and portraits aerial
photography mazes dovecotes libraries colleges
Numbers pr c1750 b&w various
fi negs c40 various
gl negs c133 b&w $3\frac{1}{2}$"x$4\frac{1}{2}$"
L sl c2669 b&w $3\frac{1}{4}$"x$3\frac{1}{4}$"
Aids *Card index index maps for vertical aerial
photographs
Access General public bona fide students
Copies available for sale subject to copyright

954
Owner James Parker Templeton
Location 201 Newtown Road Carlisle Cumbria
0228 32098
Title The Templeton Collection
Dates c1840 (1960) -
Photographer Andrews and Parkin R Little Benjamin
Scott A and C Taylor James P Templeton
Subjects OLD CARLISLE AND DISTRICT - social
sciences lifeboats transport agriculture buildings
Numbers pr c2000 b&w various
fi negs 1000 b&w
gl neg 300 b&w 5"x4"
L sl 400 b&w 3"x3"
sl 1200 col 35mm
Access Bona fide students by prior appointment only
Copies available for sale
Charges Print fee
Notes The collection is entirely confined to Cumbria.

955
Owner Cheshire County Council
Location Central Library Civic Way Ellesmere Port
Cheshire 051 355 8101
Title Pictorial Record of Ellesmere Port
Custodian Colette Sarson
Dates c1900 (c1959) -
Subjects CHESHIRE Ellesmere Port Shropshire Union
Canal Manchester Ship Canal social sciences
transport mills factories architecture aerial
photography
Numbers pr 967 b&w 8"x6"
sl 967 b&w
Aids *Accession record

Access General public
Copies available for sale
Charges Print fee
Notes This collection is concerned with the history and
development of Ellesmere Port.

956
Owner Cheshire County Council
Location Library Headquarters 91 Hoole Road Chester
CH2 3NG 0244 20055/6/7/8
Title Cheshire Collection
Custodian G A Carter
Dates 1965
Subjects CHESHIRE aerial photographs of "Old"
Cheshire county
Numbers pr 300 b&w $7\frac{1}{2}$"x$9\frac{1}{2}$"
Aids *Card index
Access General public

957
Owner Cheshire County Council County Hall Chester
0244 602424
Location Cheshire County Library 91 Hoole Road Chester
Cheshire CH2 3NG 0244 20055
Title Chester Photographic Survey
Custodian County Librarian
Dates c1870 (1963) -
Photographer G Mark Cook Francis Frith Frank Simpson
Subjects CHESHIRE Chester - all aspects
Numbers sl 11039 b&w 35mm
tr 11039 b&w 35mm 2"x2"
Aids *Card index
Access General public bona fide students
Copies available for sale subject to copyright
restrictions for loan
Charges Print fee

958
Owner Chester City Council Chester Royal Infirmary
Chester College of Education
Location City Record Office Town Hall Chester
Cheshire CH1 2HJ 0244 40144 Ext 2108
Title Chester: Victorian notables Sir Horatio Lloyd
Collection
Custodian Records Officer
Dates 1866 - 1974
History Chester Royal Infirmary was established in 1755.
Chester College of Education was founded in 1839.
The Earl of Chester's Volunteer Fire Brigade was
established in 1864. Sir Horatio Lloyd was Recorder
of Chester 1866-1920
Subjects CHESHIRE - Chester - Chester Royal Infirmary -
nurses in training theatre wards laboratories
Chester College - staff students college activities
Chester City Fire Brigade - engines and firemen
Chester - street scenes city plate and regalia
Victorian notables
Numbers pr c400 b&w various
Aids List
Access General public bona fide students

959
Owner Cheshire County Council
Location Crewe District Library Civic Centre Crewe
Cheshire 0270 2156
Title The Crewe Story
Custodian G R Pimlett
Dates (1955) - 1971
Photographer Albert Hunn
Subjects CHESHIRE Crewe - photographic survey
Numbers pr c1000 b&w various
fi negs c800
Aids Manuscript list of numbered negatives
Access General public bona fide students
Copies available on request
Charges Print fee commercial rates

Key () = dates when collections were begun or terminated
C = Century c = approximately pr = print fi = film
gl = glass neg = negative sl = slide L sl = lantern slide
tr = transparency mic = microform col = colour

b&w = black and white $\frac{1}{4}$,$\frac{1}{2}$,1-pl = quarter,half and whole
plate * = single copy,no public access ** = single copy,
access by appointment

Notes This collection includes manuscripts and prints of
varying size of a series of articles originally
published in the Crewe Chronicle.

960
Owner Chester City Council
Location 27 Grosvenor Street Chester Cheshire
CH1 2DD
Title Grosvenor Museum Collection
Custodian T E Ward
Dates Late 19thC (c1900) -
Subjects CHESHIRE Chester religion social sciences
occupations and services transport archaeology
ceramics metal work architecture numismatics
toys antiques musical instruments biography and
portraits
Numbers fi negs c5000 35mm 120mm
gl negs c2000 ½pl
L sl c4500 b&w col 3¼"x3¼" 2"x2"
Aids *Catalogue
Access Bona fide students

961
Owner Hale Civic Society
Location Hale Library Leigh Road Hale Altrincham
Cheshire WA15 9BG 061 980 6067
Title Hale Civic Society Photographic Collection
Custodian D Rendell 26 Crescent Road Hale Cheshire
WA15 9NA
Dates 1880 -
Subjects CHESHIRE areas around Hale Hale Barns
Bowdon Ringway Ashley Dunham Altrincham
all aspects
Numbers pr 700 6"x4" - 8½"x6½"
gl negs c50 6½"x4¾"
copy negs 650 3½"x2½" - 5"x4"
Aids Guide catalogue
Access General public bona fide students
Copies available for sale
Charges Print fee from 25p
Notes The collection is a record of the life of an English
community on the fringe of a rapidly expanding
industrial town and the change in its character from
rural to suburban during the last 150 years.

962
Owner Warrington Borough Council
Location Warrington Museum and Art Gallery
Bold Street Warrington Cheshire 0925 30550
Dates Late 19thC (c1890) -
Subjects CHESHIRE Warrington social sciences
occupations and services associations and societies
education transport customs and folklore botany
zoology home clothes arts and crafts
architecture painting antiques musical instruments
recreations biography and portraits geography
events
Numbers pr c5000 b&w various
gl negs c600 b&w ¼pl - 1pl
L sl c600 b&w 3¼"x3¼"
sl c400 b&w c300 col 35mm
Access General public bona fide students by appointment
only

963
Owner Warrington Borough Council
Location Warrington Library Museum Street
Warrington Cheshire
Title Warrington Broadside Collection
Custodian D Rodgers
Dates (1848) -
Photographer T Birtles Francis Frith
Subjects CHESHIRE LANCASHIRE - all aspects -
Manchester ship canal
Numbers pr c20000 b&w col various
fi negs 15 b&w various
gl negs 52 b&w 6"x8"
gl pos 5 b&w various
L sl 62 3⅛"x3⅛"
sl 66 col 35mm
fi 5 reels b&w 16mm

Dates 1934 -
Aids *Card index
Access General public
Copies available for sale
Charges Print fee

964
Owner Whitethorn Press Limited (Cheshire Life Magazine)
Location Thomson House Withy Grove Manchester
M60 4BL 061 834 1234
Title Cheshire Life Collection
Custodian L N Radcliffe - Editor
Photographer Cyril Lindley
Subjects CHESHIRE - topography crafts personalities
sports events architecture history
Numbers pr 10000 b&w 10"x8"
fi negs 4000 b&w 200 col 35mm 2¼"x2¼"
Aids Catalogue subject index
Access Picture researchers press tv media
9 am - 5 pm
Copies available for sale for loan for publication
Charges Reproduction fee print/transparency fee
Notes This is a working collection not primarily intended
for the general public.

965
Owner Cheshire County Council
Location Widnes Public Library Victoria Road Widnes
Cheshire CH2 3NG 051 424 2061 Office Hours
051 424 4482 after 5.30 pm and Saturdays
Title Widnes Local Collection
Custodian S W Dunnett
Dates c1880 (c1953) -
Subjects CHESHIRE Widnes town life children at
play transport ceremonies bridges period costume
architecture paintings portraits aerial
photography
Numbers pr 350 b&w
fi negs 211 b&w
gl pos 128 b&w
sl 30 col
Aids Guide *catalogue *card index *subject index
Access General public bona fide students on request
Copies available for sale
Charges Print fee commercial rates

966
Owner Winsford Local History Society
Location c/o 135 Swanlow Lane Winsford Vale Royal
Cheshire
Custodian Mrs M F Thomas
Dates (1966) -
Subjects CHESHIRE Winsford - photographic survey
Numbers pr b&w
fi negs 35mm
Access General public bona fide students by appointment
only
Copies available for sale

967
Owner Wirral Metropolitan District Council
Location North Wirral Area Library Earlston Road
Wallasey Cheshire 051 638 2334
Title Wallasey Local History Library Photographic
Collection
Custodian E B Irving
Dates Late 19thC (1946) -
Photographer Francis Frith
Subjects CHESHIRE - Wallasey - local history
Numbers pr c2000 b&w
fi negs c200
sl c500 b&w col
Aids *Subject index
Access General public

968
Owner Chingford Historical Society
Location Friday Hill House Simmons Lane London E4
Title Local History Collection
Custodian J M Hayward 12 Preston Avenue Highams Park
London E4 9NL 01 527 3522

Dates (1939) -
Subjects THE PARISH OF CHINGFORD
Numbers pr 2000 b&w
 fi neg 90 b&w
 gl neg 230 b&w ¼pl
 gl sl 60 b&w ¼pl
 L sl 100 b&w
 copy negs for some images
Aids Card index
Access Bona fide students

969
Withdrawn

970
Owner S R Arbuckle
Location 5 Lynmouth Road Norton on Tees Cleveland
 0642 555084
Dates c1900 -
Subjects CLEVELAND - Stockton on Tees
Numbers pr 50 b&w
 gl negs 2
Access General public bona fide students

971
Owner Middlesbrough Borough Council
Location Dorman Museum Linthorpe Road Middlesbrough
 Cleveland 0642 83781
Custodian C E Thornton
Dates 1910 - 1920
Subjects CLEVELAND social sciences occupations
 and services transport archaeology mechanical
 engineering biography and portraits events
Numbers pr c220
Aids *Catalogue
Access General public bona fide students
Charges Reproduction fee by arrangement

972
Owner Cleveland County Council 0642 48155
Location Reference Department Langbaurgh District
 Library Coatham Road Redcar Cleveland
 06493 72162
Custodian F Regan County Librarian Central Library
 Victoria Square Middlesbrough Cleveland
Dates 1890 (1942) -
Subjects CLEVELAND - Redcar
Numbers pr c1500-2000 b&w 2 col various
 postcards 15 col
 L sl 8
Access General public bona fide students
Copies available for loan at discretion of Librarian
Notes Photocopies supplied on request subject to
 copyright.

973
Owner Cleveland County Council
Location Reference Department Central Library Victoria
 Square Middlesbrough Cleveland 0642 45294
Dates 1866 (1950) -
Subjects CLEVELAND - local history
Numbers pr 2167 b&w 35 col various
 gl negs 6
 L sl 34 b&w 12 col
 sl 558
Notes Custodian, Access, Copies and Notes as for No.
 972 above.

974
Owner Cleveland County Council
Location Reference Department Stockton District Library
 Church Road Stockton Cleveland 0642 62688
Dates 1861 (1950) -
Subjects CLEVELAND - Stockton on Tees
Numbers pr 409 b&w various
 gl negs 15

Notes Custodian, Access, Copies and Notes as for No.
 972 above.

975
Owner Lancashire County Council
Location Colne Public Library Market Street Colne
 Lancashire BB8 0AP
Custodian Peter Wightman
Dates 1870 (1955) -
Photographer Arnold F Bailey Lot Dixon Edgar
 Duckworth A B Ellis S Foulds Charles Green
 Ratcliffe John Rushton Ernest Spirey
Subjects COLNE AND DISTRICT social sciences
 occupations and services associations and societies
 education transport customs and folklore
 electrical appliances and machines factories bridges
 farm buildings home period costume
 architecture recreations football cricket
 geography
Numbers pr c3000 b&w 10"x8"
 fi negs c3000 b&w various
 gl pos c2000 b&w various
 L sl 500 b&w 4"x4"
 sl 400 b&w 2"x2"
 mic 11 b&w 35mm
 fi 9 b&w 1 col 16mm 8mm
Access General public
Copies available for sale
Charges Print fee at cost from commercial printers
 photocopies 5p per copy
Notes Prints are mounted on foolscap cards (c2000) each
 containing up to 8 pictures. Cards are in classified
 subject order. Slides and negatives are filed in trans-
 parent envelopes in classified order. The majority of
 items relate to the local history of the area including
 Colne Trawden Fortridge in particular, with less
 intense coverage of other areas of Pendle District.

976
Owner North Cornwall District Council Municipal Offices
 Priory House Bodmin Cornwall Bodmin 2801
Location Public Rooms Basement Bodmin Cornwall
Title Bodmin Museum Photographic Collection
Custodian L E Long
Dates c1860 (1955) -
History The collection began as a local history project
 dealing exclusively with the town of Bodmin. The
 collection has expanded in recent years to include
 other subjects, among them scenic views of the county.
Photographer George W F Ellis Arthur Jane William
 Rochard
Subjects CORNWALL Bodmin Christian institutions
 town life prisons and crimes the army schools
 postal services transport customs and folklore
 archaeology architecture public entertainments
 biography and portraits historic and newsworthy
 events sports scenic views
Numbers pr c3000 b&w various
Aids *Catalogue in preparation
Access Bona fide students

977
Owner Cornwall County Council
Location Camborne-Redruth Public Libraries Clinton
 Road Redruth Cornwall Redruth 5243
Custodian G T Knight
Dates c1890 (c1965) -
Photographer Francis Frith
Subjects CORNWALL - rock formation - ecclesiastical
 architecture street scenes stone crosses coastal
 geography
Numbers pr c900 b&w in albums c280 b&w on boards
 various
Access General public bona fide students

Key () = dates when collections were begun or terminated
C = Century c = approximately pr = print fi = film
gl = glass neg = negative sl = slide L sl = lantern slide
tr = transparency mic = microform col = colour

b&w = black and white ¼,½,1-pl = quarter,half and whole
plate * = single copy,no public access ** = single copy,
access by appointment

978
Owner Cornwall County Council County Hall Truro Cornwall
Location County Branch Library The Moor Falmouth Cornwall Falmouth 312691
Title Falmouth Local History Collection
Custodian J K Mealor
Dates c1920 -
Subjects CORNWALL Falmouth safety at sea ships engineering mining building - exteriors biography and portraits geography
Numbers pr c2000 b&w various
 L sl c300 b&w 3¼"x3¼"
Aids *Subject index
Access General public bona fide students

979
Owner The Royal Institution of Cornwall
Location The County Museum Truro Cornwall Truro 2205
Custodian H L Douch
Dates 1890 (c1950) - 1930 -
Photographer W Hughes Philip Jordan
Subjects CORNWALL scenic church architecture social harbours and shipping mining
Numbers gl negs c5000 b&w ½pl 1pl
Access General public bona fide students on application
Copies available by private arrangement
Charges Reproduction fee

980
Owner Cornwall County Council
Location Record Office Truro Cornwall Truro 3698
Custodian P L Hull
Dates 19thC (1951) -
Subjects CORNWALL buildings portraits industrial scenes street scenes
Numbers small collection
Aids *Subject index in preparation
Access General public bona fide students
Copies available by special request subject to copyright
Charges Print fee standard rates

981
Owner B J Sullivan
Location 34 Queensway Hayle Cornwall TR27 4NJ Penzance 3068
Dates c1880 (1962) -
History The collection covers the history of the town of Hayle which was the most important mine supply port and engineering centre in Cornwall during the Industrial Revolution
Photographer B J Sullivan
Subjects CORNWALL Hayle - social sciences architecture mining mechanical engineering Romano-Celtic Christian monuments
Numbers pr c90 b&w ½pl
 fi negs c1000 b&w
 sl c2000 col
Access Bona fide students by appointment only outside working hours
Notes The collection has a street by street record of the whole town.

982
Owner Studio St Ives Limited
Location Tregenna Hill St Ives Cornwall St Ives 6249
Title Old St Ives Collection
Custodian Evan A Blandford
Dates c1880 (c1930) -
Photographer Douglas
Subjects CORNWALL St Ives - town life Seine fishing and fishing boats
Numbers fi negs 30 b&w 3¼"x2¼"
 gl negs 70 b&w various
Access General public picture researchers bona fide students press tv media 9 am - 5 pm except Thursday and Saturday 9 am - 1 pm
Copies available for sale for display for publication credit line required
Charges Reproduction fee from £5 + VAT print fees from 45p - £3 + VAT

983
Owner Noah's Ark Folk Museum Trustees
Location Fowey Cornwall 072 683 3304
Custodian Muriel E Graeme
Dates 1879 (1948) -
Subjects CORNWALL - Fowey - all aspects
Numbers pr 40 stereo
 fi negs 150 cartes de visites
 gl negs 40 8½"x6½" 6½"x4¾" 5"x4"
 L sl 20 3¼"x3¼"
 tr 6 14"x10"
 daguerreotypes ambrotypes ferrotypes
Aids Guide
Access General public bona fide students
Copies available for sale
Charges Print fee

984
Owner P G Laws
Location 2 Donnington Road Penzance Penwith Cornwall 0736 3544
Dates 1937 -
Photographer P G Laws
Subjects CORNWALL ISLES OF SCILLY - industrial archaeology lighthouses radio transport public festivals and fairs seascapes static engines mills bridges cranes mining agricultural machines and tools architecture seaside holidays china-clay industry ports harbours
Numbers pr c350 b&w 5"x3" - 10"x8"
 fi neg c100 b&w 2¼"x2¼"
 tr c8000 col b&w 2"x2"
Aids *Catalogue *subject index
Access Bona fide students upon application
Copies available for loan
Charges Reproduction fee by arrangement
Notes Mr Laws is principal author of Industrial Archaeology of Cornwall, Industrial Archaeology of Bedfordshire, Cornish Beam Engines, and The Architectural History of Penzance. The collection has a large number of 19C photographs copied as transparencies.

985
Owner Mervyn H Haird
Location 75 Lambs Lane Cottenham Cambridge CB4 4TB
Dates 1900 (1962) -
Photographer Fred Smith
Subjects COTTENHAM VILLAGE - streets and houses - local industries basket making brewery horse-drawn transport cycles old buses village groups ploughing matches floods 1914-18 war
Numbers fi neg c200 b&w 35mm
 gl neg c900 b&w ½pl - ¼pl
 sl 700 b&w c150 col 35mm
Aids *Subject index
Access By appointment only outside of office hours
Copies available for sale

986
Owner Miss M Wright 22 South Street Cuckfield West Sussex
Location West Sussex Record Office Chichester
Title Cuckfield - An Old Sussex Town
Dates 1860s - 1900
Subjects CUCKFIELD - streets and buildings
Numbers pr 29 b&w
Access General Public bona fide students
Notes Two sets of copy prints of the original photographs postcard size were made. One is deposited in the West Sussex Record Office.

987
Owner Cumbria County Council
Location County Library Stricklandgate Kendal Cumbria 0539 20254
Custodian County Librarian
Dates c1890 -
Subjects CUMBRIA - Westmorland and Lake District
Numbers pr c4000 ½pl

fi negs c50 $2\frac{1}{2}$"x$2\frac{1}{2}$"
Aids Catalogue card index
Access General public
Copies available for sale by arrangement
Charges Print fee commercial rates

988

Owner Cumbria County Council
Location Jackson Library (Cumbria County Library
North East Divisional Headquarters Tullie House
Carlisle) 0228 24166
Custodian Henry W Hodgson
Dates c1850 (1893) -
Subjects CUMBRIA CARLISLE biography and portraits
geography
Numbers pr c500 b&w various
sl c500 col 35mm
Access Bona fide students otherwise a closed access
collection
Copies Slides available for loan for lectures etc

989

Owner Carlisle City Council Civic Centre Carlisle
Cumbria
Location The Museum and Art Gallery Tullie House
Castle Street Carlisle Cumbria CA3 8TP
0228 34781
Title Carlisle Museum Collection
Custodian R Hogg
Dates Late 19th/20thC -
Subjects CUMBRIA ESKDALE miniature railways
foreign travel Roman antiquities ironwork
Numbers fi negs 1000 b&w $\frac{1}{4}$pl
gl negs 500 b&w $\frac{1}{4}$pl
L sl c1500 b&w $2\frac{1}{4}$"x$2\frac{1}{4}$" $3\frac{1}{4}$"x$3\frac{1}{4}$"
Access General public bona fide students on application
in advance
Notes Includes Miss Fair Collection P I Wilson Collection
John H Minns Collection M H Donald Collection
R Maclaren Collection Fletcher Collection.

990

Owner Carlisle City Council
Location Planning Office Department of Planning Civic
Centre Carlisle Cumbria CA3 8QG 0228 23411
Custodian C Cuthbert
Dates c1950 -
History This is an ongoing record of sites, buildings,
landscapes etc dating from the 1950's. Early coverage
not at all comprehensive
Subjects CUMBRIA Carlisle - survey of buildings to be
demolished continuing record of new development
historic buildings landscape sites of major
planning applications plans and maps
Numbers pr 500 b&w 6"x4"
fi negs 2000 b&w 35mm
sl 1400 col b&w
Aids Photographs and negatives filed by streets and
parish with full index
Access Generally no public access
Notes This is a working photographic collection
designed for record purposes and to aid planning
procedures.

991

Owner Cumbria County Council and various Depositors
Location Record Office The Castle Carlisle Cumbria
0228 23456
Custodian County Archivist
Dates c1856 (1962) -
Subjects CUMBRIA Carlisle transport customs and
folklore mining home interiors architecture
biography and portraits geography historic and
newsworthy events paintings topography industry
horse drawn locomotive - "Dandie Dinmont"
bobbin-mills shipping

Numbers pr c1000 various
L sl c600 35mm
mic c200 35mm 100'
Aids *subject index for slide collection in preparation
Access General public bona fide students
Copies available by arrangement
Charges Print fee from 50p colour slides from 15p
Notes Slides or prints can be taken of photographs in the
collection with the depositor's permission. Copies
of slides/prints can be made of those already in the
collection.

992

Owner Curwen Archives Trust
Location Cumbria Record Office County Offices
Kendal LA9 4RQ 0539 21000
Custodian Miss Shiela J MacPherson
Dates (1971) -
Subjects CUMBRIA Westmorland - photographic survey
Access General public bona fide students
Copies available for sale
Charges Print fee
Notes Prints available in County Library, Stricklandgate,
Kendal, reference negatives in Record Office, Kendal.

993

Owner Cumbria County Council
Location Whitehaven Library Lowther Street
Whitehaven Cumbria CA28 7QZ 0946 2664
Title Changing Whitehaven
Custodian David Andrews
Dates 1960 -
Subjects CUMBRIA Whitehaven all aspects
Numbers pr 1300 b&w 8"x6"
Aids *Card index
Access General public bona fide students
Copies available for sale

994

Owner J Wignall
Location 46 Newby Terrace Barrow in Furness Cumbria
0229 22676
Dates 1850 (c1962) -
Photographer Hargreaves Sankey
Subjects CUMBRIA Barrow in Furness - local history
mining shipping iron and steel industries railways
quarries
Numbers pr c650 various
tr c1400 col 35mm
Aids Place index
Access Bona fide students by appointment only

995

Owner Geoffrey Berry
Location 27 Greenside Kendal Cumbria 0539 20296
Dates 1960 -
Photographer Geoffrey Berry
Subjects CUMBRIAN LANDSCAPES CONSERVATION
traffic problems construction of M6 Kendal
Numbers fi neg c2500 $2\frac{1}{4}$"x$2\frac{1}{4}$"
tr 300
Access Bona fide students
Copies available for sale
Charges Reproduction fee £3 per photograph

996

Owner R H Alford
Location 7 The Mede Whipton Exeter Devon
Dates 1840 (1950) -
Subjects DEVON - farm transport
wagons and carts threshing and hayfield scenes
Numbers pr b&w col
Access Bona fide students publishers
Copies available by arrangement
Charges Reproduction fee

Key () dates when collections were begun or terminated
C = Century c = approximately pr = print fi = film
gl = glass neg = negative sl = slide L sl = lantern slide
tr = transparency mic = microform col = colour

b&w = black and white $\frac{1}{4}$, $\frac{1}{2}$, 1-pl = quarter, half and whole
plate * = single copy, no public access ** = single copy,
access by appointment

997
Owner W R J Baker
Location Hillside Modbury Ivybridge South Hams
 Devon PL21 ORG 054 883 342
Dates c1870 (1968) -
Photographer W R J Baker
Subjects DEVON Modbury - past and present
Numbers pr c360 various
 tr c500
Access Bona fide students by appointment only
Charges Reproduction fee by arrangement

998
Owner Brixham Museum and History Society
Location Brixham Museum Higher Street Brixham Devon
Custodian C H Rock Honorary Secretary and Curator
 8 Greenbank Road Brixham Devon 080 45 2519
Dates c1880 (1958) -
Subjects DEVON Brixham local history maritime
 activities - fishing trawlers Brixham harbour
 local streets and buildings
Numbers pr c1000 b&w col various
 L sl 30 col 2"x2"
Aids *Catalogue
Access General public bona fide students public access
 during the winter is only possible by prior
 arrangement with the curator

999
Owner Budleigh Salterton Arts Centre and Museum
Location Fairlynch Budleigh Salterton Arts Centre and
 Museum Devon Budleigh Salterton 2666
Custodian Miss Joy Gawne Cramalt Lodge 2 Cricketfield
 Lane Budleigh Salterton Devon Budleigh
 Salterton 3342
Dates c1860 (1967) -
Subjects DEVON Budleigh Salterton and district
 village life transport public festivals street scenes
 fishermen - boats lobster pots Jubilee celebrations
Numbers pr various substantial number
 fi negs c400 b&w
Aids *Subject index
Access General public bona fide students
Copies available by arrangement
Charges Print fee

1000
Owner Brian Chugg
Location 5 Shorelands Road Barnstaple North Devon
 Barnstaple 5960
Dates 1845 (1973) -
Subjects DEVON
Numbers pr c700 b&w 10"x8" 8"x6"
Access Restricted to bona fide students
Copies Certain prints only available
Notes This collection is in the course of development.

1001
Owner Clinton Devon Estates East Budleigh
 Budleigh Salterton Devon
Location Bicton Gardens Rolls Estate Office Budleigh
 Salterton EX9 7DP Budleigh Salterton 3881
Title Countryside Museum Collection
Custodian N D G James Agent
Dates 1850 (1968) - 1950 -
Subjects DEVON country life the army land army
 farm machines forestry cattle
Numbers pr 22 b&w
Access General public bona fide students
Notes The Countryside Museum is open daily from 24th
 March to 15th October each year. There is an
 admission charge to the Gardens and Museum.

1002
Owner Cookworthy Museum Society
Location 108 Fore Street Kingsbridge South Devon
Title Cookworthy Museum Collection
Custodian Kathy Tanner
Dates 19thC - 20thC -
Photographer Fairweather of Salcombe
Subjects DEVON Kingsbridge and district social
 sciences lifeboats lighthouses safety at sea
 education transport - rail road sea docks and
 harbours customs and folklore farms clothes
 street scenes portraits
Numbers pr c300
Access Bona fide students by appointment
Notes This collection is entirely local.

1003
Owner South Hams District Council
Location Dartmouth Museum The Butterwalk Dartmouth
 Devon
Title Dartmouth Museum Collection
Custodian R Cawthorne
Dates Mid 19thC -
Subjects DEVON Dartmouth local and maritime history
Numbers pr 300
Access General public open daily except Sunday
Charges Reproduction fee by arrangement

1004
Owner Dawlish Museum Society
Location The Dawlish Museum The Knowle Barton
 Terrace Dawlish South Devon
Custodian Mrs Elsa Godfrey Honorary Secretary-
 Curator 7B Barton Villas Dawlish South Devon
 EX7 9QT Dawlish 2749
Dates 1880 (1967) -
Subjects DEVON Dawlish the army associations and
 societies schools transport public festivals
 ceremonies seascapes bridges farm buildings
 tools period costume earthenware architecture
 painting dolls costumes seaside holidays
 landscapes historic events
Numbers pr substantial number various
Aids Partial card index
Access General public bona fide students on request

1005
Owner Devon County Council Library Service
 Administrative Centre Barley House Isleworth Road
 Exeter
Location Central Library Drake Circus Plymouth Devon
 PL4 8AL 0752 68000 Ext 3123
Title West Devon Area Library Local History Collection
 Naval History Collection
Custodian J R Elliott
Dates c1855 (1956) -
Photographer L Duprez Fitzgerald Francis Frith
Subjects DEVON Cornwall Plymouth topography
 street scenes communications customs mining
 civil engineering architecture historic events
 naval history naval life British and foreign navies
 ships of war World War II wrecks
Numbers pr 16200 b&w ½pl 1-pl
 fi negs 2100 b&w 5"x3"
 gl negs c100 b&w 5"x3"
 L sl 1050 b&w 3"x3"
 sl 5800 200 b&w 5600 col 35mm
 postcards 1800 various
Access General public Monday - Saturday 9 am - 9 pm
Copies available for loan

1006
Owner Devon County Council
Location Devon Record Office Concord House
 South Street Exeter Devon EX1 1DX 0392 79146
Title Copeland Collection Chapman Collection
Custodian P A Kennedy
Dates cLate 19thC
Subjects DEVON
Numbers pr c8500
Access General public bona fide students Monday to
 Friday 9.30 am - 5 pm Saturday 9 am - 12.30 pm

1007
Owner Charles Hulland
Location Exe View High Street Bampton Tiverton
 Devon 039 83 292
Title Local History of Devon

Dates c1965 -
Photographer Charles Hulland
Subjects DEVON - local history vernacular architecture Devon landscape development archaeology churches ancient tracks wool trade occupations town houses country houses
Numbers sl c1000 col 2"x2"
Aids Card index
Access Bona fide students

1008

Owner Ilfracombe Museum Trustees
Location Wilder Road Ilfracombe Devon EX34 8AF Ilfracombe 63541
Custodian John Longhurst
Dates 1850 - 1939 -
Subjects DEVON Ilfracombe lifeboats lighthouses saftey at sea nature: biology botany: plants recreations seaside holidays landscapes events
Numbers pr c500 b&w
L sl c200 b&w col 3½"x2½"
Access General Public bona fide students
Copies available for sale

1009

Owner North Devon Athenaeum (Rock Trust)
Location The Square Barnstaple North Devon Barnstaple 2174
Title Includes C Whybrow's Exmoor Collection
Custodian G A Morris
Dates 1885 (1888) -
Photographer Ron Birchall B W Oliver C Whybrow
Subjects DEVON Barnstaple Exmoor local history churches archaeology geography shipping
Numbers pr various
L sl c100 b&w 3¼"x3¼"
sl c2400 col 35mm
Access Bona fide students for reference only and by special appointment

1010

Owner J R Pim
Location Herondyke West Charleton Kingsbridge Devon Frogmore 289
Dates 1955 -
Subjects DEVON local history topography industrial archaeology vernacular architecture Island Cruising Club - tall ships races French ports and coasts transport mills factories farm buildings painting static and working models seaside holidays winter sports geography travel abroad fishing seascapes
Numbers pr c50 b&w various
fi negs b&w
Aids *Guide *subject index
Access Bona fide students on appointment
Copies available for sale for loan by arrangement
Charges Reproduction fee by arrangement
Notes The collection is used regularly in local history lectures.

1011

Owner Plymouth City Council
Location City Museum Drake Circus Plymouth Devon PL4 8AJ
Title Old Plymouth Record Collection
Custodian J Barber
Dates c1855 -
History The collection has been built up as a matter of Museum policy since the Institution was founded in 1899. Old photographs have been acquired from time to time by gift bequest and purchase. Since 1961 Museum staff have systematically taken current record photos and copied older ones.
Photographer J Barber Cynthia Gaskell-Brown Catharine Forrest Betty Fox Francis Frith

R Jackson R Rugg Monk Major General Tripe R P Yeo
Subjects DEVON Plymouth - architecture local social life topography - adjoining areas of Devon and Cornwall
Numbers pr substantial number b&w
sl including b&w 3¼"x3¼"
paper negs 9
gl negs substantial number
Aids Card index in advanced state of preparation
Access General public - selection on view bona fide students - reserve collection on application
Copies available in certain instances on application to Custodian
Charges Print fee

1012

Owner Devon County Education Authority County Hall Exeter Devon
Location Schools Museum Service 33a Meadfoot Lane Torquay Torbay Devon 0803 25779
Title Educational Resources
Custodian L A J Jackman Schools Museum Officer N E Watkins Graphic Design and Photographer
Dates 1860 (c1965) -
Photographer N E Watkins
Subjects DEVON social sciences occupations and services education communications transport army - uniforms and regalia microscopy geology meteorology palaeontology archaeology anthropology nature botany zoology agriculture period costume arts and crafts architecture toys fishing biography and portraits geography aerial photography
Numbers pr c1000 b&w col various
fi negs c2000 b&w 35mm
sl c3500 col 35mm
microscopic sl 100 col
Aids Published catalogue *card index *subject index
Copies Only prints produced by N E Watkins for sale for loan
Notes The collection is intended for educational purposes only. Material is distributed to schools in Devon.

1013

Owner Tiverton Museum Society Trustees
Location St Andrew Street Tiverton Devon Tiverton 56295
Title Photographs relating to Tiverton and District
Custodian W P Authers Chairman and Curator Horsden House Tiverton Devon
Dates c1880
History The photographs have been obtained from many local sources
Subjects DEVON - Tiverton - all aspects
Numbers pr several hundred various
Access General public
Copies available on request
Charges Print fee at cost reproduction fee
Notes Photographs can be copied free of charge providing they are not removed from display fixtures.

1014

Owner Beaford Centre
Location Beaford Winkleigh Devon EX19 8LU Beaford 201
Title The Beaford Archive
Dates c1850 -
Photographer Roger Deakins James Ravilious
Subjects NORTH DEVON village life country life and customs transport agriculture domestic interiors architecture recreations events rural costume rural industries
Numbers Total many thousands negs and contacts
Aids *Card index and *subject index in preparation

Key () = dates when collections were begun or terminated
C = Century c = approximately pr = print fi = film
gl = glass neg = negative sl = slide L sl = lantern slide
tr = transparency mic = microform col = colour

b&w = black and white ¼, ½, 1-pl = quarter, half and whole plate * = single copy, no public access ** = single copy, access by appointment

Access Bona fide students minimum of a fortnight's notice is requested
Copies available for sale copyright reserved
Charges Reproduction fee subject to rights of reproduction
Notes The photographs together with a sound archive of recordings of North Devon people are intended to constitute a comprehensive record of a rural area past and present. Exhibitions are being prepared and will be available for loan hire.

1015

Owner Devon County Council
Location Area Library (South Devon) Central Library Lymington Road Torquay South Devon TQ1 3DT 0803 211251
Custodian John R Sikes
Dates c1860 (1963) -
Subjects SOUTH DEVON - local and social history
Numbers pr 1500 b&w various
 gl negs 450 b&w ¼pl ½pl
 L sl 200 b&w 3¼"x3¼"
 sl 300 b&w 35mm
Aids Partial card index
Access General public bona fide students

1016

Owner Derbyshire County Council Council Offices Matlock Derbyshire 0629 3411
Location Area Library and Museum The Crescent Buxton Derbyshire SK17 6DI 0298 5331
Title North West Derbyshire Photographic Collection
Custodian I E Burton
Dates 1870 (1947) -
Subjects DERBYSHIRE - all aspects
Numbers pr c1000 b&w 14"x9"
 L sl 200 b&w 200 col 2"x2"
Access General public bona fide students

1017

Owner Derby Borough Council
Location The Strand Derby DE1 1BS 0332 3111
Title Derby Museums and Art Gallery Collection
Custodian The Director
Dates c1920 -
Subjects DERBY - aerial views Midland Railway portraits porcelain
Numbers pr 4000 b&w various
 fi negs 2300 b&w various
 gl negs 260 b&w various
 L sl 700 b&w 3¼"x3¼"
 sl 200 35mm
 fi 4 b&w 16mm
Aids Card index
Access Bona fide students
Copies available for sale

1018

Owner J W Allen
Location The Old Hall Hognaston Ashbourne Derbyshire DE6 1PR
Title Derbyshire - Aspects of Countryside
Dates (1954) -
Photographer C E Brown
Subjects DERBYSHIRE - architecture country life and customs inland-waterways archaeology
Numbers pr c250 b&w 6½"x8½"
 gl neg c50 b&w 3"x3"
 stereo tr c200 b&w c400 col
 Copy negs for some images
Aids *Subject index
Access By special request
Charges Reproduction fee £1 plus postage
Notes These photographs are essentially associated with a study of the countryside generally.

1019

Owner G F and P F Cholerton
Location 19 Wilsthorpe Road Chaddesden Derby DE2 4QR
Dates c1900 (1965) -
Subjects DERBYSHIRE Chaddesden - all aspects
Numbers pr 38 b&w 6 col 3½"x5½"

Aids Guide 25p each
Access Bona fide students

1020

Owner Derbyshire County Council
Location Local Studies Department Central Library The Wardwick Derby 0332 31111 Ext 2184
Title Derby Libraries Photograph Collection
Custodian A R Langworthy
Dates c1860 (c1920) -
Photographer W R Bland R Keene
Subjects DERBYSHIRE Derby social sciences trnsport archaeology bridges mills architecture biography and portraits geography historic and newsworthy events
Numbers pr c2500 b&w 10"x8"
 postcards c400 b&w col
 gl negs c850 b&w 8½"x6½" 6½"x5"
 sl 250 b&w col 2"x2"
 mic 360 16mm 35mm
Aids Card index subject index
Access General public bona fide students
Copies available for sale
Charges Reproduction fee

1021

Owner Derbyshire County Council
Location Public Library Ilkeston Derbyshire
Custodian C G Bourne
Dates c1880 -
Subjects DERBYSHIRE Ilkeston local government transport fairs and ceremonies architecture recreations portraits aerial views events
Numbers pr c3000 b&w
 L sl 100 b&w
 tr 800 col
 fi 3 b&w 16mm 35mm
Aids *Card index *subject index
Access General public to sections of the collection on request
Copies available in exceptional cases

1022

Owner Derbyshire County Council
Location County Offices Matlock Derbyshire Matlock 3411
Dates 19thC (c1930) -
Subjects DERBYSHIRE town and village life
Numbers pr c1060 b&w
 fi negs 35 b&w
 gl negs 103 b&w
 gl 1 b&w
 fi tr 39 col
Aids *Card index in preparation
Access General public

1023

Owner Derbyshire County Council
Location Reference Library Chesterfield Central Library Corporation Street Chesterfield Derbyshire S41 7TY 0246 2047
Title Local History Illustrations Collection
Custodian D Inger
Dates c1880 -
Subjects DERBYSHIRE Chesterfield local history architecture geography
Numbers pr c2840 b&w col various
 fi negs c50 b&w
 gl negs 193 b&w various
 L sl 1424 b&w 3"x3"
 sl 649 b&w col 2"x2"
 fi 4 b&w 35mm
Aids *Subject index
Access General public
Copies available for sale

1024

Owner Brian Woodall
Location Allmen Joy Lower Terrace Road Tideswell Buxton Derbyshire

Title Derbyshire Heritage Lecture Peak District Calendar
of Events Life and Tradition in Derbyshire
Castleton - Portrait of the Past Derbyshire - Past
and Present
Dates (1969) -
Photographer Brian Woodall
Subjects DERBYSHIRE - rural life national park village
brass bands horse-drawn transport archaeology
water mills dams mining agriculture domestic
interiors architecture antiques pageants camping
cave exploration walking portraits geography
social events
Numbers pr 350 b&w
gl pos 24 b&w
sl c750 col
Copies available for sale
Charges Reproduction fee standard rates
Notes These slides are used for lectures and field study.

1025
Owner Dorset County Council Colliton Park
Dorchester Dorset DT1 1XJ
Location Central Library Landsdowne Bournemouth
Dorset 0202 3131
Title The D S Young Collection
Custodian N H Heissig
Dates 1860 (1925) -
Photographer Robert Day William James Day
Subjects DORSET - Bournemouth - all aspects
Numbers gl negs c500
sl c650 35mm
mic 125 rolls - local newspapers and census reports
Aids *Subject index
Access General public bona fide students
Copies available for loan
Notes William James Day 1854 - 1939 was the son of
Robert Day 1822 - 1873.

1026
Owner Dorset County Council
Location Dorset County Library Colliton Park
Dorchester Dorset DT1 1XJ Dorchester 3131
Title Dorset County Library Collection
The Holland/Hankinson Collection on Thomas Hardy
is also included
Custodian H E Radford
Dates Late 19thC (1930) -
Photographer Francis Frith Clive Holland (Charles James
Hankinson) D J Popham
Subjects DORSET all aspects
Numbers pr c2300 b&w col 6½"x8½"
fi negs 38 b&w 3¼"x3¼"
L sl 80 b&w 3"x3"
tr 293 b&w c4000 col 35mm
fi strips 5 col 35mm
fi 2 16mm
Aids Card index and subject index in progress
Access General public
Copies available for sale by private arrangement

1027
Owner Dorset County Council and Trustees
Location Dorset County Museum High West Street
Dorchester Dorset DT1 1XA 0305 2735
Title Dorset Photographic Record
Custodian R N R Peers
Dates c1850 (c1920) -
Subjects DORSET - all aspects
Numbers pr c11500 b&w includes 1000 aerial
L sl c1000
tr 2120 col
Access General public bona fide students by appointment
only 10 am - 1pm 2 pm - 5 pm
Copies available for sale for publication
Charges Print fee reproduction fee £5 for rights in U K
£10 for World rights copyright not granted

1028
Owner Dorset County Council
Location Museum and Art Gallery South Street Bridport
Dorset 0308 2116
Custodian J M Reynolds
Dates 1900 (1965) -
Photographer E C Hare Hider and T H J Pinn
Shepherds P C Smith Walter Stephens
Subjects DORSET - Bridport - all aspects
Aids *Subject index
Access Bona fide students
Copies available for sale by arrangement
Charges Print fee reproduction fee by arrangement
Notes This collection is purely a local collection .

1029
Owner Durham County Council
Location The Bowes Museum Barnard Castle Durham
Barnard Castle 2139
Custodian M H Kirkby
Dates (1862) -
Subjects DURHAM social sciences occupations and
services the forces associations and societies
education communications transport customs and
folklore chronology crystalography mineralogy
palaeontology archaeology anthropology zoology
mechanical engineering civil and building
construction mining agriculture and food production
domestic home clothes arts and crafts
architecture recreations biography and portraits
Numbers pr c500 b&w
L sl c200 b&w
Aids Catalogue card index subject index in preparation
Access General public bona fide students
Copies available for sale
Charges Reproduction fee print fee on application

1030
Owner Durham County Council
Location The Bowes Museum Barnard Castle Durham
Barnard Castle 2139
Title The Pattison Collection
Custodian M H Kirkby
Dates 1885 (1970) - 1974
Photographer Rev James Pattison
Subjects DURHAM social sciences occupations and
services children at play transport seascapes
agriculture and food production fishing home
clothes ecclesiastical buildings seaside holidays
biography and portraits geography
Numbers pr 500 b&w ¼pl ½pl
L sl 241 b&w 3¼"x3¼"
Aids Guide in preparation
Access General public bona fide students
Copies available for sale
Charges Print fee reproduction fee on application
Notes A collection of photographs by the Rev James
Pattison showing the everyday life of two quite
different parts of County Durham over half a century
ago. The parishes shown are Seaton Carew and
St John's Chapel, Weardale.

1031
Owner Durham County Council
Location Branch Library South Street Durham
0385 64003
Custodian C Nelson
Dates c1870 (c1923) -
Subjects DURHAM - all aspects
Numbers pr c420
Aids Filed by subject headings
Access General public

1032
Owner Durham County Council
Location Durham County Record Office County Hall
Durham DH1 5UL 0385 64411 Ext 253

Key () = dates when collection were begun or terminated
C = Century c = approximately pr = print fi = film
gl = glass neg = negative sl = slide L sl = lantern slide
tr = transparency mic = microform col = colour

b&w = black and white ¼,½,1-pl = quarter, half and whole
plate * = single copy, no public access ** = single copy,
access by appointment

Custodian J Keith Bishop
Dates Late 19thC (1961) -
Subjects DURHAM social sciences occupations and
 services associations and societies education
 transport customs and folklore mining domestic
 architecture recreations athletic sports and
 outdoor games biography and portraits geography
 events
Aids *Catalogue *card index
Access General public bona fide students
Copies available for sale on request
Charges Photographs from 70mm negatives. First copies
 from 85p - £2.00. Subsequent copies 25p - 85p
 (A4 - AO size).

1033
Owner J W Fell
Location Stressholme Farm Darlington Co Durham
 0325 65419
Title Darlington and District
Dates c1880 (1953) -
Photographer J W Fell
Subjects DURHAM Darlington and district - buildings
 railway houses Stockton pottery and flints farm
 work
Numbers pr c100 b&w 35mm
 fi negs c100 b&w
 tr 500 col 35mm
Access Bona fide students picture researchers press tv
 media appointment by letter only
Copies available by private arrangement for loan
 in certain cases only

1034
Owner Dr C W Gibby Prebends' Gate Quarryheads Lane
 Durham
Location Durham University Library Science Section
 South Road Durham 0385 64971
Title Gibby Collection
Dates c1860 (c1900) -
Photographer W A Bramwell
 C W Gibby
Subjects DURHAM local history buildings
 prominent local people
Numbers fi negs c50 $3\frac{1}{2}$"x$2\frac{1}{2}$"
 gl negs c950 $4\frac{1}{4}$"x$3\frac{1}{2}$"
Aids Catalogue
Access General public bona fide students on application
 to the Keeper of Science Books
Copies available for sale
Charges Reproduction fee on application

1035
Owner Cleveland County Council
Location Central Library Clarence Road Hartlepool
 Cleveland 0429 2905
Title Hartlepool Photographic and Print Collection
Custodian G R Fletcher
Dates Late 19thC -
Photographer Francis Frith D R P Ferriday
Subjects DURHAM - Hartlepool - all aspects
Numbers pr 2500 various
 including c1200 negs
 c500 1-pl
Access Bona fide students under librarian's supervision
 only
Copies available for sale by arrangement
Charges Print fee commercial rates

1036
Owner W Robinson
Location The Populars Cotherstone Barnard Castle
 Durham Cotherstone 432
Dates 1895 -
Photographer Yeoman
Subjects DURHAM Teesdale
Numbers pr c300 various
Access General public bona fide students by personal
 application only

1037
Owner City of Durham Trust (University of Durham)
Location Department of Geography South Road Durham
 0385 64971
Custodian Dr Douglas Pocock Secretary
Dates 1960 -
Subjects DURHAM - buildings - general environment
Numbers pr 200 5"x4"
Access Apply to secretary
Copies available by arrangement apply to Secretary

1038
Owner University of Durham
Location Science Section Library South Road Durham
 0385 64971
Title Edis Collection
Custodian The Librarian
Dates c1880 - 1950
History The collection was compiled by John Edis and
 his daughter Daisy
Photographer Daisy Edis John Edis
Subjects DURHAM historic buildings local people
Numbers gl negs c1500 $6\frac{1}{2}$"x$8\frac{1}{2}$"
Access General public bona fide students
Copies available for sale
Charges Print fee

1039
Owner Owen H Wicksteed
Location 5A Harewood Hill Darlington Co Durham
 DL3 7HY 0325 63382
Dates c1880 (1926) -
Subjects DURHAM Darlington family photographs
 Norway - Hardanger
Numbers pr 15"x12" 10"x16"
 fi negs $2\frac{1}{4}$"x$2\frac{1}{4}$" $2\frac{1}{4}$"x$3\frac{1}{4}$"
 tr $2\frac{1}{4}$"x$2\frac{1}{4}$" Dufaycolor 35mm subtractives
 daguerreotypes
Access Bona fide students by previous appointment only

1040
Owner Joint Committee for the North of England Open Air
 Museum
Location North of England Open Air Museum Beamish
 Hall Beamish Nr Stanley Durham 02073 3586/3580
Custodian Rosemary E Allan
Dates 1850 (1960) -
Photographer J W Bee Daisy Edis Dr W C Fothergill
 Francis Frith Rev J W Pattison
Subjects DURHAM NORTHUMBERLAND TYNE AND
 WEAR CLEVELAND - social sciences occupations
 and services education transport customs and
 folklore archaeology mechanical engineering
 precision instruments mining agriculture
 domestic home clothes architecture antiques
 biography and portraits
Numbers fi negs 10000 b&w
 gl negs 2070 b&w 6"x$8\frac{1}{2}$"
 L sl 2000 b&w
Aids Catalogue to be published in the future
Access General public bona fide students by appointment
 only Monday to Friday 9 am - 5 pm
Copies available for sale for display for publication
Charges Print fee reproduction fee no reproduction fee
 if for educational use
Notes Aided by the English Tourist Board.

1041
Owner Durham County Council
Location Darlington Reference Library Crown Street
 Darlington Co Durham 0325 2034 69858
Title Local History Illustrations Collection
Custodian Stanley Dean
Dates 1856 (c1885) -
Photographer Dr W C Fothergill Francis Frith
 O H Wickstead
Subjects DURHAM COUNTY NORTH YORKSHIRE
 DARLINGTON - all aspects railway history
 portraits historic and newsworthy events

Numbers pr c6000 b&w various
gl negs c50 b&w 10"x8"
gl pos c450 b&w 3¼"x3¼"
sl 32 b&w 625 col 2"x2"
Aids *Card index *subject index
Access General public 9 am - 1 pm 2 pm - 5 pm
Monday and Saturday 9 am - 1 pm 2 pm - 7 pm
Tuesday to Friday
Copies and photocopies available by arrangement
credit line required
Charges Reproduction fee on application to County Librarian
Notes The photographs taken by Dr W C Fothergill are
mainly foreign and non-local glass slides.

1042

Owner Museum of East Anglian Life
Location Stowmarket Suffolk IP14 1DL
Stowmarket 2229
Title Museum of East Anglian Life Photographic
Collection
Custodian Geoffrey Wilding
Dates 1870 (1956) -
History The collection includes both old photographs and
ones taken as part of the Museum's fieldwork
Subjects EAST ANGLIA - Norfolk Suffolk Essex
Cambridgeshire agriculture crafts domestic and
social life industries
Numbers pr c2000 3"x4" - 12"x10"
fi negs c2500 35mm - 6"x5"
gl negs c1500 7½"x5½"
L sl c50 b&w col 3"x3" 5½"x5½"
Aids Photographs stored according to Museum of English
Rural Life classification scheme catalogue forms
stored in accession number order
Access Students and interested persons by appointment
Copies available for sale
Charges Reproduction fees are set at levels recommended
by the Museums Association print fee from 30p ½pl
copy negatives 50p postage and packing 25p on all
orders
Notes Emphasis is placed on maximum documentation
of each photograph.

1043

Owner E A Alleyn-Gilmour
Location 29 Coopers Hill Marden Ash Ongar Essex
CM5 9EE
Title Historic Views of Chipping Ongar
Dates c1910 -
Subjects ESSEX - Chipping Ongar - all aspects street
scenes George V Jubilee
Numbers sl 80 2"x2"
Access Bona fide students
Copies available for loan
Charges Borrowers are asked to make a donation to Ongar
Council of Christian Service

1044

Owner London Borough of Redbridge
Woodford Photographic Society
Location Borough Library High Road Woodford
London E18
Title Woodford in the time of Sir Winston Churchill
W F L Wastell Collection
Custodian Borough Librarian
R L Fowkes 17 Shenfield Road Woodford Green Essex
Dates 1900 (1901) -
History Woodford was Winston Churchill's constituency
for many years. W F L Wastell, well known
photographic journalist, past president of the RPS and
one time mayor of Woodford
Photographer W F L Wastell
Subjects ESSEX - Woodford - photographic survey
Numbers pr 567 ½pl
fi negs 400 2¼"x2¼" 35mm
Access General public bona fide students on request

Notes A photographic survey of the Parish of Woodford
conducted by the Woodford Photographic Society
between the years 1901 and 1965. Includes the Emler
Collection (1901), the Coronation Collection (1953),
the Fowkes Collection 1964-24th January 1965.

1045

Owner Essex County Council
Location Chelmsford District Library Civic Centre
Duke Street Chelmsford CM1 1JF Chelmsford
61733
Title Essex Collection
Custodian S M Jarvis
Dates 1870 (c1960) -
Photographer Francis Frith Frederick Spalding
Subjects ESSEX social sciences transport
archaeological sites wind and water mills
architecture seaside holidays biography and
portraits
Numbers pr c800 b&w 7"x5"
gl negs c200 b&w 2"x2"
L sl c200 7"x5"
sl c200 b&w col 35mm
Aids *Guide *card index *subject index
Access General public bona fide students
Copies available for sale
Charges Print fee at cost

1046

Owner Colchester Borough Council
Location The Castle Colchester Essex CO1 1TJ
0206 77475
Title Colchester and Essex Museum Collection
Custodian D Clarke
Dates c1875 -
Photographer E A Girling Ernest Mason Harrington Lazell
Oscar Way
Subjects ESSEX Colchester - architecture biography and
portraits painting numismatics transport
archaeology museum exhibits
Numbers pr c2000
fi negs c500 b&w 35mm
gl negs c3000 ¼pl ½pl 1-pl double pl
L sl c1000
Aids *Subject index partial card index
Access General public bona fide students by appointment
Copies available for sale for loan in special cases only
Charges Reproduction fee on application

1047

Owner Essex County Council County Hall Chelmsford
Location Colchester Public Library Shewell Road
Colchester Essex 0206 70378
Title Colchester and Essex Local Collection
Custodian Borough Librarian
Dates 1870 -
Photographer William Gill Ernest Mason
Subjects ESSEX Colchester - customs architecture
biography and portraits pageants
Numbers pr c1300 b&w various
gl pos 5 various
mic 1100 b&w
Aids *Card index *subject index
Access General public bona fide students on request after
completion of application form

1048

Owner Essex County Council
Location Essex Record Office County Hall Chelmsford
Essex CM1 1LX Chelmsford 67222
Dates c1895 (1938) -
Photographer T Hammond H F Hayllar F Spalding
Subjects ESSEX - all aspects
Numbers pr c5000
Aids Published guide
Access General public bona fide students

Key () = dates when collections were begun or terminated
C = Century c = approximately pr = print fi = film
gl = glass neg = negative sl = slide L sl = lantern slide
tr = transparency mic = microform col = colour

b&w = black and white ¼, ½, 1-pl = quarter, half and whole
plate * = single copy, no public access ** = single copy,
access by appointment

Copies available for sale
Charges Microfilm charges on application prints from
microfilm from 30p document paper and from 37p
bromide paper xerox prints single copy 8p inc VAT
transparencies 35mm monochrome from 9p and 35mm
colour (ektachrome from 18p) VAT will be charged
extra except in the case of a single xerox print postage
and packing charged extra prepayment is normally
required before despatch of order

1049
Owner Essex County Council
Location Thurrock Central Library Orsett Road Grays
Essex RM17 5DX 0375 76827
Title Local History Illustrations Collection
Custodian D Bishop
Dates 1850 (1954) -
Subjects ESSEX - Thurrock - buildings
Numbers pr 1750 b&w various
fi negs 100 b&w various
gl negs 7 b&w various
L sl 322 col 2"x2"
Aids *Card index *subject index
Access General public bona fide students
Copies available for loan

1050
Owner Maldon Museum Association
Location 71 High Street Maldon Essex
Custodian Catherine Backus Evelyn House Market Hill
Maldon Essex 0621 2493
Dates 1912 -
Subjects ESSEX Maldon - buildings street scenes
Numbers pr 200 various
Aids Card index
Access Interested persons on application
Copies could be available for sale for loan under
adequate security and return conditions

1051
Owner Ongar Civic Trust
Location c/o 2 Landview Gardens Ongar Essex
Custodian Michael Leach
Dates 1870 (1971) -
Subjects ESSEX Ongar - photographic survey record
of all buildings demolished or altered since 1971
Numbers fi negs 120
Access General public bona fide students
Copies available on request
Charges Print fee commercial rates

1052
Owner Saffron Walden Museum Society
Location Saffron Walden Museum Saffron Walden Essex
0799 22494
Custodian Sheila M Jordain
Subjects ESSEX ARCHITECTURE - local and historical
buildings
Numbers gl negs c30-50 b&w various
L sl c500 b&w col 4"x4"
Aids General accession register
Access Bona fide students
Copies available by arrangement
Charges Print fee reproduction fee by arrangement

1053
Owner Southend on Sea Borough
Location Prittlewell Priory Museum Southend Essex
0702 42878
Title Southend Museums Collection
Custodian L Helliwell
Dates c1890 (c1900) -
Photographer Alimonda Hunting Air Service
St Joseph (Air Photographs)
Subjects ESSEX Southend occupations and services
the forces associations and societies transport
archaeology zoology civil and building construction
sculpture and carving architecture painting
numismatics recreations biography and portraits
aerial photography

Numbers pr c100
gl pos c5
sl c500
Aids *Card index
Access Bona fide students
Copies available for sale for loan credit line required

1054
Owner London Borough of Waltham Forest
Location Leyton Library High Road London E10 5QH
Title Leyton and Essex Collection
Custodian M L Savell
Dates c1880 (1892) -
Subjects ESSEX Leyton - churches occupations and
services education transport architecture shields
of arms biography and portraits
Numbers pr c17000 b&w various
fi negs 2327 b&w various
L sl c1800 b&w 2"x2" 3"x3"
Aids *Card index
Access No open access when necessary for special
purposes access under supervision allowed
Copies available for loan only in special circumstances
Charges Print fee at cost no reproduction fee -
complimentary copy of publication required

1055
Owner Peter D Thomas
Location 1 Topsham Road Exeter Devon
Exeter 58678
Title Isca Collection
Dates 1870 (1966) -
Photographer Henry Wykes
Subjects EXETER and district history of photography
Numbers pr gl negs L sl 40000 ½pl 1-pl
Access General public bona fide students press tv
media publishers
Copies available
Charges Fees on application
Notes Mr Thomas lectures on photography.

1056
Owner Eynsford Village Society
Location Whitestacks Cottage Crockenhill Lane Eynsford
Kent
Title Eynsford through the Ages
Custodian R F J Peck
Dates 1890 -
Subjects EYNSFORD - old photographs through the ages
Numbers fi neg 150
L sl 100
Copies available by special arrangement
Charges Reproduction fee by arrangement

1057
Owner Albert R Butler
Location 7 Hyde Cottages Brook Close Winchcombe
Gloucestershire
Dates 1890 (1968) -
Subjects GLOUCESTERSHIRE Winchcombe
Sudeley Castle
Numbers pr c500 various
Aids Subject index

1058
Owner Costwold District Council
Location Corinium Museum Park Street Cirencester
Gloucester Cirencester 5611
Title Corinium Museum Collection
Custodian D J Viner
Dates c1900 (c1930) -
Subjects GLOUCESTERSHIRE Cirencester social
sciences archaeology arts and crafts farm
buildings architecture coins museum objects
Thames and Severn canal
Numbers pr c150 b&w various
fi negs c400
gl negs c50 b&w
sl 2500 col 35mm
Aids *Card index *subject index
Access Bona fide students

Copies available for sale for loan
Charges Reproduction fee
Notes In addition the Museum has a collection of slides
and black and white prints of excavations in the town.
Reference to this collection should be made to the
Director of Excavations c/o Corinium Museum.

1059

Owner Gloucestershire County Council
Location Gloucester City Libraries Brunswick Road
Gloucester GL1 1HT 0452 20020/20684
Title Gloucestershire Collection Illustrations Collection
Custodian W Woodman
Dates 19thC (1900) -
Photographer Russell Adams Sydney Pitcher
Subjects GLOUCESTERSHIRE religion Christian and
other institutions social sciences banks police and
fire service parks and cemeteries hospitals
prisons associations and societies education
schools transport - rail road inland waterways
bicycles motor-cycles cars trams stations
docks and harbours customs and folklore
archaeology architecture recreations
biography and portraits aerial photography events
Numbers pr c2500
Aids *Catalogue *subject index
Access General public bona fide students
Copies available on request
Charges Print fee
Notes Collection includes 35000 photographs 1959
onwards from the local newspapers.

1060

Owner Gloucestershire County Council
Location Gloucestershire Record Office Shire Hall
Westgate Street Gloucester GL1 2TG 0452 21444
Ext 229
Title Gloucestershire Photographic Survey
Custodian Brian S Smith
Dates c1840 (c1937) -
Photographer Abdela and Mitchell H H Albina
Francis Frith Hunt and Winterbotham Norman Jewson
W H Fox Talbot Henry Taunt Peter Turner
Subjects GLOUCESTERSHIRE social sciences
education transport customs and folklore
archaeological sites water mills bridges
mining operations farm buildings and lands home
architecture base metal work antiques pageants
portraits geography cloth making sculpture
local crafts
Numbers pr c2500 b&w various
fi negs c1000 ½pl 1pl
gl negs c500 b&w 1pl
gl pos c200 b&w
sl 105 b&w col 35mm
mic c400 b&w 35mm
Aids Duplicated subject and placename index classified
index
Access General public bona fide students
Copies available for sale
Charges Print fee on application microfilms 35mm
£12 per reel

1061

Owner Tewkesbury Borough Council
Location Tewkesbury Museum Barton Street Tewkesbury
Title Tewkesbury Museum Photographic File
Custodian A Hannan
Dates Late 19thC (1964) -
Subjects GLOUCESTERSHIRE Tewkesbury and district
town life local government the forces transport
stations customs and folklore water mills
bridges architecture events
Numbers pr c300 b&w
Aids *Card index *subject index
Access General public bona fide students on request

Copies available for sale subject to copyright
Charges Print fee from 10p minimum charge £1.00 per
order including postage

1062

Owner David Verey Barnsley House Cirencester
GL7 5EE
Location Arlington Mill Museum Bibury Gloucestershire
028 574 281
Custodian David Verey
Dates 1897 - 1903
Subjects GLOUCESTERSHIRE Bibury and Barnsley
villages local photographs
Numbers pr c15
gl negs c100
Access General public
Charges To enter Museum

1063

Owner Cambridge University Board of Extra-Mural
Studies Stuart House Mill Lane Cambridge
Location Hampshire Record Office 20 Southgate Street
Winchester Hampshire SO23 9EF Winchester 63153
Title Hampshire Slide Collection
Custodian County Archivist
Dates 1910 - 1912
Photographer J H Fisher
Subjects HAMPSHIRE - views parish churches buildings
ancient monuments
Numbers L sl 957 b&w
Aids Catalogue place index
Access General public bona fide students picture
researchers press tv media by arrangement
9.15 am - 4.30 pm

1064

Owner Mrs D K Coldicott
Location Hydegate Long Sutton Basingstoke Hampshire
Long Sutton 320
Title Old Long Sutton Photographs
Dates c1865 (1969) -
Photographer F H Low
Subjects HAMPSHIRE - Long Sutton - village life and
country life
Numbers pr c90 b&w col
Aids Index of negatives
Access General public bona fide students press tv
media by arrangement only
Notes This collection consists of copy prints made whilst
the originals were on loan.

1065

Owner Fawley Local History Society
Location Ashlett Meade Stonehills Fawley Southampton
Hampshire SO4 1DU 0703 891353
Custodian Mrs I C Murley
Dates 1890 (c1965) -
History The Local History Society is a section of the
Fawley and District Community Association and the
collection began as a result of its formation and
lecture on local history to Association members
Photographer E W Mudge
Subjects HAMPSHIRE Fawley - air force transport
associations and societies customs and folklore
farm buildings portraits local events schools
industrial buildings from 1923
Numbers pr c800 b&w 63 col various
fi negs 250 b&w 63 col various
gl negs c50 b&w various
sl c50 b&w c200 col 35mm
fi b&w col 16mm 8mm
Aids *Catalogue in preparation
Access Bona fide students
Copies available for sale to order
Charges Print fee commercial rates

Key () = dates when collections were begun or terminated
C = Century c = approximately pr = print fi = film
gl = glass neg = negative sl = slide L sl = lantern slide
tr = transparency mic = microform col = colour

b&w = black and white ¼,½,1-pl = quarter, half and whole
plate * = single copy, no public access ** = single copy,
access by appointment

1066
Owner Hampshire County Council
Location Aldershot Library 103/113 High Street
Aldershot Hampshire Aldershot 22456
Title Local Illustrations Collection
Custodian F W Holling
Dates (c1963) -
Subjects HAMPSHIRE Aldershot social sciences
the forces historic and newsworthy events
Numbers pr c750 b&w various
Access General public bona fide students
Copies Credit line required

1067
Owner Hampshire County Council County Museum
Service
Location Chilcomb House Chilcomb Lane Bar End
Winchester Hampshire Winchester 66242
Custodian Margaret Macfarlane
Dates c1860 (1929) -
Photographer Terry Hunt Henry Taunt
Subjects HAMPSHIRE social sciences traditional
craftsmen transport customs and folklore
archaeology botany - plants agriculture and food
production geography
Numbers pr 6800 b&w $\frac{1}{2}$pl
fi negs c200 b&w
gl negs 1500 $\frac{1}{4}$pl $\frac{1}{2}$pl
L sl c250 b&w
sl 1700 col 35mm 40mm
Aids *Catalogue *card index *subject index
Access Bona fide students by appointment Monday to
Friday 9 am - 1 pm 2 pm - 5.30 pm
Copies available for sale
Charges Print fee transparency fee handling fee
reproduction fee postage and packing

1068
Owner Hampshire County Council
Location Record Office 20 Southgate Street Winchester
Hampshire SO23 8PR Winchester 63153
Custodian County Archivist
Dates c1900 - 1912
Photographer J H Fisher
Subjects HAMPSHIRE all aspects
Numbers pr 500 b&w
L sl 900 b&w
Aids Subject index
Access General public bona fide students picture
researchers press tv media by arrangement
9.15 am - 4.30 pm
Copies Copy prints can be supplied
Charges Reproduction fee print fee

1069
Owner Hampshire County Council
Title Frith Collection
Dates Early 20thC
Photographer Francis Frith
Subjects HAMPSHIRE - views
Numbers pr 503 b&w
Aids List of parishes place index
Notes Location, Custodian, Access, Copies and Charges
as for No. 1068 above.

1070
Owner Hampshire County Council
Title Hampshire Photographs
Dates c1890 - c1930
Subjects HAMPSHIRE - views
Numbers pr 415 b&w
Aids Catalogue place index
Notes Location, Custodian, Access, Copies and Charges as
for No. 1068 above.

1071
Owner E E Moss
Location 12 Fairclose Whitchurch Hampshire RG28 7AN
Dates c1890 -

Subjects HAMPSHIRE - Whitchurch - streets houses
fire brigades football teams sport
Numbers substantial number
pr
tr

1072
Owner Edward Roe
Location Harewarren Farm House Dogmersfield
Basingstoke Hampshire RG27 8TG 0252 850387
Dates 1870 (1958) -
Subjects HAMPSHIRE Fleet Crookham events
personalities
Numbers pr 500 $\frac{1}{2}$pl contained in albums
Access Bona fide students by appointment only
Copies available on request
Charges Print fee commercial rates

1073
Owner Roy Romsey
Location 70 The Avenue Southampton Hampshire
0703 22566
Dates 1880 (c1970) -
Subjects HAMPSHIRE Southampton - shipping buildings
Numbers pr c100 b&w 10"x8"
Access General public
Copies available for sale

1074
Owner Hampshire County Council
Location Central Library Civic Centre Southampton
SO9 4XP 0703 23855
Custodian H A Richards
Dates Mid 19thC (1942) -
Photographer O G S Crawford Max Mills
Subjects HAMPSHIRE Southampton archaeology
architecture aerial photography
Numbers pr c1500 b&w various
gl negs 254
Aids *Subject index
Access General public
Notes Includes a collection of the archaeologist, O G S
Crawford.

1075
Owner Southampton City Council
Location Civic Record Office Civic Centre Southampton
Hampshire 0703 23855 Ext 251
Custodian Miss S D Thompson
Dates c1880 (c1956) -
Subjects HAMPSHIRE Southampton local history
social sciences transport architecture geography
Numbers pr substantial number b&w various
gl negs 650 b&w
L sl 117 b&w $3\frac{1}{4}$"x$3\frac{1}{4}$"
sl c350 b&w col 35mm
Aids *Catalogue
Access General public
Copies available for sale by special arrangement
Charges Print fee

1076
Owner F Clifford Stallard
Location 28 Lower Road Bedhampton Havant Hampshire
070 12 3118
Dates Late 19thC (1930) -
Photographer W Scorer
Subjects HAMPSHIRE - Havant - social sciences
transport public festivals farm buildings and
machines architecture parchment pageants
football
Numbers pr 180 b&w various
Notes The collection includes many more than the
mounted photographs enumerated above and is
constantly being added to. It consists of old
photographs and copies. Photographs from this
collection have been published in 'Havant and
Bedhampton Past and Present'.

1077
Owner Winchester City Council Guildhall Winchester
 Hampshire 0962 68166
Location Hampshire Record Office 20 Southgate Street
 Winchester Hampshire 0962 63153
Title Winchester City Archives
Custodian A P Whitaker
Dates Late 1800's (1951) -
Subjects HAMPSHIRE Winchester - police schools
 roads ceremonies mechanical engineering
 architecture bowls portraits historic and
 newsworthy events - military
Numbers pr c50
Access General public bona fide students
Copies Some available for sale for publication
 subject to Town Clerk's sanction
Charges On application

1078
Owner Winchester City Council
Location Winchester City Museum The Square
 Winchester Hampshire
Dates 1860 (c1860) -
Subjects HAMPSHIRE Winchester social sciences
 occupations and services army schools transport
 customs and folklore archaeology water mills
 farm buildings beekeeping architecture pottery
 painting biography and portraits historic and
 newsworthy events civil and building construction
Numbers pr c5000 b&w various
 fi negs c2000 b&w various
 gl negs c1000 b&w various
 L sl 5000 b&w 3¼"x3¼"
 sl 700 col 35mm
 fi 25 16mm
 mic 20
 radiographs c50
Aids *Card index *subjects index
Access Bona fide students

1079
Owner Douglas R P Ferriday
Location 104 Stockton Road Hartlepool Cleveland
 TS25 1RP 0429 69133
Dates 1895 -
Photographer Douglas R P Ferriday
Subjects HARTLEPOOL - buildings people industries
 shipping transport shops Middlesbrough
 Stockton villages around Hartlepool
Numbers pr 300 b&w 8"x6"
 fi neg c1500 b&w 2¼"x2¼"
 gl neg c400 8"x6"
Aids Catalogue card index
Copies available for sale for loan
Charges Print fee from 35p
Notes There is a copy of the entire collection in
 Hartlepool Library.

1080
Owner David Gorsky
Location 4 The Grange Hartley Wintney Hampshire
Title Old Hartley Wintney
Dates c1890 -
Subjects HARTLEY WINTNEY buildings village life
Numbers pr 80 b&w 5½"x3½"
 sl c60 col 35mm
Access Bona fide students
Copies available for sale for loan
Charges Print fee commercial rates

1081
Owner Mrs Winifred Cooper
Location Foresters 5 Church Street Harwich Essex
 CO12 3DR Harwich 2872
Dates 1854
Photographer Mrs Winifred Cooper

Subjects HARWICH - especially the Redoubt
Numbers pr 1pl
 fi negs 2¼"x2¼"
 postcards
Access By arrangement
Charges Print fee reproduction fee by arrangement
Notes Winifred Cooper has built up a collection of copies
 of old prints and postcards relating to Harwich and
 has photographed nearly all the corners of the town.

1082
Owner Basil Butcher
Location 177 Ledbury Road Hereford HR1 1QD
Dates c1939 -
Subjects HEREFORD - buildings at demolition
Numbers pr c20 various
 gl negs c20 b&w ¼pl
 L sl c20 b&w
 sl c700 col 35mm
Access General public bona fide students publishers
 press tv media by arrangement

1083
Owner Hereford City Council
Location Hereford Museum Broad Street Hereford
 HR4 9AU 0432 2456
Custodian N R Dove
Dates 1900 (c1940) - 1960
Subjects HEREFORD army transport chronology
 archaeology nature: biology agriculture and
 food production domestic home clothes
 arts and ceramics
Numbers fi negs 500 b&w 35mm
Access Bona fide students
Copies available for sale
Charges Reproduction fee at cost

1084
Owner Hereford and Worcester County Council
Location Hereford Library Reference Department
 Broad Street Hereford HR4 9AU 0432 2456
Title Includes the Watkins Collection Morgan Collection
 and the Wilson Collection
Custodian B J Whitehouse
Dates c1870 -
History Alfred Watkins was a pioneer photographer,
 inventor of the exposure meter and author of "The Old
 Straight Track"
Photographer F C Morgan Alfred Watkins
Subjects HEREFORD social sciences occupations and
 services transport customs and folklore
 archaeology agriculture and food production
 domestic home clothes ceramics sculpture and
 carving architecture painting numismatics
 toys recreations biography and portraits
 geography events
Numbers pr c1000 b&w various
 fi negs c500 b&w various
 gl negs c9000 b&w various
 L sl c1000 b&w 2"x2"
 mic c300 reels
Aids *Catalogue *subject index
Access General public
Copies available for sale
Charges Print fee

1085
Owner Hereford and Worcester County Council
Location Record Office St Helens Fish Street
 Worcester WR1 2HN 0905 23400
Title County of Hereford and Worcester Photographic
 Survey
Custodian County Archivist
Dates c1880 (c1890) -
Subjects HEREFORD AND WORCESTER all aspects

Key () = dates when collections were begun or terminated
C = Century c = approximately pr = print fi = film
gl = glass neg = negative sl = slide L sl = lantern slide
tr = transparency mic = microform col = colour

b&w = black and white ¼,½,1-pl = quarter, half and whole
plate * = single copy, no public access ** = single copy,
access by appointment

Numbers pr c52000 b&w ½pl 1pl
 fi negs c1000
 gl negs c150
Access General public bona fide students
Copies available subject to copyright
Notes Photographs mainly connected with the old county of Worcestershire.

1086

Owner Hereford and Worcester County Council
 Divisional Headquarters Foregate Street Worcester
 0905 22154/24853
Location Evesham Public Library Market Place
 Evesham Hereford and Worcester WR11 4RW
 0386 2291
Title Social History Collection Arthur Ward Collection
Custodian The Librarian
Dates c1905 -
Photographer Arthur Ward
Subjects HEREFORD AND WORCESTER - Evesham - buildings and events
Numbers pr c90 b&w
 gl negs 199
Aids Index for Arthur Ward Collection
Access General public

1087

Owner Hereford and Worcester County Council
Location Kidderminster Library Market Street
 Kidderminster Wyre Forest Hereford and Worcester
 0562 62832
Title Kidderminster Local Photographic Survey
Custodian Librarian
Dates Mid 19thC (1948) -
Subjects HEREFORD AND WORCESTER Kidderminster transport architecture biography and portraits geography events
Numbers pr 2750 b&w 8½"x6½"
 fi negs 120 b&w
 sl 300 b&w col 2"x2"
Access General public bona fide students
Copies available for sale

1088

Owner Herbert Powell
Location 1 King Street Hereford Hereford and Worcester
Dates 1956 -
Subjects HEREFORD AND WORCESTER Hereford - houses colleges churches Hereford Cathedral
Numbers tr c200 col 2"x2"

1089

Owner Hereford and Worcester County Council
Location Worcester City Library Foregate Street
 Worcester WR1 1DT
Title Worcester Local Studies Library Photographic Collection
Custodian John Stafford
Dates 1890 (1900) -
Photographer M Dowty W W Dowty A J Woodley
Subjects HEREFORD AND WORCESTER Worcester local history shops trams
Numbers pr c5000 b&w
 gl negs c5000 b&w
 sl c2000 b&w col
Access General Public
Copies available subject to copyright
Charges Print fee commercial rates

1090

Owner Wyre Forest District Council
Location Museum and Art Gallery Market Street
 Kidderminster Hereford and Worcester
Title The Kidderminster Museum Photographic Collection
Dates 1870 -
Subjects HEREFORD AND WORCESTER Kidderminster religion social sciences army navy transport astronomy botany medicine farm buildings architecture painting seaside holidays climbing biography and portraits geography

Numbers gl negs c2500 b&w various
 L sl c2400 b&w 3¼"x3¼"
Access General public under supervision
Copies available for sale

1091

Owner Herongate and Ingrave Village Preservation Society's Museum of Local History
Location 5 Heron Chase Herongate Brentwood Essex
Custodian C C Stephens Friars 192 Brentwood Road
 Herongate 027 787 353
Subjects HERONGATE - local scenes and people
Numbers c200
Aids *Card index indexed alphabetically and geographically
Access General public bona fide students picture researchers publishers press tv media at any time by prior appointment

1092

Owner Ashwell Village Museum Trustees
Location Ashwell Village Museum Swan Street
 Ashwell Baldock Hertfordshire
Custodian Albert W Sheldrick
Dates 1876 (1927) - 1930 -
Subjects HERTFORDSHIRE Ashwell religion army navy air force schools windmills local architecture musical instruments biography and portraits
Numbers pr c100 b&w
Access Bona fide students 3 pm - 5 pm or at any time by arrangement with Mr Sheldrick adequate notice must be given

1093

Owner Bishop's Stortford Civic Society
Location 93 Parsonage Lane Bishop's Stortford
 East Hertfordshire
Custodian Mrs Anson
Dates 1967 -
Subjects HERTFORDSHIRE Bishop's Stortford old buildings demolished buildings before town development
Access Bona fide students by arrangement

1094

Owner Stuart Fisher
Location 44 Danescroft Letchworth Hertfordshire
 SG6 4RW 046 26 72939
Title Mr A Clutterbuck's Letchworth
Custodian Stuart Fisher and Eric Adams 18 Eastern Way
 Letchworth Hertfordshire 046 26 3194
Dates 1906 -
Photographer Arthur Clutterbuck
Subjects HERTFORDSHIRE Letchworth-street scenes
 Sir Ebenezer Howard O B E
Numbers gl negs ½pl
Aids Subject index full list of plates available
Access Shows can be arranged by projection
Notes Includes a photographic account of the institution and development of the first Garden City.

1095

Owner R G Grace
Location White House 99 Western Road Tring
 Hertfordshire HP23 4BN
Title Old Tring
Dates c1860 (1890) -
History The collection was started in 1890 by Mr Grace's father
Photographer R G Grace
Subjects HERTFORDSHIRE - Tring - buildings streets people neighbouring villages agriculture Rothschild Estates
Numbers pr c300 b&w
 L sl c1000 3¼"x3¼"
Notes The lantern slides form part of a lecture on the locality.

1096
Owner Hertfordshire County Council
Location Public Library "Lowewood" High Street
Hoddesdon Hertfordshire Hoddesdon 62296
Title Hayllar Collection
Custodian The Librarian
Dates 1910 (1911) - 1935
Subjects HERTFORDSHIRE village scenes
Numbers pr c200 b&w 5"x4" contained in 2 albums
Access General public bona fide students

1097
Owner Hertfordshire County Council
Location Central Library Victoria Street St Albans
Hertfordshire St Albans 60000
Title St Albans Visual History
Custodian E P Keyte
Dates c1900 -
Photographer E S Kent
Subjects HERTFORDSHIRE St Albans local history
Numbers L sl c350 b&w
sl c1000 b&w col
Aids *Catalogue
Access General public
Copies available for loan
Charges Reproduction fee commercial rates

1098
Owner Hertfordshire County Council
Location Hertford Museum 18 Bull Plain Hertford
East Hertfordshire SG14 1DT Hertford 2686
Custodian A G Davies
Dates c1850 (Late 19thC) -
Subjects HERTFORDSHIRE social sciences occupations
and services the forces transport ceremonies
clocks archaeology water mills home clothes
architecture painting numismatics biography and
portraits historic and newsworthy events
Numbers pr c100 various
Access General public bona fide students
Copies available for sale
Charges Print fee from 40p

1099
Owner Hertfordshire County Council
Location Record Office County Hall Hertford
Hertfordshire SG13 8DE 0992 4242
Title County Views Collection including F H Stingemore
Collection
Custodian Peter Walne
Dates (1950) -
Photographer F H Stingemore
Subjects HERTFORDSHIRE local history buildings
flora topography
Numbers pr c10000 b&w various
gl negs c10500 b&w 6¼"x4¾" 4½"x3½"
L sl
mic
Aids *Card index *partial subject index
Access General Public bona fide students
Copies available for sale
Charges Print fee from 70 p if there is no existing
negative a charge of £2 is made for each new
negative. These charges are subject to alteration
without notice and V A T at 8% is extra

1100
Owner North Hertfordshire District Council Gernon Road
Letchworth
Location Hitchin Museum & Art Gallery Paynes Park
Hitchin Hertfordshire 0462 4476
Custodian A L Fleck
Dates 1854 (1939) -
Photographer T W Latchmore H G Moulden

Subjects HERTFORDSHIRE Bedfordshire - social
sciences customs and folklore architecture
biography and portraits
Numbers pr 3500 b&w various
L sl 300 250 b&w 50 col 2¼"x2¼"
sl 500 200 b&w 300 col 2"x2"
Access General public by appointment bona fide students
Copies available for sale
Charges Print fee

1101
Owner Brian D Parkins
Location 10 Claymores Stevenage Hertfordshire
Dates 1870 (1960) -
Photographer T Latchmore
Subjects HERTFORDSHIRE - Hitchin and district
Stevenage - street scenes
Numbers pr 60 b&w 10"x8"
fi negs 70 b&w
gl negs 10 b&w
Copies available for sale

1102
Owner Sawbridgeworth Preservation Society
Location Cherry Tree Whitehall Lane Bishops Stortford
Hertfordshire
Custodian A R Odell
Dates 1964 -
Photographer A R Odell
Subjects HERTFORDSHIRE - Sawbridgeworth
conservation area
Numbers pr 20 col
fi negs 20
sl 120 35mm
Aids Slides annotated

1103
Owner Watford and District Industrial History Society
Location c/o 65a Chalk Hill Watford Hertfordshire
0923 43441
Custodian Mrs D Petty
Dates (c1971) -
Subjects HERTFORDSHIRE Watford - housing shops
Grand Union Canal - Watford Stretch - locks bridges
Numbers pr c50
Access General public bona fide students by appointment
only
Copies available for sale for loan for publication
Charges On application

1104
Owner Alec Miller Watts
Location 53 Baker Street Potters Bar Hertfordshire
Title Around Potters Bar around 1900
Dates 1869 (1970) - 1972
Subjects HERTFORDSHIRE Potters Bar country life
and customs
Numbers sl 100 b&w 35mm
Aids *Subject index
Access General public bona fide students picture
researchers press tv media
Charges Nominal for inspection reproduction fee by
arrangement
Notes All old photographs have been restored to an
acceptable condition.

1105
Owner C D Yule
Location Ash Tree Cottage Mill Lane Broxbourne
Hertfordshire EN10 7AZ Hoddesdon 63412
Title Hoddesdon Collection
Dates 1961 -
Photographer C D Yule
Subjects HERTFORDSHIRE Hoddesdon buildings
roads social sciences changes in town and
countryside

Key () = dates when collections were begun or terminated
C = Century c = approximately pr = print fi = film
gl = glass neg = negative sl = slide L sl = lantern slide
tr = transparency mic = microform col = colour

b&w = black and white ¼,½,1-pl = quarter,half and whole
plate * = single copy,no public access ** = single copy,
access by appointment

Numbers sl 400 col 35mm
Aids Slides are numbered and classified
Access General public bona fide students by appointment
Notes Collection includes transparency copies of 19th
centrury photographs and earlier prints.

1106
Owner Dr J B Ball
Location 58 Brigg Road Barton upon Humber
South Humberside 0652 32354
Dates 1860 (1973) -
Photographer A Brummitt A Canty B Parker
Subjects HUMBERSIDE - Barton upon Humber - street
scenes men at work and leisure period costumes
schools plays statute hirings political meetings
church notices and foundation stone laying
engravings return of men from South African War
1901
Numbers pr c30
sl c700 35mm
Aids Card index
Access Bona fide students by appointment only

1107
Owner Humberside County Council
Location County Record Office County Hall Beverley
Humberside 0482 887131 Ext 489
Custodian K D Holt
Dates 1878 - 1930
Subjects HUMBERSIDE old East Riding of Yorkshire
Numbers pr 81 b&w
Aids Xerox list of prints
Access Bona fide students picture researchers
publishers press tv media Monday to Thursday
9 am - 5 pm Friday 9 am - 4 pm
Copies available subject to permission of County
Archivist and/or depositor
Charges Print fee reproduction fee

1108
Owner East Yorkshire Local History Society Purey Cust
Chambers York YO1 2EJ 0904 24778
Location Humberside County Record Office County Hall
Beverley North Humberside 0482 887131
Custodian K D Holt
Dates c1880 (1970) -
Subjects HUMBERSIDE former East Riding of Yorkshire
buildings windmills seaside resorts trawlers
Hull fair portraits flood bands social sciences
haymakers schools almshouses churches
commandeering transport 1914 horse drawn
transport ploughing cricket Hunt Bishop Burton
Beverley Hessle Selby North and South Cave
Numbers pr 28 b&w various
fi negs 190 b&w 35mm
Aids Catalogue
Access General public bona fide students
Copies available for sale

1109
Owner Humberside County Council
Location Local Studies Library Hull Central Library
Albion Street Hull Humberside 0482 223344
Title Local Illustrations Collection
Custodian Director of Leisure Services
Dates c1900
Subjects HUMBERSIDE Hull and East Riding of
Yorkshire all aspects
Numbers pr 3000 b&w 16 x 12cm some larger
gl negs c100
Aids Card index
Access General public bona fide students
Copies Photocopying facilities available subject to
copyright publication requests considered separately
Charges Photocopies 5p per sheet

1110
Owner Kingston upon Hull City Council
Location City Record Office Guildhall Kingston upon
Hull Humberside Kingston upon Hull 223111
Custodian Geoffrey W Oxley

Dates c1880 -
Subjects HUMBERSIDE Kingston upon Hull occupations
and services the army transport geology
anthropology mechanical engineering civil and
building construction domestic home architecture
biography and portraits newsworthy events
war damage
Numbers pr c1555 b&w col various
Aids *Summary list
Access General public bona fide students

1111
Owner Humberside County Council
Location Central Library Town Hall Square Grimsby
Humberside DN31 1HG 0472 56012
Title Lincolnshire Collection
Custodian D Wattam
Dates c1850 (1901) -
Subjects HUMBERSIDE all aspects
Numbers pr c10000 b&w various
Access General public bona fide students
Copies available for sale on request
Charges Print fee

1112
Owner Richard F Smith
Location 'Chandura' 68 Ferriby Road Barton on Humber
Humberside DN18 5LH
Title A Photographic History of Barton on Humber and
District
Dates 1930 -
History The earlier negatives were for most part taken
for publication in the press but with the owner
retaining copyright, the more recent ones were
taken as a specific record
Photographer Richard F Smith
Subjects HUMBERSIDE Barton on Humber - photographic
survey
Numbers pr c200 b&w col various
Access General public bona fide students by appointment
Copies available for sale

1113
Owner Humberside County Council
Location Beverley Public Library Champney Road
Beverley North Humberside
Title Local Studies Collection
Custodian J Gettings
Dates c1860 (1906) -
Subjects NORTH HUMBERSIDE Beverley and area
topography local history
Numbers pr c380 b&w 24 col various
Access Bona fide students
Copies by arrangement only
Notes The collection includes c1000 topographical
postcards from c1900 - 1950.

1114
Owner Humberside County Council 0482 223344
Location Public Library Carlton Street Scunthorpe
South Humberside 0724 60161
Title Scunthorpe Area Photographic Collection
Custodian Director of Leisure Services
Dates 1890 (1965) -
Subjects SOUTH HUMBERSIDE LINCOLNSHIRE
SCUNTHORPE
Numbers pr 1750 b&w 5"x3½"
sl 1250 b&w
Aids Subject index
Access General public bona fide students
Copies available for sale for loan
Charges Print fee cost plus 10%

1115
Owner Manx Museum Trustees
Location Kingswood Grove Douglas Isle of Man
Title Manx Museum Library Collection
Custodian A Harrison
Dates Mid 19thC (1922) -
Subjects ISLE OF MAN - buildings transport portraits
topography

Numbers pr c2500 b&w col
 fi negs c1000 b&w
 gl negs c1000 b&w
 gl pos b&w
Aids *Card index
Access General public bona fide students picture
 researchers publishers
Copies available for sale by arrangement credit line
 required

1116

Owner Isle of Wight County Council
Location Isle of Wight County Library Parkhurst Road
 Newport Isle of Wight PO30 5TX
Title Isle of Wight County Library Local History Collection
Custodian L J Mitchell
Dates 1865 (c1906) -
Photographer Francis Frith Julia Margaret Cameron
Subjects ISLE OF WIGHT village life town life
 country life and customs lifeboats safety at sea
 wrecks locomotives rolling stock omnibuses
 railways stations docks and harbours hovercraft
 seaside holidays geography events
Numbers pr 850 b&w 50 col various
 fi negs c100 b&w 120 & 35mm
 gl negs 20 b&w 24"x16"
 gl pos 10 col 8"x6"
 L sl 10 b&w 50 col 2½"x2½"
 sl c50 col
Aids *Catalogue *card index *subject index
Access General public bona fide students daily 9 am -
 5 pm Saturday by appointment
Copies available for sale on request for loan only to
 approved people
Charges Print fee

1117

Owner Kent County Council
Location The Beaney Institute High Street Canterbury
 Kent CT1 2JF Canterbury 63608
Custodian R T Chadwick
Dates Late 19thC -
Subjects KENT Canterbury - history topography
 architecture
Numbers pr c1200 b&w 150 col various
Aids *Card index *subject index
Access General public bona fide students picture
 researchers press tv media 9.30 am - 5 pm

1118

Owner Canterbury City Council
Location Royal Museum Beaney Institute High Street
 Canterbury Kent
Title Local Photographic Collection
Dates Late 19thC -
Photographer Fisk-Moore
Subjects KENT Canterbury Herne Bay Bridge
 Whitstable villages
Numbers pr c600
Aids *Card index *subject index
Access Bona fide students during office hours
 preferably by prior arrangement
Copies not readily available but possible through local
 commercial photographers where copyright has expired
 and on permission from copyright holders
Charges Reproduction fee by arrangement depending on
 individual cases
Notes This contemporary on-going survey of Canterbury
 includes the 1939 survey of Canterbury and an
 Edwardian survey of Canterbury and district. Donations
 welcome or information on material in collections
 outside Kent.

1119

Owner Roy Cooper
Location Bove End Chartham Hatch Canterbury Kent

Title Chartham Conservation Survey
Dates 1972 -
Subjects KENT Chartham buildings townscape
 furniture
Numbers pr c500
 negs c500 3½"x5½"
Access General public
Copies available for sale for loan

1120

Owner Michael Court
Location The Oast House Mariners Westerham Kent
 Crockham Hill 342
Dates 1962 -
Subjects KENT Westerham Algarve Portugal Greece
Numbers tr c350 2¼"x2¼"
Aids Catalogue

1121

Owner Kent County Council
Location Dartford Divisional Central Library
 Central Park Dartford Kent DA1 1EU
Title Dartford Local History Collection (Photographic
 section)
Custodian C Crook
Dates 1860 (1900) -
Subjects KENT Dartford and district all aspects
Numbers pr c12000 b&w various
 fi negs c1000 b&w various
 gl negs c2000 b&w various
 L sl c400 b&w col 32mm
 sl c500 200 b&w 300 col 2"x2"
Aids *Card index *subject index
Access General public bona fide students
Copies available for sale for loan in approved
 circumstances
Charges Print fee copy negatives from 50p
 6"x8" prints from 45p 4"x6" prints from 35p
Notes This collection is purely a local collection for the
 purposes of local history.

1122

Owner Kent County Council
Location Central Library Grace Hill Folkestone Kent
Title Folkestone Library Collection
Dates c1880 -
Subjects KENT Shepway district Folkestone Hythe
 Romney Marsh
Numbers pr c8000 various
 fi negs c600 various
Access General public
Copies on request
Charges On request

1123

Owner Kent County Council
Location Archives Office County Hall Maidstone
 ME14 1XH Kent 0622 54321 Ext 320
Custodian Felix Hull
Dates c1850 (20thC) -
Subjects KENT the Forces aerial survey buildings
 and plans India Australia
Numbers pr c5000 b&w various
 fi negs c8000 b&w various
 mic 33 32mm
Aids Negs of the documents realting to Kent kept in the
 Archives Office catalogue
Access General public bona fide students
Copies available for sale
Charges Print fee

1124

Owner Kent County Council
Location Central Library High Street Gillingham Kent
 ME7 1BG Medway 51066
Title Gillingham Local History Photographic Collection

Key () = dates when collections were begun or terminated
C = Century c = approximately pr = print fi = film
gl = glass neg = negative sl = slide L sl = lantern slide
tr = transparency mic = microform col = colour

b&w = black and white ¼, ½, 1-pl = quarter, half and whole
plate * = single copy, no public access ** = single copy,
access by appointment

Custodian Divisional Librarian
Dates 1860 (c1955) -
Subjects KENT Gillingham the Medway towns
 local history
Numbers pr c1000 b&w various
 sl 25 col
 mic 15 reels
Access General public bona fide students
Notes Includes material relating to Major J T B
 McCudden the World War I fighter pilot who was born
 in Gillingham and also Louis Brennan the inventor
 who lived in Gillingham.

1125

Owner Kent County Council
Location Gravesend Central Library Windmill Street
 Gravesend Kent DA12 1AQ Gravesend 2758
Title Kent County Library Gravesend Division Local
 Collection
Custodian W T W Woods
Dates c1875 (c1906) -
Photographer Frederick Charles Gould
Subjects KENT Gravesend and surrounding area
 River Thames
Numbers pr c3000 b&w various
 fi negs c300 b&w various
 gl negs c200 b&w various
 sl c100 b&w 35mm
Access General public bona fide students
Copies Post cards available for sale for loan at the
 discretion of the librarian
Charges Post cards from 6p

1126

Owner Kent County Council
Location Springfield Maidstone Kent 0622 54371
Custodian Dean Harrison
Dates c1890 (1960) -
Subjects KENT topographical photographs
Numbers pr c1000 b&w
Access General public bona fide students

1127

Owner Queenborough Society
Location c/o Honorary Secretary 59 High Street
 Queenborough Kent
Title History of Queenborough
Custodian P W C Maxwell
Dates c1890 -
Subjects KENT - Queenborough - houses street scenes
Numbers pr c30
 tr c20 35mm
Aids Card index
Access General public bona fide students by prior
 arrangement
Copies available for sale for loan to bona fide
 individuals or societies only
Charges Print fee commercial rates loan fee by
 arrangement

1128

Owner Ray Warner Limited
Location 42 Townwall Street Dover Kent Dover 206451
Dates c1935 -
Photographer Ray Warner
Subjects KENT Dover local history trams
Numbers fi 30 16mm
Access On request to Ray Warner or Dover District
 Council
Copies Only 1 copy of each film available
Charges Postage both ways
Notes This collection is made with the help of the local
 district, films are for interest and local history only.

1129

Owner Kent County Council
Location Tenterden and District Local History Society
 Tenterden Trust
Custodian Mrs D I Jewell 11 Roethorne Gardens
 Tenterden Kent
Dates c1866 -

Subjects KENT - Tenterden - local scenes buildings
 windmills
Numbers pr substantial numbers

1130

Owner Maritime and Local History Museum Trustees
Location Maritime and Local History Museum 22 St
 George's Road Deal Kent
Custodian W H Honey 119 Sandown Road Deal Kent
 Deal 4869
Dates c1860 (1967) -
Subjects KENT Deal local history town life
 seafront beach boats lifeboats wrecks
Numbers pr c2000 b&w ½pl
 fi negs c2000 b&w 35mm
Access Bona fide students
Copies available for sale

1131

Owner Westerham Society
Location Ash Cottage Westerham Kent
Title Westerham Collection
Custodian Chairman of the Westerham Society
Dates 1971 - 1972
Subjects KENT Westerham buildings
Numbers pr c30 4½"x3½"
Access General Public bona fide students by appointment

1132

Owner M B Winch
Location Boughton Monchelsea Place Nr Maidstone
 Kent 0622 43120
Dates 1904 -
Subjects KENT Kent houses Boughton family life -
 all aspects
Numbers pr contained in albums
Access Bonf fide students by appointment only

1133

Owner Mr and Mrs P Moxon
Location St Albans 46 Blencathra Street Keswick Cumbria
Title Lakeland Slide Shows
Dates 1967 -
Photographer Norah Moxon Peter Moxon
Subjects LAKE DISTRICT NORTH WEST HIGHLANDS
 OF SCOTLAND air force - mountain rescue
 vehicles geology meteorology archaeology
 seascapes botany animals water mills
 bridges farm buildings and machines home
 interiors stone carving architecture antiques
 Morris dancing outdoor life geography historic
 and newsworthy events glaciology environmental
 studies
Numbers gl negs 20 b&w ½pl
 tr 7000 col 35mm
 tr 30 col 5"x4"
Aids Subject index scripts of slide shows
Access Picture researchers press tv media
 10 am - 5pm
Copies available for publication
Charges Reproduction fee print/transparency fee
 handling fee holding fee service charge search fee

1134

Owner Lake District Museum Trust
Location Museum of Lakeland Life and Industry
 Abbot Hall Kendal Cumbria 0539 22464
Title Hardman Collection
Custodian Miss M E Burkett
Dates c1880 (1965) -
Photographer Joseph Hardman Herbert & Sons
 Lovell Mason Walmsley Bros
Subjects LAKE DISTRICT all aspects
Numbers gl negs 6000 b&w ¼pl ½pl 1pl
 gl 400 b&w 3¼"x3¼"
 L sl 400 col 3¼"x3¼"
Access General public picture researchers bona fide
 students press tv media by prior appointment only
 9.30 am - 5.30 pm
Copies available for sale for display for loan for
 publication

1135
Owner Blackburn Borough Council
Location Blackburn Museum and Art Gallery
 Library Street Blackburn Blackburn 59511
Title Photographic Collection of Blackburn Museum
Custodian The Curator
Dates c1850 (c1872) -
Subjects LANCASHIRE Blackburn social sciences
 occupations and services clothes
Numbers pr c300 b&w various
Access Bona fide students
Copies available for publication on request subject to
 approval

1136
Owner Lancashire Coutny Council
Location Central Reference Library Town Hall Street
 Blackburn Lancashire BB2 1AH 0254 661221
Title Blackburn Local Studies Photographic Collection
Custodian J B Darbyshire
Dates 1850 -
Subjects LANCASHIRE Blackburn local history
Numbers pr c3500 b&w 10"x8"
 fi negs c500 b&w 120mm
 gl negs c500 b&w 5"x4"
Aids *Card index *subject index
Access General public bona fide students
Copies for sale
Charges Print fee from 20p
Notes The library has recently acquired the photographic
 archive of a local engineering firm and contains
 record photographs of various machines.

1137
Owner Lancashire County Council 0772 54868
Location Blackpool Central Library Queen Street
 Blackpool Lancashire FY1 1PX 0253 23977
Title Blackpool Public Library Local History Collection
Custodian The Librarian
Dates 1840 (1950) -
Subjects LANCASHIRE Blackpool local history
Numbers pr 1050 b&w
 gl negs 300 b&w
Aids *Card index
Access General public bona fide students

1138
Owner Lancashire County Council
Location Central Library Burnley Lancashire
 BB11 2BD 0282 37115
Title Local Collection
Custodian Richard Caul
Dates 1880 (1920) -
Subjects LANCASHIRE Burnley social sciences
 occupations and services education transport
 mining architecture textiles athletic and outdoor
 games biography and portraits events
Numbers pr 2500 b&w various
 gl negs 200
 L sl 4000 b&w 3¼"x3¼"
 sl 500 b&w
Aids *Card index partial catalogue
Access Bona fide students
Copies available for sale copy prints can be provided if
 they are required for non-commercial use
Charges Print fee from 25p

1139
Owner Burnley Borough Council
Location Towneley Hall Art Gallery & Museum Burnley
 Lancashire 0282 24213
Custodian Hubert R Rigg
Dates 1870 (1910) -
Subjects LANCASHIRE Burnley social sciences
 occupations and services army associations and
 societies education transport archaeology

 anthropology botany engineering building
 agriculture architecture painting antiques
 biography and portraits geography
Numbers pr c1500 b&w various
 gl negs 315 b&w 6"x4" 4½"x3½"
 gl pos 27 b&w 3½"x3½"
 sl 800 col ½pl 1pl
Aids *Card index *subject index
Access General public on request under supervision
 bona fide students
Copies available for sale for loan on request
Charges Print fee at cost

1140
Owner Chorley Borough Council
Location Amenities Department Town Hall Chorley
 Lancashire Chorley 5611 Ext 235
Custodian G Howarth
Dates 1922
Subjects LANCASHIRE Chorley
Numbers pr 37 various

1141
Owner The Feoffees Chetham's Hospital School and
 Library
Location Chetham's Library Long Millgate
 Manchester M3 1SB 061 834 7961
Title Phelps Collection of Slides
Custodian Anne Sharpe
Dates cLate 19thC - c1919
Photographer J J Phelps
Subjects LANCASHIRE Manchester - buildings
 transport roads history Chetham's Hospital
 School Salford Japanese lacquer work and metalwork
 misericords churches cathedrals portraits
 plates of books and manuscripts
Numbers L sl c2000 b&w 3"x3"
Aids Catalogue subject index
Access Bona fide students

1142
Owner Lancaster District Council
Location Lancaster Museum Old Town Hall Lancaster
 Lancashire 0524 64637
Title Lancaster Museum Collection
Custodian Mrs Edith Tyson
Dates (1923) -
Photographer Sam Thompson
Subjects LANCASTER transport local architecture
 biography and portraits events
Numbers pr c1000
 gl negs 500 b&w ¼pl
 L sl 250 b&w
Aids *Card index
Access Bona fide students
Copies available for sale
Charges Print fee at cost plus 10%

1143
Owner Lancaster and Morecambe College of Further
 Education
Location Torrisholme Road Lancaster LA1 2TY
 0524 66215
Custodian A S Taylor
Dates 1887 (c1964) -
Subjects LANCASHIRE Lancaster Morecambe
 local history
Numbers pr 50 b&w 5 col various
 sl 25 col
Aids *Guide
Access Bona fide students

1144
Owner Lancashire County Council
Location Central Library 143 Corporation Street
 Preston PR1 8RH 0772 54868

Key () = dates when collections were begun or terminated
C = Century c = approximately pr = print fi = film
gl = glass neg = negative sl = slide L sl = lantern slide
tr = transparency mic = microform col = colour

b&w = black and white ¼, ½, 1-pl = quarter, half and whole
plate * = single copy, no public access ** = single copy,
access by appointment

Title Local Studies Collection
Custodian Diana Winterbotham
Dates Late 19thC -
Subjects LANCASHIRE all aspects
Numbers pr various
 fi negs various
 gl negs various
 sl various
Access General public bona fide students by prior
 arrangement
Copies available for sale subject to copyright
 restrictions
Charges Print fee from 20p

1145
Owner Preston Society: Record and Survey Section
 Ellesmere Chambers Church Street and Lancashire
 County Council
Location Reference Library Harris Public Library
 Preston 0772 53191
Custodian James Brown
Dates Mid 19thC (1900) -
Photographer Francis Frith
Subjects LANCASHIRE Preston customs and folklore
 architecture public entertainments aerial
 photography events - Preston Guild Merchant
Numbers pr c1500 b&w various
 L sl c200 b&w 3¼"x3¼"
Aids *Subject index
Access General public
Copies available for sale on request by arrangement
 with the curator subject to copyright

1146
Owner Wilfred M Spencer
Location 130 Keighley Road Colne Lancashire
 028 24 4310
Dates c1860 (1957) -
Subjects LANCASHIRE - Colne and district - architecture
 local events
Numbers pr c1500 b&w
 fi negs c5000 b&w 2¼"x3¼" 35mm
 gl negs 100 ½pl 1pl
 L sl c500
 tr 1500 b&w 500 col 35mm
Access Bona fide students by personal contact and approval

1147
Owner Trustees for R C Purposes 114 Mount Street
 London W1Y 6AH
Location Stonyhurst College Lancashire
Title The Fenton Photographs
Custodian T P Dunphy
Dates 1858 - 1859
History The collection was originally gifted to the
 college by Roger Fenton. His family owned much of the
 surrounding lands in the mid 19thC
Photographer Roger Fenton
Subjects LANCASHIRE Ribble Valley Hurst Green
 Stonyhurst College
Numbers pr 125 various contained in one album
Aids Photographs titled by Fenton
Access Bona fide students by appointment in writing
Copies available for loan
Charges By arrangement

1148
Owner Whitethorn Press Limited (Lancashire Life
 Magazine)
Location Thomson House Withy Grove Manchester
 M60 4BL 061 834 1234
Title Lancashire Life Collection
Custodian W Amos - Editor
Dates 1947 -
Photographer Cyril Lindley
Subjects LANCASHIRE - topography crafts
 personalities sport events architecture history
Numbers pr 10000 b&w 10"x8"
 fi negs 3000 b&w 200 col 35mm 2¼"x2¼"
Aids Catalogue subject index

Access Picture researchers press tv media
 9 am - 5 pm
Copies available for sale for loan for publication
Charges Reproduction fee print/transparency fee
Notes This is a working collection not primarily intended
 for the general public.

1149
Owner The Thoresby Society
Location Claremont 23 Clarendon Road Leeds
 West Yorkshire LS29 NZ
Custodian Mrs J M D Forster
Dates 1889 -
Photographer Alf Mattison
Subjects LEEDS AND DISTRICT - buildings views
Numbers gl negs c480 ½pl 1pl
 L sl c850 3¼"x3¼"
Aids Card index
Access Open to members of the society and certain
 non-members on written application
Copies Special arrangements might be made at
 discretion of the council on written application
Charges At the discretion of the council of the society

1150
Owner Leicestershire County Council
Location Loughborough Public Library Local History
 Room Granby Street Loughborough Leicestershire
 050 93 2985
Title Loughborough Public Library Photographic
 Collection
Custodian R Bosmouth
Dates c1850 -
Subjects LEICESTERSHIRE Loughborough social
 sciences occupations and services education
 transport customs and folklore factories
 civil and building construction architecture
 recreations athletic sports and outdoor games
 biography and portraits rivers aerial photography
Numbers pr c2000
 gl negs
Aids *Card index *subject index
Access General public bona fide students under
 supervision
Notes Some photographs of Zeppelin raid (1914-18 War)
 on Loughborough.

1151
Owner W E R Hallgarth
Location 6 Bulwick Avenue Scartho Grimsby Humberside
 0472 822312
Title Bygone Lincolnshire
Dates c1850 (pre 1950) - c1930
Photographer Edwin Nainby A Stephenson F Warren
 J Wilkinson
Subjects LINCOLNSHIRE - all aspects
Numbers pr c4000 b&w
 fi and gl negs c4000
 L sl c4000
Aids Catalogue in preparation
Access General public by invitation only
Copies available for sale

1152
Owner Lincolnshire County Council Brayford House
 Brayford Lincoln 0522 26445
Location Lincolnshire County Library Central Library
 Free School Lane Lincoln 0522 28621
Title Local History Collection Tennyson Collection
Custodian E H Roberts
Dates c1857 (1910) -
Photographer H Barraud Bassano Julia Margaret
 Cameron Harrison of Lincoln G A Howard
 W Jeffrey I Mayall James Mudd O G Rejlander
 Henry Walker
Subjects LINCOLNSHIRE Lincoln religion social
 sciences occupations and services associations and
 societies education trasport customs and folklore
 mechanical engineering civil and building
 construction domestic home clothes architecture
 painting antiques musical instruments recreations

biography and portraits geography historic and
newsworthy events
Numbers pr c3500 b&w 50 col various
fi negs c2300 b&w various
L sl c5000 b&w col
Aids *Card index subject index catalogue to Tennyson
Collection only
Access General public bona fide students
Copies available for sale
Charges Print fee

1153
Owner Lincolnshire County Council
Location County Planning Department Newlands Lincoln
0522 29931
Custodian M R Sellors
Dates 1969 -
Subjects LINCOLNSHIRE - social sciences roads
wind and water mills land reclamation farm
buildings and lands architecture athletic sports
and outdoor games geography aerial photography
Numbers fi negs c3000 b&w c500 col 35mm
Aids Card index
Access Bona fide students picture researchers press
tv media 8. 30 am - 5 pm
Copies available for sale for display for publication
Charges Print/transparency fee

1154
Owner North Kesteven District Council
Location Planning Department County Offices Sleaford
North Kesteven Lincolnshire Sleaford 3421
Custodian Planning Officer
Dates 1947 (1969) -
Subjects LINCOLNSHIRE Stamford old town and St
Martins - architecture
Aids Subject index
Access General public bona fide students 9 am - 1 pm
2 pm - 5 pm
Copies available for sale

1155
Owner Lincolnshire County Council and various
depositors
Location Lincolnshire Archives Office The Castle
Lincoln LN1 3AB
Custodian C M Lloyd
Dates 1845 - 1956
Subjects LINCOLNSHIRE Lincoln social sciences
local history biography and portraits - church
dignitaries peers politicians tanks mechanical
engineering oil engined tractors early mechanical
farm implements - threshing machines diesel engines
churches
Numbers pr c1500 b&w col various
Aids *Card index typescript list
Access Bona fide students

1156
Owner Miss Pearl Wheatley
Location Middlebrook House Kirkby on Bain
Woodhall Spa Lincolnshire
Title Horncastle Building Survey
Dates 1966 -
Subjects LINCOLNSHIRE Horncastle buildings and
street scenes
Numbers sl c160 col 2"x2"
Access General public at meetings only bona fide students
Copies available for loan
Notes The collection is much used by local societies and
individuals when giving talks and undertaking
research.

1157
Owner Lincolnshire County Council
Location Museum of Lincolnshire Life Burton Road
Lincoln 0522 28448
Custodian Mrs C M Wilson
Dates 1890 (1969) -
Photographer F Parkinson
Subjects LINCOLNSHIRE all aspects especially
folk life and local history
Numbers pr 200 b&w various
fi negs 500 b&w 35mm
gl negs 300 b&w ½pl 1pl
sl 700 col 2"x2"
Aids *Subject index
Access General public bona fide students
by arrangement only
Copies available for sale

1158
Owner Lincoln Photographic Survey
Location Loncoln Divisional Library Free School Lane
Lincoln
Title The Lincoln Photographic Survey
Custodian Graham Bottomley 2 Raynton Close
Washingborough Lincoln LN4 1HD 0522 790648
Dates c1970 -
Subjects LINCOLNSHIRE Lincoln - photographic survey
architecture - exteriors - buildings - public
ecclesiastical residences commercial
street scenes
Numbers pr c5000 b&w
Aids Card index
Access General public bona fide students
Tuesday 7. 30 pm - 9. 30 pm
Copies available for sale
Charges Prints ¼pl - 10p ½pl - 20p 1pl - 35p
subject to review
Notes Negatives held at City Hall Beaumont Fee
Lincoln.

1159
Owner Lincolnshire County Council
Location County Planning Department County Offices
Lincoln
Title Vertical Aerial Photographic Survey of Lindsey
Custodian M R Sellors
Dates (1971) -
Photographer Hunting Limited
Subjects LINCOLNSHIRE aerial survey
Numbers substantial number
Aids Map index
Access County Council Departments and Lincolnshire
District Councils. Limited access to other bodies
and individuals for specific purposes. By prior
appointment only.
Copies available from Hunting Surveys Limited
Elstree Way Boreham Wood Hertfordshire

1160
Owner Stamford Survey Group (University of Nottingham)
Location Department of Adult Education Adult Centre
Broad Street Stamford Lincolnshire
Title Photographic Survey
Custodian M Key 24 Downing Crescent Stamford
Lincolnshire
Dates (1969) -
Subjects LINCOLNSHIRE Stamford - buildings -
photographic survey
Numbers pr c400
Access Bona fide students notice must be given

1161
Owner N R Wright
Location 13 Witham Bank East Boston Lincolnshire
Dates (1964) -
Subjects LINCOLNSHIRE Boston - photographic survey

Key () = dates when collections were begun or terminated
C = Century c = approximately pr = print fi = film
gl = glass neg = negative sl = slide L sl = lantern slide
tr = transparency mic = microform col = colour

b&w = black and white ¼, ½, 1-pl = quarter, half and whole
plate * = single copy, no public access * = single copy,
access by appointment

Numbers pr c2000 b&w 6"x4"
Copies available for sale
Charges Print fee

1162

Owner David Lionel Roberts
Location Orbost House By Dunvegan Isle of Skye
 Inverness Dunvegan 207
Dates c1900 (1968) -
Subjects LINCOLNSHIRE ARCHITECTURE - secular
 agricultural vernacular buildings
Numbers pr c12000 b&w
 fi negs c12000 b&w 35mm
 tr c1000 col
Aids Guide card index
Access Bona fide students by appointment only at
 least 30 days notice
Copies available for sale
Charges Print fee invoice prices + 10%

1163

Owner Scunthorpe Borough Council Civic Centre
 Scunthorpe Lincolnshire 0724 3463
Location Scunthorpe Museum Oswald Road Scunthorpe
 0724 3533
Title Scunthorpe Museum Photographic Collection
Custodian S A Holm
Dates c1860 (c1950) -
Subjects NORTH LINCOLNSHIRE social sciences
 occupations and services associations and societies
 education transport customs and folklore geology
 archaeology nature: biology mechanical
 engineering agriculture and food production
 domestic homes clothes architecture recreations
 athletic sports events
Numbers pr c1500 b&w ¼pl
 fi negs
 gl negs
 L sl
 sl c600 b&w
 postcards col
Aids *Catalogue
Access General public bona fide students
Copies available for sale
Charges Print fee from 20p

1164

Owner Royal Borough of Kensington and Chelsea
Location Central Library Phillimore Walk London
 W8 7RX 01 937 2542
Title Kensington Local History Collection
Custodian Melvyn Barnes
Dates c1860 (1889) -
Photographer Argent Archer H & R Stiles
Subjects LONDON Kensington topographical views
 and buildings
Numbers pr c8000 various
 fi negs c8000 35mm c360 various
 gl negs 173 8"x10"
 sl c400 col c250 b&w
Aids General guide for local history collection as a whole
 in preparation
Access General public bona fide students
Copies available for sale for loan
Charges Price list available
Notes Some photographs deposited by London Transport
 Executive showing buildings adjacent to the line of the
 Piccadilly underground railway 1902-4.

1165

Owner John Singleton Wellsman
Location Prospect Cottage The Common Flackwell
 Heath High Wycombe Buckinghamshire
 06 285 22201
Dates (1956) -
Photographer John Singleton Wellsman
Subjects LONDON history topography architecture
 social sciences transport heraldry
Numbers tr c900 col 35mm
Aids *Catalogue *subject index

Access Picture researchers bona fide students
 press tv media by appointment only
Copies available for sale for display for loan
 for publication
Charges Charges are made depending on use
Notes The collection is used in conjuntion with owner's
 lecture programme.

1166

Owner London Borough of Barking Council Valence House
 Dagenham RM8 3HT
Location Valence Reference Library Becontree Avenue
 Dagenham 01 592 2211
Title Local Studies Photographic Collection
Custodian James Howson
Dates c1900 (c1935) -
Subjects GREATER LONDON Barking social sciences
 occupations and services education transport
 customs and folklore factories bridges
 architecture painting recreations biography and
 portraits local events
Numbers pr c13000 1pl 1¾"x2¼"
 fi negs c13000 1¾"x2¼" 4½"x6¼"
 gl negs c500 4¾"x6½"
 L sl 288 3 3/16" x 3 3/16"
 sl c400 35mm
Access Bona fide students by arrangement
Copies available for sale for loan
Charges Print fee

1167

Owner Kent County Council
Location Local Studies Department Central Library
 Hall Place Bourne Road Bexley Kent
 Crayford 526574 Ext 42
Title Bexley Local History Collection
Custodian Mrs S J Ilott
Dates c1880 (c1950) -
Photographer A H T Boswell
Subjects GREATER LONDON - Bexley - all aspects
Numbers pr c7000 b&w 10"x8"
 fi negs c2500 b&w 35mm
 gl negs c1300 b&w ¼pl
 L sl 13000 b&w
 sl 600 b&w col 35mm
Aids Lantern slides listed
Access General public bona fide students
Copies available for loan duplicates only

1168

Owners Bishopsgate Institute
Location 230 Bishopsgate London EC2M 4QH
 01 247 6844
Title Bishopsgate Institute Photographic Collection
Custodian D R Webb
Dates c1860 (c1900) - c1940 -
History Complete set of photographs taken by Society for
 Photographing Relics of old London and a collection
 of views of interiors (and few exteriors) of City
 Churches c1870 - 1880 taken by Salmon
Photographer C A Mathew Salmon John Todd
Subjects GREATER LONDON topography street scenes
 buildings air views traffic entertainment
 Diamond Jubilee 1897 Queen Victoria's death 1901
 Coronation of Edward VII and George V World War I
 Armistice London at night portraits
Numbers pr c200 b&w various
 gl negs c50 b&w various
 L sl c5000 b&w 3"x3"
Aids *Card index *subject index
Access General public bona fide students
Copies available for sale

1169

Owner London Borough of Bromley 01 460 9955
Location Central Library Bromley: District Libraries of
 Beckenham Orpington: Branch Library of Anerley
 (Penge)
Title London Borough of Bromley Libraries Local
 Illustrations Collection
Custodian Borough Librarian

Dates c1863 -
Subjects GREATER LONDON Bromley buildings
street scenes biography and portraits churches
railways local archaeology Crystal Palace
Numbers pr 6260 b&w various
gl negs 350 b&w various
gl pos 300
L sl 2500 b&w 3¼"x3¼"
sl 615 col 35mm
mic 86
daguerreotypes 5
Access General public on application
Copies available for sale for loan to adults only
prints can only be supplied from the Library negatives
Charges Print fee commercial rates
Notes The five daguerreotypes are interior scenes of the
Crystal Palace at Sydenham.

1170
Owner London Borough of Brent Town Hall Forty Lane
Wembley London
Location Brent Central Library The Grange Neasden
Lane London 01 452 8311
Title Brent Local History Collection
Custodian Borough Librarian
Dates c1800 (1900) -
Subjects GREATER LONDON Brent Willesden
religion town life occupations and services
associations and societies education transport
customs and folklore windmills factories
farm buildings architecture recreations athletic
sports and outdoor games geography biography and
portraits historic and newsworthy events
Numbers pr c2100 b&w various
fi negs various
gl negs c20 b&w various
gl pos 4 b&w various
L sl c260 b&w 3¼"x3¼"
sl c400 b&w col 2"x2"
tr 302 b&w col 2"x2"
mic 4 b&w 35mm
Aids Card index
Access General public bona fide students
Copies available by private arrangement only
Charges Reproduction fee by arrangement

1171
Owner London Borough of Camden Libraries and Art
Department 100 Euston Road London NW1
01 278 4444 Ext 3007
Location Swiss Cottage Library Avenue Road London
Holborn Library Theobalds Road London WC2
01 405 2706
Title London Borough of Camden Local History Collection
Custodian William R Maidment
Dates 1867 (c1895) -
Photographer E Milner
Subjects GREATER LONDON Camden all aspects
Numbers pr c6000 b&w various
gl negs 150 b&w various
L sl c600 b&w 3¼"x3¼"
sl c200 col 2"x2"
mic c250 reels b&w
Aids *Card index *subject index
Access General public bona fide students by appointment
Copies available by arrangement
Charges Print fee commercial rates from £1.50
reproduction fee by arrangement

1172
Owner London Borough of Ealing
Location Ealing Central Library Walpole Park Ealing
London W5 5EQ 01 567 3456
Title London Borough of Ealing Library Service
Local History Collection
Custodian Miss M Gooding

Dates c1860 (1902) -
Subjects GREATER LONDON Ealing all aspects
Numbers pr c4000
fi negs c1000
gl negs c60
L sl 364 3¼"x3¼"
sl c425 b&w c139 col 35mm
Access General public bona fide students
Copies available for sale for loan
Charges Print fee

1173
Owner London Boroughs of Ealing and Hounslow
Location Gunnersbury Park Museum Gunnersbury Park
London W3 8LQ 01 992 1612
Custodian Miss B B Goshawk
Dates 1927 -
Subjects GREATER LONDON Ealing Hounslow
social sciences local government army education
communications transport archaeology
agriculture and food production domestic home
clothes arts and crafts toys antiques
recreations biography and portraits events
Numbers pr c600 b&w various
fi negs 50 rolls b&w 35mm
gl negs 387 b&w ¼pl ½pl 1pl
L sl 150 b&w 3¼"x3¼"
sl 300 col reversal 2"x2"
Aids *Card index
Access General public bona fide students
Copies available for sale
Charges Print fee commercial rates

1174
Owner Greater London Council
Location Central Library 68 Holloway Road Islington
London N7 8JN (for Islington) 01 607 4038
245 St John Street London EC1V 4NB (for Finsbury)
Custodian C A Elliott
Dates 1890 -
Subjects GREATER LONDON Islington and Finsbury -
photographic survey
Numbers pr 12"x10"
Aids Guide
Access General public bona fide students Monday to
Friday 9 am - 8 pm Saturday 9 am - 5 pm
Copies Photocopies available

1175
Owner Greater London Council London Borough of
Enfield Libraries and Museums Department
Location Broomfield Museum Broomfield Park
Palmers Green London N13 Cecil Road Enfield and
Southgate Town Hall Green Lanes Palmers Green
London N13
Custodian D O Pam
Dates c1900 -
Subjects GREATER LONDON Enfield Edmonton
Southgate - historical and current photographs
Numbers pr 3000 b&w 6"x8"
Access General public bona fide students

1176
Owner London Borough of Enfield
Location Forty Hall Museum Forty Hill Enfield
Middlesex EN2 9HA 01 363 8196
Title Forty Hall Museum's Collection
Custodian M H O Paterson
Dates 20thC (c1967) -
Subjects GREATER LONDON Enfield local history
village life town life home farm buildings
portraits ceramics architecture painting antiques
Numbers pr c50 b&w ½pl
sl negs c6 col ektachromes
sl c450 col 2"x2"
Aids *Card index *subject index

Key () = dates when collections were begun or terminated
C = Century c = approximately pr = print fi = film
gl = glass neg = negative sl = slide L sl = lantern slide
tr = transparency mic = microform col = colour

b&w = black and white ¼, ½, 1-pl = quarter, half and whole
plate * = single copy, no public access ** = single copy,
access by appointment

Access General public bona fide students by appointment
only
Copies available for loan one at a time only
Charges Print fee postcards from 5p
Notes The main collection of prints and some slides are
with the Department of Libraries, Arts and
Entertainment (Local History and Museum's Officer:
Mr D O Pam, Town Hall, Green Lanes, Palmers Green,
London N13 4XD).

1177
Owner Greater London Council
Location Room B66 Main Building County Hall
London SE1 7PB 01 633 7193/3255
Title Greater London Council Photograph Library Collection
Custodian Miss R E Watson
Dates c1860 (1950) -
Subjects GREATER LONDON - changing face of London
occupations and services housing estates schools
parks bridges streets public buildings
dwelling houses - palatial and slum people at work
and play and in need of care ante-natal clinics
old people's homes transport clothing
Numbers pr c250000 b&w various
gl negs c8950 various
fi negs substantial number
Aids Catalogue card index hand list - alphabetical
subject index to collection for library use only
Access General public bona fide students Monday to
Friday 9.15 am - 5.15 pm
Copies available for sale for loan
Charges Print fee from 29p including VAT reproduction
fee for council photographs £2.27p UK £6.80p
outside UK including VAT - waived in certain
circumstances

1178
Owner Greater London Council
Location Record Office (Middlesex Records) 1 Queen
Anne's Gate Buildings Dartmouth Street London
SW1H 9BS 01 633 4431/4430
Title Print and Photograph Collection
Custodian W J Smith
Dates c1900 (c1948) -
Subjects GREATER LONDON civil defence schools
transport architecture biography and portraits
Numbers pr c5500 b&w various
fi negs 32 b&w various
gl negs c300 b&w various
gl pos 9 b&w various
L sl 9 b&w
Aids *Catalogue *card index
Access General public bona fide students
Copies available for sale subject to copyright restrictions

1179
Owner London Borough of Greenwich
Location Local History Library Woodlands 90 Mycenae
Road Blackheath London SE3 7SE 01 858 4631
Title Greenwich Local History Library Photographic
Collection
Custodian J Watson
Dates c1855 -
Subjects GREATER LONDON Greenwich town life
army transport - rail trams tar lorries stations
observatories factories farm buildings architecture
biography and portraits
Numbers pr c3500 b&w various
L sl c200 b&w 3¼"x3¼"
sl c800 400 b&w 400 col 2"x2" 35mm
Aids *Card index
Access General public bona fide students
Copies available for sale
Charges Print fee
Notes Collection includes photographs of the Arsenal at
Woolwich and Deptford power station as designed by
Ferranti, and a unique print of the convict hulks.

1180
Owner London Borough of Greenwich
Title Spurgeon Collection

Custodian J Watson
Dates 1884 - 1886
Subjects GREATER LONDON Greenwich - town life
police fire service trams horse drawn vehicles
street scenes string instruments
Numbers pr 53 b&w 1pl
gl negs 53 ½pl
Aids Published catalogue
Notes This collection was commissioned in the 1880's
by the Rev Charles Spurgeon to illustrate a lecture
on street life in Greenwich. Location, Custodian,
Access and Copies as for no. 1179 above.

1181
Owner Corporation of London
Location Guildhall Library and Art Gallery Aldermanbury
London EC2P 2EJ 01 606 3030
Dates 1857 (19thC) -
Subjects GREATER LONDON London topography
London life
Numbers pr c10560 b&w c20 col various
fi negs c2000 b&w various
gl negs c2000 b&w various
L sl 845 col 35mm
ektachromes c200 col various
Access General public
Copies available for reproduction
Charges Reproduction charge of £3 per item

1182
Owner London Borough of Hammersmith
Location Central Library Shepherds Bush Road
London W6 7AT 01 748 6032
Title Hammersmith Local History Collection
Custodian Miss E A Bull
Dates 1860 (c1890) -
Photographer Miss D Short Sir Frank Short
Emery Walker
Subjects GREATER LONDON Hammersmith - all aspects
Numbers pr 12629 b&w 12 col various
fi negs 2945 b&w various
gl negs 1935 b&w various
L sl c560 b&w 3¼"x3¼"
tr 1162 col 2"x2"
Aids Card index subject index
Access General public bona fide students
Copies available for sale
Charges Print fee
Notes Includes the Hampshire House Photographic
Society Collection associated with M O Dell.

1183
Owner London Borough of Hammersmith
Location Reference Department Fulham Library
598 Fulham Road London SW6 01 736 1127
Title Fulham Local History Collection
Custodian Mrs C Bayliss
Dates c1860 (c1890) -
Photographer Mrs Broom
Subjects GREATER LONDON Fulham - all aspects
Numbers pr c9000 b&w col various
fi negs c7000 b&w various
gl negs c300 b&w various
L sl 752 b&w 3¼"x3¼"
mic 85 reels b&w 35mm
Aids Card index subject index
Access General public bona fide students preferably by
appointment
Copies available for sale
Charges Print fee at cost from existing negatives
Negatives can be made on request for an additional fee

1184
Owner London Borough of Hillingdon
Location Public Library 22 High Street Uxbridge
0895 32242
Title London Borough of Hillingdon Libraries: Local
History Collection (Illustrations Collection)
Custodian Borough Librarian
Dates Late 19thC (1930) -

Subjects GREATER LONDON London Borough of
 Hillingdon - local history
Numbers pr c3000 b&w various
Aids *Card index *subject index
Access General public
Copies available for loan subject to adequate precautions

1185
Owner London Borough of Hounslow
Location Libraries Department Hounslow Library
 Treaty Road Hounslow Middlesex 01 570 7510
Dates 1864 (c1905) -
Subjects GREATER LONDON Hounslow - all aspects
Numbers pr c2000
Aids Card index subject index
Access General public
Copies available
Charges Standard scale

1186
Owner London Borough of Hounslow
Location Reference Library Duke's Avenue Chiswick
 London W4 2AB 01 994 1008
Custodian Miss A T Cameron
Dates 1870 -
Subjects GREATER LONDON - Brentford and Chiswick -
 all aspects
Numbers pr c2000
Aids Card index subject index
Access General public
Copies available
Charges Standard scale

1187
Owner National Photographic Record
Location Royal Photographic Society 14 South Audley
 Street London W1Y 5DP 01 493 3967
Title The Society for Photographing Old London Collection
Custodian The Editor National Photographic Record
Dates 1875 - 1885
History The first such Society, predecessor of modern
 Local Buildings Surveys
Subjects GREATER LONDON buildings street scenes
 street furniture
Numbers pr 108 10"x8"
Aids Bound in three large volumes with explanatory text
Access By appointment through the National Photographic
 Record
Copies available at cost
Notes A limited number of editions of these three volumes
 was produced, some of which are separately entered in
 this Directory, and one of which is with the British
 Library. The prints constitute a rare pictorial
 commentary on Victorian, Dickensian London.

1188
Owner Royal Borough of Kingston upon Thames
Location Central Library Fairfield Road Kingston
 upon Thames Greater London 01 546 2121
Title Kingston upon Thames and area local Illustrations
 Collection
Custodian Mrs C A Cornish
Dates c1870 (c1900) -
Subjects GREATER LONDON Kingston upon Thames -
 local history architecture topography
Numbers pr c3000 b&w col various
 gl negs
Aids Punched card index
Copies available for sale negs of most of the collection

1189
Owner London Borough of Lewisham
Location Archives and Local History Department
 The Manor House Old Road Lee Greater London
 SE13 5SY 01 852 5050

Title Includes Baker Collection Thankful Sturdee
 Collection Lewisham Borough News Collection
Custodian R A Greenhill
Dates 1880 (1960) -
Photographer Anthony Runacres Thankful Sturdee
Subjects GREATER LONDON Lewisham local history
Numbers pr c5500 b&w various
 fi negs c2000 b&w various
 gl negs c1000 b&w various
 L sl c800 b&w 3¼"x3¼"
 sl c500 col 2"x2"
Aids Self indexing system
Access General public
Copies available for sale
Charges Print fee commercial rates

1190
Owner Greater London Council
Location Stratford Reference Library Water Lane
 London E15 4NJ 01 534 4545
Title Local History Photographic Collection Historic
 Commercial Vehicle Photographic Collection -
 (held at East Ham Reference Library but all
 enquiries should be made to Stratford)
Dates 1890 (c1920) -
Subjects GREATER LONDON Newham - local history
 biography topography historic commercial vehicles
Numbers pr 20000 b&w 1pl
 gl negs 500 b&w
 L sl 300 b&w col
 tr 2600 b&w col
Aids Card index subject index
Access Selections can be made available for specific
 requests
Copies available for sale for display for publication
 for loan to local schools credit line required
Charges Print/transparency fee
Notes Newham, formerly the County Boroughs of East
 and West Ham.

1191
Owner London Borough of Merton Merton Cottage
 Church Path London SW19 3HH 01 542 6211
Location Mitcham Library London Road Mitcham
 CR4 2YR
 Morden Library Morden Road London SW19 7NB
 Wimbledon Library Wimbledon Hill Road London
 SW19 7NB
Title Merton Public Libraries Collection
Custodian E J Adsett
Dates (Early 20thC) -
Subjects GREATER LONDON Merton Mitcham Morden
 Wimbledon local history
Numbers pr 2000 b&w
 gl negs 293 b&w 3¼"x3¼"
 L sl 293 b&w 3¼"x3¼"
 sl 100 b&w 100 col 2"x2"
 mic
Aids *Card index *subject index included in local
 collection indexes
Access General public

1192
Owner London Borough of Redbridge
Location Central Reference Library 112b High Road
 Ilford Essex IG1 1BY 01 478 4319
Title Redbridge Public Libraries Local History Collection
Custodian Reference Librarian
Dates c1865 (c1900) -
Subjects GREATER LONDON Redbridge local history
Numbers pr 3518 b&w col various
 fi negs 1543 b&w col
 gl negs 1089 b&w various
 L sl 589 b&w 3¼"x3¼"
 sl 291 b&w col 2"x2"
 mic 127 b&w

Key () = dates when collections were begun or terminated
C = Century c = approximately pr = print fi = film
gl = glass neg = negative sl = slide L sl = lantern slide
tr = transparency mic = microform col = colour

b&w = black and white ¼, ½, 1-pl = quarter, half and whole
plate * = single copy, no public access ** = single copy,
access by appointment

Aids *Subject index
Access General public bona fide students
Copies available for sale for loan

1193
Owner London Borough of Richmond upon Thames
Location Richmond Central Library Little Green
 Richmond 01 940 0031
 Twickenham District Library Garfield Road
 Twickenham
Title Richmond upon Thames Local History Collection
Custodian Derek Jones
Dates (c1880) –
Photographer Nathaniel Lloyd W S Stuart
Subjects GREATER LONDON Richmond upon Thames
 architecture painting local history
Numbers pr c1000 b&w various
 fi negs 2239 b&w
 gl negs 1190 b&w
 L sl 725 b&w
 sl c3000 b&w col 2¼"x2¼" 35mm
Aids *Card index
Access General public bona fide students
Copies available for sale by arrangement for loan for
 exhibition purposes

1194
Owner London Borough of Southwark
Location Newington District Library 155/157 Walworth
 Road London SE17 1RS 01 703 3324
Title Southwark Collection
Dates Mid 19thC (c1890) –
Subjects GREATER LONDON Southwark local history
Numbers pr 17000 various
 tr c900 col 35mm
Aids Accession register
Access General public bona fide students

1195
Owner London Borough of Waltham Forest Central
 Library High Street E17 01 520 4733
Location South Chingford Library Hall Lane Chingford
 London E4 01 529 2332
Title South Chingford Library Local Collection
Dates 1870 (1950) –
Photographer Francis Frith
Subjects GREATER LONDON Chingford area
 buildings landscape
Numbers pr c200 b&w various
 L sl 100 2"x2"
 sl 100 various
Aids *Catalogue *subject index
Access General public bona fide students for reference
 only
Copies available for sale
Charges Reproduction fee by arrangement

1196
Owner London Borough of Tower Hamlets
Location Tower Hamlets Local History Library
 Central Library Bancroft Road London E1 4DQ
 01 980 4366
Custodian Borough Librarian
Dates c1863 (c1900) –
Photographer William T Whiffin
Subjects GREATER LONDON Stepney Poplar Bethnal
 Green shipping – sail steam
Numbers pr c12000 b&w
 gl negs c1000 b&w
 tr c500 col
 fi c300 reels
Aids Card index
Access General public bona fide students picture
 researchers press tv media 9 am – 8 pm
 Monday to Friday 9 am – 5 pm Saturday
Copies available for display for loan for publication
 credit line required
Charges Reproduction fee print/transparency fee

1197
Owner London Borough of Waltham Forest

Location Vestry House Museum Vestry Road
 Walthamstow London E17 9NH 01 527 5544
 Ext 391
Title Vestry House Museum Collection
Custodian H L Chambers
Dates 1853 (c1900) –
Subjects GREATER LONDON Waltham Forest – town life
 local government transport public festivals
 home interiors architecture portraits
Numbers pr c12700 b&w col various
 fi negs c1700 b&w col 35mm 120mm
 gl negs 675 ¼pl ½pl 1pl
 gl pos 2 b&w ¼pl ½pl
 L sl 5332 b&w col
 sl c450 col
Access General public bona fide students under
 supervision on request by appointment
Copies available for sale for loan
Charges Print fee

1198
Owner Wembley History Society
Location Brent's Museum The Grange Neasden
 London NW2
Title Wembley History Society Local Collection
Custodian Hon Archivist A H Murgatroyd 25 Forty Avenue
 Wembley Middlesex HA9 8JL 01 908 1730
Dates 1850 (1952) –
Photographer Campbell Gray King and Hutchings
 Kamera Kraft
Subjects WEMBLEY – events at Wembley Stadium and
 Wembley Empire Pool architecture archaeological
 sites pottery earthenware parks guides and
 scouts schools railways historic and newsworthy
 events in Wembley
Numbers pr c2600 b&w various
 fi negs
 gl negs c20 b&w
 L sl 50 b&w
Aids Catalogue card index subject index
Access General public
Copies available for loan to students, museums etc
Charges By arrangement with copyright holders
 reproduction fee

1199
Owner City of Westminster Council
Location Victoria Library Buckingham Palace Road
 London SW1W 9UD 01 730 0446
 Marylebone Library Marylebone Road London
 NW1 5PS 01 828 8070
Title Westminster History Collection
Custodian Miss M J Swarbrick Victoria Library
 R A Bowden Marylebone Library
Dates c1850 (c1930) –
Subjects GREATER LONDON Westminster architecture
 aerial photography
Numbers pr c7933 b&w various
 fi negs 880 b&w various
 gl negs 890 b&w various
 L sl 1080 2"x3"
 sl 1475 b&w col 35mm
Aids *Card index *subject index
Access General public

1200
Owner John R Oldfield
Location 15 Haye Close Lyme Regis Dorset
Dates 1880 – 1910 –
Subjects LYME REGIS – all aspects
Numbers pr c130 b&w
 fi negs c130 b&w
Copies available for sale for loan
Notes This collection is made up of copies taken from
 originals lent by their owners.

1201
Owner Manchester City Council Cultural Committee
Location Local History Library Central Library
 St Peters Square Manchester M2 5PD 061 236 7401
Custodian Director of Libraries

Dates 1851 -
Subjects MANCHESTER all aspects
Numbers pr 110000 various
 L sl c4000
Aids Index
Access General public
Copies available for sale
Charges Reproduction fee
Notes Public not allowed into place where collection is
 kept, material is brought out to them.

1202

Owner Bolton Borough Council
Location Bolton Museum and Art Gallery Civic Centre
 Bolton Greater Manchester 0204 22311 Ext 386
Custodian Helen Caffey
Dates c1890 (Early 20thC) -
Subjects GREATER MANCHESTER Bolton - social
 sciences local government botany zoology
 mechanical engineering mining domestic home
 clothes architecture portraits geography
 historic and newsworthy events industries
 textile industry transport trade war
Numbers pr c500 b&w various
 fi negs c100 b&w
 gl negs c300 b&w
 sl c100 col
Aids Card index
Access General public bona fide students on application
 to the museum staff
Copies available for sale for loan on application
Charges Postcards for sale

1203

Owner Oldham Borough Council
Location Local Studies Library Local Interest Centre
 Greaves Street Oldham Greater Manchester OL1 1DN
Title Oldham Local Studies Photographic Collection
Custodian J W Carter
Dates c1845 -
Subjects GREATER MANCHESTER Oldham and
 district - all aspects
Numbers pr 6000 b&w 50 col various
 fi negs c500 b&w 35mm
 gl negs c100 b&w various
 L sl c200 b&w 3"x3"
 mic c650 reels 35mm 16mm
Aids *Card index *subject index
Access General public bona fide students
Copies available by arrangement
Charges Print fee black and white from 30p ½pl

1204

Owner Metropolitan Borough of Bury Council
Location Bury Reference Library Manchester Road
 Bury 061 764 4110/061 761 4021
Title Bury Reference Library Photographic Collection
Custodian H C Barrett
Dates c1852 -
Subjects GREATER MANCHESTER Bury and district
 portraits transport industry local government
 religion
Numbers pr c4000 b&w 1pl
 gl negs c500 b&w various
 L sl c40 b&w various
 mic 202 b&w
Aids *Card index
Access General public
Copies available for sale for loan
Charges Print fee from 15p postcard from 28p ½pl

1205

Owner Salford City Council Cultural Services
 Department Astley Road Irlam Manchester M30 5LL
Location Eccles Central Library Church Street Eccles
 Greater Manchester 061 789 1430

Title Salford City Libraries Photographic Collections
Custodian M W Devereux
Dates 1858 (c1900) -
Subjects GREATER MANCHESTER - Eccles all aspects
Numbers pr c10000 b&w
Aids *Catalogue *card index *subject index
Access General public bona fide students
Copies available for sale by arrangement
Charges Reproduction fee for commercial use

1206

Owner Salford City Council Cultural Services Department
 Astley Road Irlam Manchester M30 5LL
Location Salford Central Library Peel Park Salford
 Greater Manchester 061 736 3353
Title Salford Local History Library Photographic Collection
Custodian M W Devereux
Dates 1858 (c1900) -
Subjects GREATER MANCHESTER Salford - associations
 and services education transport customs and
 folklore factories architecture biography and
 portraits outdoor games historic and newsworthy
 events aerial photography
Numbers pr 5000 b&w
 L sl 250 b&w
 sl 500 b&w
Aids *Catalogue *card index *subject index
Access General public bona fide students
Copies available by arrangement
Charges Reproduction fee for commercial use

1207

Owner Salford City Council Cultural Services Department
 Astley Road Irlam Manchester M30 5LL
Location Swinton Central Library Chorley Road
 Swinton Greater Manchester 061 794 7440
Title Salford City Libraries Photographic Collections
Custodian M W Devereux
Dates 1858 (c1900) -
Subjects GREATER MANCHESTER - Swinton aspects
Numbers pr 4500 b&w
 L sl 380
 sl 137 col
Aids *Catalogue *card index *subject index
Access General public bona fide students
Copies available for sale by arrangement
Charges Reproduction fee for commercial use

1208

Owner Salford City Council
Location Peel Park Museum and Art Gallery Salford
 Greater Manchester M6 061 736 2649
 Ordsall Hall Museum Taylorson Street Salford
 Greater Manchester M5 3EX 061 872 0251
Title Salford Museum and Art Gallery Collection
Custodian S Shaw Peel Park Museum and Art Gallery
Dates 1854 (1850) -
Photographer James Mudd
Subjects GREATER MANCHESTER Salford social
 sciences occupations and services transport
 customs and folklore archaeology anthropology
 home clothes ceramics architecture painting
 antiques geography travel abroad
Numbers pr c1500 b&w various
 gl negs c250 b&w
 gl pos c100 b&w
 L sl c4500 b&w
 sl c200 col
Aids Partial card index
Access Bona fide students on request
Copies available by special order only
Charges Reproduction fee £4

1209

Owner Rochdale Metropolitan Borough Council
 Town Hall Rochdale Greater Manchester

Key () = dates when collections were begun or terminated
C = Century c = approximately pr = print fi = film
gl = glass neg = negative sl = slide L sl = lantern slide
tr = transparency mic = microform col = colour

b&w = black and white ¼, ½, 1-pl = quarter, half and whole
plate * = single copy, no public access ** = single copy,
access by appointment

Location Central Library Long Street Middleton
 Greater Manchester 061 643 5228
Custodian Area Librarian
Dates 1840 (c1934) –
Subjects GREATER MANCHESTER Middleton local
 history
Numbers pr 3000 b&w various
 gl negs c50
Aids *Subject index
Access General public bona fide students
Notes A few photographs in the collection have been
 published as selection entitled 'Bygone Middleton:
 a photographic record'.

1210

Owner Rochdale Metropolitan Borough Council
Location Libraries and Arts Services Rochdale
 Greater Manchester 0706 47474
Title Local History Collection
Custodian J Swain
Dates Mid 19thC –
History Includes a collection of photographs of mill
 engines
Subjects GREATER MANCHESTER Rochdale religion
 social sciences occupations and services army
 associations and societies education communications
 transport customs and folklore mechanical
 engineering civil and building construction
 clothes architecture textiles genealogy
 recreations sports biography and portraits
Numbers pr 12000 b&w various
 gl negs 200 b&w $2\frac{1}{2}$"x$2\frac{1}{2}$"
 L sl 200 $2\frac{1}{2}$"x$2\frac{1}{2}$"
Access General public
Copies available for sale
Charges Print fee commercial rates

1211

Owner Rusholme and Fallowfield Civic Society
Location 103 Dickenson Road Rusholme Manchester
 M14 5AZ
Custodian P R Helm Honorary Secretary
Dates c1830 (c1960) –
Subjects GREATER MANCHESTER buildings of Victoria
 Park area of Manchester
Numbers pr c150
 fi negs c150 35mm
 sl c50
Access Bona fide students by appointment only
Copies available for sale

1212

Owner The Old Mansfield Society
Location Mansfield Museum Mansfield Nottinghamshire
 0623 23861
Title Old Mansfield Collection
Custodian J Purdy 17 Garnon Street Mansfield
Dates c1880 –
Subjects MANSFIELD – local history street buildings
Numbers sl c400 various
Aids Card index
Access Bona fide students at discretion of the custodian
Charges Print fee at cost reproduction fee by arrangement
Notes Mr Purdy lectures with slides.

1213

Owner Delf and Eaton families
Location Norfolk Record Office Central Library Norwich
 Norfolk NR2 1NJ Norwich 22233
Title Delf Collection and Eaton Collection
Custodian J M Kennedy
Dates c19thC – 1950
History Eaton collection includes portrait studies of
 the insane by Dr H W Diamond
Subjects NORFOLK Suffolk wind and water mills
 buildings wherries ships flora and fauna
 biography and portraits – especially of the insane
Numbers L sl c1300
Copies available by arrangement

1214

Owner Peter Newbolt
Location High Street Cley-next-the-Sea Holt North
 Norfolk Cley 469
Title Norfolk: Mediaeval Churches and Religious
 Buildings
Dates 1972 –
Photographer Peter Newbolt
Subjects NORFOLK – churches – interior and exterior
Numbers pr c500 b&w 12"x10"
 fi negs c1500 b&w $2\frac{1}{4}$"x$2\frac{1}{4}$"
 sl c350 col $2\frac{1}{4}$"x$2\frac{1}{4}$"
Aids Subject index
Access Bona fide students by appointment only
Copies Black and white prints for sale transparencies on
 loan for reproduction only
Charges Print fee reproduction fee on application

1215

Owner Norfolk County Council County Hall Norwich
 Norfolk 0493 22288
Location Central Library Great Yarmouth Norfolk
 0493 4551
Title Local History Collection
Custodian Divisional Librarian
Subjects NORFOLK Norwich social sciences
 transport occupations and services biography
 and portraits
Aids *Card index
Access General public bona fide students but not
 open access

1216

Owner The Brackley Amenity Society
Location 64A Banbury Road Brackley Northamptonshire
Custodian Mr and Mrs E J Morris
Dates 1970 – 1971
Subjects NORTHAMPTONSHIRE Brackley buildings
Numbers pr 64 $4\frac{1}{2}$"x$3\frac{1}{2}$"
Access Members of the Brackley Amenity Society

1217

Owner Northamptonshire County Coucnil
Location Central Library Abington Street Northampton
 0604 35651 and office hours 34881
Title Local History Collection
Custodian J B Stafford
Dates c1870 –
Subjects NORTHAMPTONSHIRE religion social sciences
 occupations and services schools transport
 ceremonies mills factories bridges architecture
 events aerial photography
Numbers pr c6500 b&w various
 gl negs 1576 various
 gl pos 12 3"x4"
 L sl 415 b&w 3"x4"
 sl 540 col 2"x2"
 mic 250 reels of local newspapers and manuscripts
Aids Microfilm reader/printer
Access General public bona fide students

1218

Owner Northamptonshire County Council
Location Record Office Delapre Abbey Northampton
 0604 62129
Custodian P I King
Dates c1860 (c1930) –
Subjects NORTHAMPTONSHIRE religion social sciences
 education transport customs and folklore
 mechanical engineering farming domestic
 home clothes architecture genealogy pageants
 biography and portraits historic and newsworthy
 events
Numbers pr c5050 b&w col various
 gl negs c500 b&w 7"x5"
 gl pos c500 7"x5"
 L sl c500 b&w $2\frac{1}{2}$"x$2\frac{1}{2}$"
 sl 328 col 35mm
 mic 8 b&w 35mm
Aids Card index subject index
Access General public
Copies available by arrangement for personal use or study

Charges Print fee at cost Copyright fees as applicable
may be payable
Notes The terms of custodianship, ie varying from
ownership to temporary loan, as well as the terms
of the copyright acts, determine the availability of
copies and the uses to which they may be put.
These factors may be reflected in the charges made.

1219

Owner Birkenhead College of Technology
Location Visual Aids Department Borough Road
Birkenhead Merseyside LW2 9QD
Title College Slide Collection
Custodian A Leather
Dates 1964 -
Subjects MERSEYSIDE local history industry Wirral
Deeside geology archaeological sites
factory equipment Mersey and Dee estuaries
Numbers fi negs c500 b&w
L sl 150 b&w
Aids Duplicated catalogue
Access Bona fide students

1220

Owner H J Foster
Location 38 Greenfield Road Little Sutton Wirral
Merseyside L66 1QR 051 339 2023
Title H J Foster Wirral Photographic Survey
Dates c1860 (1965) -
Photographer H J Foster
Subjects MERSEYSIDE Wirral - social sciences
occupations and services army associations and
societies education transport customs and folklore
architecture
Numbers fi negs c300 b&w 6cm x 6cm
gl negs c45 b&w $\frac{1}{2}$pl 1pl
Access Bona fide students researchers press tv media
Copies available for sale
Charges By negotiation

1221

Owner Liverpool City Council
Location Liverpool City Libraries William Brown Street
Liverpool Merseyside L3 8EW 051 207 2147
Title Photographs and Small Prints Collection
including Binns Collection Frith Collection Eastham
Collection Inston Collection
Custodian R Malbon
Dates 1852 -
History The Binns Collection, acquired in 1852, was
the first attempt to survey Liverpool pictorially
Photographer Binns J Eastham F Frith Inston
Subjects MERSEYSIDE and Liverpool - all aspects
Numbers pr 240000
gl negs 3296 various
L sl 3593 3$\frac{1}{4}$"x3$\frac{1}{4}$" 2"x2"
Access General public bona fide students
Copies available for loan to recognised bodies
Charges Print fee
Notes This collection includes commissioned and
deposited photographs, selections from photographs
retained by Corporation departments and photographic
archives of Corporation departments eg Housing
Department.

1222

Owner Merseyside County Council
Location St Helens Local History Library Central Library
Gamble Institute Victoria Square St Helens
Merseyside 0744 24061 Ext 246
Custodian R L Hart
Dates c1860 (Late 19thC) -
Subjects MERSEYSIDE St Helens local history
Numbers pr c2500 b&w various

Access General public bona fide students picture
researchers press tv media 9 am - 7 pm Monday
to Friday 9 am - 5 pm Saturday
Copies available for sale for publication
Charges Copies done by staff only for set charge

1223

Owner Sefton Metropolitan District Council Oriel Road
Bootle Merseyside
Location Atkinson Library Lord Street Southport
Merseyside 0704 5523 Ext 278
Title Southport Local History Prints Collection
Custodian A R Hardman 051 922 4040 Ext 245
Dates c1850 (c1875) -
Subjects MERSEYSIDE Southport local history
Numbers pr 1548 various
gl negs 32 b&w
gl pos 65 b&w
L sl c600 b&w 3"x3"
mic 322 b&w
Aids *Card index *subject index
Access General public on application to staff

1224

Owner A G S Priestley
Location 19 Elm Park Road Wallasey Merseyside
L45 5JH 051 639 2857
Dates 1889 (1890) - 1932
Photographer J C North Priestley and Sons Limited
Subjects MERSEYSIDE - Wallasey district army - all
aspects transport seaside holidays rugby yachting
portraits
Numbers pr 455 b&w various
Aids Catalogue

1225

Owner Wirral Country Park Centre
Location Wirral Country Park Station Road Thurstaston
Wirral Merseyside 051 648 4371
Title Development of Wirral Country Park
Custodian Head Ranger
Dates 1956 (1969) -
Subjects MERSEYSIDE Wirral - development of a
Country park from a former railway line
Numbers pr 40 col 8"x6"
sl 500 col 35mm
Access Bona fide students

1226

Owner University of Liverpool Senate House Abercromby
Square PO Box 147 Liverpool L69 3BX
051 709 6022 Ext 735
Cunard Steam-ship Company Limited Cleveland
House St James Square London SW1
Location University of Liverpool and Harold Cohen
Library Ashton Liverpool
Title University Archive Collection Cunard Archive
Collection Central Photographic Service
Dates 1948 -
Photographer Stewart Bale Limited Elsam Mann and
Cooper Limited Wilfred Lea J W Stammers
Subjects MERSEYSIDE architecture University -
buildings staff groups students White Star Line
ship interiors visits to the West Indies ships
medicine portraits
Numbers pr substantial numbers various
Aids Accession lists
Access Bona fide students
Copies available for sale
Charges Print fee

1227

Owner West Drayton and District Local History Society
Location Winsley Bagley Close West Drayton
Middlesex 089 54 43861
Custodian A H Cox

Key () = dates when collections were begun or terminated
C = Century c = approximately pr = print fi = film
gl = glass neg = negative sl = slide L sl = lantern slide
tr = transparency mic = microform col = colour

b&w = black and white $\frac{1}{4}$, $\frac{1}{2}$, 1-pl = quarter, half and whole
plate * = single copy, no public access ** = single copy,
access by appointment

Dates Late 19thC (1949) -
Subjects MIDDLESEX - village life fire service
 Home Guard and Civil Defence scouts schools
 teachers inland-waterways agriculture
 architecture street scenes stained glass football
 cricket portraits rivers aerial photography
Numbers pr substantial number b&w col various
 tr col b&w 35mm
Aids Catalogue
Access Bona fide students by appointment

1228

Owner Newark District Council
Location Newark Museum Appletongate Newark
 Nottinghamshire NG24 1JY Newark 2358
Custodian H V Radcliffe
Dates c1875 -
Subjects NEWARK AREA - all aspects
Numbers pr 2000
 fi negs c25000
 L sl 300
Aids Card index
Access General public bona fide students
Copies available for sale
Charges Reproduction fee by arrangement
Notes Prints may be ordered.

1229

Owner J C Barringer
Location 23 St Davids Road Hethersett Norwich
 Norfolk NR9 3DH 0603 810557
Dates 1953 -
Photographer J C Barringer
Subjects NORFOLK - village life town life geology
 archaeology farming cattle sheep architecture
 mountains and hills rivers and lakes in the Lake
 District Yorkshire Dales Norway and North
 Lancashire ice and snowscenes in Iceland and
 Norway medieval earthworks vernacular
 architecture
Numbers pr c500 b&w
 fi negs c1000 b&w
 tr c4000 col 35mm
Access Bona fide students
Notes Nearly all the photographs in this collection
 were taken to illustrate physical geography and
 landscape history. Special research interests
 medieval earthworks, agricultural history and
 vernacular architecture.

1230

Owner T W Mollard
Location 39 Denton Road Norwich Norfolk
Dates 1880 (1973) -
Subjects NORFOLK Downham Market and district local
 interest
Numbers sl c200 b&w 35mm

1231

Owner Norwich City Council City Hall Norwich Norfolk
Location Bridewell Museum Bridewell Abbey Norwich
 Norfolk 0603 22233
Custodian F W Cheetham
Dates 1870 -
Subjects NORFOLK local industries urban and rural
 life crafts
Numbers pr c500
 gl negs c200
Aids *Card index
Access General public bona fide students
 10 am - 5 pm Monday to Friday preferably by
 appointment
Copies available for sale
Charges Print fee
Notes Includes a collection of photographs taken by a local
 drainage firm of marsh and fen drainage c1900.

1232

Owner Norwich City Council
Location Castle Museum Norwich Norfolk NOR 65B
 0603 22233

Title Norwich Museums Collection
Custodian Rachel Young
Dates c1860 (c1870) -
Photographer P H Emerson
Subjects NORFOLK country life and customs
 associations and societies transport nature
 mechanical engineering agriculture and food
 production domestic home clothes ceramics
 architecture painting antiques musical instruments
 biography and portraits
Aids *Card index *subject index
Access Bona fide students by prior arrangement
Copies available for sale
Charges Print fee

1233

Owner Norfolk County Council County Hall Martineau
 Lane Norwich Norfolk 0603 22288 Ext 302
Location Central Library Norwich Norfolk NOR 57E
 0603 22233 Ext 628
Custodian Divisional Librarian
Dates 1845 (1914) -
Photographer W J Clutterbuck T D Eaton P H Emerson
 Payne Jennings
Subjects NORFOLK Suffolk Cambridge Essex
 occupations and services transport the forces
 customs and folklore palaeontology geology
 archaeology wind and water mills bridges
 agriculture home clothes sculpture and carving
 architecture paintings genealogy recreations
 outdoor games biography and portraits historic
 and newsworthy events
Numbers pr c25000 b&w 8"x6"
 fi negs c700 b&w various
 gl negs c1500 b&w various
 L sl 6443 col 35mm
Aids Card index subject index
Access General public bona fide students
Copies available for sale
Charges Print fee from existing negative from 12p
 if a negative has to be made 50p

1234

Owner Northumberland County Council
Location Blyth Central Library Blyth Northumberland
 067 06 2401
Title Blyth Central Library Local Photographic
 Collection
Custodian M A Taylor
Dates (1970) -
Subjects NORTHUMBERLAND Blyth - Demolished
 buildings re-development
Numbers pr b&w 3"x4"
Access General public bona fide students
Copies available for sale
Notes Photographs in this collection are the copyright of
 Blyth News.

1235

Owner Hexham Civic Society
Location 2 West Terrace Corbridge Northumberland
Title Hexham Civic Society Photographic Library
Custodian Leo Davies
Dates 1970 -
Subjects NORTHUMBERLAND Hexham general survey
Numbers pr 25 10"x8"
 fi negs c120 35mm
Aids File index
Access Bona fide students by prior arrangement
Copies available for sale at cost

1236

Owner Northumberland College of Education
Location Audio Visual Education Department Ponteland
 Newcastle upon Tyne
Title Regional Slide Collection
Dates 1972 -
Subjects NORTHUMBERLAND local history buildings
 castles harbours tile kilns forests railways
 cathedrals landscapes iron steel works
 peat beds reservoirs brickworks Grace Darling's

Lighthouse islands seals birds flowers coal mine quarries Scotland Holy Island Tyne shipyards Lake District lead mill ruins Newcastle upon Tyne - quayside barrel makers fish quays sheep dressing miners' houses Pele towers pollution Roman Wall
Numbers tr c3000 col 35mm
Aids Duplicated catalogue *card index *subject index
Access Bona fide students
Copies available for loan
Charges Print fee from 15p per slide

1237

Owner Northumberland County Council
Location Northumberland Record Office Melton Park North Gosforth Newcastle upon Tyne NE3 5QX
Title Various collections and individual photographs Including the Mitford Collection
Dates c1875 (1959) -
History The Mitford collection is a set of photographs of Northumberland country life taken by Canon R C McLeod who was the vicar of Mitford 1896-1940
Subjects NORTHUMBERLAND Old Newcastle religion - pilgrimage to Holy Island social sciences occupations and services the forces associations and societies education transport lifeboats customs and folklore geology meteorology archaeology wind and water mills mining agriculture and food production home interiors architecture recreations outdoor games biography and portraits world wide travel village orchestra
Numbers pr c1000 gl negs substantial number 3"x3"
Aids Accession register
Access General public bona fide students
Copies available for sale for loan
Charges On application

1238

Owner University of Newcastle upon Tyne
Location Department of History Newcastle Tyne and Wear NE1 7RU 0632 28511
Custodian Professor N McCord
Dates c1850 -
Photographer N McCord D J Rowe
Subjects NORTHUMBERLAND TYNE AND WEAR DURHAM religion social sciences occupations and services associations and societies education transport customs and folklore archaeology mining agriculture and food production architecture recreations football biography and portraits aerial photography historic and newsworthy events
Numbers sl c1000 b&w c4000 col 35mm
Aids *Catalogue *card index
Access Bona fide students 10 am - 5 pm
Copies available by arrangement
Charges Print fee on application

1239

Owner Nottingham City Council
Location Castle Museum Nottingham NG1 6EL 0602 43615
Custodian Brian Loughbrough
Dates 1880 (1878) -
Subjects NOTTINGHAM Nottingham bicycle club recreations biography and portraits landscapes
Numbers pr c75 b&w various gl negs c12 b&w 1-pl
Access General public bona fide students by appointment
Copies available for sale
Charges Print fee reproduction fee for commercial use

1240

Owner Nottinghamshire County Council

Location Public Library Arnold Nottingham NG5 6JN 0602 264114
Custodian K M Negus
Dates 1875 (1958) -
Subjects NOTTINGHAM Arnold - religion customs demonstrations Guides Scouts uniformed organisations bands education transport public festivals civil and building construction bridges pageants geography football and cricket teams
Numbers pr c1300 b&w 1-pl fi negs c1300 b&w various sl c1300 b&w 2"x2"
Access General public bona fide students
Copies available for loan
Notes The collection covers all aspects of Arnold, people and buildings - views of before and after.

1241

Owner Nottingham Historical Film Unit
Location 96 Hucknall Road Carrington Nottingham 0602 605686
Custodian Richard Iliffe
Dates 1843 -
History Founded in 1960 by Richard Iliffe
Photographer John Lambert Charles Shaw
Subjects NOTTINGHAM - all aspects especially music hall theatre cinema public transport recreations
Numbers Total several thousands
Access Press tv media
Copies available by arrangement
Charges Reproduction fee by arrangement
Notes This collection is not purely photographic it contains many prints paintings theatre music hall and cinema bills. About 20000 items altogether also five hours running time of old Nottingham film. All the material is gradually being made available to students and the general public. The Society has already published 15 volumes of Victorian Nottingham and 5 volumes of Old Nottingham each volume contains over 100 illustrations plus extended commentary.

1242

Owner Bernard W Beilby
Location 630 Western Boulevard Nottingham 0602 76891
Dates 1858 -
History This collection originated from an inheritance of about 3¼"x3¼" slides taken before the first world war. It was then added to in 1956 when J Holland Walker, former secretary of the Thornton Society of Nottinghamshire gave his collection of glass slides
Photographer A E Beilby B W Beilby Mr Laughton J Holland Walker
Subjects NOTTINGHAMSHIRE architecture historical remains of Europe and the Middle East
Numbers pr 650 b&w various fi negs c800 b&w 35mm L sl 5000 b&w 3¼"x3¼" sl 350 b&w 200 col 2"x2"
Aids Catalogue subject index
Access Bona fide students
Copies could be made available for bona fide students
Charges Print fee at cost no reproduction fee if not for financial gain credit line required and offprint

1243

Owner Derbyshire County Council
Location Public Library Tamworth Road Long Eaton Nottingham NG10 1JG Long Eaton 5426
Custodian P A Langham
Dates c1860 (1951) -
Subjects NOTTINGHAM Long Eaton - local history
Numbers pr 3500 fi negs 87 gl negs 29

Key () = dates when collections were begun or terminated
C = Century c = approximately pr = print fi = film
gl = glass neg = negative sl = slide L sl = lantern slide
tr = transparency mic = microform col = colour

b&w = black and white ¼,½,1-pl = quarter,half and whole plate * single copy, no public access ** = single copy, access by appointment

fi 2 16mm
copy negs of some images
Aids Card index
Access General public to items selected from index
Copies available

1244

Owner Nottinghamshire County Council
Location Central Resources Section County Library
South Sherwood Street Nottingham NG1 4DA
0602 43591
Title Pictorial Survey of Nottinghamshire
Custodian Head of Local Studies Library
Dates c1860 (1918) -
History The collection was built up by nine independent
library systems amalgamated in 1974
Photographer Samuel Bourne Joseph Byron
Francis Frith
Subjects NOTTINGHAMSHIRE all aspects
Numbers pr c40000
Aids Classified topographically and then by subject
Access General public Monday to Friday 9am - 8 pm
Saturday 9 am - 4 pm
Copies available for sale for loan
Charges Print fee reproduction fee commercial rates
Notes Enquiries accepted by post, telephone or in person.
Copyright of some items in the collection does not lie
with the County Council and permission to reproduce
such material must be sought from the copyright
holder.

1245

Owner Nottinghamshire County Council 0602 247858
Location Gedling House Wood Lane Gedling
Nottingham NG4 4AD
Title Nottinghamshire Educational Museum Service
Topographical Collection
Custodian P R Cousins
Subjects NOTTINGHAMSHIRE all aspects local
traditional craftsmen
Numbers pr c750 b&w 5"x7" 10"x8"
fi negs c100 b&w 6cm x 6 cm
Aids *Card index *subject index
Access Bona fide students
Copies available for sale for loan to Educational bodies
others by arrangement
Charges Print fee reproduction fee by arrangement

1246

Owner Nottinghamshire County Council
Location Nottinghamshire Record Office County House
High Pavement Nottingham NG1 1HR 0602 54524
Custodian A J M Hemstock
Dates c1880 (c1949) -
Subjects NOTTINGHAMSHIRE education customs and
folklore architecture historic and newsworthy
events
Numbers pr c400 b&w various
Aids *Card index
Access General public bona fide students
Copies available for sale by special arrangement
Charges Print fee commercial rates reproduction fee £1

1247

Owner Nottinghamshire County Council
Location Public Library Memorial Avenue Worksop
Nottingham 0909 2408
Title Worksop Local History Collection
Custodian Miss B M Attenborough
Dates 1900 (1938) -
Subjects NOTTINGHAM Worksop - town life
local government customs and folklore archaeology
civil and building construction mining architecture
recreations geography events
Numbers pr c600 b&w 3"x3"
fi negs c1000 b&w 2"x2"
L sl c200 b&w 3¼"x3¼"
sl 50 col 35mm
Access Bona fide students
Charges Print fee at cost

1248

Owner Nuthall and District Local History Association
Location c/o 14 Temple Drive Nuthall Nottinghamshire
Title Nuthall and District
Custodian T Leafe Secretary
Dates (1971) -
Subjects NOTTINGHAMSHIRE - Nuthall Watnall and
Awsworth - photographic survey
Numbers sl 35mm

1249

Owner Cherwell District Council Bodicote House
Bodicote nr Banbury Banbury 52535
Location Banbury Museum Marlborough Road Banbury
Oxford OX16 8DF
Title Banbury Museum Collection
Custodian Mrs Sarah Gosling
Dates c1920 (c1920) -
History The collection was started by William Potts who
was a Banbury historian and editor of the Banbury
Guardian
Photographer Blinkhorns of Banbury Henry Taunt
Subjects OXFORD Banbury religion social sciences
occupations and services army history associations
and societies transport customs and folklore
astronomy archaeology anthropology nature
zoology bridges agriculture and food production
domestic home clothes architecture painting
numismatics athletic and outdoor games biography
and portraits geography events
Numbers pr c650 b&w c30 col various
fi negs c75 b&w
gl negs 1586 b&w various
gl pos 2446 b&w col various
L sl c243 b&w col
sl c936 b&w col 3¼"x3¼"
Aids Accession register
Access General public bona fide students notice must be
given
Copies available for sale on request for loan only
occasionally

1250

Owner The Charlbury Society
Location Charlbury Museum Corner House Charlbury
Oxfordshire OX7 3PR
Title Charlbury Collection of Historical Photographs
Custodian R T G Smith Church Street Charlbury
Oxfordshire
Dates c1880 (1951) -
Subjects OXFORD Charlbury all aspects
Numbers pr 300 various 20 b&w sl 2 3"x3"
Access General public bona fide students
Copies available for loan by arrangement with Museum
Curator
Charges Depending on use

1251

Owner Woodstock Society
Location Oxfordshire County Museum Woodstock
Parish Council Woodstock Society National
Buildings Record
Custodian The Director Oxfordshire County Museum
Woodstock
Dates 1967 - 1970
Subjects OXFORD Woodstock architectural survey
Numbers pr 160 b&w 6½"x8½"
Aids Card index
Access Bona fide students

1252

Location The Bodleian Library Oxford OX1 3BG
Title Includes the Minn and the John Johnson Collections
Dates c1860 -
Photographer Julia Margaret Cameron
Subjects OXFORDSHIRE Oxford streets and buildings
architecture portraits topography manuscripts
Numbers pr substantial number some contained in albums
cartes de visite

daguerreotypes
sl
fi
Aids Catalogue accessions list indexes
Access 9 am - 10 pm during term time Monday to Friday
9 am - 7 pm during vacations Saturday 9 am - 1 pm
Bona fide students on production of duly filled in
application form or letter of introduction. Readers'
tickets from other institutions not acceptable
Copies available for sale
Charges Reproduction fee
Notes Includes the personal collections of many notable
Oxford photographers, dons, graduates and
Societies and an album by Julia Margaret Cameron.

1253
Owner Oxfordshire County Council
Location Central Library Westgate Oxford OX1 1DJ
0865 815749
Title Includes the Taunt Collection
Custodian M Graham
Dates 1860 (1924) -
Subjects OXFORDSHIRE social sciences towns and
village scenes buildings occupations and services
transport customs and folklore mechanical
engineering agriculture and food production
home interiors recreations biography and portraits
geography River Thames Gloucestershire
Berkshire Buckinghamshire aerial photography
Numbers pr c30000 b&w
gl negs c2000 b&w
L sl c400 b&w
tr 2261 b&w col
Access General public
Copies available for sale selected photographs will be
reproduced as postcards
Charges Print fee with negative from 75p without
negative from £1.50p sets of 6 postcards 30p per set

1254
Owner Oxfordshire County Council
Location County Planning Department Macclesfield House
New Road Oxford OX1 2EG 0865 722422
Title Aerial Survey of Oxfordshire - 1961
Custodian David Porter
Dates 1961
Subjects OXFORDSHIRE
Numbers pr c2400 b&w 9⅜"x9⅜"
Aids Key map
Access General public bona fide students picture
researchers press tv media 8.30 am - 5 pm
Copies available for display for loan for publication
Notes Original negatives no longer available.

1255
Owner Pinner and Hatch End Local Historical and
Archaeological Society
Location Local History Collection Reference Library
Civic Centre Harrow Middlesex 01 863 5611
Title Pinner and Hatch End Local Historical and
Archaeological Society Photographic and Street
Survey
Dates 1864 (1972) -
Photographer D Bednall
Subjects 1864 PINNER PARISH AREA street by street
survey interiors of certain houses
Numbers pr c50 b&w c1200 col 5"x3½"
fi negs c50 b&w c1200 col 35mm
Aids Guide card index by street name publication on
street survey available from the Secretary 66 Waxwell
Lane Pinner Middlesex
Access Library hours
Copies available for sale
Charges Print fee at cost

Notes Photographs to be used in conjunction with
completed street survey form file also housed in
Reference Library.

1256
Owner Dorset County Council
Location Poole Central Library Arndale Centre Poole
Dorset 020 13 3919
Title Poole Photograph Collection
Custodian Director of Libraries and Museums
Dates c1890 (1958) -
Subjects POOLE all aspects
Numbers pr 950 1-pl
Aids Card index
Access Bona fide students
Copies available for loan
Charges Print fee

1257
Owner F A J Emery-Wallis
Location Froddington Craneswater Park Southsea
Portsmouth Hampshire
Dates 1860 (1940) -
Subjects PORTSMOUTH SOUTH EAST HAMPSHIRE
social sciences occupations and services army
navy associations and societies education
communications transport portraits landscapes
events
Numbers pr c3000 b&w
gl negs c100 b&w
Access Bona fide students

1258
Owner W M Bushby
Location 1 Evesham Road Reigate Surrey
Dates 1880 (1898) -
Photographer Walter Bushby
Subjects REIGATE - personalities
Numbers pr c200 b&w
gl negs c270
L sl c270
tr c90 b&w
Access General public by arrangement
Copies available for loan for special purposes

1259
Owner Reigate Society and W A Hutchinson
Location Fairlead Chart Lane Reigate Surrey
Title Redhill, Earlswood and Merstham in the Borough
of Reigate and Banstead
Custodian W A Hutchinson
Dates 1956 -
Photographer W A Hutchinson
Subjects BOROUGH OF REIGATE AND BANSTEAD -
buildings landscapes townscapes trees
Numbers sl c400 35mm
Aids Catalogue
Access Bona fide students
Copies available for sale and loan
Charges Colour slides from 14p

1260
Owner R E Brinton
Location 52 Upton Road Ryde Isle of Wight
Title Ryde
Dates 1860 (1963) -
Subjects RYDE - town life hospitals lifeboat
transport docks and harbours architecture
seaside holidays
Numbers pr 300 b&w 175 col postcard and ½pl
gl neg 52 b&w various sizes
tr 300 b&w 50col 35mm
Aids *Card index
Access Bona fide students by appointment
Copies available for sale
Charges Print fee on application

Key () = dates when collections were begun or terminated
C = Century c = approximately pr = print fi = film
gl = glass neg = negative sl = slide L sl = lantern slide
tr = transparency mic = microform col = colour

b&w = black and white ¼, ½, 1-pl = quarter, half and whole
plate * = single copy, no public access ** = single copy,
access by appointment

1261
Owner Andrew Lanyon
Location Little Park Owles Carbis Bay St Ives
 Cornwall
Dates 1890 - 1930
History This collection of photographs is relevant to the
 history of St Ives, particularly to the decline of
 fishing and the beginnings of the art colony
Photographer J Douglas H Lanyon
Subjects ST IVES - rich and poor fishermen boats
 portraits cliff scenery farmland artists
Numbers gl neg c500 b&w $\frac{1}{4}$pl - 15"x12"
Access Individuals by arrangement
Copies Some postcard prints available special requests
 considered
Charges Reproduction fee by arrangement

1262
Owner Salop County Council
Location Record Office Shire Hall Abbey Foregate
 Shrewsbury Salop 0743 222100
Custodian Mrs M Halsord
Dates 1900 - 1910
Photographer G W Copeland Frances Frith R Hughes
 M Wright
Subjects SALOP Shrewsbury British Isles - topography
 landscapes Shrewsbury Infirmary churches bridges
Numbers pr
 fi negs
 gl negs
 gl pos all substantial numbers
Aids Lists
Access General public bona fide students

1263
Owner Salop County Council
Location County Museum Old Street Ludlow
 South Shropshire 0584 3851
Title Salop County Museum Collection
Custodian G I McCabe
Dates 1850 (1960) -
Subjects SALOP social sciences the forces associations
 and societies education transport customs and
 folklore microscopy geology palaeontology
 nature botany zoology agriculture and food
 production domestic home clothes recreations
 biography and portraits events
Numbers gl negs c20
 gl pos c20
 L sl c200
 sl c1000
Access Bona fide students
Copies available for sale on request only
Charges Print fee

1264
Owner Bishop's Castle Civic Society
Location Castle Mynd Bishop's Castle Salop
Title Listed Buildings of Architectural Interest in
 Bishop's Castle
Custodian Miss H Morton
Dates 1966 -
Subjects SALOP Bishop's Castle record of buildings
 from 1966 after alteration and modernisation
Copies available for sale if urgently required

1265
Owner Ironbridge Gorge Museum Trustees
Location Southside Church Hill Ironbridge Telford
 Salop
Title Ironbridge Gorge Museum Collection including
 Coalbrookdale Collection
Custodian S Smith
Dates 1850 (1880) -
Subjects SALOP Telford locality - industry foundries
 steam engines
Numbers pr 500 b&w 100 col
 fi negs c2000 b&w $\frac{1}{2}$pl
 gl negs c5000 b&w $\frac{1}{2}$pl 1-pl
 L sl 100 b&w 2$\frac{1}{2}$"x2$\frac{1}{2}$"
Aids *Catalogue *card index *subject index

Access General public bona fide students
Copies available for sale
Charges Print fee on application

1266
Owner Shrewsbury District Council
Location Clive House Museum College Hill Shrewsbury
Custodian R James Curator
Dates c1950 -
Subjects SALOP - topography buildings and townscape
 record
Numbers fi negs c200
 pl c150 1-pl
 L sl c3000 3$\frac{1}{4}$"x3$\frac{1}{4}$"
 sl 2500 col 35mm
Access General public on request
Copies available for loan for lectures and other uses
Charges Reproduction fee
Notes A comprehensive collection of the Shropshire
 scene in colour is being built up on the basis of these
 holdings.

1267
Owner Salop County Council
Location Public Library Castle Gates Shrewsbury Salop
Title Shropshire Collection
Dates 1888 -
History The collection stems originally from the holdings
 of the Shropshire Camera Club founded c1888
Subjects SALOP - all aspects biographical
Numbers pr c7050 various
Aids Card index
Access General public
Copies available for loan for use in publication

1268
Owner Salop County Council
Location c/o Shropshire Central Library Column House
 7 London Road Shrewsbury Shropshire 0743 52561
Title Local Collection
Custodian C W Jones
Dates c1860 (c1900) -
Subjects SALOP topography biography
Numbers pr c8000 b&w various
 fi negs c600 b&w
Aids Card index accessions register
Access General public bona fide students

1269
Owner Sandgate Society
Location 59 Sandgate High Street Sandgate Folkestone
 Kent
Title Sandgate Society Slides of Rene-Martin Album
 Sandgate Society Slides of Old Sandgate
Custodian Mrs L Lachlan Albion Cottage The Parade
 Sandgate Folkestone Kent Folkestone 38138
Dates c1890 -
History Began in form of photographic record of the
 Society's Exhibition Slides of pictures of Old Sandgate
Photographer A H T Todd
Subjects SANDGATE - views of old parts engravings
Numbers sl 284 col 35mm
Aids Card index
Access General public
Copies The Society would co-operate in trying to obtain
 permission from owner of originals and in obtaining
 the copy
Charges Print fee costs and expenses

1270
Owner Gerald H D Pitman
Location Upgrene 3 Higher Cheap St Sherborne Dorset
Title The Gerald Pitman Sherborne Pictorial Record
 Collection
Dates c1855 (c1945) -
Photographer Adam Gosney Gerald H D Pitman
Subjects SHERBORNE - all aspects
Numbers pr c2000 mainly b&w
 fi neg c500 3"x2" b&w
 L sl c50 3$\frac{1}{4}$"x3$\frac{1}{4}$" b&w
 sl c4000 2"x2" col

L

Access Bona fide students by appointment written
application to be made well in advance of
proposed visit
Copies available for copying a number of the earlier
photographs have been copied as 2"x2" slides
Charges Negotiable
Notes This collection includes prints and drawings
illustrating the buildings of Sherborne.

1271
Owner C & J Clark Limited
Location High Street Street Somerset 045 84 3131
Title Street Shoe Museum Collection
Custodian Elaine Dyer
Dates 1860 (1950) -
Photographer Frederick H Evans
Subjects SOMERSET Street village life politicians and
parliament bands schools fossils shoe factory
shoe machines shoe shops and interiors shoes
street scenes landscapes French fashions of late
1920's

Numbers pr c500 b&w
Access Bona fide students
Copies available for sale
Charges Print fee handling fee

1272
Owner Somerset County Council
Location Public Library Bridgwater Sedgemoor Somerset
Bridgwater 2597
Dates (1966) -
Subjects SOMERSET Bridgwater - buildings
Numbers pr substantial number col 2½"x2½"
Access General public bona fide students
Copies available for sale for loan

1273
Owner Shepton Mallet Amenity Trust Limited
Location 24 Leg Square Shepton Mallet Somerset
Custodian W Holt 52 Cowl Street Shepton Mallet Somerset
Dates c1914 (1965) -
Subjects SOMERSET - Shepton Mallet - buildings
Numbers fi negs c900 b&w
Access General public bona fide students Tuesday only
9 am - 5 pm

1274
Owner Somerset Archaeological and Natural History
Society
Location Taunton Castle Taunton Taunton Deane
Somerset Taunton 2429
Custodian Honorary Secretary
Subjects SOMERSET - topography archaeological
excavations botany
Numbers gl negs c6400 b&w various
L sl 4600 b&w 3¾"x3¾"
Aids Catalogue in preparation
Access Bona fide students

1275
Owner Somerset County Council
Location Somerset Record Office Obridge Road
Taunton Taunton Deane Somerset TA2 7PU
Taunton 87600
Custodian Ivor P Collis
Dates c1890 -
Photographer Messrs Chapman Francis Frith
Subjects SOMERSET urban views including Bath
Bridgwater Frome Minehead Taunton Wells
geography including Cheddar Gorge and caves
Wookey Hole Caves Tarr Steps and local
beauty spots
Numbers pr c300
gl negs c430
gl pos 4

Aids Topographical arrangement within individual
collections
Access Bona fide students
Copies available by arrangement

1276
Owner Staffordshire County Council Friars Terrace
Stafford 0785 53653
Location Central Library Manor Avenue Cannock
South Staffordshire
Title Local History Survey
Custodian R H Whiting
Dates Mid 19thC (c1961) -
Subjects STAFFORDSHIRE Cannock mining
architecture biography and portraits
Numbers pr c3500 b&w
Access General public bona fide students on application
Copies available for sale on request for loan
if negative available

1277
Owner Staffordshire County Council
Location Burton Library Union Street Burton on Trent
Staffordshire DE14 1AH 0283 63042
Custodian K S Stainsby
Subjects STAFFORDSHIRE Burton on Trent local history
Numbers pr c200 b&w
L sl c200 b&w 2¼"x2¼"
sl c100 b&w col 35mm
Aids Duplicated catalogue
Access General public

1278
Owner Staffordshire County Council
Location Reference Library Ironmarket Newcastle
under Lyme Staffordshire ST5 1AT
Title Local History Photographic Collection
Dates c1870 -
Photographer E Harrison
Subjects STAFFORDSHIRE Newcastle under Lyme
religion social sciences occupations and services
the forces associations and societies education
communications transport customs and folklore
recreations mining biography and portraits
geography events
Numbers pr c1450 c1370 b&w c80 col
sl c250 c150 b&w c100 col 2"x2"
Aids *Card index *subject index
Access General public bona fide students
Copies Negatives loaned
Notes Negatives (when available) are loaned to the public
when they require a copy print. Very occasionally
prints are loaned for copies to be made at the
borrower's own expense.

1279
Owner Staffordshire County Council
Location Staffordshire County Museum Shugborough
Stafford ST17 0XB 088 96 388
Title Department of Social History Photographic
Collection
Custodian Mrs Pamela Murray
Dates c1880 (1963) -
Subjects STAFFORDSHIRE - social sciences
occupations and services education rail transport
customs and folklore agriculture and food
production domestic home clothes
Numbers pr c3750 b&w 3"x4" 6"x8"
fi negs c1500
sl c300
Aids *Catalogue
Access Bona fide students
Copies available for sale for loan
Charges Print fee reproduction fee commercial rates

Key () = dates when collections were begun or terminated
C = Century c = approximately pr = print fi = film
gl = glass neg = negative sl = slide L sl = lantern slide
tr = transparency mic = microform col = colour

b&w = black and white ¼,½,1-pl = quarter, half and whole
plates * = single copy, no public access ** = single copy,
access by appointment

1280
Owner Staffordshire County Council
Location Record Office William Salt Library
Eastgate Street Stafford 0785 3121 Ext 156
Custodian F B Stitt
Dates 1860 (c1920) -
Photographer G S McCann B Sinkinson
Subjects STAFFORDSHIRE religion social sciences
occupations and services the forces associations
and societies education communications
transport customs and folklore zoology
mechanical engineering bridges mining
agriculture and food production domestic home
clothes ceramics architecture painting
antique furniture pageants outdoor games
biography and portraits geography historic and
newsworthy events
Numbers pr c9000 b&w various
fi negs 100 b&w
gl negs 4000 b&w $6\frac{1}{2}$"x$4\frac{1}{2}$" $8\frac{1}{2}$"x$6\frac{1}{2}$"
L sl 200 b&w
sl 2500 b&w
Aids *Catalogue partial card index partial subject index
Access General public bona fide students

1281
Owner Staffordshire County Council
Location City Central Library Bethesda Street
Stoke on Trent Staffordshire ST1 3RS 0782 44338
Title Bentley Collection
Custodian V Tyrell
Dates (c1962) -
Subjects STAFFORDSHIRE Stoke on Trent - photographic
survey neighbouring towns and villages
Numbers sl 9662 35mm
Access General public bona fide students Tuesday
9 am - 9 pm Monday Wednesday and Friday
9 am - 9 pm Thursday and Saturday 9 am - 5 pm
Copies available by special arrangement
Charges Print fee commercial rates

1282
Owner Newcastle under Lyme Borough Council
Location Borough Museum Brampton Park Newcastle
under Lyme Staffordshire Newcastle under Lyme
619705
Title Newcastle under Lyme Photographic Archives
Dates 1860 (1943) -
Subjects NORTH STAFFORDSHIRE local government
transport customs and folklore archaeology
electrical appliances and machines factory
equipment mining ceramics architecture
circuses pageants historic and newsworthy events
Numbers fi negs 4000 b&w 35mm
sl 300 col 35mm
Aids *Card index *subject index
Access General public bona fide students on application

1283
Owner Mrs Dent-Brocklehurst
Location Sudeley Castle Winchcombe Cheltenham
Gloucestershire GL54 5JD 0242 602308
Custodian A E Salmon
Dates c1860 -
Subjects SUDELEY CASTLE - family groups servants
in the 1860's
Numbers pr c50
Access Bona fide students by appointment only
Copies available by arrangement
Charges Print fee by arrangement
Notes Photographs are not in a compact collection,
some on public view, some in various parts of the
house.

1284
Owner Aldeburgh Museum Trustees
Location Moot Hall Aldeburgh Suffolk
Custodian J Marsh
Dates 1880 (1940) -
Subjects SUFFOLK Aldeburgh - all aspects
Numbers pr c180

Aids Prints contained in albums
Access General public bona fide students

1285
Owner Waveney District Council
Location Council Offices 12 Earsham Street Bungay
2176
Title Bungay Museum Collection
Custodian Dr L H Cane 19 Trinity Street Bungay Suffolk
Bungay 2891
Dates c1880 -
Subjects SUFFOLK Bungay town life architecture
street scenes
Numbers pr various
Access General public bona fide students

1286
Owner G F Cordy
Location 47 Undercliff Road West Felixstowe Suffolk
Felixstowe 4709
Dates 1854 (c1950) -
Photographer C J Emeny
Subjects SUFFOLK Felixstowe - dock and railway
sea front (beach and promenade) early sea planes
paddle steamers World War I
Numbers pr c300 $6\frac{1}{2}$"x$8\frac{1}{2}$"
Access General public bona fide students at the owners
discretion and by appointment only
Notes Includes some of the C J Emery Collection.

1287
Owner East Anglian Magazine Limited
Location 6 Great Colman Street Ipswich Suffolk
IP4 2AE 0473 56291
Dates 1890 (1946) -
Subjects SUFFOLK NORFOLK ESSEX
CAMBRIDGESHIRE
Numbers pr c3000 b&w various
gl negs c720 b&w
tr 50 col
Aids Card index subject index
Access By prior arrangement
Copies available
Charges Print fee by arrangement reproduction fee

1288
Owner Ford Jenkins Limited
Location The Studio 11 The Bridge Lowestoft Suffolk
Lowestoft 4647
Custodian H Jenkins
Dates 1896 -
Photographer Ford Jenkins H Jenkins
Subjects SUFFOLK fishing fishing craft fishermens
heads harbour activities herring fishery
fishery protection gun boats wrecks sailing smacks
sailing wherries
Numbers gl negs c1000 b&w various
L sl c500 b&w
Access General public picture researchers press tv
media 9 am - 5 pm
Copies available for sale for publication
Charges Reproduction fee print/transparency fee
handling fee search fee

1289
Owner Ipswich Borough Council
Location Borough Planning Department Civic Centre
Civic Drive Ipswich Suffolk 0473 211211/211511
Custodian G I Ramsdale
Dates (1960) -
Subjects SUFFOLK Ipswich - photographic survey
Numbers sl c2000 col 35mm
Aids Card index
Access Bona fide students

1290
Owner Ipswich Borough Council
Location Main Museum High Street Ipswich Suffolk
IP1 3QH 0473 213761
Branch Museum Christchurch Mansions Ipswich
Suffolk 0473 53246

Title Ipswich Museums Collection
Custodian Patricia M Butler
Dates Late 19thC (1880) -
Subjects SUFFOLK Ipswich transport palaeontology archaeology botany domestic home clothes arts and crafts painting numismatics textiles toys antiques
Numbers L sl c200
 pr and postcards
Access General public bona fide students by appointment only

1291
Owner Suffolk County Council
Location Area Library Clapham Road Lowestoft Suffolk Lowestoft 66325
Title Lowestoft Local History Photographic Collection
Custodian W James
Dates 1860 (c1950) -
Photographer Michael Barrett Ford Jenkins H Jenkins
Subjects SUFFOLK Lowestoft social sciences lifeboats and lighthouses transport architecture antiques recreations biography and portraits
Numbers pr c3000 b&w 20 cm x 16cm 13cm x 8cm
 fi negs 125 b&w
 gl negs 250 b&w
 sl 200 col 35mm
Access General public
Copies available subject to copyright
Charges Reproduction fee

1292
Owner Suffolk County Council
Location Record Office Ipswich Branch County Hall Ipswich Suffolk IP4 2JS 0473 55801
Title Includes Suffolk Photographic Survey Suffolk Building Record Vick Collection Munro-Cautley Collection Girling Collection Cowell Collection Backhouse Collection Lovell Collection
Custodian W R Serjeant
Dates c1860 -
Subjects SUFFOLK views and buildings domestic industrial and ecclesiastical architecture mills architectural details agriculture industry transport biography and portraits
Numbers pr c17000 b&w various
 gl negs c28000 b&w various
 sl c700 35mm
Aids Catalogue duplicated subject indexes place and subject card indexes to some parts only
Access General public advance notification required
Copies available for sale
Charges available on request

1293
Owner Brian R Blackman
Location 21 Hilltop Road Reigate Surrey RH2 7HL Reigate 42182
Title Reigate, Surrey
Dates 1968 -
Photographer Brian R Blackman
Subjects SURREY Reigate town and locality buildings studies of local children in schools boys in cub packs and scout troops
Numbers pr c1000 col 2½"x3½"
Access Bona fide students
Copies available for sale
Charges Print fee 2½"x3½" from 20p
 Kodacolour print negs from 40p

1294
Owner Runnymede District Council
Location Chertsey Museum Windsor Street Chertsey Surrey 093 28 3423
Custodian J L Bentley

Dates 1879 (1965) -
History Includes small collections from local residents of Chertsey area
Subjects SURREY Chertsey area - all aspects
Numbers pr c1000 various
 sl c100 35mm
Aids All photographs in labelled transparent bags
Access General public bona fide students under supervision of museum staff
Copies available for sale for loan to responsible organisations
Charges Print fee black and white from 35p ½pl

1295
Owner Claygate Village Residents' Association
Location 11 The Elms Church Road Claygate Surrey
Title Old Claygate
Custodian Charles McLeod Secretary
Dates Late 19thC -
Subjects SURREY - Claygate - views and groups old postcards
Numbers pr 40
 postcards 40
Access General public on request
Copies available for loan for short periods on request no objection to copies being made when on loan

1296
Owner London Borough of Croydon
Location Reference Library Katherine Street Croydon CR9 1ET 01 688 3627
Title Photographic Survey and Record of Surrey
Custodian Chief Librarian
Dates 1902 (1902) - 1953
Subjects SURREY - topography buildings events
Numbers pr c9000
 L sl c1000
Aids Stock Register
Access General public bona fide students on application
Copies available for sale upon application

1297
Owner Dorking and Leith Hill District Preservation Society
Location Barthorpe Deepdene Avenue Drive Dorking Surrey
Custodian J Carter Secretary
Dates 1967 -
Subjects SURREY Dorking and district local history
Numbers pr c500 5½"x3½"
 L sl c300
 pictures 50 various
Access Bona fide students
Copies available subject to laws of copyright

1298
Owner Elmbridge Borough Council
Location Weybridge Museum Church Street Weybridge Surrey KT13 8DE 0932 43573
Title Local History Photographic Collection
Custodian Mrs Avril Lansdell
Dates c1870 (1909) -
History Photographs collected by museum staff and donated by local residents since 1909
Subjects SURREY - Walton Weybridge Horsham Esher Molesey Claygate Thames Ditton Cobham village life town life local government fire service hospitals parks and cemeteries army - personnel training postal services transport archaeology bridges clothes architecture outdoor games rivers and lakes farms pubs recreations
Numbers pr c1000 b&w various
 fi negs c300 b&w 35mm
 gl negs c100 b&w various
 sl c1000 col 35mm
Aids Card index subject index
Access General public bona fide students

Key () = dates when collections were begun or terminated
C = Century c = approximately pr = print fi = film
gl = glass neg = negative sl = slide L sl = lantern slide
tr = transparency mic = microform col = colour

b&w = black and white ¼, ½, 1-pl = quarter, half and whole plate * = single copy, no public access ** = single copy, access by appointment

Copies available for sale by arrangement
Charges Print fee from 20p

1299

Owner Waverley District Council
Location Farnham Museum 38 West Street Farnham
Surrey GU9 7DX 025 13 5094
Title Farnham Museum Collection including John Henry
Knight Collection
Custodian H G A Booth
Dates 1880 (1967) –
History John Henry Knight born 1847 of Farnham Surrey,
inventor of the brick laying machine, hopground digger,
'Trusty Oil Engine' first English Two Seater motor
car. Author of 'Light cars and Voiturettes',
'Electric lighting for Country Houses' etc
Photographer John Henry Knight
Subjects SURREY Farnham rural crafts farming
architecture transport
Numbers pr c20 b&w 10"x12"
gl negs c100 b&w 10"x12"
sl c1500 col 35mm
Aids Card index subject index
Access General public bona fide students on appointment
under supervision
Copies available for sale to order
Charges Print fee at cost

1300

Owner Surrey County Council
Location Godalming Library Godalming Surrey
048 68 22743
Title Godalming Local History Collection
Custodian J A Potter
Dates (c1950) –
Subjects SURREY Godalming social sciences
occupations and services associations and societies
education transport customs and folklore
archaeology domestic home clothes ceramics
architecture painting antiques recreations
biography and portraits geography
Numbers pr c1500 b&w various
L sl c350 150 b&w 100 col various
Aids *Card index *subject index
Access General public bona fide students
Copies available for loan

1301

Owner Guildford Borough Council Municipal Offices
High Street Guildford Surrey
Location Guildford Museum Quarry Street Guildford
Surrey
Custodian F W Holling
Dates c1850 –
Subjects SURREY portraits groups geography
Numbers pr c1000 b&w
fi negs c4500 b&w
gl negs c150 b&w
Aids *Card index *subjects index
Access General public bona fide students
Copies available for sale
Notes Includes three special collections. Survey of
churches 1936-1940. Survey of Guildford 1930.
Guildford 1920-1930.

1302

Owner Surrey County Council
Location Public Library North Street Guildford
Surrey GU1 HAL 0483 68496
Title Local History Illustrations Collection
Custodian Chief Librarian
Dates 19thC (1962) –
Subjects SURREY local history and topography
Numbers pr c400 b&w various
sl c200 col various
Access General public bona fide students

1303

Owner Haslemere Museum Trustees and Management
Committee

Location Haslemere Educational Museum High Street
Haslemere Surrey 0428 2112
Custodian Arthur L Jewell
Dates 1870 (1888) –
Subjects SURREY Haslemere Sussex Hampshire
geography social sciences postal services
associations and societies customs and folklore
anthropology nature biography and portraits
Numbers pr c1000 b&w
gl negs c200 b&w col
L sl c500
sl c500 b&w col
Access Members of the museum only bona fide students
very exceptionally
Notes The museum is a private institution with four trustees
and Management Committee: it is registered as a Charity
with the Department of Education and Science. It was
founded in 1888 and is essentially a teaching museum.

1304

Owner London Borough of Lambeth
Location Archives Department Minet Library
52 Knatchbull Road London SE5 9QY 01 733 3279
Title Surrey Collection
Custodian M Williams
Dates Mid 19thC (1890) –
Subjects SURREY SOUTH LONDON social sciences
occupations and services the forces associations
and societies education transport customs and
folklore civil and building construction domestic
pottery architecture recreations athletic sports
and outdoor games biography and portraits
geography events
Numbers pr c5000 b&w various
fi negs
L sl c500
mic 16mm 35mm
Aids *Card index
Access General public
Copies available by private arrangement only some
negatives available postcards for sale

1305

Owner Surrey County Council
Location Reigate Priory Bell Street Reigate Surrey
Title Reigate Priory School Museum
Custodian Mrs A J Ward
Dates c1910 –
Photographer Francis Frith
Subjects SURREY Reigate – local history Reigate
Priory
Numbers pr 90 b&w various
sl 100
Access General public bona fide students during school
term time only
Copies available for sale for loan

1306

Owner Surrey Archaeological Society
Location Castle Arch Guildford Surrey
Custodian G Underwood
Dates 1870 –
Subjects SURREY – archaeology churches buildings
Numbers pr c500 b&w
fi negs c400 b&w
L sl 1269 b&w
Aids Catalogue
Access Bona fide students
Copies available for sale for loan by arrangement
Charges Reproduction fee by arrangement

1307

Owner Surrey Heath District Council Council Offices
Bagshot Surrey
Location Camberley Museum Knoll Road Camberley
Surrey Camberley 64483
Title Local History Collection
Custodian Mrs M R Rendell
Dates 1880 (1936) –
Subjects SURREY local history of Camberley Frimley
Bagshot Windlesham Chobham

Numbers pr 380 b&w 20 col various
fi negs 80 b&w 20 col various
gl negs 1 b&w
sl 50 b&w 250 col 35mm
Aids Catalogue *card index *subject index
Access Bona fide students
Copies available for sale for loan
Charges Reproduction fee
Notes General public must make an application to inspect collection, giving 48 hours notice.

1308
Owner London Borough of Sutton
Location Central Library St Nicholas Way Sutton
Surrey SM1 1EA 01 643 4461
Title Local Illustrations Collection
Custodian R P Smith
Dates c1860 (1936) -
Subjects SURREY Sutton - people places buildings transport
Numbers pr 15000 b&w col various
fi negs c1200 b&w c20 col 35mm
gl negs c400 b&w various
gl pos c10 b&w various
L sl c400 b&w 4"x4"
tr c1250 b&w c1000 col 35mm
Aids Partial subject index
Access General public bona fide students

1309
Owner J J Greenwood
Location Deerings Place 50 Reigate Road Reigate
Surrey RH2 0QN
Dates c1870 - 1930
History All photographs are proofs from the original plates taken for Frith of Reigate and acquired on liquidation of same
Photographer Francis Frith
Subjects SUSSEX REIGATE/REDHILL
Numbers pr c200 b&w 8¼"x6"
Aids Card index in preparation
Access Bona fide students on application
Copies available for sale and loan
Charges Print fee

1310
Owner Joan A Astell 18 Hawth Hill Seaford
East Sussex Seaford 894567
Location Seaford Museum of Local History
"West House" Pelham Road Seaford East Sussex
Dates 1862 (1968) -
Photographer Francis Frith
Subjects EAST SUSSEX Seaford social sciences
local government transport wrecks architecture
recreations painting biography and portraits
geography mapping
Numbers pr c400 b&w various
gl pos 4 b&w
L sl 6 col
sl c1000 b&w 35mm
fi 2 b&w 9.5mm
Access Bona fide students during museum hours
a selection of photographs are on view to the public
Copies available by private arrangement only subject to copyright
Notes Included in the slides are copies of 18thC local papers, documents and maps.

1311
Owner East Sussex County Council
Location Public Library Church Street Brighton
East Sussex BN1 1UE 0273 691195
Custodian C Batt
Dates c1870 -
Photographer Francis Frith

Subjects EAST SUSSEX Brighton all aspects
transport archaeology world wide travel
London Brighton South Coast Railway sheep farming
charcoal burners London before the bombing
Queen Mary in dock under construction
Numbers pr c13700
fi negs c4000
L sl
postcards c30000

1312
Owner D A Calvert
Location 10 Highview Close Windmill Hill Herstmonceux
Hailsham East Sussex BN27 4TR Herstmonceux 2047
Dates 19thC (1971) -
Subjects EAST SUSSEX Herstmonceux - old buildings
portraits country life motor and horse buses
games teams farming street scenes
Hertsmonceux Castle
Numbers pr c15 b&w 10"x8"
fi negs c150 b&w 5"x4"
Access Bona fide students by appointment only
Copies available for sale

1313
Owner L S Davey
Location 22 Ferrers Road Lewes East Sussex
079 16 3197
Dates Mid 19thC - early 20thC
Photographer Case Miller Reeves
Subjects EAST SUSSEX - Lewes and district - all aspects
Numbers pr c500 b&w
Access Requests will be dealt with

1314
Owner East Sussex County Council
Location County Library Southdown House 44 St Anne's
Crescent Lewes East Sussex 079 16 5400
Title Newhaven Harbour and Dock Works
Custodian R Hassell
Dates 1879 - 1883
Subjects EAST SUSSEX sea transport docks and
harbours
Numbers pr 59 b&w 10½"x14¼"
Aids Contents list only
Access General public

1315
Owner East Sussex County Council
Location Eastbourne Area Library Grove Road
Eastbourne East Sussex BN21 4TL
Eastbourne 22834
Title Eastbourne Local History Collection
Custodian Area Librarian
Dates c1880 -
Subjects EAST SUSSEX Eastbourne street scenes
buildings portraits
Numbers pr c5000 b&w various
gl negs c5000 b&w ¼pl ½pl 1pl
L sl c1000 b&w 3"x3"
Aids *Card index *subject index
Access General public bona fide students

1316
Owner East Sussex County Council
Location Reference Library Central Library
Brassey Institute 13 Claremont Hastings
East Sussex TN34 1HE Hastings 420501
Custodian J Powys
Dates 1864 (c1890) -
History The collection includes some photographs taken
by Lord Brassey on his journeys around the world
Photographer Lord Brassey
Subjects EAST SUSSEX Hastings all aspects
world travel

Key () = dates when collections were begun or terminated
C = Century c = approximately pr = print fi = film
gl = glass neg = negative sl = slide L sl = lantern slide
tr = transparency mic = microform col = colour

b&w = black and white ¼, ½, 1-pl quarter, half and whole
plate * = single copy, no public access ** = single copy,
access by appointment

Numbers pr 5120 b&w 801 col various
fi negs 596 b&w various
gl negs 418 b&w 5"x4"
L sl 602 b&w 5 col 3"x3"
sl 302 b&w 75 col 35mm
fi 1 b&w 1 col 8mm
mic 73 b&w
Access General public bona fide students on request only

1317

Owner East Sussex County Council
Location Hove Area Reference Library Church Road
Hove BN2 3EG 0273 70472
Title Hove Area Library Photographic Collection
Custodian Judith Dale
Dates 1900 -
Subjects EAST SUSSEX Hove Brighton social sciences
Numbers pr 2898 b&w various
Aids *Card index *subject index
Access General public bona fide students
Copies available for loan

1318

Owner Miss M Wright 22 South Street Cuckfield
East Sussex Haywards Heath 3100
Location East Sussex County Record Office
Title Cuckfield Collection
Custodian Miss M Wright
Dates 1863 (1900) -
Subjects EAST SUSSEX Cuckfield - village life
architecture swimming portraits
Numbers pr 39
tr 50
Access General public bona fide students

1319

Owner East Sussex County Council
Location Lewes Area Library Albion Street Lewes
East Sussex BN7 2ND Lewes 4232
Title Lewes Photographic Survey
Custodian C Connelly
Dates 1968 (1971) - 1973
Photographer Miss Verna Smith
Subjects EAST SUSSEX Lewes architecture pageants
painting
Numbers pr 487 b&w 6½"x4¾"
Copy negs 262
Aids Self indexing with card cross-references inserted
Access General public
Notes The collection includes a personal photograph
album belonging to the late Lord Edward Gleichen
about 'The pageant of Ashdown Forest' Lidbroke Park
Forest Row with programme map and historical
notes (1929).

1320

Owner East Sussex County Council
Location Record Office Pelham House St Andrews Lane
Lewes East Sussex 07916 5400 Ext 580
Title Prints and Drawings Collection
Custodian A A Dibben
Dates c1870 (1954) -
Subjects EAST SUSSEX social sciences ships
architecture genealogy geography
Numbers pr c100 b&w various
Aids *Catalogue
Access General public 8.45 am - 4.45 pm Monday to
Thursday 8.45 am - 4.15 pm Friday

1321

Owner Sunday Times Magazine
Edward Reeves
Location (Sussex Archaeological Society) Barbican House
Lewes East Sussex
Title Reeves Collection
Custodian Edward Reeves
Dates 1855 -
History Collection founded by the owner's grandfather
who was a close friend of James Russell who was
once a Court Photographer

Subjects EAST SUSSEX Lewes portraits groups
local houses and views
Numbers pr c750000
gl negs substantial number various
L sl substantial number
Aids Recorded in number books typed lists at Barbican
House
Access Bona fide students
Copies available for sale

1322

Owner East Preston and Kingston Preservation Society
and R Standing 40 Sea Road East Preston West
Sussex Rustington 6859
Location c/o Baytree Cottage Sea Road East Preston
West Sussex BN16 1JP
Custodian Mr Eschbaccher
Dates 1900 (1972) -
Subjects WEST SUSSEX East Preston Kingston -
local history buildings people events carnival
procession
Numbers pr c200 b&w various
fi negs c200 b&w
Aids *Catalogue
Access General public bona fide students
Copies available for sale

1323

Owner Bognor Regis College of Education
Location Bognor Regis West Sussex PO21 1HR
024 33 5581
Title The Gerard Young Collection
Dates 19thC -
Subjects WEST SUSSEX Bognor Regis - local history
topography
Aids Grouped by place and topic
Access Bona fide students
Copies usually available
Charges Print fee

1324

Owner West Sussex County Council
Location Central Public Library Chapel Road Worthing
West Sussex Worthing 34928
Title Worthing and Sussex Photographic Survey
Custodian Local Studies Librarian
Dates c1870 -
History The collection was formed during the period
1940-1945 with material donated from various
sources. From 1955 systematic recording of building
and changes began and continues at present
Photographer Philip Johnson
Subjects WEST SUSSEX - churches archaeology
topography Worthing
Numbers pr c2000 b&w various
sl 2000 b&w 3¼"x3¼"
daguerreotypes 20
Aids Partially indexed
Access General public bona fide students publishers
press tv media

1325

Owner Horsham Museum Society
Location Horsham Museum Causeway Horsham
West Sussex 0403 4959
Dates c1850 (1893) -
Subjects WEST SUSSEX Horsham occupations and
services the forces associations and societies
transport customs and folklore architecture
athletic and outdoor games biography and portraits
Numbers pr c900 b&w various
gl negs c50
gl pos c40
L sl c200
Aids *Subject index
Access Bona fide students

1326

Owner The Marlipins Committee of Management
Location Marlipins Museum High Street Shoreham
West Sussex
Custodian Honorary Curator

Dates c1860 (1926) -
Photographer Frederick Page
Subjects WEST SUSSEX Shoreham social sciences
fire service lifeboats army training schools
vehicles docks and harbours airports bridges
architecture seaside holidays biography and
portraits
Numbers pr c1000 b&w
fi negs c500
gl negs c200
gl pos 1

1327

Owner West Sussex County Council
Location West Sussex County Library Tower Street
Chichester 0243 85100 Ext 642 0243 86563 Ext 5
Custodian R Huse
Dates 1890 (1971) -
Photographer Francis Frith
Subjects WEST SUSSEX social sciences
Numbers pr 1200 b&w 9"x5"
Access General public Bona fide students

1328

Owner West Sussex County Council
Location Record Office County Hall Chichester
0243 85100
Custodian Mrs P Gill
Dates c1860 (1950) -
Subjects WEST SUSSEX local history buildings
organisations historic and newsworthy events
Numbers pr c4000 b&w various
Aids *Card index
Access General public

1329

Owner Mrs A E Perrott
Location 9 Elton Parade Darlington Co Durham
0325 63981
Photographer Dr William Creighton Fothergill
Subjects TEESDALE autumn scenes landscapes plants
fungus Corgi dogs
Numbers pr 60 col 3"x5"
tr 90 col
Access Bona fide students press picture researchers
publishers tv media
Copies available by private arrangement for loan for
publication
Charges Reproduction fee

1330

Owner Tonbridge Civic Society
Location 7 Yardley Park Road Tonbridge Kent
Custodian Mrs Margaret Peckham Honorary Secretary
Dates 1964 -
Subjects TONBRIDGE - river townscape trees
scheduled buildings
Numbers pr substantial numbers

1331

Owner Tyne and Wear Metropolitan County Council
Location Laing Art Gallery and Museum Higham Place
Newcastle upon Tyne Tyne and Wear NE1 8AG
0632 26989
Title Laing Art Gallery Collection including The
Fenwick Collection
Custodian B Collingwood Stevenson
Dates c1850 (1904) -
Subjects TYNE AND WEAR Newcastle architecture
portraits local events circus fairground
painting engraving sculpture glass ceramics
textiles
Numbers pr substantial number b&w
L sl b&w
Aids Partial card index
Access General public bona fide students

Copies available for sale for loan for publication
Charges Reproduction fee from £3 print fee from £1
from existing negative c£5 if a negative has to be
made
Notes The Fenwick Collection includes a considerable
number of prints and original negatives related to the
circus and fairground.

1332

Owner Newcastle upon Tyne City Council
Location Newburn Central Library Denton Park Centre
West Denton Way Newcastle Tyne and Wear
NE5 2LF 0632 677922
Title Newburn Public Libraries Local History Collection
Custodian A Wilson
Dates 1890 (1971) -
Subjects TYNE AND WEAR Newburn and district
local history
Numbers pr 125 b&w 25 col various
gl pos 90 col 3½"x3½"
Access General public

1333

Owner Newcastle upon Tyne City Council - Trustees
Location Central Library New Bridge Street
Newcastle upon Tyne NE99 1MC 0632 610691
Title Newcastle City Libraries Local History Collection
Custodian Local History Librarian
Dates 1850 (1881) -
Photographer M Auty J P Gibson G Hastings
W Parry J Signey Thompson
Subjects TYNE AND WEAR NORTHUMBERLAND
DURHAM all aspects of North East life views
social sciences
Numbers pr c20000 b&w col various
fi negs c3000 b&w 5"x3"
gl negs c8000 b&w ¼pl ½pl 1pl
gl pos c4000 b&w ¼pl ½pl 1pl
L sl c4000 b&w 3¼"x3¼"
sl c9000 b&w 2"x2"
tr c1000 col 2"x2"
Aids *Card index *subject index
Access All photographic requests dealt with by staff
Copies available for sale
Charges Print fee from 20p plus 50p if negative has
to be made Dalcopies 20p

1334

Owner South Tyneside District Council
Location Central Library Ocean Road South Shields
South Tyneside Tyne and Wear 089 43 4321 Ext 36
Title Including Flagg and Willets Collection
Parry Collection
Custodian A Bishop
Dates c1880 (c1930) -
History Flagg and Willets Collection deposited by Miss
Flagg, local historian. Parry and the other
collections are donations
Photographer Miss Flagg Parry Willets
Subjects TYNE AND WEAR - South Shields social
sciences occupations and services transport
civic ceremonies archaeology biography and
portraits shipping
Numbers pr 4214 b&w 8½"x6½"
fi negs c134 b&w various
gl negs c2138 b&w various
L sl c30 b&w 3½"x3½"
Aids Subject index
Access Bona fide students under supervision
Copies available for sale
Charges Print fee from 13p ¼pl plus postage and packing
if relevant negative cannot be traced 55p will be
charged for a copy negative

Key () = dates when collections were begun or terminated
C = Century c = approximately pr = print fi = film
gl = glass neg = negative sl = slide L sl = lantern slide
tr = transparency mic = microform col = colour

b&w = black and white ¼, ½, 1-pl = quarter, half and whole
plate * = single copy, no public access ** = single copy,
access by appointment

1335
Owner Tynemouth Photographic Society Record Group
Location Front Street Tynemouth Tyne and Wear
Title County Borough of Tynemouth Past and Present
Custodian E Clark
Dates c1860 (1948)
Subjects TYNE AND WEAR Tynemouth religion
occupations and services the forces associations
and societies education communications
transport customs and folklore agriculture and
food production domestic home clothes architecture
recreations athletic sports and outdoor games
biography and portraits geography historic and
newsworthy events
Numbers pr c600 b&w 8½"x6½"
L sl c100 b&w 3¼"x3¼"
Aids *Card index *subject index
Access Bona fide students
Copies available for sale for loan
Charges Reproduction fee £1

1336
Owner Tyne and Wear Metropolitan County Council
Location Museum and Art Gallery Borough Road
Sunderland Tyne and Wear SR1 1PP 0783 70417
Custodian J Wilson
Dates 1850 -
Photographer Edward Backhouse J Dixon Johnson
P Stabler
Subjects TYNE AND WEAR transport archaeology
electrical appliances windmills mining antique
furniture period costume ceramics architecture
coins
Numbers pr b&w col various
fi negs 1500 b&w various
gl negs c475 b&w various
L sl 1000 col 35mm
mic b&w
Aids *Catalogue *card index *subject index
Access General public bona fide students under
supervision
Copies available for sale
Charges Print fee

1337
Owner A H Murgatroyd
Location 25 Forty Avenue Wembley Middlesex HA9 8JL
01 908 1730
Dates 1950 -
Photographer A H Murgatroyd
Subjects WEMBLEY - architecture sites finds
antiquities police: fire: ambulance service
coastal and mountain scenery botany
Numbers sl 50 b&w 650 col 2"x2"
Charges Reproduction fee by arrangement depending
on use
Notes This collection is used for lectures and will be left
to Wembley Historical Society.

1338
Owner Coventry City Council
Location Reference Library Bayley Lane Coventry
0203 25555
Title Local Studies Illustrations Collection
Custodian Miss V Gilbert
Dates c1865 (1946) -
Photographer Dr V Wyatt Wingrave
Subjects WARWICKSHIRE Coventry social sciences
the forces customs anf folklore archaeology
buildings recreations historic events
Numbers pr c9000 b&w various
fi negs 10 b&w col 16mm
gl negs c40 b&w ½pl
L sl c300 b&w 3"x3"
sl c60 col 35mm
Aids *Subject index
Access General public bona fide students
Copies available for sale on request for loan in specified
cases

Charges Consultation and loan facilities are free
negatives made by City Architect's Reprographic
Section cost £1 at present print fee on application
Notes The Local Studies Section includes material relating
to the novelist George Eliot and includes photographs
of places and people associated with her.

1339
Owner The Marquess of Hertford
Location Ragley Hall Alcester Warwickshire
078 971 2845
Dates 1958 -
Subjects WARWICKSHIRE Ragley Hall - interior and
exterior
Numbers postcards
Aids Guidebook
Access General public bona fide students May to
September except Monday and Friday
Copies Postcards and slides are on sale when the house
is open

1340
Owner Warwickshire County Council
Location Borough Library St Matthews Street Rugby
Warwickshire 0788 2687
Title Rugby Borough Library Photographic Survey
Custodian Borough Librarian
Dates 1841 (1948) -
Subjects WARWICKSHIRE Rugby town life local
government transport mechanical engineering
architecture biography and portraits customs
and folklore
Numbers pr 6180
Aids *Subject index
Access General public

1341
Owner Warwickshire County Council
Location Public Library Church Street Warwick
Warwickshire 0926 42215/42077
Custodian T W Howard County Librarian P Bolitho
Warwick Librarian
Dates c1900
Subjects WARWICKSHIRE - Warwick and district
Leamington Spa Kenilworth Coventry
Birmingham Stratford on Avon
Numbers postcards 1148
Access on request for reference only

1342
Owner Warwickshire County Council
Location Record Office Priory Park Cape Road
Warwick 0926 43431
Dates c1890 (1953) -
Subjects WARWICKSHIRE topography social sciences
prisons education transport customs and folklore
wind and water mills architecture biography and
portraits
Numbers pr c14000 b&w col ½pl
fi negs c4400 b&w col ½pl
gl negs c150 b&w col ½pl
sl c150 b&w col 35mm
Aids *Card index
Access General public bona fide students

1343
Owner Birmingham Metropolitan District Council
Location Local Studies Department Reference Library
Birmingham B3 3HQ 021 643 2948
Title Local Studies Illustration Collection
Custodian City Librarian
Dates c1870 (c1892) -
History The collection began when in 1892 over one
thousand photographs were donated to the Library by
the Warwickshire Photographic Survey. Soon after the
library was established as the offical repository for
the Survey. The Survey ceased to exist in the mid 1950s.
Since then the collection has grown by donations,
purchases and by sending out library photographers
to photograph new buildings, local affairs, incidents etc
Photographers Harold Baker William Jerome Harrison
F C Lewis Thomas Lewis Lewis Lloyd J H Pickard

Subjects WEST MIDLANDS Birmingham - all aspects
buildings slums geology royalty and nobility
Warwickshire - country life
Numbers pr c26650
gl negs c47120
L sl c6580
Aids Card index subject index
Access General public
Copies available on request
Charges Print fee reproduction fee on request

1344

Owner Black Country Society
Title Black Country Society Photographic Collection
Custodian President 98 Bescot Road Walsall West
Midlands 0922 27989
Dates 1869 -
Subjects WEST MIDLANDS all aspects of life in the Black
Country
Numbers pr c3000 b&w various
Aids *Catalogue in progress
Access Can be referred to on application to Secretary
49 Victoria Road Tipton West Midlands
Copies available for sale
Notes Copies of older photographs supplemented by
photographs taken since 1945.

1345

Owner Dudley Metropolitan Borough Council
Location Central Library St James's Road Dudley
DY1 1HR 0384 56321
Title Dudley Public Libraries Illustrations Collection
includes Dudley Photographic Survey T W King
Collection
Dates (1947) -
Subjects WEST MIDLANDS Dudley and the Black Country
all aspects - topographical architectural industrial
Numbers pr c12000 c100 col 10"x8" 6"x4"
fi negs c3600 35mm
gl negs c500 various
sl c3000 2"x2"
Aids Card index subject index
Access General public bona fide students
Copies available for sale for loan by personal call
Charges Print fee at commercial rates
Notes One of the leading sources for illustrations of all
aspects of Black Country life and Dudley.

1346

Owner Handsworth Historical Society
Location 39 Copthall Road Handsworth Birmingham
West Midlands B21 8JP 021 554 2828
Custodian Mrs B M Berry
Dates 1875 (1952) -
History There are several photographs in connection
with William Murdoch Matthew Boulton and James
Watt
Subjects WEST MIDLANDS old Handsworth
old Birmingham
Numbers pr 505
tr 423 2¼"x2¼"
gl pl 14
Aids Subject index for transparencies
Access General public on special occasions
bona fide students
Copies Not normally available
Charges Reproduction fee by negotiation

1347

Owner David Jewsbury Penmon 91 Old Street
Upton upon Severn Worcester WR8 0NN
Location Warwick Record Office Warwick
Title Jewsbury Collection
Dates 1850 (1935) - 1940
Photographer Hugh Taylor Trinder

Subjects WEST MIDLANDS Solihull local celebrities
and scenes mainly Victorian and Edwardian
Numbers L sl c100 b&w 3¼"x3¼"
Access Bona fide students on application to Archivist
at Warwick no items to be taken away
Copies available on application to owner with full reason
stamped and addressed envelope for reply
Charges Print fee reproduction fee on application

1348

Owner John Whybrow Limited
Location 200 Stratford Road Birmingham B11 1AB
West Midlands 021 772 4671
Title John Whybrow Collection
Dates 1870 (1960) -
Photographer Thomas Lewis Henry Joseph Whitlock
Subjects WEST MIDLANDS Birmingham buildings
street scenes
Numbers gl negs c1500 b&w 12"x10" 8½"x6½"
Aids *Catalogue
Access Picture researchers bona fide students press
tv media 9 am - 5 pm to original images
Copies available for sale for display for publication
Charges Reproduction fee print/transparency fee
Notes Part of this collection has been published in a book
by John Whybrow called 'How does your Birmingham
grow?'.

1349

Owner Metropolitan Borough of Sandwell Council
Location Smethwick District Library High Street
Smethwick Warley West Midlands
Title Sandwell Pictorial Civic Record Warley Pictorial
Record
Dates c1900 (c1926) -
Subjects WEST MIDLANDS Sandwell local history
including Smethwick West Bromwich Oldbury
Rowley Regis Tipton Wednesbury Warley
Numbers pr c8500 b&w col 8"x6"
gl negs c100 b&w
L sl c550 b&w
sl c250 col
Aids *Subject index
Access General public bona fide students
Copies available for sale for loan subject to certain
restrictions

1350

Owner Walsall Metropolitan District Council
Location Walsall Public Libraries Lichfield Street Walsall
West Midlands WS1 1TR 0922 21244 Ext 135
Title Local Studies Photographic Collection
Custodian Local Studies Librarian
Dates 1845 (1920) -
Subjects WEST MIDLANDS Walsall local history
Numbers pr 2700 b&w 8½"x6½"
L sl 200 b&w 3¼"x3¼"
Aids *Card index *subject index
Access General public bona fide students on application
only
Copies Photographs copied commercially on request
Charges Print fee commercial rates with negative
from 40p without negative from 70p

1351

Owner Wolverhampton Metropolitan District Council
Location Central Library Snow Hill Wolverhampton
West Midlands WV1 3AX 0902 20109
Title Wolverhampton and District Photographic Collection
Custodian T Mason
Dates 1870 (1870) -
Subjects WEST MIDLANDS Wolverhampton aerial
photography biography buildings civic regalia
historic events streets transport

Key () = dates when collections were begun or terminated
C = Century c = approximately pr = print fi = film
gl = glass neg = negative sl = slide L sl = lantern slide
tr = transparency mic = microform col = colour

b&w = black and white ¼, ½, 1-pl = quarter, half and whole
plate * = single copy, no public access ** = single copy,
access by appointment

Numbers pr 3000 b&w ½pl 1-pl
fi negs 500 b&w 35mm
gl negs 2500 b&w ½pl 1-pl
sl 500 col 35mm
Access General public

1352
Owner Whitby Literary and Philosophical Society
Location The Museum Pannett Park Whitby
North Yorkshire 0947 2908
Custodian Honorary Librarian
Dates Late 19thC -
History The Whitby Literary and Philosophical Society
was founded in 1823 by the Rev George Young and a
small group of enthusiasts
Photographer Frank Meadow Sutcliffe T Watson
Subjects WHITBY - and district people and places
Numbers pr substantial number
Aids Catalogue in preparation
Access Bona fide students

1353
Owner Douglas West
Location 66 High Street Whitstable Kent CT5 1BB
Whitstable 2415
Title Old Whitstable Photographs
Dates 1860 -
Subjects WHITSTABLE Whitstable oyster industry
Whitstable - Canterbury railway
Numbers pr c2000 b&w 2¼"x2¼" - 6½"x4¾"
gl negs c2000
Access General public
Copies available for sale
Charges Print fee from 55p
Notes All known historic photographs of Whitstable have
been copied and placed in the collection.

1354
Owner Calne Civic Society
Location Byeways Castle Walk Calne North Wiltshire
SN11 ODZ Calne 2662
Custodian Paul Buckeridge Secretary
Dates 1870 (1968) -
Subjects WILTSHIRE Old Calne district all aspects
Copies could be made available
Notes The Society's objective is the complete photographic
recording of the old parts of the borough on Calne.

1355
Owner Corsham Civic Society
Location Old Malt house High Street Corsham Wiltshire
Dunsford House Prospect Corsham Wiltshire
Custodian Miss B Neillson Mr T C Burnard
Dates 1930 -
Subjects WILTSHIRE Corsham buildings street
furniture stonework housing developments
Numbers pr c300 various
fi negs 102 35mm
Aids Index to be produced
Access General public bona fide students picture
researchers publishers press tv media
by arrangement
Copies available for sale

1356
Owner Malmesbury Civic Trust
Location Area Library Cross Hayes Malmesbury
Wiltshire SN16 9BG
Custodian Mrs M Feachem Dolphin Cottage Bristol
Street Malmesbury Wiltshire
Dates 1964 - 1965
Subjects WILTSHIRE Malmesbury - photographic survey
Numbers pr c700 b&w 6"x4"
Access General public bona fide students

1357
Owner The Lord Methuen
Location Corsham Court Chippenham Wiltshire
Dates c1870 -
Subjects WILTSHIRE Old Corsham

Numbers pr contained in c20 albums
sl c50
Access Bona fide students

1358
Owner Marlborough Civic Society
Location c/o Kennet Beeches 54 George Lane
Marlborough Wiltshire SN8 4BX
Custodian James D Young
Dates (c1969) -
Subjects WILTSHIRE Marlborough - architecture
local history photographic survey
Numbers pr
fi negs
Access General public bona fide students by appointment
only
Copies available for sale

1359
Owner Wiltshire County Council
Location Museum and Art Gallery Bath Road
Swindon Wiltshire Swindon 26161 Ext 560
Title Eric Arman Collection
Custodian S J Woodward
Dates 1860 (c1950) -
Subjects WILTSHIRE Swindon - social sciences
fire service parks and cemeteries transport
customs and folklore archaeology home interiors
biography and portraits geography historic and
newsworthy events
Numbers tr 1400 b&w 165 col 2"x2"
Aids Catalogue card index subject index
Access General public bona fide students picture
researchers press tv media 10 am - 5.30 pm
Copies available for sale for display for loan
for publication
Charges Reproduction fee print/transparency fee

1360
Owner Thamesdown District Council
Location Technical Services Civic Offices Swindon
Wiltshire 0793 26161
Title Aerial Survey of Swindon
Custodian The Controller
Dates (1964) -
Subjects WILTSHIRE Swindon - photographic survey
Access Bona fide private developers
Copies available for sale

1361
Owner Salisbury and South Wiltshire Museum Trustees
Location Salisbury and South Wiltshire Museum St Ann
Street Salisbury Wiltshire 0722 4465
Custodian H de S Shortt
Dates 1866 -
Subjects SOUTH WILTSHIRE dress uniforms tools
the forces-uniforms and regalia transport stations
public festivals ceremonies watches archaeology
anthropology farm-buildings machines tools
lands domestic home clothes ceramics
architecture painting numismatics textiles
toys events
Numbers pr c4000 b&w various
Aids *Card index *subject index
Access General public bona fide students on request only
Copies available for loan
Charges Reproduction fee £3 per photograph

1362
Owner Wirral Metropolitan Borough Council
Merseyside 652 6106
Location Local History Collections Bebington Library
and Birkenhead Library
Title Wirral Photographic Collection
Custodian Brian J Barnes
Dates Late 19thC -
History The collection was acquired by public donation
and commission
Photographer William Cull H Foster
Priestley and Sons Limited James A Waite
Subjects WIRRAL - history geography social sciences

Numbers pr c4800 b&w
 sl c370 b&w col
 mic c878 b&w
Aids Microfilm readers C A P S A2 microfilm printer
 slide projectors film projectors microfiche reader
Access General public
Copies available as required
Charges By arrangement

1363

Owner C C Houghton
Location Austin House Broadway Worcestershire
Title Broadway Village
Dates c1860 -
Subjects WORCESTERSHIRE - Broadway village -
 architecture street scenes
Numbers pr c400 b&w ½pl 1-pl
 L sl
Access Bona fide students publishers press tv media
Notes This very comprehensive collection of photographs
 was compiled by the owner who has been the village
 doctor for 38 years.

1364

Owner York City Council
Location Archives Department City Library Museum
 Street York North Yorkshire 0704 55631
Custodian R J Green
Dates c1909 - c1937
Photographer Hencock Longstaff
Subjects YORK education health education
 architecture - slums
Numbers gl negs 186 4"x3" 4½"x6½"
 L sl 107 3"x3"
Access General public bona fide students
Copies available on request
Notes Prints of the negatives dealing with housing are
 mainly in one large book kept by the Environmental
 Health Department 8 St Leonards Place York - access
 to which may be gained by first contacting the City
 Library Archivist.

1365

Owner York Georgian Society
Location The King's Manor York YO1 2EW
Custodian J A Hingston
Dates 1944 -
Subjects YORK AND YORKSHIRE Georgian architecture
Numbers pr 375
 sl 40
Aids Guide
Access Bona fide students
Copies available for loan

1366

Owner Leeds City Council
Location Reference Library Municipal Buildings Leeds
 LS1 3AP 0532 31301 Ext 364
Title Local History Department Print Collection
Custodian A B Craven
Dates c1857 (1872) -
Photographer Godfrey Bingley G Bernard Wood
Subjects YORKSHIRE Leeds local history
Numbers pr c30000 various
 L sl c700 b&w
 sl c50 col
Aids *Catalogue *card index *subject index
Access General public by request only
Copies available for sale
Charges Print fee subject to revision

1367

Owner Craven District Council
Location Craven Museum PO Box 13 The Town Hall
 Skipton North Yorkshire 0756 4079

Title John Crowther Collection Munn Rankin Collection
 John Peacock Collection
Custodian P J Harding
Dates c1895 - 1925
Photographer John Crowther F G Hudson John Peacock
 W Munn Rankin
Subjects NORTH YORKSHIRE Yorkshire Dales
 Skipton Crosshills - Glusburn area of South Craven
 country life and customs social sciences biography
 and portraits geology geography buildings
 archaeology rock formation physical features
Numbers gl negs 338 b&w various
Access Bona fide students
Charges Reproduction fee from £1 per print

1368

Owner The Dales Teachers Centre
Location Sussex Street Bedale North Yorkshire
 Bedale 2401
Custodian Miss J L Bickerton
Dates Late 19thC -
Subjects NORTH YORKSHIRE Swaledale - farming
 transport vernacular architecture costume smithy
 scenery sheep clipping sheep dipping croquet
 musicians Lake District Bedale railway Hull
 Scarborough Newcastle Durham Thurcroft
 Blackpool Fleetwood Norway
Numbers pr c200 b&w ½pl
Access Bona fide students by arrangement
Copies available on short loan
Notes These photographs form part of an educational
 collection of social history material for use by
 teachers in the North Yorkshire area.

1369

Owner D T Atkinson and Associates
Location 16 Kirkgate Ripon North Yorkshire HG4 1PA
 0765 3880
Custodian D T Atkinson
Dates 1863 (1950) -
Subjects NORTH YORKSHIRE - Ripon - all aspects
Numbers pr 400 b&w various
 fi negs c300 b&w various
 gl negs c100 b&w 5"x4" ½pl
 L sl 11 b&w
Aids Partial loose leaf index
Access Written enquiries only
Copies available for sale for publication
Charges Print fee reproduction fee IIP rates

1370

Owner W R Mitchell
Location 18 Yealand Avenue Giggleswick Settle
 North Yorkshire 072 92 2371
Dates 1892 -
Photographer T R Clapham
Subjects NORTH YORKSHIRE Austwick Liverpool Docks
 Bowland Sika Deer Lake District and Yorkshire
 personalities natural history Settle-Carlisle
 Railway Pennines
Numbers pr c130 b&w
 sl c100
Notes Includes an interesting study of a North
 Yorkshire village in Victorian times. This is a private
 collection not normally open to inspection.

1371

Owner North Yorkshire County Council Grammar School
 Lane Northallerton 0609 5381
Location Public Library Vernon Road Scarborough
 0723 64285
Title Scarborough Local History (Photographic) Collection
Custodian The Curator
Dates c1855 (1930) -

Key () = dates when collections were begun or terminated
C = Century c = approximately pr = print fi = film
gl = glass neg = negative sl = slide L sl = lantern slide
tr = transparency mic = microform col = colour

b&w = black and white ¼, ½, 1-pl = quarter, half and whole
plate * = single copy, no public access ** = single copy,
access by appointment

Subjects NORTH YORKSHIRE Scarborough social
sciences transport architecture biography and
portraits recreations geography
Numbers pr c1200 b&w various
fi negs c150 b&w
Aids *Subject index
Access General public bona fide students
Copies available for sale
Charges Print fee

1372
Owner Ryedale Museum
Location Hutton le Hole North Yorkshire
Custodian B Frank 075 15 367
Dates c1865 -
Subjects NORTH YORKSHIRE Ryedale local history -
especially rural domestic occupational brass bands
Numbers pr c100 b&w
Access General public view prints on show

1373
Owner Scarborough Borough Council
Location Scarborough Museum Vernon Road Scarborough
North Yorkshire 0723 69151
Title Archaeological Photographic Collection
Custodian J G Rutter
Dates (1950) -
Subjects NORTH EAST YORKSHIRE archaeology
archaeological sites
Numbers pr 2000 b&w
L sl 1000 b&w
Access General public bona fide students
Copies available for sale

1374
Owner H R Tempest
Location Broughton Hall Skipton North Yorkshire
BD23 3AE 0756 2267
Title Tempest Collection
Dates 1895 -
Photographer Miss Blanche Cecil Tempest
Mrs R S Tempest H R Tempest
Subjects NORTH YORKSHIRE - Broughton Hall
village life country life and customs Great Wars
army - personnel in action and training children at
play gardens dogs horses buildings interior
decorations and furniture antiques seaside holidays
horse riding ponycraft gymkhanas hunting
shooting portraits landscapes travel abroad -
South Africa
Numbers pr c100 b&w various
gl negs c700 b&w ½pl
Access by appointment to approved applicants only
Charges Reproduction fee

1375
Owner Tindale's of Whitby
Location 14 Skinner Street Whitby YO21 3AJ
North Yorkshire 0947 2084
Title Whitby and the area
Dates 1947 -
Photographer J Tindale
Subjects NORTH YORKSHIRE Whitby and district
Captain James Cook Captain William Scoresby
Numbers fi negs 75000 b&w 2¼"x2¼" 5"x4"
Aids *Card index *subject index
Access Picture researchers press tv media
9 am - 5.30 pm no physical access to negatives
Copies available for sale
Charges Reproduction fee

1376
Owner North Yorkshire County Council
Location Department of Biology Yorkshire Museum
Museum Gardens York YO1 2DR 0904 29745
Custodian T M Clegg
Dates 1905 - 1925
Photographer Oxley Grabham Sidney H Smith Watson
Subjects NORTH YORKSHIRE social sciences nature
biology food production - hunting trapping
fishing country life and customs flowers
flowering plants gardens trees ferns vertebrates

Numbers gl negs c3000 b&w ¼pl ½pl
L sl c900 b&w 3¼"x3¼"
Aids Catalogue
Access Bona fide students
Copies available for sale by arrangement
Notes Early 20th century 'Country Pursuits' strongly
represented.

1377
Owner Doncaster Borough Council
Location Reference Library Doncaster Central Library
Waterdale Doncaster DN1 3JE 0302 69123
Title The Bagshaw Collection
Custodian C Howarth
Dates Late 19thC - early 20thC
Photographer Bagshaw
Subjects SOUTH YORKSHIRE Doncaster - all aspects
Numbers gl negs c700 - 1000 b&w various
Access General public bona fide students
Copies available for sale

1378
Owner Rotherham Photographic Society
Rotherham Metropolitan Borough Council
Custodian Peter Brook
Dates c1900
Subjects SOUTH YORKSHIRE Rotherham - photographic
survey
Numbers pr b&w
L sl b&w
tr c400 col 35mm
Access General public bona fide students
Copies available by arrangement
Charges By arrangement

1379
Owner Sheffield City Council
Location Local Studies Department Central Library
Surrey Street Sheffield South Yorkshire
0742 734753
Custodian R F Atkins
Dates c1860 (1960) -
Subjects SOUTH YORKSHIRE - Sheffield - local history
portraits topography North Derbyshire - local
history topography
Numbers pr c30000 b&w 10"x8"
L sl c3000
tr c1300 35mm
Aids Catalogue
Access General public on request
Copies available for sale by special request
Notes The library plans to have postcards and slides
produced for general sale in the future.

1380
Owner E G Tasker
Location 102 Sackville Street Barnsley South Yorkshire
Title Barnsley, Yorkshire
History This collection illustrates the changes in the
streets of Barnsley. Names of occupants, trades, etc,
and the date of rebuilding between 1822 and 1972 are
noted in an accompanying text
Photographer E G Tasker
Subjects SOUTH YORKSHIRE - Barnsley
Numbers pr 1132 b&w 10"x8"
copy negs of some images
Aids Guide catalogue card index subject index
Access Bona fide students
Charges Reproduction fee depending on use
Notes Many of the photographs are reproduced in the
owner's 'History of Barnsley Streets'.

1381
Owner J Edward Vickers
Location 144 Steade Road Sheffield South Yorkshire
S7 1DU
Title Sheffield - Old and New
Dates Late 19thC (1956) -
Photographer J Edward Vickers
Subjects SOUTH YORKSHIRE Sheffield all aspects

Numbers pr c250 b&w various
fi negs c200 b&w 35mm 2¼"x2¼"
sl c300 b&w c1500 col 35mm
Aids List
Access Publishers by arrangement
Charges Reproduction fee by arrangement
Notes The collection is used in connection with lectures on Old and New Sheffield.

1382
Owner David K Atkinson
Location 47 Springfield Lane Morley Leeds West Yorkshire LS27 9PL
Dates 1962 -
Photographer David K Atkinson
Subjects WEST YORKSHIRE - Morley - record of building and streets transport industrial machinery slum clearance local dignitaries sporting events maps processions celebrations
Numbers pr c3000 b&w
fi negs c3000 35mm
sl c4000 b&w col 35mm
Access Bona fide students
Copies available for sale originals for loan for publication purposes only copy prints for loan
Charges Print fee commercial rates plus 20%
Notes 236 photographs from this collection have been published in a book of photographs of Morley by David K Atkinson.

1383
Owner Bradford City Council
Location Museums in Bradford Keighley Ilkley
Custodian Keeper of History Bolling Hall Museum Bowling Hall Road Bradford BD4 7LP 0274 23057
Dates c1850 (c1915) -
Subjects WEST YORKSHIRE local history people and views
Numbers pr c200
Aids Card index
Access General public by appointment only
Copies Permission to copy photographs for private use can be given at time of request for publication have to be referred to the Director
Notes Photographs are part of the collection of social history material collected as such and not as a photographic archive.

1384
Owner Bradford City Council
Location Bingley Library Myrtle Walk Bingley West Yorkshire BD16 1AW Bingley 68697
Custodian K Harries
Dates 1900 (1967) -
Subjects WEST YORKSHIRE Bingley - all aspects
Numbers pr c1400
Access General public bona fide students research students press tv media
Copies available for sale for display for loan for publication subject to copyright and suitability of material
Charges Print fee

1385
Owner Bradford City Council
Location Central Library Princes Way Bradford West Yorkshire BD1 1NN 0274 33081
Title Bradford Collection
Custodian W Davies
Dates Late 19thC (early 20thC) -
Subjects WEST YORKSHIRE Bradford - all aspects
Numbers pr c6000 b&w various
L sl c100 b&w
fi c1500 b&w 35mm
Aids Partial card index partial subject index
Access General public bona fide students picture researchers press tv media Monday to Friday

9 am - 9 pm Saturday 9 am - 5 pm
Copies Some of the prints are available for loan for publication credit line required
Charges Print/transparency fee

1386
Owner Bradford City Council
Location Central Library Prince's Way Bradford West Yorkshire BD1 1NN
Title Local Studies Illustrations Collection
Custodian W Davies
Dates (1959) -
Subjects WEST YORKSHIRE Bradford - photographic survey
Numbers pr c1300 b&w 6"x8"
fi negs c300 4"x2½" 6"x4"
Aids Lists arranged by area
Access General public bona fide students Monday to Friday 9 am - 9 pm Saturday 9 am - 6 pm
Copies available for sale for loan by arrangement
Charges No charge for consultation or loan reproduction fee

1387
Owner Bradford City Council
Location Public Library Station Road Ilkley West Yorkshire
Title Ilkley Local History Collection
Dates 1860 (1907) -
Subjects WEST YORKSHIRE Ilkley town life
Numbers pr 350 b&w 2"x4" - 10"x12"
L sl 20 b&w
Access General public bona fide students

1388
Owner Boston Spa Village Society
Location Clarendon Lodge 60 High Street Boston Spa West Yorkshire
Custodian Mrs B Scott Secretary
Dates 1871 -
Subjects WEST YORKSHIRE - Boston Spa - views houses - architectural and historical interest
Numbers pr b&w col
L sl
Access Bona fide students
Copies available for loan

1389
Owner Bradford City Council
Location City Hall Bradford West Yorkshire
Custodian C R Atkinson
Dates 1962 -
Subjects WEST YORKSHIRE Bradford - buildings photographic survey
Numbers pr b&w 4"x4"
fi negs b&w 2¼"x2¼"
Access General public bona fide students
Copies available for sale
Charges Print fee from 50p

1390
Owner Calderdale Metropolitan Borough Council
Location Bankfield Museum Halifax Calderdale West Yorkshire 0422 54823
Title Calderdale Museums Collection
Custodian The Director
Dates 1890 -
Subjects WEST YORKSHIRE Calderdale army inland-waterways horse drawn vehicles village life town life country life and customs architecture farming
Numbers pr c1000 various
Aids *Catalogue *card index
Access Bona fide students
Copies available for sale

1391
Owner Calderdale Metropolitan Borough Council
Location Calderdale Central Library Belle Vue Lister Lane Halifax West Yorkshire HX1 5LA
Title Photographic Survey of Calderdale
Dates 1965 -
Subjects WEST YORKSHIRE Calderdale buildings
Numbers pr c3000 b&w 10"x7¾" 6"x4¼"
Aids Card index
Access General public bona fide students
Copies available by arrangement with photographers
Charges Reproduction fee by arrangement with photographers

1392
Owner Calderdale Metropolitan Borough Council
Location Folk Museum of West Yorkshire Shibden Hall Halifax West Yorkshire 0422 52246
Custodian Pauline Millward
Dates c1870 (c1955) -
Subjects WEST YORKSHIRE Calderdale - buildings views social history crafts folk life social history of West Yorkshire textile machines costume
Numbers pr c550 various
fi negs c300
tr c900 35mm
Aids Card index subject index
Access General public bona fide students by appointment only

1393
Owner Calderdale Metropolitan Borough Council
Location Sowerby Bridge Branch Library Hollings Mill Lane Sowerby Bridge West Yorkshire 0422 31627
Custodian Mrs Susan Newbould
Dates c1860 -
Subjects WEST YORKSHIRE Sowerby Bridge all aspects
Numbers pr c200 b&w various
L sl c1100 b&w 3¼"x3¼" 2"x2"
Aids *Catalogue
Access General public

1394
Owner Ian Dewhirst
Location 14 Raglan Ave Fell Lane Keighley West Yorkshire BD22 6BJ
Dates c1850 (1960) - 1930s
Subjects WEST YORKSHIRE KEIGHLEY town life country life army training trams omnibus public festivals fairs street scenes recreations seaside holidays portraits landscapes - mainly European historic and newsworthy events
Numbers pr c50 b&w
fi neg c300 b&w
gl neg c500 b&w
L sl c200 b&w 3"x3"
Copies available for sale to picture researchers bona fide students authors
Charges Print fee 1pl from 50p

1395
Owner Horsforth Civic Society
Location 44 Fink Hill Horsforth West Yorkshire
Title Survey of Buildings in Horsforth
Custodian J Northrop
Dates 1880 -
Subjects WEST YORKSHIRE Horsforth survey of buildings local history
Numbers fi negs 300 35mm
sl 100 35mm
Access General public bona fide students on request

1396
Owner Bradford Metropolitan District Council
Location Area Library North Street Keighley West Yorkshire BD21 3SX 053 52 2309
Title Local Photographic Collection
Custodian G Kitching
Dates c1860 (c1930) -
Subjects WEST YORKSHIRE Keighley town life fire service transport ceremonies architecture biography and portraits aerial photography

Numbers pr c2500 b&w various
fi negs 400 b&w 2½"x2½"
gl negs c50 b&w 4½"x6"
sl 50 col 1"x1½"
Aids *Guide *card index *subject index
Access General public bona fide students on application
Copies available for sale at cost where negatives exist Negatives can normally be made for serious enquirers e.g. authors

1397
Owner Kirklees Metropolitan Borough Council Central Library Princess Alexandra's Walk Huddersfield West Yorkshire HD1 2SU
Location Central Library Wellington Road Dewsbury West Yorkshire 0924 465151
Custodian Frederick Smith
Dates 1859 (1961) -
Subjects WEST YORKSHIRE Dewsbury topography events personalities
Numbers pr c400 b&w 8"x6"
Aids *Catalogue
Access General public bona fide students

1398
Owner Kirklees Metropolitan Borough Council
Location Huddersfield Library Princess Alexandra's Walk Huddersfield West Yorkshire HD1 2SU 0484 21356
Title Demolished Buildings of Huddersfield
Custodian Chief Librarian and Curator
Dates (c1965) -
Subjects WEST YORKSHIRE demolished buildings in Huddersfield Batley Cleckheaton Colne Valley Derby Dale Dewsbury Heckmondwike Holmfirth Huddersfield Kirkburton Meltham Mirfield
Numbers pr c16000 10"x8"
fi negs c2000 35mm
contact prints
Aids Internal catalogue classified by subject and area
Access General public bona fide students
Copies available for sale
Charges From 75p

1399
Owner Leeds Civic Trust
Location Claremont Clarendon Road Leeds West Yorkshire
Custodian The Secretary
Dates 1870 (1968) -
Subjects WEST YORKSHIRE - Leeds - domestic and municipal architecture street views road views layouts
Numbers pr 10"x8"
fi negs c600 3½"x2½"
pl negs c300 8"x6"
Access 9 am - 5 pm by arrangement
Copies Requests would be considered

1400
Owner Leeds City Council and depositors
Location Leeds Archives Department Chapeltown Road Sheepscar Leeds 7 0532 628339
Custodian The Archivist
Dates 1890 -
Photographer Pearson and Denham
Subjects WEST YORKSHIRE Leeds Haworth street scenes aerial photographs planning photographs slums schools Boer War photographs U S A San Francisco - buildings biography and portraits travel in the U K drains and sewers machine tools
Numbers pr substantial number various
Access General public by appointment Monday - Friday 9 am - 5.30 pm Saturday - 9 am - 12.30 pm Lunch 12.30 am - 2 pm

1401
Owner Leeds City Council
Location Rothwell Public Library Marsh Street Rothwell Leeds West Yorkshire LS26 0AE 0532 822225

Title Rothwell Public Library Local Collection
Custodian D M Gulliver
Dates Late 19thC (1960) -
Subjects WEST YORKSHIRE Rothwell buildings
 people and events
Numbers pr c300 b&w
 sl 29 col 35mm
Access General public

1402

Owner Wakefield City Council
Location Area Library Headquarters Carlton Street
 Castleford West Yorkshire WF10 1BB 097 75 59552
Custodian Miss F M Milnes
Dates c1850 -
Subjects WEST YORKSHIRE Castleford town life
 nurses transport ceremonies archaeology
 bridges ceramics architecture street scenes
 recreations football rugby cricket biography
 and portraits aerial photography
Numbers pr c470 b&w c6 col
 sl c250 col 35mm
Aids Card index subject index
Access Bona fide students

1403

Owner Banff and Buchan District Council
Location Arbuthnot Museum and Art Gallery St Peters
 Street Peterhead Aberdeen AB4 6QD
 Peterhead 2554
Custodian G H Brebner
Dates Late 19thC (c1935) -
Subjects ABERDEEN Peterhead social sciences
 occupations and services the forces transport
 ceremonies archaeology civiland building
 construction clothes architecture geography
Numbers pr 1265 b&w various
 gl negs 750 b&w various
Aids *Subjects index
Access General public bona fide students
Copies available for sale
Charges Print fee

1404

Owner Angus District Council
Location Arbroath Public Library Hill Terrace
 Arbroath Angus Arbroath 2248
Title Arbroath Room Collection
Custodian G Moore
Dates c1850 (1930) -
Subjects ANGUS Arbroath all aspects
Numbers pr c1200 b&w
Aids *Card index *subject index
Access General public
Copies available by arrangement
Charges By arrangement

1405

Owner Angus District Council 20 West High Street
 Forfar Angus East Scotland Forfar 3468
Location Forfar Public Library
Title Local Photographic Collection
Custodian Ernest Mann
Dates 1840 (1965) -
Subjects ANGUS Forfar social sciences opera
Numbers pr c500 b&w various
Notes Two books have been published incorporating 160
 photographs from the collection.

1406

Owner Signal Tower Museum
Location Ladyloan Arbroath Angus Scotland DD11 1PU
Custodian Mrs K L Moore
Dates 19thC (1972) -
Subjects ANGUS Arbroath industry harbour
 engineering fishing lighthouse flax industry

Numbers pr c100 b&w various
 L sl 50 b&w
 sl 12 col 2"x2"
Aids *Card index
Access General public
Copies available
Charges Print fee

1407

Owner Argyll District Council
Location Rothesay Library The Moat Stuart Street
 Rothesay Bute 0700 3266
Title Argyll and Bute Library (Rothesay): Local
 Collection
Custodian Martin O'Dowd
Dates c1880 (c1953) -
Photographer J A R Darling
Subjects BUTE trams paddle boats steamers docks
 and harbours ceremonies seascapes monuments
 street scenes landscapes physical features
 mountains and hills historic and newsworthy events
 public buildings Rothesay Academy Norman
 Stewart Institute
Numbers pr 250 b&w col various
 fi negs 35 b&w 3"x2"
 postcards c120 b&w col 5½"x3½"
 zincographs 3 b&w 12"x8"
Access General public bona fide students
Copies available for loan to bona fide researchers

1408

Owner Buteshire Natural History Society
Location The Museum Stuart Street Rothesay Isle of Bute
Title Buteshire Natural History Society Collection
Custodian Donald T Maclagan 43 Crichton Road Rothesay
 Isle of Bute
Dates c1890 -
Subjects BUTE Rothesay - buildings transport events
 Clyde steamers
Numbers pr 150 b&w various
Access General public bona fide students under
 supervision
Copies available for sale from the custodian

1409

Owner William J Anderson
Location 111 Ralston Road Campbeltown Argyll
Title Old Campbeltown
Dates c1870 (1945) -
Subjects CAMPBELTOWN AND DISTRICT - transport
 fishing trade lifeboat streets characters
Numbers pr c600 b&w
Access Bona fide students
Copies available for loan by private arrangement

1410

Owner Renfrew District Council
Location Clydebank Public Library Dumbarton Road
 Clydebank Dunbarton 041 952 1416
Custodian Ian M Baillie
Dates Mid 19thC (1910) -
Subjects DUNBARTON - Clydebank - local history
Numbers pr c1200 b&w
 sl c120
Access General public bona fide students
Copies available for loan
Notes Includes material of some of the ships built at
 John Brown's yard and some 'blitz' photographs.

1411

Owner Dumfries and Galloway Regional Council
 Regional Council Offices Dumfries
Location Ewart Library Catherine Street Dumfries
 Dumfries 3820
Title Dumfries and Galloway Collection
Custodian D Donaldson

Key () = dates when collections were begun or terminated
C = Century c = approximately pr = print fi = film
gl = glass neg = negative sl = slide L sl = lantern slide
tr = transparency mic = microform col = colour

b&w = black and white ¼, ½, 1-pl = quarter, half and whole
plate * = single copy, no public access ** = single copy,
access by appointment

Dates c1860 (1931) -
Subjects DUMFRIES AND GALLOWAY
Numbers pr c1000
Access General public
Copies available for sale
Charges Print fee at cost

1412
Owner Dundee City Council City Chambers Dundee
 Angus Tayside Region Scotland
Location Central Library Albert Square Dundee DD1 1DB
 Dundee 24938/9
Title Dundee Public Libraries Photographic Collection
Custodian D M Torbes
Dates c1870 (c1910) -
History The greater part of the collection was gifted by a
 relative of the photographer Alexander Wilson who was
 a freelance photographer in Dundee c1870-1910
Photographer Alexander Wilson
Subjects DUNDEE local street scenes buildings
 portraits
Numbers pr c5000 b&w ¼pl ½pl
 fi negs c200 b&w 35mm
 gl negs c4000 b&w ¼pl ½pl
 L sl c1700 b&w
 sl 225 b&w
Aids Stock record
Access General public bona fide students
Copies available for sale limited numbers only
Charges Print fee
Notes There is a policy of reproducing the prints as
 postcards and in booklet form and at present only
 those prints which have been reproduced in this
 fashion are for sale.

1413
Owner Eastwood District Council
Location Eastwood District Libraries Capelrig House
 Capelrig Road Newton Mearns Glasgow G77 6NH
 041 639 4555/6677
Custodian Helen Young
Dates 1860 (1970) -
Subjects EASTWOOD Busby Eaglesham Clarkston -
 formerly country communities of Renfrewshire
Numbers pr 96 8½"x5½" 8½"x6½"
Aids Typed list
Access General public bona fide students by appointment
 only

1414
Owner Kirkcaldy District Council
Location Kirkcaldy Museums and Art Gallery War
 Memorial Grounds Kirkcaldy Fife Kirkcaldy 2732
Custodian The Curator
Dates 1890 (1959) -
Photographer McNaughton
Subjects FIFE Kirkcaldy transport customs and
 folklore geology archaeology botany plants
 zoology animals arts and crafts painting
 biography and portraits geography
Numbers L sl c1100 b&w 2¼"x2¼"
 sl c3750 b&w col 2"x2"
Aids *Catalogue
Access General public bona fide students

1415
Owner Dunfermline District Council
Location Dunfermline Public Library Abbot Street
 Dunfermline Fife Dunfermline 24404
Title Local History Collection
Custodian James K Sharp
Dates 1890 (1960) -
Subjects WEST FIFE DUNFERMLINE local history
Numbers pr c2000 c1500 b&w c500 col various
 sl 200
Aids *Card index
Access General public bona fide students
Copies available for sale
Charges Print fee

1416
Owner T and R Annan and Sons Limited
Location 130 West Campbell Street Glasgow Strathclyde
 G2 4UE 041 221 5087
Title Old Glasgow
Custodian John C Annan
Dates 1888 (1947) - 1939 -
Photographer Thomas Annan J Craig Annan John Annan
Subjects GLASGOW street scenes buildings - Cathedral
 University School of Art
Numbers gl negs c140 b&w 8"x6"
Aids Lists
Access General public picture researchers bona fide
 students press tv media 9 am - 5 pm
Copies available for display for sale for publication
Charges Print/transparency fee reproduction fee
Notes The collection was inherited by T and R Annan and
 Sons. It includes photographs of work by Charles
 Rennie MacIntosh and Greek Thompson who were
 notable Glasgow architects.

1417
Owner Glasgow City Council
Location The Mitchell Library Charing Cross
 Glasgow G3 7DN 041 248 7121
Title Graham Photographic Collection
Custodian W A G Alison
Dates c1845 - 1914
History William Graham was a Springburn locomotive
 driver and photographer
Photographer William Graham
Subjects GLASGOW AND DISTRICT - local history
Numbers pr c300
 gl negs c3000
 L sl c4000 3¾"x3¼"
Aids Card index
Access General public bona fide students
Copies available for sale

1418
Owner Stewartry Museum
Location St Mary Street Kirkcudbright South West
 Region Scotland
Custodian T R Collin Honorary Curator
Dates 1880 (1881) -
Subjects KIRKCUDBRIGHT country life and customs
 ceremonies windmills fishing portraits
 rivers and lakes pastoral geography
Numbers pr c100
 gl negs 50
Access General public on special application

1419
Owner Glasgow City Council
Location Botanic Gardens of the City of Glasgow
 Glasgow G12 0UE 041 334 2422
Custodian E Curtis
Dates c1865 -
Subjects LANARK Glasgow - Botanic Gardens plants
 orchids Kibble palace John Kibble
Numbers pr c300 various
Access Bona fide students by appointment only
Copies available by arrangement
Charges Print fee reproduction fee by arrangement
Notes The Kibble Palace is a noteworthy Victorian
 conservatory of glass and iron, re-erected here
 in 1873.

1420
Owner New Lanark Conservation
Location The Counting House New Lanark Lanarkshire
 Lanark 61345
Dates c1880 -
Subjects LANARK New Lanark falls of Clyde
Numbers sl c100 various
Aids Catalogue card index subject index
Access Bona fide students by appointment only

1421
Owner Mrs S Onwin
Location 11 Carfrae Gardens Edinburgh 031 336 2007

M

Dates c1840 - 1914
Subjects LANARK festivals street scenes portraits
Numbers gl negs c60 2¼"x2¼" ½pl
Notes This collection is the work of Mrs Onwin's father.

1422

Owner Strathclyde Regional Council
Location Strathclyde Regional Archives City Chambers
 PO Box 27 Glasgow G2 1DU 041 221 9600
Title Includes the Ralston Collection
Custodian Richard F Dell
Dates c1860 -
Photographer W Ralston Limited
Subjects LANARK Glasgow social sciences local
 government navy education transport engineering
 civil and building construction architecture
 personalities Clyde navigation and harbours
 industrial and commercial forms churches
 aerial views
Numbers pr c2000 b&w
 fi negs c3000 b&w
 gl negs c10000 b&w
 L sl c500 b&w
Aids Catalogue card index subject index
Access General public
Copies available for sale for loan
Charges Print fee at cost
Notes W Ralston Limited was established in 1856
 and is one of Britain's oldest photographic businesses.
 The collection of negatives contains a record of ships
 and traditional Clydeside industries.

1423

Owner Hamilton District Council
Location Central Library Cadzow Street Hamilton
 Lanarkshire West Region Hamilton 21188
Title Hamilton Public Libraries and Museum Photographic
 Collection
Custodian G Walker Hamilton Burgh Museum 229 Muir
 Street Hamilton Lanarkshire Hamilton 24230
Dates c1850 (1940) -
Photographer Thomas Annan
Subjects LANARKSHIRE Hamilton social sciences local
 government children at play transport docks
 and harbours customs and folklore archaeology
 mechanical engineering mining agriculture and
 food production home clothes architecture
 biography and portraits events
Numbers pr 2380 b&w ¼pl ½pl 1-pl
 fi negs 1800 b&w ¼pl
 gl negs 510 b&w ¼pl ½pl 1-pl
 gl pos 10 b&w 1-pl
 L sl 1400 b&w 3¼"x3¼"
 sl 1800 b&w col 35mm 4cm x 4cm
 mic 92 neg 100' rolls b&w
 95 pos 100' rolls b&w
Aids *Card index
Access Bona fide students

1424

Owner National Library of Scotland
Location George IV Bridge Edinburgh Midlothian
 EH1 1EW 031 226 4531
Dates 20thC -
Photographer D O Hill and R Adamson
Subjects MIDLOTHIAN Edinburgh transport bridges
 architecture climbing geography
Numbers pr c125000 b&w various
 L sl 216 b&w
 sl 910 col
Access General public bona fide students
Copies available for sale
Charges Print fee
Notes Includes Graham Brown Collection and 3 Portfolios
 of Hill and Adamson calotypes.

1425

Owner John Tweedie
Location 30 Palmer Road Currie Midlothian
Subjects MIDLOTHIAN Currie Colinton buildings
 industrial archaeology social sciences mills
 early farming
Numbers substantial
Notes Includes a study of land use from early farming to
 intensive urban development.

1426

Owner Orkney Natural History Society
Location Stromness Museum 52 Alfred Street Stromness
 Orkney
Custodian J A Troup
Dates c1905 (c1960) -
Photographer William Baikie George Ellison
Subjects ORKNEY lifeboats transport water mills
 agriculture and food production architecture
 geography
Numbers pr 11 albums
 gl negs c120
 L sl c80
Aids Each album is catalogued
Access General public bona fide students to albums only
Copies Mounted exhibition prints available for temporary
 loan only

1427

Owner Dr Kenneth Robertson
Location 'Tigh Geal' Daliburgh Isle of South Uist
 Outer Hebrides Lochboisdale 253
Title Lifestyle and Environment of Outer Hebrides
Dates 1956 -
Photographer Dr Kenneth Robertson
Subjects OUTER HEBRIDES - local people dwellings
 work and environment
Numbers fi negs c2500 b&w 2¼"x2¼" 35mm
 pos c100 col 2¼"x2¼" 35mm
Aids Contact sheets
Access Bona fide students
Copies available for sale
Charges Reproduction fee standard current rates

1428

Owner Perth and Kincross District Council
Location District Library Sandeman Public Library
 16 Kinnoull Street Perth 0738 23329
Custodian Arthur F Bryce
Title Perthshire Illustrations Collection
Dates Late 19thC (c1965) -
Photographer Dr W H Findlay
Subjects PERTH - local history
Numbers pr c1000 b&w 9"x6" 10"x8"
 gl negs c50 b&w 2½"x2½"
 sl c50 col 1½"x1"
Aids *Card index
Access General public bona fide students on application

1429

Owner Perth and Kinross District Council
Location Perth Museum and Art Gallery George Street
 Perth Perth 24241
Dates 1875 -
Photographer Magnus Jackson Messrs Wood of Perth
Subjects PERTH social sciences transport architecture
Numbers gl negs c5200 b&w 12"x10" 8½"x6½"
Aids *Card index
Access General public bona fide students
Copies of negatives and prints available
Charges Commerical rates

Key () = dates when collections were begun or terminated
C = Century c = approximately pr = print fi = film
gl = glass neg = negative sl = slide L sl = lantern slide
tr = transparency mic = microform col = colour

b&w = black and white ¼, ½, 1-pl = quarter, half and whole
plate * = single copy, no public access ** = single copy,
access by appointment

1430
Owner Renfrew District Council
Location Paisley Museum High Street Paisley PA1 1BA
 Renfrew 041 889 3151
Title Paisley Museum Collection
Custodian David R Shearer
Dates c1848 (c1880) -
Photographer James Mure Robert Russell
Subjects RENFREW Paisley parks hospitals
 associations and societies schools inland -
 waterways ships docks and harbours customs
 and folklore archaeology nature: biology
 botany: plants zoology: animals home clothes
 ceramics sculpture and carving architecture
 textiles shields of arms geography aerial-
 photography
Numbers pr c1000 b&w
 fi negs c1000 b&w
 gl negs c2000 b&w various
 gl pos 10 b&w various
 L sl c2000 b&w 3''x3''
 sl 500 col 35mm
Access General public bona fide students
Copies available for sale for loan
Charges Print fee on application

1431
Owner Roxburgh District Council
Location Hawick Museum Wilton Lodge Hawick
 Roxburgh Borders Region 0450 3457
Custodian Michael Robson
Dates c1860 -
Photographer John Y Hunter J E D Murray
Subjects ROXBURGH Hawick social sciences
 customs and folklore archaeology civil and
 building construction architecture recreations
 athletic sports and games biography and portraits
Numbers pr c700 b&w 8''x6'' 6''x4½''
 gl negs c400 b&w 8''x6'' 6''x4½''
 L sl 500 250 b&w 250 col 3''x3''
 sl c500 col 35mm
Access Bona fide students
Copies available for loan
Notes Catrail (Earthwork) - 70
 Hadrian's Wall - 100
 Border Pele Towers - 100
 Border Line between Scotland-England - 100.

1432
Owner Mrs E Maclean
Location 100 Henderson Street Bridge of Allan
 Stirling FK9 4HA Bridge of Allan 3191
Dates 1880 -
Subjects STIRLING Bridge of Allan - local history
 Royal visits
Access General public

1433
Owner Strirling District Council
Location Reference Department Stirling Public Library
 Corn Exchange Road Stirling FK8 2HX
 Stirling 3969
Custodian I Robertson
Dates c1850 -
Photographer George Washington Wilson
Subjects STIRLING - views personalities
Numbers pr c70 various contained in scrapbook
Access General public bona fide students picture
 researchers press tv media 10 am - 5.30 pm or
 7 pm
Copies available for loan
Charges Print/transparency fee

1434
Owner Ulster Museum Trustees
Location Armagh County Museum The Mall East
 Armagh BT61 9BE
Title Armagh County Collection
Dates Late 19th and 20thC (1935) -
Subjects ARMAGH social sciences occupations and
 services army associations and societies

education transport customs and folklore
geology archaeology botany mechanical
engineering civil and building construction
agriculture and food production home clothes
ceramics architecture numismatics recreations
outdoor games biography and portraits
Numbers pr c5000 b&w various
 fi negs c3000 b&w various
 gl negs c150 b&w ¼pl ½pl
 sl c2000 col 18x24mm
Access Bona fide students
Copies available for sale

1435
Owner Joseph Cafolla
Location 15 Conway Square Newtownards Co Down
 N Ireland 024 781 2185
Subjects CO DOWN Newtownards all aspects
Numbers pr small collection

1436
Owner Ifor Edwards
Location 'Berwyn' Park Road Ponciau Wrexham Clwyd
Dates c1920 -
Subjects CLWYD Wrexham old Ruabon parish
 religion village life industry schools transport
 architecture biography and portraits geography
 historic events
Numbers pr c1000 b&w ½pl
 fi negs
 sl 2000 b&w
Access Bona fide students

1437
Owner A W Furse
Location Nerquis Hall Mold Clwyd Pontybodkin 360
Dates c1880 - 1910
Subjects CLWYD Nerquis Hall
Numbers pr 9 ½pl
Access Written application please

1438
Owner Clwyd County Council
Location Record Office Old Rectory Hawarden
 Alyn and Deeside Clwyd 0244 532364
Title Clwyd Record Office Photographic Collection
Custodian A G Veysey
Dates Late 19thC (1951) -
History The collection includes some Gladstone family
 photographs
Subjects CLWYD Hawarden social sciences customs
 and folklore architecture events
Numbers pr c5000 b&w
Aids Arranged and listed by parishes
Access General public bona fide students
Copies available for sale

1439
Owner Dyfed County Council
Location Regional Library Headquarters Dyfed County
 Library Corporation Street Aberystwyth Dyfed
Title Ceredigion Photographic Collection
Dates c1880 (c1950) -
Subjects DYFED Ceredigion social sciences schools
 transport customs and folklore agriculture
 architecture seaside holidays biography and
 portraits geography historic and newsworthy events
Numbers fi negs c6000 b&w
 sl c2850 b&w col
Aids *Card index *subject index
Copies Certain items for loan

1440
Owner Lower Wye Valley Preservation Society
Location Rosehill Llandogo Monmouth Gwent
 St Briards 254
Custodian A W Thomas
Dates Late 19thC -
Subjects GWENT architecture - Monmouth Chepstow
 Wye Valley

Access By appointment with the Custodian
Charges Reproduction fee on application

1441
Owner Gwent County Council
Location Central Library John Frost Square Newport
Gwent NP6 1XG 0633 65539
Custodian M F A Elliott
Dates c1860 -
Subjects GWENT Newport - streets and buildings
Numbers pr c3000
Access General public bona fide students
Copies available by private arrangement

1442
Owner Monmouth District Council
Location Abergavenny & District Museum Castle Grounds
Abergavenny Gwent
Custodian R P Davies
Dates 1870 (1958) -
Subjects GWENT POWYS HEREFORDSHIRE all
aspects early aeroplanes social history of
Abergavenny
Numbers pr c200 b&w various
Aids Catalogue *card index
Access General public bona fide students

1443
Owner Gwynedd County Council
Location Caernarfon Record Office County Offices
Caernarfon Gwynedd 0286 4121
Custodian County Archivist
Dates 1850 (1947) -
Photographer Guy Hughes
Subjects GWYNEDD Caernarfonshire biography and
portraits geography shipping quarrying
Numbers pr 10000 b&w various
fi negs 500 b&w
gl negs 7000 b&w ½pl 1pl
gl pos 100 b&w 2"x3"
L sl 500 b&w
Aids *Card index *catalogue *subject index
Access General public bona fide students
Copies available for sale to order subject to depositor's
copyright For loan to schools only on application to
the Education Service
Notes Includes c1200 separate collections. Many are not
the property of the Gwynedd County Council but are
held on deposit.

1444
Owner Gwynedd County Council
Location Llangefni Central Library Lôn-Y-Felin
Llangefni Anglesey Gwynedd LL77 7RT
Llangefni 723262
Title Anglesey Area Illustrations Collection
Custodian J Clifford Jones
Dates c1930 (c1961) -
Subjects GWYNEDD Anglesey social sciences
lifeboats and lighthouses associations and societies
schools transport customs and folklore windmills
bridges agriculture and food production architecture
biography and portraits geography historic and
newsworthy events
Numbers pr c2100 b&w col various
sl 340 b&w col 35mm
fi 120 b&w col 35mm
Aids Accession List
Access General public bona fide students during normal
library opening hours
Copies available for loan for copying

1445
Owner South Glamorgan County Council
Location Central Library King Square Barry South
Glamorgan 044 62 5722

Title Barry Public Library Local History Collection
Custodian P John
Dates c1890 (1965) -
Subjects GLAMORGAN Barry - historical development
Barry Railway Company Barry Boy Scouts
Numbers pr c1500 b&w
fi negs c2000 b&w
Aids Partial guide
Access General public

1446
Owner Mid Glamorgan County Council
Location Rhondda Borough Libraries Administrative
Centre Treorchy Mid Glamorgan
Title Local History Photographic Collection
Custodian E Davies
Subjects MID GLAMORGAN Rhondda local history
Numbers pr 400 b&w 10"x8"
Aids *Card index
Access General public bona fide students under
supervision

1447
Owner South Glamorgan County Council
Location Central Library The Hayes Cardiff CF1 2QU
0222 22116
Custodian G A Dart
Dates c1864 (c1885) -
Subjects SOUTH GLAMORGAN Cardiff all aspects Wales
Numbers pr c12000 b&w various
sl 217 b&w col 50mm 82mm
fi 80 b&w col 35mm
Access General public

1448
Owner Royal Institution of South Wales/University College
of Swansea
Location Swansea Museum Victoria Road Swansea West
Glamorgan SA1 1SN 0792 53763
Title Includes Dillwyn Llewelyn Collection Vivian
Collection Ernest Morgan Collection
Custodian Dr D E Painting University College Library
Singleton Park Swansea SA2 8PP 0792 25678
Dates 1849 -
Photographer James Andrews H Bath Calvert Jones
J Dillwyn Llewelyn W H Fox Talbot
J H and P H Vivian
Subjects WEST GLAMORGAN local topography ships
family portraits
Numbers pr c300 b&w various
gl negs c50 b&w various
L sl c400 b&w 3¼"x3¼"
Aids Subject index to Royal Institution Collection only
Access Bona fide students
Copies available for loan by special request only

1449
Owner Daniel C Meadows
Location 36 Surrey Road Nelson Lancashire BB9 7TZ
0282 62994
Title The Free Photographic Omnibus
Dates 1973 - 1974
Photographer Daniel C Meadows
Subjects ENGLAND changing face of England
Numbers pr 175 b&w 10"x8"
fi negs c500 b&w
Aids *Subject index
Access Bona fide students
Copies available for sale for publication
Charges Reproduction fee of £2 per print
Notes Photographs from this collection have been
published in 'Living Like This' by Arrow books.

1450
Owner National Library of Wales
Location Aberystwyth Dyfed SY23 3BU 0970 3816/7

Key () = dates when collections were begun or terminated
C = Century c = approximately pr = print fi = film
gl = glass neg = negative sl = slide L sl = lantern slide
tr = transparency mic = microform col = colour

b&w = black and white ¼,½,1-pl = quarter, half and whole
plate * = single copy, no public access ** = single copy,
access by appointment

Custodian David Jenkins
Dates 1860 (1909) -
Photographer Francis Bedford W A Call Francis Frith
 Shirley Jones Arthur Lewis John Thomas
Subjects WALES social sciences customs and folklore
 architecture portraits period costume historic
 and newsworthy events transport mining - lead and
 gold geography
Numbers pr c2500 b&w various
 gl negs c10000 b&w various
 L sl c250 b&w $3\frac{1}{4}$"x$3\frac{1}{4}$"
Aids Card index
Access Bona fide students and holders of reader's tickets
Copies available for sale to order
Charges Print fee from 30p 35mm transparency from 5p
 microfilm minimum charge £1 microfilm
 printouts from 10p

1451
Owner Monmouth Museum Trustees
Location Monmouth Museum Monmouth
Title Monmouth Museum Collection
Custodian K E Kissack Dixton Cottage Monmouth
Dates 1860 (1955) -
Photographer Charles Rolls (of Rolls-Royce)
Subjects WALES Monmouth all aspects
Numbers pr c2500 b&w
 gl negs c1890 topographical
 L sl
Aids Catalogue card index
Access General public bona fide students from April
 to October
Copies available for sale
Notes Large number of aerial photographs.

1452
Owner Wales Tourist Board
Location Welcome House High Street Llandaff
 Cardiff South Glamorgan CF5 2YZ 0222 567701
Custodian Mrs Iris Davies
Dates 1968 -
Photographer Colin Molyneux
Subjects WALES tourism tourist enterprises scenery
Numbers pr 2500 b&w 10"x8"
 sl 5000 b&w $2\frac{1}{4}$"x$2\frac{1}{4}$" 35mm
 tr 12654 col $2\frac{1}{4}$"x$2\frac{1}{4}$" 35mm
Aids *Card index
Access General public bona fide students
Copies available for loan

1453
Owner K M Andrew
Location 17 Bellrock Avenue Prestwick Strathclyde
 Region KA9 1SQ 0292 79077/77503
Dates 1955 -
Photographer K M Andrew
Subjects SCOTLAND mountaineering landscape
 architecture social sciences geology natural history
Numbers pr c5000 b&w $8\frac{1}{2}$"x$6\frac{1}{2}$"
 fi negs c18000 b&w $2\frac{1}{4}$"x$2\frac{1}{4}$" $2\frac{1}{4}$"x$3\frac{1}{4}$"
 sl c15000 col 35mm $2\frac{1}{4}$"x$2\frac{1}{4}$" $2\frac{1}{4}$"x$3\frac{1}{4}$"
Aids *Subject index
Access Picture researchers press tv media
 by special arrangement only
Charges Reproduction fee standard rates

1454
Owner Department of the Environment
Location Photographic Library Room B110B
 Scottish Headquarters Argyle House Lady Lawson
 Street Edinburgh EH3 9SD 031 229 9191 Ext 5184
Title Ancient Monuments Crown Buildings
Custodian T McVittie
Dates c1920 (c1930) -
Subjects SCOTLAND ancient monuments Crown buildings
Numbers pr 250000 b&w 1pl
 fi negs 250000 b&w $\frac{1}{2}$pl 5"x4"
 gl negs 250 $\frac{1}{2}$pl
 sl 3500 col 35mm $\frac{1}{2}$pl 5"x4"
Aids Duplicated card index duplicated subject index

Access General public bona fide students appointment
 preferably by letter
Copies available for sale for loan crown copyright
Charges Print fee reproduction fee

1455
Owner Nithsdale District Council
Location Burgh Museum Corbelly Hill Dumfries
 0387 3374
Custodian A E Truckell
Dates 1850 -
Photographer Dr Werner Kissling Joseph Milligan
Subjects SCOTLAND S W Scottish towns farms
 agriculture families
Numbers pr sl c1000
Access General public bona fide students
Copies available for sale for loan on request
Notes Collection being added to by Dr Werner Kissling's
 photographic survey of old rural buildings, mills, etc.

1456
Owner Edinburgh City Council
Location Central Library George IV Bridge Edinburgh
 EH1 1EG 031 225 5584
Title Scottish Department Collection
Custodian A P Shearman
Dates 1850 (1961) -
Photographer Thomas Keith Valentine and Sons
 George Washington Wilson
Subjects SCOTLAND country life and customs
 transport wild animals factories architecture
 biography and portraits landscapes
Numbers pr 700 b&w various
 L sl 862 b&w 3"x3"
 sl 3617 col 2"x2"
Aids Catalogue
Access General public
Copies available for sale

1457
Owner Inverness District Council Town House Inverness
 IV1 1JJ 0463 39111
Location Inverness Museum and Art Gallery Castle Wynd
 Inverness Highland Region 0463 31138
Custodian Graeme Farnell
Dates 19thC -
Subjects SCOTLAND - landscapes ancient monuments
 folk life Inverness Caithness - archaeological
 excavations Highland Railway - Pitlochry to the north
 dairy farming livestock architecture
Numbers pr c50 b&w various
 gl negs 1140 b&w various
Aids Catalogue in preparation
Access General public bona fide students by prior
 appointment
Copies available for sale

1458
Owner Dr K J H Mackay
Location Hayford House Cambusbarron Stirling
 Central Region 0786 61539
Subjects SCOTLAND Central Region - local history
Numbers pr c60 $\frac{1}{2}$pl
 tr c2000 2"x2"
Aids Filed geographically
Copies available for loan
Notes This is a personal collection for the purposes of
 local history research and lectures.

1459
Owner Ian R Macneil of Barra
Location Kisimul Castle Isle of Barra Western Isles
 Scotland Castlebay 300
Dates c1900 -
Subjects SCOTLAND - Kisimul Castle Barra
Numbers substantial numbers
 pr
 sl

1460
Owner Morrison and Macdonald (Paisley) Limited
 Murray Street Paisley Renfrewshire

Location Collins Exhibition Hall University of
Strathclyde Richmond Street Glasgow G1
Title Morrison and Macdonald Collection
Custodian S R Elson
Dates 1880 - 1894
History Matthew Morrison founded the Paisley Amateur
Photographic Society in 1886
Photographer Matthew Morrison
Subjects SCOTLAND the forces - history uniforms
and regalia uniformed organisations bands
period costume architecture recreations
athletic sports and outdoor games biography and
portraits
Numbers gl negs 350 b&w 8"x6" ½pl ¼pl
Aids List
Access Bona fide students
Copies available for sale on request
Charges Print fee
Notes An extensive collection of glass negatives
discovered by accident in the premises of Morrison
and Macdonald (Paisley) Limited. From this
collection one can build up an impression of
Victorian middle class life in the West of Scotland.

1461
Owner National Museum of Antiquities of Scotland
Location Scottish Country Life Section N M A S
Queen Street Edinburgh 031 556 8921
Custodian Gavin Sprott
Dates 1959 -
Photographer Alasdair Alpin MacGregor
Subjects SCOTLAND culture of the Scottish countryside
and coastal communities farming education
transport buildings horticulture fishing trades
and skills textiles public entertainment land and
sea communications diet dress home and social
life
Numbers pr c9000 b&w
fi negs c23000 b&w
fi negs c500 col 35mm 120 ½pl
gl negs c550 b&w ¼pl ½pl 1-pl
sl 800 35mm
Access General public bona fide students
Copies available for sale
Charges Print fee from 30p ½pl reproduction fee from £1
Notes Photographs in this collection are an integral part
of the Country Life Archive.

1462
Owner National Register of Archives (Scotland)
(Western Survey)
Location P O Box 36 H M General Register House
Edinburgh EH1 3YY 031 556 6585 Ext 40
Title The A Brown of Lanark Collection
Custodian D M Hunter
Dates 1921 -
Photographer A Brown
Subjects SCOTLAND SWITZERLAND Scottish views -
power station castles portraits the Forces
cattle outdoor games croquet landscapes
Switzerland - landscapes ski-ing Swiss chalet
Clydesdale horses Lanarkshire Yoemanry
Numbers pr c50
Aids Duplicated list

1463
Owner National Register of Archives (Scotland)
(Western Survey)
Location P O Box 36 H M General Register House
Edinburgh EH1 3YY 031 556 6585 Ext 40
Title The Frank Martin of Paisley Collection
Custodian D M Hunter
Dates 1939 -
Photographer Frank Martin
Subjects SCOTLAND horse drawn lorries motor
lorries - vintage Paisley iron works river views -

steamers ferry barges hand-loom weavers cars
shop views Paisley operatic society hospitals
buildings churches farm sport Coronation
decorations cinemas Paisley Museum parks
bridges portraits choirs Seedhill flour mill
societies fishing street scenes YMCA buildings
banquet models of Royal State coach and horses
mannequin parade
Numbers pr substantial number
Aids Duplicated list

1464
Owner Scottish Civic Trust
Location 24 George Square Glasgow G2 1EF
041 221 1466/7
Custodian John Gerrard
Dates 1968 -
Subjects SCOTLAND street improvement schemes
architecture conservation areas and other subjects
related to the built environment
Numbers sl 400 35mm 2"x2"
Access General public bona fide students civic societies
Copies available for loan
Charges Print fee at commercial cost slides on loan
postal charge only
Notes To consult the collection prior appointment advised.
Slides used frequently for lectures by staff and may
not always be readily available to others.

1465
Owner Scottish Record Office
Location PO Box 36 HM General Register House
Edinburgh EH1 3YY 031 556 6585
Custodian The Keeper
Dates c1850 -
Subjects SCOTLAND industrial scenes geography
portraits the forces occupations and services
travel biography uniforms transport - locomotives
pumping engines rolling stock buildings
personnel shipbuilding and ship trials
Numbers pr 42000 various
Aids Catalogue
Access Bona fide students
Copies available for sale
Charges Print fee on request
Notes The photographs owned by the Scottish Record
Office are miscellaneous items included in family,
industrial and other types of archives.

1466
Owner The Scotsman
Location P O Box No 56 North Bridge Edinburgh
EH1 1YT 031 225 2468
Custodian Stewart J Boyd
Dates c1946 -
Subjects SCOTLAND sport stage music art and
literature politics law Royalty Kenya Paris
Air Show scenic views
Numbers pr c750000
fi negs 157769 2¼"x2¼" 35mm
tr col 2¼"x2¼" 35mm
Copies available for loan for publication
Charges Reproduction fee

1467
Owner Stirling District Council
Location District Library 33 Spittal Street Stirling
Central Region Scotland Stirling 64127
Custodian Graham Wonall
Dates 1882 -
Subjects SCOTLAND - buildings Scottish country houses
sculptured stones Murray family portraits Cannes
Nice
Numbers pr 177 6"x8" 2¼"x3¼"
tr 307
Access Bona fide students

() = dates when collections were begun or terminated
entury c = approximately pr = print fi = film
ss neg = negative sl = slide L sl = lantern slide
sparency mic = microform col = colour

b&w = black and white ¼, ½, 1-pl = quarter, half and whole
plate * = single copy, no public access ** = single copy,
access by appointment

1468
Owner D C Thomson and Company Limited
Location 7 Bank Street Dundee DD1 9HU East Region
 Scotland 0382 23131
Title Robert M Adam Collection
Dates 1904 – 1955
Photographer Robert M Adam
Subjects SCOTLAND botany agriculture and food
 production architecture geography street scenes
Numbers pr c5000 b&w
 gl negs c14000 b&w $\frac{1}{4}$pl $\frac{1}{2}$pl
Aids *Card index
Access Picture researchers press tv media by
 appointment only
Copies available for sale for display for publication
 credit line required
Charges Publication/reproduction fee print fee
 by arrangement

1469
Owner Vista of Glasgow
Location Vista House 22 Royal Crescent Sauchiehall
 Street Glasgow G3 7SL 041 332 1241
Title Vista Picture Library
Custodian G Borthwick
Dates 1956 (1958) –
Subjects SCOTLAND Glasgow scenes industrial and
 commercial scenes in Scotland old Glasgow from
 engravings
Numbers fi negs c33000 b&w col various
 tr c100 col 35mm
Aids Negative file
Access Bona fide students picture researchers
 9.30 am – 5.30 pm
Copies available for sale for loan for display
 for publication
Charges Reproduction fee print/transparency fee
 handling fee service charge for research search fee
Notes Research service undertaken into finding and
 photographing Scottish illustrations and subjects if
 not available from above collection.

1470
Owner Frank Worsdall
Location 403 Kingsbridge Drive Rutherglen Glasgow
 G73 2BT 041 647 4171
Dates 1962 –
Photographer Frank Worsdall
Subjects CENTRAL AND SOUTHERN SCOTLAND –
 railway stations docks and harbours archaeology
 gardens wind water and cotton mills bridges
 dams farm buildings lands architecture stained
 glass church organs
Numbers fi neg 19800 b&w 35mm
 tr 8600 col 2"x2"
Aids Subject index
Copies available for sale

1471
Owner National Trust for Scotland
Location 5 Charlotte Square Edinburgh EH2 4DU
 031 226 5922
Custodian Philip Sked
Dates (1931) –
Subjects PROPERTIES OF THE NATIONAL TRUST FOR
 SCOTLAND including islands of St Kilda
Numbers pr substantial number
 sl
Access Bona fide students by appointment only

1472
Owner Ulster Society for the Preservation of the
 Countryside
Location West Winds Carney Hill Holywood Co Down
 Northern Ireland
Title Survey of River Blackwater and Survey of River
 Owenkillew
Custodian W M Capper Hon Secretary
Dates 1969 – 1973
Photographer W M Capper
Subjects NORTHERN IRELAND River Blackwater

before during and after government arterial
drainage scheme with reference to the effect
on amenity and wild life. River Owenkillew before
and after government arterial drainage scheme
showing harmful effect on amenity
Numbers Sl c40 col 35mm
Access Bona fide students or other organisations
Copies available for sale
Notes This collection includes photographs of the River
 Blackwater used at a public enquiry and photographs
 of the River Owenkillew used in discussions with
 government departments.

1473
Owner Public Record Office of Northern Ireland
Location 66 Balmoral Avenue Belfast Northern Ireland
 Belfast 661621
Dates c1860 –
Subjects NORTHERN IRELAND social history political
 demonstrations army police topography
 archaeology geology aerial photography
 personalities parades portraits construction
 sport recreations architecture agriculture
 railways travel abroad ships engravings schools
 politicians England Scotland Wales
Numbers pr c8500 b&w
 fi negs c204000 b&w
 L sl 150 b&w
Aids Typescript lists and catalogues
Access General public bona fide students picture
 researchers press tv media Monday to Friday
 9.30 am – 4.45 pm
Copies available for sale for publication
Charges Reproduction fee print/transparency fee
Notes Includes Cooper Collection, Belfast Telegraph
 Collection, and Allison Collection.

1474
Owner Ulster Folk and Transport Museum Trustees
Location Ulster Folk and Transport Museum Cultra Manor
 Holywood Co Down N Ireland BT18 OEU
Title Ulster Folk and Transport Museum Archives
Dates (1960) –
Photographer W A Green W F Little
Subjects NORTHERN IRELAND social sciences
 education transport customs and folklore clocks
 agriculture and food production home ceramics
 textiles toys genealogy recreations geography
Numbers fi negs c6000 b&w various
 gl negs c3000 b&w $\frac{1}{2}$pl
 tr 200 col 6"x6"
 sl 3000 col 35mm
Aids *Card index *subject index
Access Bona fide students
Copies available for sale
Charges Reproduction fee on application
Notes The collection incorporates an important collection
 of original glass negatives dealing with Northern
 Irish life and topography c1910–1925 by the late
 W A Green together with copy negatives of the work
 of some earlier Northern Irish photographers.

1475
Owner Peter Fraenkel
Location 3 Eden Court Station Road Ealing Road London
 W5 3HX 01 997 0247
Dates 1968 –
Photographer Peter Fraenkel
Subjects AFRICA AND WESTERN ASIA all aspects
Numbers fi negs c7000 b&w 35mm
 sl 7000 col 35mm 6cm x 6cm
Aids Duplicated guide
Access available for inspection only by special
 arrangement
Copies available for sale for display for loan
 for publication
Charges Reproduction fee print fee holding fee
 search fee
Notes Original colour transparencies lent for reproduction.

1476
Owner John Judkyn Memorial
Location Freshford Manor Bath Avon BA3 6EF
Limpley Stoke 3312
Custodian James E Ayres
Dates 1855 -
Photographer Eadweard Muybridge
Subjects AMERICA AND AMERICANS Pennsylvania
railroad passengers in 1930's
Numbers pr c61
sl c200
Aids Card index
Access Bona fide students
Copies available for sale
Charges Print fee colour transparency fee (new subject)
£10.50p black and white print (new subject) £5
black and white print from £1 reproduction fee for
1 print or transparency £5 reproduction fee for
any number above 1 £3 each facility fee £1.50p
(irrespective of number)

1477
Owner Australian Government Department of Media
Canberra Australia
Location Australian High Commission Canberra House
Maltravers Street London WC2R 3EH 01 836 2435
Custodian Photographic Librarian
Dates c1870 -
Subjects AUSTRALIA
Numbers pr 9000 b&w 8½"x8½"
fi negs c9700 b&w
sl 3000 col 4"x6" 35mm
Aids *Subject index
Access General public bona fide students
Copies available for loan only
Charges No charge for reproduction credit line only

1478
Owner Anglo-Chinese Educational Institute Trustees
Location 152 Camden High Street London NW1 0NE
01 485 8241
Title Anglo-Chinese Educational Institute Picture Library
Custodian Alan Paterson
Dates 1966 -
Subjects CHINA industry agriculture the Arts
education medicine society commerce
science and technology
Numbers pr c500 b&w c200 col various
Aids Filed under subjects headings
Access Library open weekdays 10 am - 6 pm
Copies No pictures can be borrowed from the library
for reproduction until the text and captions which
the pictures will illustrate have been submitted to the
Institute for approval, and permission for the use of
the pictures has been received in writing
Notes The great majority of the prints in this collection
come from the Chinese People's Association for
Friendship with Foreign Countries and also from
the Hsinhua News Agency.

1479
Owner Miss Iris C Rhodes
Location 28 Belmont Avenue Guildford Surrey
0483 63336
Title R Cecil Rhodes Collection
Dates c1910 - c1930
Subjects EGYPT - sea transport social sciences
dress Suez Canal Panama Canal monuments
street scenes deserts portraits pyramids
temples
Numbers pr 69 b&w various
Aids List
Access Bona fide students picture researchers press
tv media by request evenings or weekends
Charges Reproduction fee print/transparency fee
handling fee

1480
Owner Mr and Mrs J Speed
Location 21 Wandsworth Common West Side London
SW18 2EH 01 870 3743
Custodian John Speed Joan Speed
Dates 1923 - 1928
History Major Pridham was Commanding Officer the
2nd Battalion Duke of Wellingtons Regiment and
these photographs were taken whilst serving in the
Middle East and elsewhere
Photographer Major C H B Pridham
Subjects EGYPT - Egyptian antiquity British Army in
Egypt Cairo Nile Valley Battle of Flowers tennis
1926 Test Match against Australia at the Oval the
fleet at Gibraltar in 1928 Peking Shanghai Macao
Monaco Monte Carlo
Numbers pr c272 b&w
Access Bona fide students publishers press tv media
by appointment only
Charges Reproduction fee

1481
Owner Robert Goodsall
Location Steade Hill Harrietsham Maidstone Kent
ME17 1HR Harrietsham 222
Dates 1906 -
History The collection includes colour work produced by
numerous processes from 1910 - 3¼"x3¼"
Autochromes, Paget neg/pos process etc
Photographer Robert Goodsall
Subjects EUROPE NORTH AFRICA MIDDLE EAST
SOUTHERN ENGLAND - topography scenery
Ireland Peak District City of London Worshipful
Company of Dyers Roman forts Canterbury
Numbers fi & gl neg thousands 35mm - 1-pl
L sl numerous sets 3¼"x3¼"
Access Bona fide students only by special arrangement
Notes Much of the black and white work has been used to
illustrate Mr Goodsall's books.

1482
Owner D C Williamson
Location 68a Redcliffe Square London SW10 9BN
01 373 2160
Title David Williamson's Library of Eastern European
Transparencies
Dates 1965 -
Subjects EASTERN EUROPE all aspects other
countries family photographs
Numbers sl c10000 col various
Aids Register cross-indexed by place and subject
Copies available for sale for loan
Charges Reproduction fee
Notes Photographs taken with travel brochures and
encyclopaedias in mind.

1483
Owner Wiener Library
Location 4 Devonshire Street London W1 01 636 7247
Dates 1914 (1933) - c1950
Subjects NAZI GERMANY EUROPEAN JEWRY
and related subjects
Numbers pr c750 b&w 10"x8"
gl pos c100 b&w 2½"x2½"
Aids Duplicated subject index
Access Bona fide students publishers press tv media
Copies not available researchers to provide own
photographer
Charges To commercial users: £2 for permission to
copy + £1.50p for UK reproduction additional
£10 for world rights research fee usually £3

1484
Owner R P M T Barrett
Location 24 Bracken Road Darlington Co Durham
0325 67965

Key () = dates when collections were begun or terminated
C = Century c = approximately pr = print fi = film
gl = glass neg = negative sl = slide L sl = lantern slide
tr = transparency mic = microform col = colour

b&w = black and white ¼, ½, 1-pl = quarter, half and whole
plate * = single copy, no public access ** = single copy,
access by appointment

Dates 1925 - 1950
Subjects THE GOLD COAST AND SIERRA LEONE -
Her Majesty's customs prevention service bands
Abyssinian cattle market portraits hospitals
Numbers pr 1000 b&w 3"x5"
Access Bona fide students

1485
Owner Hong Kong Government Information Services
Department Beaconsfield House Queen's Road Central
Hong Kong
Location 6 Grafton Street London W1X 3LB 01 499 9821
Title Hong Kong Government Office Library Photographic
Collection
Custodian Ursula M Price
Dates 1953 (1960) -
Subjects HONG KONG - religion social sciences
occupations and services the army uniforms and
regalia education transport public festivals
science botany: plants mechanical engineering
civil and building construction agriculture and food
production domestic home clothes ceramics
sculpture and carving architecture painting
textiles toys musical performances outdoor games
and amusements athletic sports and outdoor games
portraits geography aerial photography landscape
industry newsworthy events
Numbers pr c10800 b&w 10"x8"
tr 10 sets col 2"x2"
Aids Card index
Access Bona fide students picture researchers press
tv publishers
Copies Colour transparencies available by request
credit line required
Charges No charge is made for editorial use, but a fee
may be required for commercial purposes

1486
Owner Mrs G D Fanshawe
Location Farley Farm Farley Nr Salisbury Wiltshire
Farley 202
Dates 1898 - 1936
Subjects INDIA - tiger shooting
Access Bona fide students
Copies available for loan

1487
Owner Foreign and Commonwealth Office
Location Orbit House 197 Blackfriars Road London
SE1 01 928 9531
Title India Office Library and Records
Custodian R Desmond
Dates c1857 -
History The India Office, which took over the East India
Company's Library and Archives in 1858, came to an
end with Indian and Pakistani independence in 1947.
The India Office Library and Records then became
the responsibility successively of the Commonwealth
Office (1965) and the Foreign and Commonwealth
Office (1968)
Subjects INDIA British India related territories in Asia
Numbers pr 350 collections b&w
gl negs c7200 b&w
Aids Card index in preparation
Access Bona fide students by appointment details on
application
Copies can be supplied to order

1488
Owner J C Macnab of Macnab
Title The Macnab Collection
Dates 1875 - c1930
Photographer Samuel Bourne F Brenner Burke
Subjects INDIA life in India Burma Ceylon Italy
Japan Scotland World War I old Etonians
Numbers pr 200 b&w various
cartes de visites 80 b&w
Access Bona fide students press tv media
Charges on application
Notes Requests to view this collection must be made
through the National Photographic Record c/o The

Royal Photographic Society. The owner reserves the
right to refuse access.

1489
Owner Simon Portal
Location 9 Kelso Place London W8 01 937 0994
Dates c1925 - 1930
History The owner's grandfather was Viscount Goschen
Governor of Madras 1920 Viceroy of India 1929
Photographer Willie Burke
Subjects INDIA all aspects
Numbers pr 200 b&w various
fi movie 1
Access Picture researchers by appointment press tv
media
Copies available for loan for display for publication
Charges Reproduction fee
Notes 17 Lancer album of photographs compiled by the
owner's grandfather Brigadier General Sir Bertram
Portal.

1490
Owner J J Putnam
Location Wood Farm Blackawton Totnes Devon
Blackawton 368
Title Curzon's India
Dates 1897 - 1905
History In 1897 James Putnam the owner's grandfather
joined Lord Curzon's staff as a confidential private
secretary. He accompanied the Viceroy on numerous
tours both in India and Burma
Photographer James Putnam
Subjects INDIA - life scenes personages inhabitants
buildings Burma
Numbers pr c100
gl negs c400
L sl c100
Access Possibly by written request only

1491
Owner The Rt Reverend Dom Wilfrid Weston
Location Nashdom Abbey Burnham Slough
Buckinghamshire SL1 8NL 062 86 3176
Dates 1889 - 1936
Photographer F H Jackson Rt Reverend Dom Wilfrid
Weston
Subjects INDIA country life and customs army training
race meetings animals silk manufacture outdoor
games geography architecture - India Burma
Numbers pr c255 b&w various
Aids Catalogue in preparation
Access Bona fide students by appointment only
Charges No charges subject to conditions

1492
Owner M G Satow
Location 50 Church Lane Ormesby Cleveland TS7 9AU
0642 34342
Dates 1945 -
Photographer M G Satow
Subjects INDIA - RAILWAYS INDUSTRIAL
ARCHAEOLOGY industrial archaeology in England
flowers trees gardens
Numbers pr c500 b&w 5½"x3½"
fi negs c200 b&w 35mm
tr neg c1500 col 35mm
sl 50 b&w 35mm
Aids *Card index *subject index
Access Regular correspondents only
Charges Commercial rates for commercial use by
negotiation for private or charitable use

1493
Owner Y Kinory
Location 3 The Gardens Harrow Middlesex
Dates 1964 -
Photographer Y Kinory
Subjects ISRAEL comparing life in Israel to England
architecture topography

Numbers pr c300 b&w 10"x8"
fi negs c1000 2¼"x2¼" 35mm
sl c1000 35mm
Access Bona fide students by appointment only

1494
Owner Japanese Embassy 43 Grosvenor Street London
W1
Location Japanese Information Centre 9 Grosvenor
Square W1 01 493 6030
Title Photographic Library
Custodian Miss E Abe
Dates 1960 -
Subjects JAPAN modern Japanese life
Numbers pr 2000 b&w
tr 1500 col
Access General public bona fide students
Copies available for loan

1495
Owner Maxwell Kramer
Location Ardmaynes Dalserf Crescent Mains Estate
Giffnock Glasgow 041 638 2311
Dates 1869 - 1900
Photographer Samuel Bourne Sache
Subjects MIDDLE EAST INDIA
Numbers pr 2 albums 200 b&w various
Access Picture researchers press tv media by
appointment only

1496
Owner Palestine Exploration Fund
Location No 2 Hinde Mews Marylebone Lane London W1
01 935 5379
Dates 1867 -
History Lord Kitchener (then Lieutenant), Colonel C R
Conder, Sir Charles Warren - all Royal Engineers -
took photographs or were heads of survey parties
taking photographs
Subjects MIDDLE EAST Palestine - religion social
sciences archaeology pottery sculpture and
carving architecture portraits geography
exploration and travel abroad Israel Trans-Jordan
Syria Lebanon Sinai
Numbers pr c800 b&w various
fi negs c300 b&w various
gl negs c800 b&w various
L sl c800 b&w 2½"x2½"
Aids Duplicated catalogue print index
Access Bona fide students picture researchers press
tv media 10 am - 5 pm
Copies available for sale for publication acknowledgement
to the Palestine Exploration Fund
Charges Publication/reproduction fee print/transparency
fee service charge search fee £5

1497
Owner Alistair Duncan
Location 56a Oakwood Court London W14 8JY
01 602 2136
Title Middle East Archive
Dates 1960 -
Photographer Alistair Duncan
Subjects MIDDLE EAST AND ISLAMIC WORLD
buildings agriculture arts and crafts geography
historic sites antiquities
Numbers tr c40000 col various
Aids Card index subject index
Access Bona fide students picture researchers press
tv media 10 am - 5 pm
Copies available for publication
Charges Reproduction fee holding fee £30 for colour
£8 for black and white
Notes Alistair Duncan is author of "The Noble
Sanctuary" and "The Noble Heritage".

1498
Owner H R Thornton
Location 52 Heathmere Avenue Birmingham B25 8RQ
021 783 3702
Title Morocco
Dates 1939 -
Photographer H R Thornton
Subjects MOROCCO
Numbers fi negs 100 b&w
tr 700
Copies available
Charges Reproduction fee usual rates

1499
Owner Baron Victor H Van Lawick
Location 6 Westbourne Avenue Emsworth Hampshire
PO10 7QU 024 34 3670
Titles The History of the Windmill The Netherlands
The History of the Hindu-Javanese Culture
Churches
Dates c1936 -
Photographer Baron Victor H Van Lawick
Subjects NETHERLANDS WINDMILLS - Dutch and
English Hindu Javanese culture churches -
England France Netherlands Hampshire West
Sussex
Numbers pr c24 b&w
sl c1250 col b&w 35mm
Access Bona fide interested parties can view slides
or prints at location depending on credentials
and for what purpose write for appointment fortnight
in advance
Copies To be discussed with interested parties
Charges Reproduction fee by arrangement dependent on
use
Notes A six course lecture has been built around the Hindu
Javanese material. Baron Van Lawick has also compiled
an eight course lecture on the Netherlands with many
slides about reclamation of land.

1500
Owner University of Exeter
Location University Library Prince of Wales Road
Exeter Devon EX4 4PT Exeter 77911
Custodian John Stirling
Dates c1898 - 1928
History Edward S Curtis was born in Wisconsin in 1868.
Later in his life he worked in films and produced
photographs for the film The Ten Commandments for
Cecil B de Mille
Photographer Edward S Curtis
Subjects NORTH AMERICA North American Indians -
ceremonies
Numbers pr 722
sl substantial numbers
mic substantial numbers
Notes This collection is in the form of a book, i.e. 20
volumes of text including some 1000 photographic
plates and 20 portfolios containing 727 plates.

1501
Owner Norwegian National Tourist Office
Location 20 Pall Mall London SW1 01 839 6255
Custodian Neil Birch
Subjects NORWAY holidays
Numbers pr c200 b&w 10"x8"
sl c150 b&w 6cm x 6cm
Copies available for loan
Notes This collection is on a strictly limited copyright and
is available only to tour operators and agents for use
in brochures and holiday advertising and press for
use only with articles about holiday travel to Norway.
In these two cases the loan is free, photographs are not
suitable for any other purposes.

Key () = dates when collections were begun or terminated
C = Century c = approximately pr = print fi = film
gl = glass neg = negative sl = slide L sl = lantern slide
tr = transparency mic = microform col = colour

b&w = black and white ¼, ½, 1-pl = quarter, half and whole
plate * = single copy, no public access ** = single copy,
access by appointment

1502
Owner Polish Social and Cultural Association
Location 238-246 King Street London W6 0RF
Title The Polish Library in London Photographic Collection
Custodian Zdzislaw Jagodzinski
Dates 1918 (1943) -
Subjects POLAND political life economic life
industry agriculture transport education
the forces architecture civil and building
construction portraits arts and crafts landscapes
customs and folklore dress archaeology genealogy
textiles sports German occupation prisoners of
war theatre concentration camps religious
celebrations European art travel abroad museums
Numbers pr 36800 b&w 770 col various
fi negs 568 b&w
gl negs 108 b&w
mic 2 b&w
Aids Subject index
Access Bona fide students
Copies available for loan
Charges Reproduction fees

1503
Owner John Massey Stewart
Location 27 John Adam Street London WC2N 6HX
01 839 2456
Dates c1900 (1961) -
Photographer John Massey Stewart
Subjects RUSSIA Asia anthropology nature
zoology agriculture architecture painting
geography travel
Numbers pr 450 b&w 12"x10"
fi negs 6000 b&w 35mm 2¼"x2¼"
tr 7000 col 35mm 2¼"x2¼"
cartes de visite
Aids Duplicated guide duplicated subject index
Access Picture researchers press tv media
10 am - 6 pm
Copies available for sale for loan for display
for publication credit line required
Charges Reproduction fee print/transparency fee
search fee holding fee
Notes This collection contains photographs of late
19th century cartes de visite and photographs of
late 19th and early 20th century original photographs.

1504
Owner Seychelles Tourist Information Office
202/204 Finchley Road London NW3 6BX
01 435 9817
Location Feature Pix Limited 9 Great Chapel Street
London W1V 4EE 01 437 2121
Custodian Press Officer
Dates 1974 -
Photographer Ken Hackett
Subjects SEYCHELLES all aspects
Numbers pr c50 b&w 10"x8"
fi negs 300 b&w
tr c1000 col various
Aids Duplicated subject index
Access by special arrangement
Copies available for loan
Charges Loans are free where the use will directly
promote the Seychelles

1505
Owner Tony Morrison Production Limited
Location 100 Park Street London W1 03943 3963
Title South American Pictures
Dates 1961 -
Photographer Marion Morrison Tony Morrison
Subjects SOUTH AMERICA - religion social sciences
education transport customs and folklore geology
archaeology anthropology botany zoology
food production clothes arts and crafts
architecture musical instruments geography -
Andes Argentina Falkland Islands
Numbers fi negs c10000 col 35mm
tr c5000 col 35mm
Aids Brochure subject index in preparation

Access Bona fide students picture researchers press
tv media by appointment
Copies available for sale for loan for display
for publication credit line required
Charges Reproduction fee holding fee postage and
packing and registration

1506
Owner Society for Cultural Relations with U S S R
Location 320 Brixton Road London SW9
Title SCR London
Custodian Mrs M Johnson Elsie L Timbey
Dates 1917 (1924) -
Subjects SOVIET UNION all aspects - cities museums
Lenin painters cathedrals education architecture
sport and recreation circus postage stamps
space travel Russian Revolution art customs and
folklore Ukraine Siberia agriculture industry
geography science army language
Numbers pr c7000 b&w 8"x6" 20"x24"
sl substantial number col
film strips
Aids Duplicated subject index duplicated card index of
illustrated art books
Access General public bona fide students by appointment
only
Copies available for loan for display for publication
Charges Reproduction fee research fee exhibition and
display fee service charge minimum £3.25
fee for loss

1507
Owner W Stirling
Location 36 North Drive Orpington Kent BR6 9PQ
0689 53718
Title Stirling Photographic
Dates 1969 -
Photographer William Stirling
Subjects SPAIN - towns cities countryside
coastal resorts castles churches people
villages tourist attractions
Numbers tr c2000 various
Aids Subject index
Access General public bona fide students by appointment
only
Charges Print fee reproduction fee by arrangement

1508
Owner Dr J F E Bloss
Location Combe House Castle Road Woking Surrey
GU21 4ET 048 62 73681
Dates 1933 -
History Dr Bloss was a member of the Sudan Medical
Service and travelled all over that country between
1933 and 1954
Photographer Dr J F E Bloss
Subjects SUDAN social sciences anthropology
Numbers fi negs c700 various
tr c500 col 2"x2"
Access Bona fide students picture researchers
publishers press tv media by arrangement
Copies Black and white prints available
Charges Reproduction fee by arrangement
Notes Some of the transparencies have been used in the
publication The Family of Man and several books and
journals of the Sudan.

1509
Owner Sonia Halliday Photographs
Location Primrose Cottage Weston Turville
Aylesbury Buckinghamshire 029 661 2266
Dates (1963) -
Subjects TURKEY GREECE ITALY Sicily Tunisia
arts architecture industries archaeology
theology Byzantine frescoes mosaics stained glass
Chinese miniatures tapestries
Numbers tr c35000 col various
Access Picture researchers press tv media
Copies available for publication
Charges Reproduction fee

Notes The collection is the largest archive on Turkey in England.

1510

Owner Western Americana Picture Library and American History Picture Library
Location 86 Park Road Brentwood Essex CM14 4TT 0277 217643
Custodian Peter Newark
Dates 1860 (1955) -
Photographer Mathew Brady Alexander Gardner W H Jackson
Subjects UNITED STATES OF AMERICA
Numbers pr 10000 b&w
tr c5000 col
Aids A printed outline of collection
Access No access business is done only by post and telephone 9 am - 6 pm
Copies available for loan for publication
Charges Reproduction fee service charge
Notes The library owns the copyright of 50% of the collection and acts as agent for photographers.

1511

Owner Lord Howick Howick Northumberland
Location University of Durham Department of Palaeography and Diplomatic South Road Durham DH1 3LE 0385 64466
Title The Earl Grey Papers
Dates Late 19thC -
History The 4th Earl Grey (1951-1917) was Administrator of Rhodesia 1896-7 and Governor General of Canada 1904-1911. Many of the photographs reflect his imperial interests
Subjects BRITISH EMPIRE Grey family
Numbers pr substantial numbers b&w various
Access Bona fide students by appointment
Copies available for sale for private study and research only
Charges Electrostatic copies (where appropriate) 5p each - subject to alteration photostats - price varies according to size

1512

Owner C D Williams
Location Collfryn Bethesda Bach Caernarvon Gwynedd
Dates 1900 - 1914
Subjects BRITISH EMPIRE general
Numbers gl negs 100 $\frac{1}{4}$pl
Access General public by appointment only
Copies available for loan

1513

Owner Commonwealth Institute
Location Kensington High Street London W8 01 602 3252
Title Compix
Custodian T Lightfoot
Dates (1973) -
Subjects COMMONWEALTH GENERAL Commonwealth countries social sciences occupations and services education transport customs and folklore archaeological sites anthropology wild animals factories bridges dams mining agriculture and food production contemporary dress architecture musical instruments recreations football biography and portraits geography aerial photography
Numbers sl c4000 col 35mm 2$\frac{1}{4}$"x2$\frac{1}{4}$"
Aids *Catalogue
Access General public by appointment
Copies available for sale on commercial library basis
Charges Print fee

1514

Owner Foreign and Commonwealth Office

Location Main Library Sanctuary Buildings Great Smith Street London SW1 01 212 6568/0663
Title Foreign and Commonwealth Office Library Photograph Collection
Custodian M A Cairns
Dates c1850 (Mid 19thC) - 1950
History This collection was originally part of the Colonial Office Library
Subjects COMMONWEALTH GENERAL all aspects of life in British Colonial territories and Commonwealth countries Colonial residences and officials events conferences
Numbers pr c600 vols b&w col various
Aids *Guide
Access By advance written application 9.30 am - 5.30 pm Monday to Friday
Copies available by written private arrangement only
Notes The collection also includes several volumes of lithographs, coloured engravings etc.

1515

Owner Royal Commonwealth Society
Location Northumberland Avenue London WC2 01 930 6733
Title Library of the Royal Commonwealth Society
Custodian Donald H Simpson
Dates c1860 (c1880) -
History The collection includes Queen Mary's Collection (India 1905-1912), Ernest Gedge's photographs (East Africa 1888-1891), Dr J W S Macfie's photographs (West Africa 1910-1922), W H C Trousdell's albums (Southern Nigeria 1905-1907), Colonel Tyer's album (Africa), and A H Fisher's albums (Empire Journeys 1907-1910)
Photographer Earl of Albemarle Sir Walter Buchanan-Smith C J Busk A H Fisher Paul Foelsche Fradelle W Ellerton Fry Ernest Gedge Langford Hindle C Hose Maull and Fox J Russell and Sons R Shelford Walery C A Woolley
Subjects COMMONWEALTH GENERAL countries of the Commonwealth portraits religion education art
Numbers pr c20000
gl negs 200
l sl 300
Aids Card index Occasional published papers 'Library Notes' available for particular collections
Access Bona fide students
Copies available for sale
Charges Publication fee
Notes The collection includes some 3000 portraits of members of the Royal Commonwealth Society from the 1880's to the 1920's. Though not restricted to any particular period this collection is very much stronger in pre 1914 material than in later items.

1516

Owner Bernsen's International Press Service Limited
Location 25 Garrick Street London WC2E 9BG 01 240 1401
Custodian Theo C Bernsen
Dates 1946 -
Photographer Russell Knight Carlo Polito Claus Schwenke Allan de Vries
Subjects NEWSWORTHY EVENTS - International
Numbers pr substantial numbers b&w various
fi negs c100000 b&w col
Aids *Card index *subject index
Access Picture researchers press tv media 9 am - 6 pm
Copies available for sale for display for publication
Charges Reproduction fee print/transparency fee handling fee holding fee service charge search fee

1517

Owner Lord John George Binning
Location Mellerstain Gordon Berwickshire

Key () = dates when collections were begun or terminated
C = Century c = approximately pr = print fi = film
gl = glass neg = negative sl = slide L sl = lantern slide
tr = transparency mic = microform col = colour

b&w = black and white $\frac{1}{4}$, $\frac{1}{2}$, 1-pl = quarter, half and whole plate * = single copy, no public access ** = single copy, access by appointment

Dates c1890 -
Photographer Lafayette
Subjects EVENTS - Coronation 1937 portraits - diplomats
army personnel Royal family
Numbers fi negs substantial numbers

1518

Owner Financial Times
Location Bracken House Cannon Street London EC4
01 248 8000
Custodian Picture Editor
Subjects HISTORIC AND NEWSWORTHY EVENTS
religion social sciences occupations and services
the forces education communications transport
anthropology animals medicine mechanical
engineering civil and building construction mining
agriculture and food production domestic arts and
crafts textiles musical instruments biography
and portraits geography
Numbers pr c200000 b&w
fi negs c1100000 b&w
Aids *Subject index
Access Picture researchers press tv media
Copies available for sale for loan for display
for publication
Charges Reproduction fee print/transparency fee
search fee

1519

Owner Huddersfield Examiner
Location Ramsden Street Huddersfield West Yorkshire
0484 27201
Custodian B Brown
Dates c1920 (1946) -
Subjects NEWSWORTHY EVENTS industry landscapes
portraits sport
Numbers pr
fi negs
gl negs substantial numbers of each
Aids Datal and numerical record
Access Bona fide students picture researchers
Copies available for sale
Charges Reproduction fee print/transparency fee
waived if credit line

1520

Owner Keystone Press Agency Limited
Location 52/62 Holborn Viaduct London EC1A 2FE
01 236 3331-4
Dates 1920 (1919) -
Subjects CURRENT AND HISTORIC EVENTS politics
wars disasters sport personalities geography
animals curiosities
Numbers pr 2000000 b&w 8"x6" - 10"x8"
fi negs 900000 b&w various
gl negs 100000 b&w 5"x4"
tr 100000 col various
Aids Card index subject index
Access General public bona fide students picture
researchers press tv media
9.30 am - 5.30 pm
Copies available for sale for loan for display for
publication
Charges Print/transparency fee holding fee publication
fee service charge search fee

1521

Owner National Photographic Record
Location see notes below
Title Richards Collection
Dates 1899 - 1902
History This collection was originally made by a resident
of Ladysmith during the siege. Having been presented
by Col. Sayer, President of Ladysmith Rotary Club, to
Mr F.G. Richards in 1952, the latter donated the
photographs to the NPR
Subjects BOER WAR - Pretoria Ladysmith troops
sports military graves shell damage Zulu campaign
Numbers pr 85 b&w 2¼"x3¼" 8"x6"
Access Bona fide students picture researchers
publishers press tv media

Copies available for sale
Charges Print fee commercial rates
Notes Requests to view this collection must be made
through the National Photographic Record c/o The
Royal Photographic Society.

1522

Owner North of England Newspapers (Westminster Press)
Limited
Location Priestgate Darlington County Durham
0325 60177 Ext 38
Custodian The Librarian
Dates 1930 -
Subjects HISTORIC AND NEWSWORTHY EVENTS
social sciences religion occupations and services
the forces associations and societies education
communications transport customs and folklore
science nature botany zoology mechanical
engineering mining agriculture and food production
domestic arts and crafts architecture recreations
athletic sports and outdoor games biography and
portraits geography royal visits
Numbers pr c100000 b&w 10"x8"
Aids Card index
Access Bona fide students picture researchers press
tv media by permission from the Editor
Copies available for sale for loan for display
for publication credit line required
Charges Reproduction fee print fee search fee

1523

Owner Pixfeatures Picture Library
Location 5 Latimer Road Barnet Hertfordshire
01 449 9946
Custodian Peter Wickman
Dates 1920 (1950) -
Subjects NEWSWORTHY EVENTS personalities travel
geography
Numbers pr 250000 b&w
fi negs 50000 b&w
gl negs 1500 b&w
sl 10000 b&w
Aids Alphabetical and subject filing
Access Staff access only unless by special arrangement
Copies available for sale for loan for publication mainly
Charges Reproduction fee print/transparency fee
holding fee service charge search fee
Notes Worldwide coverage but especially British News
photographs. Sole agents for all photographs and slides
produced by photographers of the German 'Stern
Magazine'.

1524

Owner Press Association Limited
Location 85 Fleet Street London EC4P 4BE
01 353 7440
Custodian Eric Pothecary or Miss H Down
Dates 1868 -
Subjects HISTORIC AND NEWSWORTHY EVENTS sport -
racing boxing football cricket athletics
Numbers gl negs fi negs fi substantial numbers
'low millions'
Aids Card index
Access General public but main purpose is supplying
material for publication
Copies available for sale
Charges As laid down by Council of Photographic News
Agencies

1525

Owner Rex Features Limited
Location 15/16 Gough Square Fleet Street London
EC4A 3DE 01 353 4685/6
Dates 1955 -
Subjects INTERNATIONAL EVENTS personalities
places show business animals gimmicks
human interest
Numbers pr c500000 b&w 10"x8"
tr c200000 col 2¼"x2¼" 35mm
Access Picture researchers press tv media
9.30 am - 6 pm

Copies available for display for publication
Charges Reproduction fee print/transparency fee
 service charge handling fee search fee holding fee

1526
Owner S and G Press Agency Limited
Location 68 Exmouth Market London EC1 01 278 1223
Title Sport and General Press Agency Barratt's Photo
 Press London News Service
Custodian John Rodgers
Dates c1900
History Sport and General Press Agency (Established
 1911) and Barratt's Photo Press (Established 1908)
 are the longest established of the Council of
 Photographic News Agency members. Their libraries
 were amalgamated with that of the London News
 Service (Established 1962) in August 1972 under the
 ownership of S & G Press Agency Limited
Subjects NEWSWORTHY EVENTS personalities sport
 crime portraits early Labour Party leaders
 Lords Cricket ground Twickenham Rugby ground
Numbers fi negs 500000 b&w 33000 col 2¼"x2¼" 35mm
 gl negs 500000 b&w various
Aids *Card index *subject index
Access General public picture researchers press tv
 media 9 am - 6 pm
Copies available for sale for loan for publication credit
 line required
Charges Reproduction fee print/transparency fee
 CPNA rates

1527
Owner Ian Stewart
Location 12 Charlcutt Nr Calne Wiltshire SN11 9HL
Dates c1863 -
Subjects WORLD WAR I general
Numbers pr c400 b&w various
Access General public bona fide students by special
 arrangement with the owner

1528
Owner Syndication International Limited
Location 40 Northampton Road London EC1R 0JU
 01 837 2800
Custodian Miss Hazel Jones
Dates 1903 -
History The library was started when the Daily Mirror
 was first published
Subjects NEWS SPORT PERSONALITIES nature
 domestic world wide travel especially Africa
Numbers pr c350000 b&w 8"x6" 10"x8"
 fi negs c170000 b&w 35mm 2¼"x2¼"
 gl negs c12000 b&w 9cm x 12cm 5"x4"
 tr c250000 col various
Access Picture researchers press tv media publishers
 9.30 am - 5.30 pm
Copies available for sale for loan for display
 for publication
Charges Publication/reproduction fee print/transparency
 fee search fee holding fee all by negotiation
Notes Principal source of black and white material
 is IPC newspapers colour comes mainly from IPC
 womens magazines or from freelance photographers
 with accent on sport and travel.

1529
Owner Evelyn Wardrop
Location 18 Preston Road Ayr Strathclyde Region
 0292 64894
Dates 1899 - 1908
Subjects BOER WAR ROYAL SCOTS FUSILIERS -
 on duty in South Africa and India garrison life style
Numbers pr c30 b&w

1530
Owner Woodmansterne Limited

Location Holywell Industrial Estate Watford
 Hertfordshire WD1 8RD 0923 28236/45788
Title Includes Coronation Sir Winston Churchill's
 Procession and Funeral Royal Weddings Investiture of
 Prince of Wales Garter Procession Enthronement of
 Archbishop of Canterbury 1975 Flower Festivals
 Cathedrals and Abbeys Scenery
Custodian Graham Woodmansterne
Dates 1953 -
Photographer Clive Friend Howard C Moore
 Nicholas Servian
Subjects HISTORIC AND NEWSWORTHY EVENTS
 Coronation Procession 1953 Sir Winston Churchill -
 funeral procession and funeral service Royal
 Weddings - Princess Margaret Princess Anne
 Investiture of Prince of Wales at Caernarvon
 Garter Procession - Windsor Enthronement of
 Archbishop of Canterbury 1975 flower festivals in
 cathedrals and abbeys religion social sciences
 the forces transport customs and folklore science
 astronomy nature civil and building engineering
 arts and crafts architecture painting numismatics
 textiles genealogy antiques recreations biography
 and portraits geography aerial photography
Numbers sl c8500 col various
Aids Printed catalogue printed numerical list
Access Bona fide students picture researchers press
 tv media by appointment only 9 am - 4.30 pm
Copies available for sale for display for loan
 for publication
Charges Reproduction fee print/transparency fee
 handling fee holding fee service charge search fee
 fees including licenses for commercial projection
 are issued according to circumstances
Notes Slides are sold upon the understanding that they are
 for private and non-commercial use only. If required
 for reproduction in books magazines filmstrips etc or
 in commercial lectures or presentation the owner
 will negotiate a fee upon receiving details and suggest
 appropriate acknowledgements.

1531
Owner ATV Network Limited
Location ATV Studios Eldon Avenue Boreham Wood
 Hertfordshire 01 953 6100
Title Photographic Library Collection
Custodian Miss M G Duerden
Dates (1962) -
Subjects GENERAL personalities - entertainment world
Numbers pr c25000 b&w 10"x8" 12"x9"
 tr c1000 col 35mm 2¼"x2¼"
Aids Card index subject index
Access Bona fide students picture researchers press
 tv media
Copies available for sale for loan for display
 for publication
Charges Print fee from 32p + VAT reproduction fees
 only occasionally charged

1532
Owner Audio-Visual Library Services
Location Powdrake Road Grangemouth Stirlingshire
 FK3 9UT 032 44 71521
Custodian C B Wood
Dates (1973) -
Subjects GENERAL from administration to zoology
Numbers substantial
Aids Published catalogue card index
Access Bona fide students picture researchers press
 tv media by appointment
Copies available for sale
Charges Print/transparency fee
Notes The Library Services is engaged in the field of
 audio visual supply to libraries, resource centres
 and educational institutions and retailers.

1533
Owner Barnaby's Picture Library
Location 19 Rathbone Street London W1P 1AF
 01 636 6128/9
Custodian John Buckland
Dates (1930) -
Subjects GENERAL
Numbers pr c2000000 b&w 8½"x6½" 10"x8"
 fi negs c25000 b&w
 gl negs c15000 b&w
 tr c500000 b&w col 35mm
Aids Card index subject index
Access Picture researchers press tv media
 9.30 am - 6 pm
Copies available for loan for publication for display
 credit line required
Charges Reproduction fee print/transparency fee
 holding fee search fee service charge
Notes Agents for over 3000 photographers from all over
 the world.

1534
Owner B T Batsford Limited
Location 4 Fitzhardinge Street London W1H 0AH
Custodian Ian Chilvers
Dates 1872 -
History This is a collection of photographic material
 including prints and drawings collected and used by
 a British publishing house over the last 100 years
Subjects GENERAL - from agriculture to zoology
 but especially strong on English architecture and
 topography
Numbers pr c500000 b&w
Aids Classified subject index
Access Bona fide students for research purposes only
Copies available for loan
Charges Reproduction fee research fee

1535
Owner Black Star Publishing Company Limited
Location Cliffords Inn Fetter Lane London EC4A 1DA
 01 405 3103
Custodian Mrs G A Boreham
Dates 1925 -
Subjects GENERAL countries wars expeditions
 science personalities birds animals children
 people events glamour
Numbers pr c120000 b&w 10"x8"
 fi negs c40000 b&w
 tr c20000 col 2¼"x2¼" 35mm
Aids Subject index
Access Picture researchers press tv media Monday
 to Friday 10 am - 1.30 pm 3 pm - 6 pm
Copies available for display for loan for publication
Charges Reproduction fee print/transparency fee
 holding fee after six months service charge if no sale
 search fee display fee lost transparencies are
 chargeable photostat service
Notes Commissions.

1536
Owner British Broadcasting Corporation
Location Central Stills Library Television Centre
 Wood Lane London W12 7RJ 01 743 8000
Dates 1966 -
Subjects GENERAL religion social sciences
 occupations and services the forces associations
 and societies education communications transport
 astronomic observatories meteorology oceanography
 palaeontology nature animals mechanical
 engineering civil and building construction mining
 agriculture and food production domestic arts and
 crafts architecutre carving painting genealogy
 recreations athletic sports and outdoor games
 biography and portraits geography historic and
 newsworthy events
Numbers pr 30000 b&w 10"x8"
 tr 150000 col 35mm
Aids *Card index *subject index
Copies available for sale
Notes A very large working library established to service

the wide range of BBC TV productions hence its
comprehensive scope.

1537
Owner C R Butt
Location Amwellbury Lodge Walnut Tree Walk
 Great Amwell Ware Hertfordshire SG12 9RD
 0920 870224
Dates 1966 -
Photographer C R Butt
Subjects GENERAL Islamic religion social sciences
 police service the forces transport customs and
 folklore fishing home interiors contemporary
 architecture portraits travel abroad historic
 events landscapes ballooning
Numbers tr c13000 col 35mm
Aids Catalogue
Access Bona fide students by arrangement only
 temporary restrictions some subjects
Copies available for sale

1538
Owner A Chohan
Location 208/210 Grange Road Middlesbrough
 Cleveland TS1 2AH 0642 43922
Dates c1840 (c1968) -
Subjects GENERAL religion occupations and services
 the forces education communications transport
 customs and folklore observatories oceanography
 animals medicine wind and water mills
 civil and building construction mining agriculture
 and food production domestic architecture
 textiles genealogy recreations athletic sports and
 outdoor games biography and portraits geography
 historic and newsworthy events
Numbers pr c300 b&w
 fi negs c2000 b&w
 L sl 50 b&w
 postcards c20000
Access Bona fide students
Copies available for sale on certain conditions for loan

1539
Owner Colorific Photo Library Limited
Location 16 Spring Street London W2 01 723 5031
Custodian Terence Le Goubin
Dates c1936 (1970) -
Subjects GENERAL
Numbers tr c100000 col various
Aids Published catalogue card index published subject
 index
Access Picture researchers press tv media
 9.30 am - 5.30 pm
Copies available for display for publication credit line
 required
Charges Reproduction fee print/transparency fee
 holding fee service charge search fee
Notes Colorific represents more than 50 top international
 photographers, plus the French agency 'Top' and the
 Timelife Picture Agency. All past and present
 photographers associated with 'Time' 'Life' and
 'Fortune' are members of the staff and past and
 present staff photographers of 'Realities' magazine.

1540
Owner Alex Coupar
Location 19 South Tay Street Dundee East Region of
 Scotland 0382 21819
Dates 1950 -
Subjects GENERAL
Numbers fi negs c20000 various
Aids Card index

1541
Owner Colour Library International Limited
Location 80-82 Coombe Road New Malden Surrey
 KT3 49Z 01 942 7781-5
Custodian Mark Austin
Subjects GENERAL animals - wild and domestic
 girls couples families children outdoor
 activities sport - world UK pictorials human

interest still life nature transport - modern and vintage civil and building construction industrial subjects food and drink painting crafts
Numbers tr c500000 col various
Aids Published subject index
Access Picture researchers 9 am - 5.30 pm
Copies available
Charges Reproduction fee holding fee after 1 month £1 per tr per week service fee min £5 loss and damage £150

1542

Owner Daily Telegraph
Location Colour Library Gordon House 75-79 Farringdon Street London EC4 01 353 4242
Dates 1964 (1967) -
Subjects GENERAL religion social sciences occupations the forces associations and societies education communications transport customs and folklore science botany zoology medicine mechanical engineering civil and building construction mining agriculture and food production architecture antiques recreations sport biography and portraits geography events
Numbers tr c1500000 col various
Aids *Card index *subject index
Access Picture researchers press tv media 9.30 am - 5.30 pm
Copies available for sale for display credit line required
Charges Publication/reproduction fee print/transparency fee holding fee search fee

1543

Owner Dumbarton District Council
Location Dumbarton Public Library Strathleven Place Dumbarton G82 1BD Dumbarton 3129
Title Public Library Photographic Collection
Custodian W M Martin
Subjects GENERAL
Aids *Subject index
Access General public bona fide students
Copies available for loan

1544

Owner Ealing Photographic Society
Location c/o Thirlmere Gardens Wembley Middlesex
Title Permanent Collection of Prints
Custodian Mrs G W Dishart Honorary Secretary
Dates 1890 -
Photographer H Hucklebridge Herbert Young
Subjects GENERAL
Numbers pr 33
Notes Prizewinning prints by members of the Society since its inception in 1890.

1545

Owner East Lothian District Council
Location North Berwick Museum Victoria Road Haddington East Lothian EH41 4DO 062 082 2370
Custodian Brian M Gall
Dates c1888 -
Subjects GENERAL
Numbers gl negs c330 b&w ¼pl ½pl
Access General public Easter - October

1546

Owner George W F Ellis
Location 46 St Nicholas Street Bodmin Cornwall Bodmin 4316
Dates c1904 (1923) -
Photographer Jack Brice Clifford Clemens George W F Ellis Keith J M Ellis Maurice Retallick
Subjects GENERAL press photographs weddings sports deep sea fishing customs and folklore views of Devon Cornwall Wye Valley Forest of

Dean Somerset voyage on three masted barque to Labrador and Newfoundland
Numbers fi negs c100000 b&w col various
Aids Indexed by date
Access The negatives are not at the above address and can only be inspected by appointment
Copies available for sale
Charges On application
Notes Perhaps the best individual collection of deep sea fishing in the country.

1547

Owner Charles Eshborn
Location Beechfield Garstang Road Barton Preston Lancashire PR3 6DR 0772 862200
Dates 1915 -
Subjects GENERAL
Numbers pr substantial number fi negs 10000 L sl 3000 3¼"x3¼"

1548

Owner Robert Estall
Location 25b Christchurch Hill London NW3 1LA 01 435 0042
Dates 1960 -
Subjects GENERAL UK standing stones and circles folklore haunted sites industrial archaeology ancient monuments atmospheric scenes London European travel seasides winter sports horses cats farm animals cheese and wine making Canada
Numbers tr c25000 col 35mm 70mm
Aids Duplicated guide
Access Picture researchers press tv media 9.30 am - 10.30 pm telephone for appointment
Copies available for publication
Charges Publication fee compensation for loss or damage

1549

Owner Miss Serena Fass
Location 2 Chesil Court Chelsea Manor Street London SW3 01 352 8472
Dates 1965 -
Subjects GENERAL psychology religion social sciences children at play transport customs and folklore science nature botany agriculture and food production arts and crafts architecture painting textiles musical instruments recreations geography
Numbers sl 3000 col 35mm
Copies available for sale

1550

Owner Focal Point Filmstrips Limited
Location 251 Copnor Road Portsmouth Hampshire 0705 65249
Title Focal Point Filmstrips Slide Collection
Custodian Derek Riley
Dates (1967) -
Photographer Derek Riley
Subjects GENERAL microscopy geology meteorology nature botany zoology civil and building construction arts and crafts sculpture and carving architecture textiles winter sports geography
Numbers tr c6000 col 35mm
Copies available for sale for publication credit line required
Charges Reproduction fee
Notes The collection is intended mainly for use in education.

1551

Owner Ronald Grant
Location The Guildhall 20/21 High Street Clare Nr Sudbury Suffolk CO10 8NY 078 727 669
Title Ronald Grant Collection
Dates 19thC - c1950

Key () = dates when collections were begun or terminated
C = Century c = approximately pr = print fi = film
gl = glass neg = negative sl = slide L sl = lantern slide
tr = transparency mic = microform col = colour

b&w = black and white ¼, ½, 1-pl = quarter, half and whole plate * = single copy, no public access ** = single copy, access by appointment

Photographer Edward H Bonney Francis Frith
John Harris Harold J Motley J Valentine
George Washington Wilson
Subjects GENERAL English and foreign scenery and
architecture travel holidays family albums
portraits transport
Numbers pr c30000 various
fi negs c10000
gl negs c10000 $4\frac{1}{4}$"x$3\frac{1}{4}$"
L sl c1200 b&w c200 col
tr c150 $2\frac{3}{4}$"x$2\frac{3}{4}$"
stereo photographs pr & negs c270
Access Press tv media
Copies No copies but original material loaned
Charges Reproduction fee on application

1552
Owner John Hannavy
Location 2 Sandycroft Avenue Wigan Greater Manchester
0942 45838
Dates 1843 (1969) -
Photographer Francis Bedford Roger Fenton
Francis Frith Thomas Keith Carl Norman
Alfred Pettit James Valentine George Washington
Wilson
Subjects GENERAL including portraits landscape
UK Germany Egypt Suez early book illustrations
Numbers pr c800 b&w various
paper negs 12 $11\frac{1}{2}$"x$9\frac{1}{2}$"
gl negs 4 $\frac{1}{2}$pl
gl pos 20 1/6pl ambrotypes
daguerreotypes
tintypes
Aids Card index subject index
Access by arrangement
Copies available for loan
Charges Reproduction fee by negotiation
Notes Essentially a collection illustrative of
photographic history and most of the early processes.

1553
Owner D R Hardwick
Location 72 Oxbridge Lane Stockton Cleveland
92 64899
Dates c1900 - ?
Subjects GENERAL Western pioneers Indians lifeboats
fire engines Life of Queen Victoria and Edward VII
Transvaal War nursery rhymes religion scenery
Numbers pr 28 b&w 6"x4" $3\frac{1}{2}$"x$2\frac{1}{2}$"
L sl 50 b&w 120 col $3\frac{1}{4}$"x$3\frac{1}{4}$"
Access Appointment by letter only
Copies available for sale by arrangement
Charges Print fee by arrangement reproduction fee within
stipulated range of charges

1554
Owner Paul Hill
Location The Photographer's Place Bradbourne
Ashbourne Derbyshire Parwich 392
Dates c1850 (1969) -
Photographer Bill Brandt Julia Margaret Cameron
Dr P H Emerson Frederick Evans Francis Frith
D O Hill Paul Strand Frank Sutcliffe
Sir Benjamin Stone J Valentine George Washington
Wilson Edward Weston
Subjects GENERAL social sciences occupations and
services the forces transport customs and folklore
agriculture and food production architecture
recreations geography
Numbers pr c100 b&w various
Access General public bona fide students by appointment
only
Copies available for sale
Charges Print fee £1.50p (10"x8" b&w)
Notes Although the collection has many 19thC pieces
the strength is in the 20thC particularly contemporary
work.

1555
Owner Frank Hoppé

Location Ogbeare Hall North Tamerton Holsworthy
Torridge Devon North Tamerton 208
Dates 1908 - 1970 (1972)
History The late Emil Otto Hoppé left the majority of his
work to Frank Hoppé, his son
Photographer Emil Otto Hoppé
Subjects GENERAL religion social sciences
occupations and services associations and societies
education transport customs science natural
history engineering agriculture domestic
arts and crafts recreations sports portraits
geography
Numbers Total c3000 images
Aids Card index subject index
Access Picture researchers bona fide students press
tv media on occasion by private appointment
Copies available for sale for loan for display
for publication credit line required
Charges Reproduction fee print fee handling fee holding
fee search fee service charge

1556
Owner Anwar Hussein
Location 29 Wyndham Street London W1 01 723 2158
Dates 1965 -
Photographer Anwar Hussein
Subjects GENERAL social sciences communications
transport customs and folklore zoology fashion
arts and crafts architecture antiques photography
musical instruments recreations athletic sports and
outdoor games biography and portraits geography
newsworthy events - royalty pop people foreign
countries
Numbers tr c20000 col 35mm
Aids Published guide published subject index
Access Picture researchers bona fide students press
tv media 9 am - 6 pm
Copies available for sale for display for loan
for publication credit line required
Charges Reproduction fee print/transparency fee
holding fee charged after one week

1557
Owner I P C Business Press Limited
Location Photographic Department Dorset House
Stamford Street London SE1 9LU 01 261 8000
Custodian W E Banks
Dates c1908 -
Photographer W E Banks P C Collingworth P Osmond
Subjects GENERAL hospitals and medical air force
communications transport mechanical engineering
agriculture and food production yachting aerial
photography
Numbers fi negs substantial number b&w 35mm
gl negs substantial number b&w 9"x12" 5"x4"
Aids Catalogue
Copies available for sale for display for publication
Charges Print/transparency fee handling fee search fee
Notes This is a "collection of collections" each relating to
a particular journal in which the photographs first
appeared - Flight Motor Autocar Nursing Mirror
etc.

1558
Owner Lake District Art Gallery Trust
Location Kendal Cumbria 0539 22464
Title Abbot Hall Art Gallery Exhibition Service -
Northern Arts
Custodian Mrs M E Brown
Dates 1870 -
Photographer Thomas Bewick Colin Curwood
Sirkka-Liisa Konttinen Joseph Koudelka
Karen Melvin Spectro Arts Workshop Frank Sutcliffe
Subjects GENERAL Whitby fashion townscapes
parts of machines Newcastle Victorian inventions
American rural life
Numbers pr c503 b&w various
Aids Catalogue
Access General public
Copies available for sale for loan
Charges Print fee loan fee £10 per fortnight

N

1559
Owner David Livesey
Location The Vicarage Osbaldwick Lane Osbaldwick
 York North Yorkshire
Dates c1870 -
Photographer David Livesey
Subjects GENERAL religion education transport
 animals architecture portraits Isle of Man
 Manchester
Numbers pr 60 b&w 10"x12" some contained in 1 album
 L sl c50 b&w
 tr substantial number
Access Bona fide students picture researchers
 publishers press tv media
Copies available
Charges Print fee by arrangement

1560
Owner Mack of Manchester Limited
Location Victoria Mill Pollard Street Manchester
 M4 7AY 061 273 3625
Title Industrial Commercial and Public Relations
Custodian Director and General Manager
Dates c1964 -
Subjects GENERAL occupations and services
 associations and societies education communications
 transport mechanical engineering civil and
 building construction agriculture and food
 production architecture photography geography
 industry and commercial and public relations
Numbers fi negs c42000 b&w col various
Copies available for sale for display for publication
 with the written permission of copyright holder
Charges Reproduction fee print/transparency fee
 handling fee service charge search fee

1561
Owner John R Myers
Location 9 Brook Road Oldswinford Stourbridge
 West Midlands 038 43 73116
Dates (1973) -
Photographer Tony Ray-Jones August Sander
Subjects GENERAL
Numbers pr contained in albums
Access Bona fide students

1562
Owner North Atlantic Press Agencies Limited
Location 11 Wakefield Drive Welford Northampton
 Welford 346
Title N A P A Library
Custodian M A B Coulthard
Dates 1965 -
Subjects GENERAL religion politicians parks
 prisons occupations and services the forces
 societies transport customs and folklore
 archaeology anthropology plants animals
 engines mills bridges dams agriculture
 painting circuses theatre athletics outdoor life
 portraits landscapes travel abroad
Numbers pr c1000000 b&w
 fi negs c850000 b&w
 tr c750000 col
Aids Duplicated catalogue card index subject index
Access General public picture researchers press tv
 media 9 am - 8 pm telephone for appointment
Copies available for sale for loan for display for publication
Charges Reproduction fee print/transparency fee
Notes Over 2000 photographers are represented in this
 collection.

1563
Owner Orbis Publishing Company Limited
Location 20/22 Bedfordbury London WC2 4BL
 01 379 6711
Custodian M A Knight

Dates (c1970) -
History The collection of photographs has been used in
 the following publications - World of Pets Mind and
 Body Junior Science Encyclopedia Series
 American History World War II
Photographer Ray Dean Terence Le Goubin
 Mikki Slingsby John Wallace
Subjects GENERAL psychology hospitals and medical
 dress uniforms the forces education
 communications transport science nature
 precision instruments food production precious
 stones antiques geography historic and
 newsworthy events portraits - Nobel Prize winners
 Batik fashion animals World War II
Numbers pr c5000 b&w
 tr c10000 col 2¼"x2¼" 35mm
Aids Card index and subject index in preparation
Access Bona fide students picture researchers press
 tv media 9.30 am - 5.30 pm
Copies available for loan for publication subject to
 copyright
Charges Reproduction fee holding fee if material is not
 used search fee £1.50

1564
Owner Oxford University Press and Clarendon Press
Location Walton Street Oxford 0865 56767
Custodian Illustrations Officer
Dates (c1920) -
Subjects GENERAL
Numbers pr 20000 + b&w
Aids Card index
Copies Originals occasionally available for loan to another
 publisher
Notes The photographs illustrate over 2000 book titles.

1565
Owner Paul Popper Limited
Location 24 Bride Lane London EC4 01 353 9665
Title Popperfoto
Dates 1850 (c1900) -
History This collection is associated with Herbert
 Ponting who was the photographer with Scott's
 expedition and includes photographs found on Scott's
 body
Subjects GENERAL NEWSWORTHY EVENTS Royalty
 topography biography World Wars 20thC history
 expeditions
Numbers pr 10 million various
 fi negs 6 million various
 gl negs ½ million various
 tr 2 million various
 engravings ¼ million
Aids There are guides, catalogues card index
 photographers chronological job books to various parts
Access Bona fide users of photographs personal callers
 not known to the Librarian should bring a letter of
 authorisation
Copies available for loan photographs, engravings or
 transparencies are loaned for a period of 30 days to the
 customer and remain the property of Paul Popper
 Limited
Charges Reproduction rights must be agreed with Paul
 Popper Limited prior to publication, rights granted are
 conditional upon payment being made on or before
 publication reproduction fee standard rates for
 British publishers Traditional market - monotome £7
 colour £15 fees paid are for one edition for a maximum
 period of three years. Co-editions each language
 (including simultaneous paper back editions) and
 subsequent editions are subject to an additional fee of
 half the appropriate rate. Other fees on application
 VAT extra where applicable
Notes this large collection includes Oldhams
 Periodicals Library, illustrated Today, from Bull, Planet,
 ACME and UPI libraries, deposits from various
 agencies, the largests single collection of World War II

Key () = dates when collections were begun or terminated
C = Century c = approximately pr = print fi = film
gl = glass neg = negative sl = slide L sl = lantern slide
tr = transparency mic = microform col = colour

b&w = black and white ¼, ½, 1-pl = quarter, half and whole
plate * = single copy, no public access ** = single copy,
access by appointment

colour transparencies, Conway Picture library
Exclusive News Agency, National photo Agency,
H.G. Polting.

1566
Owner Photo Library International
Location 11 Bennett Road Leeds West Yorkshire
LS6 3HN 0532 757724
Title General Library Collection
Custodian M Woodward
Dates (1974) -
Subjects GENERAL abstracts aeroplanes animals
archaeology architecture barges beaches birds
cars carnivals castles cathedrals children
crafts churches cottages couples crowds
farming flowers fruit gardens girls harbours
historical places horses industrial insects
lakes marine life markets monuments moon
motor cycling-racing mountains mountaineering
night shots sky diving space parks people
pollution railways rivers and waterways
roadways sailing seascapes seaside snow scenes
sport stately homes storms still-life street
scenes sunsets and sunrise trees tribal vintage
cars engines transport windmills travel
UK and abroad glamour
Numbers tr c15000 col various
Aids Duplicated subject index
Access Picture researchers press tv media
9.30 am - 5.30 pm
Copies available for publication
Charges Reproduction fee print/transparency fee
holding fee search fee

1567
Owner Photoresources
Location 21 Ashley Road London N19 3AG 01 272 5062
Custodian C Miller
Dates 1952 (1974) -
Photographer M Barnett A Ede R Hields P King
Subjects GENERAL human behaviour religion
social sciences occupations tools education
transport ceremonies chronology geology
meteorology palaeontology archaeology
anthropology trees animals physiology
mechanical engineering civial and building
construction precision instruments mining
agriculture and food production food home
clothes arts architecture paintings numismatics
textiles antiques recreations athletic sports and
outdoor games biography and portraits geography
travel abroad historic events
Numbers pr c500 b&w 8"x10"
fi negs c1000 b&w various
sl c60000 col various
Aids Duplicated guide subject index
Access Picture researchers press tv media
by arrangement 9 am - 5 pm
Copies available for sale for reproduction credit line
required
Charges Reproduction fee print fee search fee and
holding fee sometimes charged

1568
Owner Pictor International Limited
Location 24-32 Kilburn High Road London NW6 5XW
01 328 1581
Dates 1956 -
History This library was founded by Leo Aarons
Subjects GENERAL
Numbers pr c25000 b&w 10"x8"
tr c500000 col various
Aids Catalogue in preparation
Access Art directors printers or anyone interested in
acquiring reproduction rights of photographs
9 am - 6 pm
Copies Originals for loan for reproduction credit line
required
Charges Reproduction fee holding fee
Notes Pictor International Limited represent English

French Italian German American and Japanese
photographers.

1569
Owner Pictorial Press Limited
Location Woodbridge House 1 Woodbridge Street
London EC1R 0BL 01 253 4023
Dates c1938 -
Subjects GENERAL from animals to zoos
Numbers pr 1500000 b&w 10"x8"
fi negs c1000000 b&w
tr 500000 col 6cm x 6cm 35mm
Aids Duplicated catalogue
Access Picture researchers press tv media
9.30 am - 5.30 pm
Copies available for sale for publication
Charges Reproduction fee service charge
Notes The collection is mainly post 1938 to present day,
but includes Crimea, World War I, and early China.

1570
Owner Radio Times Hulton Picture Library
Location 35 Marylebone High Street London W1M 4AA
01 580 5577 Ext 4621
Custodian Miss C Sergides
Dates c1855 -
History The library began as the Picture Post Library
after World War II. It was established to organise and
make available the photographs taken for Picture
Post 1939-1945. Other collections were added to the
current intake of Picture Post material until 1957
when Picture Post ceased. The library was then
re-named the Hulton Picture Library after the
owner of Hulton Press, Sir Edward Hulton
Photographer Too numerous to mention
Subjects GENERAL theatre ballet portraits
natural history Britain Ireland USA Canada
France Royal family topography newsworthy
events seascapes Boer War world travel
sporting personalities war pictures
Numbers pr c6000000+
Aids Accession catalogue subject catalogue
Access Picture researchers 9.30 am - 5.30 pm
Monday to Friday
Copies available for loan for publication
Charges Reproduction fee or service fee in UK Eire and
North America the rest of the world print fees are
charged in addition commercial rates
Notes The largest commercial collection in Britain, it
includes Gordon Anthony and Derrick de Marney
Theatre Collection, Baron Ballet and Portrait
Collection, Dixon-Scott Collection, William England
Collection, Herbert Felton Collection, Le Grice
Collection, Henry Guttman Collection and many many
more.

1571
Owner Royal Scottish Museum
Location Department of Technology Royal Scottish
Museum Chambers Street Edinburgh EH1 1JF
031 225 7534
Custodian A Q Morton
Dates 1841 -
Photographer D O Hill and R Adamson
W H Fox Talbot
Subjects GENERAL
Numbers pr c2000
fi negs 500
gl negs 2000
Aids Card index arranged according to the subject of the
photograph
Access The collection can be inspected by appointment
Copies Some copies available
Charges Reproduction fee
Notes Publishers are asked to apply to the Administrative
Department, Royal Scottish Museum.

1572
Owner Science Museum Library
Location South Kensington London SW7 5NH
01 589 6371

Title Science Museum Photographs and Lantern Slides
Custodian Dr D B Thomas
Dates 1910 -
Subjects GENERAL acoustics aeroplanes agriculture
and food production anchors astronautics astronomy
atomic physics aviation boilers brick making
bridges buildings carts chemistry carriages
chronology cinematography civil and building
construction communications cycles diving
equipment docks and harbours domestic
electrical engineering and equipment electronics
firemaking appliances and protection food
production gas manufacture geodesy and surveying
geophysics glass heat engines heating
internal combustion engines Leonardo da Vinci
lifting appliances lighthouses lightships lighting
lightning locks magnetic instruments marine
engines measuring mechanical handling
merchant steamers metallurgy meteorology
microscopes mining navigation optics paper
making photography physics pile driving
portraits pottery power transmission precision
instruments printing propellors - marine pumps
radar radio railways - locomotives and rolling stock
refrigeration road construction and transport roofs
sanitation sesismology sewing machines ships -
sailing steam war merchant steam engines -
static telegraphy TV textiles tides tools
transport tunnels turbines typewriting vacuum
pumps vehicles - steam electric motor
ventilation water supply Watt's workshop
weighing wind and water mills X-rays
Aids Lists of titles supplied on request
Access General public
Copies available for sale
Charges on application
Notes The collection consists mainly of photographs of
items from the Museum's collections.

1573

Owner G Selkirk
Location 40 Parkside Grove Bradford West Yorkshire
BD9 5LL
Dates c1900 -
Subjects GENERAL family interests
Numbers pr c1000 b&w 50 col various
fi negs c1000 b&w col 35mm
sl 100 col 2"x2"
Access Bona fide students publishers
Copies available for sale
Charges Print fee reproduction fee

1574

Owner Spectro Arts Workshop
Location 18 Station Road Whitley Bay Tyne and Wear
089 44 22336
Title Northumbrian Photographic Collection
Custodian Norma A Tilley
Dates c1880 (1970) -
Photographer W and D Downey Lyddell Sawyer
Scott-Hyde Frank Meadow Sutcliffe
James Valentine
Subjects GENERAL
Numbers pr c500 b&w col
fi negs c2000 b&w col
gl negs c600 b&w
gl sl 2 12"x10"
L sl c300 3¼"x3¼"
copy images of some negs
Aids Catalogue in preparation
Access General public bona fide students by
appointment only

1575

Owner Spectrum Colour Library

Location 44 Berners Street London W1P 3AB
01 637 1587/2108
Custodian Ann Jones Keith Jones
Dates 1969 -
Subjects GENERAL
Numbers pr 10000 b&w 10"x8"
tr c1000000 col 35mm 2¼"x2¼"
Aids Guide catalogue card index subject index
Access Picture researchers press tv media
appointment preferred 9.30 am - 5.30 pm
Copies available for sale for display for publication
credit line required
Charges Reproduction fee print/transparency fee
service charge handling fee search fee holding fee
after 30 days on approval damages payable
Notes Spectrum own the copyright of 50% of the material
and act as agents for the owners of the remaining 50%.

1576

Owner Frank Spooner Pictures
Location City Golf Club Bride Lane Fleet Street
London EC4 01 353 9933
Dates (1958) -
Photographer David Burnett Giles Caron
Raymond Depardon Marie Louise Decker
Charles Gerretson William Karel Kurita Kuko
Subjects GENERAL
Numbers substantial
Aids Card index
Access Picture researchers press tv media
10 am - 7 pm
Copies available for publication
Charges Reproduction fee print/transparency fee
handling fee holding fee service charge search fee

1577

Owner Staffordshire County Council
Location Museum and Art Gallery The Green Stafford
0785 2151
Custodian J Rhodes
Dates 1860 (c1960) -
Subjects GENERAL
Numbers pr c500 b&w
gl negs c100 b&w
L sl c200 b&w
Aids *Catalogue *card index
Access General public bona fide students by appointment
only

1578

Owner Stratford Express
Location High Street Stratford London 01 534 4555
Custodian Martin Mallin
Dates 1973 -
Photographer John Curtis John Hercock Martin Mallin
Subjects GENERAL politicians the forces - training
children at play recreations athletic sports and
outdoor games
Numbers fi negs c5000 b&w 35mm
Aids *Card index
Access Picture researchers press
Copies available for sale for loan
Notes All events of any importance have been covered.

1579

Owner Thompson Holidays Limited
Location Greater London House Hampstead Road
London NW1 01 387 9321
Title Thompson Holidays Photographic Library
Custodian Library Manager
Dates (1960) -
Photographer Joan Bethell Laurie Haskell
Hans Linder Colin Maher
Subjects GENERAL portraits shopping nightlife
sport food flowers transport hotels
scenic views - Spain Portugal Italy Yugoslavia

Key () = dates when collections were begun or terminated
C = Century c = approximately pr = print fi = film
gl = glass neg = negative sl = slide L sl = lantern slide
tr = transparency mic = microform col = colour

b&w = black and white ¼,½,1-pl = quarter, half and whole
plate * = single copy, no public access ** = single copy,
access by appointment

Greece Tunisia Malta Algeria Rumania
Switzerland Austria France Andorra Jamaica
Egypt Russia
Numbers tr c40000 col 35mm $2\frac{1}{4}''$x$2\frac{1}{4}''$
Aids *Subject index
Copies available for loan

1580
Owner Tyne and Wear Metropolitan County Council
Location Gateshead Central Library Prince Consort Road
 Gateshead Tyne and Wear NE8 4LN 0632 73478
Custodian Borough Librarian
Dates 1850 -
Subjects GENERAL transport town life village life
 occupations and services societies education
 mechanical engineering mining ceramics
 architecture genealogy musical performances
 football biography and portraits
Numbers pr 4000 b&w $\frac{1}{2}$pl 1pl
 fi negs 500 b&w
 gl negs 300 $\frac{1}{4}$pl
 sl 400 b&w col 35mm
Aids Self indexing on cards
Access General public bona fide students
Copies available for sale
Charges Print fee from 40p $\frac{1}{2}$pl

1581
Owner University of Leeds

Location Brotherton Library Leeds LS2 9JT
 0532 31751 Ext 6551
Custodian D Cox
Subjects GENERAL
Numbers pr substantial numbers
 L sl
 mic c2800 35mm
Aids Catalogue of microforms
Access Bona fide students

1582
Owner ZEFA Picture Library (UK) Limited
Location P O Box 2 32A Shelton Street London
 WC2H 9HY 01 836 7977
Title General Colour Library of Colour Transparencies
Dates (c1955) -
Photographer Walter Benser
Subjects GENERAL
Numbers tr 500000 col various
Aids Guide catalogue punched card computer system
 for all transparencies
Access Picture researchers press tv media
 9 am - 6 pm
Copies available for sale for display for loan
 for publication
Charges Reproduction fee print/transparency fee
 holding fee charged after 30 days search fee
 charged only in certain instances
Notes A large and comprehensive collection representative
 of the work of 500 photographers, chiefly European.

o

P

S

T

SELECT BIBLIOGRAPHY

Annual Directories and Year-Books

Civic Trust Environmental Directory. Civic Trust, London

Directory of British Associations. CBD Research Publications, Beckenham

Historic Houses, Castles and Gardens in Great Britain and Ireland. ABC Travel Guides Ltd., Dunstable

The Institute of Incorporated Photographers Yearbook, Ware

Corbett, E. V. (ed.), *The Libraries, Museums and Art Galleries Year Book*. James Clarke and Co., Cambridge

Museums Calendar. Museums Association, London

Museums and Galleries in Great Britain and Ireland. ABC Travel Guides Ltd., Dunstable

The Photographic Alliance of Great Britain Handbook. Woodford Green, London

Publishers in the UK and Their Addresses. J. Whitaker and Sons Ltd., London

The Times 1000 Leading Companies in Britain and Overseas. London

Whitaker's Almanack. London

Willings Press Guide. Thomas Skinner Directories, Croydon

World of Learning. Europa Publications, London

The Writers' and Artists' Year Book. A. and C. Black, London

Occasional Directories

Barley, Professor M. W., *Guide to Collections of Topographical Drawings*. Council for British Archaeology, London, 1973

International Directory of Photographic Archives of Works of Art. UNESCO, 2 vols., London, 1950–54

Evans, Hilary and Mary, and Nelki, Andra (eds.), *The Picture Researchers Handbook*, David and Charles, Newton Abbot, 1973

Harrison, Molly, and others (eds.), *Picture Source Book for Social History*. George Allen and Unwin, 5 vols., London, 1951–67

Alenberg, S. (ed.), *Picture Sources*. Special Libraries Association, USA. New York, 1975

Record Repositories in Great Britain. Royal Commission on Historical Manuscripts, 5th edition, London, 1973

Evans, Hilary and Mary. *Sources of Illustration: 1500–1900*. Adams and Dart, Bath, 1971

International Directory of Arts. Deutsche Zentraldruckerei A.G. 7th edition, 2 vols., Berlin, 1963–64

History of Photography

Gernsheim, Helmut and Alison, *A Concise History of Photography*. Thames and Hudson, London, 1965

Gernsheim, Helmut and Alison, *Creative Photography: 1826 to the Present*. Wayne State University Press, Detroit, 1963

Gernsheim, Helmut and Alison, *The History of Photography from the Earliest Use of the Camera Obscura in the Eleventh Century up to 1914*. Aperture Inc., New York, 1973

Gernsheim, Helmut, *Masterpieces of Victorian Photography*. Phaidon Press, London, 1951

Pioneers of Photography. British Broadcasting Corporation. London, 1975

Pollack, Peter, *The Picture History of Photography from its Earliest Beginnings to the Present Day*. Abrams, London, 1970

Powell, Tristam, *Victorian Photographs of Famous Men and Fair Women by Julia Margaret Cameron*. Hogarth Press, London, 1973

Thomas, D. B., *The First Negatives*. The Science Museum, London, 1970

Catalogues

Campbell, Robin and Drew, Joanna, *The Real Thing: An Anthology of British Photographs 1840–1950*. Arts Council of Great Britain, 1975

David Octavius Hill and Robert Adamson: Centenary Exhibition Catalogue. Scottish Arts Council, Edinburgh, 1970

Ford, Colin and Strong, Roy, *An Early Victorian Album: The Hill/Adamson Collection*. Jonathan Cape, London, 1974

Ford, Colin (ed.), *Lewis Carroll and Christ Church*. National Portrait Gallery, London, 1974

Preservation

Castle, Peter, *Collecting and Valuing Old Photographs*. Garnstone Press, London, 1973

The Conservation of Colour Photographic Records. The Royal Photographic Society of Great Britain, Colour Group, Monograph No. 1, London, 1974

Howarth-Loomes, B. F. C., *Victorian Photographs and Collector's Guide*. Ward Lock, London, 1974

The Preservation of Technological Material. Report and Recommendations of the Standing Commission on Museums and Galleries. The Museums Association and HMSO, London, 1971

The Recognition of Early Photographic Processes, Their Care and Conservation. The Royal Photographic Society of Great Britain, Historical Group, London, 1974

Technical

British Standard 1000A: Universal Decimal Classification. Abridged English (3rd Revised)

Edition. British Standards Institution, London, 1961

Non-Book Materials Cataloguing Rules. National Council for Educational Technology, with the Library Association Media Cataloguing Rules Committee, Working Paper No. 11, London, 1973

Photographic Reproductions

In recent years there has been a mushrooming growth in the production of books devoted to photographic reproductions, with short captions and the minimum of textual material. This new phenomenon has been made possible, at least in part, by the work of the National Photographic Record. A number of collections which feature in this Directory have contributed to such publications – the owner and the author being one and the same. The titles of some of these books are given under the heading *Notes* for the appropriate entries. A special case are publications which feature contrasting views of buildings, townscapes and street scenes by means of antique and contemporary photographs of the same locations. An instance is the series 'Then and Now' by Educational Productions of Wakefield. The 'As it was' series put out by the Hendon Publishing Company, of Nelson, Lancs, is entirely based on antique photographs.

Cardlist design/print Eyre & Spottiswoode Ltd Grosvenor Press Portsmouth England